INITIATIVE, PATERNALISM,

AND RACE RELATIONS

EDMUND L. DRAGO

Initiative, Paternalism, & Race Relations

Charleston's Avery Normal Institute

The University of Georgia Press Athens & London

© 1990 by the University of Georgia Press

Athens, Georgia 30602

All rights reserved

Designed by Rich Hendel

Set in Mergenthaler Ehrhardt

Typeset by Tseng Information Systems, Inc.

Printed and bound by Thomson-Shore

The paper in this book meets the guidelines for permanence and
durability of the Committee on Production Guidelines for Book
Longevity of the Council on Library Resources.

Printed in the United States of America

94 93 92 91 90 5 4 3 2 1

Library of Congress Cataloging in Publication Data

Drago, Edmund L.

Initiative, paternalism, and race relations :

Charleston's Avery Normal Institute / Edmund L. Drago.

p. cm.

Bibliography: p.

Includes index.

ISBN 0-8203-1124-3 (alk. paper)

1. Avery Normal Institute—History. 2. Afro-Americans—Education
(Secondary)—South Carolina—Charleston—History. 3. Charleston
(S.C.)—Race relations—History. 4. Paternalism—South Carolina—
Charleston—History. I. Title.

LC2852.C443D73 1990

373.757′915′08996073—dc20 89-33108

CIP

British Library Cataloging in Publication Data available

To my parents, Dr. and Mrs. Rosario C. Drago

CONTENTS

PREFACE

Shortly after arriving at the College of Charleston in 1975, I was asked by one of our history majors, Carl Gathers (College of Charleston, 1978), for information about a black school founded near the college during Reconstruction. I thought he was referring to Shaw Memorial School. But, in fact, he was alluding to Avery Normal Institute, which Joel Williamson mentioned briefly in his monograph on South Carolina blacks during Reconstruction. I soon learned that several of my coworkers at the college were Avery graduates, including Lucille Whipper, Head of Human Relations, and Eugene C. Hunt, a member of the English department. Avery also came to my attention through the news media. H. Carl Moultrie (Avery, class of 1932) presided over the trial of the eleven Hanafi gunmen who had occupied three Washington buildings and seized 134 hostages in March 1977. Paul Washington (class of 1937) came to national attention in 1980 during the Iranian hostage crisis. He joined a fact-finding delegation, composed of ministers and lawyers, headed by former United States Attorney General Ramsey Clark, that defied the Carter administration by traveling to Iran. Washington was an Episcopal minister and Philadelphia civil rights activist.[1]

Having just completed a book on Reconstruction, I was encouraged to pursue my interest in Avery by Lucille Whipper, who suggested that I write a paper on Avery for a 1980 meeting of the Association for the Study of Afro-American Life and Culture. Whipper then headed the Avery Institute of Afro-American History and Culture, a local group dedicated to acquiring the old Avery buildings and turning the site into a museum and archives of Low Country Afro-American history and culture. The group subsequently received a planning grant from the federal government to pursue the project. Under its auspices Eugene C. Hunt and I conducted a series of interviews to document the historical significance of the buildings. In 1980 I received a grant from the National Endowment for the Humanities to finish a history of the school.

Although Amistad Research Center, Tulane University, New Orleans, Louisiana, had some wonderful American Missionary material on Avery, the manuscript collection covered in depth only the years 1865–1880, and 1930–1954. Fortunately, interviews were most helpful, since most of them were with the oldest graduates, some of whom are now deceased. These gradu-

ates shared with Hunt and me their cherished documents, including year-books, school newspapers, programs, photographs, and artifacts. Additional materials surfaced both during and after our Avery exhibit in 1981.

I have approached the history of Avery chronologically. This entailed the repeating, interweaving, and developing of significant themes in a time framework which I have divided into seven chapters. The story starts in the antebellum period. Chapter 1 focuses on the antebellum events and forces that shaped the political, social, and cultural milieu from which Avery arose. Chapter 2 deals with the actual establishment of the school and ends with the demise of Radical Reconstruction (1877). Chapter 3 covers the Gilded Age and concludes in 1914 with World War I and the arrival of Benjamin F. Cox, the first permanent black principal after Francis L. Cardozo (1866–1868). Chapter 4 traces those years of the school under his leadership, ending with his resignation in 1936. Chapter 5 is concerned with the school's last years as a private institution, 1936–1947. Chapter 6 follows the history of Avery as a public institution with John F. Potts as its principal. The seventh chapter takes the story from Avery's closing in 1954 through the 1969 Charleston hospital strike, the last mass demonstration mounted by the civil rights movement. It is fitting that the book concludes with the Second Reconstruction. The last chapter, based largely on interviews and newspaper reports, makes no pretense at being a definitive history of the civil rights movement in Charleston. I hope only to give the reader the flavor of the times and to document the role some Averyites played in the Charleston movement.[2]

I had intended to write a brief institutional history of Avery, but as I related the school's history to its larger surroundings, the scope of the manuscript grew. The school not only provided teachers for black public schools throughout the state, it produced the city's black leaders. Averyites were at the center of the city's black institutional life. In founding the Charleston Chapter of the National Association for the Advancement of Colored People (NAACP), they were also in the forefront of the nascent civil rights movement in the Low Country. In recording their efforts, this study offers the reader a glimpse into larger issues: black initiative, Yankee paternalism, race relations, and color tensions within the city's black community. Because of this expanded scope, it addresses the interplay of state and national trends or events at the local level. I also hope the book will have merit as a reference work. In placing Avery in its educational setting, I have described the evolution of some of the city's most important black schools. They show what Avery might have become. I have included miniature biographies of important Averyites to illustrate the impact of the school. Ardent proponents of the

social uplift philosophy, they believed that by making themselves useful and productive citizens, they were contributing to the uplift of the entire race.

Many people made this book possible. My wife Cheryle's support and encouragement never wavered. Eugene C. Hunt's contribution was indispensable. Together we interviewed nearly two dozen persons. Their testimonies made this book richer. Likewise, I am indebted to Edwina H. Whitlock, who not only shared valuable family papers with me but also quickly edited the manuscript to meet a pressing deadline. I want to thank John F. Martin and Yvette R. Murray for helping me proofread the page proof, and Gregory Teague, who read proof for the University of Georgia Press.

With the assistance of Kenneth M. Stampp, Paul Hamill, Leon Litwack, and Jack Sproat, I obtained a fellowship from the National Endowment for the Humanities. The College of Charleston granted me a sabbatical to complete the book. Charles Royster provided long-term moral support and offered valuable suggestions on how to improve the manuscript. Other scholars who commented on the manuscript include O. Vernon Burton, Clarence Walker, Charles Joyner, Jacqueline Jones, George Rogers, Jr., Clarence Mohr, William Pease, Joe Richardson, Alvin Skardon, Robert L. Harris, Jr., and I. A. Newby. I relied heavily on Michael F. Finefrock's considerable skills as a computer consultant. For whatever weaknesses there are in this book, I have no one to blame but myself. I would also like to thank Clifton H. Johnson, executive director of the Amistad Research Center, New Orleans, for his thorough reading of the manuscript. His assistant, Lester Sullivan, was relentless in uncovering materials for me. Other helpful archivists include Esme E. Bhan, Moorland-Spingarn, Howard University; Margaretta P. Childs, South Carolina Historical Society; Catherine E. Sadler, Charleston Library Society, and Carolyn James, Office of Archives and Records, Charleston County School District. The staff at the Robert Scott Small Library did yeoman work on my behalf, particularly Oliver Smalls, Dorothy Fludd, Veronique Aniel, and Sheila Seaman.

Finally, I want to thank Malcolm Call and the University of Georgia Press, especially Madelaine Cooke and Gene Adair. Susan Thornton did a fine job of editing the manuscript.

INITIATIVE, PATERNALISM,

AND RACE RELATIONS

INTRODUCTION

Avery was shaped by a variety of events and people, including white Charlestonians, northern blacks, missionaries, and a diverse Low Country Afro-American population. Charleston's white population, ranging from white laborers to mechanics, storekeepers, planters, lawyers, and merchants, was never monolithic. Today its spectrum ranges symbolically from the Naval Shipyard, located in North Charleston, to the Battery and South of Broad, on the peninsula, where some of the descendants of the planters still live. Charleston's nineteenth-century white mechanics and their modern counterparts, hard-pressed by competition from blacks, viewed the city's black population as a threat to their livelihood. Their resentment toward blacks, periodically resulting in violence, was often a factor in municipal elections as the Low Country elite found that it had to placate them.

Located in a city that prided itself on an aristocratic ethos, Avery was, in turn, influenced by it. The city's antebellum aristocratic heritage has survived time and the influx of industry. Despite his upcountry birth, John C. Calhoun has come to symbolize this aristocratic ethos. Shortly after his death in 1850, various civic groups in the city decided to erect a monument to South Carolina's "Great Nullifier." Inspired by the Ladies Calhoun Monument Association (1854), the locals laid the cornerstone of the monument in Francis Marion Square in 1858. The Civil War postponed efforts to complete the monument until 1887. The original monument's poor casting necessitated a total remodeling less than ten years later. The new Calhoun monument, some eighty feet high, stood on a pedestal erected on the thirty-six-square-foot granite base that was part of the original. It was unveiled on June 27, 1896.[1]

Some people, especially those living South of Broad, are loath to admit that a slave market ever existed in the city, but even the progeny of the slaveholders concede the impact of slavery on the culture of the Low Country. In 1966 the Charleston *News and Courier* explained that the all-white Society for the Preservation of Spirituals had "its beginnings nearly a half a century ago when descendants of plantation owners who had moved into Charleston to live gathered at each others' houses to sing the beloved songs learned from the Negro friends. Asked to perform at a church bazaar, they proved such a hit that a formal organization was set up and soon became well-known." The group staged two concerts a year, once performing in the White House.

Besides their love of plantation music, the descendants of the planters continue to share with Low Country blacks a common language. Recalling the radio and television speeches of the former United States senator Burnett Rhett Maybank, Averyite Septima P. Clark observed, "Senator Maybank was a Charlestonian of the Charlestonians, born on Legare Street—pronounced, incidentally Luh-gree—and he spoke Charlestonese straight and unadulterated." Clark concluded: "I don't mean that Senator Maybank, of course, spoke Gullah. He spoke the dialect of the most aristocratic Charlestonians. But I am quite sure he was understood perfectly by the people of the island who spoke Gullah and I am quite sure he understood what they were saying."[2]

If Charleston's white elite adopted some of the culture of Low Country blacks, the process was certainly mutual. The emphasis placed on manners at Avery was not introduced by Yankee missionaries. Charleston's black elite, free and slave, had always prided themselves on their gentility. Their concern for decorum can be seen in the rules of their various antebellum black and brown benevolent societies. Exactly how much of this emphasis on manners was a product of Charleston's aristocratic ethos is open to question, but the impact of this ethos on the city's free black elite is undeniable. In the 1830s, for example, Charleston-born free black Daniel A. Payne, later a bishop of the African Methodist Episcopal Church (AME) in the North, was very much impressed by the way in which the city's white elite conducted its social and cultural life, especially after he visited the home of John Bachman, a Lutheran minister and naturalist.[3]

Avery was also shaped by the Yankee presence. The school would remain under the auspices of the American Missionary Association (AMA) from 1865 to 1947. Ironically, although emphasis on planter paternalism has been enjoying a renaissance in which some historians stress its beneficial effects, Yankee paternalism has been found particularly bankrupt. In 1980, for example, Elizabeth Jacoway issued a stinging indictment of Yankee paternalism at Penn School, located on the South Carolina Sea Islands, a two-hour drive from Charleston. Penn School, the only school to survive for any length of time the Port Royal Experiment, in which northern missionaries sought to demonstrate to the federal government in 1862 that blacks could handle freedom, lasted for nearly seventy years. Conceding that the white missionaries brought some improvement to the islanders, for example, helping them retain their lands, Jacoway made a convincing case that with the white ladies leading the way, no indigenous black leadership emerged.[4]

Like the missionaries at Penn School, AMA teachers and officials could also be suffocatingly condescending. The AMA home office, "the pater,"

knew what was best for the family. When its Charleston clients, sometimes even abetted by AMA officials on the scene, attempted to assert their independence or point of view, the New York home office often responded like a parent being sorely tried by an adolescent child. But Charleston blacks were not simply children forced into becoming ebony Puritans. Long before the first Yankee schoolmarm ever set foot in South Carolina, Charleston blacks had evolved by dint of their own initiative a community that prided itself on some of the values so precious to the New Englanders. Many, slave and free, had subscribed in varying degrees to both Christianity and the Protestant ethic. As skilled artisans, living in an urban environment, they placed a high premium on working with their hands. A variant of an artisan ethos prevailed. Their outlook was also shaped by a national free black community with whom they were in constant contact. Before the Civil War, they subscribed to a social uplift philosophy that highly valued education, including the classical. After the war, northern missionaries attempted to refashion Charleston blacks into their own New England image, but the missionary ethos was itself reshaped and assimilated into a preexisting worldview. When the last white teachers left the school around 1914, the social uplift philosophy took on an even greater black dimension.

Insofar as the missionaries and their Charleston clients had a shared vision, the negative effects of paternalism were somewhat mitigated. When the vision differed, conflict occurred. Sometimes, the tensions were mutually beneficial. If the Averyites exhibited a tendency toward too much exclusiveness, the home office acted as a corrective. On the other hand, the Averyites' appreciation for a classical education acted to check the efforts of some of the missionaries to jettison the classical for a purely progressive, sometimes intellectually lightweight, education. Avery became a synthesis of both classical and progressive education.

Although the distance of the home office from Charleston sometimes softened the worst aspects of missionary paternalism, it also contributed to it. Policies covering myriad different schools, dictated by a distant home office, were not always conducive to fulfilling local needs. Inevitably, serious conflicts resulted when the home office and its agents on the scene attempted to make the locals conform to a policy that did not suit their specific situation. Eventually, there developed a diverging vision that would lead to a break between the AMA and its Charleston patrons. In 1947 the AMA formally ended its association with Avery.

Whether Avery, unlike Penn, produced, or at least fostered, an indigenous and responsive black leadership in Charleston is one of the main subjects of this book. Some contemporaries, such as Mamie Garvin Fields, as well

as various AMA officials and teachers, thought that the school was fatally flawed by a strong color and caste prejudice. Fields refused to attend Avery for this reason. "Read E. Franklin Frazier's *Black Bourgeoisie*," she counseled. "He got it so authentic until some of the people are still mad today." Frazier, a black sociologist, was extremely critical of the northern missionaries' attempts to leave "the imprint of their Puritan background upon Negro education." He feared that such an education could ultimately add to the gulf between the black elite and "the Negro masses." But the real target of Frazier's wrath was not the old elite. In an essay, "Durham: Capital of the Black Middle Class," in *The New Negro: An Interpretation* (1925), he extolled the virtues of the old elite. According to G. Franklin Edwards, Frazier's colleague at Howard University, Frazier "believed that the new Negro middle class which emerged with the great migrations lacked many of the stable virtues of the older middle class, represented by free Negroes and their descendants and the businessmen of Durham." The new elite had lost the service orientation of the pre–World War I elite. They also rejected identification with "the Negro and his traditional culture. Through the delusions of wealth and power they have sought identification with the white America which continues to reject them." Frustrated in such attempts, they proceeded to create a "world of make believe . . . a reflection of the values of American Society," which lacked "the economic basis that would give it roots in the world of reality."[5]

Scholars, including Frazier himself, have already documented the fissures that wracked and divided antebellum Afro-American society, especially in the South. Distinctions existed among slaves, between slaves and free persons of color, and between free persons of color. If emancipation legally ended the distinction between slaves and free persons of color, there still remained one's past status. Despite the growing literature on such divisions, including color ones, no one has ever taken a black institution and studied it over an extended period. Located in a city rife with such divisions, Avery also reflected them. A study of the school, therefore, offered the unique opportunity to examine such tensions in a single black institution from the antebellum period to 1954. I have studied the extent that color discrimination, or intrasegregation, existed at Avery; how long it lasted; and why it lessened. Since much of the evidence on intrasegregation is anecdotal, partisan, sketchy, and often contradictory, I have described specific examples of it in great detail, placing them in the larger context from which they emerged.[6]

Color discrimination was a fact of life among the city's Afro-American population, and Avery mirrored it. Avery drew the children of Charleston's Afro-American elite. Its commencement programs read like a *Who's Who*

of this elite. Most of the students, whatever middle-class aspirations they cherished, however, were not from affluent families. Some were only able to attend the school briefly. Most of the graduates also came from humble families, whose parents struggled to provide them with the best education available locally. Recently, at a memorial service for Averyite Ralph T. Grant (1915–1986), his son, Ralph, Jr., recalled how difficult the struggle was for his father to provide for his wife and eight children. A painter at the Charleston Naval Shipyard for more than thirty years, Grant lived with his family in a cold-water flat. The Newark, New Jersey, alderman recalled how his father once literally gave him the socks off his feet so that the young man could attend a spelling contest at Avery.[7]

Even before Avery was founded, intrasegregation was on the decline. This can be partially attributed to modernization and the growing sectional conflict. The sectional conflict pitted a more industrialized section against a less industrialized one. However much Low Country aristocrats envisioned free persons of color as acting as a barrier between whites and the mass of dark-skinned slaves, the three-tier system of race relations never really fully existed. As the sectional conflict heated up, the three-tier system, or what approached one, gradually and steadily deteriorated as whites began lumping all blacks into one category. While some members of the light-skinned Afro-American elite frantically attempted to reconstruct barriers between themselves and the slaves, circumstances drew the two groups closer together. Reconstruction continued the process. The city's black elite, often the first to seek office under the new Republican regimes, found themselves competing for the votes of their darker-skinned and less-affluent black neighbors. Moreover, whatever their faults, some of the white missionaries considered color discrimination at the school akin to leprosy. Their efforts were aided by an unlikely ally, the South Carolina legislature. The Jim Crow laws of the 1890s served to bind the community together. Any black ancestry, no matter what the legal definition stated, was enough to force even the lightest-skinned and wealthiest black person to the back of the bus. Although segregation inhibited the modernization of the South, it could not halt it. The winds of war, especially World War I, brought changes. A vast migration of blacks out of South Carolina, for example, coincided with the two world wars. This, too, would weaken intrasegregation as Charleston was brought kicking into the twentieth century.

Modernization also fostered the acculturation of Low Country blacks, many of whom were still African in their ways. In the antebellum period, the process was most noticeable in Charleston, where a large number of artisans, slave and free, plied their trades. In producing teachers for the rural

Low Country, Avery contributed to the modernization process, as these new teachers brought the ways of the city to Gullah blacks. But the process was a slow one. As late as World War I, some of the islands surrounding Charleston could be reached only by ferry. For Charlestonians, white and black, these islands were the hinterland. Island blacks, in turn, viewed the city as "the mainland." Improved transportation, spurred on by two world wars, brought the entire Low Country closer together physically and culturally. But it would take the civil rights struggle to integrate urban and rural blacks in a united movement. Today, distinctions along color lines have practically vanished. The main division seems to be between newcomers and old-timers.[8]

Ironically, although Avery was never free of vestiges of color discrimination, it did undermine the tenets of white supremacy. John C. Calhoun was alleged to have said, "Show me a negro who knows Greek syntax and I will believe that he is a human being and should be treated like a man." Avery produced such persons. Although most Charleston blacks probably never heard this quotation, they knew that Calhoun stood for their enslavement. According to black folklore, the city fathers decided to place the second Calhoun statue on such a tall pedestal because the city's black population regularly defaced the original statue. Such negative feelings were shared by even the lightest-skinned Averyites. A 1938 graduate who later taught at the school recalled accompanying her "blue-eyed" classmate to Francis Marion Square. The young girl, who could have passed for white, threw stones at the statue because Calhoun "didn't like us." When she informed a family member what her girlfriend had done, the adult replied: "You better not throw at him because he might be a member of your family. . . . Your grandmother came from his county."[9]

Although some Averyites may have fit E. Franklin Frazier's negative characterization of the black elite, most did not. Frazier himself visited the school after it had become public in 1947. When he retired in 1959 as professor emeritus from Howard University's sociology department, his replacement as full professor would be Averyite G. Franklin Edwards. After graduating from Avery in 1932, Edwards attended Fisk, where Frazier encouraged him to major in sociology. In 1941 Edwards became a teaching assistant at Howard University. Frazier had been at Howard since leaving Fisk in 1934. In his book *The Negro Professional Class* (Free Press, 1959, p. 5), Edwards acknowledged the book's "kinship" to Frazier's writings. His study of the social mobility of black professionals in the District of Columbia was one of the first to deal systematically with the role of skin color in the upward mobility of the black middle class.[10]

In the last analysis, Avery did produce an indigenous, responsive elite that provided the cutting edge of change in South Carolina. During World War I, the school became the center of the city's NAACP. It produced important civil rights leaders, such as Septima Clark, John H. McCray, J. Arthur Brown, and John H. Wrighten, Jr. When the civil rights movement reached its stride in the state in the late fifties and early sixties, Averyites were in its forefront.

A final note on my use of the terms *black* and *Afro-American*. I have followed the modern usage by employing the terms interchangeably to describe all persons having any African ancestry. Where appropriate, I have added adjectives *dark-* or *light-skinned*. I have decided not to use *black*, as Michael Johnson and James Roark have suggested, to mean "individuals of unmixed African descent," because, as they themselves have conceded, "we can seldom be certain of ancestry." Finally, I have used the term *mulatto* sparingly because it obscures more than it clarifies. The United States Census Office, for example, used the term inconsistently. In 1850 and 1860 census takers were asked to identify mulattoes but were not given any clear definition of the term. In 1870 and 1910 they were asked to apply it to "all persons having any perceptible trace of Negro blood, excepting of course, Negroes of pure blood." In 1890 the government required census takers to subdivide people of "mixed-blood" into mulattoes, quadroons, and octoroons. Given the imprecise nature of the term, historians have classified various historical personages differently. Even such a symbol of black liberation as Denmark Vesey has not escaped such arbitrary classifications. For Johnson and Roark, Vesey was a "black" Moses, but for William W. Freehling, the Charleston black leader was "a mulatto." [11]

1

Antebellum Context

Although Avery Normal Institute traces its origins back to 1865, the political, social, and cultural milieu from which it arose was in great part a product of antebellum Charleston. However determined the first handful of Yankee teachers were to mold their young charges into ebony Puritans, their success depended on an acceptance by a local Afro-American community whose traditions, values, and mores had evolved long before the missionaries came to South Carolina. More important, Avery's first two principals, Thomas W. Cardozo and his brother Francis, as well as some of the first teachers and students, came from the city's antebellum free black elite. The Cardozo brothers had been educated in the city's self-supporting schools for free blacks. With an established educational tradition, this urban middle class played a significant role in shaping Avery. Their worldview, an aristocratic-artisan ethos, drew on a variety of sources which are impossible to separate neatly. Closely associated with Charleston's planter-merchant elite, they exhibited an appreciation for Low Country aristocratic traditions. As artisans, they took pride in their craftsmanship. Moreover, like the northern blacks with whom they maintained close connections, they subscribed to the Protestant ethic and the promise of individual and group uplift through its application. Their outlook was also influenced by an African heritage.

The aristocratic-artisan heritage shared by antebellum Charleston blacks, like their society, was never static nor fixed. The proponents of this ethos sometimes disagreed over its interpretation. Some like Thomas Bonneau and Michael Eggart stressed its aristocratic and exclusive implications. Daniel A. Payne, the Holloway family, and others emphasized those more inclusive and egalitarian aspects generally associated with the Protestant ethic. Payne and the Holloways came from a Methodist tradition that encouraged a more inclusive interpretation. The black benevolent societies reflected these ten-

sions. Events and forces, such as the growing sectional conflict, which eroded the advantages and privileges of the free black elite, exacerbated tensions to such an emotional level that conflicts and splits were inevitable.

The alliance between the free black middle class and the city's "better sort" was one of mutual convenience. It provided the white elite with a ready source of skilled labor and a potential barrier between the slaveowner and the slave (the middle tier in a so-called three-tier system of race relations). The free black elite, in turn, received, in addition to any "cultural" and economic benefits from a close association, a tacit promise of protection from their powerful patrons against any white assault. The three-tier system, however, never became firmly established in Charleston. The free black population was too small to sustain it. White South Carolinians were also unwilling to give free blacks legal and other privileges usually associated with such a system. For example, they refused free blacks the right to bear arms or to testify in court against whites. Moreover, the sectional conflict gradually undermined any semblance of a three-tier system. To an increasingly defiant and apprehensive South, bent on proving that slavery was a positive good and an absolute necessity for the survival of both races, free blacks became a sore point. Capitalizing on such sentiments, white mechanics in Charleston struck out against their black competition, slave and free. The material progress and gentility of the free black elite only served to fuel their envy. On the eve of the Civil War, Charleston's free black elite had to acknowledge something they already suspected, that their wealthy white patrons had neither the will nor the power to defend them adequately. This was the antebellum context from which Avery emerged.[1]

The Aristocratic-Artisan Ethos

Happily situated between the Ashley and Cooper rivers, Charleston was able to recoup from the financial difficulties caused by the American Revolution. As a southern seaport dependent on the cultivation of rice and cotton, it, however, suffered from the vicissitudes wrought by depressions, embargoes, international disputes such as the War of 1812, and the growing sectional conflict over slavery. Despite a slow recovery, Charleston never regained the proportional share of the nation's imports which it once held. An English visitor touring the city in 1838 compared it to "a distressed elderly gentlewoman," aristocratic, picturesque, and "a little down in the world, yet remembering still its former dignity."[2]

In 1861 Charleston's population of 48,409 was roughly 55.7 percent white,

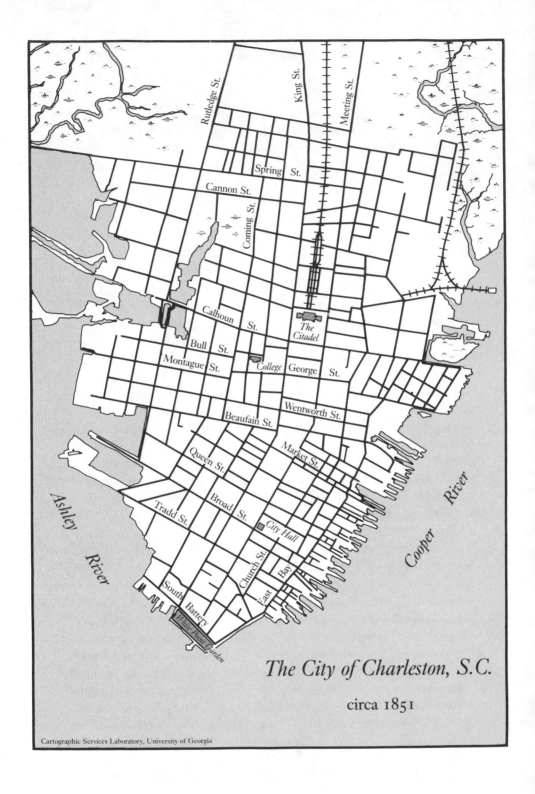

The City of Charleston, S.C.

circa 1851

36.5 percent slave, and 7.8 percent free black. Despite the aristocratic ve-
neer of the city, almost half of the white male inhabitants of voting age were
workers; 61.3 percent were skilled; the rest, unskilled. Many were foreign-
born; they composed 47.6 percent of the skilled white workers, and 81.8
percent of the unskilled. The black labor force, slave and free, posed seri-
ous competition for these white workingmen, especially the mechanics. By
1860 a majority of the city's workingmen were slaves. They composed at
least a fifth of the skilled labor force, of which 13 percent was free black.
Three-quarters of the free black males over age fifteen were artisans. They
dominated certain trades: carpenters (25 percent), tailors (nearly 40 percent),
and millwrights (75 percent).[3]

Much of the city's wealth was in the hands of a planter-merchant elite.
In 1860 some 160 individuals, slightly more than 3 percent of the popula-
tion, possessed half of this wealth; 75 percent of the whites as well as about
99 percent of the free blacks owned less than five thousand dollars in real
estate. An Episcopal minister doing mission work in the upper wards of the
city during 1853 discovered extreme poverty and ignorance in many white
households. His findings were confirmed by the observations of Frederick
Law Olmstead, who traveled through the region. The hardest hit were poor
white women so unskilled they could not even earn wages by sewing or
repairing garments.[4]

A small number of planters not only controlled a great deal of the wealth
in the Low Country but also dictated its "aristocratic ethos." Not surpris-
ingly, this ethos and other aspects of planter life reflected the influence of the
Caribbean, especially Barbados, or "Little England." By the mid seventeenth
century, the wealthy sugar planters of Barbados had produced a generation
of younger sons who sought new frontiers where they could duplicate the
success of their fathers. The more well known Barbadian pioneers included
Edward and Arthur Middleton, brothers who established a dynasty in the
Low Country. South Carolina with its semitropical climate and undeveloped
lands provided many of these pioneers the opportunity to create a slave-
based plantation society similar to that from which they came. The slave
code, parish system, and other social-political structures reflect this influ-
ence. In Barbados and the other sugar islands, the wealthy planters stub-
bornly clung to English customs and defied tropical realities. Both they and
their wives wore hoods, neckcloths, and other clothing "to keep their com-
plexions as white as possible, in contrast to their black-skinned slaves and
red-necked servants." The sons of this wealthy sugar planter class brought
to the Low Country not only their slaves but also the values, customs, and

precedents of Little England. Toward the mid nineteenth century, the Low Country planter elite was still pursuing "English genteel standards." By the 1830s wealthy King Street merchants (who had prospered on the rice and cotton trade), having imbibed the planter ethos and life-style, could attain the status of "self-made" aristocrats. Nonetheless, the uppermost echelon of Low Country society was still the preserve of the Middleton, Manigault, and other old planter families.[5]

The climate and large black population of Charleston caused an English officer visiting in 1817 to perceive the seaport as "not very unlike some of the cities on the Mediterranean coast of Africa." The blacks composed 44.3 percent of its population in 1861. Of these 21,440 blacks, 82.3 percent were slaves; 56.3 percent of these slaves were female, and apparently less than 10 percent were mulatto. Many, particularly the women, were house servants. Some Low Country slaves imbibed the aristocratic ethos of their masters. Mamie Garvin Fields proudly remembered how her great-great uncle Thomas Middleton, sent as a valet with the Middleton boys to Oxford, learned Hebrew and Greek. "Since the Middleton family was outstanding around this part of the state," she explained, "the people from their plantation acted accordingly. They began to think they were a cut above. Some kept this up even after slavery."[6]

City life offered some slaves educational, economic, and other opportunities less accessible on the plantations. Although 1740 legislation made it a crime in the state to teach a slave to read and write, some Charleston slaves managed to obtain an education by blending in with the free black population and attending their private schools. "The evil," one white Charlestonian predicted in 1822, "will increase rather than diminish." Thomas Middleton, for example, taught relatives and slave acquaintants who, in turn, taught others. According to one account, city authorities permitted "schools for colored children, and for such slave children as were permitted to attend school, and they were not a few. Some were grandchildren of white aristocrats." In 1867 former slaves composed 80 percent of the most advanced classes at Charleston's Shaw Memorial School, founded by northern missionaries. "It is an interesting fact," Reuben Tomlinson, a Freedmen's Bureau official, observed "that, among the most distinguished scholars in these classes, those who were formerly slaves rank equally with those who were free and had received some instruction before and during the war."[7]

Charles Just, Sr., exemplified how the advantages of city life enabled some resourceful slave artisans to apply the Protestant ethic and even achieve a quasi-free status. He learned his trade as a wharf builder from his owner, a Methodist German immigrant named George Just. When George Just died

in 1853, he requested that his wife not dispose or sell his mulatto servant Charles "except at his Own request." Charles Just, Sr., belonged to a small mulatto slave population that was able to blend in with the free black community. He was a member in good standing of Cumberland Street Methodist Church, where he worshipped with prominent free blacks like the Westons, Holloways, and Daniel Payne. In 1844 he cooperated with seventeen other persons to found the Unity and Friendship Society to take care of their families in case of their deaths. Although Just could not legally own property as a slave, he purchased in 1852 real estate valued at eight hundred dollars. When his first wife died, she left him two slaves and two lots. His son, Charles Fraser Just, also a wharf builder, was the father of Ernest E. Just, the biologist.[8]

Another well-known Methodist of Charleston's antebellum black community was former slave Mary Ann Berry. She married into a dark-skinned free black family of carpenters, who helped found the Humane Brotherhood. (William Berry was the first president of this benevolent society of "free dark" men.) Mary Ann Berry gained acclaim for her school, which was part of the formal religious training provided by Charleston Methodists.[9]

Although education for slaves was illegal, organized religious instruction for them increased as the abolitionist movement grew. Stung by abolitionist charges that the white South was denying blacks the word of God, South Carolina's religious leaders met in Charleston in 1845 to map a strategy to reach the slave population more effectively. They thought that religious education would be the best way to refute the abolitionists. Underlying their strategy was the tenet that proper Christian instruction would reinforce the ideal of a paternalistic society in which the slaves were loyal and obedient servants to a benevolent master. The plan was to establish separate black churches under a white minister and core of white officers. The upper gallery would be reserved for these officers and other whites who wished to observe the services.[10]

The Episcopalians and Presbyterians met "mixed success." By 1850, the High Church Episcopal minister Paul Trapier had established Calvary Church. (The very first services had been held in the basement of St. Philip's parsonage.) At its peak in 1856 Calvary had no more than fifty-five black members; however, up to six hundred blacks attended its Sunday school. These numbers declined rapidly after Trapier, failing in health, resigned the following year. Anson Street Church, founded by John Adger, an Old School Presbyterian minister, had similar results—a small black congregation but a more successful Sunday school. It took the Presbyterian minister John L. Girardeau, who was born on nearby James Island and could speak the Gul-

lah dialect, to develop a program of preaching and religious instruction that drew the blacks. Replacing the ailing Adger in 1852, Girardeau established a parish system whereby the congregation was divided into classes, each headed by a black leader who performed such pastoral duties as meeting weekly with the group, regularly visiting members in their homes, and caring for their needs. In many ways he was similar to the Methodist class leader, who was often the black preacher on the plantations. Girardeau moved his growing black congregation to a larger building on Calhoun Street. The blacks named it Zion.[11]

A. Toomer Porter, a Georgetown planter, was less successful in his endeavor during the late 1840s to reinforce through religious education the ideal patriarchal society on his estates. Although claiming to be opposed to slavery, he reasoned that it was an inherited and solemn responsibility because if the "naked African savages" remained in Africa, "their descendants would be naked African savages still." With his mother's assistance, Porter "organized a large Sunday-school for all the children, to which many of their parents came." He devoted his Sunday afternoons and evenings to the religious instruction of his slaves. Controlling and disciplining them, however, remained a problem, aggravated, he felt, by the Methodist class leader, who undermined his authority (for example, assisting the slaves in devising a way to harvest rice for themselves without his knowledge). Growing weary of the problem, Porter sold his estates and entered the Episcopal ministry. In 1854 he became rector of the Church of the Holy Communion in Charleston. Immediately canvassing the upper wards of the city for black and white members, he organized a morning Sunday school for white children and an afternoon one for the blacks. Both were well attended.[12]

The success of Porter's Sunday schools suggests that the religious training provided blacks had some educational value. Scriptural study offered slaves an opportunity to meet, a chance for some self-expression, and the possibility of doing some analytical thinking. In stressing the worth of the Bible, Sunday schools probably stimulated the desire to learn to read and placed benevolent slaveowners in a quandary. "As Christians," a South Carolinian judge asked a convention of planters in 1848, "how can we justify it, that a slave is not to be permitted to read the Bible? . . . The best slaves in the State, are those who can and do read the Scriptures." Mary Ann Berry's school demonstrated the close connection between religious training and literacy. She opened it in the family house on George Street, located near the present College of Charleston campus. A northern Methodist, writing after the Civil War, stated that Abram Middleton, son of Thomas Middleton, the slave

valet, was taught at her school "in spite of all the laws against negro educa-
tion." Mamie Fields, explaining how literacy spread among slaves, described
this school as "clandestine" because slaves attended it.[13]

By 1850 about half of Charleston's twenty thousand blacks belonged to
white churches. Despite early setbacks, the Methodists were most success-
ful in converting them, both slave and free. The appeal of Methodism to
Richard Allen, a former slave who during 1816 helped found the African
Methodist Episcopal church in Philadelphia, gives insight into the attraction
of Methodism to black Charlestonians. Allen attributed his success in pur-
chasing his freedom and amassing a fortune to the Methodists, who taught
him that moral improvement and personal achievement were possible for
even a slave like him if he assiduously applied the Protestant ethic of hard
work, self-reliance, clean living, and self-improvement through education.
The hierarchical structure and religious program of Methodism instilled not
only these values but also the discipline to live by them.[14]

The Methodist church in Charleston offered blacks tangible opportuni-
ties. By 1790 its Sunday schools had taught slaves to read. Until 1815 white
Methodists allowed blacks considerable independence, including a separate
conference. Blacks had the right to take up and disperse their own collec-
tions and to conduct their own church trials. Numbering 3,793 in 1815,
they composed 93 percent of the total Methodist membership in Charleston,
which was 4,075.[15]

Such liberality, coupled with the antislavery sentiments of some Method-
ist leaders such as the bishop Thomas Coke, provoked the hostility of white
Charlestonians. According to Francis Asbury Mood, a bishop, "Methodists
were watched, ridiculed, and openly assailed. Their Churches were styled
'negro churches,' their preachers 'the negro preachers.'" Methodist services
were disrupted by mobs, particularly at Cumberland; this caused the blacks
to attend Bethel, where they were still harassed. Such hostility took its toll
on the membership; the leadership began to despair of recruiting whites.
Finally, in 1815, the presiding white preacher, Anthony Senter, conducted a
crackdown. Charging that the blacks were corrupt in handling their financial
affairs, Senter demanded their collections be turned over to the stewards;
he eliminated their separate conference and suspended their conducting
church trials without the rector. Black Methodists, led by Morris Brown,
made tentative contacts with the African Methodist Episcopal church in
Philadelphia. Two years after the crackdown, 4,367 of the 5,690 black Meth-
odists withdrew to establish their own African church. City officials arrested
hundreds of them on a variety of charges. In 1817 some 469 "black and

colored persons" who built a church on a lot they had purchased were jailed. The next year, 143 were arrested for attempting to educate slaves without white supervision.[16]

Gradually the Methodist church in Charleston rebuilt its membership. Some important and extremely pious black members, including Samuel Weston, Richard Holloway, Francis Smith, and Mary Ann Berry, remained in the church. They attracted others, such as Abram Middleton, a carpenter, who later organized Methodist parishes throughout the state. By 1846 the number of black Methodists reached its previous high of 1818. That year, the Charleston parishes had 6,102 members, of whom 5,267 were black.[17]

In 1861 free blacks composed 17.7 percent of Charleston's black population: 2,279 females; 1,506 males. Nearly three-quarters of them were mulatto. Many of the women earned a living by making or cleaning clothes, and most of the men worked at a skilled trade. Despite these broad similarities, important differences existed. The 1848 city census described them as "blacks and colored." The rules and regulations of some of their benevolent organizations made such distinctions. The Brown Fellowship Society and the Friendly Moralist Society admitted free "brown" men; the Humane Brotherhood recruited free "dark" men. Some "free persons of color," often belonging to these associations, steadfastly maintained they were "Indian." In some cases, like that of the DeWeeses, they may have been referring to West Indian origins.[18]

Although many free black men were artisans, economic and occupational differences also occurred. In 1860 unskilled laborers composed about a quarter of the free black male population. Many had to contend with stiff competition from slaves "hiring their time." Some lived in abject poverty. Roughly another 55 percent were skilled laborers, who worked alongside slaves. They were a bit more affluent than the unskilled but paid no municipal tax. Samuel Wigfall, a carpenter, was probably representative of this group. His wife Annie, an illiterate slave, was a mantua maker from the town of Mt. Pleasant, across the Cooper River. When Wigfall died in 1876, contemporaries could not recall whether he had been slave or free before the war; they were not sure that his guardian had not been his master.[19]

In 1860 there were 1,845 free black and Indian adults over age twenty in Charleston. Approximately 20 percent were municipal taxpayers, who paid over twelve thousand dollars in taxes for horses, goods, commissions, real estate, slaves, and other property. Most of these 371 taxpayers had accumulated modest wealth. About 35.6 percent (132) owned a total of 390 slaves (three-dollar tax per head). Although 38.6 percent (51) of the slaveholders

owned only 1 slave, some had much to lose when slavery ended. About 11.4 percent (15) owned 6 or more slaves.[20]

Not all slaveholders possessed real estate, and vice versa. About 80.3 percent (298) of the 371 taxpayers (55.3 percent, or 73, of the 132 slaveholders) owned real estate. The assessed real estate value of these taxpayers came to a total of $759,870. Of these, 207 paid taxes on real estate assessed at less than $2,000, probably the value of the family home. Sixty-two paid taxes on real estate worth between $2,001 and $5,000. The top 29 each paid taxes on real estate worth more than $5,000. This last group constituted only 1.6 percent of all free black and Indian adults, yet held 43 percent ($326,795) of the entire real estate assessed for this population. They also owned 30.5 percent (119) of the 390 slaves.[21]

Representative of this top 1.6 percent (twenty-nine) was Francis L. Wilkinson, a butcher born in the late eighteenth or early nineteenth century. Although his family had close ties with St. Philip's, he was a member of Cumberland and taught in its Sunday school. He was also a president of the Friendly Moralist Society (FMS). By 1863 he had managed to accumulate a sizable estate. Joseph Dereef, William McKinlay, and T. B. Maxwell appraised its value at more than eleven thousand dollars. In addition to owning six slaves (none of whom appeared to be a family member), Wilkinson possessed several houses in the Charleston Neck area, a suburb north of Boundary (now called Calhoun) Street where many city merchants and businessmen had their residences. During the war, he purchased a Confederate certificate worth two hundred dollars.[22]

This top 1.6 percent was overwhelmingly light-skinned, although there was at least one exception, Thomas R. Small, a carpenter and shrewd real estate speculator. In 1860 Small owned three slaves in his name alone and shared ownership of several others. He had accumulated real estate worth seventy-three hundred dollars. Only sixteen other free persons of color had real estate worth more than his. A founder of the Humane Brotherhood, Small held "in great contempt" the "exclusive activities" of some of the light-skinned elite. Even today people in Charleston's Afro-American community recall fiercely proud dark-skinned antebellum free black families, such as the Berrys, Mickeys, Poinsetts, Simmonses, and Logans.[23]

In 1860 much of the wealth in the free black community was concentrated in a few light-skinned families, such as the Westons, Holloways, and McKinlays. They had developed their wealth and position over four or five generations when opportunities for free blacks were greater and restrictions less severe. Judicious intermarriage within this elite preserved and

augmented its wealth and influence. A good example is the Bonneau family. Thomas S. Bonneau was a wealthy landowner, slaveholder, educator, and pillar of Charleston's free black community in the first quarter of the nineteenth century. He managed to marry at least five of his seven daughters into the top of South Carolina's free black society, including the Westons, Holloways, and Ellisons. His daughter Sarah Ann married Jacob Weston, who, with his brother Samuel, operated a tailor shop on Queen Street. By 1860 the Westons had accumulated the greatest amount of wealth of any free black family in Charleston. They paid taxes on more than sixty thousand dollars worth of real estate and owned more than thirty slaves. Another Bonneau daughter, Frances Pinckney, married Richard Holloway, Jr., whose father, born in Maryland in 1777, came to Charleston at age twenty as a sailor on a British ship. Discharged, Holloway, Sr., found lodgings with a free black carpenter, James Mitchell, also a notary public. In 1790 Mitchell had helped found Charleston's first black benevolent organization, the Brown Fellowship Society. Holloway's association with Mitchell was fortuitous and mutually beneficial. In a town where there was a shortage of eligible free black males, Mitchell acquired a promising son-in-law, and Holloway gained both a trade and considerable social mobility. Mitchell taught the young man carpentry. In 1803 Richard Holloway, Sr., was married to Mitchell's daughter Elizabeth by the rector of St. Philip's. Starting a carpenter's shop on a Beaufain Street lot purchased from his father-in-law, Holloway developed a flourishing harness business. He built his home on the adjacent lot given by Mitchell. Holloway, at the time of his death in 1845, had fathered thirteen children, including James W. (the eldest son), Charles H., Richard, Jr., and Edward. The family harness shop passed on to Charles's son, James H.[24]

As the sectional conflict grew, the number of black slaveowners in the Charleston area dropped—34.5 percent between 1840 and 1850, and another 42 percent the ten years thereafter. Exactly what kind of masters these slaveowners were is difficult to measure with any precision. The evidence for any one of them is scanty and sometimes contradictory. None of their slaves left any extensive description of them. Although benevolent free blacks purchased hapless slaves other than relatives to make the lot of these individuals a better one, many used their slaves commercially. Butchers, wood dealers, and other artisans found slave labor useful in their businesses and a valuable commodity to be sold or hired out, for once the slaves were trained in a skill, their monetary value jumped. George Shrewsbury, a thriving butcher, bought sixteen slaves between 1840 and 1846 and hired out some of them. In 1860 he reported owning twelve slaves. When the war ended, he continued to supply Charleston's white elite with his meat products.[25]

Besides hiring out their slaves, some free blacks, like the whites, used them as collateral for mortgages, advertised for runaways, and sold those who were unruly. Juliet Eggart, bequeathing her slave Celia in 1833 to her children, added that if Celia "should misbehave, so as to render it expedient for the interest of my children that she should be sold, that my said executor should sell and dispose of the said Negro girl." Her son Michael, a millwright, came to represent that segment of the light-skinned free black elite who saw a great gulf between themselves and the largely dark-skinned slave population and consequently considered themselves a separate people. Eggart's in-laws, the Dereefs, denied being black. In 1821 R. E. Dereef, Sr., and his brother Joseph, refused to allow the Charleston tax collector to describe them as free mulattoes. They took their case to the Court of Common Pleas and won a decision naming them as "free Indian." (Ironically, some family members may have been dark-skinned.) The Dereefs, like other large slaveowners, stood to lose much if the South lost the war. In 1860 R. E. Dereef owned fourteen slaves and twenty-three thousand dollars worth of real estate. His brother's holdings included six slaves and sixteen thousand dollars in real estate. Understandably, R. E. Dereef was civil but not cordial when the abolitionist Henry Ward Beecher entered his home uninvited shortly after the war.[26]

Other elite black slaveowners, especially the Methodists, like the Holloways, were more benevolent, though they, too, on occasion, bought and sold slaves for commercial reasons. The carpentry business of Richard Holloway, Sr., an exhorter in the Methodist church, often took him to the "Country," which afforded him an opportunity to spread his religion. He could not exhibit the same exclusive attitudes as Michael Eggart if he wanted to win converts to the cause. Holloway, for example, purchased fellow Methodist Charles Benford and gave him as much freedom as possible. They worked together to win converts. Holloway's grandson, James H., admitting that his ancestors, to remain under the aegis of the planter-merchant class, had stood for slavery "to a certain extent," argued that they had also "sympathized with the oppressed, for they had to endure some of it, and fellow feeling makes us wondrous kind, and many times they had as individuals helped slaves to buy their freedom." As a family of master carpenters, the Holloways could have benefited handsomely from buying, training, and selling slave artisans. Yet in 1859, although nine members paid municipal taxes on $28,165 worth of real estate, only one reported owning a slave.[27]

The more exclusive attitude of other members of the light-skinned elite was reinforced by the close ties between them and the planter-merchant class. Some free persons of color traced their lineage to Charleston blue-

bloods whose names they shared (Legare, Trescot, Poinsett, Kinloch, and Noisette). State laws against miscegenation did not exist until the black codes of 1865. Even the term *white* was not rigidly defined as having seven-eighths Caucasian blood until Reconstruction. James L. Petigru, a lawyer, defended fellow Unionists accused of being black. They became collectively known as "Goose Creekers whom he had white washed." Prominent whites feared that too many good people, including some of their own offspring, would have been pushed into the black world. Such flexibility might also have been designed to placate mulattoes by allowing them the possibility of joining the white world. A more plausible explanation was the shortage of eligible white women in contrast to the abundance of unmarried free black ones. For example, among the free black population in 1848, there were 169.08 females for every 100 males, with 234 males and 525 females between the ages of twenty and seventy. The white population, in contrast, had 98.66 females for every 100 males, with 4,047 males and 3,953 females between the ages of twenty and seventy.[28]

Some whites, often immigrants or merchants, chose free persons of color as mates and wives. Such women may have been more cultured and imbued with the Protestant ethic than their poor white counterparts. Being the daughters of black artisans, they possibly had the opportunity to meet prosperous whites who had established business contacts with their fathers. Isaac N. Cardozo, a customhouse employee from "a well-known Jewish family," fathered three highly cultured sons. Two, Thomas and Francis, born in 1837 and 1838, respectively, became Avery's first two principals. Their mother, Lydia Williams, was a free mulatto. Robert Purvis, a black abolitionist, was born in Charleston in 1810 to an Englishman who immigrated to America in 1790 and became a cotton broker. The mother was the daughter of a German-Jewish flour merchant and his wife, a Morocco-born African, who entered Charleston as a slave but managed to obtain her freedom.[29]

The history of the Wall family illustrates the process whereby prosperous white immigrants chose mates from the elite free black community. Born in the county of Limerick, Ireland, in 1754, Richard Wall, the family's patriarch, traveled to France with his brother Gilbert to join the American fight for independence. In April 1779 a squadron of armed vessels under the command of John Paul Jones was being fitted at the Port of L'Orient. The brothers enlisted and boarded the *Bon Homme Richard* as marine cadets, each with the rank of midshipman. Shortly afterward, off the west coast of Ireland, several of the ship's crew deserted. Richard Wall, ordered to pursue them, was captured and sent from Ireland to England's Forton Prison. According to Wall, he was "exposed to more than the usual hardships and

privations a Prisoner of War is compelled to submit to, being put on a very short allowance and daily threatened with execution as a rebel." In 1782 he returned to Philadelphia as part of a prisoner exchange. He then joined his brother Gilbert on the frigate *South Carolina*. After its capture, the two men decided to make Charleston their permanent home.[30]

Exactly when Richard Wall married his wife, Amelia, a free person of color, is impossible to determine, but two of their sons, Lancelot and Edward, were baptized at St. Philip's between 1818 and 1830. The Wall offspring became a vital part of the city's elite free black community. Edward and Lancelot, tailors, belonged to the Friendly Moralist Society. Lancelot would eventually marry Susan Motte, the daughter of a highly successful free black tailor. Before the couple wedded, Lancelot had to agree to a marriage settlement. Lancelot, Edward, and their brother William attended St. Philip's, where several of Edward's children were baptized. In 1839, for example, Edward and his wife Maria took their daughter Amelia (no doubt named after Richard's wife) to St. Philip's for baptism. Eleven years later, another daughter, Mary Elizabeth, was baptized in the same church. The child's sponsor was Joanna Eggart, a Dereef, who had married a millwright, Michael Eggart.[31]

Richard Wall's marriage to a free person of color apparently did not diminish the revolutionary war hero in the eyes of the city's white elite. In 1838, supporting Wall's unsuccessful effort to win prize money due him in the Revolution, Henry Laurens Pinckney, the mayor, testified that Wall was "a man of good character and of veracity unquestioned." As a crewman aboard the *Bon Homme Richard* and the sole heir of Gilbert, who died in 1787, Wall was entitled to prize money for the capture of the British warships *Serapis* and *Countess of Scarborough*. After his death in 1842, his son and executor, Edward, pursued the matter. In 1869 the estate was awarded the prize money due the father.[32]

Edward P. Wall and his brother Lancelot show how close the ties were between some members of the free black elite and the city's planter-merchant class, even during the Civil War. Both men were employed by Guerard, Kemme, Edgerton, Richards, and other fashionable Broad Street tailor establishments. They prided themselves on their clientele, which included a Confederate general for whom Edward Wall made a uniform. Some free blacks even owned businesses that catered to wealthy whites. Jehu Jones operated on Sullivan's Island (a summer resort across the Cooper River) a hotel that served "Charleston's crème de la crème." In a city chronically short of skilled laborers, the free black community also provided Charleston's planter-merchants with a ready source of skilled artisans willing to do

work sometimes shunned by their white counterparts. Low Country gentry opposing efforts to drive free blacks out of the state sent to the South Carolina senate a petition declaring that "their Labor is indispensable to us in this neighborhood. They are the only workmen who will, or can, take employment in the Country during the summer. We cannot build or repair a house in that season without the aid of the coloured carpenter or bricklayer." [33]

Some white aristocrats considered the light-skinned free black elite a potential deterrent to slave insurrections. They perceived that a three-tier system depended on a free black slaveowning group to act as an intermediary between planter and slave. Even after the slave conspiracy of 1822 led by Denmark Vesey (a mulatto who had purchased his freedom), Edwin S. Holland, a Charleston newspaper editor, described this group as "a *barrier* between our own color and that of the black, and, in cases of *insurrection*, are most likely to enlist themselves under the banners of the whites." They "abhor the idea of association with the *blacks* in any enterprise that may have for its object the revolution of their condition. . . . [and can be counted on to uncover] any plans that may be injurious to our peace." [34]

The alliance with the white elite brought tangible benefits to light-skinned members of the free black elite, who felt caught in a wedge of racial hostility. James H. Holloway, commenting on his ancestors' connections with the planter-merchant class, argued: "On the one hand we have the dominant race[,] on the other we have the backward race. The first looked with scrutinizing eye on our every movement, so as to charge us with being a disturbing element in conditions that existed. . . . but fortunately there were the classes in society, and as our fathers allied themselves with them, as a consequence, they had their influence and protection and so they had to be in accord with them and stand for what they stood for." [35]

Like their white aristocratic allies, elite free blacks bought and sold slaves, intermarried, made marriage settlements, owned church pews, and organized exclusive societies. These exclusive tendencies were mitigated by the free black elite's admiration of the noblesse oblige and aristocratic ethos as lived by the city's white clergy, "that type of Southern Christian gentlemen, represented by such men as the Mood brothers, Seabrook, A. Porter, Girardeau, the Capers, and Carlisle, . . . who felt it no disgrace or dishonor to stoop down to the humblest of God's creatures, that they might lift them up to a higher level." The Moods and Capers were prominent Methodist leaders. Dr. James H. Carlisle, president of Wofford College, was a "distinguished Methodist Minister." J. B. Seabrook, like A. Toomer Porter, was a planter and slaveholder who became an Episcopal minister. Girardeau was pastor of the black Zion Presbyterian church. John Bachman, a Lutheran

minister originally from New York State, was especially admired by Daniel Payne, who described him as "the learned divine and naturalist." Recalling a visit to Bachman's home, Payne wrote, "There I sat and conversed with his family as freely as though all were of the same color and equal rank; and by my request his daughter skillfully performed several pieces upon the piano." Payne thought that Bachman "had about him every thing to make his home pleasant." [36]

It was not surprising that Payne greatly admired the fine piano performance of Bachman's daughter as well as the minister's genius as a naturalist. The free black middle class, like the white elite, cultivated a musical tradition, which would be continued at Avery. Among the free blacks listed in the 1856 city directory were two band directors (a McKinney, leader of the Washington Light Infantry Band, and Peter Brown, a leader of the Cadet Band), a dance master named John Hopkins, and Paul Poinsett, a musician, who also made his living as a barber. Poinsett would later join the Union Philanthropic Band, one of numerous such groups appearing during Reconstruction. [37]

Some scholars have argued that the free black elite's behavior was "a replica of that class in the white society which they aspired to be like." The ideology embraced by the free black elite may be more correctly described as "aristocratic-artisan," rather than just "aristocratic." They were not gentlemen-farmers; their wealth was not based on the ownership of land. They did not show a disdain for working with their hands. C. W. Birnie, an Avery graduate of 1891, whose family was of this elite, pointed out that their values were sufficiently different from the "aristocratic element" who had "the old English idea that it was beneath a gentleman to work or to attend to business." Although most planters did not show a disdain for commercial endeavors, they most certainly would not have looked with favor on their sons' becoming mechanic-businessmen. On the other hand, elite free black families, like the Holloways, took great pride in their family businesses and tried to pass them on to younger generations. The Holloways carefully preserved the history of their harness shop in a family scrapbook. [38]

The social institutions of Charleston's free black elite were not mere "replicas" of those of the white aristocrats but reflected trends emanating from northern black communities. Although the Brown Fellowship Society might have been established in 1790 at the insistence of the St. Philip's rector, it was part of a national black benevolent movement that began during the American Revolution and early national period. Northern black attitudes reached Charleston through the African Methodist church, which came to the city shortly after 1816. Restrictions placed on free blacks after the Vesey

plot of 1822 never halted the flow of information between Charleston and the northern black communities. Hundreds of free black families who migrated north reinforced the connection. Edward Holloway, who moved to New York City, kept his Charleston relatives abreast of events in the North. In 1857 he reported that New York blacks were eager to go to Jamaica. He urged that the Christian Benevolent Society make such emigration the topic for its annual day meeting.[39]

The social thought of Charleston's free black elite was very similar to that of antebellum northern black leaders, who also believed that by practicing the Protestant ethic and making themselves "useful," "respectable" citizens, blacks could convince whites that their prejudices were unfounded. These black leaders encouraged communities to establish such organizations as benevolent, temperance, and literary societies, that would both reflect and promulgate such values, which constituted the social uplift philosophy.[40] Just as in the North, many black benevolent societies emerged in antebellum Charleston. The first and most prestigious was the Brown Fellowship Society (established in 1790). Others of note were the Minors' Moralist Society (1803), the Friendly Union Society (1813), the Friendly Moralist Society (1838), the Christian Benevolent Society (1839), the Humane Brotherhood (1843), and the Unity and Friendship Society (1844). Together they offered various services, including burial assistance, sickness and disability insurance, loans, education for orphans, and charity for the poor. Besides providing experience in self-governance, they served as a forum for discussing topics of interest (such as emigration to Jamaica). Like their northern black counterparts, they all fostered moral reform, good living, and self-help. The Humane Brotherhood fined members who broke "good decorum" by smoking, whispering, and so forth, at the meetings and requested those "under the intoxicating influence of liquor" to leave.[41]

Devout Methodists like the artisans Richard Holloway, Sr., and Samuel Weston bolstered the practice of the Protestant ethic in the black community. These two class leaders taught their pupils at Cumberland how to become useful and respectable members of society. They took care to apprentice young men to virtuous individuals. Daniel Payne, for instance, learned carpentry under Holloway's eldest son. Fellow class leaders in their letter of condolence to Holloway's widow in 1845 lauded his "long life of usefulness" and lamented, "The church have lost a pious and useful member, a Sound and Zealous exhorter and a faithful leader. The poor have lost a [true friend,] Society an ornament. The community an Honest, Upright, Industrious, intelligent member." [42]

Although the free black elite stressed the Protestant ethic, their institu-

tions were also shaped by an African heritage. The emphasis their benevolent associations placed on proper burial and moral conduct was similar to the tradition of comparable mutual aid societies in Africa. Yankee missionaries after the Civil War noted the distinctive features of Charleston mourning customs. The Friendly Moralist Society drafted and adopted a set of rules very similar to that of the German Friendly Society, a local white counterpart established in 1766; however, the German Friendly was mainly social and educational in its activities, whereas the Friendly Moralist served primarily as a burial aid association. The Brown Fellowship Society, the Unity and Friendship Society, and others had their own cemeteries. Such connections with Africa are nearly impossible to substantiate concretely, but Charleston's free black community had undeniable ties with its African past. Some families retained African-derived surnames (such as Quash) and given names (Jehu, Abby). Jehu Jones, the wealthy hotel owner, was married to a pastry cook named Abby. Their son Jehu Jones, Jr., a tailor, was a member of the Brown Fellowship Society. The patriarch seriously considered relocating to Liberia. Moreover, the white elite's emphasis on manners, which free blacks were said to be replicating, was itself reinforced by an African sense of gentility and decorum. The slaveowners entrusted their children to black nursemaids, called *Dahs*, "who assumed the role of teacher of manners and disciplinarian." In West Africa, *Dah* meant "mother" or "older sister." [43]

Perhaps the best way to analyze the aristocratic-artisan ethos of Charleston's free black elite is to examine one of their purely cultural organizations. The "sole object" of the Clionian Debating Society (CDS) was to pursue "learning and mental improvement." Established by November 1847, it existed at least until September 1851. Annually it numbered about a dozen persons over the age of sixteen. Most of them came from elite families like the Westons, Dereefs, Cardozos, and Deas. [44]

CDS offered young men the opportunity to research and debate topics at weekly, sometimes monthly and semimonthly, meetings. A committee of queries recommended topics or resolutions from which the membership chose one. Most of the debates between 1847 and 1851 dealt with Western civilization. Once the topic was chosen, one member was designated to present the affirmative case, another the negative. The president of the society served as judge, deciding who won. In addition to the debates, annual and quarterly orations were delivered on such subjects as "Education," "Neglected Genius," and the "happy effects resulting from the pursuit of an Energetic and Persevering mind." To support the society's educational activities, each member paid monthly dues for buying books kept in a library under an assistant librarian. Books purchased or donated included Thomas

SELECT LIST OF DEBATE TOPICS

The Clionian Debating Society (1847–1851) (*Free Blacks*)	The Chrestomathic Literary Society (1848–1852) (*College of Charleston*)
1. Which is the happier, civilized or savage life?	1. Which is the more happy, a barbarian or civilized man?
2. Which was the greatest and most virtuous general, Washington or Alexander?	2. Which was the greater Hero, Washington or Napoleon?
3. Is the Republic of France likely to remain permanent?	3. Is the Democratic Government of France likely to last?
4. Which is the most Advantageous, Desirable, and Beneficial—a Married or Single Life?	4. Which is the happiest, a bachelor or a married man?
5. Was England right in banishing Napoleon Bonaparte to the Island of St. Helena?	5. Was the banishment of Napoleon to St. Helena a justifiable proceeding?
6. Which was calculated to shed the brightest lustre and influence on Grecian manners and character, "The laws of Solon or Lycurgus"?	6. Were the laws of Lycurgus beneficial to the nation?
7. Whether a Republican or Monarchical government tends most to the happiness of a people?	7. Does the testimony of history incline us to believe that a Democracy is more favorable to the happiness of the people than any other government?
8. Which tends most to the diminution of murders, "capital" punishment or "life-time" imprisonment?	8. Ought Capital Punishment to be abolished?
9. Which tends most to the ruin of the human race: dishonesty or intemperance?	9. Which does the greater injury to the Society? The Miser or the Spendthrift?

Source: Proceedings of the Clionian Debating Society, Charleston Library Society; Chrestomathic Literary Society Minute Book, 1848–1852, Special Collections, Robert Scott Small Library, College of Charleston, Box CCLII-4.

Moore, *Poetical Works;* Thomas B. Macauley, *The History of England from the Accession of James II;* Thomas Carlyle, *The French Revolution: A History;* William Grimshaw, *The History of France;* Francis Hawks, *The Monuments of Egypt;* and James Paulding, *Works.*[45]

The library, the debate and oratory topics, and the proceedings themselves suggest a clientele reminiscent of Thomas Jefferson. The group decided that a republican government tended to the happiness of the people more than a monarchy; a nation benefited more from its agrarian than commercial advantages; and rural life was more conducive to moral purity than urban life. They also judged George Washington a greater and more virtuous general than Alexander the Great. It is no wonder that the *South Carolina Historical Magazine*, reprinting a microfiche register of the Charleston Library Society's manuscript holdings (where the original CDS minutes are located), failed to identify the club as black. The Charleston Library Society, founded in 1748 by the planter Thomas Middleton and his associates, prepared the way for establishing the College of Charleston.[46]

During the approximate lifespan of CDS, two white counterparts existed at the College of Charleston. They were the Cliosophic Debating Society (established in 1838) and the Chrestomathic Literary Society (1848). The similarities of the three are striking. Both the Clionian and the Cliosophic were named after the Greek muse of history, Clio. All three adopted the same format, including a committee on queries, honorary members, diplomas, orations, annual celebrations, and constitutions. The topics they debated between 1847 and 1852 were practically identical. The Clionian connection with the College of Charleston was more than coincidental. Students and graduates of the college, such as John Mood, Jr., and Francis A. Mood, attended Clionian meetings. They donated books to its library and commented on the quality of the debates. The black elite's affiliation with the Moods arose through Cumberland. The Clionians probably celebrated their anniversaries in the private school managed by black Methodists who hired the two brothers as teachers.[17]

Although influenced by an aristocratic ethos, the Clionians, nearly all artisans, espoused a Protestant work ethic. Many, like the Beards, Holloways, and Westons, were Methodists. As much as they might have admired George Washington, they decided in a debate that Martin Luther did more good. They purchased for their library a copy of Benjamin Franklin's *Autobiography*. Debate and oratory topics dealt with the importance of such virtues as industry, perseverance, patience, temperance, and honesty. The proceedings themselves repeatedly referred to the members' "punctuality."[48]

For the Clionians, the Protestant ethic and education were interrelated;

both would help make them "useful" and "respectable" members of society. W. H. Gailliard, the annual orator, argued that "the principle of self-application" was the "true path to knowledge and consequently usefulness." The Clionians unanimously passed a resolution declaring education as "one of the most important of duties devolved upon man, and the improvement thereof to be most essential." In educating themselves, they were uplifting the entire group. They promised never to "give up the good fight of usefulness" to themselves and others.[49]

However much the Clionians might have been members of a free black elite, they were well aware of their lack of formal college education and consequently of cultural parity with whites. Their proceedings made a point of lauding individual achievements to overcome this. S. J. Maxwell was praised for his oration on education, "characterized by great depth of thought, and a flow of elegant language that would do honour to one of greater advantages." The presence of the Moods and other sympathetic whites at their meetings bolstered their belief that education was a means to achieve cultural equality and overcome racial prejudice.[50]

Like the benevolent societies, the CDS was influenced by the social thought of northern blacks. The Clionians were in constant contact with former Charlestonians in the North. They made A. M. Bland of Philadelphia and Daniel A. Payne of Baltimore honorary members. Bland's private school education had been paid for by a College of Charleston graduate. His father sent him to Philadelphia because of its "superior opportunities." The Clionians appointed a special committee to carry on correspondence with Payne, an abolitionist.[51]

Many of the values espoused by the Clionians were shared by a number of students at the College of Charleston. An uplift philosophy based on the Protestant ethic permeated this institution. Although some planters enrolled their children there because they "feared that boys educated far from home would be corrupted or, still worse, should never return to their native city," the wealthiest sent their children to South Carolina College (University of South Carolina) or Ivy League schools, even abroad, for a college education. Many students had families who "could not afford to send their sons to distant colleges." W. D. Porter, for example, was the son of a grocer. He graduated from the local college and became a successful lawyer. Ever mindful of his humble origins, Porter lectured white apprentice mechanics on the ways in which they could uplift themselves. The Clionians, considering Porter's counsel important, included some of his speeches in their library. The Chrestomathic Literary Society appealed to men like Porter because it promised to make them "useful" citizens. (The term *Chrestomathic* comes

from the Greek word for "useful.") It would be wrong, however, to assume that the two college debating societies and the Clionian had identical philosophies. Unlike the Chrestomathic members, the Clionians never debated "Can Dueling under any circumstance be justifiable?" The free black elite could ill afford to indulge in dueling or pander to its code of honor; the premature death of the breadwinner was usually a financial disaster to the family.[52]

The Erosion of the Three-Tier System

The free black elite's position in antebellum Charleston society, like their ideology, was never fixed or static. More than anything else, they were adversely affected by the sectional conflict. One of the many consequences was the erosion of the three-tier system, or rather, the approximation of one. The sectional conflict produced a series of tremors in South Carolina between 1820 and 1861 that produced increased restrictions and greater hardships for the free black population. Anti–free black hysteria accompanied each tremor. Although in almost every instance this hysteria abated, it took its toll. Its cumulative effect, climaxing in 1860 with a campaign to enslave free persons of color, undermined whatever confidence Charleston's free black elite had that they could safely occupy a middle tier in a three-tier system of race relations. Low Country aristocrats may not have had the will to implement a three-tier system, but they certainly did not have sufficient political clout to do so. Charleston's white mechanics used the sectional conflict to attempt to eliminate their black competition, slave and free. Finally, members of Charleston's free black elite were not united in their attitudes toward their less fortunate black brethren. Some reacted to the increasingly dangerous situation by trying frantically to distance themselves from the larger black community, slave and free. Others, usually Methodists, had a less exclusive attitude, but in the end nearly all of them realized that they were caught in "the vise of racism."[53]

With the depression of 1819, the sectional conflict began in earnest. The Missouri Compromise of 1820 temporarily diffused the issue of slavery in the territories, but not before it affected Charleston. Black Methodists, like Denmark Vesey, were already alienated by the arbitrary treatment they had received at the hands of the white Methodists. When Vesey sought out support for his insurrection, he told his followers about antislavery speeches made by Rufus King, a U.S. senator from New York. The immediate effect of the aborted uprising was an 1822 state law severely limiting the rights of

free persons of color. Those free male blacks over the age of fifteen had to find a white guardian to guarantee their "good character and correct habits" or face enslavement. The law also prohibited free blacks from leaving the state. Even the richest and most prominent free blacks felt its impact. In 1823 Jehu Jones, who had sent his family ahead of him to New York City, decided not to emigrate to Liberia but was unable to bring them back. Seven years later a Scottish traveler touring Charleston reported that her driver, a "free man of colour" who used to visit New York every year when his business was slow, "feels himself really and truly a prisoner in the state of South Carolina." The Tariff of 1824 aggravated sectional tensions. The resulting nullification crisis (1832–1833) worsened the economic situation, increasing the competition and tensions between Charleston's white mechanics and the blacks. A quarter of the free black population left Charleston between 1828 and 1834.[54]

With the abolitionist campaign to petition Congress to halt slavery in Washington, D.C., in full swing, the South Carolina legislature, convening in December 1834, reaffirmed and expanded the state law against the education of slaves. Free blacks were forbidden to "keep any school or other place of instruction for teaching any slave or free person of color to read or write." Daniel Payne's school and four others were closed. This was the final bitter blow to his "manhood." In 1831, while he was standing on a street in Charleston "with a small walking cane in his hand, a white man snatched it from him and struck him, indignant at the idea of a 'nigger' carrying a cane." To many white southerners, the cane was a symbol of the southern aristocrat. Payne "retaliated and was imprisoned." In May 1835, shortly after the closing of his school, he left Charleston for the North.[55]

Technically, schools for free blacks were legal if staffed by whites, but the political climate rendered this aspect of the law moot. In 1835 the American Anti-Slavery Society as part of a campaign mailed abolitionist tracts to religious and other leaders of the Charleston community. A mob broke into the city post office, burned the antislavery mail, and turned its wrath against John England, a Catholic bishop who had established a school for free blacks. Alerted by the bishop, Irish members of the local militia thwarted the mob. However, a committee of "respectable" citizens convinced him and other religious authorities to close their schools for free blacks.[56]

By the early 1840s much of the overt antiblack hostility had subsided. But the laws were not relaxed, making it difficult for slaves to blend in with the free black population. In 1843 John Chichester and Ann Hoff were "proved" slaves and their names struck from the state list of free blacks in Charleston. Free blacks, aware of their tenuous position in Charleston, remained

guarded. On June 13, 1842, Edward P. Wall, secretary of the Friendly Moralist Society, declined to serve as the annual orator because he was "opposed to having addresses before the Society believing the same to be dangerous to the Pease and security of the Society." The acquisition of new territories during the Mexican War again raised the whole issue of the expansion of slavery. When Pennsylvania congressman David Wilmot introduced his proviso in 1846, turmoil and antiblack hysteria hit Charleston. On July 13, 1849, an outbreak that made the situation explosive occurred. An unruly slave named Nicholas defied the workhouse master and threatened to strike him with a hammer. The white man, escaping through a door, was pursued by half a dozen black prisoners assaulting the locked entrance. One of them shouted he was "Santa Anna." A day later, after Nicholas was captured and tried, a mob of whites threatened to destroy the nearby "nigger" Calvary Episcopal Church. Its white pastor believed the incident was caused by the "rabble of the city, set on by some demagogues, and inciting the jealousy of the white mechanics against the Negroes."[57]

The whole labor issue became a political one used by the incumbent mayor, T. L. Hutchinson, to be reelected. In August 1849 "A Charleston Mechanic" informed readers of a local newspaper that he and his friends supported the mayor because Hutchinson refused to employ black mechanics, whereas the other candidate, Ralph Izard Middleton, a wealthy slave-owning planter, believed his "negro mechanics" competent "to vie with the white man." In the September election, Hutchinson defeated Middleton by a vote of 1,142 to 920.[58]

The agitation caused whites to view all free blacks as the same and served to undermine further whatever existed of the three-tier system. In 1848 the city census taker found, "It is impossible to separate the free blacks from the free colored population." The free black elite probably wished the Mexican War had never occurred. In 1847 the Clionians decided in a debate that the war was disadvantageous to the United States. Some members of the free black elite attempted to distance themselves from the bulk of the city's black population. On June 11, 1848, Michael Eggart, vice president-elect of the Friendly Moralist Society, exhorted the members at their annual meeting that "Necessity places us in a middle ground." We are "hemmed" in "by the prejudice of the white man" and "the deepest hate of our more sable brethren." According to Eggart, "an Amalgamation of the races produced [in] us its results and this is the Whirlpool which threatens to swallow us up entirely." He urged that they withdraw into themselves, "though this nationality is confined to the narrow limits of our neighborhood."[59]

Relying on the minutes of the FMS between 1841 and 1856, Michael P.

Johnson and James L. Roark have pronounced Eggart's speech representative of the membership. In 1848 the FMS had forty-three members, about 11.5 percent of Charleston's free black males between the ages of fifteen and eighty. The FMS included a wider and financially less secure segment of this community than did the Brown Fellowship Society.[60]

Eggart's vision, however, was impractical, was unrepresentative of the FMS membership, and ran counter to a more inclusive view articulated by Methodist members, like Charles H. Holloway and Francis A. Smith. According to FMS rules, membership was to be limited to free "brown" men over the age of eighteen. Interpreted literally, this regulation would have threatened the continued existence of the society. In 1848 Charleston had only about 280 mulatto men between the ages of fifteen and eighty who were eligible. Many of them could not afford the fifteen-dollar initiation fee plus monthly dues. "The hardness of times," including financial exigencies and sickness, took its toll on the membership. There was also the competition from other benevolent societies. Moreover, like all such organizations, the FMS was racked with factional dissension. In 1841, 1848, and 1853 dissident groups broke from the society. Finally, the antiblack hostility and turmoil engendered by the Wilmot Proviso caused some members to leave the state. Thus, it was an extremely difficult task for the organization to keep a full complement of fifty members. All of these circumstances exerted a powerful force on the organization to open its doors to a wider constituency.[61]

Long before Eggart's impassioned speech, FMS traditionalists feared that the membership rules were being too loosely interpreted. In 1841 its secretary Edward P. Wall was fined for not notifying a member, who was a slave, of a meeting. Wall complained that "the Society by the Violation of its established principles Elects a Bondman."[62] Three years later, the society, after careful consideration, denied membership to a quasi slave, Charles Just, Sr., who later that year founded the Unity and Friendship Society. Likewise, in 1844, the group narrowly denied membership to Richard Gregory, whose skin was decidedly darker than that of most members.[63]

The denial of membership to Richard Gregory and Charles Just, Sr., followed by the turmoil and loss of members caused by the Wilmot Proviso, prefigured the fierce factional battle of 1848 over the candidacy of dark-skinned Edward Logan, Jr. At the annual meeting of June 11, 1848, when Eggart delivered his impassioned speech, Logan's *second* letter of application was first read. Despite Eggart's warnings, Logan was elected a member by a two-thirds majority on August 14, 1848. His opponents, led by Philip M. Thorne, the president, called a special meeting on September 6, 1848, to reconsider his admission on the technicality that one of the persons voting

for him, Francis Smith, had not paid his dues. Thorne declared the election null and void. Arriving late, Charles Holloway argued that the president did not have the right to veto arbitrarily the decision of two-thirds of the membership. In Thorne's defense, Edward P. Wall declared "that the minority claims equal right with the majority." Francis P. Main, the secretary, besides labeling Thorne "a usurper of power," accused Edward Wall of being "personally hostile" to Logan and "the Ambitious leader of A party Which seeks only the accomplishment of its own object. Irrespective of the rights of others or the constitution." Thorne threatened "that if the Minority are to bee ruled by the Majority in all cases he might as well take his portion of stock and leave the society." A series of hotly emotional sessions over Logan's candidacy followed. During one meeting, Eggart protested, "Logan is not eligible to membership being A black man." At Francis L. Wilkinson's inquiry, a debate on the meaning of *brown* ensued with the term defined as "the individual must be the descendant of brown parent or white amalgamated with black." Finally, on October 16, 1848, Thorne's opponents, led by Charles Holloway, triumphed. Seventeen disgruntled members, including Michael Eggart, bolted from the society. On October 24, 1848, by a unanimous vote, Thorne's ruling was declared unconstitutional. Holloway recommended "that the [b]earer of Mr Logans Letter withdraw the same in order that the Revolted party may not have A clew whereby they may seek to justify themselves in their Revolutionary design."[64] Despite the financial setback engendered by a loss of more than a third of its members, the FMS succeeded in rebuilding its membership. Six years later, on November 18, 1854, P. Poinsett was received into the organization. He was probably the barber-musician Paul Poinsett, a member of the Humane Brotherhood and relative of one of its founders.[65]

Although other issues (the dispute over the investment and use of funds, proposed loans to Charles Holloway and others) encouraged the schism, the emotional issue of Logan's candidacy was the propelling force behind the bolting of the "seceder party." The leaders of both factions—Michael Eggart, Edward Wall, and Philip Thorne on one side, and Charles Holloway and Francis Smith on the other—were all members of a light-skinned affluent elite. They represented various trades. Eggart was a millwright; Wall and Smith were tailors; Thorne, Holloway, and Francis Main were carpenters. Therefore, the split was not along purely economic, occupational, or color lines.[66]

The leadership of the "seceder party" was close-knit by family and church ties. Eggart and Wall were intimate friends. When Wall's son Robert was baptized at St. Philip's in 1845, Eggart was the baby's sponsor. Five years

later, Eggart's wife, Joanna, was the sponsor when Wall's daughter Mary Elizabeth was baptized at St. Philip's. Joanna was the eldest daughter of the extremely wealthy Richard E. Dereef, Sr. Thorne's sister Caroline was married to Richard E. Dereef, Jr. The children of Joanna's uncle, Joseph Dereef, were baptized at St. Philip's. At least six of the seventeen seceders had ties with this church.[67]

Charles H. Holloway and Francis A. Smith, leaders of the triumphant side, were strong Methodists. The Holloway family, with its six members, composed a sizable voting bloc within the society. Its patriarch, Richard Holloway, Sr., was a mentor of the orphan-apprentice Daniel Payne, who became a Methodist Sunday school teacher and educator. Payne married one of his daughters. The patriarch, as an exhorter and class leader, had contact with slaves and darker-skinned free blacks. Charles followed in the father's footsteps, as did his own son James H. Francis P. Main, the FMS secretary, and Samuel D. Holloway were in the same Cumberland Sunday school class conducted by Jacob Weston. John Weston supported Charles Holloway in the Logan controversy. During 1857 William Weston, Charles Holloway, and Francis Smith were class leaders at Trinity Methodist Church. Born in Charleston in 1812, Smith spent more than forty years as a class leader, exhorter, and local preacher.[68]

It is hardly surprising that the Methodists were less exclusive in their attitudes toward the larger black community than the Episcopalians. While white Episcopal leaders were establishing Calvary, the Methodist churches continued to have mixed congregations of whites, free blacks, and slaves. James H. Holloway, explaining why he was a Methodist, stated, "The Methodist Church has always been the champion of freedom and equality. Her stand in 1844 against the worst of all inequities, slavery, shows that she would rather sacrifice territory, members and associations than principles and is sufficient reason for me to stand by one that was a friend in time of need." Holloway declared, "So, as long as Methodism stands for *Spirituality, Intel[l]ectuality, Equality* and *Uplift,* may I stand for it and thus honor God and my Father and Mother."[69]

Religious or church affiliation was an important but not conclusive index to discerning and understanding the FMS struggle over opening up the membership to a wider constituency. T. Mishow was a Methodist. Conversely, not all the members affiliated with St. Philip's joined the seceders. Paul Wilkinson, who strongly supported the Holloways in the Logan controversy, remained in the society. Ironically, Logan had been baptized at St. Philip's on May 16, 1826, when he was six years old. Furthermore, the distinctions between the Methodists and the Episcopalians in the free

black community were not always clear-cut. According to A. Toomer Porter, many free black Methodists, like the wealthy butcher George Shrewsbury, preferred that their children be "baptized, married, and buried by an Episcopal minister," leading to "a kindly feeling" between parties. The Wilkinsons had close ties with St. Philip's (whose rector performed Paul's wedding ceremony, baptized his children, and buried his father Richard); Paul's brother Francis, who also supported the Holloways, was a Cumberland Sunday school teacher. He had been the class leader of Michael Eggart, who had been raised a Methodist but had probably developed close ties with St. Philip's after his marriage to Joanna Dereef. The aegis of a white guardian like Porter or the rector of St. Philip's, who could vouch for one's "good character," became increasingly important with the growing racial tensions engendered by the sectional conflict.[70]

The Methodists were not immune to such tensions. As they regained their black membership after the split of 1817, their city churches became increasingly crowded. In an effort to ease the crowding, officials in 1833 allowed black members to sit on the first floor behind the whites, instead of in the galleries. Some of the "older free persons of color" began sitting in pews allotted to the whites. Increasing encroachment by other black members caused a group of white "mechanics and small tradesmen" to protest that all nonwhites be confined to the galleries. Some class leaders, like Samuel Weston, chafed at the discrimination they experienced. "My father who has been an exhorter in the Methodist Church for nearly forty years," William O. Weston wrote in 1865, ". . . by the dastardly customs of South Carolina exclusiveness was debar[r]ed the title even of Local Preacher." Without consulting the black members, white Methodists decided in 1844 to break away from the northern church over the issue of slavery. Charles Holloway, Francis Smith, Samuel Weston, and other black Methodists still considered themselves part of "the Old Mother Church," or "the John Wesley Church." When the war ended, Holloway, Smith, Samuel Weston, and his son William all joined the northern church. During Reconstruction, Holloway and George Shrewsbury as trustees of "the Old Mother Church" sued John Mood, administrator of the Methodist church, South, to regain ecclesiastical property.[71]

However much the Wilmot Proviso agitated Charlestonians and influenced the FMS proceedings, the Compromise of 1850 prevented a war. Still, repeated efforts were made in South Carolina to restrict the rights of free blacks. In 1850 Governor Whitemarsh B. Seabrook, a Low Country planter, urged that all free blacks without slave or real property be expelled from the state. Between 1856 and 1859 seventeen grand juries called the atten-

tion of the legislature to the problem of free blacks. Petitioners continually advocated the enslavement of the state's entire free black population. The anguish free blacks felt can be gleaned from a letter Edward Holloway sent to his family from New York in 1857 to explain his decision to migrate to Jamaica. "My mind aspires for greater attainment," he wrote, "and I feel that the Day is not far distant when I shall enjoy the full freedom of Political Intellectual, and Physical *Manhood*."[72]

On the eve of the presidential election of 1860, even the most affluent free blacks feared for their safety. With the sectional conflict reaching its peak, white mechanics used the opportunity to attempt to limit their black competition. Mayor Charles McBeth, a Charleston-born aristocrat, fearing the political clout of the white mechanics, promised to keep the black population in line. In the summer of 1860 his police force began routinely rounding up scores of slaves who had failed to obtain the required badges for working in the city. Many of those arrested argued that they did not need these badges because they paid taxes and were not slaves. In August the police stepped up the arrests. Even some of the most prominent and wealthiest free blacks, such as the millwright Anthony Weston, had never bothered to obtain the appropriate legal documents proving their freedom. Free blacks were not eligible to testify on behalf of their friends and acquaintances. Panic ensued. Hundreds of free blacks voluntarily took out slave badges. The total number of blacks forced to comply reached about seven hundred before the crisis was over.[73]

The white mechanics' campaign was part of a statewide effort to enslave all free persons of color by January 1, 1862. To combat it, the free black elite circulated among Low Country aristocrats a petition pledging their support to the South. This helped their white allies defeat the enslavement proposal in the state legislature. Nevertheless, the crisis once again demonstrated how fragile their freedom was. Hundreds sold everything and fled north.[74]

Antebellum Schools for Free Blacks

Between 1803 and 1865 dozens of schools for free blacks existed. Thomas Bonneau, "the most popular school-master in the city," operated his school from 1803 until his death around 1828. His enterprise was successful enough to require two assistants, William McKinney and F. K. Sasportas. Bonneau, McKinney, and Sasportas were members of Charleston's free black elite. Early educators like Bonneau probably considered education as a way for the light-skinned free black community to instill in their children the "good

character and correct habits" which put some distance between themselves and the rest of the blacks. Though his school included orphans like Daniel Payne, it catered to the better families. In 1827, Bonneau charged Richard Wilkinson a tuition of $1.50 per month for his sons "Master Francis and Edward Wilkinson." This sum seems modest by today's standards, but in Charleston it was illegal for free black workers to demand more than $1.00 wage per day.[75]

An important segment of Charleston's free black elite never deviated from Bonneau's concept of education. As racial tensions increased with the sectional conflict, some clung to a narrowly exclusive interpretation as a panacea to their dilemma. At the 1848 annual meeting of the FMS, Michael Eggart proclaimed education "our life our sun our shield," without which "the Amelioration of our race can never bee Effected." He asserted, "Education raises us Above the level of slaves, in this land the ignorant and degraded are taken as the Representatives of our people, if this class would bee enlightened by the Power of Education how much more vivid more brighter would the line of separation bee between us and the slaves, it would bee so bright that it would Eventually triump[h] over the prejudice of the white man." Proposing that "our community" unite to pay the salary of a single teacher, he asked that "our several societies take their part in this great moral Reformation." Eggart clearly did not include slaves or dark-skinned blacks in his definition of "our race" or "our community."[76]

Ironically, Michael Eggart's teacher, Daniel Payne, evolved from his experiences a more inclusive notion of education. He sought to extend it to a wider segment of the city's black community. Reaching maturity in the post-Vesey period, he saw education as the means of uplifting the entire race. Born in 1811 of "free parents" with "brown" and "light-brown" complexions, Payne was orphaned by age ten. Since his parents had attended Cumberland, he attracted the attention of church elders like Samuel Weston and Richard Holloway, Sr. His conversion to Methodism was a turning point in his life. He aspired to become a soldier of fortune until a voice called upon him, "*I have set thee apart to educate thyself in order that thou mayest be an educator to thy people.*" After finishing Bonneau's school, Payne continued studying on his own. In 1829, shortly after his teacher's death, he opened his first school, on Tradd Street. Unlike Bonneau's, it included several adult slaves.[77]

Payne improved the curriculum. Bonneau had taught his students spelling, reading, writing, and basic arithmetic. They had read histories of Greece, Rome, and England and learned declamation through *The Columbian Orator*, a compendium of famous speeches extolling liberty, including a denuncia-

tion of black slavery. Frederick Douglass used this same book to develop his abolitionist ideas and oratorical style. Payne's students underwent a more rigorous schedule, including geography, map drawing, English grammar and composition, descriptive astronomy, botany, natural philosophy, and gymnastics. Parents and white religious leaders were invited to an annual examination of the scholars. Payne pioneered techniques carried on at Avery Normal Institute.[78]

Almost immediately, Payne's school was a success. Attracting children from the "leading families," it grew from three to sixty students. Robert Howard, one of the city's wealthiest free blacks, built Payne a new and larger school on Anson Street. Ironically, Payne's success was his undoing. Three of his advanced students, including Michael Eggart, were sent to a nearby plantation to purchase a moccasin snake from the slaves so Payne could pursue his scientific experiments. The plantation belonged to the Kennedy family. Lionel Kennedy had been one of the examining magistrates in the Vesey trials and was active in politics as a city alderman and state house representative. The Kennedys were aghast to discover what Payne was teaching his young charges. Later, this family played a major role in pressuring the legislature to pass the Act of 1834 tightening restrictions on free black schools.[79]

Despite this legislation, self-supporting schools for free blacks continued to exist. Shortly after the nullification crisis, around 1838, a group of Charleston's free black Methodists, including Samuel and William Weston, asked Henry Mood, a fellow white parishioner, to conduct a school in the afternoons after he attended his college classes. They had already organized a board of trustees and rented from the Holloway family a house "on the South side of Beaufain Street between Archdale and Mazyck Streets." Between 1838 and 1845, four Mood brothers, Henry, John, James, and Francis, took turns teaching while they attended Charleston High School and the College of Charleston. The trustees paid them four dollars a student per quarter. Their teaching duties were a natural extension of earlier Sunday school efforts organized by their father in 1832. Francis, who became a bishop, had "taught the catechism to the little blacks in Cumberland Church basement when so young as scarcely able to read well" himself. It was probably after the Moods quit teaching that J. A. Sasportas, a Methodist, and other free blacks hired a white man, W. W. Wilburn, to conduct another school on Coming Street.[80]

Exactly what philosophy prevailed in these schools is impossible to determine, but many Methodists, including the Beard, Holloway, Weston, and Sasportas families, were at the center of education for free blacks. Edward

Beard operated a school but closed it during the crisis of 1860, when he decided to leave. His brother Simeon, a Methodist preacher, taught at a school on Wall Street. After the war, Simeon moved to Georgia, where he became a member of the state's radical constitutional convention of 1867–1868. Thomas Bonneau's daughter, Frances, most likely tutored by Daniel Payne, taught in such schools. Her students included the children of her brother-in-law, Charles H. Holloway.[81]

In the 1840s and 1850s, less affluent free blacks received some education, mostly practical, through the various benevolent associations. The Minors' Moralist Society educated Daniel Payne and other orphans until it closed in 1847. The Humane Brotherhood promised to educate the children of deceased members until they were prepared for a trade. Since many free black women were dressmakers, some benevolent associations sent female orphans to sewing schools. In 1851 the Friendly Moralist Society enrolled the two daughters of the deceased Edward G. Cotton in a sewing school run by a black woman named Seymore.[82]

During the 1850s, schools for the black elite continued to exist "in secluded places." Some were similar to college preparatory schools. William O. Weston, educated in the 1840s and 1850s, described his training as "favorable." Besides the basics, he studied logic, rhetoric, surveying, geometry, astronomy, mental philosophy, algebra, Latin, and Greek. As a Clionian, he improved his learning skills by debating on virtually the same topics as College of Charleston students. Nevertheless, some free blacks, like Thomas and Francis Cardozo, left the city to pursue their education. The two brothers, after attending the local private schools, were apprenticed out, Thomas to a manufacturer of rice-thrashing machines, and Francis to a carpenter. A few years after their father's death in 1855, they departed. In 1857 Thomas settled in New York with his mother. A year later, his brother Francis sailed for Scotland to enroll at the University of Glasgow. Supporting himself as a part-time carpenter, Francis won awards in Greek and Latin and graduated with honors, indicating the relatively high standards some of the antebellum schools maintained.[83]

The decision of the Cardozos was probably influenced by the escalation of the sectional conflict. However, even during the war, schooling for free blacks never ceased. In July 1864 the widow of Francis Wilkinson was paying a tuition of $2.50 a month for the education of her daughter, Sarah, who was probably attending the school operated by Jacob Weston's daughter, Mary, for forty or fifty free black women. Although Mary Weston was arrested twice, city authorities allowed her to keep it open "on condition that no slaves should be admitted to it, and that a white person should be always

in the room during school hours. She complied with these conditions, hiring a white woman to sit in the schoolroom with her sewing, and kept the school open till the capture of the city." Mary Weston, like her cousin William, taught at Avery after the war.[84]

The desire for education continued to exist among the less affluent free blacks as well. Some enterprising parents tried to sneak their children into white public schools during the war. The practice became so widespread that in 1862 city authorities decided to make an example of one of the parents. The mayor sentenced Phillis Stuart to thirty days in solitary confinement "for sending a mulatto child to a school for white children." The Charleston *Mercury* reporter added, "We understand that there are some other cases of this character, which will soon be looked after." Another local newspaper informed its readers, "the Mayor has determined to have all the offenders brought before him and punished." The dangers that free blacks risked to educate their children demonstrate the high priority many, even the poorest, placed on the importance of education. This enthusiasm extended to the schools opened by Yankee missionaries in Charleston after its fall in February 1865 to a black Massachusetts regiment.[85]

Avery and the Antebellum Context

Daniel Payne returned to his native city shortly after its surrender. Joyfully recalling the experience in his memoirs, he wrote, "I visited the colored schools in which were gathered, it is said, three thousand colored children and taught by white teachers from the North, controlled by so radical an abolitionist as James Redpath, and under the protection of United States black troops. With the colonel of the Massachusetts regiment at my right, and Major Alexander Augusta on my left, my emotions overwhelmed me, and expressed themselves in tears of gratitude, thanksgiving, and love to that God who had wrought such a marvelous change in the condition of a helpless race. There and then I realized the fulfillment of the promises which God the Father of all the families of the earth had made to me in 1835. It was there and then that I believed what I beheld was a prophecy of the future, that New England ideas, sentiments, and principles will ultimately rule the entire South." [86]

Although emancipation shattered the shaky semblance of a three-tier system, economic tensions and intrasegregation (that is, color discrimination among blacks) would linger. The abolitionist zeal of the Yankee missionary teachers would conflict with the aristocratic aspirations held by some of the

antebellum free black elite. The preconceptions of these missionaries would further strain relations. Their mission to purify the South would propel them to mitigate, if not eradicate, intrasegregation and caste-class distinctions. At the same time, they would reinforce those more inclusive and egalitarian values of the aristocratic-artisan ethos that they shared with the black middle class. These values included the respect for manual labor, the Protestant ethic, and the service-oriented aspect of the uplift philosophy envisioned by Payne.

CHAPTER

2

Reconstruction, 1865–1877

On May 5, 1868, Reuben Tomlinson, superintendent of public education for the Freedmen's Bureau in South Carolina, invited Charles H. Holloway, one of Charleston's first black aldermen, to "the dedication of the New School-building for colored children, on Bull Street." The ceremony was to take place on Thursday, May 7, at 3:30 P.M. Also attending would be General Robert K. Scott, former state head of the Freedmen's Bureau. Scott, Tomlinson, and Holloway were part of a larger cast of northern philanthropists, missionary teachers, soldiers, black Charlestonians, and white Southerners who participated in the establishment of Avery Normal Institute.[1]

During Presidential Reconstruction (1865–1866), Avery's antecedents, Tappan and Saxton schools, barely survived as the American Missionary Association (AMA) was forced to vacate the buildings provided by the army. Under President Andrew Johnson's lenient policy, many of the antebellum municipal leaders returned to power. There was little local white sympathy for the establishment of a school for blacks, especially one sponsored by the AMA, itself a product of antislavery sentiment. The new building was symbolic of the hopes and aspirations of Charleston blacks on the eve of Congressional Reconstruction (1867–77), a radical departure from the president's. With the support of a newly rejuvenated Freedmen's Bureau, Saxton School was renamed after the northern philanthropist Charles Avery, whose estate provided the much-needed money. With the problem of the physical plant resolved, the AMA and its black allies attempted to upgrade the school into a college preparatory and normal institute.

Viewed from the perspective of a century-long interim, Congressional, or Radical, Reconstruction was relatively conservative, but to the participants the effort was "revolutionary." To win black support for the Republican party, while sending a message to recalcitrant Charleston whites, the mili-

tary removed thirteen of Charleston's eighteen aldermen from office in the spring of 1868. Mayor Palmer Gaillard, a former Confederate officer, was replaced by General W. W. Burns, next by Colonel Milton Cogswell, and eventually by a civilian, George W. Clark, a northern Republican. Seven of the new aldermen were black. In the November 1868 elections, Gilbert Pillsbury, a Massachusetts-born Republican and former Freedmen's Bureau agent, was elected mayor, together with a biracial ticket of aldermen.[2]

Avery, founded by northern missionaries and headed by Francis L. Cardozo, an antebellum free black, stood to gain by the changed political circumstances. (Cardozo would soon become a Republican state officeholder; his elder brother Henry, a Methodist minister, would become a state senator.) Unfortunately, Republican hegemony in Charleston was more apparent than real. Pillsbury won a narrow victory by a margin of twenty-two votes out of nearly ten thousand cast. The Republican mayor was not inaugurated until May 1869, after the last court challenge against the election was dismissed. Fierce party factionalism and a scramble for office immediately plagued the Republicans. The new administration was further hamstrung by financial problems. A five-million-dollar debt, accrued by the city for internal improvements before the war and due in April 1870, threatened municipal bankruptcy. The ensuing crisis forced severe retrenchment, including the closing of the city's public schools. In 1871 the financially beleaguered city was prematurely "redeemed" by the Democrats. Fortunately for the Republicans, the panic of 1873, coupled with internal problems within the Democratic party, as well as the victors' own inability to overcome financial problems, brought the Republicans back into office, as they temporarily put aside their bickering. A fusion ticket with the Democrats prolonged the Republican stay in power until 1877, but continued factionalism and the election of Redeemer Wade Hampton as governor in 1876 signaled the end of the line for Charleston Republicans. After the last Republican mayor completed his term in 1877, the party in Charleston, for all practical purposes, collapsed.[3]

Given such political turmoil and uncertainty, the perpetuation of Avery was not assured. The situation was complicated by internal problems. The missionary teachers themselves had conflicting views of what should be done. Shunned by the larger white population, they withdrew into the mission home, where their internal disputes sometimes erupted into internecine warfare. Dedicated to Christianizing and educating "unfortunate" blacks, the Yankee missionaries discovered that their pupils were already Christians; some had been free before the war. Instead of finding freedmen who were willing to follow their lead uncritically, these missionaries confronted a num-

ber of proud, educated, and cultured freeborn blacks, who had their own vision for Avery. Although all parties passionately believed in uplift, there were differences among them. Francis Cardozo wanted to use the advanced students, who were predominantly from antebellum free black families, to turn Avery into a college preparatory and normal institute that would produce teachers and other race leaders. The northern missionaries, on the other hand, criticized Cardozo and these families for "elitism." In a sense, both sides checked the other's worst tendencies. The missionaries' stultifying paternalism was mitigated by the independent attitude of a local black artisan middle class, but some of the missionaries were quick to detect and condemn color consciousness and exclusiveness. Although the lingering semblance of a three-tier system of race relations, on which color and caste consciousness was based, continued to deteriorate after the war, these color and caste differences persisted in Charleston. Despite such difficulties, Avery survived the death knoll of Radical Reconstruction.

The Missionary Impulse

Although most Northerners went to war to preserve the Union, they came to view the South's defeat as the triumph of good over evil, a vindication of abolitionism and American democracy. The northern press, particularly relishing the liberation of Charleston by black troops, treated its surrender as the final act of a morality play in which the den of inequity was cleansed by the righteous. "Charleston is a symbol," the New York *Times* editorialized. The shot fired in its harbor four years before "awoke a more terrible echo and was the prelude to a grander drama, than the world ever experienced. . . . the capture of Charleston is the knell to the Southern ear, foretelling the doom of the wicked Confederacy."[4]

For abolitionist missionaries waiting on the Sea Islands off South Carolina, the fall of Charleston was not the last act of a morality play but the beginning of a crusade to uplift and educate the freedmen. Part of a larger nineteenth-century reform movement drawing on evangelical Protestantism, abolitionism inspired the birth of a variety of organizations devoted to ending slavery in the United States. The AMA traces its origins to 1839, when a group of northern abolitionists established a committee to provide legal defense for slaves, charged with mutiny, who had seized the schooner *Amistad* and taken it into a Long Island port. Their legal efforts were successful and led to the establishment of the AMA in 1846 as a protest against the failure of northern churches to condemn slavery.[5]

The AMA ideology was permeated with the logic of abolitionist thought. Slavery, a sin against God and man, not only endangered the mortal soul of the slaveowner but also had a morally debilitating effect on both the slave and southern society. Unable to make decisions for himself, the slave sank to moral depravity. Since a decadent slaveowning aristocracy ruled, slavery was allowed to poison all southern institutions, including the press, church, and school. AMA missionaries, in accompanying the northern armies, hoped to "uplift" the freedmen from the degradation of slavery by inculcating in them the Protestant ethic. Although nonsectarian, the AMA had close ties with the Congregationalists and Presbyterians. The impact of these ties would be seen in the establishment of Avery. The AMA mission, reflecting the covenant theology of the Congregationalists, was to transplant New England's "pure democracy" to the South, that is, to reconstruct southern institutions in the New England image. The AMA proposed establishing common and normal schools and institutions of higher learning, so that the black race could "work out its own future with its own teachers and educators." These black leaders would "be made" to be like northern teachers and thinkers. Ultimately, the AMA hoped that the educated freedmen would unite with other progressive elements of southern society to reform its institutions, particularly by establishing public schools.[6]

As one of the oldest and best organized societies of its kind, and with missionaries as near as Beaufort, the AMA was in a good position to beat its competitors into Charleston. During Reconstruction, six men would superintend its educational interests there: Thomas W. Cardozo, April–August 1865; Francis L. Cardozo, August 1865–April 1868; J. B. Corey, October–November 1868; Mortimer A. Warren, January 1869–December 1873; James T. Ford, 1874–1875; Amos W. Farnham, 1875–1879.[7]

Breaking New Ground: Thomas W. Cardozo and the Founding of Tappan and Saxton Schools

The Cardozo brothers were the most important superintendents during Reconstruction. They not only uniquely shaped Avery's faculty and student body but also made it a college preparatory and normal institute. The school would serve these two basic functions for most of its eighty-nine years. Both Cardozos were most qualified to provide Avery the direction and guidance it needed to become established. Francis, after attending the University of Glasgow and Presbyterian seminaries in London and Edinburgh, pursued a career in the ministry. In May 1864 he returned to the United States to

become pastor of the Temple Street Congregational Church in New Haven, Connecticut. That same year he married Catherine R. Howell, a New Haven resident. When the Civil War began, Thomas was teaching in Flushing, New York, where he had met and married a fellow teacher, Laura J. Williams, a mulatto from Brooklyn.[8]

By the time Thomas reached Charleston on April 6, 1865, the AMA found itself at a disadvantage. Two other northern missionary societies had already opened schools. Military authorities, concerned over the influx of missionaries from the nearby Sea Islands, had sought guidance from a Massachusetts-born abolitionist, James Redpath, who was an agent of the New England Freedmen's Aid Society of Boston. On February 27, 1865, they designated Redpath the city's superintendent of public instruction, giving him the authority to determine who would occupy its public school buildings and other confiscated facilities. With Redpath as its agent, the New England Freedmen's Aid Society obtained the old Morris Street public school building, which it opened up on March 14, 1865. By the end of the month a thousand students were attending the facility (later renamed Shaw Memorial School). The other rival, the New York National Freedmen's Relief Association, also met success. Leaving a palace guard at its schools on the Sea Islands, it had sent its main force into Charleston and had set up its operations in the Meeting Street public school facility. Two hundred students were enrolled by the beginning of April 1865.[9]

This was the stage setting when Thomas Cardozo arrived as superintendent of the AMA mission in Charleston. Cardozo defined his task as "the elevation of my oppressed brethren." Initially, it consisted of dispensing relief packages to destitute freedmen, hiring and supervising AMA personnel in the city, establishing a mission home, and locating buildings for mission schools. The AMA authorized Cardozo to hire ten teachers and later several more. He had no trouble filling these positions. The home office sent two northerners, Vira Gould and Sarah A. Thayer, as the first two teachers to join Thomas and Laura Cardozo at #8 Rutledge Avenue, the mission residence. They were followed by Mr. and Mrs. H. H. Hunter, a black couple from New York. The home office also sent a black missionary, Ennals J. Adams, to administer to the spiritual needs of Charleston's black Congregationalists. Cardozo filled the rest of the teaching slots with members of the city's antebellum free black community.[10]

Finding building space for schools was a more difficult task. Redpath, reminding Cardozo that "All the Public School Buildings were occupied," suggested that the AMA establish several schools in downtown churches. Apparently his suggestion was already being implemented. In May 1865

H. H. Hunter reported, "Our schools in Charleston are in a very flourishing condition." Hunter was principal of a school located on St. Michael's Alley with over two hundred students. In June Cardozo was listed as principal of the school, probably after the Hunters left for Hilton Head, South Carolina. Cardozo also presided over a night school named after the abolitionist Lewis Tappan, an original member of the Amistad Committee.[11]

Redpath's secular attitude created tensions between him and the AMA, hurting his effort to unite the three abolitionist societies. He irritated the AMA missionaries by forbidding them to open each school day with a prayer and a brief Bible reading. Redpath reasoned that the children, not yet organized enough for such exercises, "did not pay strict obeisance to them." Cardozo was able to persuade him to reverse his decision. When in April 1865 Redpath asked the AMA to join in a consortium with the two other societies to take turns paying the teachers, the AMA refused. It had fewer in the city. Moreover, it did not want to pay all "regardless of character"; some might have been "godless or Unitarians."[12]

The failure of the AMA to cooperate with Redpath did not have any lasting repercussions. On July 1, 1865, he was relieved as superintendent. By mid-June, the Freedmen's Bureau was already subsuming his duties. The national head of the bureau was General Oliver Otis Howard. His assistant commissioner for South Carolina was Rufus B. Saxton. James W. Alvord was general superintendent of education, with his headquarters in Washington, D.C. Reuben Tomlinson, a Quaker who had a more conciliatory attitude toward white southerners than Redpath's and probably had a more sympathetic view of the AMA vision, served as South Carolina's first state superintendent of public education.[13]

On June 14, 1865, Tomlinson, hoping to prevent the return of the school buildings to white southerners, wrote to the AMA for its cooperation. By that date the association seemed to have consolidated its schools at one large location. It agreed to continue its operations through the summer of 1865 and to increase student enrollment. A decline in enrollment during the summer would have strengthened the case of local whites who wanted their old school buildings restored. Cardozo staffed his summer school entirely with local blacks. Statistics for Charleston's schools in July were encouraging. As city superintendent of public instruction, Redpath had required his eighty-three teachers, mostly local whites and blacks, to pledge to treat all children, black and white, equally. Modeled after New England educational systems, the schools, fourteen in number by July, had a combined enrollment of four thousand pupils, probably most of the city's black school-age population and nearly a quarter of the entire black population.[14]

In his letter seeking AMA cooperation, Tomlinson praised both Cardozo and his school. "Mr. Cardozo's school has reflected great credit upon all persons connected with it," he wrote, "and is exercising a powerful influence for good among all classes of the community. Mr. C. is a gentleman, educated, intelligent, discreet, and faithful." Unfortunately, Tomlinson was only partially correct. While at a teaching post in Flushing, New York, Thomas, then married, had either seduced or been seduced by a female student. When the AMA sent his brother Francis to Charleston to investigate the rumors, Thomas confessed. Francis confirmed the charges leveled against his brother but, finding him repentant, recommended that he be allowed to stay on. The AMA home office thought otherwise, replacing Thomas with Francis. Thomas remained in the city and opened a grocery business, but a fire destroyed it. He eventually went to Mississippi, where he was elected state superintendent of education in 1873.[15]

Francis L. Cardozo and the Establishment of a Normal School Legacy

From the AMA's perspective, Francis L. Cardozo was the ideal person to replace his brother in Charleston. Passionately sharing the AMA's vision of purifying southern society, Francis fully concurred with its theorists, who recommended the establishment of normal schools in the South to inculcate into future black teachers Christian and moral virtues that would act as an antidote to the poisonous effects of slavery. "The object for which I left all the superior advantages of the North and came South," he explained, "for which I am willing to remain here and make this place my home . . . [is] to establish a Normal School." One year after his arrival, he proposed sending his three best students up north for further education. "I am aware," he wrote to the AMA secretary, "of the elevating and stimulating influences they can obtain at the North. . . . It seems to me that slavery has produced such corrupting and degrading influences, it requires a generation to remedy, and the whole of the social organization must be remodelled. I am glad therefore to have them removed to the purer influences of the North."[16]

Under Presidential Reconstruction, former owners could regain their lands by simply petitioning the federal government. Therefore, the most pressing problem facing Cardozo in August 1865, when he became AMA superintendent in Charleston, was finding another mission home and school building. The military provided the solution by offering the residence at 10 Montagu Street and the large state normal school building on St. Philip

Street. Cardozo and his teachers, hoping to placate the military, named their school after General Rufus Saxton. Unfortunately, the solution proved temporary. In November 1865 Cardozo complained, "We have been compelled to remove again," to a house at the corner of Vanderhorst and Thomas streets. "The property is being restored so fast that we scarcely get settled in one house before we are compelled to remove to another." [17]

Hardly sympathetic with educating blacks, white Charlestonians were particularly incensed over their homes and schools' being confiscated for this purpose. "One thing especially provokes them," Cardozo wrote in October 1865, "that is, Our schools." A local white businessman, Jacob Schirmer, confided in his diary during the summer of 1866, "I suppose the . . . buildings will be kept until the little *nigger race* shall be prepared to enter College." When James Redpath had been superintendent of public instruction, he demanded the College of Charleston "for a school for coloured children, and the Library for his own residence." Ironically, several years later, with the radicals in power, conservatives in the state legislature, hoping to prevent the integration of the University of South Carolina in Columbia, would offer the Citadel, the military college in Charleston, as the campus for a black university.[18]

By the fall of 1865 white Charlestonians had established a school committee. When it approached General Saxton for the return of the city's public school buildings, Cardozo, branding the group as the "Secession School Committee," considered the effort a ploy to destroy education for the freedmen, especially since the whites conceded that they did not have sufficient funds to put the schools back into operation. "These people here have been entrusted with power too soon," he protested, "they are still disloyal at heart, and are most treacherous; they are trying their best to have civil power fully restored, and are willing to adopt *any means* for that purpose. The feeling of hate and revenge toward the colored people seems to me fiendish. They are throwing every obstacle in their way." Since blacks were taxpayers, Cardozo urged them to "claim half the buildings, and if the Committee won't give them to take the case to the U.S. Supreme Court." His morale received an additional blow when Saxton, "obnoxious to these Rebels on account of his devotion to the interest of the colored people," was removed. The AMA superintendent had to vacate his staff and pupils from the state normal school site at the end of August 1866. Fortunately, Tomlinson managed to secure for them Military Hall on Wentworth Street, once the headquarters of the Freedmen's Bureau in Charleston.[19]

Recognizing the negative impact that continual moving had on his staff and pupils, Cardozo worked to secure permanent facilities. Promised sup-

port from friends in New Haven, Connecticut, he set about finding a lot for the new school and money to finance the project. Tomlinson pledged one thousand dollars, and General O. O. Howard promised a contribution. Even a former slave broker, J. S. Ryan, who was Cardozo's real estate agent, offered five hundred dollars, provided he had "the right of sending two colored scholars, and he offered to collect Five Hundred more from his friends—the Brokers." Cardozo estimated that he needed ten thousand dollars for a school housing three hundred scholars. The government would donate five thousand dollars; southern friends, one thousand dollars; blacks, two thousand dollars; and northern friends, the remaining two thousand dollars. Unfortunately, the "New Haven Enterprise" collapsed.[20]

When all seemed lost, Cardozo's luck changed. The AMA's traveling secretary, Edward P. Smith, falling ill on his way to Atlanta, was forced to recuperate at the mission home in Charleston before he could proceed. Smith informed Cardozo about the philanthropy of the late Charles Avery, a Wesleyan clergyman, of Pittsburgh, Pennsylvania. The trustees of the Avery estate were planning to pledge ten thousand dollars for the establishment of a black college in Atlanta, provided Smith could obtain the approval of the governor of Georgia and the mayor of Atlanta. At Cardozo's urging, Smith won a similar pledge from the Avery trustees to finance the construction of a new school in Charleston.[21]

For Cardozo to apply the Atlanta formula, he would have to swallow his pride and seek the support of the conservative establishment. Fortunately, as a member of Charleston's antebellum free black elite, he had access to this group. A communing member of the city's Second Presbyterian Church before the war, Cardozo had received a letter of recommendation to study abroad from its pastor, Thomas Smyth. The minister "is a man of a great deal of influence," Cardozo told the AMA, "and I shall try and keep on the best terms with him, as long as I can do so without sacrificing any principle."[22] Times were propitious for a rapprochement. The Episcopal convention of South Carolina had decided to establish a school for blacks in Charleston. It delegated three ministers, A. Toomer Porter, C. P. Gadsen, and C. C. Pinckney, rector of Grace Church, and George A. Trenholm, the former Confederate secretary of treasury, to visit Saxton School in late May 1866. Cardozo noted they were the first southern whites who ever came "into our school. They expressed themselves very much pleased both with our methods of teaching and the efficiency and behavior of the scholars. They certainly seemed much surprised." Armed with their approval, Cardozo sought the backing of some of the state's most important officials and citizens. Theodore D. Wagner, business associate of George Trenholm, gave

his support. Wagner with Trenholm had initiated blockade running during the war. Both men were staunch parishioners of A. Toomer Porter. Cardozo also won the approbation of Thomas T. Simons, editor of the Charleston *Courier;* George T. Bryan, U.S. district court judge; Henry Buist, state senator; W. D. Porter, lieutenant governor; and James L. Orr, governor. The AMA superintendent was even successful with Charleston's mayor, P. C. Gaillard, despite the skepticism of Bryan and Wagner, who tried to dissuade Cardozo by claiming the mayor's "influence was after all of no consequence as he did not belong to the 'First Families.'" Cardozo later reflected, "I thought it a most singular thing that I should hold the document for a one-armed Confederate officer to sign to educate and elevate the men for whose perpetual enslavement he had lost an arm."[23]

Promised ten thousand dollars from the Avery estate to purchase a home for teachers and an adjoining lot, Cardozo and the AMA sought further financial help from the Freedmen's Bureau through the Congressional Appropriations Act of March 1867. In April 1867 Cardozo and his teachers moved into 35 Bull Street, bought for five thousand dollars from the estate of Samuel S. Farrar, a retail grocer. The transaction included an adjacent lot large enough for erection of a new school.[24]

Constructed in the fall of 1867 by Henry Oliver and Robert McCaroll, local white contractors, at a cost of seventeen thousand dollars, the school building was "88 feet long, 68 feet wide, 50 feet high, and to the top of the flagstaff 90 feet." Raised "on brick pillars, with spacious brick basements, and a large cistern underneath," it had, on each side, "spacious piazzas running the entire length, and opened from the class-rooms." The building was "finely ventilated on a new and improved plan." The size and shape of the new school were dictated by its purpose. Cardozo and the AMA envisioned a college preparatory and normal institute with 350 to 400 students. The school would be divided into three departments—primary, preparatory normal, and normal. The primary department would be composed of four classes (40 students each, totaling 160). The rest of the student body would be enrolled in either the normal preparatory (two classes, 50 each) or the normal (two classes, 50 each). Students successfully completing the normal course of study would be required to practice teach in the primary department. Cardozo requested that the architects include in the design a large assembly hall for "General Exercises." The hall would provide a place of worship for Charleston's black Congregationalists until they established Plymouth Church; it would also serve as a cultural center for the black community.[25]

Next to finding permanent quarters for the AMA mission home and

school, Cardozo's main goal was to develop the school into an institute to train black teachers. Arriving in August 1865, Cardozo had found the students unprepared to enter teacher's training. He decided to operate "a good Common school" until enough students were ready to make a normal institute feasible. In October 1865, when he opened the Saxton School at the St. Philip Street site, nearly one-fourth of Charleston's black school-age population was on hand for instruction. The 1,000 students (600 girls, 400 boys) were enrolled in three departments—primary, intermediate, and grammar. Eight hundred students regularly attended. Eighteen teachers were responsible for handling fifteen classes; twelve had been hired directly by the AMA and six were transfers from the National Freedmen's Relief Association. The final staff was reported to be twenty teachers—ten northern whites and ten southern blacks. The next year, when the school moved to Military Hall on Wentworth Street, the size of the student body was 800, the maximum number the building could accommodate. Eight northern whites and eight southern blacks made up the faculty. In the fall of 1867, when Cardozo determined to make the transition to a normal institute, he sharply reduced the enrollment to 438 (65 in the primary department, 281 intermediate, and 92 advanced). Eight northerners composed the teaching staff. Thus, when Cardozo turned over the keys to his temporary replacement, the senior instructor Ellen M. Pierce, he had achieved his goals. He went on to serve as a delegate to the state constitutional convention of 1868, then state secretary of state (1868–1872), and finally state treasurer (1872–1877).[26]

During his tenure as superintendent, Cardozo was lauded by a variety of people for his tireless efforts, administrative ability, and the academic excellence he brought to the AMA school. In addition to a legacy of academic excellence, Cardozo had firmly established the school's mission to turn out service-oriented, dedicated Christian teachers. Both would be continued by his successors. J. B. Corey, the superintendent, wrote in October 1868, "In the organization of our school, as a Normal school, I was anxious to impart to those who are preparing to teach, a knowledge of the great truths which form the basis of our whole great Christian work. We want to make them Christian teachers." Mortimer A. Warren, of Connecticut, who shortly replaced Corey, felt "obliged to do a constant educational missionary work to keep the scholars in the school and hunt up new ones who might make good teachers." Warren's successor, James T. Ford, of Stowe, Vermont, sought to instill into his students the same missionary spirit that motivated the staff. That élan can be perceived in the notes school officials penciled in the margins of an 1873 commencement program about some of the student orators:

Leonora Johnson—"Excellent mind & character—ought to be helped on in a higher English course."

Lydia Rollinson—"Has taught in the country—full of love for her people & ambition to be a good teacher."

Rebecca Peace—"We hope she may teach in this school soon."

Martha Gadsen & Susan Artson—"Are to be sent to college by their parents."

Peter Hazel—"A Baptist—good mind—would make a good minister. We want to help him. He is very anxious to go to Atlanta." [27]

The need for black teachers was all the more pressing after February 1870, when South Carolina put into effect the common school system mandated by the constitution of 1868. Shaped by men like Cardozo, the constitution required that all children receive at least two years of education. Financed by a state property and poll tax, the common school system was to be implemented by elected county superintendents. A Freedmen's Bureau official, Edward L. Deane, perceiving that black superintendents would prefer to hire black teachers, noted that aside from Charleston's Shaw Memorial School and Claflin University in Orangeburg, only Avery could meet this demand. Deane's prediction proved correct. "It is difficult to exaggerate the prospects of usefulness before this school," Avery's superintendent, Mortimer A. Warren, exclaimed in 1870. "It is situated in the commercial centre, in a State in which the negro element is largely in the majority. Schools are organizing in the country round about us. Clamorous calls for teachers and schools come from every part of the State. Already I am asked to furnish fifty teachers, and another year still greater demand will be made." [28]

Avery responded to the challenge by increasing the percentage of normal students enrolled from 18.5 percent in 1870 to 33.8 percent in 1876, and 65.5 percent in 1880. Four years after the new building was dedicated, commencement ceremonies were held for the school's first graduating class. Between 1872 and 1877 Avery graduated eighty-six students. Most of them pursued additional studies or a career in teaching. In 1873 a report on the graduates concluded, "all have been teaching . . . with the exception of those who have gone to higher schools to pursue collegiate or technical courses of study." The exact number of students who attended the AMA school and became teachers during Reconstruction is nearly impossible to determine since some dropped out to teach before graduation. In 1906 forty-six (56.7 percent) of eighty-one surviving graduates (1872–1877) taught in public schools. Some, like Martha C. Gadsen and Sallie O. Cruikshank, taught at Shaw in Charleston. The others had to leave the city to teach since Shaw,

founded by the New England Freemen's Aid Society and turned over to the public school system in 1874, was the only one of the two black municipal public schools to hire black teachers.[29]

The record of those students who attended the AMA school and left the city during Reconstruction in order to pursue additional studies is impressive. When Francis Cardozo was superintendent, he alone procured college scholarships for Joseph Wilkinson, Walter Jones, Arthur O'Hear, Thomas McCants Stewart, and Joseph W. Morris. Arthur O'Hear, who attended Oberlin College in Ohio, completed his studies at Howard University in Washington, D.C. T. McCants Stewart transferred from Howard to the University of South Carolina (USC) in Columbia, where he received an A.B. and L.L.B. Cardozo was responsible for a large Avery contingent at USC. He persuaded several other Averyites attending Howard to transfer to the Columbia school; he even lent them money for traveling expenses.[30]

During Radical Reconstruction, USC was reorganized, enabling Averyites to attend it instead of going out of state to continue their education. When this institution admitted its first black students in 1873, critics called it "The Radical University." Under the new system, four of the nine trustees were black. Of fourteen faculty members, four professors were removed and three resigned. One of their replacements was Richard T. Greener, a graduate of Harvard. As professor of mental and moral philosophy, he was the only black on the faculty. Despite some vandalism, the reorganization was fairly smooth.[31]

"The Radical University" attracted Avery officials as well as graduates. When Francis Cardozo left Avery to enter politics and become a state officeholder, he enrolled at USC and obtained a law degree. Mortimer A. Warren eventually moved to USC to head its preparatory department but soon resigned to become principal of the State Normal School, located on the university campus. Warren's efforts to create a comfortable environment for the black students included his personally conducting religious services on campus every Sunday. He also found time to complete USC law school. James T. Ford, who succeeded Warren at Avery, attempted to become a librarian at the university.[32]

According to Cornelius C. Scott, who graduated from USC in 1877, a number of the black students at the university between 1873 and 1877 were Avery graduates like him. At least half of all the black students (many of them Charlestonians) were "the sons of parents who were 'free persons of color' during slavery, and attended school before or during the War of Secession, having as teachers Mrs. Sarah Bee-Leland, Mr. Wilbur[n], the Mood brothers, white, and the Beaird brothers, William Ferrette, Mary Weston and

Fannie Bonneau-Holloway, colored." For instance, Joseph W. Morris, who was born of free parents in Charleston in 1850, attended Simeon Beard's school. The youth, after attending his Avery classes, learned printing in the afternoons from R. B. Elliott, a black congressman, who at the time was editor of the Charleston *Leader*. Graduating from Avery and Howard, Morris obtained a law degree from USC and became president of Allen University in Columbia. Cornelius C. Scott, John M. Morris, and William M. Dart were teaching assistants in the classics at USC. Other Averyites on campus included Paul J. Mishow, Alonzo G. Townsend, William D. Crum, John L. Dart, Thaddeus Saltus, Robert L. Smith, Merton B. Lawrence, Whitefield McKinlay, and Robert P. Scott (Cornelius C. Scott's brother).[33]

The careers of these people illustrated how the children of the antebellum free black artisans were forming a professional middle class embodying the social uplift philosophy. William M. Dart, for example, played an important role in expanding public education for blacks. Soon after obtaining his B.A., he became principal of Howard Elementary School, established in Columbia around 1867. Under his leadership, it added in 1883 a three-year high school, marking the beginning of public secondary education for blacks in the state capital. John M. Morris also went into education but died soon after graduation. Merton B. Lawrence's career as a successful insurance agent and Cornelius C. Scott's activities with fraternal orders such as the Masons, Odd Fellows, Pythians, and the Good Templars, as well as his involvement in the temperance movement, revealed how middle-class blacks were developing institutions of a national scope to take over many of the functions formerly fulfilled by local antebellum benevolent societies. Many of the South Carolinians in A. B. Caldwell's *History of the American Negro* (published in 1919) were property owners and belonged to orders like the Masons, Odd Fellows, and Pythians.[34]

Cornelius C. Scott's work as the executive committee chairman of the first race conference in South Carolina presaged the Interracial Councils of the 1920s. In 1911, he wrote for a Columbia newspaper an article defending the integration of the USC campus during 1873–1877, the road, he believed, interracial cooperation should follow. The son of devout Methodists, Scott taught at Avery and in the state's public schools and summer normal institutes before he entered the Methodist ministry. Besides being a public school principal, he edited and published a newspaper first at Sumter and later in Columbia. A highlight in his life was his trip in 1889 to London, England, as a delegate to the World's Sunday School Convention. The Grand Lodge of the Good Templars of England invited him to act as the Grand Worthy Counselor at their session in the Crystal Palace. Also during his

visit, he met British temperance leaders. In 1891 he received an honorary
M.A. from Syracuse University, and later a Doctor of Divinity degree from
Wilberforce University.[35]

Like Scott, John L. Dart pursued the calling of a minister-educator and
newspaper editor-publisher. Born of free parents in Charleston in 1854, Dart
was valedictorian of Avery's first graduating class (1872) and obtained an
M.A. from Atlanta University. After studying at Newton Theological Semi-
nary in Massachusetts, he was ordained into the Baptist ministry. He taught
in Washington, D.C., and held pastorates in Providence, Rhode Island, and
Augusta, Georgia, before he returned in 1886 to Charleston. He served as
pastor of Morris Street Baptist Church for sixteen years and then spent
ten years at Shiloh Baptist Church. In 1894 he established the Charleston
Normal and Industrial Institute to educate poor black children crowded out
of the local public schools. Around 1905 he became editor and publisher
of *The Southern Reporter*. Although he failed to persuade the municipal au-
thorities to take over or subsidize his institute, he prepared the way for the
city's first black public high school (Burke [Industrial] High School, formerly
the Charleston Colored Industrial School). The kindergarten he established
and the private library he opened for the young men of his parish laid
the groundwork for his daughter, Susan ("Susie") Dart Butler, a milliner-
teacher, to build on after his death. The first public library for blacks in
Charleston would be established in the building that once housed his school
and newspaper.[36]

Dart exemplified the way that within the antebellum aristocratic-artisan
tradition many Averyites valued books, culture, and higher education but at
the same time were open to an interpretation of the social uplift philosophy
along the lines of Booker T. Washington. Several, including T. McCants
Stewart, William D. Crum, Robert L. Smith, and Whitefield McKinlay,
were close associates or supporters of Washington. McKinlay, a business-
man and Republican politician, served as one of Washington's advisers on
national political affairs. In 1907 the president, Theodore Roosevelt, ap-
pointed him to a commission on housing for the poor in the D.C. area. Three
years later, he became port collector of Georgetown, D.C., during William
Howard Taft's presidency. In 1912 McKinlay denounced the segregation of
federal employees.[37]

A Shared Vision and the Seeds of Division

White Charlestonians, considering themselves "best acquainted with the
character of the negroes," perceived the AMA mission as subversive. During

Reconstruction black teachers were not employed in the city's public schools except at Shaw. White Charlestonians preferred that their own kind teach blacks because they viewed northerners like the AMA teachers and the black graduates of the normal schools operated by these missionaries as extensions of Yankee imperialism. After attending the Public Examination Program held by Saxton School in May 1866, a reporter for the local *Daily News* remarked, "No small credit is due for all this to the much-abused school-marms, for the self-denial and philanthropy which induced them to leave their much vaunted and beloved New England, and visit this benighted Southern land, illuminating the night of our barbarism by the light of their countenance." Branding them "ladies of riper years" and "Plymouth pilgrims of progress," the reporter continued, "Preaching to the heathen, instructing and civilizing them, appears an innate passion with the pious descendants of the Pilgrims. Fortunate[ly,] they find the *partes infideles* brought almost to their very doors. Here they can gratify their holy zeal without incurring the danger of a long sea voyage, or the disagreeable predicament of being incorporated with a Sandwich." [38]

Such sarcasm was not entirely unprovoked or unmerited. The AMA "school-marms," like Phebe Alcott, gloated over the fact that they lived in a home once occupied by R. Barnwell Rhett, "the notorious" editor of the Charleston *Mercury*. Designating their charges "the Rhett house Regiment," Miss Alcott and her colleagues infuriated neighbors by having the students sing such "patriotic songs" as "Rally Round the Flag" and "John Brown's Body." Their glee, however, was tempered by the realization that "the Charlestonians must feel a special grudge toward it [the AMA school] —and we should none of us be surprised if they made a bonfire of us some dark night." In 1866, Cardozo recalled, "One woman, very finely dressed, and apparently quite lady like, stopped at the door, the other day, while the children were singing and said, 'Oh, I wish, I could put a torch to that building! The niggers.'" Another "Southern aristocrat," calling the school "a damned nuisance," complained, "why are you making all this noise and disturbing the neighbors." [39]

White Charlestonians were correct to conclude that the AMA missionaries thought they were transplanting the superior culture of New England, the mother country, to the newly liberated but backward "natives." This attitude was manifested in the way the missionaries perceived the AMA's supportive role in the establishment of Charleston's black Plymouth Congregational Church. Before the war, several of the members were part of the city's downtown Circular Congregational Church, but the Great Fire of 1861, which destroyed the historic church, led to the establishment of a separate black congregation. The group worshipped in a variety of places, including Avery

Hall. Hard-pressed, the congregation renamed itself Plymouth and accepted help from the AMA. In 1868 B. F. Jackson, a northerner serving as Plymouth pastor, reported, "Last Thursday we had a Thanksgiving service in regular New England style." A few years later, with a loan from the AMA, the members erected a new chapel, costing five thousand dollars. Located on Pitt Street, near Avery, it was dedicated in 1872. Their pastor at the time was a white northern missionary, James T. Ford. At his urging, the cornerstone contained a copy of "the social compact made by the Pilgrims before landing at Plymouth." Ford described the church as "a promising centre of influence in moulding for good the character of the colored people."[40]

This attitude of the AMA missionaries persisted throughout Reconstruction. In 1877 it surfaced in the criticism Amos W. Farnham, Avery's superintendent, expressed to the home office about Plymouth's pastor, W. G. Marts, a white northerner, who had become involved in local Republican politics, including the publishing of a newspaper. Farnham, concerned about the impact of these activities on Marts's teaching duties at Avery, wrote, "He is usually behind time in his appointments. You know this is a general failing among colored people. They need leaders who will compel them to be on time. Much of their deplorable condition comes from always being behind time. Late in seedtime, late in harvest."[41]

Avery's white superintendents, conveniently misreading public opinion at the school, could be too solicitous of the prejudices of some of their patrons. Farnham occasionally sounded like nineteenth-century colonialists convinced that the "natives" did not want their own kind as leaders. Farnham heard second hand that some of his older students did "not want teachers of their own color in the higher grades. They want *Northern* whites." He subsequently discouraged the light-skinned Averyite Cornelius C. Scott from remaining on the faculty after one disgruntled student, failing to graduate, complained that "he wouldn't have a *nigger* sign his diploma." Farnham, conceding Scott "a good teacher" and "moral christian," thought the man's "color hinders his popularity" and hoped he would go elsewhere "for the sake of giving the school *character*." Advising the AMA not to raise Scott's salary, Farnham believed that the Averyite's continued presence was divisive, threatening the school's fine reputation and his endeavor to upgrade it into a college. Scott himself believed he had the confidence of both the parents and the students. The white superintendent underwent a change of heart, because through his efforts, Scott was succeeded in the higher grades by another Averyite, Edward A. Lawrence, who would teach at the school for nearly twenty years and serve as interim principal. Lawrence developed such a high regard for Farnham's dedication that he named his son after the man.[42]

Farnham's preconceptions were to some degree fostered by the home office's patterning its efforts in the American South after its missions in Africa. One of the first missionaries it sent to Charleston, Ennals J. Adams, had been part of its Mende mission in Africa. In 1878 an Avery report stated, "The plan of 'native helpers' is being tried here, the faculty consisting of a principal and two lady teachers from the North, and five graduates from the school." As the report indicated, local blacks were viewed as colonials. Nearly all of the AMA missionaries, including the Cardozos, referred to them as "natives." Both Cardozos preferred northern teachers, black or white, because they were more competent. Thomas complained, "One of our Northern teachers—who has had experience in teaching—can do as much as two of these Southern ones." Some of the northern superintendents and teachers were condescending toward their fellow "native" teachers; Sarah Stansbury was particularly abrasive in supervising them. Thomas Cardozo, commenting on one of his northern female teachers, noted, "when a dark colored person comes to live in the same house . . . prejudice springs up." Although a few of these white missionaries were prejudiced against blacks, others, more accurately, were oblivious to the fact that the "natives" might have had any previous religious training. In 1865 Phebe Alcott argued, "The special need of these people and of these children is *Jesus*. Elevation after *Christianization* is comparatively easy." Nearly a decade later H. C. Foote, a missionary teacher, still referred to Charleston blacks as *"heathenish."* [43]

Although white Charlestonians found the missionary ethnocentrism of the New England "school-marms" galling, what really disturbed these southerners was probably the underlying egalitarianism of the AMA mission. Teaching patriotic Yankee songs could be perceived as a manifestation of this egalitarianism. "I can see they possess as much 'human nature' as fairer school children at the North," Alcott wrote about her charges. She along with her colleagues imparted a sense of equality and self-confidence in the students. Even the Charleston *Daily News* reporter conceded, "No Southern lady can impart that assurance and self-confidence . . . we saw cropping out on all occasions among the performers" at the May 1866 public examinations. In time some of these AMA missionaries, like Mortimer A. Warren, the superintendent, came to realize that the local blacks had their own viable religious institutions. He suggested that the AMA deemphasize religious training at Avery. "If this school were in Mende," he explained, "then we would act differently; but being where it is and the pupils getting what they do of religious instruction from their churches I see the place of this school to be not to do exactly what their churches do." Warren concluded that since Avery was not a boarding school like some of the other AMA operations, it should be managed differently. "In those schools," he elaborated, "the prin-

cipal is pro tempore, in loco parentis; and he is bound to manifest a father's interest in the spiritual well-being of his children." [44]

While mocking the ethnocentrism of the Yankee "school-marms," the Charleston *Daily News* reporter did grant these "ladies of riper years" a good deal of "self-denial." According to Francis Cardozo, "Our young ladies are constantly very busy, indeed I am afraid that they will make themselves sick with hard work, they work in the day school from half past 8 o'clock until half past two, and then in the night school from seven to nine o'clock and in the Sunday School from twelve to half past one, besides they visit the scholars in their homes, and in addition to all this they do a great deal of walking to and from the school." Phebe Alcott confirmed Cardozo when she informed AMA officials, "We are driven with work. Our session is longer than any other in the city. We distribute clothing many and many a day from the close of school till dark. We have an evening school in our parlor for recreation. We have a Sabbath School numbering now 200 scholars—for the success of which we feel responsible, the burden of which we bear." The burdens of these teachers were complicated by Samuel Hunt, the AMA general superintendent of schools, who constantly chastized Francis Cardozo for spending too much money on his operation, especially food. Cardozo defended himself by sending Hunt a typical daily menu, listing primarily bread and potatoes, with some beef. Both Phebe Alcott and Reuben Tomlinson were appalled when they heard about Hunt's complaint. [45]

Laboring under long hours and spartan conditions, subject to the heat, humidity, and diseases of the Low Country, some of the Avery missionary teachers became seriously ill. In April 1869 Abby D. Munro recalled how her colleague M. L. Kellogg's "strength failed her, from day to day, though she continued faithfully to discharge her duties, till, within three weeks of her death." Kellogg's last request was to be buried in Charleston, "to be identified with this people. . . . where the soldier fell, there he should die." That same year, Mortimer A. Warren commented that another teacher had had "a constant headache" for two months. "Teaching is killing her. Nothing but her big will keeps her at it." A year later Warren reported Munro too sick to continue teaching much longer. However, she was able to recover and continue, for in 1876 she went to Laing School, in nearby Mt. Pleasant, where she served as principal for at least thirty-seven years. She replaced the ailing Cornelia Hancock, a Yankee nurse who founded the school in 1866 with the financial support of Philadelphia Quakers. [46]

Despite cries of Yankee imperialism from white southerners, the AMA was hardly imposing an alien outlook on an unwilling or passive black population. Many black Charlestonians, especially the antebellum free elite, en-

dorsed the AMA ideology. They, too, passionately believed that by practicing the Protestant ethic, individual blacks could make themselves "respectable," "useful" citizens, thereby lessening the prejudice of whites and ensuring racial uplift. When Francis Cardozo sent up north his three best students, potential ministerial candidates from antebellum free black elite families, he felt that the project would have "an excellent and beneficial effect on the welfare and elevation of the colored people generally." Cardozo thought, "They will also do a great deal of good to the School and to the cause of education among the colored people, by stimulating the other scholars, and proving the capacity of colored young men to the *Southerners*." The AMA, strapped for northern teachers, turned to this black elite to staff its school. The local black instructors, along with the Cardozo brothers, were instrumental in implementing the AMA ideology. They composed half of the school's twenty-member teaching corps in 1866 and, in 1878, five of its seven teachers. This is remarkable, for between 1865 and 1873 the AMA employed only eighteen black teachers in the entire state of Georgia (never more than 5 percent of the state's AMA teaching force).[47]

The AMA's decision to hire many local black teachers was as much financial as philosophical. Since these teachers lived at home, the AMA was spared the expense of boarding them (which was apparently prohibitive). Unlike their northern counterparts, most could be expected to remain teaching during the hot summers. The home office also found them willing to accept the standard AMA salary of fifteen dollars per month, although some of its northern teachers were making three times as much. Eventually, the best of these local black teachers threatened to resign and work for the rival New England Freedmen's Aid Society. This action persuaded the AMA to raise their salary to thirty-five dollars per month.[48]

By employing the Cardozo brothers as superintendents of its operations in Charleston, the AMA ensured both support for and domination of the school by the city's antebellum free black elite. Thomas hired his prewar "school mates" as teachers. A majority were from families who had involved themselves in education before the war. The most prominent included William O. Weston, Mary Weston, J. A. Sasportas' daughter Margaret, and Amelia Shrewsbury. Thomas also hired Francis Rollins, who had been educated at the Institute for Colored Youth, a high school in Philadelphia. She was a member of the Rollins family, who were among the antebellum free black elite in Columbia, South Carolina. A women's rights advocate and the author of a biography of the black leader Martin R. Delany, Rollins later wed William J. Whipper, a black Reconstruction legislator. Francis Cardozo retained the best teachers hired by his brother and added several other

local blacks to his staff. They included Richard Holloway, Harriet Holloway, Rosabella Fields, Catherine Winslow, and Moncuria Weston. He also persuaded the AMA to hire as music instructors his sister and her husband, Mr. and Mrs. C. C. McKinney, then teaching in New York State. McKinney had taught in Charleston's antebellum private schools for free blacks. J. L. Alexander, Amanda Wall, and other northern black women who joined the staff also contributed to Avery's academic legacy. Wall, sister of John Mercer Langston, a black educator, apparently traveled to South Carolina with her husband, the Freedmen's Bureau official O. B. Wall.[49]

With Francis Cardozo at the helm, the AMA school became even more identified with Charleston's antebellum free black elite. Its transformation into a college preparatory and normal institute dramatically changed the makeup of its student body. The enrollment of freeborn students grew from 25 percent to 50 percent between May 1866 and 1867. The city's black elite rushed to enroll their children. Mary Weston, for example, taught some of the same students in her school before and during the war. In May 1866 a local newspaper reported, "what offered the greatest attraction to our best colored society is the fact that the Normal School is the *reserche* seminary, to which all the aristocracy send their children. . . . About three-fourths of the scholars are Freedmen, the remaining fourth (comprising the more advanced classes) is composed mainly of those who were born free, and who now constitute an aristocracy of color. . . . It is the design to make this a Normal School for the education of teachers, and the best material only has therefore been retained, as far as practicable, and the remainder sent to other schools. Thus, in some of the classes scarcely a single pure black is seen." By October 1866 the school was equally divided between the two groups, with the freeborn still dominating the upper classes. The extent of the freeborn black elite's presence at Avery becomes clearer when the institute is compared to Shaw. Whereas half of Avery's student body was still freeborn in 1867, 90 percent of Shaw's pupils were former slaves, who composed 80 percent of the most advanced classes.[50]

Under the guidance of the Cardozos, Avery grew to embody the uplift philosophy of the antebellum free blacks as fully as it expressed Yankee imperialism and AMA ideology. The school's public examinations were opportunities for the students to demonstrate to themselves, their teachers, white guests, and the black community how "respectable" they had become through education. The 1873 commencement ceremonies included student orations with titles such as "Cicero," "Elizabeth and Her Reign," "Ways of Doing Good," "Japan," "Character," "The Life of Christ," and "License or Prohibition—Which?" The school became the focus of the black com-

munity's efforts toward cultural uplift. From October through December 1865 the Charleston Sewing Circle sponsored at the school a series of public lectures designed for "mental and moral improvement." The ministers who spoke included B. F. Randolph, "The Puritan and Cavalier"; F. Cardozo, "Martin Luther and His Times"; E. J. Adams, "West Africa, Its People, and Future"; and R. H. Cain, "Our Future." During intermission, singers performed with Thomas Cardozo's wife, Laura, at the piano.[51]

Avery's emphasis on producing service-oriented Christian teachers and community leaders such as ministers ensured that the school would transcend a narrowly individualistic interpretation inherent in the uplift philosophy. Exactly how the outlooks of the antebellum free blacks and the AMA differed is difficult to discern, especially in the case of William O. Weston, who wrote to Thomas Cardozo in June 1865, "The slave whom it was a crime to teach breathes the air of Liberty. The Spelling book can now replace the vulgar amusement or song of ribaldry." Weston concluded, "I propose laboring for the cause [of educating the freedmen] as long as I possibl[y] can."[52]

Although black Charlestonians agreed with the AMA about the debilitating impact of slavery on the South, northern white missionaries failed to take into account successful attempts of antebellum free blacks to counteract its effects. Some of the missionaries, like Mortimer A. Warren, eventually realized their ignorance and modified their preconceptions accordingly. Others, identifying all freeborn blacks as an affluent light-skinned elite, failed to develop any empathy with them. This was particularly true of those missionaries more interested in helping the city's black underclass than in establishing a college preparatory and normal institute.

Francis Cardozo especially felt the barbs and criticisms of the more zealous missionary teachers who thought he pandered to the city's antebellum free black elite. Jane A. Van Allen, of Gloversville, New York, was an AMA teacher who traveled to Charleston in October 1866 to help the poor. Within two weeks she undertook seventy-six visits to the city's destitute blacks. When she received a package of clothes from home, Cardozo promised her that she could give it to the poor and needy. Apparently without further explanation, he had the clothes distributed among the student body. This action caused a rift between the two, culminating in Van Allen's transfer soon thereafter. In a bitter letter to the AMA secretary, Edward P. Smith, she declared: "I consider the scholars in the Normal School, mostly to be the children of the colored people, who are the best able to clothe their children of any of the colored people, here, in Charleston. I find the freed people to be the most needy, & the greatest sufferers. The freed people, mostly,

have my sympathies. I wish to do all I can for the *suffering* of any class, but I am not willing to labor or beg for the 'free browns,' in a manner that will help to make the difference between them & the freed people, ever greater than it was in slavery." The Yankee teacher concluded, "*Many* of the 'brown people' here, think they are a great deal better than those who were slaves; wherever you meet them, they are sure to tell you that *they were free;* but they think the Northern people *must* think the colored people are just as good as they are." [53]

Sarah W. Stansbury attributed her removal to her complaint to the AMA home office about Francis Cardozo's decision to turn away students who could not afford to pay the tuition ("fuel Money") in November 1866. The superintendent, regretting his decision, reversed it. To halt the large drop in enrollment, he sent his teachers to the students' homes to retrieve them. To ease the students' financial burden, he provided books at below cost, and free for orphans or those without fathers. An equally compelling explanation for her transfer was her arrogant and condescending attitude toward both Cardozo and the "native" teachers. In response to his request for an expert on pedagogy, she had been sent to help his local black teachers, who had never attended normal school. Stansbury was appalled at what she found. "They only know a beaten track," she complained to Cardozo's superiors. "And when in discipline, they have no idea of the beautiful order that springs out of the industry and enthusiasm of awakened thought." When Cardozo expressed his misgivings about her sending such remarks to the home office, she branded him an "autocrat." Seeking her transfer, the superintendent wrote, "she is so dissatisfied that she will scarcely speak to any one in the house, and does not speak *at all* to me or my wife." Relocated to another school, Stansbury took a parting shot at her former supervisor: "The children are all ex-slaves which is more than can be said of Mr. Cardozo's school[;] his own class and Mrs. Chipperfield's are composed, I should judge, entirely of freedmen's children, many of whom *owned slaves* before the war." [54]

As Sarah Stansbury's criticisms suggested, divisions within Charleston's Afro-American community had evolved before the war from the attempt of the planter-merchant class to approximate a three-tier system. With the conclusion of the war, some antebellum free blacks, like George Shrewsbury and Richard E. Dereef, tried to reconstitute old friendships with members of the aristocratic white elite, who, besides being their best customers, had provided them some protection against the racism that had surfaced during the sectional conflict, particularly from their competitors, the white mechanics. In February 1865 Shrewsbury offered A. Toomer Porter the

help of family members to work as servants and a loan to tide him over. The butcher was sincerely distraught that "gentlemen" like Porter, being in dire straits, would leave the city—especially because Porter was a steady customer, whose boarding school, opened after the war, would depend on him for its meat. But there was a limit to the black man's largess. When the panic of 1873 found Porter thousands of dollars in debt, Shrewsbury warned that he would have to stop supplying meat unless the minister paid his five-hundred-dollar bill.[55]

White conservatives such as Porter considered men like Shrewsbury and Richard E. Dereef "coloreds" who could be counted on to help them regain control of municipal politics. Although Dereef was appointed to the city council by the military in 1868, he voted to support an abortive attempt by conservatives to have the results of the Republican victory overturned. By 1870 Reconstruction opponents realized that they needed the support and candidacy of such men to achieve even a narrow victory in Charleston. Their efforts to build up this alliance were confirmed in 1871 when they temporarily redeemed the city by nearly eight hundred votes on a ticket including five blacks and headed by a German immigrant, John A. Wagner.[56]

The Republican defeat in 1871 brought in its wake all kinds of recriminations among party followers. Although the main culprits were factionalism and the city's pressing financial problems, some black politicians, like Martin R. Delany, a dark-skinned northerner, attributed the defeat to color divisions. Delany charged that the white Republicans, in an effort to gain hegemony over their black allies, had encouraged the divisions. The light-skinned black Republicans, he implied, by monopolizing all the offices, had demoralized and alienated their darker-skinned brethren. Delany's stance, increasing his popularity among the predominantly darker-skinned electorate, advanced his own political agenda but added to the tensions. Some of his critics noted that black northerners propagating such charges made a practice of marrying "brown" women once they had established themselves.[57]

However much such divisions contributed to the Republican defeat, they were at least temporarily overcome. Aided by the economic hardships engendered by the panic of 1873, the Republicans put aside their factional differences, at least momentarily, and won the municipal election of 1873 by a comfortable margin. The Democrats could take some solace in the fact that more conservative Republicans, like George A. Shrewsbury, were elected. "He was a member of the city council," A. Toomer Porter wrote, "though a colored man, and he represented the conservative element in that board." The local *News and Courier* described him as belonging "to a colored class in Charleston who have long been equally distinguished by their high

order of respectability and their perfect devotion to their native State and city." When he died in 1875, the newspaper declared, "the city has suffered a severe loss in the death of one who was effecting so much good by his teaching and especially by his example."[58]

Theoretically, reconstituting a kind of three-tier system by using a respectable class of colored citizens as a middle tier that could tip the balance in favor of the conservatives seemed promising. But most local whites considered such a coalition only a temporary expedient that would end with real redemption. Even in 1875, after the Republicans had convincingly regained control of the city government, some southern whites could not bring themselves to associate with the most "respectable" members of the antebellum free black elite such as Shrewsbury. "I acted as one of his pall-bearers and assisted in bearing his body to the grave," A. Toomer Porter recalled, "a thing that required some nerve to do in this community." After 1883 no black alderman, Democrat or Republican, served on Charleston's municipal council until 1967.[59]

The outcome of the sectional conflict rendered unlikely the participation of some elite black families in a reconstituted three-tier system, especially those with relatives who had left the state before the war. "Some of the sons of our members wore the Blue, and at least one contributed his life blood for freedom at the charge of Battery Wagner under the lead of the brave Col. Shaw of the Fifty-fourth Massachusetts Regiment, and thus the blood of South Carolina and Massachusetts mingled as in the case of the Revolution," James H. Holloway noted in his history of the Brown Fellowship Society. J. A. Sasportas's son Thaddeus K., who moved to Philadelphia in the late 1850s to continue his education and could not return because of travel restrictions placed on free blacks by the South Carolina legislature in 1822, joined the Fifty-fourth Massachusetts. After working as a Freedmen's Bureau official, he became a delegate to the South Carolina constitutional convention of 1868 and later a Republican representative in the state legislature from Orangeburg County. Some members of the antebellum free black elite who were affiliated with the northern Methodists became Republicans. One of them, William O. Weston, who consented to a military appointment to the city council in 1868, had contempt for white southern Methodists who had refused to ordain his saintly father a minister before the war. Similarly, Francis Cardozo, who, while living in the North, had developed close ties with the Congregational church, condemned any political alliances with the planter-merchant elite.[60]

Even some of the most conservative members of the antebellum free black elite, like Edward P. Wall, refused to join the Low Country aristocrats in a

Democratic coalition. Wall's evolution into a radical is instructive because it demonstrates how unsuccessful the Democrats were in wooing some of the most conservative-thinking members of the antebellum free black elite. It also reveals the underlying egalitarianism of the uplift philosophy. Had the white conservatives readily consented to giving the black elite the vote, Wall might have supported their cause. Ironically, it was the military who validated the uplift philosophy by naming him to the city council in 1868. Recognizing the "revolutionary" aspect of establishing a biracial city council, northern Republicans probably picked Wall because "the representation in Council of the colored race is now regarded as an experiment, upon the results of which, to an almost paramount extent, depends its future unquestioned recognition."[61]

Reelected as a Republican, Wall became increasingly radical as the white conservatives continued to refuse him the minimal regard due a gentleman. As Edward Holloway aptly stated in 1857, Wall, despite his achievements, still did not "enjoy the full freedom of Political[,] Intellectual[,] and Physical *Manhood.*" Wall certainly considered himself more cultured than the former slaves, but few whites made such distinctions themselves. In 1867 even black aldermen, like Wall, were forced to sit in inferior seats at the Academy of Music and ride on segregated streetcars. The latter proved particularly galling. On March 26, 1867, several blacks, after attending a Republican political rally, were forced off when they attempted to integrate the city's streetcars. Two years later Wall and fellow black aldermen, made to wait for service at a local tavern, were charged double the regular price for their drinks. The proprietor refused to open the windows because he did not want black customers seen in his establishment. Wall retaliated by persuading the city council to pass a nondiscriminatory rider as a requirement for a business license. When Wall died in 1891, the Charleston *News and Courier* described him as "a staunch Republican. . . . For four years he was Alderman . . . and is said to have introduced and had passed the city ordinance to enforce the Acts of Assembly giving civil rights to the colored people. This included equal privileges on the street car."[62]

As Wall's experiences indicated, there was little possibility of reconstituting a viable three-tier system. Nevertheless, color and caste distinctions did not vanish overnight. Some members of the black elite, holding on to a worldview shaped in the antebellum period and still prevalent in aristocratic Charleston, continued to act much as they had before the war. Former slaves, equally tenacious in their attitude toward this group, perpetuated, particularly through anecdotes, the stereotype of a monolithic and haughty light-skinned freeborn elite. Sometimes, newcomers contributed to these

tensions. White southerners, amused by such divisions, helped to exacerbate, if not exploit, them. Real and imagined color divisions continued to blight Charleston's Afro-American community long after the structure that gave rise to them had seriously deteriorated.[63]

To what extent intrasegregation, reinforced by "freeborn advantages," was practiced at the AMA school is difficult to determine. In 1867 the student body was equally divided between freemen and freedmen. Half of them were described as "pure African," the other half termed "of mixed blood." According to a local newspaper, "the *personnel* of the school embraces colored children of almost every hue conceivable." The same year Francis Cardozo reported that half of his student body was "free-born," and the other half, "pure African." Cardozo found "no difference in the capacity of *freemen* and *freedmen;* indeed the difference between them would not be known if it were not for the more advanced condition of the former, on account of previous advantage." The transition to the normal school resulted in a reduction in the size of the student body to between three and four hundred students, with many of the former slaves' transferring to the public schools. Still, in 1869, half of the students were former slaves. Some of the very best were dark-skinned. Mortimer Warren, ecstatic over his first class to finish *Davies' Practical Arithmetic,* exclaimed: "Some of them are very black, and some very white, but the blacks are the smarter."[64]

Those who commented on color divisions within the AMA school brought with them certain preconceptions and biases. White southerners were quick to attribute the school's success to the white blood that coursed through many of the students' veins. By reporting caste differences among blacks, they covertly exonerated their own racism. White northerners moved south with equally firm convictions. The main task of the northern missionaries was to prove that the former slave was innately equal to the white man. Educating light-skinned free blacks did not satisfy this purpose. In 1867 Reuben Tomlinson apologetically reported to General Robert K. Scott, "It may be said that there is such a large portion of free born children of mixed blood in this School [Saxton], that it does not show what the ignorant children of slaves are capable of doing." If anything, the northern missionaries exhibited a prejudice against light-skinned blacks. In 1870 Mortimer A. Warren proposed sending Thaddeus Saltus, one of his best students, to New York. "He is quite white," the superintendent told his superiors, "but is not to blame for that, and I hope you'll not allow his color to prejudice you."[65]

Color bias may or may not have been part of a larger class one, making it impossible to determine a core prejudice. In 1865 Thomas W. Cardozo stated that he could not worship at Zion Presbyterian Church, now under

Ennals J. Adams. "Rev. Mr. Adams is here," the AMA superintendent explained, "but he preaches for the class with whom I cannot worship for want of intelligence." Prewar status was another important factor, no matter the shade of one's skin or facial characteristics. When the *Nation* reporter John Richard Dennett visited the school in November 1865, he was told "that the free Negroes, as distinguished from the freed people, still cultivate a feeling of exclusiveness, and, among other modes of displaying it, still send their children to private schools."[66]

On Thursday morning, April 8, 1875, the arrival of M. E. Shaw and her baby, both dark-skinned, triggered pent-up feelings and prejudices at the mission home. Shaw was hired to fill temporarily a teaching position at Avery while her husband, J. W. Shaw, who had brought them to Charleston, taught at an AMA school in Savannah, Georgia. Because of difficulties arising over Mrs. Shaw and the baby, James Ford, the superintendent, urged J. W. Shaw to take his wife and child with him to Savannah, but the black man refused.[67]

About a week later Ford wrote to E. M. Cravath, the AMA field secretary who hired the couple, to explain the situation and his actions. "None of our ladies had I think been wholly disposed to receive a colored sister to our house," Ford remarked, "but they had swallowed their feelings in that respect. The baby however was too much for them." They feared it would cause inconveniences in the home and hinder M. E. Shaw in her teaching duties. Also her presence in the school would disrupt its daily operations. "When she visited the school," Ford related, "there was evident displeasure on the part of some of the pupils, and I am told that these said they should leave the School rather than be taught by a black teacher." He further explained, "The light *colored* people in this city—are quite as much prejudiced against the *Negro* as many of the whites. And Mrs. Shaw being undoubtedly a pure negro had this prejudice to contend with. Besides, those who have been educated in this school do not like to see a colored teacher brought in from abroad; they think that the places open for colored teachers should rather fall to them." However, the overriding reason for the minister's course of action was that J. W. Shaw "seemed considerably interested in S Carolina politics, and in the chance here for a black man to rise to distinction." Shaw had stopped in Columbia to see R. B. Elliott and, while in Charleston, had visited A. J. Ransier. Ford "thought that it would be better for him as a Christian worker to have his connections with S Carolina entirely severed."

Also about a week later Shaw wrote to Cravath from Savannah about the incident. Although Ford told Shaw that the problem was "the feeling in the school against dark teachers," the black man blamed Mrs. Ford and Miss Ludlow (a white teacher from Oswego, New York), but particularly Mrs.

Ford, for causing the difficulties. While the superintendent's wife "was not prepared to have a dark woman fill the vacancy" and questioned Shaw's motives, "the horror of a genuine black baby in the house was more than Mrs. Ford's sense of propriety could stand."

Ford's apprehension came to nought. A nurse was hired to tend the baby. In his letter to Cravath, Ford had to concede, Mrs. Shaw "is doing well, so far as I can see, in the school. . . . I do not think that any pupil has left school on account of her color." She herself wrote to Cravath about a month after her arrival at Avery. "Although my welcome here was not the most cordial," she related, "yet I am now getting on very nicely. Mr. Ford is a perfect gentleman and a most efficient Principal. The ladies treat me with uniform kindness[;] in fact I scarcely remember that I am of a different race. My school numbers thirty four, with an average attendance of twenty nine. . . . I will join my husband in Savannah at the close of the school year." M. E. Shaw did gain the respect of her students, as confirmed in another letter Ford wrote in July to the home office. "Mrs. Shaw who was sent here by Mr. Cravath to take his place did excellent service," he reported. "She was a good teacher, and secured good order with as little show of authority as any teacher in the building." Ford also mentioned the possibility of returning north: "my wife, as she has made known to some of the officers of the society—is not satisfied to remain longer in Charleston, and I myself sometimes have longings for more quiet pastoral work." Shortly afterward Ford was replaced as superintendent by Amos Farnham. The case of M. E. Shaw illustrates the difficulty of determining the extent of intrasegregation at Avery.

Whatever the color and caste divisions at Avery were, the policy of the home office was not to encourage them. It consciously sought to eradicate color consciousness by supporting the school's most progressive graduates. In 1873 school officials noted that the "christian conduct" of the graduate speaker, Monimia H. McKinlay, "has helped much to break up caste in different shades of color." Amos Farnham recommended in 1877 that the home office hire Eugenia C. Gaillard, an Avery graduate, because she "is quite an able teacher. She has great activity and strong will. She is progressive. I never met a more conscientious *teacher*." Both women became instructors at Avery.[68]

A consummate politician like Francis Cardozo understood that the support of Charleston's freeborn black elite was not sufficient in itself to secure the survival of the school. Any spread of rumors of racial prejudice at Avery threatened to estrange it from the larger black community. When S. Hunt, AMA superintendent of schools, interpreted Cardozo's preference for northern teachers because of their competency as a desire to exclude all

blacks, Cardozo demanded a retraction. If such a rumor were to be circulated in the city, it would "hurt my influence very much," he pointed out. "I am sure you would not willingly do me the injustice of supposing me guilty of such unchristian conduct requesting competent persons to be denied positions on account of their color. And indeed such conduct would be specially foolish and suicidal on my part." Cardozo, to some degree, was following an antebellum tradition established by C. G. Memminger and other local educators, who routinely went north for innovative concepts and teachers.[69]

For pragmatic reasons, Avery's superintendents had to concern themselves with the wishes and needs of the entire student body: the parents paid half of the operating cost of the school. Most of the parents struggled mightily to pay the monthly tuition. In 1869 Mortimer Warren maintained, "By far the greater number are in needy circumstances." A year later at the insistence of the home office, Warren reluctantly raised the tuition to one dollar per month. He feared losing "the most valuable material" and reducing the student body by half. Economic hard times nearly always produced a reduction in the enrollment. "This year is more trying," wrote Warren in 1871, "because of the unusual poverty of the people. . . . Our taxes [tuition] are going to come by hard grinding." In 1877 Amos Farnham reported, "With regard to the small number in school, I think the prevailing poverty of the colored people in Charleston is the prime cause."[70]

An advocate of "an American system of free public instruction," Mortimer Warren branded another AMA proposal to raise the monthly tuition as "foolish and wicked and cruel," particularly "wicked," he argued, "because it would take from this school all pretense of a missionary character and put it unmistakably on the same foundation as any other private pay school." His principled stance was bolstered by pragmatism. By 1872 Avery faced stiff competition for students. "We are surrounded by eight or ten thirsty villains," Warren complained, "who are doing their level best to eat us up." The main competition came from the Morris Street Public School, opened in the fall of 1867. When times were hard, or the Avery tuition was raised, students left the AMA school for its Morris Street competitor. Fearing that his pupils might be unduly attracted to his white southern competitors who employed white teachers exclusively, Warren preferred employing northern white teachers at Avery.[71]

When federal troops took over the city in February 1865, the local public schools were closed. The Freedmen's Bureau confiscated various facilities for use by northern missionaries to educate black children. When the local public schools were reopened in January 1867, these confiscated facilities, except the Morris Street building, had been returned to the city school

board. The bureau had arranged a six-month lease with the board to enable the New England Freedman's Aid Society to continue operating in the Morris Street facility until a new building could be constructed through federal appropriations. However, a dispute between bureau agents and the school commissioners over the renewal of the lease arose. General Robert K. Scott, state head of the bureau, reminded the school board that many blacks held receipts to prove they had paid the school tax. The board changed its plans to erect, through federal funds, a new facility to house a black public school. It also decided not to renew the lease. When the Morris Street facility was returned, the board turned it into a school for black children along the lines on which the white public schools had been established.[72]

Henry P. Archer, principal of the white Bennett Public School, organized and opened the city's first black public school in September 1867. Two months later T. W. Glen, the assistant principal, took charge. All the teachers were white southerners. In 1870 the student enrollment was eight hundred. A bureau official, Edward Deane, reported to General O. O. Howard, "I feel warranted as commending it highly[;] as far as known this is the only instance in this state of municipal authorities assuming the voluntary support of the school for freed children." In 1872 Aristippus Doty, Jr., the new principal, began upgrading its curriculum as a direct challenge to Avery. According to Warren, Doty was "avowedly trespassing on my ground, being bound to teach, as he himself told me, algebra, etc., saying that Avery Inst. shouldn't crow over his sch much longer." Following an antebellum tradition, Doty frequently visited the North for educational ideas. Two years after he had taken charge, the New York *Times* termed his school "a model of its kind."[73]

Of all the AMA competitors, Shaw Memorial School is most important because its history shows what might have happened to Avery. Shaw Memorial's predecessor, founded by the New England Freedmen's Aid Society, was named after the confiscated Morris Street school building that housed it between 1865 and 1867. After the building was returned to the city, the school moved to Military Hall on Wentworth Street. It has been confused with the Morris Street Public School, opened in 1867. Black soldiers stationed in South Carolina played an instrumental role in the establishment of Shaw Memorial. In 1866 they collected funds to erect a monument in memory of Colonel Robert Gould Shaw, commander of the Fifty-fourth Massachusetts Regiment of black troops. Shaw was killed in an assault on Fort Wagner, located on Morris Island in Charleston Harbor. The Shaw Monument Fund was organized with General Rufus Saxton as a trustee. It was later decided to use the money to establish Shaw Memorial School. With the assistance of the New England Freedmen's Aid Society and the

Freedmen's Bureau, a lot on Mary Street was purchased and a two-story building erected. It contained one assembly hall and eight classrooms. The New England Freedmen's Aid Society transferred its operations from Military Hall to the new school building. Arthur Sumner, of Massachusetts, was the first principal. He began with eight northern teachers and about four hundred students. The society maintained the school through the philanthropy of the Shaw family and other Yankees. However, in 1872 northern funds proved inadequate. The trustees of the Shaw Monument Fund proposed turning over the building and furniture to the city board of school commissioners for a period of ten years "with the proviso that the school house should be used for the education of colored children only" and that "Negro teachers be used." When the New England Freedmen's Aid Society dissolved in 1874, the city school board under the chairmanship of C. G. Memminger accepted the proposal. Sumner and "his teachers returned to Massachusetts."[74]

In May 1875 the school board elected Ennals J. Adams to replace Sumner. Adams started with a faculty of ten women. Of the seven blacks, three were Avery graduates. One of the whites served as vice principal. The enrollment in 1878 was 742. Adams, one of the pioneer AMA missionaries in the city, supervised the school for five years until he was replaced by Edward Carroll, a white Charlestonian. Frances G. Shaw continued sending monetary gifts. In 1882, funds received from her and the trustees of the Shaw Monument Fund enabled the renovation of the building, including the addition of two wings. When the ten-year agreement expired in 1884, the trustees, pleased with the condition of the school, transferred the property to the city school board for ninety-nine years. In 1938 Shaw Memorial became a settlement house.[75]

Other Avery competitors included Wallingford Academy and Franklin Street High School. Wallingford, supported by the Presbyterial Committee of Missions for the Freedmen, was named after a Pennsylvania woman donor. Organized in the Zion Presbyterian Church on Calhoun Street in 1865, it received funds from the Freedmen's Bureau to erect a new building. In 1868, it moved to its new location on Meeting Street and underwent a reorganization. The Presbyterians tried to develop a normal and college preparatory program similar to Avery's. According to Amos Farnham, Avery was in 1876 "the only place in Charleston—save the Presbyterian school—where colored youth can prepare for college." After Reconstruction, Wallingford had trouble keeping pace with Avery. It graduated only two women in 1883 and no one the next year.[76]

Guided by their inspection visit to the AMA school in May 1866, local

Episcopalians, led by A. Toomer Porter, established Franklin Street High School in the old Marine Hospital. As Porter's brainchild, it was the white southern Episcopal answer to Avery. Like his academy for white youths, Franklin was to be an expression of "Practical Reconstruction." When the war ended, Porter counseled white Charlestonians to aid the blacks to "keep them as friends, and not drive them over to the Northerners, whom they would look upon as their deliverers, and would become subservient to them." When a city board of school commissioners could be reestablished, Porter intended to become a member and do all he could "to educate the negroes, that they might learn that liberty was not licentiousness." In Porter's plan of practical reconstruction, education was closely associated with the right to vote. He proposed that the South should grant the blacks suffrage when "they could read, write, and cipher, and owned five hundred dollars in real estate. . . . This arrangement would be an incentive to education, to thrift, and to economy." If the South took the lead in giving blacks the vote, Porter reasoned that this "would forestall hasty, ill-considered action on the part of the North" and prevent innumerable troubles. He feared that the freedmen would be "a perpetual menace" unless they were "fitted for citizenship by a Christian education." Deciding that white southerners should become involved in the education of the freedmen, Porter became the motivating force behind Franklin Street High School.[77]

Before visiting Cardozo's school, Porter went up north and collected sixty-three hundred dollars to purchase and repair the Marine Hospital. This sum included the thousand-dollar donation he received directly from the president, Andrew Johnson. To circumvent an attempt by the local seamen's chaplain to prevent Porter's purchase of the Marine Hospital, the Freedmen's Bureau and the U.S. Treasury arranged a deed of gift be made in trust to Porter, his parishioner George Trenholm, and Samuel L. Bennett, a black Charlestonian. With the Freedmen's Bureau commitment on the Marine Hospital in hand, Porter was able to secure from the Protestant Episcopal Commission to the Colored People of the South a grant of twenty-four thousand dollars (six thousand dollars per year) to cover the operating expenses of the school for four years. The grant was given on the stipulation that the principal of the school be a white northern man.[78]

When the school opened, eighteen hundred children were enrolled. They were taught by fifteen "Charleston ladies" selected by Porter and paid a salary of five hundred dollars each. The student enrollment steadily declined after the first year. By 1875, it had dropped to 165 students with four teachers under the principal, Kate B. Savage. After the first four years, the continued existence of the school was in doubt. Northern financial support

dwindled. Even before the defeat of the radicals, some conservatives considered Porter's plan of practical reconstruction too visionary. In 1866 his elderly cousin, a former wealthy rice planter, accused him of going over to the enemy and turning abolitionist. When the school was finally closed, Porter turned over the building to St. Mark's Episcopal Church, founded after the war by freeborn blacks. The black congregation maintained "a library, and a general meeting-place for instruction and amusement" there. After the great earthquake of 1886 inflicted costly damages, the building remained vacant until about 1893, when it was leased to Daniel J. Jenkins, a black Baptist minister, for his orphanage and industrial school.[79]

The "Practical Reconstruction" of white moderates could not adequately fulfill the educational needs and aspirations of the black community. Overcrowding of the city's two black public schools remained a perennial problem. Despite Mortimer Warren's fears, stiff competition and the burdening tuition did not prevent black parents from sending their children to the AMA school. To what degree Avery reflected the aspirations of the majority of its students, who were from relatively humble financial circumstances, is difficult to measure. Some of Avery's students and their parents, even the poorest, identified with its mission. "Many poor people believe in us," Mortimer Warren wrote in 1873, "and cherish as the apple of their eye the hope of seeing a son or daughter read a graduating essay from the chapel platform." Most parents, however, had more modest objectives. AMA officials regretted that "so many who enter our schools, remain only long enough to read and write passably, and gain a knowledge of simple arithmetical operations and then leave to learn a trade or enter into some business that will make a pecuniary return." Frustrated by the small number of students taking normal training, Warren complained in 1869, "there is the constant tendency, year by year and term after term for our older pupils, one by one, to drop out. . . . After all our patient work, year after year, we find we have been educating children to become barbers & shoemakers and we have to preach to them, (the parents especially) over and over again, about the superiority of an education to a trade."[80]

Theoretically, the AMA had considerable power to impose its will on Avery: it paid half of the school's operating expenses and was solely responsible for hiring and firing personnel. Since the superintendents and teachers served on a yearly basis, they were at the mercy of the AMA. Still, its influence was far from absolute. Because Avery was located hundreds of miles from New York, its daily operations were relatively free of direct involvement by the home office. An overworked field secretary had many other schools besides Avery to supervise. The AMA relied on members of the mission,

or teachers', home to implement its policies. This "family" included the superintendent and his wife, the matron (usually the superintendent's wife), the teachers from the North, and any servants. The teachers' home was to be an example of Christian godliness, an inspiration for the local community. United in purpose, this Christian family was to go forward pursuing the AMA's lofty goals. These mission homes, in fact, were often like pressure cookers threatening to explode. Ostracized by most southern whites, the teachers led a narrowly confined social life aggravated by the tensions of an arduous work schedule. The most likely time for conflict occurred when the makeup of the "family" was undergoing a change. In 1872 Mortimer A. Warren wrote, "Every new 'family' make up brings in new uncombinable and explosive elements which it needs the greatest care to manage."[81]

Most AMA personnel shared the general aims of the organization, but they sometimes fought bitterly over specific issues. As a result, the home office found itself in much the same position as the absentee planter, never knowing for sure who best represented its interests on the local scene. Like the planter, the AMA was more an umpire than a disciplinarian, usually called in by the contending parties to settle internal disputes. Disagreement over the role women should play in the association underlay some conflict. Bright, experienced, and well-educated teachers, like Sarah Stansbury, Jane Van Allen, and Ellen Pierce, were expected to defer to the male head of the "family," the superintendent. This naturally bred deep resentment in some of Avery's finest women teachers and at times resulted in decidedly un-Christian confrontations. When Ellen Pierce became acting superintendent after Francis Cardozo's departure in May 1868, she obviously had all the qualifications to hold the position permanently. In 1869 W. W. Hicks, a member of St. John's Lutheran Club, described her as "able, discreet, womanly, and devoted, and, if allowed to go forward—will not only increase the influence of the school—but win the people of Charleston to its support." Abby Munro, an Avery teacher, praised her colleague's "great efficiency in discharging her duties." Sometimes, however, Pierce's efficiency proved a shortcoming. In her desire for economic savings, she practically ran Francis Cardozo out of the teachers' home after his resignation; he had planned to board there until he assumed his new position in Columbia. "Miss Pierce's conduct towards me was so unpleasant," Cardozo informed AMA officials, "and created such a feeling in the house that I left. . . . I hope Miss P. will not be returned to Charleston." Even Abby Munro had to concede that Pierce was not "as warm, cordial and winning as might be desirable in one to fill her place both as matron and teacher. But with me, to know her better is to esteem her more highly."[82]

Pierce resented her replacement by a man, J. B. Corey. Events escalated that resentment. Arriving in Charleston ill, Corey faced an administrative nightmare. In a move to retrench, the AMA had reduced its total teaching force in the South. Therefore, on the eve of the opening of the school in its new building, Corey found himself with too few teachers. In an effort to meet the emergency by transferring some of the teachers to other classes, he immediately antagonized one of them, Carrie Atkins, who threatened to resign. According to Ellen Pierce, the school was in a state of "confusion and disorder." Giles Pease, the Plymouth pastor, found "a very unpleasant & painful state of feeling existing in the family & school between the young ladies & the Superintendent." He reported, "Of all places of the South, Charleston, S.C. is the last, which should have a corps of Teachers, a mission house & a mission school, where discord holds its court." In the interest of restoring harmony, Pease recommended that Corey be terminated. The discord reached a boiling point after the ladies accused the new superintendent of making "assignations with the colored girls of the school." Such "assignations" were probably more imaginary than real since both Avery parents and the members of Plymouth Church, a total of twenty-one individuals, signed a letter expressing their continued confidence in Corey. The new superintendent, however, was banned by the ladies from ever entering the school again. Ellen Pierce wrote, "I hope you may not be disposed to censure us for not allowing Mr. Corey to go into school again. . . . I do not wish the care of the school, still we all feel that it would be vastly better to do alone than to have an incompetent unpleasant man over us." With Corey gone, Pierce's friends informed the AMA home office that she was available for the permanent position. But in the end she had to resign herself to the arrival of a new male boss. "Our school opens rather more propitiously this week," the disappointed Ellen Pierce told AMA officials. "I feel half tempted to ask you to let us alone now for the remainder of the year. . . . Still, I can see how a man of first rate ability might improve the school."[83]

Corey's replacement was Mortimer A. Warren, an 1856 graduate of the Connecticut Normal School, who soon ran afoul of Pierce. "Mr. Warren, either from want of confidence or because he does not deem it necessary, *seldom* ever leads the school on any subject, moral, religious, or intellectual," she informed the AMA, adding, "I thought this was the work a man was needed for." When the time came for renewing Warren's contract in the summer, she wrote, "Mr. W. is not the best man for this place, his executive abilities are inferior, in addition to what I have said." Warren, on the other hand, laid down his own conditions for returning, including the right to name his teachers. He also wanted his wife to replace Pierce as matron.

The AMA sought to defuse the whole situation by offering Pierce a position as matron of the teachers' home in Atlanta. Warren, perhaps unconsciously, vented his anger at her when he commented on the prospects of one of his bright, young, and idealistic male teachers. Describing the man as "earnest, pure, unselfish, gentlemanly, Christian," Warren warned, "Do not, however, if you resolve on doing so, give him a position with several (or one) of these shrewd managing old maids under him!"[84]

Although Warren was triumphant, Ellen Pierce had managed to create a suspicion at the home office over his commitment to the spiritual needs of the Avery students. These doubts were encouraged by James T. Ford, the Plymouth pastor. "Mr. Warren does not assent cordially to the Evangelical system," Ford reported. "I find it hard to judge what the *real belief* [is] of a man who talks like a 'free religionist' and prays like a Christian." Incensed over the fact that the Avery superintendent did not join his Plymouth congregation, Ford proposed himself as Warren's replacement. Since Warren engaged in unsuccessful negotiations with the city to make Avery part of the public school system, some of the suspicions seemed well founded. "Perhaps it is true that I have not sufficiently distinguished between the management of this school and a public school," Warren conceded. "I never taught any school but a public school. All my sympathy and faith is toward and in an American system of free public instruction. All my training, academic and normal has been in and by these free public schools." In 1874 Warren assumed the supervision of South Carolina's first public normal school for blacks, located in Columbia. To reduce expenses and ensure a greater spiritual effort at Avery, the AMA appointed Ford the new superintendent. Ironically, Ford found himself so swamped by the administration of the school that he had scarcely any time to tend the spiritual needs of the students. Longing for "more quiet pastoral work," he and his wife soon afterward left Charleston.[85]

Ford's replacement, Amos W. Farnham, of North Hannibal, New York, faced difficulties similar to Warren's. Jane S. Hardy, who was praised by Farnham as "the best teacher in the building," aspired to be principal at Avery with W. G. Marts, then Plymouth pastor, as superintendent to "take a general oversight of the school." Toward the end of his first term of teaching there, Marts perceived, as Hardy did, a precipitous decline of spirituality under Farnham. "Outside of Miss Hardy & myself," Marts complained, there was "a dead weight spiritually, and more than this indeed, a positive satanical weight." The "satanical" was a veiled reference to the social activities of Amos Farnham's brother Levi. A teacher at Avery, Levi Farnham dated his colleague Mary Sheriff. According to Marts, the two "are

never separated when out of school." Amos Farnham, on the other hand, condemned Marts for becoming active in local Republican politics to the detriment of his teaching and pastoral responsibilities. The last straw for the Avery superintendent was Marts's antisouthern speech on the Fourth of July 1877. "My opinion of Mr. Marts is just this," Farnham wrote to the AMA. "He is good and wants to do right, but he has no judgment. He is like an unbridled horse. He has done many extremely foolish things since he came to Charleston. . . . Mr. Marts has killed his usefulness. The papers will hit him now every time they have the opportunity." Defending himself, Marts explained, "the colored speakers went further than I did; they too stated truths quite as impotable. . . . Many colored men have tried to get work for months & can not because they can not show a piece of paper indicating that they have voted the *democratic ticket*." [86]

However much one may sympathize with Marts's radicalism, Farnham was correct in his evaluation. With the conservatives about to regain power, there was every reason to believe that black educational institutions, including Avery, might feel the brunt of their return. Already some Avery patrons were feeling their wrath. In early 1877 Farnham informed the home office, "Many lost their places (where at best they were ill paid) last fall from political differences, and as the election is not yet officially decided, matters are no better. Some families are not properly fed." Mortimer Warren, now principal of the state normal school for blacks in Columbia, agonized over the prospects of his own school. "If the democrats win, they will have no use for a colored school of advanced grade." In his letter to the AMA, Warren concluded, "I beg of you not to part with Avery Inst., at this juncture. I hope you will wait [till?] everything, political, is more calm, and everything, financial, more prosperous." Although Avery survived the vicissitudes of Reconstruction, financial exigencies and the seeds of division would continue to threaten its existence and mission.[87]

3

The Gilded Age, 1878–1915

The Gilded Age was marked by deteriorating conditions for blacks in South Carolina. In 1876 the conservative Democrats, or Redeemers, returned to power with the election of a former Confederate general, Wade Hampton, as governor. The last Yankee troops had left the state capital by April 1877. Once in office, the conservatives felt less need for restraint. Hampton was unable or unwilling to control the Negrophobes in his ranks. After being reelected in 1878, he resigned to fill a seat in the U.S. Senate. During the Redemption period (1877–1890), the number of black voters sharply declined. The emergence of the white farmers' movement, or agrarian revolt, in the late 1880s presaged the rise to power of the race radicals under the leadership of an Edgefield farmer, Ben Tillman. Tillman was elected governor in 1890 and reelected two years later. He masterminded the constitutional convention of 1895 which emasculated the Fifteenth Amendment in the state. When Tillman departed for the U.S. Senate in 1895, there were many others to continue preaching in South Carolina the message of racial radicalism. Tillman's most successful imitator was Coleman ("Cole") Blease, a state legislator who later was governor for two terms from 1911 through 1914. Racial radicalism under Tillman and Blease revealed the limits of southern white paternalism.

Under the aegis of the AMA, Avery flourished. It was able to keep its tuition low enough to remain a mission school. Dedicated to training young people for the work of organizing and teaching in public schools, it reinforced in its students a self-help ideology and service orientation that predated its establishment. Imbued with a social uplift philosophy and often unable to find a teaching position within Charleston, Avery graduates taught throughout the state, especially serving the Low Country rural poor. These graduates, acting as instruments of modernization, began to bridge the gap

between urban and rural blacks. Stressing moral and intellectual improvement, their philosophy fostered the notion shared by Averyites and the AMA that culture could serve as a bridge within the Low Country black community to transcend color and class differences. Averyites who served the rural poor thought they were imparting cultural values that would help members of their race to progress. Ironically, they manifested a missionary ethos similar to that of the Yankee teachers who went south to uplift the former slaves.

By 1883, Avery was the only institution in the city that prepared promising blacks for college. Although the preserve of an antebellum free black elite, it was a vehicle for upward mobility for children of former slaves and working-class parents with middle-class aspirations. The school played an important role in the development of a black professional class composed of doctors, lawyers, businessmen, and teachers. From this rising group of responsive professionals, the Avery Alumni Association emerged in 1877 after the last Yankee troops departed. With the future of their alma mater uncertain and northern support in question, Avery alumni established this organization to ensure the continued existence of the school. This core of staunch Averyites, supported by friends, played a vital role in the development of the institute. If on occasion the AMA home office acted to check any tendencies toward intrasegregation, or color discrimination, in the school, the Avery Alumni Association and friends mitigated some of the worst aspects of Yankee paternalism. They were less sanguine than the AMA about turning Avery over to a public school system controlled by white Charlestonians.

The triumph of racial radicalism in the 1890s initially exacerbated the color line (that is, intrasegregation) within the Low Country black community. Although the city's black leadership remained primarily in the hands of the antebellum free black elite during the Gilded Age, there emerged new leaders like the Baptist minister Daniel J. Jenkins, a former slave and non-Charlestonian, who criticized the old leadership for its elitism and color exclusiveness. However, by classifying all blacks, no matter how light-skinned, middle-class, or respectable, into one pariah category, racial radicalism undermined the remnants of any lingering semblance of an antebellum three-tier system. As Charleston's black community began groping toward a process of unification, men like Jenkins would eventually enlarge the old leadership by becoming part of it. In revealing the limits of southern white paternalism, racial radicalism caused Averyites to question a basic tenet of the self-help philosophy that an individual by making himself/herself a "respectable" member of the community would generate racial progress

and thereby lessen racial prejudice. This philosophy would be redefined to include a kind of collective activism.

Curriculum and Pedagogy at Avery

Throughout the Gilded Age, the mission at Avery remained constant. According to its catalogues, its design was "mainly professional," that is, preparation of students for organizing and teaching in public schools. However, the school also maintained the lower grades. This pool of youngsters offered the normal students the opportunity to practice teach. They could not receive such training in the city public schools, where, except for Shaw, black teachers were banned. As directed by the AMA executive board, Avery focused its limited resources on its normal and college preparatory department. Although the student enrollment averaged 336, the percentage of pupils in the lower grades diminished significantly from 72.1 percent in 1878 to 39 percent in 1910.[1]

Although the ultimate mission of Avery remained the same, the curriculum underwent modifications as the institution developed a four-year high school program offering broader training. In 1882 Avery's complete curriculum included three years of primary (including kindergarten), three years of intermediate, three years of grammar, and two kinds of advanced programs. The three-year normal track enabled graduates to teach in the lower grades; the four-year classical program prepared students for college as well as for teaching. College preparatory students had three years of Latin and two years of Greek, French, or German. By 1910 the first through fourth grades had been dropped. Both the normal and college preparatory tracks had developed into four-year programs. College preparatory students were no longer required to take educational courses. Although Latin was still required, electives were allowed, reflecting changes in college entrance requirements.[2]

The curriculum at Avery was shaped and taught by reformers who wanted to eradicate racism and transform the South through education. Abolitionism and educational reform were closely intertwined for these missionaries. Almost from the start, Avery felt the impact of Pestalozzianism. In 1866 Francis L. Cardozo asked the AMA home office for a teacher from the Oswego training school to work with his "native" teachers. The Oswego movement spread the ideas and methods of Swiss reformer Johann Heinrich Pestalozzi (1746–1827) and his disciples, Joseph Neef (1770–1854) and Fredrich Froebel (1782–1852). Some of the first normal schools in America

evolved from Pestalozzianism, which discouraged rote learning and physical punishment. This educational reform emphasized "object lessons," or learning from experience. The Avery library, reflecting the impact of this movement, circulated such pedagogical books as *Barnard on Normal Schools, The Teacher and the Parent, Theory and Practice of Teaching,* and *The Life and Work of Pestalozzi.*[3]

Cardozo's replacement, Mortimer A. Warren, wrote two "progressive" spelling books during Reconstruction. Both spellers emphasized learning from experience. For instance, to help a child comprehend the word *earth,* Warren encouraged teachers to "exhibit a handful of dirt under a microscope." To prevent rote memorizing, the spellers were carefully organized so a child progressed from familiar words to more difficult terms and concepts. Avery students helped Warren prepare his second book, *The Graded Class-Word Speller,* published in 1876 when he was principal of South Carolina's State Normal School in Columbia. This speller, circulated in South Carolina, illustrated the influence of Pestalozzian reformers on education in the South. While Warren was in Columbia, he edited *The Carolina Teacher,* the first teachers' journal published in the state after Reconstruction.[4]

One of Warren's successors at Avery was Amos W. Farnham, who later took charge of the normal department at Atlanta University. Farnham was a graduate of the Oswego Normal School. Will S. Monroe, who wrote the *History of the Pestalozzian Movement in the United States* (1907), thanked him for verifying particulars on the Oswego movement. In 1883 Farnham introduced the kitchen garden system into the primary department at Avery. Founded by a New Englander, Emily Huntington (1841–1909), this program was designed to teach little children the elements of good housekeeping. Based on the theories of Froebel, it employed miniature housekeeping tools such as brooms, pots, and pans. The Kitchen Garden Association, reorganized as the Industrial Education Association, would play a major role in the founding of Teachers College at Columbia University. Avery graduates, like Ellen E. Sanders (1889), who began her career as a kindergarten teacher, continued their own education and kept abreast with new developments through the Chautauqua movement.[5]

At the turn of the century the influence of Pestalozzi was still being felt at Avery. In 1899 the student commencement speaker, Bertha Elizabeth Bright, addressed the audience on Pestalozzi, and Ida Lulu Bright delivered an honor oration, "Froebel and His Work." One of the required manuals for Avery normal students in 1906 was Emerson E. White's *The Art of Teaching* (1901). White hailed Pestalozzi for paving the way for the child psychology of the Harvard professor William James. James's ideas were

also in vogue at the AMA school. Students used as a textbook Reuben Post Halleck's *Psychology and Psychic Culture* (1895), which James recommended as "short, clear, interesting, and full of common sense and originality of illustration." Avery teachers and normal students traveled from Pestalozzi's romanticism to John Dewey's pragmatism via James's psychology. The transition was not difficult. Dewey and Pestalozzi shared a belief in learning by doing. Their theories eroded the division between school and life. At the 1899 Avery commencement exercises, a student spoke on the class motto, "From School-Life to Life's School."[6]

Much in progressive educational reform appealed to the antebellum traditions of black Charlestonians. Reformers such as Joseph Neef preached a theory of education not antithetical to the uplift philosophy so popular among black Charlestonians. In his *Sketch of a Plan and Method of Education,* one of the first American books on pedagogy, Neef explained that because people were born neither good nor bad, education was "the only cause of our becoming either good, useful[,] intelligent, rational, moral and virtuous beings, or . . . miserable creatures." He defined education as "the gradual unfolding of the faculties and powers which Providence bestows on the noblest work of creation—man. . . . and the work of the teacher is the unfolding of these powers—to train the child to make just use of its faculties." Edward A. Lawrence, an Averyite who taught for many years at his alma mater, demonstrated the way in which the uplift philosophy and the methods of Pestalozzi complemented one another. Addressing the Avery Alumni Association in 1915 on the importance of good teachers, Lawrence noted that God had lowered a ladder to each child, who "must be taught to climb it." The black educator asserted, "Let him not attempt it by the cold calculations of the head, or of the mere impulse of the heart—but all these powers combine, and the noble enterprise will be crowned with success. These powers are already bestowed in him, and the commission is to you to assist in calling them forth."[7]

The educational vogue of manual or industrial training as well as the concept of learning by doing appealed to the practical side of Averyites. Many of their ancestors had been artisans who had learned their trades through apprenticeships. Keeping within their aristocratic-artisan ethos, the students studied stenography and bookkeeping as well as Latin, Greek, and declamation. The classical tradition was not abandoned at Avery but, through educational reform, modified and enlarged to fit the changing times.[8]

If the progressive educational reforms of the AMA missionary teachers mitigated any propensity among Averyites toward a too traditionally classical education and a "prep school" snobbery that might accompany it, the

parents and alumni helped check a growing tendency of the AMA home office to make industrial training predominant at the school. In 1884, the Kitchen Garden Association had been reorganized into the Industrial Education Association, marking the growing momentum of the industrial or practical education movement. Six years later the AMA home office mandated industrial training at all of its schools. Avery complied by renovating a separate building to house an industrial department and by requiring that all of its students have some kind of industrial training. However, Avery officials and alumni resisted any effort toward downgrading the curriculum or changing the focus of the school.[9]

The American Missionary Association and the Avery Alumni Association

By 1905 the AMA, reflecting a national trend, had moderated its once staunchly abolitionist view of the South. It placated white critics by adding industrial departments to its schools. Amory H. Bradford, a Congregationalist minister who became AMA president in 1904, wanted the "bloody shirt" buried. This descendant of William Bradford, governor of Plymouth Colony, agreed with the white South that many former slaves were not ready for the rights freedom brought them. "When they [the colored people] prove their intellectual and spiritual equality with the white race," the AMA president predicted, "then even the whites in the South who honor character and manhood will accord to them the recognition that they deserve." Throughout the Gilded Age Avery principals and teachers shared the confidence of the home office that the better class of southern whites would eventually perceive the importance of their missionary work and come to the aid of the association. At the 1882 commencement exercises, E. J. Meynardie, pastor of Old Bethel Methodist Episcopal Church, reminded the graduates that he was "the first man in the city in *antebellum* days to advocate publishing the repeal of the prohibition upon schooling for the slaves." Although the handful of white southern clergy and educators who praised the school and attended its commencement programs did not presage a movement, their support reinforced the optimism of AMA officials in the face of deteriorating conditions for South Carolina blacks; once the freedmen were uplifted, southern whites would perceive the virtues of educated and respectable blacks, and act accordingly.[10]

The ideology of the AMA was never totally fixed. The association was constantly reassessing its emphasis and priorities. It not only disbanded its

African missions but expanded its activities in North America to include poor whites, Indians, Eskimos, and foreign-born immigrants. However, the underlying spirit remained much the same. AMA missionaries sought to transform the various groups into right-thinking Anglo-Saxon Protestants. If the first generation of AMA missionaries moved south to uplift the freedmen in the urban and rural areas, the subsequent generations concentrated on producing enough black teachers to reach into the hinterland. Except for "the splendid examples of consecrated ability, culture and character which show so clearly what the race may become," Amory Bradford found the great mass of blacks in the rural South "degraded as any in Africa," with the "vices of heathenism" and "few of the virtues of civilization." He saw "this mass of ignorance and depravity . . . brought here by our fathers" as "an example of foreign missions in the heart of the American Republic."[11]

Between 1877 and 1914 nine white principals served at Avery.[12] Some, like William M. Bristoll and Elbert M. Stevens, Yale graduates, were from Ivy League universities. Amos W. Farnham and Morrison A. Holmes were the only two of the nine to serve for a length of time beyond three years. Farnham was in charge during the demise of Radical Reconstruction when the future of the institute was uncertain. In 1882, he returned to supervise the school but soon resigned during a curriculum controversy between the AMA home office and the alumni association, which he supported on the issue. Morrison Holmes was the most important of the nine in implementing AMA policies. His tenure began with the great earthquake of 1886, which caused twenty-five hundred dollars' worth of damage to the buildings and temporarily closed the school. He saw Avery through this catastrophe and served as its principal for twenty-one years, until his death in February 1907. Edward A. Lawrence, an Avery alumnus who had taught many years at the school, filled in until the arrival of Elbert M. Stevens. Frank B. Stevens was the last white principal before the school became an all-black institution under Benjamin F. Cox, its first black superintendent since Francis L. Cardozo.

In addition to the principal and matron (usually the principal's wife), the Avery staff included a permanent core of college-educated northern white women, supplemented by local blacks, who did not live in the teachers' home. These blacks filled about one-third of the teaching positions and were employed usually in the lower grades rather than in the normal or college preparatory department. By 1906 the entire teaching staff for the lower grades consisted of Avery graduates. Three years later one of them, Beulah C. Jervey (1901), had been promoted from being in charge of the fourth and fifth grades to teaching high school level courses such as English grammar, algebra, and physiology.[13]

When describing the local situation and the mission of the school to north-erners, the white principals and teachers employed the AMA rhetoric. In one of his appeals to *American Missionary* readers for financial support, Mor-rison Holmes wrote in 1900, "Here in this historical city, surrounded by lowlands of rice and cotton, the negro was found in overwhelming numbers, and after emancipation, in utter ignorance of book lore or a pure gospel. To this people the American Missionary Association, through Avery Institute and its consecrated workers, has brought the light of knowledge and a pure gospel, and awakened aspiration and hope of a better life." The principal, Elbert M. Stevens, reported in 1909, "It is in the country that most of our teachers must find their work, and the jungles of Africa can hardly present more dangers than the fever abounding coast regions of the South." Avery graduates, trained for Christian citizenship and usefulness, went to these areas of "ignorance and superstition" to serve as "helpers of their race," teaching "habits of thrift and cleanliness" as well as reading and writing.[14]

These northern missionaries remained optimistic despite deteriorating conditions perhaps because, like Amory Bradford, they did not see their work as antithetical to the ideology of southern whites. By the Christian example they set, they hoped to unite the white community behind their efforts. To critics who charged that higher education contributed to worsen-ing race relations, they argued that the AMA school, by producing stolid and respectable citizens, was ameliorating racial tensions. "Race conflicts in this city have been unknown since the days of reconstruction," Morrison Holmes asserted in 1900, "and it is not too much to claim that this better condition of things here is largely due to the influence exerted by Avery." In stressing the dignity of labor and the responsibility of workers, these prin-cipals and teachers assumed that employers, once recognizing the improved attitudes of their workers, would respond appropriately. The result would be a more equitable economic and social system, resting on "a true ethical code" characterized by "a mutual desire of helpfulness."[15]

As the primary motivating force behind the AMA missionary impulse, religion continued to have paramount importance at Avery. Septima Poin-sette Clark, a 1916 graduate, recalled, "Each morning we had worship ser-vice, and twice a year the school had what they called a religious emphasis week. During these periods meetings were held by men who came down from the national office to conduct them. And in the ninth grade we had a regular course in the study of the Bible." Benefactors and patrons apparently approved of this religious emphasis because Avery principals and catalogues pointed out that the Bible, considered the "best" and "most important text-book" in the school, was "carefully studied in classes one hour each week, and read at daily devotions." Both also stressed that the instruction and

influence, always Christian, were nevertheless nonsectarian. Every Christian denomination in Charleston, including the Roman Catholic, Morrison Holmes reported in 1890, was represented in the student body.[16]

Religious training at Avery, however, was decidedly Protestant, with a strong evangelical tinge. In 1893 Holmes hailed "the spiritual harvest" reaped by the visit of the revivalist George Moore. "There is hardly a Protestant colored church in this city," he noted, "that has not received accessions to its membership from Avery students." The great revivals shaking the North in 1905 also reached the school. A school official, reporting in April of that year on the harvest of Florence Smith Randolph, a New Jersey preacher and former Avery student, exclaimed, "What a blessing. . . . Two hundred and eighty young men and young women of the city have turned their faces heavenward." Fifty-five of them were Avery pupils, who consequently converted in the union services of Bethel and Centenary churches. School officials encouraged such revival meetings because they inspired in the students an "earnestness" to study and to do right.[17]

Besides the "strong Christian influences" in the classroom, lecture hall, and prayer meetings, the AMA encouraged the establishment of school organizations geared to molding "Christian characters" and giving the students "in concrete form an idea of the larger and more comprehensive service" they were to perform after graduation. At Avery, the King's Daughters Circle, founded to help the poor and needy, especially the old and sick, of the city, exemplified such a group. Its concerns and activities resembled the community work done outside the classroom during Radical Reconstruction by the Yankee missionary teachers. Around Thanksgiving and Christmas, the girls used their monthly dues and money contributed by the other students to purchase groceries, which they delivered in packages to the needy. In 1914 the members made a generous cash contribution to the local black hospital. It was also the custom for the circle to help "a needy and deserving girl" attend Avery.[18]

The missionary ethos at the school was preserved by the low tuition. In 1876 a "tax of $1 a month was levied" on those pupils who "could afford to pay." By 1883 the school had established a graded tuition schedule with the fees to be paid in advance each month. The tuition per calendar month was $2.00 for the classical course (which included college preparatory and normal work); $1.50 for the advanced English course (a normal program not requiring the study of Latin or any other foreign language); and still $1.00 for the other grades. Although textbooks were furnished without charge, parents were urged to provide their children with the necessary books to relieve the school of the expense. The tuition schedules during the Gilded Age

indicated the missionary focus and direction Avery was taking. From 1883 through 1910 the fee for the normal course remained $1.50 per month, just $.50 higher than the $1.00 levied in 1876. The monthly tuition for the college preparatory track, which no longer required normal work, dropped from $2.00 to $1.75. In contrast, the municipal white High School of Charleston charged in 1881 "Forty Dollars per annum, payable quarterly, in advance." According to Septima Clark, the one- or two-room private schools that local blacks operated in Charleston before World War I usually charged a monthly tuition of $1.00 for the first through fourth grades, $1.50 for the fifth and sixth grades, and $2.00 for the seventh and eighth grades.[19]

In addition to keeping the tuition as low as possible, Avery made student aid available to worthy young people. Its entrance examination announcement for the fall of 1892 declared, "Free tuition to the one passing best examination." Besides preventing the exclusion of promising young people from the school for financial reasons, the student aid program encouraged initiative and reinforced the self-help philosophy. Pupils who received loans to continue their schooling in the normal department were expected, as soon after their graduation as possible, to refund (without interest) the money so that others could also be helped. In 1910 the school catalogue announced that "employment about the school and grounds" was not "given to poor but to worthy students." Rich and poor alike were eligible for these positions. In addition to work-study assistance, a tuition scholarship was granted to the best student in the seventh, eighth, ninth, and junior grades.[20]

Individual assistance through the Daniel Hand Fund, as approved by the AMA home office, was also available. Hand, a northern businessman and philanthropist who had made his wealth in the South before the Civil War, had contributed a million dollars to the AMA in 1888 for the establishment of a trust fund to educate southern blacks. Three years later, at the Avery commencement exercises, George Washington Robinson, a graduating senior, in behalf of his class, presented to their "beloved Alma Mater" a crayon portrait of Hand to inspire others after them "to emulate his virtues and spirit, and prove worthy of his bounty." It was most apropos that this future undertaker represent his class because he exemplified the growing number of Averyite businessmen the AMA wanted to be influenced by Hand as a model. A guest speaker at the ceremonies was Hand's loyal friend and former business partner, George Williams, a Georgian who had moved to Charleston to establish a branch and was president of Carolina Savings Bank. Hand, known for his antislavery sentiments, had entrusted Williams with his share of the business to prevent confiscation by the Confederate government. For the AMA, both men, sympathetic to its mission, justi-

fied and reinforced its stance to bury the "bloody shirt" as it continued its work in the South. L. S. Rowland, of Lee, Massachusetts, the other guest speaker invited by Morrison Holmes, summarized the AMA position. "The benevolence and philanthropy of Mr. Daniel Hand," Rowland declared, "is an illustration of the proper use and mission of wealth. . . . of the essential unity of our country and people. . . . the South claims him, the nation claims him. . . . The time is not far distant when we shall cease to think of sections or races." The northern minister concluded, "The Gospel and Christian Education which this great benevolence was intended to spread and promote are the supreme needs of the time and the solvent of all our difficulties of race or of section." [21]

Having close ties with the Congregationalists, the AMA considered Plymouth Church, as much as Avery, part of its mission to propagate "the Gospel and Christian Education" in the Low Country. It regularly reported Plymouth's activities in its journal. The ties between Plymouth and Avery were close and intertwining. Both the pastors and the principals felt free to report to the AMA home office each other's work and to make recommendations. Plymouth pastors usually became involved in the operations of the school. They (as well as their wives) often taught there. Some even served as principals or trustees. George C. Rowe, a black Congregationalist from Litchfield, Connecticut, who served as pastor from 1886 to 1897, was also editor of a black weekly newspaper, the Charleston *Inquirer.* His busy schedule, however, did not excuse him from his Avery duties. Besides speaking at commencement exercises and making his "Christian influence" felt at other school events, he regularly reported these activities to the AMA journal.[22]

Theoretically, the AMA home office believed in democratic participation and self-reliance. Plymouth congregation should determine its own affairs, and Avery parents should have some say in the operations of the school. However, the AMA home office held the power of the purse and could act arbitrarily to do what it considered best. But it had to be prudent in mapping out its course of action and stratagems. Located in New York City, it depended on the reports of its Charleston officials and field representatives to determine the condition and success of its mission. Sometimes these reports provided conflicting points of view and information. Moreover, the AMA could not afford to appear so arbitrary as to offend the local blacks and lose their support or goodwill.

The limits of the home office's power can be seen in the influence it exercised over Plymouth, Charleston's only black Congregational church. Despite rosy rhetoric about Plymouth's activities in the AMA journal, the home office never had a smooth relationship with the congregation. The

blacks had refused to accept Ennals J. Adams as pastor. A local black deacon wanted the position. Adams, who eventually worked with the city's black Presbyterians, was followed at Plymouth by a string of ministers, including Giles Pease, James T. Ford, S. C. Coles, and W. G. Marts, white northerners. When Ford inquired about the possibility of installation of a permanent white pastor, he was told, "The other churches would run upon us as having a master, and they would be too much for us." The AMA also had trouble being repaid the money it loaned the congregation for the new chapel.[23]

An abortive effort by Plymouth to leave the AMA fold in 1878 manifested the desire of the black Congregationalists for independence. The attempt was caused in part by a conflict over who was to be pastor. The ensuing turmoil and the surrounding vortex of disputes demonstrated not only AMA heavy-handedness but also the larger context in which it occurred. The numerous elements that composed this milieu included professional ambitions and interpersonal relationships. Conflicting cultural values, black factionalism, white paternalism, and party politics, as well as financial exigencies, added to the complexity of the situation, illustrating the complex relationship between mission and home office.

S. C. Coles's decision to leave Plymouth in 1876 triggered the feud. Reacting to the less than enthusiastic support he had received from his Plymouth parishioners, the minister strongly counseled the home office in May that his replacement be dependent on the AMA rather than the two-hundred-member congregation and that the association treat the parish as a mission. He stressed the financial straits of the church. Amos Farnham, recognizing Coles's deficiencies as a leader and the independent tendencies of the congregation, recommended a white minister who had energy, enthusiasm, magnetism, and power to command the respect of his black parishioners. "My experience is short, but tells me," he wrote, "that as a people, the blacks are not predisposed to have colored leaders. They look *up* to whites, and regard them with greater respect."[24]

After receiving the advice of Farnham and Coles, the AMA home office in December 1876 sent W. G. Marts, of Delmont, Pennsylvania, to be the new pastor. The minister threw himself into his pastoral work with a passion. The AMA's satisfaction with Marts cooled significantly when he directed his energy into local Republican politics, sometimes at the expense of his pastoral and teaching duties. Amos Farnham also perceived Marts as a divisive element at the school. Marts had charged the principal's brother Levi and his fellow teacher Mary Sheriff of having a relationship "deleterious" to the school and church. Disapproving of the pastor's conduct and poor judgment, Farnham did not want him to teach at Avery any longer. Besides

bringing himself and his northern friends into "disrepute," Marts was hindering the principal's efforts to foster in the young people the Protestant ethic. Farnham criticized him for not being punctual. More importantly, Marts had allowed to be published in a Republican newspaper he helped establish remarks by a black pastor accusing the Avery principal of exerting "unusual and unfair pressure" on a parent to violate local mourning customs. When the mother of a senior, John L. Mills, died, the youth, adhering to Charleston custom, "did not intend to continue in school any longer nor to deliver his oration on graduation day nor his declamation on re-union day." Farnham, claiming he had Marts's approval, was able to persuade the youth and his father "to step out from this custom" as he had succeeded with others. Explaining his position to the home office, Farnham declared, "John was not called upon to lay aside his work than his father to lay aside his, nor I would be to lay aside mine. If I should bury my wife today, I should teach tomorrow." The principal accused Marts of undoing all his work. Marts, in return, acknowledged his mistake.[25]

Although Farnham, in his criticisms of Marts, claimed, "The colored people do not want men to come here and rail against the whites," a majority of Marts's congregation apparently approved of his activities. When he asked for a leave of absence and found a J. S. Knight to replace him temporarily, the congregation, wanting Marts to stay on, voted to reject Knight, who strongly objected. Threatened with a "cow hiding," Knight soon left the city. Not everyone at Plymouth approved of Marts. A faction accused him of falsehood, slander, and "adulterous intentions" or "evil habits, with several young female Members." (Marts had been seen with them in his room or at their homes.) Jane S. Hardy, whose ambition to become principal at Avery with Marts as superintendent had been dashed when he refused to marry her, supported this faction. Farnham, although he disapproved of Marts's conduct and poor judgment, defended the pastor's character and charged Miss Hardy of being "double faced" and neglectful of her duties.[26]

The scandal drew several AMA emissaries to the scene, including the AMA corresponding secretary, M. E. Strieby. Refused an honorable discharge by the AMA, Marts had decided to stay on as pastor to help the congregation raise enough money to pay back the mortgage and become self-supporting. Some time in April 1878 the AMA sent Temple Cutler to Charleston, probably to foreclose the mortgage on Plymouth Church. Perceiving the financial straits of the congregation and their mood, he cautioned: "If we press the matter now the enthusiasm is so great that they will get bitter against the Association for persecuting their pastor." Before leaving the city, Cutler addressed the congregation to assure them that

"The difficulty was entirely between Mr. Marts & the A.M.A.," which was "looking after their truest interest." He suggested they not break with the association so they could apply again for aid if their experiment of self-support should fail. The AMA, however, "could in no case help them under Marts's direction." Through Cutler's strategy, the association, holding the power of the purse, prevailed, and he returned the next year as pastor. Discontent, however, continued. This internecine fighting prevented Plymouth from becoming self-supporting until October 1895. Avery was also adversely affected. Farnham as well as Miss Hardy soon departed.[27]

The AMA was never in a position to deal so definitively with Avery. To carry out its directives, it depended on the principals and teachers, who often differed among themselves and at times with the home office. This situation forced the association to be more cautious in its actions. Since the parents paid half of the school's operating costs and the alumni were an important supportive arm, the AMA had to be somewhat sensitive to their wishes. The support of Avery parents and alumni was impressive, considering the financial difficulties of other local private schools, including the Holy Communion Church Institute (later renamed Porter Military Academy). Founded by A. Toomer Porter in December 1867 to educate white youths from the "representative families of the State," it almost closed down during the panic of 1873. Wealthy patrons in the North and Great Britain constantly had to help Porter meet expenses. In 1884, the Catholic church delineated to municipal authorities the financial burden of its one black and five white schools. That year, only half of all the students paid their tuition. The church had to depend on special collections and individual contributions. Several teachers donated their services to keep the schools operative. Three years earlier the superintendent of Presbyterian Wallingford Academy reported to city officials an annual expenditure of $2,600, only $360 of which was from tuition fees. In contrast, Avery parents steadily paid half of the operating costs.[28]

During the summer of 1883 the detailed reporting by the Charleston *News and Courier* of a curriculum controversy with the AMA home office indicated the concern of Avery parents, alumni, and friends for the well-being and direction of the school. The incident revealed the resiliency of the Avery people in dealing with AMA directives they opposed and their influence in shaping school policy. A year before the controversy the superintendent of the city's public schools lauded Amos Farnham for upgrading the curriculum. Under his leadership, the school, while maintaining its lower grades, was developing a junior college program by offering advanced courses in such topics as "political economy, Logic, evidences of Christianity and natu-

ral theology." Normal students were studying school law and economy as well as pedagogy. A teacher's institute and a free lecture series by distinguished guest speakers were made available to the public. One hundred fifty books were added to the library, and a reading room specializing in journals was opened. Being the only college preparatory school for blacks in Charleston, Avery was progressing along the path to higher education that AMA schools like Fisk and Howard had taken. Other missionary schools in the state, including Claflin and Benedict, were also moving in a similar direction.[29]

The black community approved Farnham's improvements because in the summer of 1883, the home office faced a fire storm of criticism and "great indignation" when it decided to drop several advanced courses. On July 2, 1883, a mass meeting was held at Centenary Church. A committee of seven, chaired by W. H. Lawrence, the white pastor of Centenary, was appointed to prepare and send to the AMA a memorial requesting the school be not downgraded but developed into a college or university to meet "the conditions and wants of Charleston." The memorial stressed that for blacks Avery was "the only institution in the city where those desirous can obtain a higher education." A college program was viable because "The colored people were accumulating property and were each year growing more alive to the importance of higher culture for their children." The memorial also requested that Amos Farnham continue as principal. Some time during the controversy Farnham apparently broke with the AMA home office over the curriculum issue and resigned.[30]

Reacting to this organized protest and the publicity it engendered, the AMA home office sent to the memorial committee a letter, published in the *News and Courier* on August 20, 1883. The AMA, denying that Farnham's resignation had any relation to the dispute, assured the committee that it had no intention to downgrade the school but "to push forward for still greater thoroughness and efficiency" with "an experienced and competent educator." The fears of those who wanted the school to develop into a college or university were justified, for in February 1885 the principal, William M. Bristoll, reported to the city that the normal track had been lengthened to four years but at the same time simplified to remedy "the tendency to shoot over the heads of the class for which the Institute was established."[31]

The curriculum controversy dramatically demonstrated that the AMA was forced to be more cautious in its actions and directives concerning Avery because of the organized support for the school in the community. The friends and patrons of Avery included skilled middle-class blacks like Nathan A. Montgomery and Gordon M. Magrath, who were both clerks. Montgomery

presided over the meeting at Centenary Church and the minutes were taken by Magrath, who worked for W. J. Elfe, the first black pharmacist in the state. Besides Magrath, other blacks on the memorial committee included James B. MacBeth, a porter; Thomas McG. Carr, a barber; James C. Blaney, a butcher; and Richard Birnie, a cotton shipper. They sent their children to Avery. Birnie was to serve as a trustee when the school became incorporated in 1894. His sons Charles and Richard became physicians and his daughter Marion taught at Avery. The two pastors on the committee were Lawrence and former slave Eugene C. Brown. Both served black Methodist congregations that had joined the northern church after the Civil War. Before becoming pastor of Centenary, Lawrence had taught ancient languages at Claflin University.[32]

These Charleston blacks carefully put together a coalition with local whites that impressed a home office constantly on the lookout for examples of biracial cooperation. As a result of the Civil War, this base of support was broadened not only by Yankee missionaries like Lawrence and Farnham but also by a growing number of black professionals such as Averyite William D. Crum, a doctor, and Jonathan J. Wright, a judge, who had served on the state supreme court during Radical Reconstruction. Crum and Wright, along with Lawrence and E. C. L. Browne, pastor of the Unitarian Church, were speakers at the Centenary mass meeting. Another highlight of the meeting was the reading of letters from prominent white Charlestonians Herman Baer, a wholesale and retail druggist who lived near Avery, and Peter F. Stevens, bishop of the Reformed Episcopal church and county school commissioner. Baer was a well-respected educator who would serve as a High School of Charleston trustee (1883–1901), city school commissioner (1884–1901), and alderman. Also read was a letter from George W. Williams, the former business partner of philanthropist Daniel Hand. Williams, a Methodist, had helped in the purchase of Centenary Church and would sit on the advisory board of John L. Dart's Charleston Normal and Industrial Institute. Like Baer, Williams would become an alderman. The mass meeting was held just a few days before reunion day so the committee chairman could submit the memorial to the Avery Alumni Association for its approval. The memorial was then sent to the AMA with letters from Browne, Baer, Stevens, and George Williams. This well-orchestrated campaign demonstrated the kind of community opposition the home office could provoke when it was insensitive to the needs and wishes of its Charleston clientele.[33]

Many Avery parents proved amazingly resistant to the white missionaries' pleas that their children become teachers. Of the "thousands" who attended

the school between 1872 and 1905, only 552 students graduated. Although most belonged "to a better class than the street children," they were not from affluent families. Some parents, too poor to pay the tuition, had to transfer their children to the public schools. Many hoped that a brief stay at the school would give their children access to jobs and the skills and polish necessary to keep the positions. In 1908, for example, Marcellus B. Forrest's mother, a widow, withdrew her son from Avery. The ninth grader had attracted the notice of a black tailor, William R. Campbell, who, in turn, called the youth to the attention of his employer, Louis Givner, a white businessman. The young man, working at Givner's shop on King Street, became a master tailor, earning a good deal more money than he would have as a teacher like his father, Edward Forrest, a Reformed Episcopal minister.[34]

These black Charlestonians had the wherewithal to meet what they considered the educational needs of their young people; the AMA was not dealing with a small rural clientele. The 1883 curriculum controversy reinforced the point that the leadership was drawn from a confident and sophisticated group of urban middle-class blacks. The strength of their antebellum traditions and aristocratic-artisan ethos was recognized by southern whites. In 1925 Theodore Jervey described Richard Holloway, Sr.'s, grandson, James (Avery, class of 1902), as "a saddler and harness maker by trade, but . . . nevertheless an aristocrat. . . . an unobtrusive individual, of gentle nature, true to his convictions and very virtuous." During the 1880s antebellum free blacks and their progeny continued to dominate the city's black elite. They composed 40 percent of the black upper class, which comprised less than 2 percent of the city's black population. Their presence at Avery was obvious from some of the family names of the students who graduated between 1872 and 1905: Wilkinson, Fordham, Hayne, Dereef, Small, Lawrence, Mickey, Weston, DeCosta, and Kinloch. In 1886 the Charleston *News and Courier* described an Avery commencement audience as "composed of the best class of colored people in the city." Such were the individuals who involved themselves in the administration of the school, usually through the Avery Alumni Association.[35]

With the Yankee presence in question and the return of the conservatives imminent, Avery graduates and friends realized the need for a strong alumni association to protect the interests of the school. The leadership arose from the growing number of professionals and businessmen the school was producing. William D. Crum (1875); Edward A. Lawrence (1875), a real estate agent; Robert J. Macbeth (1877), a dentist; and Edwin A. Harleston (1900), an undertaker, served as presidents. Crum conducted a course in physiology and hygiene at the school. Lawrence was an Avery teacher

for nearly twenty years. Other presidents who taught at their alma mater were Cornelius C. Scott (1872, first graduating class), a Methodist minister, and Lewis G. Gregory (1891), a lawyer. Women graduates who served as Avery teachers and alumni association officers included Florence A. Clyde (1891), Constance W. Morrison (1897), Edna P. Morrison (1899), and Ella B. Spencer (1899).[36]

Avery's principals recognized the alumni association as a "valuable auxiliary" and lobby group. Conveniently, it held its annual meetings soon after commencement exercises when plans were being made for the coming school year. Amos Farnham composed an ode for the 1883 reunion, at which time the alumni approved the memorial supporting his stance on the curriculum controversy. In 1906 they raised funds to install electric lighting in Avery Hall. More important, alumni active in the association often became directly involved in the actual governance of the school. During an emergency, Edward Lawrence filled in as interim principal. Both William Crum and he served on the board of trustees after the school was incorporated in 1894.[37]

The association's annual reunions provided Charleston and the Avery student body concrete proof that the self-help–social uplift philosophy worked. The group's motto "Vestigia Nulla Retrorsum" ("No stepping back again"), taken from Horace and adopted from the British earl of Buckinghamshire, reflected their classical bent and aristocratic ethos. But it also expressed their philosophy. When Averyite Thaddeus Saltus, deacon of St. Mark's Episcopal Church, was requested to relate his experience to the motto at the 1881 reunion, he stated that "perseverance, patience and the grace of God" made him what he was. Not only did the presence in one place of so many successful business and professional blacks give credence to this philosophy, but the annual meetings served as exercises in cultural self-improvement. The programs usually featured musical, literary, and oratorical performances. In 1881 the speaker, F. I. Johnson (1875), "forcibly urged the duty of self-culture," because "intelligent citizenship" required a broad knowledge of the world, including "the manners, customs and governments of the people of both the past and the present," and "the mental drill . . . to grapple with the hard problems of . . . life." At these reunions, the alumni renewed their pledge to do "honest work in behalf of less favored humanity" as well as to pursue cultural and mental self-improvement. H. H. Pinckney (1875), a pastor who also addressed the 1881 assembly, advised that if they made material gain the sole "object of life," they were "doomed to disappointment." To foster these values in the student body, the alumni association offered scholarships to those who had achieved the best academic records and who intended to continue their education after graduation. It also rec-

ognized and encouraged recent graduates by inviting them to address the annual meetings.[38]

These reunions highlighted the role Avery played in the growth of a black professional class. The 1906 school catalogue listed the graduates from 1872 through 1905. Of the 281 with occupations indicated, 23 (8.2 percent) were professionals other than teachers: 8 physicians, 3 lawyers, 2 undertakers, 2 pharmacists, 3 dentists, and 5 ministers. The Mickey family, who sent their children to Avery, illustrated the way the offspring of Charleston's black elite became professionals after the Civil War. Edward C. Mickey, whose father helped found the Humane Brotherhood, was a tailor before the war. During Radical Reconstruction, he served as a state legislator. Family members who graduated from Avery during the Gilded Age included Samuel G. and Edward Crum Mickey. Samuel (1884) became a physician, Edward (1901) an undertaker.[39]

The careers of Robert P. Scott (1876), Paul J. Mishow (1872), and William F. Holmes (1880) revealed the mobility of this professional class. Scott, after attending Avery and the University of South Carolina, taught but eventually became a barber in Florence, South Carolina. Mishow moved to Washington, D.C., to work as a government clerk before he earned his medical degree. Holmes, although he had a law degree, listed his profession in the 1906 Avery catalogue as teacher. This proponent of black educational reform in the state would continue his studies to become a physician.[40]

In 1899 South Carolina had only thirty black doctors, but enough of them lived in Charleston to make it the center of the state's small black medical profession. They organized a state Association of Colored Physicians. Under the leadership of Alonzo C. McClennan, a graduate of the pharmacy and medical schools at Howard University, they founded the Palmetto Medical, Dental and Pharmaceutical Society and established the Hospital and Training School for Nurses at 135 Cannon Street. The medical facility published an impressive monthly journal called the *Hospital Herald*. Also instrumental in the founding of the black hospital was Lucy Hughes Brown, a minister's wife, who was "the first woman doctor in Charleston" and the "first black female physician in the state." As a medical center, Charleston attracted newcomers, like McClennan (originally from the state capital) and Brown (a North Carolinian), who broadened the base of the established black elite.[41]

Averyites were active in the administration and operation of the Cannon Street hospital. The chief nurse was Anna T. Harenburg-DeCosta-Banks, who graduated from Avery in 1885. Sixty-two years after its founding, the hospital would be renamed McClennan-Banks Memorial. Other Averyites on the staff included Robert J. Macbeth and William D. Crum, who fol-

lowed McClennan as head of the hospital. By 1919, William H. Johnson was chief surgeon and lecturer on surgical nursing. Born in Charleston on August 13, 1865, Johnson, the son of an AME minister, attended the local public schools, Avery, and Allen University before he obtained his medical degree from Howard University. His career demonstrated Avery's creation of a professional class who assumed the leadership of the city's chapter of the NAACP. Believing that the next step in racial uplift involved "compulsory negro education, the acquiring of real estate and registering to vote," this black physician helped organize the Charleston chapter and was elected the first president of the local Peoples Federation Bank. E. B. Burroughs, Jr., the Averyite remembered as "the baby doctor" for establishing at the hospital the first black baby clinic in the city, was also active in the NAACP.[42]

George N. Stoney and Julius Linoble Mitchell were representative of the many black professionals who left the state to pursue their career aspirations. Stoney, born in Aiken, South Carolina, on October 8, 1865, graduated from Avery in 1884 and received his medical degree from Howard University three years later. Shortly thereafter he began practicing medicine in Augusta, Georgia, where he became chief surgeon of the Freedmen's Hospital. During the Spanish-American War, he served as assistant surgeon for the Tenth U.S. Volunteer Infantry with the rank of first lieutenant. After the war he returned to the hospital in Augusta, where he established a "large and lucrative practice." Julius Linoble Mitchell, born in Charleston County in 1867, attended Avery but graduated from Hampton Normal and Agricultural Institute in Virginia. After attending the U.S. Military Academy at West Point, he studied law at Allen University in Columbia, South Carolina. He received his law degree and passed the state bar examination in 1894. Six years later, Mitchell defended John Brownfield, a black barber living in Georgetown, South Carolina, who was charged with shooting to death a white deputy sheriff during an argument over delinquent taxes. Brownfield's arrest and incarceration caused the so-called Georgetown Riot, when local blacks, fearing he would be lynched, surrounded the jail. The case went before the U.S. Supreme Court in 1903. Mitchell was able to convince the court to order the jury commissioners of Georgetown County to summon black men for jury duty. Because of the noticeable worsening of conditions for blacks under the racial radicals, Mitchell felt forced to move north to practice law. In 1904 he was admitted into the Rhode Island bar and nine years later, the New York bar. By 1915 he was living in Brooklyn, New York.[43]

The rising black professional class included a growing number of black businessmen in South Carolina. In 1887, 1,057 black Charlestonians had deposited $124,936 in local banks. In 1899 a survey counted 59 black busi-

nessmen in the city; they composed approximately 48 percent of the 123 black businessmen in South Carolina. A year later John L. Dart told the first meeting of the National Negro Business Men's League that 60 black Charlestonians were engaged in enterprises worth about a quarter million dollars in capital. Some operated businesses begun before emancipation. James H. Holloway took over the family harness shop at 39 Beaufain Street. Charles C. Leslie ran guns during the Civil War to get the money to establish a thriving wholesale fish enterprise "known all over South Carolina and parts of Georgia and other states." One of the most prosperous black businessmen in the city was J. P. Seabrook. By 1910, his shoe store at 441 King Street "was said to be the largest shoe business operated by a man of color in the country." A number of these Charleston businessmen graduated from or attended Avery: some of the better known were Arthur L. Macbeth, a photographer (557 King Street, later 186 Calhoun Street); John A. McFall, a pharmacist (173 Smith Street); and Edward A. Lawrence, a real estate agent (with Swinton W. Bennett, 145 Calhoun Street).[44]

Arthur L. Macbeth was one of the most innovative of these businessmen. Born in Charleston in 1864, he was of "African, Dutch and Scotch descent." After attending Avery, he learned photography and opened up shop in 1886. A "pioneer" in the moving picture business, he invented Macbeth's Daylight Projecting Screen, which he exhibited to audiences in his hometown and Norfolk, Virginia. From 1901 to 1902 he headed the Bureau of Arts in the Negro Department of the South Carolina Interstate and West Indian Exposition. Like Dart, he supported the National Negro Business League. Macbeth had close ties within the local black community. He was a trustee of Centenary Church for twenty years. Two of his sons, Hugh and Chester, graduated from Avery. A daughter, Hazel, also attended the school. In 1910 Macbeth decided to relocate his business to Baltimore, Maryland, where his children Hugh and Hazel were working. Hugh, who received his B.A. from Fisk University and L.L.B. from Harvard University, was practicing law there. Hazel, after graduating from Norfolk Mission College, Virginia, went to work for the Baltimore *Times*, founded by her brother. In 1915, she became a teacher in the city public schools. By that time, Hugh was practicing law in Los Angeles, California. The Macbeth family illustrated the mobility of the Charleston black elite as their children became professionals and business leaders.[45]

Besides the Macbeths, other black families with business or professional connections regularly sent their children to Avery. Thomas A. McFall, who worked for Baer, helped found the black hospital and training school on Cannon Street. McFall sent his seven children to Avery. Most of them

graduated from the school. His son John became a prominent leader in the local black community. Born in Charleston in 1878, John Allen McFall attended an "A,B,C class" conducted by a Miss Montgomery on Smith Street and the local public schools (Shaw and Morris) before he entered Avery in the seventh grade. He left to pursue a career in pharmacy. He worked as an apprentice at the local People's Pharmacy, where he was trained by W. J. Elfe. McFall obtained his doctor of pharmacy degree from the Philadelphia College of Pharmacy. Besides operating a drug store, he served for forty years at the Cannon Street hospital as a teacher, board member, and dean. He was director and president of the Charleston Mutual Savings Bank during the depression of the 1930s, when the institution was voluntarily liquidated and all funds returned to the depositors. A staunch Baptist like his parents, McFall supported the efforts of Daniel Jenkins to keep the preacher's orphanage open. In 1942 the black pharmacist was selected to serve on the city board of education but declined because one of his sisters was a teacher at the time. His extensive community work included serving on the Avery board of trustees; in the 1930s and 1940s, he played an extremely important role in shaping the history of that school.[46]

Edward A. Lawrence, born in Charleston in 1858, evinced the adaptability of antebellum free blacks to exigencies. When the earthquake of 1886 temporarily closed Avery, Lawrence held his classes in a "barn." During his teaching career, he obtained a degree from South Carolina State College, where he eventually taught psychology and sociology. His wife, Eliza, the daughter of George Shrewsbury, also graduated from Avery in 1875. The two young people were "products" of Centenary Sunday school, where they taught for many years, but they married in St. Mark's Episcopal Church. Lawrence left the Avery faculty to enter the real estate business with S. W. Bennett. In 1920 he moved his family to Brooklyn, New York, where he ran a real estate and insurance business. He probably helped organize the New York chapter of the Avery Alumni Association.[47]

The noblesse oblige manifested by Lawrence and other professional Averyites demonstrated the success of the AMA principals and teachers in fostering a sense of service. The careers of Lewis Gregory, Marion Raven Birnie Wilkinson, and her husband, Robert Shaw Wilkinson, particularly exemplified this sense. As an AMA school, Avery stressed the brotherhood of all mankind; this emphasis probably nurtured in Lewis Gregory a deep commitment to brotherhood and an interest in international law. In 1891 he delivered at his Avery graduation the oration "No one lives for himself alone." A year later he addressed the Avery Alumni Association on international arbitration. After graduation from Fisk in 1896 with a B.A. in classics,

Gregory taught in the Nashville public schools and at Avery. He left teaching to obtain an L.L.B. from Howard University, practicing law in Washington, D.C., for four years before joining the U.S. Treasury Department. When Gregory became a member of the American Bahai community in 1909, he channeled his educational and legal training into serving the religious group as an administrator, lecturer, and writer. He became its "chief spokesman for racial unity."[48]

Like Gregory, Marion Wilkinson gained national repute for her work. She was the daughter of a cotton shipper, Richard Birnie. Wilkinson, graduating with high honors from Avery in 1888, taught at her alma mater until she married Robert Shaw Wilkinson, the second president of South Carolina State College. She served as chief YWCA adviser on the campus and later headed the school's boarding department. Active in the Red Cross and the Sunlight Club, a black women's group she established, Wilkinson was a charter member and president of the State Federation of Colored Women's Clubs and the third president of the National Federation. During World War I she organized recreation centers for black soldiers at Fort Jackson, South Carolina. The Hoover administration sought her counsel on a child welfare program. Under the New Deal, she helped set up a WPA training school and day nursery.[49]

Robert Shaw Wilkinson, born in Charleston on February 18, 1865, was named after the commander of the Fifty-fourth Massachusetts Regiment, Robert Gould Shaw. His paternal grandfather was an Englishman. His father, formerly in the fruit and meat business, worked for A. Toomer Porter as a janitor of the rector's church and academy. Wilkinson, after attending Shaw Memorial School, took his normal training at Avery. Orphaned when only sixteen years old, the youth worked as a janitor, waiter, pullman porter, and clerk. Attending West Point from 1884 to 1886, he was one of several black South Carolinians, including Whitefield McKinlay (West Point), John C. Whittaker (West Point), Julius L. Mitchell (West Point), and Alonzo C. McClennan (Annapolis), who participated in the integration of these military institutes. Obtaining his B.A. at Oberlin College and later an M.A. and Ph.D. from Columbia University, New York, Wilkinson taught for five years at Kentucky State University in Louisville. In 1896 he accepted a professorship in physics and chemistry at South Carolina State College. Replacing Thomas E. Miller as president in 1911, he headed the institution for twenty-one years. "Regarded as the father of organized and vocational work among Negroes of the state," he was also lauded by a Columbia black newspaper for recruiting "some of the race's brainiest men as teachers and lecturers" to the Orangeburg campus and for adding significantly "to the

cultured status of our race." Believing that racial uplift could be achieved "by education, self help, saving, land ownership," Wilkinson was president of the state Negro Business League.[50]

Emphasizing a sense of service, Avery succeeded in inducing many of its graduates to become teachers. Of the 281 graduates listed with occupations in the 1906 catalogue for the years 1872 through 1905, at least 150 (53.4 percent) were teachers. Some of the very best graduates, like Marion Wilkinson and Lewis Gregory, returned to teach at their alma mater. The majority, however, taught in the rural areas and small towns of South Carolina. Banned from Charleston's public schools, they taught all over the state. Morrison Holmes wrote in 1900, "There is not a county in the state to which our graduates do not go as teachers, and in the lower counties and along this malarial coast nearly all the schools for colored children are taught by Avery graduates. In many places conditions are such that no one can undertake this work without jeopardizing health or risking life itself." Some parents, such as the father of Anna E. Izzard (1873), balked at sending their children into the hinterlands, where these young people endangered their health. Izzard, instead, built for his only daughter a one-room schoolhouse on the family property.[51]

Several teachers who graduated from or attended Avery pursued careers outside South Carolina. Elise Minton Thomas (1898), obtaining her B.A. from Fisk University, taught in Lawrenceville, Virginia, and Brunswick, Georgia, before she became head social worker at Stillman House Settlement in New York City. Later she became a playground director in Chester, Pennsylvania, where her husband had his medical practice. Edward Porter Davis, who attended Avery, received a B.A. from Howard University (1907) and an M.A. (1911) and a Ph.D. (1923) from the University of Chicago. Beginning in 1907, he taught Greek and Latin, then German, at Howard University until he was appointed dean of its liberal arts college in 1929.[52]

The emergence of this professional class did not diminish the paternalism of the AMA's northern white principals and teachers, which could still sometimes be suffocating. A certain amount of paternalism was endemic to the missionary experience, particularly among newcomers to the school and to the teaching profession. But the experience was not static. Some principals, like Morrison Holmes, who remained at the school for over twenty years, developed a deep commitment to their students' well-being that transcended a narrow and debilitating paternalism. According to a teacher, Mattie M. Marsh, Holmes enjoyed "a devotion that few principals" experienced. In 1906 the local Ministers' Union presented him "with a handsome gold-

headed ebony walking stick as a token of their appreciation of his service and their regard." When he died, the parents and alumni instituted the Holmes Memorial Fund for needy but qualified students.[53]

Mortimer Warren and Amos Farnham also endeared themselves to the Averyites. For the 1906 commencement exercises, the two men's portraits were displayed prominently in the church alongside those of Francis Cardozo, Charles Avery, Frederick Douglass, and Abraham Lincoln. In 1886, after an absence of over ten years, Warren returned to take charge of the summer state normal institute for black teachers that was held in Columbia. A. Coward, the state superintendent of public education, concerned that the program could not continue without adequate enrollment, realized that this able northern educator, still remembered and respected by many blacks, could make the institute a success. In turn, Warren hoped Amos Farnham, who had headed the normal department at Atlanta University for almost two years, would be his assistant.[54]

The commitment of Warren, Farnham, and Holmes to black education in the South was equaled by the devotion of teachers like Mattie M. Marsh. Even today, Avery's last five white teachers are fondly remembered. H. Louise Mouzon (1914) has preserved their group picture. The two most popular of these five, Marsh, of Ohio, and Elsie B. Tuttle, of Michigan, taught at the school for an aggregate of nearly thirty years. Septima Clark (1916) recalled that after Avery became an all-black institution, these two teachers "were permitted to remain two years longer" despite city officials' disapproval of their living with blacks in the mission home. "They were as reluctant to leave as we were to have them go." Their commitment extended beyond the classroom. "They sometimes took us," Clark remembered, "to the theater when plays came and sat with us in the segregated area high up in the second balcony." Describing the indignities these teachers suffered, Septima Clark explained that they "were not accepted in Charleston society" except at the Jewish synagogue. Even after Marsh left Avery to teach at AMA's Talladega College in Alabama, she remained in contact with and encouraged her former students. She attended the last lecture-demonstration of the artist Edwin A. Harleston before his death. Averyites who went to Talladega remember the special way she welcomed them. Marsh, who treated her students as an extended family, warmly personified to them "Aunt Mary Ann," the name the older graduates called the AMA, an image the organization encouraged. Whatever the limitations of the AMA as an institution, or the shortcomings of the various missionaries, the dedication of certain individual principals and teachers came to personify the AMA, even after the association terminated its relationship with the school. In 1951 Marsh,

along with Francis L. Cardozo, Amos Farnham, and Morrison Holmes, was depicted in a school dramatization entitled "Avery—Past, Present, and Future."[55]

The Self-Help–Social Uplift Philosophy

On the Fourth of July 1890 the Avery Alumni Association held its fourteenth reunion in Avery Hall. The audience was composed mostly of Averyites, sprinkled with a few guests and friends. The featured speaker was Alonzo G. Townsend, B.A., M.A., D.D. This former pastor of Charleston's Centenary Methodist Church was a member of Avery's first graduating class in 1872 and four years later received his B.A. from the University of South Carolina. His message to the gathering was that the development of the individual and race progress were inseparable. The race problem, if it existed at all, would be solved by education and the accumulation of property. By making one-self respectable, cultured, and useful, an individual contributed to the social uplift of his or her people. Townsend's own success as a farmer, presiding elder, and Claflin professor seemed to verify his self-help interpretation of the uplift philosophy.[56]

For many of Charleston's black elite, the Methodist minister's message had real meaning. Living through emancipation and Reconstruction, they had managed to achieve a degree of status and material prosperity. Other Averyites, like T. McCants Stewart, also saw the postbellum period as a time of unparalleled race progress in which blacks were closing the gap between themselves and the so-called Anglo-Saxons. Stewart, after graduating with a B.A. and L.L.B. from the University of South Carolina, became a law partner of Robert B. Elliott, a black congressman. While practicing law, Stewart taught mathematics at South Carolina State College. After studying at Princeton Theological Seminary, he became an ordained minister and pastor of the Bethel Methodist Church in New York City. In 1883 he accepted a college professorship in Liberia. Returning to America a few years later, he lectured and practiced law. Eventually, he returned to Liberia to become an associate justice on its supreme court. The vitality of the self-help philosophy for Stewart is evident from the letters he wrote to his young son in the early 1890s. "Take my word for it, Mac," the father assured, "you will be a Man of Mark, if you strive hard to be *always busy* and *economical*." Extolling, in another letter, the life of a recently deceased aunt, who "made the world better and wiser by living in it," Stewart noted, "Your Aunt Cile may be pointed to as an example of ambition, pluck, and self-reliance.

She graduated from Avery Institute, but she wanted more knowledge, so she taught school and saved her money from 1872 to 1876; then she came North at her own expense and spent two years at the State Normal School of Massachusetts. Just before she died, she sold two lots which she owned in Charleston."[57]

In citing Aunt Cile as a model to his son, T. McCants Stewart was tacitly acknowledging Avery's role in promoting racial uplift in Charleston. A center of moral and mental improvement, the school annually produced graduates who served as examples of black progress. Hardworking, cultured, and respectable, these service-oriented graduates had been trained to be leaders. To achieve this, Avery had evolved into an institution that resembled a fine northern preparatory school, perhaps even a college. It shared many of the same characteristics, including a classical education, a postgraduate program, an alumni association, incorporation, and a board of trustees. Academic excellence was maintained through annual entrance and monthly examinations and an honor roll. Activities included compulsory chapel, gymnastics, a literary society (called the Avery Utile Club in 1882), and a school newspaper (*Avery Echo*).[58]

Each school year culminated with a grand anniversary week, carefully orchestrated to present Avery and the AMA in the best possible light. Program activities included public examinations, rhetorical exercises, lectures by guest speakers, and commencement exercises. Elaborate diplomas were awarded to the graduating seniors. Anniversary week, always well attended, was continuously "an occasion of the deepest interest to the colored people of Charleston and vicinity." The 1906 commencement program celebrating Avery's fortieth anniversary, although grander than most, was representative. Over a thousand persons assembled to hear the baccalaureate sermon preached by Francis J. Grimke, a black South Carolinian. A relative of the Grimke sisters, and the brother of Archibald H. Grimke, a black activist, Francis, born near Charleston in 1850, was pastor of a Presbyterian church in Washington, D.C. But the highlight of the week-long program occurred the next day. An hour before the commencement ceremony was to begin, hundreds of people gathered outside Zion Presbyterian Church to seek admission. The audience "almost ran wild" as the guest of honor, Kelly Miller, the "son of a black tenant farmer and his slave wife," rose to speak. Born in Winnsboro, South Carolina, in 1863, Miller graduated from Howard University in 1886 and was on its faculty as a mathematics professor. The following year he would become dean of its college of arts and sciences. His success symbolized to blacks the progress they had achieved since emancipation. "Mr. Miller is not of mixed blood, and is a true representative of

the highest type of Afro-American," the Charleston *News and Courier* surmised. "His race is proud of him and delighted to do him honor wherever he goes." Not disappointing his audience, Miller quoted Calhoun's assertion "If I could find a Negro who could master the Greek syntax, I would believe that the Negro has a soul and is capable of receiving an education." The black educator fervently wished that this southern hero, "buried as he is in Charleston," could "come to life to-day and see what the Negro has already accomplished." For black Charlestonians, Calhoun represented slavery and white racial superiority. When he died in 1850, slaves were seen rejoicing during his funeral procession. "We hated all that Calhoun stood for," Mamie Garvin Fields remembered. "Our white city fathers wanted to keep what he stood for alive. So they named after him a street parallel to Broad—which, however, everybody kept on calling Boundary Street for a long time." In 1887 the Ladies' Calhoun Monument Association had his statue erected on the Citadel Green (now Francis Marion Square). According to Fields, "Blacks took that statue personally. As you passed by, here was Calhoun looking you in the face and telling you, 'Nigger, you may not be a slave, but I am back to see you stay in your place.' . . . white people were talking to us about Jim Crow through that statue." When blacks began defacing it, "the whites had to come back and put him way up high [on a pedestal], so we couldn't get to him." [59]

The 1906 and other accounts of Avery commencement exercises reported in the AMA journal presented the school as solely the product of New England or Yankee Puritanism. But perceptive observers recognized that the AMA was building on long-established traditions. Some northern teachers attributed these traditions to the aristocratic ethos of the city. "Before the 'slight misunderstanding,' their native city was called the 'Athens of the South,'" Anna M. Nichols, of Toledo, Ohio, an instructor, noted in 1885, "and breathing the same air as the more favored race, they naturally imbibed some of its cultured modes of thought." An equally compelling explanation was offered by Edward A. Lawrence in his address to the Avery Alumni Association in 1915. Avery embodied for him an ideology originating in Charleston and northern black communities long before the war. Lawrence reminded the audience of the contributions made by Francis L. Cardozo, "its founder and first principal," and other black Charlestonians who had composed "more than half of its first faculty." They "had received their training in schools of this city before and during the war, taught in some instances by southern white teachers, as well as by members of their own race." Lawrence declared, "This latter fact comes forcibly to my mind, as I frequently hear our friends tell of the wonderful strides we have made

since the war, in education, wealth, etc., and who seem in utter ignorance of
the fact that the Negro had enjoyed any educational advantages before the
planting of schools throughout this Southland by our Northern friends."[60]

The project from 1907 to 1909 to upgrade the buildings and equipment
at Avery, especially the industrial department, demonstrated the coopera-
tion among blacks in the development of the school. With the support of
parents, alumni, and friends, the school property was expanded, the build-
ings remodeled, and equipment, including a print shop to produce the Avery
catalogue, added. Much of the work was done by the students and teach-
ers, probably under the guidance of Robert T. Watson, a Hampton Institute
graduate in charge of manual training at the school.[61]

Manual training, or industrial education, at Avery illustrated the point
made by Lawrence that the AMA missionaries were often building on long-
established traditions and values cherished by the local black community.
By 1900, the school had formally added an industrial department. With the
renovation project completed, all students were required to take some kind
of industrial training—"domestic science and art" for the women, wood-
working and printing for the men. Morrison Holmes justified such endeavors
as "in keeping with the tendencies of the times and of the newer education,
and with the traditions and practice of the American Missionary Associa-
tion." Manual training was also consonant with the customs of Charleston's
middle-class black elite, who had long provided the city with skilled labor.
Antebellum free blacks had learned their trades as apprentices and sent their
daughters to sewing schools to become dressmakers.[62]

Industrial education at Avery had a very practical side. Sewing classes
taught female students how to make their own clothes, including their
graduation dresses, and helped some of them find jobs as dressmakers. As
Morrison Holmes observed, many students, including those in the lower
classes, "go from school to some useful occupation." Another pragmatic
aspect of industrial education was explained in 1915 by Benjamin F. Cox, the
first black principal since Cardozo, when he described the Band of Mercy.
It "was organized and continues to be encouraged," he elucidated, "because
numbers of the young people who come to us either have stock of their own
or will work in rural districts where agriculture and stock raising are the
chief industries; and the direction of their thought toward right care and
proper treatment of animals and the encouragement of any of their ideals in
this direction will greatly increase their usefulness in much of their future
work." Some of Avery's brightest graduates, like John L. Dart, became ac-
tive in industrial education. Another Averyite, Robert L. Smith, became
involved when he moved to the farming community of Oakland, Texas, to

take charge of its normal school. Extending his skills and training to this community, he organized the Oakland Village Improvement Society and in 1891 the Farmers' Improvement Society. In 1906 he helped establish the Farmers' Improvement Agricultural College at Wolfe City. Ten years later he headed the agricultural extension work for blacks in Texas.[63]

Industrial education was also designed to foster moral improvement. Benjamin Cox associated the Band of Mercy with the King's Daughters and other student organizations "doing vital and indispensable work towards moulding Christian characters." Stressing the dignity of labor, Avery teachers thought they were making the students more useful and moral members of society. This emphasis on moral improvement was manifested in the topics of student speeches and essays during the anniversary week: "Not for Self, but for All" (1893), "A Purpose in Life" (1896), "No Gains Without Labor" (1898), and "Pillars of Character" (1888, 1898). Many black Charlestonians agreed with the missionaries that certain things, especially alcohol, tobacco, and profanity, threatened moral development and, consequently, race progress. In 1886 Avery students organized a Triple Pledge Society, hostile to "rum, tobacco, and impurity of work and deed." By 1888 the society had more than three hundred members, mostly Avery students, who had not only signed pledges promising to abstain from all three evils but circulated pledge cards among friends who did not attend the school.[64]

For Averyites and many other black Charlestonians, manual training was not antithetical to their interpretation of classical education, which involved for them the development of the whole person. Avery principals and teachers, disciples of Pestalozzi, shared their attitude. Edward Lawrence, in his address to the Avery Alumni Association in 1915, explained this philosophy further. Emphasizing the importance of education in enabling blacks "to take and keep the pace that is set by the American Nation," he elaborated on the "more exacting requirements" demanded of black teachers, most of whom "must teach in rural communities." Such a teacher must possess "a broad and comprehensive view of education. . . . He must ever bear in mind the fact that he is concerned with the training of a man. Some one has said, 'We have not to train up a soul, nor yet a body, but a man; and we cannot divide him.' "[65]

This interpretation of classical education explained the emphasis placed at Avery and by Charleston's black elite on culture, which was closely associated with literature, history, music, and manners (or sense of decorum). Improving oneself in these subjects helped a person become more refined, respectable, and useful. Good literature, for example, by raising moral issues, fostered moral improvement. By 1882 the school boasted a literary society,

the Avery Utile Club, which provided public literary and musical entertainments; it also afforded its members practice in rhetorical exercises and parliamentary law. The club was a junior version of the adult Douglass Literary Association (DLA), which met regularly in Avery Hall. Its membership included prominent black professionals and businessmen, among whom were S. W. Bennett, a real estate agent, and H. Cardozo, a minister. (A Cardozo had also belonged to the Clionian Debating Society.) In 1885 at the DLA's second anniversary celebration, members discussed "intellectual progress" and "the true value of a literary society." Like the Clionians, the DLA sponsored debates on such topics as "has the progress of the arts and sciences tended to purify or corrupt morals?"[66]

History was also considered an important character builder. In 1905 Avery normal students were required to take two years of U.S. history and one year each of English and general history, as well as one year of combined English and American literature. Taught by Yankee missionaries, such as Elsie B. Tuttle, this history was probably reform- and abolitionist-oriented. Tuttle used Channings's *U.S. History in Normal Classes*. The students attended lessons in classrooms named Lincoln, Sumner, Grant, Garfield, and Liberty. Geneva Burrough's commencement speech in 1906, "The Friends of Freedom," reflected this abolitionist bent. Besides elaborating on Garrison, Phillips, and other abolitionists, the student recounted how the predicament of the *Amistad* captives "resulted in the mission of the American Missionary Association." The inspirational nature of the literature and history taught by the Yankee missionaries can be seen in the poems by George C. Rowe, the Plymouth pastor, in his book *Our Heroes: Patriotic Poems on Men, Women and Sayings of the Negro Race*. Rowe's heroes and heroines included Crispus Attucks, Peter Salem, Toussaint L'Overture, Daniel A. Payne, Frances Ellen Harper, Lucy C. Laney, R. H. Cain, and Robert Smalls.[67]

Much of the history at Avery was Western-oriented. However, the local interest in African history was not ignored, especially because the continent was a mission field. In 1865 a black missionary, Ennals J. Adams, gave a public lecture, "West Africa, Its People, and Future." Twenty-six years later a student at the 1891 commencement exercises delivered a speech on "Africa, its needs and possibilities." Afro-American history also interested the students. In 1885 Joseph A. Robinson, Jr., a senior, chose "Progress of the Americo-African Race" as his graduation oration. Some Averyites augmented their Western orientation with a knowledge of local history and family experiences. Mamie Fields, who began attending Anna E. Izzard's school in 1901, recalled, "She taught us how strong our ancestors back in

slavery were and what fine people they were. I guess today people would say she was teaching us 'black history.' " [68]

Music, as well as literature and history, was an integral part of the curriculum. The school catalogues boasted a music department with "a competent instructor" and noted that "the elements of vocal music" were "taught in all classes without additional expense to the pupils." Private instruction on the piano and other musical instruments was offered on "very moderate terms," as low as twenty-five cents per lesson. Important public events like the commencement exercises and visits from dignitaries usually included some musical activity. In 1883 Henry Ward Beecher, commending "the singing and comely appearance of the pupils," added that "he had not been so stirred by any sight in the South, except at Fisk University." [69]

This emphasis on music at Avery was appreciated by black Charlestonians, who had a long-established musical tradition. It was customary for Avery parents to hire music instructors, such as J. Donovan Moore (Avery, 1899) or James R. Logan, to tutor their children. Moore was an accomplished pianist and organist, who had studied at the New England Conservatory. One of Moore's most talented students was Edmund Thornton Jenkins, the son of the Baptist minister and founder of Jenkins Orphanage. From 1914 to 1920 Edmund Jenkins was a member of the Royal Academy of Music in Great Britain. In addition to his keen interest in classical music, he developed an expertise in jazz and dance music. [70]

J. Donovan Moore's colleague, James R. Logan, was described by a local black newspaper in 1911 as Charleston's "foremost colored musician, orchestra leader and bandmaster." Born on Coming Street in Charleston on March 2, 1874, Logan graduated from Morris Street Public School in 1889. He worked as a tailor's apprentice for Meeting Street merchant August Wichmann. After passing the Civil Service Examination in 1902, he began working at the Charleston Naval Shipyard, first as a messenger in the blueprint department, later as a blueprinter. During the 1910s he was Sunday school superintendent and choir director at Zion Presbyterian Church. In 1920 he became choir director of Calvary Episcopal Church. Around 1897 Logan's Military Band played at many of the parades. He was also director of the Carpenters' Band Association, Local Union No. 809, which made its debut in 1920 on Labor Day. Logan's brother, Peter, was director of the Jenkins Orphanage Band. Anna, their sister, gave private piano lessons. Their musical activities represented the continuation of an antebellum tradition. "I came from a family of tailors—and musicians," James Logan recalled in 1943. [71]

Logan was also interested in orchestra and chamber music. In 1900 he

organized Logan's Concert Orchestra. Besides directing Charleston's black Amphion Concert Orchestra, he was a force behind the Aurorean Coterie, a black musical-literary society organized in 1905. Composed "of Charleston's representative business and professional colored men," the Aurorean Coterie included Avery teachers and graduates. Its members performed at Avery Hall for school benefits. In 1907 the Averyite George W. Robinson was the master of ceremonies for an Aurorean Coterie celebration honoring John Greenleaf Whittier. Avery teachers and alumnae Constance W. Morrison and Beulah Jervey gave the literary presentations while Logan and Moore provided the music.[72]

For black Charlestonians, Moore and Logan exemplified that the arts instilled refinement and manners. In employing them as music instructors for their children, Avery parents hoped that their sons and daughters would imbibe some of the two men's cultured ways. Moore is remembered even today by Averyites for his aristocratic bearing. Logan, an extremely eligible bachelor, possessing refinement and economic standing as a federal employee, was in constant demand at social events. The gentility and decorum of the Victorian world of culture he lived in survive in the mementoes he preserved in his scrapbook. One invitation to Mr. Logan read: "Will you call for Miss Viola Thomas, 23 Percy St., Fri. and escort her to my home for Whist? If you can not—please phone and oblige. Very Truly Your Friend, (Mrs.) H. P. Boston." The signer was Harriet Palmer Boston, whose son Harry L. was a successful King Street dentist. Both graduated from Avery. The Boston family was reported to "move in the best circles of their people."[73]

The decorum and refinement manifested by Beulah Jervey and other Avery women who participated in the cultural and social life of the local black middle class did not signify that these women subscribed completely to the Victorian ideal of true womanhood. The major attributes of this ideal were piety, purity, submissiveness, and domesticity. Avery acknowledged the importance of women as supreme arbiters in the moral sphere because of their specially benevolent temperaments. Activities for women students that fostered traditional values included cooking and selling school lunches, sewing their graduation dresses, and helping the sick, old, and needy through the King's Daughters. At the 1878 alumni reunion Susan A. Schmidt (1874) addressed the audience on "woman's position in society." This emphasis on women's moral role in society is apparent in some of the titles of the students' commencement orations: "The Ladies of the White House" (1891), "Woman as a Sovereign" (1895), "True Womanhood" (1898), "Woman's Worth and Work" (1899), and "Moral Strength of Women" (1900).[74]

At the same time, Avery challenged the submissiveness and domesticity of

true womanhood by encouraging its women students and graduates to ex-
pand the sphere of their special role as principal moral agents. The women
were required to take gymnastics as the men were. They were held to a
rigorous academic track, and those studying to be teachers studied school
management and law as well as pedagogy. They competed with the men
for class honors. These women were being prepared to cope competently
with the exigencies of life, including the rigors of teaching in rural areas
and operating one-room schoolhouses. Some of the topics that the women
orators selected reflected their perception of the "new woman": the coming
woman (1893), women in state craft (1894), women in history (1914), and
Helen Keller (1914). Having chosen "the woman's century" as her subject,
Elizabeth Nathalie Meyers expounded at the 1905 commencement exer-
cises on "some of the startling things woman will do in business lines in
her century." Addressing the Avery Alumni Association at its 1905 reunion,
Cerealia L. Lee, a teacher who graduated the previous year, described the
"club movement, and its work among colored women." Most of the topics,
however, suggested that Avery women did not view themselves as abandon-
ing traditional roles as future wives and mothers, or maiden aunts, but rather
as extending their skills and talents to a larger family, which included their
students and community.[75]

Some Avery graduates, like Sallie O. Cruikshank (1874), deferred or
even rejected marriage in pursuing a teaching career. Cruikshank became
a teacher at Shaw the year after graduation, and toward the end of her
career served as its vice principal until her death in 1932. These Avery
graduates demonstrated a certain self-sufficiency now associated with femi-
nism. However, they were part of a community that produced before the
Civil War independent women teachers like Mary Berry, Mary Weston, and
Frances Bonneau Holloway. This tradition was undoubtedly nurtured by the
northern women teachers, who were bright, independent, and unmarried.
Mattie Marsh, who had a B.A., taught Latin, Greek, astronomy, chemistry,
and civics at Avery. Highly educated, these AMA missionaries were acutely
aware of the parallel between them and their black students. Avery pro-
duced women like Marion Birnie Wilkinson and Florence Smith Randolph,
leaders in the black women's club movement. Randolph, born in Charles-
ton and educated at Avery, was an active member of the African Methodist
Episcopal Zion church. Licensed to preach in 1897, she was ordained dea-
con four years later and, in 1903, became an elder. She served as pastor of
various AME Zion churches in New York and New Jersey. For two years
she headed Negro Work for Christian Society of the State of New Jersey.
A wife, mother, and preacher, Randolph extended her services to the wider

community as a member of the executive committee of the New Jersey State
Suffrage Association and a lecturer for the Women's Christian Temper-
ance Union of New Jersey. She served as president of the New Jersey State
Federation of Colored Women's Clubs and chaplain for the North Eastern
Federation of Colored Women's Clubs. Her activities included extensive
travels to Liberia and the west coast of Africa.[76]

Limits of Southern White Paternalism and
the Emergence of Racial Radicalism

On April 10, 1877, the last federal troops left Columbia, South Carolina,
and the Republican Governor, Daniel H. Chamberlain, resigned. Neverthe-
less, South Carolina blacks had some reason to believe that the Redeemer
Governor, Wade Hampton, would prevent the worst aspects of the conser-
vative return to power. A paternalist and practical politician, Hampton had
triumphed over the extremist element in his own party. During the campaign
of 1876 he promised blacks the protection of the rights they had gained
and better educational facilities. Reassured by Hampton's moderate tone,
George Mears of Charleston and some other black legislators joined the con-
servative cause. The light-skinned Mears, a shipbuilder and volunteer city
fireman, switched to the Democrats because, according to his granddaugh-
ter, the Republicans were corrupt and "didn't recognize the poor men."
With Wade Hampton's accession to power, the paternalistic tradition en-
joyed a quick but short-lived revival. Avery, having "survived the bad odor of
carpetbaggism," benefited from this paternalism that briefly flourished after
Radical Reconstruction. When Charleston-born William A. Courtenay was
reform mayor during the 1880s (1879–1887), the school enjoyed particu-
larly good relations with local authorities, who regularly included an account
of its activities in the city yearbooks. "This school is doing good work. . . .
Our city is fortunate," the *News and Courier* declared in 1882, "to have such
a[n] institution in its midst." As late as 1890, Avery officials reported, "white
people have called to enter their servants' children, promising to pay their
tuition." [77]

 Wade Hampton's followers never fully shared his paternalism. Once in
office, the conservatives felt less need for restraint. The elections of 1878
and 1880 were marred by fraud and intimidation. Hampton's decision to
leave for the U.S. Senate presaged the triumph of the Negrophobes. The
1882 legislature enacted the eight box law, designating eight categories of

officeholding to confuse black voters. The black vote dropped accordingly from 91,870 in 1876 to 13,740 in 1888.[78]

Charleston blacks consoled themselves with the presence of a Republican in the White House. However, the presidential election of the Democrat Grover Cleveland in 1884 aroused "a dreadful state of uneasiness." A series of murders and police provocation against local black citizens after Cleveland's election seemed to confirm their worst fears. In 1885 a jury acquitted the alleged assailants of a black woman found "brutally murdered" near her home. When the case of a prominent white doctor charged with killing a black Democrat ended in a mistrial, the pastors of five black churches felt the need to petition the Charleston people to address these grievances, specifically the domination by whites of the court system, the lack of free elections, the growth of peonage, and the failure of the city to hire black teachers in its public schools. The ministers urged light-skinned members of the black community to join in their efforts because "if you have but a tenth part of Negro blood in your veins, you are placed under the same ban."[79]

With a Democrat as U.S. president, Charleston's black elite found itself dependent on a white paternalism no longer fashionable. Many white South Carolinians had reluctantly accepted Hampton's paternalism as an alternative to radical Republicanism, but with the Republicans out of office, the proponents of white paternalism faced an insurmountable disadvantage. Those who pressed too vigorously found themselves estranged. Such was the case of Peter F. Stevens, the Reformed Episcopal bishop, whose antebellum credentials were impeccable. As superintendent of the Citadel (1859–1861), Stevens and his cadets very nearly started the Civil War when they fired on the federal ship *Star of the West*. After the war, this former Confederate colonel was "socially ostracized from the white community" for his commitment to the religious training and education of blacks, which included establishing a parochial school and organizing at his church the first county institute for black teachers in the state.[80]

The agrarian revolt in the late 1880s compounded the problems facing black South Carolinians. In a period of economic decline, the state's embattled farmers embraced Tillmanism rather than populism. Benjamin R. Tillman promised to end their woes by liberating the state from silk-stockings and "broken down" aristocrats. Tillmanism became a vehicle for thousands of white South Carolinians to express their racism and discontent over the direction in which modernization was taking them under the conservatives. Radical Reconstruction had caused them to see abolitionism and industrialization as closely intertwined. The opportunities and rights blacks had

gained came to symbolize modernization, imposed upon them by northerners after the Civil War. By inhibiting racial progress, they believed they were retarding the whole hateful process.[81]

In calling for a convention in 1895 to revise the constitution of 1868, Tillman placated white South Carolinians, fearful of threats to their traditional ways, symbolized by the family, true womanhood, and "Anglo-Saxon supremacy." The convention provided a forum for them to express these anxieties and fears. Resolutions were passed to control the evils of modernization, including racial intermarriage, divorce, and atheists' holding office. Proposals advocating change were couched in traditional garb. Despite the laudable efforts of a handful of black delegates, the Tillmanites successfully emasculated the Fifteenth Amendment. Subterfuges such as contrived voter residency, literacy, and property ownership requirements were found to disfranchise the blacks but also prevent federal intervention, a fear aroused by the so-called Force Bill of 1890 introduced by Henry Cabot Lodge, a Massachusetts congressman, to supervise federal elections. Disfranchisement of almost the entire adult black population was achieved in 1896 with the establishment of a white Democrat primary.[82]

After Tillman was elected governor in 1890, legal and de facto segregation quickly spread. The practice of maintaining separate waiting rooms in doctors' offices, apparently begun in Columbia, reached the Low Country. Rigid residential segregation did not exist in Charleston until Jim Crow legislation. Before the Civil War, servants had lived in carriage houses behind the elegant "South of Broad" mansions, and free blacks had owned homes in the downtown area. These residential patterns continued after the war. But as one black resident recalled, "Tillman's law" or "Jim Crow was the turning of Charleston from a friendly city," with some neighbors' becoming "enemies overnight." Despite racial radicalism, antebellum residential patterns persisted. By 1910 many blacks could still be found "living on land adjoining some of the most beautiful residences in the city." Pointing this out, the *News and Courier* urged further reclamation to continue the beautification process now occurring and "to correct what is already an evil of long standing."[83]

Tillman, after serving two terms as governor, left for Washington, D.C., in 1895. He continued to preach his racial radicalism in the U.S. Senate until his death in 1918. He defended brutal lynchings of blacks in the South by painting lurid pictures of black brutes' assaulting innocent white women. His deep-seated racism became an obsession. Fearing that the white race might destroy itself in an orgy of miscegenation, he labeled all attempts to aid blacks as devices to turn South Carolina and the rest of the South into a

"mulatto state." In 1903 when President Theodore Roosevelt submitted the name of light-skinned Averyite William D. Crum to the U.S. Senate for confirmation as port collector of Charleston, Tillman led an effort to block the nomination.[84]

Born free in Charleston in 1859, Crum traced his paternal lineage to a German immigrant. His white father owned a plantation near Orangeburg, South Carolina. After attending Avery and the University of South Carolina, Crum obtained his medical degree from Howard. In 1901 at the recommendation of Charleston's business community, the physician was appointed director of the Negro Department of the South Carolina and West Indian Exposition. Therefore, the uproar over his appointment as port collector must have surprised Roosevelt. The local reaction to a "mulatto's" being in charge of "white lady clerks" demonstrated the shallowness of southern white paternalism. The Low Country opposition joined Tillman's campaign to induce Roosevelt's successor, William Howard Taft, to remove Crum from the position. In 1908 the *News and Courier* blamed Crum's appointment for destroying "the friendliness between the races." Two years later Taft obtained his resignation by appointing him as minister to Liberia, where he contracted malaria and died soon afterward.[85]

The whole uproar and confrontation over Crum's appointment as port collector disillusioned Charleston's black elite. "I see no way for the people, in the present plight of political annihilation than to look out for their material affairs," Crum's associate S. W. Bennett complained in 1903. For Crum himself, the opposition to his appointment seemed to invalidate the basic tenet of the self-help philosophy that once a black man became cultured, educated, and respected, white prejudice would lessen. "The honorable Mayor of this city [J. Adger Smyth], whose very arteries are poisoned against our people," Crum wrote, was "leading the malicious fight, his prejudice is so deep seated on account of his heredity, his father being the author of a work against our people and his own utterances in the past so vile against good citizenship. . . . This question as far as I am concerned is beyond the matter of the Collectorship; it is up to the people of this country to say, and at once, whether we are citizens or not." Even T. McCants Stewart, another friend and formerly one of the strongest proponents of the self-help philosophy, despaired. In 1906 he and his family moved to Liberia. He thought the whole struggle for civil rights in the United States had become "hopeless." [86]

When Tillman had departed for Washington, D.C., in 1895, Coleman ("Cole") Blease and others had been quick to fill the void and continue the race baiting. "Abusing the defenseless Negro . . . has become the rule with a certain class of office seekers," a Charleston black newspaper ob-

served in 1915. Blease, who was governor from 1910 through 1914 and eventually became a U.S. senator, was the most effective of Tillman's successors in waving the flag of racial radicalism. Although blacks were becoming politically powerless, Blease escalated his antiblack rhetoric to his advantage. Opponents either were "nigger lovers" or had "nigger-blood" in their veins. Like Tillman, Blease tirelessly defended lynching. In his enthusiastic support of Tillman's stance against black education, Blease extended his predecessor's tenets by insidiously inverting the logic of the self-help–social uplift philosophy. Tillman asserted that "over education" awakened in blacks aspirations they could never achieve, thus leading to discontent and crime. Blease, therefore, reasoned that blacks were potentially dangerous because of their striving to become educated, middle-class, and respectable. Blease even alluded to the economic threat posed by blacks as they became landowners.[87]

Having vilified the self-help philosophy, Blease exceeded Tillman in his vitriolic attack on black colleges. Opposing state support for them, he made Benedict College in Columbia the particular object of his campaign wrath. Founded in 1871 by the American Baptist Home Mission Society, the school was an unlikely target for his charges of immorality and corruption. In 1911 Blease lambasted the school for having whites on the faculty, especially women, who were not "slouches" but "handsome" and "intelligent." The school was "a stench in the nostrils of all decent people." Opposing Blease's "announced policy against the Negro," Thomas E. Miller resigned as president of South Carolina State College in 1911 after the Tillmanite was elected governor. During the gubernatorial race, Blease had threatened to cut off money to the black college if Miller remained its head. Miller had also been an outspoken critic at the 1895 constitutional convention. Blease's appeal was economic as well as racial. The "mill people," like the antebellum white mechanics, wanted black labor competition eliminated. The Segregation Act of 1915 promised to prohibit employment of black workers in most mill occupations.[88]

Considering the accelerated deterioration of conditions for black South Carolinians with the rise of racial radicalism, the optimistic tone of a fundraiser circulated around 1898 for the Charleston Normal and Industrial Institute was surprising. "I have visited Rev. J. L. Dart's School in Charleston, S.C.," the flyer quoted Booker T. Washington, "and I feel that Mr. Dart is doing a good and much needed work among the colored people in that vicinity, and I am sure that any help given him will be used in a way to accomplish good in the upbuilding of our people in that part of the

South." The Institute, incorporated in 1897, came to symbolize the success and validity of Washington's self-help program and underlying philosophy.[89]

The optimism of the circular and Washington's comments contrasted sharply with the concern privately expressed by Dart on January 10, 1899, in a letter asking Archibald H. Grimke for his support of the institute. Dart painted a dismal picture of conditions causing "hundreds of our people" to leave. "In this city and State, as well as in other southern communities," he wrote, "the situation and outlook for colored people, educationally and generally, are getting worse constantly. Employment that was formerly given to colored men and women is now given to white people. The colored school population here, though larger than the white, gets one third as much of the public school fund as do the whites." Dart's pessimism was substantiated by a report by the state superintendent of education in 1900. Although the enrollment in South Carolina public schools for that year was 126,289 whites in contrast to 155,602 blacks, the amount of state, county, and municipal money expended on the whites totaled $693,807.60 while that for the blacks was $203,033.45. The frustrating dilemma confronting the black middle class was succinctly described in 1904 by Julius L. Mitchell when he explained to James R. Logan his reasons for moving to Providence, Rhode Island, to practice law. "Things have become so very dull in my native state," he wrote, "and the prejudice against us so great that it is almost impossible for the professional Negro to amount to much."[90]

The growing frustration and bitter resentment of Charleston's black middle-class elite were fully expressed during the fall of 1906 by Anna F. Johnson in "An Age of Advancement—Our Men Must Advance," her address to the Aurorean Coterie. Ten years earlier Johnson had graduated from Charleston's Shaw Memorial School as its Peabody bronze medal winner. Although still reiterating the uplift philosophy, her speech was pessimistic, resentful, and even militant in tone. The moral improvement of blacks, she felt, had not lessened white prejudice. As blacks became more cultured and educated and their aspirations grew, whites denied them the fruits of their self-improvement. Her condemnation of Booker T. Washington's emphasis on industrial education revealed to what degree Charleston's black middle class was moving away from his program. "If we as a race are just 1,000 years behind," the black woman expostulated, "how in this world does he ever expect us to even attempt keeping abreast of the times with only an industrial education? . . . I am not condemning industrial education at all, but want a classical along with it. The better education a man has, the easier his task. 'The man who thinks must govern those who toil.'" Believing that the

race was "actually dying for the want of more business enterprises among
our people," Anna Johnson also stressed the importance of an education that
helped blacks advance in the business world.[91]

Perceiving the limitations of the self-help philosophy, three Averyites,
John L. Dart, William D. Crum, and Joseph C. Berry (a businessman and
educator who was the grandson of Mary Ann Berry), were already mov-
ing toward local collective political action at the turn of the century when
they helped establish in Charleston the Negro Co-operative and Protec-
tive Union. Seen by its founders as a movement to involve the "responsible
and respectable tax-paying citizens" of the black community in an "orga-
nized and intelligent effort," the union presented a specific platform for race
progress. Besides advocating black business enterprises and protection of
the legal and civil rights of black citizens, the platform emphasized better
educational facilities, including "colored teachers for colored schools."[92]

As reprehensible as the racial radicals were, Low Country opposition to
Crum's appointment as port collector revealed that their conservative pre-
decessors were hardly much more enlightened. This can be seen in the way
some of them dealt with St. Mark's Episcopal Church in Charleston during
a bitter thirteen-year controversy (1875–1888) over the status of black clergy
and parishes in the South Carolina diocesan convention. During 1865 when
Grace parish, the only Episcopal church operating in the city at the time,
became too crowded, black Episcopalians decided to form a separate and in-
dependent parish. The new St. Mark's congregation, composed of "the elite
of the colored people of Charleston," included those who had worshipped
at Grace, St. Philip's, St. Michael's, St. Paul's, and the Church of the Holy
Communion before the war. Richard Birnie, Nathan A. Montgomery, and
C. C. Leslie were prominent lay leaders. The first pastor was a white aris-
tocrat, J. B. Seabrook. At his death in 1877 he was followed by another
impeccable white aristocrat, A. Toomer Porter. In 1888 Porter was replaced
by the church's first black pastor, J. H. M. Pollard, of Norfolk, Virginia.[93]

Almost from its inception, St. Mark's sought entry into the diocesan
convention but was told that it had yet to demonstrate its permanency. In
1875 the parish, with the approval of the bishop, William Bell White Howe,
formally applied for entry. Despite the support of prominent Low Coun-
try clergy and lay leaders like A. Toomer Porter and George Trenholm,
St. Mark's admission into the ruling body was blocked by the majority of
lay delegates, led by Edward McCrady of St. Philip's. According to Porter,
McCrady refused to accept the logical outcome of Appomattox. The Demo-
cratic legislator may be considered the spiritual father of the eight box law.
After the election of 1880 a joint committee of the General Assembly asked

McCrady for his opinion of the state's election law. In a pamphlet, McCrady proposed an educational qualification for the vote. In 1882 the state legislature adopted the so-called eight box law, which in practice allowed election managers to include the votes of those illiterates who voted Democratic.

Using the same logic the racial radicals would later employ, the opponents argued that recognizing the legitimacy of St. Mark's would be tantamount to accepting miscegenation, perhaps even furthering it. Unsuccessful attempts to gain entry in 1878 and 1880 became intertwined with St. Mark's efforts to have its black deacons, Thaddeus Saltus and later J. H. M. Pollard, included in the list of clergy eligible to sit and vote in the diocese. After St. Mark's declined sending delegates to black-only conferences (which they considered a prelude to organizing separate black missionary districts in each southern diocese), their opponents accused the congregation of racism, snobbery, and elitism. In 1886 Mr. Benet, a deputy to the General Convention from the diocese of South Carolina, charged that St. Mark's "did not want a white man in their churches," "drew the colorlines themselves," and was "a congregation of mulattoes [who] did not want any 'niggers' among them."

In an extraordinary letter to the Charleston *Messenger*, a black newspaper, St. Mark's vestry defended its position: "We distinctly repudiate the charge made by Mr. Benet, for we welcome all of any race or color, who will worship in our church; and furthermore, we fully recognize our complete identification with the Negro race." The vestry reported that "one of the original incorporators of this church was a black man, who had been a slave and who was for many years a vestryman. That there are a number of the members who are black persons, pew holders and communicants, and that many others of those who are not black, now members, and have been so from our organization were slaves before the war." The black Episcopalians conceded "that there is white blood in the veins of many of the members of this congregation . . . but for this surely we are not responsible."

Facing a growing schism in the South Carolina diocese that threatened to topple Howe, St. Mark's "friends" chose to abandon the fight. In 1888 Porter, with the bishop's apparent consent, introduced a resolution designed to ultimately place the black congregations in a separate organization under the bishop of the diocese. Porter and Howe justified their actions on the grounds that they would encourage St. Mark's to expand their missionary efforts. Although Howe eventually agreed to allow St. Mark's to continue in its independent status, he counseled: "As regards uniting with other colored congregations, in a convention, my advice to you is, unite. . . . An isolated position assumed by St. Mark's when by associating with others you could help in the work among the plantation negroes, will be neither to your

growth nor strength. If you stand aloof from it and do nothing in the dio-
cese for colored people whom you might help; if you content yourselves with
your own services and rest satisfied with being a congregation composed of
the 'e[li]te of the colored people of Charleston,' you will miss . . . a good
opportunity of helping others."

Throughout the controversy the principal aim of St. Mark's was to become
a self-supporting parish in good standing with the right of its black clergy
and lay representatives to sit and vote in the diocesan convention. Thus,
Porter's resolution was a great shock to his congregation. "We feel . . . like a
cyclone bad struck us," the vestryman C. C. Leslie complained. The vestry
condemned as antithetical to the catholic spirit of the church what it con-
sidered both class legislation (laws aimed at blacks alone) and legislation
without representation (the attempt to force them into a separate black con-
ference without their consent). The group denied that it was not interested
in missionary work: "This parish, even when hampered in its own work, has
endeavored through the assistant minister to do missionary work among the
brethren of our own race in the town of Summerville and in St. Andrew's
Parish, and . . . we hope to extend the scope of the work." The Charles-
ton church refused to acquiesce in a black-only convention, preferring an
independent status. They also declined joining other black Episcopal con-
gregations who went over to the Reformed Episcopal church of the bishop
P. F. Stevens in 1888.

Analyzing the situation, the Charleston *News and Courier* detected a good
deal of hypocrisy in the convention's position, predicting that "the clerical
party, which heretofore has had the sympathy of the Episcopal Church at
large in standing up for the Christian equality of the inferior race, may have
forfeited that sympathy." Because the diocesan convention decided in 1889
to cease adding blacks to the list of clergy, the name of the last black minister
was dropped from this list when Pollard transferred to North Carolina in
1898. As late as 1947 the Diocese of South Carolina did not have black
representation.[94]

The limitations of white paternalism were particularly evident in the
operation of the black public schools in Charleston. A black public school
in the lower wards of the city was especially needed. Many local whites felt
that public educational facilities for blacks already exceeded those for whites.
This was a misconception because as early as 1876 the city school board real-
ized that its Morris Street and Shaw facilities were overcrowded. On several
occasions it considered acquiring Porter's Franklin Street School to rectify
the situation. Whatever the plans were, the building remained vacant after
the earthquake of 1886 until it was turned over in 1893 to Daniel J. Jenkins

for his orphanage. The renovation and enlargement of Shaw through northern funds in 1882 did not substantially alleviate the problem. By 1902 over six thousand black children were unable to attend a public school because Shaw and Morris Street were already overcrowded with a total enrollment of 3,773. That year the Ministers' Interdenominational Union of Charleston requested that the school board ameliorate the situation. Six years later a committee of black citizens (probably the Negro Co-operative and Protective Union) headed by John L. Dart petitioned the board about the overcrowding. In March 1904 Jenkins reported that the expenses to educate the downtown black children were becoming too burdensome for him to bear. The Colored Ministers' Union petitioned the board in 1913 to take over the Jenkins Orphanage school. Despite the various petitions and proposals, not until 1921 was the George L. Buist public elementary school on Calhoun Street constructed for black children living in the lower wards of the city.[95]

An equally pressing issue that evolved during the Gilded Age was the downgrading of the curriculum in the Charleston black public schools. In 1893 the Charleston public school system was "regraded" under Henry P. Archer, who had become city school superintendent three years earlier. The two black public schools, Shaw Memorial and Morris Street (renamed Charles H. Simonton in 1891), provided a preparatory class for the primary grade and the first eight grades. A black child beginning at the minimum school age of six years would complete his or her public education at the age of fifteen. No provisions were made for a black public high school. Students who wished to continue their education could try to be admitted into Avery, Claflin, or South Carolina State College, if they could afford the tuition and other expenses. Occasionally the school board would offer a promising student a scholarship to Claflin or South Carolina State. "If the cravings of intellectual tastes could be awakened," a state educational official explained in 1899, "there is little opportunity to gratify them."[96]

Under the "regrading" system, the three white public schools (Bennett, Crafts, and Courtenay) provided a preparatory class for the primary grade and the first seven grades. A white child beginning at the minimum school age would graduate at the age of fourteen. The girls usually went on to Memminger, a public high school which provided normal training and did not become coeducational until 1947. Many of the boys pursued their education at Porter's academy or the tax-supported High School of Charleston. Through a state legislative measure passed in 1882, the "first honor" boy graduates at Bennett, Crafts, and Courtenay were awarded four-year scholarships to the High School of Charleston. Eventually these scholarships were extended to all the boy graduates. In 1903 the city school superin-

tendent included in his disbursement statement $3,602.00 for High School of Charleston scholarships, $75.00 for one Claflin scholarship, and $41.20 for one South Carolina State College scholarship. Besides the scholarship arrangement, the city council regularly made special appropriations for the maintenance and repair of the High School of Charleston buildings. The "liberality" of the city council enabled the school to relocate in 1881 and to erect an annex in 1895.[97]

The second "regrading" of the black public schools was instigated when John L. Dart proposed in 1898 that the city take over his Charleston Normal and Industrial Institute. About the same time an AMA agent requested that the school board consider subsuming Avery Normal Institute. Although the educational philosophies of these two institutions were not mutually exclusive, the board chairman, Charles H. Simonton, presented these two proposals as polar alternatives. The school commissioners could choose the path of industrial education for blacks by taking over Dart's institute or establishing an industrial department in each of the black public schools. The second alternative was to provide blacks normal training by subsuming Avery. Simonton argued that industrial education would provide the greater good to a greater number. If the school board were to provide blacks normal training, this would challenge its policy of employing white teachers and principals in the black public schools. Although enough money was raised through the Peabody and Slater funds to negotiate the takeover of Dart's institute, the board decided to erect a new industrial school at the corner of Fishburne and President streets. Using Booker T. Washington's argument for industrial training, it would start implementing its plan for black public education in 1910 when the construction of the new school was completed. One of the architects of this plan was Augustine T. Smythe, the brother of the former mayor J. Adger Smyth, who virulently opposed Crum's appointment as port collector of Charleston. The Charleston Colored Industrial School opened on January 3, 1911, with 375 students and eight teachers. The teachers and pupils of the three upper grades at Shaw and Simonton had been moved to the new school. Two months later, James R. Guy, of Norfolk, Virginia, became its permanent principal. Dart, who retired in 1913 because of ill health, died two years later. Although his wife, who had taught in the public schools of Washington, D.C., attempted to carry on his educational work, his institute eventually closed.[98]

In 1913 Guy lectured at a conference of educators in Nashville, Tennessee, on the "right kind of education for [the] southern Negro in the city." He delineated the course black public education had taken in Charleston under his leadership. "I believe the right kind of education for the negro

in the cities," he asserted, "is exemplified in the system now in force in Charleston. Conditions in the schools there are ideal for the development of any system of training for the colored race." The black children attended the elementary schools until the fourth grade, then the Colored Industrial School for three years. Guy, emphasizing that all the teachers were white, advised "the selection of Southern ladies who have only the kindest feelings for the negro children, sympathize and understand their many different difficulties and trials, and yet at the same time require and receive the respectful consideration that is due them from a race of retarded civilization." [99]

Septima Clark and Mamie Fields, who attended these schools, remembered them as overcrowded and substandard. Clark described her white instructors at Shaw as generally "rather poor teachers; I soon hated the school, and thought little of them." Fields recalled that one of her teachers was from "Charleston's 'aristocratic' white families. . . . she couldn't stand the little black children she had to teach. She always walked with an old parasol, rain or shine, and she used that parasol to make sure you didn't come too near her." Edwina H. Whitlock, the niece of the portrait painter Edwin A. Harleston, explaining why he was sent to Avery, recounted, "As a pupil at the Simonton Public School, one day he proudly showed his sketch of a horse to his teacher. . . . 'How very nice, Edwin,' she said, 'maybe some day you'll grow up to become a hostler.'" His attendance at the public school ended when he reported the incident to his mother. Avery teachers, like Anna Hammond, also opposed the board's policy of employing the "daughters of ex-confederate soldiers and broken down aristocracy," who taught "simply for their pay" and showed "no interest" in their students after school hours. [100]

There were exceptions. Septima Clark fondly remembered her fifth-grade teacher, Miss Seabrooke, "an elderly woman" especially skillful in teaching arithmetic and geography. Joseph Irvine Hoffman, Jr., a physician who attended the Colored Industrial School before World War I, considered his teacher Miss Grimke "very good." She came "from really the old aristocrats" who "had lost everything." Hoffman, who was Catholic, remembered two Catholic instructors who befriended him, and a Jewish teacher as well. [101]

Many years later Peter Manigault of the *News and Courier* defended "the custom of using white teachers for Negro pupils." The precedent, set by northern abolitionist societies that "imported white women teachers," was maintained during and after Reconstruction "simply because qualified Negro teachers were not available in sufficient numbers." The only exception to this practice was the "two colored teachers" at Shaw in compliance with the 1874 transferral proviso. Manigault claimed that the policy, including

the apprenticing of inexperienced Memminger graduates in the black public schools, was not opposed by local blacks. "Negro citizens in the city," he claimed, "were fairly well satisfied with white teachers and did not present a formal request to the city board for teachers of their own race until January of 1919." [102]

Despite Manigault's assertion, formal complaints about the exclusion of black teachers were heard from the black community before 1919. In 1885 the pastors of five black churches protested, "It does seem unfair that after they have qualified themselves to become capable teachers, they should be shut out from the opportunity of instructing their own people, except in the poor country schools in which the compensation of the best does not exceed thirty-five dollars per month, and where the average length of the school year does not exceed four months!" Three years later William F. Holmes, an Averyite, pressed the Charleston school board to give blacks a chance to teach in its black public schools even if they might fail. He asked the board to undertake this experiment, which had worked in other cities of the New South, including "all of the leading towns of our State." [103]

However, the ideas held by whites about black teachers were hard to dispel. Colonel A. Coward, the state superintendent of education who hired Mortimer A. Warren to direct the 1886 summer institute for black teachers, counseled, "I do not think that the addition of a colored teacher is at all necessary, even as a matter of policy. The more intelligent and influential portion of the colored teachers know that few of their race have had the opportunity to 'dig deep' enough to enable them to teach authoritatively. Last year's observation convinced me that the skillful white teacher is followed by them with more faith and docility." Warren asserted that the guiding principle should be "not color, but character and worth," and enclosed with his reply an application from one of his former-black students, who, having completed one year of a medical course, wanted to teach physiology and anatomy at the institute. [104]

In 1901 Charleston County employed thirty-eight black teachers. Some of the black schools (for example, Fifteen Mile School) were named for their distance from the county government complex located in the city of Charleston on Meeting Street. The next year William Holmes supervised a Charleston County summer school for these black teachers. His assistant was Mary Deas Mancebo, who had graduated from Avery in 1886 as valedictorian and had taught there for many years. No matter how respectable and educated these black teachers had become, their racial descent prevented them from being employed in the city's black public schools. [105]

Given the sorry condition of Charleston's black public schools and an

antebellum tradition of private schools, many parents sent their children to the one- and two-room private schools that appeared after the Civil War and prior to World War I. These schools provided older black women a livelihood and Avery graduates a way of staying in the city. Some of the schools became permanent fixtures in the community with fixed fee schedules. A few held classes up through the eighth grade. In addition to Anna E. Izzard, the following teachers operated one-room schoolhouses: Catherine Winslow, Coming Street, next to Cannon; Ellen E. Sanders, Calhoun Street; Anna R. Macgrath, Society Street; Gustavus A. Sinkler, Anson Street; Claudia Smith; Susie Dart Butler, Dart Hall, Kracke Street; Mrs. Knuckles, Society Street; Miss English, Coming Street, near Cannon; Tattie, or Essie, McKinley, Calhoun Street; Miss Montgomery, Smith Street; Lydia Michael, Rutledge Street. Other schools existed on Line Street and Tradd Street. Most of these one- and two-room private schools, like Miss Winslow's and Mrs. Knuckles's, numbered between forty and fifty students, usually in the lower grades.[106]

Ellen Sanders's school at 188 Calhoun Street was the most permanent and best known. One of the longest-lasting, it consisted of students from grades one to eight. The students might have numbered as many as one hundred at one time. Sanders, born in Charleston, attended Simonton before she went to Avery. For a while, she taught at the bishop P. F. Stevens's school on Nassau Street. She operated her own school until around 1920, when she became one of the first black teachers admitted into the city's public school system. She taught at Buist until her retirement in 1945. During the evenings she was an instructor at the adult night school established by the city school board around 1926; she later held night classes in her own home to train young people to obtain better jobs. She also taught at Centenary Sunday school and gave private music lessons. The present Sanders-Clyde public elementary school at 805 Morrison Drive was named after her and fellow Averyite, Florence A. Clyde.[107]

Charleston authorities and Low Country conservative politicians staunchly defended the status quo because it provided blacks the "right kind of education." In defeating the Fortner bill, an attempt by the governor, Coleman Blease, to ban whites from teaching in black schools, private or public, one member of the Charleston County delegation asserted, "It has been found necessary for the preservation of communities where negroes outnumber the whites, to teach the negroes from the very beginning that they are inferior to whites. . . . if we should turn the teaching of negroes over to Yankee-educated negroes, nobody could predict the result."[108]

The increasingly hostile attitude of South Carolina politicians, including

Low Country legislators, toward blacks was encouraged by the presence of Woodrow Wilson, a southern-born Democrat, in the White House. In attempting to remove black Republican officeholders and to segregate more rigidly the federal service, Wilson applied what was already being done on the state and local levels in the South. For example, the year before his election, the Navy, averting an "Embarrassing Situation" at the Charleston Naval Shipyard, quickly transferred a new black male stenographer to its Philadelphia shipyard, because "the duties of the [Charleston] position required him to work in the same office with lady stenographers." James R. Logan escaped a similar fate, probably because his blueprint division was composed entirely of males.[109]

In 1915 when D. W. Griffith's *Birth of a Nation* made its debut in South Carolina, white residents throughout the state, academics and nonacademics, hailed the movie. D. D. Wallace, a Wofford College professor-historian, called it "stupendous." He concluded, "it is something that no American, certainly no Southern man or woman can afford not to see. I took the whole family except the baby, and if it comes along after she's big enough, I'll take her, too." A Charleston newspaper reviewer, after seeing the movie at the Academy of Music, described it as "remarkable." The epic, partly based on Wilson's *History of the American People*, was perceived by the president himself as "writing history with lightning." Edward A. Lawrence, expressing the growing fears and anxieties of black South Carolinians, denounced the film as "conceived with the purpose . . . of arraying one race of people against another, of breeding discord where there should be peace and harmony." [110]

The Color Line Within Charleston's Black Community

D. W. Griffith's parody of the former lieutenant governor, Alonzo J. Ransier, in *Birth of a Nation* symbolized the end of any three-tier system of race relations as the ideal. According to Mamie Garvin Fields, after the passage of the Jim Crow laws, some light-skinned persons "carried themselves like members of the community, and proud of it." The Brown Fellowship Society tried to change its image of exclusiveness by opening its doors to a wider constituency, including women, after the Civil War. In 1892 it changed its name to the Century Fellowship Society. (Only when faced with such legal complications as the selling of property purchased under the antebellum title, did it resume its old name.) As racial radicalism and the economic forces of World War I accelerated the fading of the color line and encouraged the light-skinned "antebellum aristocracy" to move toward a more solid alli-

ance with the rest of the black community, the leadership of this elite was challenged by newcomers. Reconciliation between the two and unification of the black community would be punctuated by much strife but would finally occur after World War I. In 1919 the black community and its leaders would be united enough to successfully confront white authorities over the issue of employing black teachers in the city's black public schools.[111]

For some observers, strict intrasegregation as well as stringent segregation existed in Charleston before World War I. According to Fields, the city "had two segregations. White people said, 'You're a nigger. You can't go to this place, and you can't wear that dress.' You were that 'nigger' no matter what complexion you were. Now, here come our black and our light colored people to discriminate again." Fields argued, "if we didn't have so much 'black' this and 'brown' that, 'mulatto,' and so forth we could have done more in Charleston. . . . But Charleston was a bad place for that color business, and our organizations often suffered from it."[112]

The "color business" was a statewide phenomenon, not unique to Charleston and the Low Country. It also caused friction among blacks in the "Up Country" counties of Abbeville and Greenwood. Conservative educational officials on the state, county, and local levels often fostered these color divisions. In 1901 when the superintendent of Horry, a coastal county, sought the help of J. J. McMahan, the state superintendent, to fill a position, McMahan contacted an Avery teacher, Mary Deas Mancebo. Complying with his written request, she wrote back, "All of our girls, whose ability would make them acceptable to you and whose complexion would please the fastidious patrons of that school in Horry, are now teaching." Mancebo, however, suggested Laura McFall, the sister of the pharmacist John McFall, because she would be needing employment soon. Unable to teach in the city, Laura McFall, an Avery valedictorian (1898) and postgraduate student with a first grade certificate, had found a teaching position on Kiawah Island, which became temporary as large numbers of her students moved with their families to Johns Island to follow a former employer. It is not known whether the Horry official communicated and reached an agreement with McFall. In 1906 she was working as an insurance clerk in Charleston.[113]

To what extent intrasegregation was practiced in the Charleston black community and its institutions is difficult to measure. The evidence is scarce, sometimes contradictory, often highly partisan and incomplete. Not always available are the perspectives of all the significant parties involved in an incident, particularly those accused of intrasegregation. Much of the evidence is anecdotal and difficult to verify. These anecdotes become part of the folk culture of the community as they are passed on from one generation

to the next. Anecdotes are used because, like parables, they are a concrete way to explain simply and quickly a complex situation. Couched in humor, they provide a palatable or safe way to deal with taboo subjects like miscegenation as well as to let off steam. Although it is difficult to trace or pinpoint exactly the lineages of these anecdotes, they tend to appear more frequently in times of crises. Although they are often historically inaccurate, sometimes shamefully so, they usually contain a germ of truth. Their purpose, however, is not to record historical events accurately but to preserve and pass on cultural or social attitudes and mores.

Perhaps no other institution in the Charleston black community has been the subject of more color anecdotes than St. Mark's Episcopal Church, much to the chagrin of its current members. They correctly point out that most denominations had certain churches, like Central Baptist, Mt. Zion AME, and Centenary Methodist, in which light-skinned persons predominated. Although the first parishioners of St. Mark's were largely free persons of color, pictures of the founders in the church office reveal that some were dark-skinned. St. Mark's demonstrates the planter-merchant elite's fostering of color and status divisions among Charleston blacks. Before the war, St. Philip's Episcopal Church admitted a handful of mostly light-skinned, free black families. It also helped establish Calvary Church as a separate mission parish for the slaves, who were predominantly dark-skinned, by 1849. After the Civil War, the split continued, with the free blacks worshipping at St. Mark's, and the former slaves at Calvary.[114]

Unlike some of the Caribbean islands, antebellum Charleston had no table of elaborate and minutely defined skin-color classifications. However, anecdotes associating St. Mark's with color categorizations emerged probably between the turn of the century and World War I when racial tensions were increasing. One folk story followed Charlestonians wherever they went until as late as 1946, when it was published: "It seems that there's an Episcopal church down there with its entrance panels painted a light shade of yellow. Anyone whose color matches the panel or is of a lighter hue passes on to the next barrier—a fine-tooth comb hanging from the door sill. If your hair passes through without any trouble you're the kind of person the congregation would welcome. Otherwise—why not try the OTHER Episcopal church [Calvary]."[115] A second anecdote has been preserved in Mamie Garvin Fields's memoirs. "Slaveowners founded St. Mark's as a place for their mulatto children," she wrote. "Some of them liked their half-white children, and some of the children inclined toward their fathers. So, acknowledging those children to a point, the white man built that church, and only half-whites went there for many years."[116]

Both anecdotes are historically misleading. No such entrance panel or tooth comb ever existed. St. Mark's could not have been founded by slave-owners for their favored "half-white children" because the church was not established until 1865. But both anecdotes vividly express a community dislike for the exclusiveness of some light-skinned antebellum free blacks and their progeny and, in dealing with the taboo subject of miscegenation, reveal a black-skinned chauvinism.

The emotional and anecdotal nature of the color line must be considered when on April 10, 1915, the Charleston *Messenger* published a stinging indictment of the established black leadership on this issue. The anonymous author, headlining the article "Charleston's Lost Opportunities: Charleston Messenger's High Critic Continues to Criticize and None Dares to Answer Him," was pressing an attack begun in his earlier piece, "Charleston's Shame." The critic preempted any charges of his being "some 'black nigger' . . . mad because he or she can not enter the upper stratum of the Negro aristocracy," by stating, "You have another guess coming." He found Charleston backward, a veritable "Sleepy Hollow," because "Here. . . . It matters not how ignorant or poor a person may be, if the color is there, it is alright. When will 'Sleepy Hollow' learn that character is the thing that counts and not the color of the skin and the texture of the hair?"[117]

The critic maintained that the "foolish color question" prevented black Charlestonians from capitalizing on "splendid opportunities" afforded them by the changing political situation. It prevented them from uniting behind Ben Tillman's 1890 proposal to ban white teachers from the city's black public schools. "The yellow Negroes did not want and would not have 'black niggers' to teach their children," the critic related. "The black Negroes did not [want] and would not have any 'yellow niggers' teaching their children." The two sides acted like "two dogs fighting for a bone. While they are tearing at each other's throats, a third dog comes up and takes the bone and carries it off without the least trouble." Such factional conflict enabled local white officials to continue their policy of employing white principals and teachers in the black public schools.[118]

Sometimes the split along color lines spilled into Republican politics. The conservative press encouraged the phenomenon. During his career as a state legislator and congressman, Thomas E. Miller, reputed to be one-sixty-fourth black, constantly found himself defending his light complexion to his predominantly darker-skinned constituents. The white press exacerbated tensions by calling Miller "Canary Bird." The label stuck to him; in 1954 the Charleston *News and Courier* referred to him as "Thomas E. (Canary) Miller."[119]

The *Messenger* critic also attributed the failure of some black businesses to the color problem. "They say that there is a certain store conducted by Negroes," he reported, "that if a dark person enters, no one cares to hasten to serve; and when service is rendered, it is done with such manifest displeasure that no self-respecting person would think of entering it again. When such a place fails, as fail it must, they say, lack of race pride." The black YMCA, YWCA, and churches received equally harsh criticism. Informed by the member of one church that the new minister "looked like Jesus, sitting in the pulpit," the writer discovered, "the minister was a light man." The opportunity to build a new YMCA building at the corner of St. Philip and Warren streets vanished because "certain persons can not be head and forefront" and "because the color line was being drawn by some of the members." The YWCA was doing "very little good" for the needy by holding meetings where "a few men and women who are fortunate to be up in the world" discussed "big matters."[120]

Though not specifically named, Avery was singled out for special criticism as an institution where "the distinction of color among Negroes has been taught and practiced since its organization." The writer qualified his charge, "Now, don't understand me to say that invidious distinction was taught by all the members of the faculty, or even in the class-room. . . . But it is a fact, none the less, that it has been instilled into the students from one generation to the other," engendering in them feelings of "hatred" for each other, and "widened the breach that education and refinement ought to heal." Northerners inadvertently fostered such feelings by raising questions like "What per cent. of your school is brown? Don't the browns receive instruction more readily than the blacks?" Attempting to end these inquiries once and for all, Amos Farnham conducted a color poll of the school in 1878, published in the *American Missionary: "Black,* 19; *brown,* 55; *fair,* 12."[121]

When the AMA executive board, responding to the pressure exerted by Blease's Fortner bill, decided in 1914 to turn over Avery to an all-black faculty, it voted to send a Talladega professor, William Pickens, to oversee the transaction. According to the Charleston *Messenger* critic, "There was consternation in certain quarters. A certain name [dark-skinned Pickens] was mentioned for the head of the said institution. More consternation. After a while, another one [the light-skinned Benjamin F. Cox] showed up. Great joy in certain quarters and now they say the machinery is running smoothly. However, we fail to see any material changes along certain lines." The historian James M. McPherson also believed that skin color was a major factor. According to him, the AMA official Lura Beam was referring to Pickens and Avery when she quoted a rejected candidate as saying, "I would really like

the job, but the truth is, I am too black. That crowd has never had a dark man and they would set out to break me, perhaps end by breaking up the school. It makes me lose my self-control to think about it, but the principal there has to look white for a good while." It is difficult to determine that Pickens made such a statement about Avery. Beam did not specify in her anecdote the date of the incident, the name of the rejected candidate, nor the institution. No evidence has yet been found to prove that Pickens wanted the job or visited Charleston for an interview.[122]

In his autobiography, Pickens did not mention skin color as a reason for *his rejection* of the Avery principalship. The white president of Talladega considered his activities with the Niagara movement and the NAACP as "radical." Because he continued his political pursuits, it was natural, he wrote, "that a desire should arise among those who controlled Talladega College to 'promote' me suddenly, by taking me out of my professorship there and sending me to the 'headmastership' of a minor school in another State, with an advance in pay. Only I preferred not to be so promoted, and taking a choice of my own I began in another college at a lower salary than what I had received when I started teaching ten years previously." Recalling his years at Talladega, Pickens wrote, "Because of the peculiar genius which has been developed in the white-and-black relationship in America, even the good, conscientious, missionary white people are likely to find a really straight-out, straight-up, manly and self-respecting Negro coworker *inconvenient* at times, to say the least." Apparently, some of the Averyites, like Pickens, balked at what they considered a unilateral action by the AMA home office. This example of AMA politics and heavy-handed paternalism shows how easy it is to reduce a complex problem into one focusing principally on the color line.[123]

Ironically, though the so-called High Critic of the Charleston *Messenger* took Avery to task for fostering the color line, the school was part of a process that was, in fact, eroding such antebellum divisions as freeborn versus slave and light-skinned versus dark-skinned which had survived the Civil War. Striving to create an atmosphere where the social uplift philosophy worked and emphasizing service, this AMA school mitigated blatantly exclusive tendencies in its students, including the progeny of the antebellum "free brown" elite. Mamie Fields affectionately remembered Sallie O. Cruikshank, who belonged to the Brown Fellowship Society, as one of the two colored teachers she had at Shaw. "Not only was she a good teacher," Fields recalled, "but she was a nice woman, very gentle with the children, and she would often have us come over to her house. We were fond of Miss Cruikshank."[124]

Morrison Holmes noted in 1900 that despite the lapse of more than a

third of a century, "an aristocracy of color" still existed at the school with the "freeborn" dominating the higher grades. However much Avery might have been a preserve of the antebellum free upper class, it also drew the descendants of slaves and of the less affluent free black families. The first barrier to erode was that between the antebellum free brown and free dark elites. The progeny of Thomas Small, one of the founders and treasurer of the Humane Brotherhood, attended Avery and married into the antebellum free brown elite. The case was the same for Edward Mickey, another founder of the Humane Brotherhood. His offspring married into the Harleston and Crum families.[125]

Avery came to offer the offspring of slaves, usually house servants, upward mobility. Septima Poinsette Clark's father, Peter Porcher Poinsette, had been a slave valet to his master's son on the plantation of the Joel Poinsett family and had served in the Confederate army. After the war, he catered some of the St. Cecilia Society balls. Septima Clark had a very successful stay at Avery. The secretary of the King's Daughters and vice-president of her senior class, she also was assistant editor of the school yearbook, played center position on the girls' basketball team, and sang in the glee club. Some time after graduation, she returned to Avery as a teacher. Mamie Fields's brother Herbert Garvin, who was as dark-skinned as she, enjoyed a good social life at the school. He was much in demand because, as she explained, "the 'white' colored girls didn't mind going to a party with a black boy from a respectable family."[126]

As these slave offspring married the children of free persons of color, antebellum freeborn status grew to mean less. This probably occurred first between the free brown elite and the light-skinned children of the slave elite. Julia Craft DeCosta (Avery, 1915) was descended from William and Ellen Craft, the famous Georgia fugitive slaves. Also related to William D. Crum, she traced her lineage to the Kinlaws (Kinlochs), a Scottish family. She married a fellow Averyite, Herbert A. DeCosta, Sr., despite the misgivings of some of his relatives over the antebellum slave status of the Craft family. Herbert, born in Charleston in 1894, inherited his father's contracting business in 1918. Specializing in restoring historic Charleston buildings, he was praised by the *News and Courier* as knowing "precisely how to get along with clients and employ[e]s." On the vestry of St. Mark's, this wealthy contractor symbolized black Charleston's old aristocracy.[127]

That such a sweeping indictment of the city's black leadership should appear in the Charleston *Messenger* during 1915 was hardly surprising. Anecdotal in nature, the article was a classic piece of muckraking. It was part

of a series called "Charleston's Shame," a title echoing Lincoln Steffens's *Shame of the Cities*. This specific piece in the series resembled "Following the Color Line," a collection of articles written eight years earlier by the muck-raking journalist Ray Stannard Baker, who popularized the phrase "color line." Like some muckrakers, the "High Critic" was indiscriminate in his assault. He ignored those members of the established elite, like John L. Dart and William D. Crum, who held an interpretation of the social uplift phi-losophy which extended to the wider black community. Moreover, although Charleston, compared with Atlanta and the other cities visited by the "High Critic," was a kind of "Sleepy Hollow," it was finally embarking on economic changes, engendered by World War I, which would produce a challenge to its traditional black leadership.[128]

The immediate challenge to the old leadership came in the person of Daniel J. Jenkins, the publisher and editor of the Charleston *Messenger*. Jenkins was the first dark-skinned former slave and non-Charlestonian to become a leader of primary stature in the Low Country seaport since Recon-struction. Ironically, the Baptist minister, successful in obtaining financial assistance from municipal authorities for his orphanage and farm facilities (reformatory), would fill the vacuum created when John L. Dart, a member of the old elite, retired in 1913 because of ill health. Jenkins, born at Beaufort Bridge in Barnwell County on April 1, 1865, arrived in the Charleston Neck area around 1885. He started a successful lumber business and eventually became pastor of Charleston's New Tabernacle Fourth Baptist Church. The black preacher carefully cultivated support for his enterprises among the city's white elite. Municipal officials preferred sending black youth offend-ers to him rather than putting them up in the city jail at taxpayers' expense. Jenkins augmented municipal subsidies with money raised by the orphan-age brass bands, which played for tourists on Charleston streets. The bands eventually toured all over the United States and in 1895 one traveled with Jenkins to England. Some of their members became noted musicians. By the time of Jenkins's death in 1937, five thousand young blacks had passed through his orphanage or lived on the farm facilities.[129]

Jenkins's organ, the Charleston *Messenger*, became a leading proponent of black pride. On January 7, 1911, the weekly hailed the Emancipation Day speaker, Julius L. Mitchell, as "a Full Blooded Negro Orator of No Mean Ability." The black lawyer described Jenkins as "a man . . . who has done more for the people than anyone of this state." Jenkins's continuing strong support of Booker T. Washington may account for some of the antagonism that developed between him and the city's light-skinned elite, which was

moving in the direction of W. E. B. Du Bois. When Du Bois visited Charleston in March 1917, he was photographed with a group of the city's black leaders, including several Averyites. Jenkins was absent from the picture.[130]

The *Messenger*'s warm support of Mitchell, who had attended Avery, suggested that the gulf between Jenkins and the old elite was hardly insurmountable. Jenkins also considered culture and refinement necessary elements of self-improvement and racial uplift. His pilgrimage to Europe with the orphanage band was, in fact, an exercise in cultural progress. Jenkins saw to it that his own children were refined and cultured; he did not encourage them to mix with the orphans. Besides sending his offspring to Avery, he employed Averyites. For instance, Eloise C. Harleston, the daughter of Edwin G. Harleston, worked in his front office. Eventually, she became his second wife, their marriage uniting the Harleston and Jenkins families. When her brother Edwin A. Harleston organized a Charleston branch of the NAACP, she, rather than Jenkins, became a charter member.[131]

Another dark-skinned newcomer was Arthur J. H. Clement, Sr., the grandson of slaves. Born in 1879 in Rowan County, North Carolina, Clement attended its public schools and obtained his bachelor's degree from Biddle University, at Charlotte. In February 1907 he moved to Charleston as district superintendent for North Carolina Mutual Life Insurance Company. By 1919 he employed fifteen agents and owned a retail business at the corner of Cannon and Coming streets. Clement became president of the local black YMCA during the late 1910s. Under his leadership, the factionalism along color lines was overcome and the Charleston branch became more responsive to the needs of a wider black community. Clement also served as an Avery trustee and a legal adviser for the local NAACP in the 1930s.[132]

Soon after Clement arrived in Charleston, he hired as a clerk Sadie K. Jones, a former public school teacher who graduated from Avery in 1891. Her mother was a seamstress for an affluent white family. The young couple married in 1908 and had three children, who attended the local one- and two-room private schools before they went to Avery. The oldest son, Clement, Jr., after graduating from Johnson C. Smith University in Charlotte, North Carolina, eventually took over the family business as district manager for North Carolina Mutual. He married an Averyite, Irma Robinson (1926), and they sent their two children to the AMA school. Clement, Jr., served as the first chairman of the Avery Administrative Council, which replaced the board of trustees in the 1940s. He also became an NAACP leader. The Clement family, like the Jenkins family, illustrated that the established elite assimilated newcomers, even those who seemed to challenge its leadership, and consequently became less exclusive.[133]

Culture became the vehicle that would help unite the leadership. Even Charleston's "High Critic" agreed that one goal of education was "refinement," and that education would serve to unite the community. The process was best seen in the person of James R. Logan. Having close ties with Jenkins, he served as the associate news editor of the Charleston *Messenger*. Like Jenkins, he was a supporter of Booker T. Washington; he kept in his scrapbook articles critical of Du Bois. On the other hand, Logan's love of culture also drew him toward Avery, where his sister Anna graduated in 1906 to become a teacher.[134]

James Logan along with many Averyites envisioned culture, especially music, as a way of bringing Charleston's diverse groups together. In 1912 Logan's Concert Orchestra performed a program consisting of "works of Colored Authors and Composers, including Coleridge Taylor, William Tyers, Rosamond Johnson, and Paul Lawrence Dunbar." The Aurorean Coterie gave a similar concert three years later. Its trio (comprising J. Donovan Moore at the piano; Logan's cousin, the doctor W. H. Miller on the clarinet; and Logan on the violin) was joined by a choral group made up of a number of Averyites. Lester A. Walton of the New York *Age*, hailing the event, declared, "just such organizations . . . have a great mission to perform, for they are developing within us the most-needed of all things—RACE CONSCIOUSNESS." The reporter concluded, "A more fertile field to plant the seeds of race consciousness could not have been found than in Charleston, S.C., where some years ago, the fires of color prejudice and caste burned fiercely among the Negroes themselves. . . . these fires have not been entirely extinguished, and are said to be faintly burning this very day." Logan included Walton's review of the concert in his scrapbook, along with the "High Critic's" article published just eight months earlier.[135]

These cultural attempts to bridge the color chasm were helped by demographic changes. The so-called mulatto population was on the decline. By 1918 whites were no longer appreciably adding to this pool. The Jim Crow laws encouraged many fair-skinned blacks, even whole families, to migrate north in search of greater economic opportunity and security. There, many passed for white. As the mulatto population began intermarrying with the rest of the black population, so-called mixed-blood inevitably increased. A federal census expert reported that by 1910 three-quarters of the nation's black population were probably of "mixed-blood." It was inevitable that Charleston, with a large mulatto population, would see many of its black families acquire "mixed-blood" characteristics. Mamie Fields remembered the "basketful of different skin colors and eyes, different types of hair" that appeared in her family and others. She concluded, "If you looked white, your

sister might not. Now, what were you going to do in Charleston? The consequence of all this mixture was that some community gatherings you could attend years ago would make you think that Charleston was already a desegregated city." This demographic trend and the efforts of organizations like the Aurorean Coterie prepared the way for the Avery principal Benjamin F. Cox to turn the school into an all-black institution.[136]

4

The Cox Era, 1914–1936

The social uplift philosophy continued to permeate Avery under the tenure of Benjamin F. Cox, the first permanent black principal since Francis L. Cardozo. Cox tried to mold his students into cultured, learned, and responsive citizens, who would involve themselves in the community and serve as examples. To achieve this goal, he had to help the students overcome the legacy of antebellum divisions within the black community. His success in "dismantling" this legacy manifested itself in the relatively smooth transition Avery underwent as the white teachers were phased out and the school became an all-black institution. Cox's achievements rested on his and his wife, Jeannette's, combined efforts to create an environment of learning and culture which encouraged the students and faculty to transcend the prescribed and sometimes divisive social lines of their neighborhood circles. Culturally related activities, such as rhetorical presentations, dramatics, and music, instilled in the young people a knowledge of their heritage as well as a sincere love of culture and learning.

Under Cox, Avery experienced the most important changes in its history since Radical Reconstruction. Besides overseeing the transition of the school into an all-black institution, he upgraded it physically and academically and contained the growing rift between the home office and alumni. Cox found himself in a delicate situation. Alumni, parents, and friends wanted Avery to continue as a college preparatory and normal institute or be upgraded into a college. The AMA, however, wanted to withdraw from urban black secondary education so it could concentrate its activities in rural areas. Moreover, it always cherished the belief that the various state, county, or municipal authorities would subsume the AMA schools and operate them as part of the public educational system. Failing to turn over Avery to municipal authorities, the home office envisioned relocating it on the outskirts of Charleston,

where it would become an industrial normal school serving the needs of rural blacks. The ensuing dispute almost led to the school's termination, save for the persevering determination of local blacks to keep it open and Cox's ability to manipulate the home office. In the process, he managed to achieve a good deal of independence from the AMA in the operation of the school.

Cox's principalship coincided with a new political activism among the city's black leadership. Racial radicalism, revealing the limits of southern white paternalism, nurtured among blacks a growing sense of solidarity. The self-help philosophy was in danger of becoming irrelevant without collective activism to force white authorities to accommodate the black community on certain issues commonly espoused by them, such as better public education. In 1917 a group of local black leaders, largely Averyites, established a Charleston branch of the NAACP. Their most successful campaign was bringing black teachers into the city's black public schools. During this period the black community made other gains in public education. Buist Elementary School opened in 1921. The city school board began making concessions in upgrading the Charleston Colored Industrial School (to be renamed Burke). Ironically, as black Charlestonians were striding toward racial solidarity and collective activism, the divisive color line became a pressing national problem as thousands of southern rural blacks, spurred by deteriorating conditions and the economic effects of World War I, migrated north.

The Consensus

By the 1910s the AMA had taken on the trappings of a big business with investments totaling over $8 million. Nevertheless, the core of its ideology had remained intact, still resting on a religious interpretation of history and faith in American democracy. In 1923 the AMA secretary, Fred L. Brownlee, remarked, "In less than a century, an enslaved race, ministered to by such agencies as the A.M.A., has passed from barbarism to a race of noble, cultured, intelligent Christian men and women." Although most Averyites would have resented characterization of their relatives as barbarians, they shared the belief in race progress. Brownlee, describing the AMA's past efforts as "preferred dividends" and "investments" now bearing fruit, cited the dramatic increase in the number of blacks owning their homes and operating businesses. He commended blacks for their "distinctive contributions"

to American life, which also yielded dividends by "doing much to dispel the erroneous idea held by not a few white people as to the limited capacities of Negroes."[1]

Although AMA officials continued to hope for the conversion of the entire white South, whites' racial radicalism forced them to develop a more realistic analysis. In 1920 a writer for the *American Missionary* acknowledged the existence of a class "of the white South, in which intensified race prejudice is carried over with positive hostility." This group "is contemptuous —as well as contemptible—and has such leaders as Tillman and Vardaman and the Reverend! author of the 'Birth of a Nation.' From this class, the mobs and lynchers with their murders and burnings are chiefly recruited, and the very name of humanity defamed. This class . . . is not large relatively, but it depends upon the inaction—if not indifference—of the great majority." AMA officials, patiently optimistic, believed that through continued efforts, particularly focusing on interracial projects to reach and enlighten the "great majority," the spirit of "better-minded" white southerners would prevail and "the wall of race prejudice," bolstering a "cruel disregard" of civil and human rights, would crumble.[2]

The AMA's chief operatives in Charleston were Benjamin and Jeannette Cox. Educated, cultured, and service-oriented, they represented the AMA ideal. Products and proponents of the AMA educational system, they were living embodiments of the Christian uplift philosophy. Born in Columbus, Mississippi, Benjamin F. Cox knew little about his parents. It was "whispered" that his father was a German-Jewish merchant. His mother, a seamstress, died when he was young. A Fisk recruiter discovered Cox singing at a church meeting; this led to his entering the school as an eighth grader. Joining the Fisk Jubilee Singers, Cox remained at the school for eight years. Graduating with a B.S., he pursued a career in education with the AMA. In 1897 he was appointed assistant principal at Albany Normal School in Georgia. He moved to Florence, Alabama, in 1903 to supervise Burrell Normal School but returned soon thereafter to Albany to be principal for about eight years. In 1914 he took charge of Avery.[3]

Jeannette Cox was the daughter of Samson Wesley Keeble, a barber in Nashville, Tennessee. Her mother, Rebecca Gordon Keeble, was a seamstress. Studying law on his own, Samson Keeble passed the state bar exams and became the first black member of the Tennessee legislature. When he died, his wife sewed to support herself and the two children. Living on the block next to Fisk, Jeannette was grateful for the cultural and intellectual opportunities the school offered her. After graduating, she pursued a teaching career with the AMA. In 1896 she was employed at Brick School in

North Carolina. For a brief interim she taught at Albany. Marrying Benjamin Cox when she was at Brick, she joined him at Burrell in 1904. She was matron of the teachers' homes at Albany and Avery.[4]

Within the tradition of the AMA ideology, Cox sought to win the support of sympathetic and powerful white Charlestonians, who, ideally, would enlist their friends, and perhaps the larger white community, in the AMA cause. Consequently, local dignitaries, including the Mayors John P. Grace and T. T. Hyde, spoke at these events often held at Morris Brown AME or Morris Street Baptist Church. Cox also cultivated the friendship of white ministers such as George E. Paddack, the pastor of Circular Congregational Church. In 1925 Paddack praised Cox as "a man whose culture and personality impress all who come to know him." Cox, after addressing the White Ministers' Union in 1926, reported to the AMA home office, "One of the most gratifying signs of progress is the interest which our white neighbors are taking in the work of Avery Institute. The light is breaking through clouds of indifference and isolation which have been our portion during the years."[5]

As principal of Avery, Cox took advantage of opportunities for interracial contact through meetings, organizations, and cultural or educational activities. He soon set the tone of his administration by attending the annual Shakespeare performances at exclusive Ashley Hall, a local private school for white women. In 1928 a joint meeting of the white and black ministerial unions was held at Avery during Easter week. Also that year, Avery sponsored a concert at the Academy of Music on behalf of the Charleston Interracial Committee, a branch of the Commission on Interracial Cooperation (CIC). The next year Avery's chorus was asked to join white groups in a program at the Citadel. "Mr. Cox was asked to make a few remarks," the AMA reported, "probably the first remarks ever made by a colored man to the students from the Citadel's platform." In 1930 Charleston's white philharmonic orchestra played a benefit concert for Avery on its campus. "This great event has marked a new era in the interracial program of this city," a state black newspaper proclaimed, "and the writing of a new historic event of this great leadership of Prof. B. F. Cox."[6]

The CIC demonstrated the success and limitations of these interracial endeavors to foster "understanding between the races." It was a national organization or movement that developed after the nationwide riots of 1919. That year Charleston experienced an ugly series of incidents between white enlisted men and local blacks. Naval investigators described the entire episode as "a spontaneous outburst, the like of which has occurred throughout the country." The CIC was designed so that whites and blacks could join and try to reach a "meeting of minds" on mutual problems. Local committees sprang up throughout the South.[7]

The Charleston Interracial Committee was organized during the 1920s under the auspices of the YWCA. Avery people, including Edwin A. Harleston, an undertaker and artist; A. J. Clement, Sr., an insurance executive; and C. S. Ledbetter, the Plymouth pastor, participated. However, the local chapter was dominated by white paternalists like Clelia P. McGowan. Born in Columbia, South Carolina, on January 30, 1865, just before its burning, Clelia P. (Mathewes) McGowan spent her early years in north Georgia. She married William C. McGowan of Abbeville, South Carolina. Her father-in-law was a Confederate general, Samuel McGowan. In 1919 the governor appointed Clelia McGowan to the state board of education, on which she served for seven years. The appointment made her the first South Carolina woman to hold such a position of public service. A staunch supporter of women's suffrage, she became Charleston's first female alderman in the 1920s. Despite her goodwill and intentions, she embodied the aristocratic ethos of the local white elite. "Stately, she wore her elegant suits and dresses," Mamie Garvin Fields recalled. "She talked slowly and softly. 'Now, we must be friends,' says Mrs. McGowan, 'and we must all work together in the community.'"[8]

Given that the white members were paternalists with no intention of overturning white supremacy, most of the committee's activities were usually cosmetic, if occasionally helpful. When the whites and blacks gathered together, the whites sat on one side of the room, the blacks on the other. The black contingent was divided into two groups, one for men and another for women. Not until 1931 did the black men and women meet together. State black leaders, not discouraged by these limitations, viewed the organization as a vehicle for "getting the white man to really know the Negro."[9]

Many of the activities sponsored by the Charleston Interracial Committee were related to education. Its most important annual event was Race Relations Sunday, held in February, the month of Abraham Lincoln's birthday. The committee proved a nuisance to some members of the city's board of school commissioners. In 1927 the board denied the group's request to allow white pupils to participate with black pupils in an essay contest on the topic "Negro progress since the Civil War." In 1932, twelve years after black teachers and principals were allowed in the local black public schools, James Andrew Simmons, an Averyite who supervised Simonton Elementary School, provoked an investigation by the board after some whites in the audience on Race Relations Sunday accused him of advocating social equality.[10]

Some committee endeavors yielded "dividends." In 1925 the group successfully petitioned the city school board to establish a night school for blacks between the ages of fourteen and eighteen years. At the same time

it persuaded the board to hire a truant officer to enforce the city's compulsory school attendance law in the black community. The more successful activities of the committee were those begun by the blacks themselves. For instance, the pioneering efforts of Susan ("Susie") Dart Butler to establish and maintain a private library for the black community evolved into an effective committee campaign to obtain a city public library system, funded by the Julius Rosenwald Foundation. In 1931 the blacks, better organized than the whites, opened their branch at Dart Hall first.[11]

The "spirit of service" motivating Avery graduates and former students active in the interracial committee was attributed by Benjamin Cox to "the strong Christian influences brought to bear" at the school by its "consecrated" teachers. Cox was determined to continue this tradition at Avery. Realizing that classroom lessons alone could not effectively inculcate the social uplift philosophy in the students, he instituted weekly mandatory chapel meetings. Sometimes he cut short his regular mathematic lectures to deliver impromptu remarks on good decorum, manners, and other matters which, he felt, could not be learned from books. He considered these informal sessions, the weekly assemblies and school organizations, such as the King's Daughters, important in giving "the student in concrete form an idea of the larger and more comprehensive service which he must give the world as he goes out into it." The mandatory chapel assemblies were Cox's most effective means of proselytizing. With the teaching staff sitting behind him, he would review the work of the past week, and "take up punctuality, obedience, industry, truth, etc., according to the needs of the hour." Sometimes he would dramatize those traits, such as loudness and gum chewing, which he found particularly loathsome in some of the students. To reinforce his preaching, Cox invited prominent visitors to address the student body at these assemblies. According to L. Howard Bennett, Cox found a way to seduce "any distinguished visitor that came to town, white or black." Sometimes this meant speeches by such important AMA officials as George White. At other times George Washington Carver, W. E. B. Du Bois, Langston Hughes, Charles S. Johnson, Walter White, and other nationally known blacks inspired the students. Thomas E. Miller, former congressman and president of South Carolina State College, talked to the students about Reconstruction. James Andrew Simmons and other successful Avery graduates also addressed them.[12]

Cox's weekly chapel sermons and impromptu classroom lectures demonstrated the intertwining of the "spirit of service" with manners, culture, education, and the Protestant ethic in the matrix of social uplift. In his impromptu classroom lectures, Cox reminded the students, "Your conduct

reflects your home, your school, and your church." He encouraged them to enjoy themselves at public events, but not to "get boisterous, act ugly so that people will label you and your school, your home, and your church by those actions." His presence at public events was enough to dissuade any attending Avery student from acting in a discourteous or unruly manner. Cox was also a stickler for punctuality. Those students arriving at school after the 8:30 A.M. bell often found themselves locked out. Only two exceptions were made. Students who had to take the ferry to get to the city from Mt. Pleasant were exempted, and on rainy days, those who walked to school from Marysville were excused.[13]

Throughout his principalship, Cox worked to produce Averyites whose lives would be testimonials to the social uplift philosophy. Leroy F. Anderson, a 1935 graduate, recalled that Cox's favorite phrase was "noblesse oblige," which the black principal defined to mean "if you had a better experience than others, go back and help them." Anderson described Cox as a "very warm, lovable man. . . . Wanted the best, to really stretch yourself to the limit. . . . Made us stretch ourselves to be something better than we might have been." Other former Avery students, reminiscing in the 1980s about their school, confirmed that Cox was loved as well as successful in inculcating the social uplift philosophy: "Just a fine person. He knew how to handle you. . . . a psychologist and he did a whole lot, he and his wife, to . . . bring culture to these kids"; "a splendid man, encouraged young people to excel"; "very fine man . . . interested in educating kids and keeping a high . . . standard there during the whole time"; "gave us a new culture, wanted us to throw ourselves into the community"; "excellent teacher, remarkable man, set a tone in this town for excellence in scholarship"; "true cultured gentleman . . . knew how to implant his . . . superior values." One teacher remembered Cox as "a good disciplinarian," who "had presence" and was at the same time "likeable—a nice person." Another described him as "the perfect administrator for that time."[14]

Under Cox history, music, literature, and declamation continued to be essential elements in instilling culture and building character. Many of the activities he instituted or expanded reflected an educational philosophy that focused on learning by doing. The five senses as well as the intellect were to be aroused. Cox stirred the intellectual curiosity of the students by decorating the chapel (Avery Hall) with replicas of artifacts from the classical era (pictures of the Forum and Coliseum, busts). To stimulate their interest in music, he played operas on the Victrola, which the students had helped purchase for the school through voluntary nickel and dime contributions. Cox created at Avery the ambience of a fine small liberal arts college. "It

was more like a college than a high school," a 1918 graduate recalled. Cox was successful in his endeavors because he was reinforcing values instilled in the students by their parents. He knew he was appealing to an antebellum tradition, "something that began before Avery began but which Avery has been largely instrumental in bringing to fruition." [15]

Music, especially vocal, flourished at the school. "Visitors have been astonished," the school newspaper boasted in 1931, "at the whole hearted fervent singing of the student body as well as the difficulty of the choruses successfully attempted." The repertoire ranged from spirituals to Handel's "Hallelujah Chorus" and Gounod's "Sanctus." Cox made the singing of the "Hallelujah Chorus" at the commencement excercises an Avery tradition, probably influenced by his days at Fisk. The role music played at the school demonstrated how he and his teachers were building on an already established foundation. Parents nurtured in their children a love for music by sending them to cultured, educated musicians such as J. Donovan Moore and James R. Logan for private lessons. This interest was further cultivated by those teachers who were Fisk graduates and brought with them their alma mater's excellence in and enthusiasm for music. Maude H. Smith's career reflected such influences. She began her musical training as a pupil of J. Donovan Moore. After graduating from Avery in 1915, she continued her musical studies at Fisk. Around 1922 Smith returned to Avery to take charge of its music program, including the Girls' Glee Club. She composed the music while another Averyite, Beulah Schecut (1928), wrote the words for the school song. Maude Smith's male counterpart on the faculty during the 1930s was John W. Whittaker, Jr. Besides teaching English and French, he fostered his pupils' musical interests. A talented pianist and arranger and an accomplished singer, Whittaker invited selected students to the teachers' home to hear him play jazz. Like Cox, he had been a member of Fisk's internationally famous Jubilee Singers. In 1932 under his direction the Avery octette performed on a local radio station.[16]

Drama took on new importance at Avery. At the chapel assemblies, Cox encouraged an interest in Shakespeare. Impressed by a student presentation at Ashley Hall, he began in 1917 the Avery tradition of having the senior class annually perform Shakespeare. That year the students put on *As You Like It*. In 1932 the senior class presented *The Merchant of Venice*. Under the direction of the eighth-grade teacher Edna P. Morrison, the repertoire of student dramatics expanded to include such comedies as *The District Attorney*. By 1932 the school boasted a dramatic club having the very capable supervision of Margaret Lucille Rutland Poinsette. Working with a limited budget, she managed to turn the small confines of Avery Hall into believable sets for her

productions, including *Children of the Moon, Smilin' Through, Double Door, Wuthering Heights, Marcheta, Daddy Long Legs,* and *The Importance of Being Earnest.* For Poinsette, drama built character.[17]

Declamation especially served as a vehicle to shape character and reinforce classroom lessons. The students built on what they had learned in their literature, history, and other classes to prepare their declamation or rhetorical exercises, which they usually performed in Avery Hall. Speech contests were held annually, frequently in the evenings for the public to attend. In 1936 the topics for the boys' contest included "the death of Benedict Arnold," "Spartacus to the gladiators at Capua," "speech before the Paris Anti-Slavery Conference," "the prohibition speech of 1888," and "the character of Napoleon Bonaparte." On Friday morning pupils in grades nine through twelve delivered their rhetorical exercises to the student body and faculty assembled in Avery Hall. More than a half century later, alumni still vividly recall the experience with some trepidation and a good deal of relish. At a usual assembly, eight presentations were given, each lasting several minutes. "The rhetoricals gave all the children of the high school," Sarah Green Oglesby (1918) explained, "a chance to show their art of communicating with people, to interpret, and it was beautiful." The freshmen recited poetry, the sophomores read prose, and the juniors concentrated on the great works. Every senior had to deliver a speech on a topic researched in consultation with his or her English teacher. J. Michael Graves, a 1932 graduate, remembered reading Julius Caesar as a freshman; his senior year rhetorical dealt with "Negro art in its natural setting." Oglesby recalled interpreting one of Paul Lawrence Dunbar's works. Anna DeWees Kelly (1932) still remembers how she had the delicious pleasure of correcting Benjamin Cox, who thought she had cited the wrong name for Gandhi. She reminded the principal that "Mahatma" was not Gandhi's real name, only his title. Between the presentations, other students sang or played instrumental music. The rhetoricals, fostering a sense of self-confidence and expertise in the students, were serious affairs. No student could graduate without completing them. Leroy Anderson recalled that he had to return to Avery after his graduation ceremony to complete his rhetoricals before he was given his diploma. The penultimate achievement for an Avery senior was not only to complete the rhetoricals but to be chosen a speaker for the commencement exercises. The titles of these commencement speeches mirrored the times: "The Colored Soldiers" (1918), "Woman's Place in the World War" (1919), "Woman Suffrage" (1920), "The Purpose of Disarmament" (1922), "The Problem of the City" (1925), "Has Prohibition Failed?" (1928), "Some Factors Contributing to the Present Economic Depression in the United States"

(1930), "The Application of the Big Brother Policy in Haiti" (1930), "The Negro and Communism" (1934), "Must There Be Another War" (1935).[18]

Physical culture was still considered important in developing well-rounded, self-disciplined individuals. Besides gymnastics, this included team sports, introduced during Cox's tenure. The organizing of a women's, as well as a men's, basketball team and later a football team showed how Cox and his faculty responded to and built upon the interests of the students. It also demonstrated that Cox's success in the expansion and development of the Avery curriculum was supported by alumni and friends. In 1914 A. W. Murrell, who taught physics, chemistry, and manual training at the school, began playing basketball with several of the male students. Noting their enthusiasm, an Avery alumnus, Robert F. Morrison, persuaded Cox to field a men's basketball team in 1915. Shortly thereafter a women's basketball team was formed. Avery competed with other black educational institutions throughout the state, and within five years the men's team won the state championship. Morrison was also instrumental in bringing football to Avery. In 1923, when visiting Jacksonville, Florida, he was so impressed by a game he witnessed between the local high school and another from Savannah, Georgia, that he proposed that Avery start a football team. He argued that this sport activity, like basketball, would bolster the school's male enrollment. He enlisted the financial support of two other alumni, E. B. Burroughs, Jr., the doctor, and E. L. Hern, a pharmacist. In 1932, eight years after the school fielded a football team, Cox boasted in the annual AMA report, "Our athletic program has been one of the means of encouraging young men to enter school and of keeping them in school. We have winning football and basketball teams the entire year. Avery is one of the few schools in which the enrollment of boys about equals that of the girls and because of this very largely, with one exception, Avery's high school enrollment more than doubles the high school enrollment of any of the A.M.A. schools."[19]

Jeannette Cox's efforts reinforced those of her husband, though she usually worked behind the scenes—"the power behind him," as one Averyite noted. The students also remember her as an "extraordinary person" and "a lady," "a very dignified" and "Christian upstanding lady." A woman graduate recalled, "Mrs. Cox was like a mother at the school. I could tell her any problem that I had and she was never one to make spot decisions." She scheduled regular conferences with women students to discuss good decorum and proper conduct. "I would put her in a class of a counselor that we have today," a 1924 graduate recently explained. "Mrs. Cox would gather the girls together and she would give them lectures on how they must act and dress and conduct themselves in the classroom and out." She would say,

"you want their [the young men's] respect so don't let them fondle you. . . . always be a lady . . . and they will respect you then when they're ready to pick a wife. . . . they're not going to pick the type of girl that they can do [with] as they choose." The young women were also instructed on how to set a dining room table.[20]

Besides counseling the women students, Cox was "a cultural developer. . . . quite capable in many fields." She founded the Phyllis Wheatley Literary and Social Club at Avery and became the group's historian. In December 1916 she met with a few friends at the teachers home to lay the groundwork for the organization. The number of members was limited to twenty. About half of the nineteen charter members were Averyites. Almost all the women on the Avery faculty were charter members, including Florence A. Clyde, Hattie L. Green, Lulu W. DeMond, Serena Hamilton, Edna P. Morrison, and Esther Spencer. The ladies supported the school's library and fund drives. They annually awarded the Phyllis Wheatley English Prize to a promising student at the school. In 1925 the club became part of Avery when the school was reincorporated.[21]

Like its nineteenth-century male predecessors, the Phyllis Wheatley sought cultural self-improvement, whereby its members made themselves more useful and respectable citizens. Self-improvement activities included the development of self-governing skills. Sponsoring cultural, fund-raising, and other community events helped these women develop their organizational and leadership abilities as well as their self-confidence. The club invited black artists, musicians, and intellectuals to appear as guests or sponsored them at citywide programs. One of these guests was William Sanford Lawrence, an Avery graduate and former pupil of J. Donovan Moore. Lawrence studied at the New England Conservatory of Music and became the accompanist of Roland W. Hayes, the noted tenor. The two men performed in Charleston on February 28, 1916, at Morris Street Baptist Church. Lawrence's first cousin, Edwin A. Harleston, whose wife was a club member, strongly supported its cultural activities. He participated in its production of Oscar Wilde's *Lady Windermere's Fan* performed at South Carolina State College in July 1922. Besides presenting plays, the women reviewed books, delivered papers, and engaged in spirited debates. Their feminism revealed itself in some of the topics of papers and debates. During the first year of the club's existence, one member presented a report dealing with "the first Congress woman, Miss Rankin," and another, on vivisection. In 1927 the members decided in a debate "that married women may have careers." At the same time, these women upheld a somewhat Victorian attitude toward life, which colored Jeannette Cox's historical account of the

club. In 1922 the women declined to present Oscar Wilde's *Salome* because of "the inappropriateness of the text."[22]

The Phyllis Wheatley was affiliated with the National Federation of Colored Women's Clubs. The Charleston City Federation was organized in Centenary Church in the spring of 1916. Jeannette Cox was chosen its first delegate to the annual conference of the state federation. On February 13, 1917, the Phyllis Wheatley joined the Charleston City Federation and remained an active member. Subscribing to the motto of the National Federation, "Lifting as we climb," the Phyllis Wheatley supported various community organizations, including the Red Cross, YWCA, Charleston Hospital and Training School, and Jenkins Orphanage. In 1929, at the request of the Charleston Colored Medical Association, the club hosted an afternoon entertainment for the state medical convention held in the city during April. The group's main concern was supporting the state federation's efforts to maintain Fairwold School (later renamed the Marion Wilkinson Home for Girls), located in Cayce, South Carolina, near Columbia. The Phyllis Wheatley also reinforced the efforts of the Coxes and other black leaders to foster interracial progress in the city. In 1922 it invited the chairperson of South Carolina's Interracial Commission, Clelia P. McGowan, to address its members. When reporting the success of its 1927 and 1929 concerts by Marian Anderson, Jeannette Cox proudly noted that both were attended by whites and blacks.[23]

Sometimes the group's undertakings became political. During the 1920s Jeannette Cox headed a state federation committee which protested, "Our people have been largely intimidated and denied the privilege of seeking sleeping car accommodations all over the South." The women also supported the NAACP's "Million Dollar Anti-Lynching Campaign." In 1929 one of the orphanages they supported housed two girls whose mother had been lynched. The Phyllis Wheatley again helped the NAACP in 1925 by contributing financially to its successful defense of a black physician, Ossian Sweet, and his family in Detroit, Michigan. The Sweets had moved into a white neighborhood and were arrested for shooting to death a white man who was part of a mob surrounding their house.[24]

The "spirit of service," exemplified in the Phyllis Wheatley activities, even shaped the lives of those Averyites who did not go into teaching. Joseph Irvine Hoffman, Jr., is an example of the "noblesse oblige" Cox wanted to instill in the students. Born in Charleston in 1898, Hoffman recalled that his grandfather was a German immigrant who had operated a grocery store in the city. The father, a Methodist turned Catholic, married Daisy M. Horsey, an Averyite. Opening his first shop near the historic Sword Gate,

he earned his living as a butcher, attracting many white patrons. The son helped make deliveries to their homes, some located on what is now the College of Charleston campus. After Catherine Winslow's one-room school on Coming Street, the boy attended St. Peter's Catholic School and then the Colored Industrial School. Graduating from Avery in 1918, he went to Howard University and then to medical school at Meharry College in Nashville, Tennessee. During World War I Hoffman was in the Students Army Training Corps. Receiving his M.D. in 1928, he served his internship at the Freedmen's Hospital in Washington, D.C. Concerned about his mother's health, he returned to Charleston in 1929 to practice at 43½ Cannon Street. Because it was difficult for Johns Island blacks to reach the mainland, Hoffman would "go over once a week" to see patients "in a little office" especially built by a farmer on his land for the doctor. Hoffman often accepted produce as payment for his services because many of these patients were extremely poor. He went to many of the islanders' homes to deliver their children and became well acquainted with their medicinal customs, such as placing on the bed of a woman giving birth her husband's trousers and underneath it an ax "to cut the pain." Later Hoffman served as a physician for the city's black public schools, Simonton and Burke. During World War II he was an examining physician for draftees and also for civilian workers employed at the Charleston Naval Shipyard. Through the Coxes, he met his wife, the former Ellen Wiley, a Fisk graduate who was an Avery teacher and a member of the Phyllis Wheatley society. Their daughter married a grandson of the Coxes.[25]

Life was never easy for those graduates who entered teaching, especially before 1920. Banned from teaching in the city's public schools, they faced a life of hardship in rural schools, even within Charleston County. Single and young, many were relatively ignorant of the rural people they were about to serve. Septima Poinsette Clark was typical of these pre–World War I graduates. Through the assistance of her Methodist pastor, E. B. Burroughs, Sr., she was able to secure in the fall of 1916 a position at Promised Land School on Johns Island. "My parents, too, were happy," Clark recalled, "that I had got the teaching job. Teaching was an honorable work that ranked well above most other work available to Negro girls. And it would be a life of service."[26]

Armed with visions of reduplicating on the islands what they had experienced at Avery, young women like Clark were in for a rude awakening. "Growing up in Charleston we knew little about these islands or the people on them," she admitted many years later. "From time to time we would see stories in the papers about them and often we would hear snatches of weird tales told about them by fishermen, and other seamen who had visited them." Clark, an eighteen-year-old high school graduate with no teaching experi-

ence and equipment, was "principal in a two-teacher school with 132 pupils ranging from beginners to eighth graders." The schoolhouse, "constructed of boards running up and down, with no slats on the cracks," had a fireplace at one end to provide the only heat during winter. Clark still recalls how "horribly frostbitten" her feet were "from the long walk in the cold and the chill schoolroom all day." For supervising the 132 pupils, she received from the state a monthly thirty dollars (also five dollars from the county), while the state paid her colleague twenty-five dollars. Their white counterpart at a nearby school with only 3 children received eighty-five dollars a month.[27]

The poverty, illiteracy, and disease these teachers found appalled them. Much of the antebellum plantation regime remained intact. Overseers still rallied the tenants, entire families, to work for which they received little more than "their living quarters and staple food—such as flour, rice, fatback, molasses—that could not be grown in their garden plots." Hookworm, coupled with a poor diet and unsanitary conditions, killed many islanders. The boll weevil made a bad situation desperate. Many young islanders left in search of jobs in mainland Charleston.[28]

For some of the young Avery graduates on the islands, the poor working and living conditions, as well as the cultural shock, were too much. Clark's assistant, another Averyite, left the school after her mother visited them and found the living conditions "too rigorous." Clark concluded, "This girl had grown up in a family that had enjoyed more economic advantages than mine had; perhaps had I been reared as she had I would have been forced to give up too."[29]

Just as the experiences of the northern missionaries during Reconstruction caused some of them to modify their preconceptions, Clark began developing an appreciation for an island people she had once considered "superstitious" and "primitive." The islanders formed a close-knit community she grew to love. Exactly how the islanders felt about the attempts of Clark and other Averyites to transplant a bit of their alma mater to these "Promised Land" schools is impossible to determine. Some Averyites even had their charges perform plays. However, the enthusiastic cooperation and support the parents gave Clark made the experience for her both bearable and worthwhile. Some Averyites found Gullah hard to understand; Clark was fluent in the dialect. "I did have one thing, at least, in my favor," she explained, "one big thing; I spoke their language. I could communicate with them."[30]

Septima Poinsette Clark found herself drawn increasingly into the daily lives of the islanders. The men, desiring to organize fraternal societies, asked her to teach them to read and write. The whole experience helped her fulfill a childhood dream. "It was the Johns Island folk," Clark felt, "who, if

they did not set me on my course, surely did confirm me in a course I had dreamed of taking even as a child, that of teaching and particularly teaching the poor and underprivileged of my own underprivileged race." For Clark, race progress began with "the advancement of our lowly ones to the opportunities of first class citizenship." Believing that the process itself would ultimately benefit all people, this black teacher was prophetic to perceive that "in lifting the lowly we lift likewise the entire citizenship." Decades later, the island people supported the civil rights movement in Charleston that lifted the city's middle-class blacks to a better life.[31]

The work of Clark and other black Charlestonians on the islands followed the antebellum tradition of Richard Holloway, Sr.; Samuel Weston; and other black Methodist elders who strove to convert the slaves on the Low Country plantations. This tradition was nurtured by northern missionaries who moved south after the Civil War to establish schools like Avery and Claflin. E. B. Burroughs, Sr., who helped Clark, was also Mamie Garvin Fields's pastor. Through him, Fields secured a scholarship to attend Claflin to fulfill her missionary teaching aspirations. A poem she composed to express her thoughts on going to Johns Island as a young teacher revealed a missionary impulse echoing that of the first northern missionaries:

> If I cannot give my millions
> And the heathen lands explore,
> I can find the heathen nearer.
> I can find him at my door.

If the earliest teachers to the islands arrived with such preconceptions, the best of them, including Fields, grew with the experience and like Clark developed an appreciation for the island people.[32]

By 1920 Avery graduates had the option of teaching in Charleston's black public schools, but most still went into the rural districts to carry on what they had received at Avery. To become a teacher, Genevieve Nell Ladson went to Avery after she attended the Catholic School of Immaculate Conception. When she graduated in 1928, she was certified to teach anywhere in the state up through the eighth grade. To fulfill her aspirations, she left her home in Charleston to teach in Horry County. After she married in 1930, she continued teaching, although this meant working away from home. She taught in Colleton, Dorchester, and Berkeley counties. Often she was the only teacher in the schools. At one place, the schoolhouse was a barn with seven windows without panes. "Something had to be done about it," she recalled. "I knew a lot about building things because both my daddy and my husband were carpenters." She threw herself into the project. "When I

say I built a school," she explained, "I mean I built it, from helping them cut down the trees with my saw, to hammering boards in place." Away from home and fending for herself, Ladson became involved in the rural life of the people she served. She "learned to pick cotton, harvest tomatoes, drive a horse and wagon, slaughter hogs and cows, grind sugar cane and make 'white lightning' (moonshine)." [33]

According to a survey conducted around 1941, the typical Avery graduate of the 1930s continued to be female, single, high school–educated, teaching somewhere in South Carolina, and earning less than ten dollars a week. Between 1930 and 1940 Avery graduated 385 women and 172 men, totaling 557. Only 165 (71 women, 94 men), or 29.6 percent of these graduates, went on to college. In 1941 a great proportion were Low Country residents, most residing in Charleston County. Unfortunately, the survey did not examine the economic background of the graduates' parents. Many Avery families had higher incomes than the average black family living in Charleston during the period. However, because by white standards these incomes were probably modest, any division solely based on family income would exaggerate the differences between Averyites and the white middle class as well as obscure the differences among black families in Charleston. As W. E. B. Du Bois noted in his 1897 study of Philadelphia blacks, income was an insufficient index to measure the substantial differences among the city's black families. About two-thirds of them lived on incomes of less than ten dollars a week. Income as the sole index failed to reflect what the black and white middle classes had in common. Du Bois redivided the black families by "moral considerations" as well as economics. By "moral considerations," he meant their ability to espouse and practice the Protestant ethic. His four categories were as follows: (1) Those families living in a well-kept home with sufficient income to "live well." The wife did not work. The children, not needed to supplement the family income, were in school. (2) Respectable working-class families in "comfortable circumstances" with a "steady remunerative income." The children were in school. (3) Poor families not earning enough to keep them always above want: "Not always energetic or thrifty," but with "no touch of gross immorality or crime." (4) The "submerged tenth," consisting of "the lowest class of criminals, prostitutes, and loafers." [34]

By Du Bois's classification, Avery families fell somewhere in the first three grades. Some definitely fit into the third one. Charlotte DeBerry Tracy, an Avery teacher, recalled that some of the homeroom teachers who visited their students' homes hesitated to go into the poorest ones because of their physically deteriorating condition. But even these parents she described

as ambitious although poor. Most Avery families fell somewhere between grades one and two, probably closer to two. In many instances both the wives and children had to supplement the family income. Still, they were better off financially than most Low Country blacks, certainly more so than the islanders. According to Septima Clark, Avery was black Charleston's version of "the Massachusetts Institute of Technology."[35]

The reminiscences of three graduates of the 1930s, J. Michael Graves (1932), Leroy F. Anderson (1935), and Eugene C. Hunt (1935), give valuable insight into the family life of Averyites who graduated during 1930–1940. These three men were close friends. Although nostalgic in their reminiscences, they nevertheless captured the ideal and flavor of the times. Like the majority of the graduates, they were from families with modest means who struggled to get them through school. Today they remember the strong familial and neighborhood support that nurtured them. They lived on or near "Little" Smith Street in the Radcliffeborough area. Their family histories, together with information from other contemporary Avery graduates, depict the kind of background and neighborhood community from which many came.[36]

All three men had ancestors who were either favored slaves (house servants) or free before the Civil War. J. Michael Graves's paternal grandfather, born around 1854, ran a tailor shop in Charleston. The Graveses, a free black Charleston family descended from French Huguenots, looked askance at the grandfather's marriage to a woman of slave and Indian descent. Graves's mother came from a long line of gardeners. Her father ran a delivery service for King Street merchants. Leroy Anderson, somewhat dark-complexioned like Graves, traces his lineage to house servants. There was some family resentment of his father's marriage to his mother because she did not come from Charleston, but from Eutawville, South Carolina. Eugene Hunt's family had worked for some of Charleston's first families, including the Smythes and Stoneys. His grandfather served as a kind of all-purpose manager in the Smythe household. His uncle by marriage, Samuel Faber, was a butler for the Stoney family.[37]

The fathers of all three men had steady, if not particularly well-paying, jobs. Albert Hunt, a steward on the Clyde-Mallory Luxury Ship Lines, sailed a route covering New York, Boston, Charleston, Jacksonville, and Puerto Rico. James Anderson worked at two King Street shops, Schwettmann's Drugstore and the Berlinsky brothers' clothing store for men (now Berlin's), until around World War I, when he was employed by the U.S. Post Office. James Graves was a Pullman porter. Except for Anderson's father, an artist-painter who graduated from South Carolina State, none of the parents had

attended college. Headed by a father with a steady if modest job, all three families owned their own homes. However, their financial situations varied. The Anderson and Graves households had four children each. Since Hunt was one of eight children, his mother had to work as a private nurse. The older Hunt children did odd jobs during the year; the brothers worked each summer to earn money for the coming school year. Despite some financially hard times, especially during the lean days of the Depression, the three families never considered themselves poor or disadvantaged. They devised ways to make ends meet. Irene Hunt, a fine seamstress, took work home. As was the custom, both Anna Anderson and Rose Graves had attended sewing schools as young women. "Mom made everything we wore," Graves recalled, "except our shoes and socks."[38]

A common set of values permeated all three homes. The parents instilled in their children a sense of family pride, self-worth, and appreciation of culture. They subscribed to the uplift philosophy and believed in educating their young. At five years of age, Graves attended Claudia Smith's one-room kindergarten. After finishing the sixth grade at Burke, which he remembers as woefully overcrowded, he enrolled at Avery, from which his mother and two aunts had graduated. His two brothers and sister were also educated at Avery. Hunt first attended Simonton and Burke. Although he was the seventh of eight children, there was no question that he would continue on to Avery and then college. All eight Hunts attended college. When Anderson, who first went to Shaw, passed the Avery entrance examination for the second grade, there was some concern over whether his family could afford to pay the tuition. With some help, the three Averyites were able to attend college. Through contacts made by Jeannette Cox, Hunt obtained financial aid to attend Talladega. The Graveses and Andersons mortgaged their homes to send their sons to Fisk. All three men subsequently obtained advanced degrees and entered careers in education. Today Graves and Anderson are retired, and Hunt teaches Afro-American literature and speech at the College of Charleston.[39]

The three families were extended ones. Hunt's grandmother took care of the home while his mother was away working. When his brothers needed summer employment but balked at working with their father aboard ship, they were sent to Atlantic City, New Jersey, where their maternal uncle, the head bellman at the Biltmore Hotel, arranged jobs as bellmen. Graves's maternal grandfather allowed the boy to accompany the employees on the wagons as they made deliveries to white families living on the city's Battery. Since the three families lived near one another, a collective parenting prevailed.[40]

The neighborhood itself was a kind of extended family, which reinforced the common set of values shared by the parents. Hunt was delivered by the son of Thomas E. Miller, both of whom lived in the Radcliffeborough neighborhood. Other families in the area included the Mears, Dashes, and Simmses, who also sent their children to Avery. Florence A. Clyde lived on Smith Street near the Andersons and across from Hunt's maternal aunt, Ella Murray Faber. This Avery teacher acted as a neighborhood early warning system. "If you were playing with the wrong person in the street," Leroy Anderson recalled, "she rang your bell" and "told your parents to get you in the house. Those kids were more exciting than ones who came to your birthday party." The exciting playmates Clyde disapproved of were probably from poorer families in the neighborhood. There was also the city's East Side beyond Meeting Street. This area was considered off-limits— especially south of Columbus Street, near the wharves, or where the prostitutes plied their trade. Although Avery students lived in the East Side, the section was considered dangerous. If a neighbor, working in the area, happened to see a neighborhood youth there, the young man was likely to get two whippings, one from the neighbor himself and the second from the parents after the neighbor informed them about the culprit's whereabouts. Not surprisingly, the three families were churchgoing. Graves and Anderson attended Mt. Zion AME Church; Hunt went to Central Baptist until age twelve. When the pastor told him he could not join the senior choir unless he was baptized, Hunt left to sing in other churches. Because of his fine tenor voice, the various churches in the area, including the Catholic church, St. Peter's, tried to recruit him. Throughout his high school years he was with the Centenary Church choir directed by J. Donovan Moore. He also sang with one of his sisters at St. Mark's, which she had joined. Eventually, he became a member, too.[41]

The Radcliffeborough neighborhood in which the three youths grew up was one of several composing the larger black community. Septima Clark, a pre–World War I graduate, also remembered the strong familial and neighborhood support she received during her childhood on Henrietta Street. Recalling birthday and holiday celebrations, she reminisced, "Never shall I forget these happy occasions, shared with cousins, school friends, and neighbors' children with whom our parents permitted us to associate." These neighborhoods were interconnected by various institutions, including the schools, churches, YMCA, YWCA, and myriad social clubs. Of these institutions, the schools and churches were especially important in nurturing the value system the families and neighbors strived to inculcate in the children. "Any teacher who saw you doing something you weren't supposed to be

doing," J. Michael Graves explained, "could call home, or reprimand you. Every child in the neighborhood was the child of everybody in the neighborhood. The family saw to it that you lived up to the standards of the family." Cox reinforced these efforts through his lectures and sermons, reminding the students that their conduct reflected their home, school, and church. After 1919 when blacks could teach in the city's black public schools, Averyites like H. Louise Mouzon (1914) carried on this supportive role. One of the first black teachers assigned to Burke in 1920, she taught there for thirty-seven years. "I tried to teach more than book learning," she explained. "I tried to instill the principles of character." [42]

One of the most prestigious of the social groups was the Owls, a whist club for men. It was founded in 1914 when sixteen young men, excluded from a social event they dearly wanted to attend, met in a local tavern to plan a gala patterned after the St. Cecilia Society balls. This led to their organizing a club they named after the stuffed owl in the tavern. By the 1930s there existed numerous clubs, including the Cosmopolitan Bridge, the Carnation, the Bonvivant Social, and the Excelsior. When men like Hunt, Graves, and Anderson, who had joined fraternities in college, returned to Charleston to settle down, they socialized at fraternity functions. [43]

Cordial relationships with whites sometimes evolved out of the workplace, leading to whites' serving as part of the extended family. When Leroy Anderson's father passed the Civil Service Examination, his employers intervened downtown to help him obtain a job at the post office. "Old Man" Smythe, who had employed Eugene Hunt's grandfather, recommended the father as a Pullman porter. Hunt did chores for the Stoney family. Samuel Stoney, a storyteller, interested him in local history and Gullah (the topic of Hunt's senior paper at Talladega). Hunt played with the younger Stoney offspring and their friends, including the oldest son of Albert Simons, an architect. Given the lack of strict residential segregation, it was inevitable that black and white children would play and nap together. Parents, white and black, monitored the children as a group. The children went to movies together, though they were segregated on the bus and in the theater itself. Leroy Anderson recalled that the writer John Bennett and his wife, Susan, (formerly Smythe) attended family weddings and funerals. Originally from Ohio, Bennett, who lived nearby on Legare Street, remained interested in the activities of Anderson, Hunt, and the other youths after they became adults. [44]

Racial contacts were not always so idyllic. "I can't play with you any more because you're colored," Felder Hutchinson's Irish-American playmate told him. Hutchinson, who graduated from Avery in 1939, remembered how upset the playmate's mother was after Hutchinson's mother related the inci-

dent to her. She attributed her son's behavior to the negative influence of her son-in-law, whom she described as shanty-Irish. The adults did all they could to shield their children from the harmful effects of segregation. If the children could not attend a white event, then the parents made sure they had a black equivalent. Anderson's father kept an old Dodge so that his family did not have to ride the segregated trolley cars. He also took great pains to make sure his boy knew that there were white people who might hurt him. The father once took his son to a Ku Klux Klan parade in Charleston to impress upon him how dangerous some white people could be.[45]

For the Radcliffeborough families, uplift and culture were vaguely synonymous. Music was a vital part of family and community life. It was fostered in the schools and churches. Graves believed this musical tradition carried back to antebellum times. For Hunt, music was part of family life. "I come from a family of singers," he explained. James R. Logan's sister, Anna, who taught Hunt at Simonton and was an accomplished pianist, encouraged the youth in his singing. Anna and James Logan were J. Michael Graves's second cousins. Graves's paternal grandfather, a member of Logan's Aurorean Coterie, was a talented violinist, who tutored white students attending the College of Charleston. At Avery, all three youths fell under the spell of John Whittaker, the choral instructor. The three students joined St. Julian Bennett Dash, Jr., and other neighborhood talents to form an orchestra. Dash, who graduated from Avery in 1934 and spent two years at Alabama State College, played in Harlem's Up Town House and became the leading tenor saxophonist for the Erskine Hawkins band. Hunt and Graves maintained their interest in music at college. Today their musical talent is still in demand for community events.[46]

The families sent their children to J. Donovan Moore, James R. Logan, and other local musicians for private lessons. Hunt studied piano under Moore, who advised him to stick to singing. Anderson took violin lessons from Logan for six years though he concedes today that he had little aptitude for the instrument (his fingers were not long enough). Dressed in linen knickers and carrying his conspicuous violin case, Anderson had to brave the taunts of neighborhood boys screaming "Mamma's Little Boy" as he made his way to Logan's residence. He remembered Logan as a "very polished" and exacting taskmaster. Another Logan student was Septima Clark's brother, Peter Timothy Poinsette, who played for many years with friends in the Utopian Concert Orchestra.[47]

For these black Charlestonians, culture also encompassed a knowledge of one's past and ancestors. Children usually learned family and local history by listening to the elders' telling stories. "What we didn't get from Avery,"

Felder Hutchinson recalled, "we got from Gene's [Hunt] [grand]mother." Although Hunt learned much local black history from his grandmother, he also remembered that his teachers at Simonton, such as Mary Brawley Robinson, nurtured his love of the subject. Graves's cousin James R. Logan was a veritable treasure of local and national black history. Others who are still remembered for keeping the past alive, usually through storytelling, included Robert F. Morrison, Julia Leslie, Louise DeMar Purvis Bell, and John A. McFall. Morrison, a Fisk graduate and former educator, was often called upon to settle disputes on history and politics. Sometimes the elders directed their attention to specific young persons with the appreciation and patience to listen. Charles Leslie's daughter, Julia, spent hours telling Felder Hutchinson about the family fish business. Hunt spent a good deal of time listening to Robert Morrison, Louise Bell and John McFall. Whenever Hunt visited McFall's drugstore on the corner of Smith and Morris streets, the pharmacist regaled him with stories of the neighborhood. McFall's drugstore, which once had a soda fountain, was a neighborhood institution. Even today Hunt remembers vividly how immaculately clean and full of interesting odors it was. The pharmacist, while meticulously preparing prescriptions, enjoyed telling the youth little-known facts about Charleston blacks. During Negro History Month, McFall lectured on the subject at Dart Hall Library. Before his death in 1954 he completed a manuscript, "History of the Negro in the Lowcountry." He failed to find a publisher for it, but the Charleston *News and Courier* praised it as "another legacy for his people." Arthur Clement, Jr., a close friend of McFall, provided through his writings and lectures much of the same function the black pharmacist performed decades ago. In turn, Gene Hunt passes on to interested listeners the stories and facts told him by his grandmother and the others.[48]

Families in these neighborhoods often preserved their family histories in scrapbooks and Bibles. Lillie Ransier Wright still has the family Bible. Her grandfather, Alonzo J. Ransier, lieutenant governor of South Carolina during Radical Reconstruction, carefully inscribed in it the birth and death dates of family members. Scrapbooks were also popular ways to preserve both family and local history. James R. Logan's scrapbook, starting with his graduation speech at Morris Street Public School in 1889, covers his entire career at the Charleston Naval Shipyard, extending into the 1940s. The Holloway scrapbook is a chronicle of the adversity and achievements of the family, beginning with Richard Holloway, Sr. His grandson James began the scrapbook, which traces the family harness shop well into the first decade of the twentieth century. Both the Holloway and Logan scrapbooks are testimonies to the efficacy of the uplift philosophy. They were used to educate the youth

of the community as well as scholars. Logan allowed young persons study-
ing black history to peruse his scrapbook. It was valuable because he kept
newspaper clippings on local and national events. Besides articles from the
Charleston *Messenger,* he included whole pages from the Pittsburgh *Courier*
and Marcus Garvey's *New World.* The Holloway scrapbook also contains
newspaper items on local and national events. Mae Holloway Purcell, the
niece of James Holloway, preserved the scrapbook and other family papers,
which she donated to the College of Charleston. Purcell, who graduated
from Avery in 1909 and five years later from Fisk, taught in the city's pub-
lic schools before she worked at Dart Hall Library with Susie Dart Butler.
E. Horace Fitchett, Marina Wikramanayake, Asa H. Gordon, and James B.
Browning used the Holloway material to write their histories. Gordon and
Browning also studied documents provided by John A. McFall. An Averyite,
C. Wainwright Birnie, used records and papers belonging to several fami-
lies, including his own, to write an article on antebellum black education in
Charleston.[49]

Several churches and other local black institutions have preserved their
records. Some even have appointed historians. Felder Hutchinson and
Eugene C. Hunt act in that capacity for St. Mark's. Jeannette Cox, historian
for the Phyllis Wheatley, used the club's minutes to record the achieve-
ments of its first seventeen administrations. Minutes exist for the Clionian
Debating, Brown Fellowship, and the Friendly Moralist societies. Like the
folk stories and scrapbooks, these minutes, all meticulously written and pre-
served, are testimony to the community's desire to preserve its past.[50]

No stronger testimony was provided than that of Louise Purvis Bell, an
ardent believer in the preservation of black historical sites. She unsuccess-
fully opposed the College of Charleston's use of eminent domain to take
the Bell house. Located at 2 Green Street, the building had been in the
family since 1843. Born in Charleston in 1890, Bell was the granddaughter
of the Reconstruction state legislator Robert Purvis, a black abolitionist from
Philadelphia. Educated in the early grades at Shaw and perhaps Avery, Bell
completed her high school and college training at Howard. Among the first
black teachers in Charleston's public schools, she also taught at Laing in
Mt. Pleasant and Booker T. Washington High School in Columbia. In 1923
she married Hiram Bell, a widowed Charleston bricklayer, in St. Mark's.
Two sons, Hiram L. and James A., attended Avery. James Bell recalled that
his mother frequently wrote letters to the editor of the Charleston *News and
Courier,* in an effort to document local black history accurately.[51]

Public celebrations illustrate that culture, particularly music, declamation,
and drama, became almost synonymous with history for many black Charles-

tonians. Events such as the Emancipation Day and Labor Day parades were ways for the community to commemorate and preserve its heritage. The Emancipation Day parade, begun during Reconstruction, continues today. In 1926 Edwin A. Harleston was the Emancipation Day orator. Various institutions kept alive their heritage through historical plays. Students performed at commencement exercises plays outlining the history of their school. In 1951 the Avery senior class presented a history of the institute, memorializing Francis L. Cardozo, Morrison A. Holmes, and Benjamin F. Cox. Funeral services provided an opportunity to honor important members of the community. Memorial services for men like musician Edmund T. Jenkins and his father became significant public events. Musical traditions were perpetuated on these occasions. Singers such as Eugene C. Hunt were and still are in demand for funeral or memorial services and other public events. A talented tenor, a gifted orator, and a knowledgeable historian, Hunt both embodies and transmits the heritage of the community at such affairs. His first participation in a funeral of note was two years after he graduated from Avery when he was chosen to sing at the ceremonies for Daniel J. Jenkins.[52]

The burial grounds, especially those off Meeting Street, are testimonials to the past. If traditional histories denied blacks their famous personages, the gravestones read like a *Who's Who* of black Charleston, from the Darlington County sheriff Thomas C. Cox, who died in 1893, to the physician William D. Crum. Most impressive are the achievements of Thomas E. Miller: "LAWYER, EDUCATOR, SCHOOL COMMISSIONER OF BEAUFORT IN 1872. STATESMAN, AUTHOR, MEMBER OF STATE HOUSE AND SENATE 1874–1896. MEMBER OF 51. U.S. CONGRESS. FOUNDER C. A. & M. COLLEGE AND FIRST PRESIDENT. DELEGATE CONSTITUTIONAL CONVENTION 1896. PRESBYTERIAN 64 YEARS." Also documented is the service orientation of this light-skinned congressman: "I SERVED GOD AND ALL THE PEOPLE, LOVING THE WHITE MAN NOT LESS, BUT THE NEGRO NEEDED ME MOST."[53]

Diverging Visions

Financial exigencies made the curtailment of some AMA activities mandatory. "We will not do business unless we can pay our bills," the chairman of the AMA executive committee declared in 1923. Reflecting this profit-and-loss mentality of a big business, Fred L. Brownlee, the AMA secretary, pronounced "largely over" those "pioneer days," to which the urban secondary schools belonged. This attitude of the home office not only ended any chance Avery had of becoming an AMA college, but also threatened

the school's continued existence. Between 1922 and 1927 the association, hard-pressed to operate even its colleges, began divesting itself of its urban secondary schools; it hoped that city, county, or state officials would take them over. During this period four schools were closed, including those in Savannah, Georgia, and Wilmington, North Carolina.[54]

As early as 1915 the AMA considered closing Avery. Four years later its executive board issued an ultimatum. Averyites were required to donate a sixty-acre site, on which the AMA, if it could raise a quarter million dollars, would build a new industrial normal school. Located on the outskirts of the city, the facility would be better able to reach the rural areas. If this plan could not be adequately enacted, Avery would be discontinued under the AMA after one or two years. Given the precarious condition of AMA finances, it was highly unlikely that such a large sum of money could be raised. The ensuing crisis revealed how Avery alumni and many other residents perceived the school as a Charleston institution pertinent to upgrading black education in the Low Country, whereas the AMA considered the facility as just one of several in a larger scheme.[55]

Benjamin Cox probably thought Avery doomed when he was assigned to an AMA subcommittee to study further reduction in schools. He turned to the Avery advisory board, founded in 1918, to keep the school open. Staffed predominantly by alumni, it included many of the same people responsible for establishing during the previous year a successful branch of the NAACP in Charleston. The pharmacist John A. McFall would chair the advisory board in 1924 and the Plymouth pastor C. S. Ledbetter in 1925, when it was in the midst of an elaborate campaign to ensure the school's continued existence. Other members included Edwin A. Harleston, Edward C. Mickey, and Robert F. Morrison, a businessman. President of the Alumni Association in 1923, Morrison played a key role in keeping the school alive and upgrading black education in the Low Country.[56]

Like many others on the advisory board, Robert Francis Morrison ("Mr. Bob") was part of a tradition which recognized the importance of organized group activities and self-governing skills for survival. Born in Charleston in 1883, he was the grandson of Francis L. Wilkinson, the antebellum butcher who was president of the Friendly Moralist Society. Morrison's paternal grandfather was apparently the antebellum free black carpenter Robert Morrison. The grandson attended Simonton before he transferred to Avery, graduating in 1902. Three years later he received a B.A. from Fisk. He worked his way through college as a Pullman porter during the summers. After one year of managing a drying plant for a knitting mill in Nashville, Tennessee, he decided to become an educator and began teaching at Mason

City, Alabama. Between 1906 and 1909 he was principal of Wilson School in Florence, South Carolina. Finding his salary insufficient to live on, he found employment with the Railway Mail Service, for which he worked during the next thirty-three years. In 1914 he returned to Charleston. A Mason and member of Centenary Church, he involved himself in a variety of civic activities, including the YMCA. He developed close ties with his alma mater. He was chairman of the Holmes Scholarship Committee. In 1916 he headed the Avery alumni executive committee, the antecedent of the advisory board he helped found. His sisters, Constance and Edna, both Averyites, taught at the school. His future wife, Serena Hamilton, a Talladega graduate, also was an Avery teacher. The president of Talladega officiated at their marriage in 1918.[57]

Morrison's connections with that college proved fortuitous for Avery. To buy time, he worked through an intermediary, W. H. Holloway, a Talladega professor, who suggested that the alumni "demonstrate their desire to preserve the school by donating some tangible gifts." The alumni subsequently gave the school its "first laboratory equipment." This paved the way for the long-term fund-raising campaign of the Avery advisory board in response to the 1919 AMA ultimatum. The board succeeded in raising from the local community approximately two thousand dollars each school year between 1921 and 1925, for Avery's operating expenses.[58]

The Coxes were at the center of these annual fund-raising efforts. A former teacher recalled the couple's endurance. Cox used every means at his disposal. "Our singing, particularly the singing of Spirituals, attracted our white neighbors as nothing has heretofore," he reported in 1927. "Many tourists visited us this year—some contributing appreciatively to the work. A special group of singers has visited hotels in Charleston and vicinity and has collected over $300.00." That year, when the fund drive fell $1,820 short of the $3,500 mark, Cox assembled the faculty and students in the chapel to explain the financial crisis. They responded by organizing a variety of activities to raise the shortfall. The students, "infecting" their parents with their enthusiasm, collected more than $1,100. Cox also tapped the local black churches, which had made "liberal contributions" in the past. They cooperated by designating January 23, 1927, as Avery Sunday, when envelopes distributed the previous Sunday were collected.[59]

The campaign to save the school depended on loyal alumni. In compiling his *Who's Who in Colored America*, Horace Mann Bond noted that Averyites were most numerous of those furnishing high school affiliation. In 1928 Averyites in New York established an alumni chapter that would provide the school and its students ongoing support. The chapter would remain active

until the school became public and no longer needed its financial help. Despite alumni efforts to raise over twelve thousand dollars between 1922 and 1927, the tuition had to be increased to meet the commitment to the AMA.[60]

In addition to their fund-raising drives, Cox and his supporters had to demonstrate to the AMA that they had exhausted all other alternatives. In 1924 they formally requested aid from the city but were turned down. A year later the group failed in their bid to obtain funds from the Duke Foundation. In 1926 they tried to convince the city to hold its teacher training for blacks at Avery rather than begin such a program at Burke. Their request that the city pay the salary of one or more Avery teachers to do the work was denied.[61]

As part of the campaign strategy, Cox employed his wherewithal to convince the AMA of Avery's unique and significant contributions to black education in the South. To make his case, Cox enlisted the support of George E. Paddack, pastor of Charleston's Circular Congregational Church, who appealed directly to the readers of the *American Missionary* in 1925. "There is a strong feeling that the grammar grades are as far as the colored youth should be taught," Paddack explained. "This is a condition which will not be overcome in one generation or two." He noted that city officials had repeatedly refused requests to make Avery part of the public school system. Without it, there would be no four-year high school for blacks in Charleston. Paddack believed that Avery occupied "a unique place among the schools of the A.M.A. It would be a sad loss to all this section to have the influence of Avery taken from it." Cox used statistics to strengthen the argument. He underlined the extremely high illiteracy rate in South Carolina, especially in Charleston County, where there were 13,586 illiterate blacks in 1927. The closing of Avery would cripple efforts to reach such people. Cox pointed out that in 1927 two-thirds of the teachers in Charleston County's black public schools were Avery graduates. They also composed 85 percent of the teachers in the city's black public schools. Moreover, with Avery closed, there would be no normal institute or high school, private or public, for blacks within eighty miles.[62]

By enlisting Paddack to present Avery's case, Cox was appealing to the belief deeply cherished by the AMA that eventually white southerners would support black education. Cox was extremely adept at playing on the heartstrings of AMA emissaries. In 1925 the Marine chaplain John H. Clifford, a missionary for many years, visited Avery, apparently on a fact-finding tour for the AMA; his report appeared in the *American Missionary*. Cox carefully orchestrated his visit. The tour de force came in Avery Hall, where 420 students assembled for chapel. "You are at once charmed by the sound of youthful voices singing quaint old Negro melodies," Clifford exclaimed.

"God draws very near you and you feel the living presence of the crucified Christ as they sing out in unison the grand old invitation to cast your troubles and cares upon him." Cox's finely honed routine was just as effective when applied to northern tourists. As Arthur J. Clement, Jr., observed, "the well-trained singing of these students and their sense of decorum combined to loosen the purses of many of their visitors."[63]

The efforts of Cox, the alumni, and other supporters gradually bore fruit as the campaign unfolded. The initiative they displayed pleased Fred L. Brownlee and other AMA officials, who placed a great premium on local self-sufficiency. By 1923 Brownlee was realizing how hopeless it was to believe that local authorities would take over the AMA schools. Wherever such schools existed, public ones were not established. In January 1925 he acknowledged to C. S. Ledbetter his disappointment with Charleston city officials. "What pains me more [than the refusal from the Duke Foundation]," he wrote, "is the fact that the city authorities have turned down the petition [for appropriations] sent to them. Doubtless the thing was not given very careful consideration." About two months later Brownlee met with the Avery advisory board to discuss the basic provisions of an agreement. W. H. Holloway, a Talladega professor who had apparently visited Charleston earlier to pave the way for this conference, was also present. In May of that year the AMA executive board gave its approval to reincorporate Avery and to establish a new board of trustees. Apparently the trustee board established in 1894 had become inactive. The new one was to subsume the work of the advisory board as a permanent fund-raising body. Although it would be composed of AMA officials, alumni, members of the parent-teacher association, and friends, it would be dominated by Averyites. The AMA executive board ratified in September the election of the trustees, who included Robert F. Morrison, Jesse E. Beard, John McFall, Edward C. Mickey, Arthur J. Clement, Sr., Mrs. A. P. Smith, George N. White, W. H. Holloway, and Fred L. Brownlee. The AMA associate secretary, George White, visited Avery during January 1926 to review the work of the new trustees.[64]

The agreement reached with Brownlee did not preclude difficulties between the AMA and the alumni leadership, who still aspired for Avery to develop into a college. The "active" management of the school was still in the hands of the AMA secretary; its "financial" management would remain under the AMA until the association saw fit to transfer these duties to the new board of trustees. Curriculum development was to "be that of an accredited High School, featuring as its chief department a teacher training school." Averyites serving on the new trustee board tried to hurry along the

process of self-government by involving it in the management of the school. When Cox refused to give the board information it requested, the board wrote directly to the home office. Moreover, the new charter superseded the agreement the AMA had entered. According to John McFall, the state charter allowed Avery's "extension into that of a college . . . and had as its purpose the perpetuation of the school along local lines." Another document declared that the school had been "reincorporated with a view toward its development into a college-level school under local control." Whatever the intent of the new charter, the board's activism infuriated AMA officials. Rather than risk losing AMA support, the board reluctantly suspended its activities.[65]

Cox emerged stronger from the controversy. On the one hand, he won local approval by persuading the AMA to continue its support for Avery. On the other hand, by backing the AMA in the confrontation with the board of trustees, he won for himself considerable leverage in dealing with the home office. As early as 1925 Cox was already making personnel decisions usually handled by the home office. That year it appointed Ruby Pendergrass (Cornwell) to teach English and history at Avery. Her mother was a Charlestonian; her father, Durant P. Pendergrass, an AME minister once active in Republican politics, was a presiding elder and trustee of Allen University. When Ruby (who had attended Avery) arrived, she discovered that her good friend Edith McFall had been hired by Cox to fill the position. Despite the mixup, both women remained on the staff.[66]

While wrestling with Avery's survival and severe financial restraints, Cox also had to overcome several obstacles hindering its being accredited by the state. Major problems were the substandard physical condition of the school, lack of space, poor equipment, deficient library, and older teaching personnel who were not properly certified. From the moment he stepped onto the campus, Cox started to upgrade the school by renovating the buildings, adding new courses and facilities, including a modern science laboratory. He eased the pressing need for space by persuading the AMA to purchase in 1930 the Adam-style house (circa 1815–1820) at 54 Montagu[e] Street, which became the new teachers' home. This move freed up space for enlarging Avery's vocational department. Additional books from the defunct AMA school in Capahosic, Virginia, were especially welcomed, for the library was a serious obstacle to accreditation. In 1927 Charlotte D. Tracy, a social science teacher, reorganized the library. Two years later after another reorganization, it was "one of the best in the state." By 1935 Cox had added a full-time librarian to the staff.[67]

The black principal also began sending the older teachers back to school

and hiring more qualified ones. Oldtimers like Florence A. Clyde and Susie A. Butler spent summers studying at northern colleges. Clyde received a lifetime South Carolina teacher's certificate after attending Teachers College at Columbia University (1920, 1930, 1934), the University of Pennsylvania (1923, 1926), and South Carolina State College (1931). Cox hired the best Avery graduates, including Alphonso W. Hoursey and Frank A. DeCosta. After receiving a B.A. from Fisk in 1926, Hoursey taught Latin and French at Avery. In 1941 he earned an M.A. in education from the University of Michigan. Frank A. DeCosta finished Avery in 1927. After receiving his B.A. in 1931 from Lincoln University in Pennsylvania, he joined the Avery staff. In 1936 he would replace Cox as principal. Cox also augmented his staff with other AMA alumni. William Edward Bluford, a history teacher, for example, had attended Gloucester Agricultural and Industrial School at Capahosic, Virginia. He was drawn to teaching because it afforded him "the greatest opportunity to impart to others the benefits of intellectual and Christian experience." After receiving his B.A. from Virginia Union University at Richmond, he returned to Gloucester to teach between 1930 and 1933. Immediately thereafter he went to Avery. Like Hoursey, he pursued graduate studies at the University of Michigan and received an M.A. in 1937. Through Cox's efforts, Avery was state accredited by 1932. The Southern Association of Colleges and Secondary Schools also accredited the school.[68]

Although Cox succeeded in upgrading Avery both physically and academically so that it was finally accredited, he did not win the full accolade of the home office. He did not emphasize agricultural training as had his predecessor Frank B. Stevens, a farming expert from Iowa primarily interested in working with the soil. Stevens, in tune with the AMA shift toward rural industrial education, had taught agriculture to the Avery students. Cox, instead, created at the school the ambience of a fine small liberal arts college. This was not in accord with the 1919 ultimatum of the AMA executive board. Therefore, although AMA officials publicly praised Cox's tenure as a "happy" one and the man himself as "able," privately they chafed over the hegemony he managed to achieve over the school. They considered his tenure as too traditional and not progressive enough.[69]

Toward Racial Solidarity

It was not coincidental that Jeannette Cox founded the Phyllis Wheatley when Avery had begun its second year as an all-black institution. Like the Aurorean Coterie, the club was to provide a cultural environment to over-

come the "prescribed social lines" still dividing the black middle class in Charleston. Culture was to serve as a bridge uniting the black leadership and fostering racial solidarity. "The lines which bound the existing groups," Cox explained, "were to be altogether ignored and some members were to be chosen from this, that and the other social groups. . . . For at that time all of Charleston's ills were laid to the lack of unity among its social groups. And it must also be remembered that that mighty leveler—Negro teachers in the city schools—was still the substance of things hoped for." The Phyllis Wheatley then was to be "a sort of social crucible" to begin a "united, homogeneous Negro society." Avery teachers, who were to be members, were to help achieve this.[70]

For the Coxes, a black dimension was essential to the role culture was to play in fostering race uplift and solidarity. Under the Coxes, the emphasis on black history and culture increased dramatically. The Phyllis Wheatley activities reflected the importance placed on this dimension. The women admired the achievements of both W. E. B. Du Bois and Carter G. Woodson. As early as 1917 the club "voted to discuss some of the lives of the great men of our race using as a guide Brawley's book 'The Negro in Literature and Art.'" Between 1916 and 1934 guest speakers and performers included local artists and musicians like Edmund Jenkins, William Lawrence, and Edwin A. Harleston, as well as such nationally known celebrities as W. E. B. Du Bois, Marian Anderson, and Langston Hughes. The books displayed at Hughes's poetry recital in 1931 were part of the club's collection "on Negro life or by Negro authors," which the members had started amassing in 1920. The collection was apparently made available to the general public in 1932 through Susie Dart Butler, a charter member and head of Dart Hall Library, because the ladies had complained of the scarcity of such books at this public facility. Their interest also extended to Africa. One meeting in 1921 was devoted entirely to "Africa's contribution to world civilization."[71]

Cox, a former member of the Fisk Jubilee Singers, was knowledgeable about the spirituals. He lectured on the topic and succeeded in spreading his enthusiasm and appreciation. The 1916 Avery yearbook, *The Pinnacle*, reprinted the salutatory of the senior Naomi Wilkerson Delesline. Relying heavily on W. E. B. Du Bois's *Souls of Black Folk*, Delesline proclaimed, "The Negro Folk song stand to-day not simply as the sole American Music, but as the most beautiful expression of human experience born this side of the seas altho it has been neglected and even now is half dispised [despised], and is continually mistaken and misunderstood, still it remains as the singular spiritual heritage of the nation and the greatest gift of the Negro people."[72]

Cox stirred the students' curiosity about black history and culture by

inviting to Avery Hall noted black speakers. One graduate recalled that Cox brought "anybody who was anybody" in the Harlem Renaissance to the school. For the students, chapel became "one place where we learned about Negro history." To pursue the subject further, they could go to the Avery library, which Cox had stacked with books on black history and culture. According to J. Michael Graves, its collection on black history was "more extensive than [those in] some college libraries." Graves used books by Carter G. Woodson in writing his rhetorical "Negro Art: Its Natural Setting."[73]

Like Benjamin and Jeannette Cox, many Avery teachers had been educated at AMA schools such as Fisk, where they had developed an appreciation for black history and culture. They had studied under men like A. A. Taylor, Rayford Logan, and Carter G. Woodson. The history teacher William Bluford had been a student of Rayford Logan's at Virginia Union University. The titles of Avery student commencement speeches between 1918 and 1936 reflected the influence of the Coxes and the faculty: "The Negro in Literature and Art" (1918), "The Negro a Factor in American History" (1919), "The Black Defenders of American Liberty" (1920), "The Preservation of Negro Melodies" (1925), "The Negro's Contribution to American Life Through Science" (1930), "Newer Trends in Negro Education" (1935). In 1934 the honor senior, Carlton G. Cooper, titled his speech after Woodson's *The Mis-Education of the Negro*, published the previous year.[74]

The Avery Alumni Association supported Cox's emphasis on black history and culture. In 1931 it cooperated with the Holmes Memorial Committee to bring to Avery an exhibition of works by Afro-American artists recently displayed at New York and sponsored by the Harmon Foundation. The foundation was established in 1922 to foster the "Negro Renaissance" by recognizing and encouraging achievements by blacks. In 1931 it awarded Edwin A. Harleston its Alain Locke Portraiture Prize for his "Old Servant." This painting, included in the exhibit, was one of the many Harleston portraits that attempted to transcend racial caricatures by giving individual blacks the dignity they deserved.[75]

Interest in black history and culture became more intense at Avery as the administration and staff became entirely black. This phasing out of white teachers reflected a trend. In 1895 only 9 percent of the teachers in AMA secondary schools were black. Ten years later this percentage reached 53 percent. By 1915 the percentage of black teachers in black colleges and schools with northern missionary affiliations was 60 percent. If some whites viewed the trend with alarm, so did some blacks, who feared that the loss of white teachers meant a decline in standards. Du Bois himself had op-

posed all-black faculties because he wanted every school, black or white, to be integrated. Nevertheless, most black principals and teachers welcomed the increased control of their institutions. Racial radicalism and the Coxes' arrival hastened the transition at Avery. City officials disapproved of whites and blacks' living together at the teachers' home. As much as the students genuinely missed some of the older white teachers, they delighted at the prospects of a totally black-run school. The class of 1916 dedicated their yearbook "to Avery's First Colored Faculty."[76]

Cox and his staff felt a special need to demonstrate academic excellence. Hattie L. Green, a first-year teacher, informed the readers of the *American Missionary* in 1916 that it was "the earnest desire of the principal and the teachers to maintain and if possible increase the high standard Avery Institute has ever held. They feel this responsibility very keenly and are determined that the loyalty for the school which the white teachers for nearly half a century have instilled into the people may not be shaken, nor the standard lowered." In a city that did not allow blacks to teach in the black public schools, the example Cox and his teaching corps set served as a precedent for change. Their devotion during the fund-raising campaign of the 1920s to keep the city's only black high school open caused the pastor of Charleston's Circular Congregational Church to compare them to the early faculties of Oberlin, Olivet, Yankton, and Grinnell. Their sacrifices bore fruit in 1927 when Avery's enrollment reached 478, making it the largest secondary school in the AMA system.[77]

The Charleston board of school commissioners with the cooperation of Low Country legislators was able to slow down but not overcome the combined efforts of the racial radicals and a resurgent black community to remove white teachers from the city's black public schools. Ironically, this issue demonstrated that racial radicalism had within it the seeds of its own destruction. Its very success would begin the process. In preaching rigid segregation, racial demagogues encouraged a solidarity among blacks that would provide an antidote to the virulent racism they spawned. Their logic, carried to its conclusion, dictated that only blacks could teach other blacks. This practice would inevitably lead to a measure of black independence. Moreover, rigid segregation fostered the growth of a black professional-business class of ministers, undertakers, doctors, and real estate agents, who served a black clientele rather than a white one. This made them somewhat independent of whites. At the same time, they had to be more responsive to the needs of the larger black community than had their clientele been exclusively white. Products of a tradition that valued organized group efforts as a means of overcoming problems, they had the expertise necessary to lead

the black community in a successful movement to put black teachers in the black public schools.[78]

On February 27, 1917, eighteen men and eleven women gathered to form a Charleston branch of the NAACP. These twenty-nine were mainly professional and business people with some artisans. Averyites dominated the new organization. Three of the four original officers had attended, if not graduated from, the school: Edwin A. Harleston (president); Richard H. Mickey (secretary); Susie Dart Butler (treasurer). Edward C. Mickey, John A. McFall, Robert F. Morrison, and Benjamin F. Cox were on the executive committee. Edwin ("Teddy") Augustus Harleston was the driving force behind the group. His sister, Eloise, the wife of Daniel J. Jenkins, was a charter member. Their father, one of eight children, was the son of William Harleston, a white planter, and Kate Wilson, a slave, who eventually received her freedom. Edwin Gaillard Harleston, called "Captain" because he owned a schooner that transported rice and other produce between Wilmington, North Carolina, and Brunswick, Georgia, went to Charleston to set up a produce business after his vessel had an accident at sea. He gave up the enterprise to help his sister, Hannah Mickey, whose husband's death required that someone take over the family undertaking business. Their partnership lasted until the two Mickey sons were of age. Harleston then established his own funeral home on Calhoun Street.[79]

Teddy Harleston, born in Charleston in 1882, graduated from Avery in 1900 as valedictorian. Four years later he received his B.A. from Atlanta University. In 1905 he enrolled at the Boston Museum of Fine Arts school. A talented portrait painter, he reluctantly returned to Charleston in 1913 to help his father with the family business. In 1920 he married an Averyite and photographer, Elise Forrest of Charleston. Together, they opened up the Harleston studio. Teddy's artistic career received a boost when he joined Aaron Douglas to complete the Fisk library murals. In 1931, after winning the Alain Locke Portrait Prize, he contracted pneumonia from his father and died just three weeks after the Captain. Locke described his premature death as an "untimely loss—for Negro art was just on the threshold of a larger audience."[80]

Teddy Harleston's efforts to organize an NAACP chapter in Charleston probably evolved from his days at Atlanta University, where he was befriended by W. E. B. Du Bois. Scarcely a month after Harleston founded the chapter, Du Bois visited Charleston. A group of professional and business leaders, including Benjamin F. Cox, gave the noted scholar a grand tour of the city. During a subsequent visit in 1921 Du Bois delivered a lecture, "The Second Pan-African Congress," and was honored the next day by the local

NAACP. Avery became the center of NAACP activities in Charleston. The NAACP appealed to people like the Coxes. Like the AMA, it was northern-based and traced its roots to abolitionism. Avery offered the NAACP the closest thing it could get in Charleston to a safe haven. Financed by the AMA, parents, and alumni, the school was relatively free of reprisals by racial demagogues. Since it was private, it was not under the dictum of the city board of school commissioners. Thus, while racial radicals were rallying against the "black beasts," Charlotte McFall and other Avery students were extolling the NAACP at commencement exercises.[81]

The Coxes remained staunch supporters of the NAACP. Benjamin Cox was a charter member of the chapter and belonged to its executive committee; Jeannette Cox involved herself in both national and local NAACP activities. In 1923 she was appointed to collect funds locally for the organization's "Million Dollar Anti-Lynching Campaign." When the chapter nearly became defunct in the midtwenties, Cox sought to revive it. Her efforts drew support from Daniel J. Jenkins's Charleston *Messenger*. In 1927, when the chapter was successfully reorganized, Jenkins's wife, Eloise, was elected secretary with another Averyite, the physician E. B. Burroughs, Jr., as president. The close ties between Avery and the NAACP were reaffirmed in February 1934, when Mary White Ovington, head of the NAACP national board of directors, stayed with the Coxes at the teachers' home during her visit. Besides attending a mass meeting held at a local church, she addressed the Avery student body about the NAACP.[82]

Deteriorating local and national conditions for blacks caused Charleston's black elite to gravitate toward collective activism. With Woodrow Wilson in the White House, they recognized that such organized group action was needed to make the social uplift philosophy relevant. With the outbreak of World War I thousands of rural whites and blacks migrated into Charleston in search of jobs. Racial radicals wanted to limit new federal jobs to whites. In 1917 the clothing factory at the Charleston Navy Yard advertised for 600 women, but refused to consider black applicants. Edwin A. Harleston, head of the Charleston NAACP, sought the counsel of W. E. B. Du Bois and Francis J. Grimke, a former Charlestonian who was president of the NAACP chapter in Washington, D.C. Harleston consequently wired a protest to the secretary of war, Josephus Daniels. Within six months, 250 black women were employed at the clothing factory.[83]

The war generated tensions between U.S. naval personnel and the black community. Harleston, who had acted as a defense department consultant for the establishment of a black officers' training camp in Des Moines, Iowa, was especially sympathetic to the plight of returning black veterans.

In 1918 his two-act play, *The War Cross*, was performed in Charleston as a benefit for Atlanta University. When in April 1919 black veterans and their families were turned away from visiting the transport *Mercury*, which had brought American soldiers home from the war, the NAACP leader protested against "the needless humiliation" suffered by blacks, "especially our colored women."[84]

A month after the *Mercury* incident a fight between white sailors and a black Charlestonian precipitated a riot between enlisted men, "assisted by some civilians apparently," and local blacks. Sailors, soldiers, and marines raided two shooting galleries. A number of blacks were victimized by the mobs. Fridie's at 305 King Street, a black barber shop catering to a white clientele, was "demolished." Fridie's was also a gathering place for local black YMCA leaders. A marine detachment helped the police prevent the riot from spreading. The entire episode resulted in the killing of two blacks and the wounding of at least seventeen others, including a thirteen-year-old youth paralyzed from the hips down. Seven sailors and one white policeman were injured. Despite "fanciful reports," a coroner's jury blamed the enlisted men.[85]

To relieve some of the tensions, Charleston's black Interdenominational Ministers' Union, headed by the Calvary Episcopal Church pastor, E. L. Baskervill, joined forces with Harleston and other NAACP officials. They formed a committee to present authorities with "a number of suggestions and a constructive program." Besides urging the Navy to control its enlisted personnel, the group recommended that the city hire blacks on its police force, which, they noted, needed to be expanded to protect all citizens adequately. They asked for improved black "housing, lighting, sanitary, and educational conditions." Requesting support from the white press and religious leaders, they pointed out the need for interracial cooperation by suggesting the appointment of a white committee to confer with a black counterpart on issues of mutual interest. Eventually the Charleston Interracial Committee emerged.[86]

The Charleston chapter of the NAACP grew dramatically from twenty-nine members in February 1917 to over two hundred by November 1918. Although the clothing factory victory initially spurred membership growth, the high point was the chapter's decision to get black teachers into the city's black public schools. In April 1916 the black ministerial union asked the city school board to employ black teachers "as soon as practicable." When the board ignored the request for two years, local NAACP officials took action. The chapter enlisted the support of the former congressman Thomas E. Miller and the Centenary pastor Charles C. Jacobs to form a committee to

petition the board in December 1918. Whereas the ministers' request had not mentioned eliminating white teachers, the NAACP petition appealed to the prosegregationist sentiments of Bleasites in the state legislature. Resting on pedagogical grounds that "there must be reciprocity in love, affection and sympathy between teacher and pupil," the petition stressed, "Without the aforesaid reciprocity there can be no hope planted in the breast of the pupil by the teacher to elevate him and make him a strong man or woman." [87]

The NAACP position on white teachers was understandable. The black public schools were being used indiscriminately to provide teaching experience to Memminger graduates before they were promoted to the white schools. In 1918 the city school superintendent, A. B. Rhett, conceded, "The demand [for teachers] is such that there is no weeding out process." In 1925 in his tribute to the late Edward Carroll, the white southerner who replaced Ennals J. Adams as Shaw principal, Rhett acknowledged other "advantages of first rate importance" for the practice. "I have always been of the opinion that the reason why there has been so little race friction in Charleston," he reasoned, "was that the colored children from a very early age were under the control and influence of white principals and teachers and were taught to look up to and respect white people." [88]

In a hearing held on January 9, 1919, the school board declared that it was impossible to make personnel changes while a bond issue was pending. Thomas E. Miller, a veteran of the state legislature, circumvented the Charleston delegation by persuading a senator from Laurens County to introduce a bill excluding whites from teaching in the state's black public schools. The city school board sent its vice-chairperson and superintendent to the state capital to oppose it. In a desperate last-ditch attempt, a Low Country politician argued that the bill did not represent "the wishes of the colored people generally." Exploiting the color line, white Charlestonians claimed that it was not their cooks and laundresses who wanted the change but the "mulattoes." A similar tactic had worked in the 1890s. Miller decided to undertake a massive petition drive among blacks to disprove the assertion. He asked Cox to urge his teachers to canvass the neighborhoods with petitions. "That's when I got into the fight," Septima Clark recalled. "I volunteered to seek signatures and started visiting the grass roots people. . . . I realize now that the experience of teaching at Avery was one of the most important and formative experiences of my life. It was then that I first became actively concerned in an organized effort to improve the lot of my fellow Negroes." [89]

When the petition drive ended, the canvassers had succeeded in getting signatures from the heads of 4,551 households, representing 22,755 indi-

viduals, or roughly two-thirds of the city's black population. John A. McFall had the petitions certified by the Charleston educator and lawyer Paul M. Macmillan. The emissaries were accompanied to the train depot by hundreds of well-wishers. The strategy of the Low Country politicians to kill the bill on the grounds that grass-roots blacks did not want it had backfired. As one state newspaper explained, they "dug a pit" for themselves and set a "precedent which might be invoked in other fields." The Charleston school board abided by the new legislation by agreeing to employ only black teachers in its black public schools as of September 1, 1920. The stunning victory garnered Harleston and the Charleston NAACP favorable national publicity. During the summer of 1919 Harleston addressed the NAACP national convention in Cleveland. W. E. B. Du Bois requested that he write an article about the campaign for the *Crisis*.[90]

Charleston's Black Public Schools, 1920–1940

The period 1920–1940 highlights the unique and significant contributions Avery continued to make as the city's only black high school. By the late 1920s most of the principals as well as teachers in Charleston's black public schools were Avery graduates. Despite its employment of black principals and teachers, the school board was determined to maintain white control over its black schools and to continue its industrial education policy. A history of the local black public school system during the two decades illustrates what might have happened to Avery had the AMA turned it over to the city in 1898.[91]

The NAACP victory in 1919 did not automatically mean the employment of black principals in the black public schools. The Charleston delegation managed to win a concession whereby whites would still be in charge as principals; however, the city superintendent, A. B. Rhett, was unable "to secure suitable principals." The "experienced, middle-aged white women teachers" as well as the white men he approached declined. Forced to hire blacks, Rhett had misgivings about them; none had any experience handling student bodies larger than two hundred students. But toward the end of their first school year, Rhett conceded that the three black men had done "fairly well."[92]

Only the Burke principal, David R. Hill, experienced any real difficulties. Ten of his teachers, led by Louise D. Purvis (Bell), charged that the Averyite had failed to maintain discipline. A physically small man, the new principal may have experienced difficulty in dealing with larger unruly students. With

Purvis's encouragement, nineteen students signed a petition agreeing with the dissident teachers. The board, perceiving the protest as a threat against its authority, dismissed Purvis and suspended the student leader. The youth had to write a letter of apology and read it at a general assembly of the school. For good measure, the board suspended his father, one of its employees, for one week. Forced to transfer Hill to the new Buist School, Rhett gathered all the city's black principals and teachers for a meeting at Shaw and censured those involved in the Burke protest. Hill's replacement, B. B. Jones, faced similar disciplinary problems, especially among the "larger boys," until five students were suspended.[93]

The summary transfer of Hill suggested that the city school commissioners and superintendent intended to maintain rigid control over their black schools. One of Rhett's first acts following the transition to black teachers and principals was to appoint Edward Carroll, the former white principal of Shaw, as "supervisor of Negro schools." Rhett claimed this additional layer of bureaucracy was necessary to show "teachers and pupils that the white people still have an interest in the schools and an authority over the schools, which they are prepared to exercise." According to Rhett, Carroll "was widely respected by the Negroes, knew how to talk to them, and how to influence them. He exerted over them at all times a wise and salutary influence." However, conflicts between the black principals and their white supervisor were inevitable. When Carroll died in 1925, he was replaced by F. W. Wamsley. In 1932 a board committee investigated charges made by Wamsley that the Burke principal, B. B. Jones, had refused to recognize his authority "in matters relating to the conduct of the school." The committee recommended that the board send to the black principal a letter instructing him to do so. Wamsley continued to serve as supervisor of Negro schools until his retirement. In 1944 the board appointed William H. Grayson, Jr., an Averyite, to be his successor.[94]

As the warning to Jones suggested, the board closely monitored the black principals' work. It also monitored their after-school activities. Bright, articulate, and independent-minded, the Averyite James Andrew Simmons found this out the hard way. Born in Charleston in 1903, Simmons was a member of a family of fiercely proud, dark-skinned antebellum free blacks. His father was a tailor; his mother, a seamstress. The parents, Catholics, sent their only child to the School of the Immaculate Conception from grades one through eight before they enrolled him in Avery. Their son, finishing high school in 1920, went on to obtain a B.A. at Fisk and later an M.A. and Ph.D. in educational administration from Columbia University. After graduating from Fisk in June 1926, Simmons returned to Avery as a sci-

ence teacher, taking over the biology classes. He taught there until he was appointed principal of Simonton in 1930. Simmons provoked the wrath of local white authorities by urging his teachers to register and vote; he further irritated officials by a speech he delivered on Race Relations Sunday in February 1932. According to one account, Simmons protested against "the segregated seating arrangements on the Battery, on streetcars, and at Colonial Lake Park," which, he claimed, had occurred after he had left for Fisk. Some of the white persons in the audience, especially Homer Starr, were offended. Starr was rector of the Church of the Holy Communion and chaplain at the Citadel. The Episcopal minister charged that Simmons was a "dangerous man," whose speech implied "social equality." F. W. Wamsley, the supervisor, reported the incident to the board, which launched a full-scale investigation into the matter and also Simmons's "political activity."[95]

When the board interviewed Simmons, the young principal admitted he had been critical but denied he had gone so far as to advocate social equality. He pointed out "that he had been born and raised in Charleston and fully understood the local situation." Simmons acknowledged that in his speech he had deplored the circumstances whereby many occupations formerly held by blacks were now being filled by whites. He also had urged that the city hire one or two black policemen for the black neighborhoods. As for his involvement in politics, he conceded that he had advised his teachers to register to vote but "had done this outside of the school and school hours." Whites interviewed as character witnesses denied Starr's charges. One of the board members tried to defend the black principal by claiming that Simmons had "always opposed the teaching of Du Bois and had told the colored people that these teachings were doing a great deal of harm." The board, inducing Starr to admit Simmons had not advocated social equality, closed the matter by instructing the chairman to make the black principal understand that if in "public addresses" he should make "harmful statements," he would be held responsible as a public school official.[96]

Rather than acquiesce in the board's dictum, Simmons resigned and moved to Columbia to head Booker T. Washington, the state's largest black high school. Under his leadership, it was "the first of the only two grade A high schools for Negroes in South Carolina accredited by the Southern Association of Colleges and Secondary Schools." During the early 1940s Simmons again provoked the wrath of the white establishment by "instigating" a lawsuit against the Columbia school board for equalization of black and white teachers' salaries on the basis of equal certification.[97]

Simmons represented the emergence of a cultured and college-educated black leadership that advocated a more activist-oriented interpretation of the

social uplift philosophy. He had participated in the 1924–1925 demonstrations at Fisk for student rights as enjoyed on white campuses. On February 5, 1925, Simmons delivered a speech at a mass meeting in Nashville to protest the arrest of five students in connection with the demonstrations. Seeking parental support for a student strike, he published a pamphlet, *The Fisk Situation,* with his name and Charleston address. Inspired by his example, Septima Clark recalled the hardships this black educator and his mother endured for his "political activities" in Charleston and Columbia. Simmons was motivated to some extent by his study of teachers in the state's black high schools, both private and public. Conducted around 1935 for his M.A. thesis, the survey included 141 teachers, or 42 percent of the 333 teachers reported to be employed in the black high schools. Only 5 of these 141 teachers were white. Simmons discovered that the median annual salary of the men was $640 while that of the women was $475—both of which were below the average teacher salaries paid white men ($1,249) and white women ($832). Simmons realized that a more equitable salary schedule was needed to retain the better qualified teachers and to encourage professional growth.[98]

The attitude of the Charleston city school board and superintendent had manifested itself earlier on the salary issue when the officials were still planning the transition to the employment of black teachers. The superintendent, A. B. Rhett, told the board in May 1919, "It is customary in cities where negro teachers are employed to teach negro children to have an entirely different salary schedule for negro teachers. This ranges from 50% to 75% of the white salary schedule. I would recommend that a salary schedule for colored teachers in Charleston be adopted, which shall amount to ⅔ of the white schedule." Not surprisingly, the black principals were paid salaries lower than those received by their black counterparts in other southern cities. The board avoided the whole issue of pensions for black teachers. It was able to do this because, with a few exceptions, such as Sallie O. Cruikshank, who had taught at Shaw since Reconstruction, none of the new teachers would be eligible for pensions for many years. A few years before her death in 1932, the board made Cruikshank a vice principal at Shaw to avoid "the very troublesome question." By 1936 blacks were forced to petition the board about the deplorable salary schedule and the lack of a pension plan. They complained that the black elementary school teachers had not received a salary raise for fifteen years and the black high school teachers were being paid only fifty dollars more per month. The petitioners also called to the board's attention black teachers who having "reached a certain age find it impossible to do creditable work."[99]

The board's monitoring activities included maintaining strict segregation

in the schools. When white parents complained in 1934 that their children were being forced to associate with blacks at one of the city schools, both the board chairman and vice-chairman, as well as the principal of the school, went to Summerville to investigate where the parents of the allegedly black children had lived. The board decided that the parents were "of mixed blood" because they had resided in the predominantly "brass ankles" section of town. The "brass ankles" were those of mixed blood who were descendants of whites, blacks, and Indians.[100]

Between 1914 and 1940 Charleston's black public schools were both overcrowded and underfinanced. "The schools that we have are insufficient to accommodate the numbers who apply during the enrollment season," the Colored Ministers' Union informed the board in 1916. "They have either to be turned away or sent to the Industrial School where temporary provision may be made for a limited number; and the distance to the school is almost prohibitive to small children." The situation worsened when black enrollment dramatically grew after black teachers were employed in the public schools. The George Lamb Buist School opened in 1921, but the enrollment increase for the year was so "tremendous" that the black schools remained "extremely overcrowded." The average number of students per teacher at Shaw (60.6:1), Buist (53.7:1), and Simonton (56.6:1) was disproportionately high, especially when compared with that of their white counterparts at Mitchell (37:1), Courtenay (39.4:1), and Simons (42.7). To redress the imbalance, the city school board would have had to increase the proportion of money spent on the black schools. Determined not to do this, it argued that 75 percent of the expenditures went for white schools and 25 percent for black ones in 1925, because blacks paid only 3.23 percent of local taxes, while whites paid 96.77 percent. The result was that the black students were forced to attend school part-time or in double sessions. The addition of Henry P. Archer School in 1936 did little to alleviate the situation. In January 1940 the outgoing chairman of the board, M. Rutledge Rivers, admitted that "the present congested condition of the negro schools is . . . a disgrace to us and a potential factor for breeding unhealthy conditions in our City; in some of our negro schools the situation of the pupils may be compared to the enforced proximity of sardines in their cans."[101]

An additional shortcoming of the board was its attempt to maintain the industrial educational program it had enacted for blacks in 1911. Its endeavors were supported by Andrew Burnett Rhett, superintendent from 1911 through 1946. Born in Charleston at the end of Radical Reconstruction (November 22, 1877), the superintendent was the son of the major Andrew Burnett Rhett and Harriett Aiken Rhett. A graduate of the High School of

Charleston, he attended the College of Charleston but obtained his B.A. and M.A. from the University of Virginia. At the time he was selected to replace Henry P. Archer (tenure 1885–1911) as superintendent, Rhett was principal of Memminger and Archer's assistant. During his thirty-five years as superintendent, Rhett personified the reactionary tradition of the Charleston white elite.[102]

Before the city's industrial education program for blacks was established, the two existing black public schools, Shaw and Simonton, provided an education from preparatory school through the eighth grade. After the Colored Industrial School (Burke) was opened in January 1911, black children were to attend the elementary schools for five years, then the industrial school for three more years. This concluded their public education. In 1916, when the Colored Ministers' Union petitioned the board to ameliorate the deteriorating conditions of the black public schools, one of the requests was an upgrading of the courses of study. The ministers wanted the education at the black elementary public schools extended from the fourth to the sixth grade. They also asked that a more advanced program be offered at the industrial school because "an eighth-grade education, with a large percent of that industrial, is not sufficient qualification for race leadership nor for the profession of a teacher." Despite the addition of grades at Burke and other concessions, the board remained consistent in its opposition to higher academic education for blacks, even after it employed black teachers and principals. By 1925 the board had added the eleventh grade at Burke but refused to allow French and Latin to be taught there. That year the superintendent, A. B. Rhett, staunchly defended the policy as a plan based on the philosophy that to gain a livelihood "the education the negro needed most was industrial." He added, "This, of course, is the well-known plan worked out at Hampton Institute by Dr. Armstrong and at Tuskegee by Booker T. Washington." Asa H. Gordon, a black professor at South Carolina State College, wrote in 1929, "The Burke Industrial School was built in 1910 near a dumping ground. It has from the fifth to the eleventh grade and an enrollment of nearly 1,000 under 24 teachers. This is supposed to be the high school, but the real high school for the city is a private school, Avery Institute." As late as 1937 Rhett maintained that "the Board has a definite policy of encouraging vocational training in the high schools rather than strict academic training." Two years later a committee representing black PTA, civic, and ministerial organizations petitioned for an accredited high school because Burke graduates found "it impossible to enter higher institutions without repeating one to two years of work that they had not had because of lack of facilities."[103]

Despite these handicaps, Charleston's black public schools showed marked improvement after the employment of black teachers and principals, the majority of whom were Avery graduates. Perhaps the Colored Industrial School, renamed J. E. Burke in 1921, benefited most from this influx of Averyites. The Burke principal, William Henry Grayson, Jr. (Avery, 1925), labored hard to give it his alma mater's excellence. His teaching corps included exceptional Averyites like H. Louise Mouzon and Sarah Green Oglesby.[104]

Louise Mouzon was the daughter of Henry Mouzon, a shoemaker, carpenter, and Methodist minister from Kingstree, South Carolina. One of the French Huguenots who settled in Williamsburg County, South Carolina, between 1720 and 1737 was a Henry Mouzon. A Captain Henry Mouzon fought in the American Revolution. In 1853 Louise Mouzon's maternal grandfather lived at 16 Anson Street, Charleston, where the family residence is still located. Mouzon was born in 1896 at Sumter, where her father was district superintendent of the northern Methodist church. From 1905 to 1912 he served as pastor of Charleston's Centenary Church. After Mouzon graduated from Avery in 1914, she taught in the state's small rural towns. In 1920 she became one of Charleston's first black public school teachers. She served thirty-seven years at Burke and five at Buist. During most of the period at Burke she taught mathematics. Throughout her teaching career she continued her formal education. She attended Hampton Institute and received a B.A. from Claflin, where her father had studied. Later she obtained an M.Ed. in mathematics from Boston University. She also did graduate work at the University of Chicago. Mouzon represented the synthesis of an antebellum black educational tradition and northern missionary efforts. Both of her parents had been teachers. Her sister Mattie and her brother Matthew also graduated from Avery to pursue teaching careers. Matthew Mouzon became acting head of Burke and later principal of Buist. Louise Mouzon remained active in the work of the Methodist church after she retired from Burke in 1962.[105]

Sarah ("Sadie") Green Oglesby, graduating from Avery in 1918, revealed the Cox stamp on Low Country education. Through a work scholarship obtained by Cox, Oglesby was able to continue her education at Fisk, where she received a B.A. in classics. She later obtained her master's degree from New York University. After she taught briefly at Avery and Allen University, she moved to Burke at the insistence of her former pupil, William H. Grayson, Jr. Coming from Avery, where writing and declamation were highly valued, Oglesby believed that students needed to know standard English. On one occasion, with Grayson's support, she confronted her Burke colleagues

through a general letter, chastising them for tolerating nonstandard English in the classroom. Besides her regular teaching duties, she was drama coach at the school and her church. "The culture that I received in my high school," she remembered, "has caused me to make a contribution to the community. I have a philosophy that I'll never regret and I'll say it was started by Mr. Cox at Avery, carried on by Fisk. . . . My philosophy is to give a part of myself and my intelligence to all with whom I'd come in contact."[106]

The Fading Color Line

The NAACP campaign to get black teachers into Charleston's black public schools was a landmark in the development of racial solidarity within the black community. Yet eleven years later the color line, although fading, remained a volatile issue. In the summer of 1930 Thomas E. Rodgers publicly accused John A. McFall along with Thorne and Miller of promoting intra-segregation. The two doctors were probably the NAACP leader William Miller Thorne and Thomas E. Miller, Jr., the son of the former congressman T. E. Miller. Thorne, a member of the Charleston County, Palmetto, and National Medical associations as well as a surgeon at the local black hospital, was descended from the light-skinned antebellum free black elite. His paternal grandparents were Philip M. and Elizabeth (Weston) Thorne. Rodgers charged the three men of asking the Riverside Park Company that "special days or special part of the said Park be set aside for people of color and that black people be barred from attendance from such Park or on such days from said Park." Incensed, McFall decided in August to sue Rodgers for slander. The Charleston *Messenger,* coming to McFall's defense, described him as "a first citizen in all things pertaining to the advancement of his race." Although there were members of the light-skinned elite who exhibited sentiments Rodgers decried, the three men accused did not belong to this group. Thorne, who had worked his way through college and medical school, believed that racial uplift could be achieved by "improvement in the school system, together with more unity and less caste."[107]

The 1930 incident revealed that stereotype perceptions, bolstered by color consciousness, continued to exist. Even today when people relate local stories and events, they refer to the son and namesake of the former congressman Thomas E. Miller as "the white Dr. Miller" and to the dark-skinned William H. Miller as "the black Dr. Miller." The Charleston Mutual Savings Bank is still remembered as "the white bank," the Peoples Federation Bank "the black bank." Such distinctions were never so clear-cut, even

during antebellum times. Important political and social organizations such as the NAACP and YMCA had a leadership composed of both light- and dark-skinned individuals. In 1921 directors of "the white bank" (J. H. Rodolph and J. A. McFall) as well as "the black bank" (William H. Johnson and J. E. Beard) were on the executive committee of the local NAACP. "The black Dr. Miller," along with Edwin A. Harleston, was active in both the NAACP and the Cannon Street Branch of the YMCA. In 1920 the educational and publicity committee of this YMCA branch indicated a leadership of professionals and businessmen (many of them Averyites) that transcended color lines. Members included E. A. Harleston, R. F. Morrison, J. D. Moore, William H. Miller, J. R. Logan, E. C. Mickey, and J. C. Berry (chairman).[108]

Easter Monday, April 17, 1922, about twelve years preceding the Riverside Park flap, the local black community celebrated the opening of Lincoln Park, located eight miles north of Charleston on Ashley River. The event was promoted by Daniel J. Jenkins, whose orphanage owned the park. Local black pastors who were key speakers included N. B. Perry (president of the Interdenominational Ministers' Union), J. E. Beard (Morris Brown AME), E. L. Baskervill (Calvary), C. S. Ledbetter (Plymouth), W. P. Jones (Central Baptist), C. H. Uggams (Zion Presbyterian), W. R. A. Felder (Mt. Zion AME), L. F. Allston (St. Luke AME), and the presiding elder, E. H. Colt. The guest speaker was the evangelist Alex. Willbanks of Washington, D.C., the noted "Black Billy Sunday of America." A one-hundred-voice choir and the orphanage band provided the music. The program was followed by a "great" hog-and-calf barbecue. A singing contest among the various church choirs and Sunday schools was judged by Benjamin F. Cox, J. Donovan Moore, William L. Blake, James Logan, and William Lawrence. To maintain order and decorum, there was a committee of one hundred, composed of two representatives from each church in the city. The Lincoln Park celebration revealed the progress made toward the ideal of a close-knit black community with a leadership responsive to its welfare and needs. The Riverside Park episode that occurred twelve years later illustrated how deeply embedded in the psyche and folklore of black Charlestonians were the antagonisms associated with color and caste.[109]

Paradoxically, racial radicalism not only helped create a black professional class by pressing segregation but also undermined the economic basis of the color line. The old elite, basically artisans, held jobs that afforded them some economic opportunity. As long as their livelihood and economic advantages rested on their servicing the white elite, they were encouraged to maintain a caste-and-color line. However, the segregation wrought by racial radicalism

led to Charleston blacks' losing skilled jobs to whites. In 1915 the Averyite Edward A. Lawrence poignantly made the point. "Today, we find that from necessity positions that we formerly filled to our pecuniary advantage," he explained, "are now held by others, and from which we seem forever barred. . . . It used to be a pleasure to take strangers to see the numerous homes occupied by members of our race, whose history would be something like this: The husband is a mechanic, or a driver of a truck of some kind, or for that matter an ordinary laborer, his wife a dressmaker, a laundress, a cook; the home, and sometimes additional pieces, represented the industry and thrift of that prudent people." The loss of jobs to whites eroded the economic base of the old elite and the pragmatic validity for their practicing the color line. For J. Andrew Simmons, the crime of segregation was the economic damage it inflicted on the black community. If blacks had economic opportunity, they could elevate themselves. They could "have dining rooms of their own to eat in and would not have to eat as now in the kitchen."[110]

World War I as well as racial radicalism produced economic changes undermining the color line among blacks. Both phenomena, especially the war, ended Charleston's relative isolation as thousands of its blacks, light- and dark-skinned, traveled far outside the South. For some returning veterans, the color line must have appeared provincial and undemocratic.

Although the "old order" had practically passed away by 1925, color and caste divisions lingered. Other black communities in South Carolina faced these divisions, but Charleston's "aristocratic conceit" was deeper and longer-lasting. Septima Clark, recalling her experiences in the state capital during the 1920s, noted, "I hadn't been in Columbia long, before I discovered that up-country Columbia in the center of the state was different from my native Low Country. Charleston, both white and Negro, was deeply rooted in tradition; Columbia was more democratic. In Charleston I had never been able to outlive the fact that I had been born of a father who had been a slave and a mother who had taken in washing and ironing." Clark's observations were echoed by northern blacks who settled in Charleston. Charlotte DeBerry Tracy, who grew up in Springfield, Massachusetts, remembered some wealthy black Charlestonians who resembled their "South of Broad" white counterparts in their disdain for physical labor and their desire for cheap domestic servants. Because some wealthy black Charlestonians could hire servants from the country for two or three dollars a week, their children did not have to learn to do housework. One day, a man, seeing Tracy sweeping in front of her home, told her that ladies were not supposed to do such work.[111]

Charlotte Tracy's background afforded her a unique perspective to view the situation in Charleston. A dark-skinned northern black whose ancestors had been slaves before the war, she was the daughter of William N. DeBerry, the pastor (1899–1935) of St. John's Congregational Church in Springfield. Educated in predominantly white public schools, Tracy later graduated from Fisk, where she was the roommate of W. E. B. Du Bois's daughter, Yolande. In 1923 Tracy went to Avery as a social studies teacher and soon thereafter joined the Phyllis Wheatley. She married Henry G. Tracy, a Charleston barber. Their son, William D., graduated from Avery in 1948 and attended Fisk.[112]

Henry G. Tracy learned his trade at Felder's Barber Shop, established in the late nineteenth century. By 1926 Tracy had saved enough money to open up his own establishment on the ground floor of the Berkeley Court Apartments. At his shop, as well as Felder's and Fridie's, the predominantly light-skinned barbers catered "exclusively to a white clientele." A limited but regular patronage provided a stable livelihood for the barbers, many of whom owned their homes. These shops usually serviced a customer and his male progeny for several generations. Even after Felder's death in 1941, the King Street shop remained a "Charleston fixture." The three establishments, especially Felder's, represented the last vestiges of a three-tier system. Even these barbers, however, defy any easy generalization. In the 1930s both Felder and Tracy belonged to the Charleston chapter of the NAACP.[113]

Charlotte Tracy was in a unique position to see how the elusive color line, though fading, still survived in Charleston. According to her, Avery mirrored the divisions within the larger black community. The children reflected the attitudes of their parents. Some "free" fair students felt superior to the "free" brown ones, who, in turn, sometimes considered themselves superior to those without "free" ancestors. The "free issue" division was real enough when Tracy began working at Avery in 1923. Lecturing in a social studies class on the causes of the Civil War, she started to talk about slavery. Observing that a fair-skinned male student was refusing to pay attention to her, she proclaimed that *all* the students should be interested in the subject because at one time or another they *all* had ancestors who were slaves. This faux pas proved too much for the young man. The new Yankee teacher was making generalizations about his ancestors he did not think accurate. He told her that she was mistaken, that his ancestors had not only always been free but, in fact, had owned the ancestors of some students in the classroom. Tracy had the presence of mind not to contest his assertion, which proved to be true. However, by the 1930s, with the passing of most of the Civil War generation, the "free issue" division had subsided.[114]

Tracy also detected an unstated attitude that a person who "looked like white" had more to offer than a dark-skinned black who might have more character and substance. Dark-skinned students felt the burden of having to prove themselves. Some believed that no matter what they were, or how hard they worked, they would be excluded from certain student awards and extra-curricular activities. Returning to Avery as teachers, they still felt a need to prove themselves to skeptical colleagues and students.[115]

Although it appeared to some outsiders that cliques developed along color lines, whatever intrasegregation existed at Avery was apparently not planned. The overwhelming majority of graduates interviewed—fair-, brown-, and dark-skinned—recalled no inflexible color line's socially prescribing their relationships. Many cliques can be traced back to neighborhood circles, which frequently served as extended families. Friendships often transcended any color line. Lucille Williams remembered that her "fair" and "blue-eyed" playmate Thelma Hamilton Woods used to go to Francis Marion Square to throw stones at John C. Calhoun's statue because "he didn't like us." Woods, a member of St. Mark's, graduated from Avery in 1937 with Williams, who later taught at the school. In 1956 Woods "upset a lot of apple carts" by becoming the postmistress at the Ashley Avenue substation. "As a (black) clerk waiting on the public," she recalled, she went "strongly against the traditions of the times." During the 1960s she was active in the NAACP.[116]

Most Avery teachers were probably free of overt color prejudice, but they had their biases. Some were manifestations of a private school dependent on steady patrons and active alumni. Over the years Avery had developed a regular group of patrons, or families, who had been sending their progeny to the school for several generations. Many of the children, after graduating, became active alumni. The students from these families, whatever their skin color, had an advantage. The wealth and status of a student's family also influenced the way some teachers and administrators viewed their charges. Given the financial straits of the school during most of its existence, it would be hardly surprising that some of its wealthier patrons received preferential treatment. Ironically, the teachers most prone to this kind of favoritism were non-Charlestonians, newcomers hoping to win their way into the city's black social life. The children of the well-to-do, who seemed to win a lion's share of the student awards and to dominate the various student extra-curricular activities, became collectively known as "the syndicate."[117]

Of all the teachers, Florence Alberta ("Bertie") Clyde embodied old Charleston. Born in the city in 1873, she was the daughter of a post office mailing clerk. Like her parents, she attended St. Mark's. Graduating from Avery in 1891, she served an eleven-year stint in the Charleston County

schools, before she joined its faculty in 1902. She had a reputation for being "color struck." Some graduates, even today, are absolutely convinced that Clyde slighted them because of their skin color. She certainly had her favorites. Joseph I. Hoffman, Jr., remembering Clyde as "a close friend" of his mother's, remarked, "She was a person who was very partial to those children who were friends of hers. . . . She used to embarrass me by being very partial to me and I never did like that kind of thing." [118]

Clyde's defenders, including dark-skinned graduates, argued that much of the resentment against her was due to her high standards. She was a disciplinarian who could on occasion flay the children of the rich and poor with equal abandon. The state legislator Herbert U. Fielding, son of an undertaker family, recalled that Clyde used to rap his knuckles. He considered her a fine teacher. Even her critics conceded she was a crackerjack teacher. Promoted from teaching the eighth grade to supervising the normal department, she helped turn out a long line of effective teachers. For several years she also directed the summer teachers' training program at South Carolina State College. Acknowledging "her loyalty, faithfulness, and dependability," the Avery class of 1939 codedicated its yearbook to her. In 1943 the AMA asked her to be acting principal. Eight years later "honor" seniors, preparing a dramatization of "Avery—Past, Present and Future," considered Clyde, along with Francis L. Cardozo, Morrison Holmes, and Benjamin F. Cox, one of the "characters . . . who figured in the history of the school." In 1959 the Interdenominational Ministers Alliance was one of several local community organizations, including the Burke PTA, which recommended that one of the public elementary schools be named after her because she was "an excellent teacher" and "a leader in education during her time." Having continued her own education through the Chautauqua movement and later at northern universities, she was ahead of her time in the teaching methods she introduced to her students. "Nearly every school," the ministers noted, "in this city and in neighboring towns and cities have in them teachers who have studied under Miss Clyde." [119]

Florence Clyde was part of a Charleston tradition of strong black teachers who were generally respected and admired for strictly enforcing a standard of excellence within and outside the classroom. Several of these teachers operated the small private schools that mushroomed before World War I when they were not allowed to teach in the city's public schools. One of these teachers was Mrs. Knuckles. Like Clyde, she was a strict disciplinarian who had strong biases. "She had great pride," Septima Clark recalled, "and demanded that her children, her school pupils, have pride too. In the first place, the children of her school were a selected group. She didn't take

just anybody who had the money for tuition. She chose her pupils from the Negroes who boasted of being free issues; these people constituted a sort of upper caste. But our teacher required that we act in a manner befitting our superior position." Knuckles severely punished her charges when she caught them violating "her rules of culture," for example, by eating out of a bag on the streets or chewing gum. Paradoxically, Knuckles must have bent her rules to accept Clark into her school. Clark's mother, though born free, was an outsider who took in washing; her father was a former slave with no formal education. Despite Knuckles's biases and severe disciplinary methods, her former pupil greatly admired her. "I suspect," Clark explained, "that my admiration for her influenced in some way at least my early ambition to be a teacher. . . . I remember her as a great teacher. I still feel that many of her methods were more effective than some modern ones extolled by highly trained educators. I bless her memory." Knuckles, like Clyde, personified an old Charleston flawed by an elusive caste-and-color line but still cherished as a model of excellence.[120]

The annual competition for the selection of the valedictorian illustrated the contentions dividing the Charleston black community. "The competition is great," the niece of Edwin A. Harleston wrote in November 1933, "and as we realize, in fact, the whole class realizes, that a friendly, yet bitter fight is going on, the room gets as quiet as a pin when John, Gussie, Carl, Louis, and I recite. We are all studying like Trojans, and each of us has given up some extra-curricular activity or office. John is no longer associate editor of the 'Avery News.' Louis is no longer 'Editor-in-Chief,' and I am no longer President of my class." The victories and defeats arising from these valedictorian contests gave rise to a great stock of anecdotes. According to one story, a disappointed female contender became insane. Although Harleston's niece was not chosen to be valedictorian, she overcame her disappointment. Graduating with honors, she spoke at her commencement exercises on the American Missionary Association and its ideals. Color-line tensions sometimes erupted over these contests. Even before the faculty and administration had become all-black, rumors abounded in the community that there was a conspiracy at the school to prevent the dark-skinned students from winning the awards. Mamie Garvin Fields refused to enroll at Avery because she believed "honors were always given to mulatto children, light-skinned half-sisters and brothers, grands and greatgrands of white people. It didn't matter what you did if you were dark." Arthur J. Clement, Jr., who attended Avery from the fifth through the ninth grade (1918–1924), recalled that the leaders in his class for those five years were not dark-skinned but "black." He also thought that a number of valedictorians and salutatorians were "black

students." However, there appears to be some truth to the charge of favorit-ism. L. Howard Bennett recalled how absolutely convinced his mother was that Florence Clyde had manipulated the grades to prevent his older sister from becoming valedictorian. The competition had boiled down to a strug-gle over grade points. Her teacher Susie A. Butler had given the Bennett girl a monthly grade of 93 percent, but it was finally reported as an 87 percent, causing her to lose out to the other contender, who was probably the one Clyde preferred. There is some evidence to suggest that late in life Clyde regretted some of her earlier prejudices. In her old age she was visited and cared for by some of the darker-skinned graduates whom she had slighted as a teacher. Despite her flaws, they found merit in her lifelong dedication to Avery.[121]

Exactly how much the Coxes countenanced the attitudes of persons like Clyde cannot be determined. Most students, whatever their skin color, be-lieved that Benjamin Cox had their well-being at heart. Family members argued that the Coxes gradually but systematically strived to eliminate the color line. Their daughter, Ann Rheba Cox Davis, explained, "The color/ caste situation was quietly 'dismantled' rather than being discussed. Wher-ever it was noticeable, caused someone discomfort or denied an opportunity —my father took *firm* steps to effect a change. He actively introduced other positive values other than 'color' and personal appearance. In my life time at Avery, I saw a healthy improvement in this area." Cox placed culture above color and class, an ideal which the Charleston black elite, by their own uplift philosophy, advocated. Steps he took to "dismantle" the color-caste problem included the enforcement of a dress code among the young women to minimize class pretensions, the broadening of the faculty and student body to include more dark-skinned individuals (a process begun during Re-construction), and the promoting of such persons to positions of authority. Jeannette Cox reinforced her husband's efforts by being a counselor to the young women and a "cultural developer." Perceiving what the Coxes were trying to do, L. Howard Bennett, described as "progressive," believed that his mentor did contribute to "the erasure of the color-caste lines in proud old Charleston."[122]

The dress code Cox enacted was one of the firm steps he took to dis-courage some of the class pretensions he found at Avery. He minimized the competition that had developed between parents over the graduation dresses for their daughters by mandating that the cost of a dress not exceed $1.25. Lace and other elaborate trimming were not allowed. In addition, Cox enforced everyday dress regulations; the young women had to wear cotton stockings instead of the costly silk ones. This was a great relief to many par-

ents, like Septima Clark's, who could ill afford to spend their hard-earned money in such a manner.[123]

Cox appointed teachers, such as Septima Poinsette Clark, Sarah Green Oglesby, Geneva Pinckney Singleton, G. Hortense Bowden, J. Andrew Simmons, and John Whittaker, who detested any caste or color line. None of them was a member of the "upper crust" families of the antebellum light-skinned, free black elite. Arthur J. Clement, Jr., remembered a "slew" of dark-skinned teachers, including Oglesby and Cox's assistant, John M. Moore. Some of these teachers provided solace to students with real or imagined grievances. Leroy Anderson recalled the counseling he received from "Prof" John Whittaker as an adolescent concerned about his future. Early in his freshman year, Anderson had anxieties about himself and his studies. He felt frustrated by the "subtle slights and exclusions experienced daily at Avery." He confided in Whittaker about his anxieties, which were especially acute after he had not been accepted into several extracurricular activities. He believed that he had been excluded because he was not a member of one of the "privileged" families. After talking to Leroy's parents about their plans for his future, Whittaker placed the youth in his octette and got him into the drama club and onto the basketball team. Worried that Leroy would dwell on the negative and allow his grades to suffer, the teacher warned, "Now listen boy. We aren't going to use this for an excuse any longer. You are going to . . . study hard."[124]

Septima Clark, who taught the sixth grade at Avery during 1918–1919, revealed that the teachers had problems in disciplining the children of "certain" parents, usually those of better economic standing. According to Clark, these parents "were positive that their children were all A students and that their conduct was exemplary. Visits to them by the teacher to report on the work of their children accomplished little. Most of the time these parents, if the teacher's report of the pupils was not too favorable, simply refused to believe the teacher." Not catering to these parents, Cox supported teachers who attempted to discipline the children. One incident involved the dark-skinned Geneva Pinckney Singleton, a former Avery student and Fisk graduate who returned in 1927 to teach mathematics. Married to William C. Singleton, a dentist, she remained at the school until its closing in 1954 and then transferred to Burke. During the early 1930s some young women from the "better" families arrived late at Singleton's algebra class. Calling them "privileged characters," she sent them to the principal's office. Cox ordered them to go home and not return without their parents. Several of the parents withdrew their daughters and enrolled them elsewhere—the local School of the Immaculate Conception, another school in Washington, D.C.,

and an Episcopal preparatory school in Virginia. The incident did not hurt
Singleton's career at Avery. Eventually she became dean of girls. At the rec-
ommendation of L. Howard Bennett, Avery principal during the 1940s, she
was promoted to supervisor of the senior high school.[125]

Mamie Garvin Fields, critical of intrasegregation at Avery, remembered
some of these teachers in her memoirs. In addition to Singleton, she singled
out the dark-skinned Thomas Robinson, her son's shop instructor when the
lad attended Avery. Besides being in charge of the manual training depart-
ment at the school, Robinson cooperated with the Charleston Federation of
Colored Women's Clubs to establish and direct a manual shop program for
black youths living in the public housing projects.[126]

Another teacher who did not cater to color and class lines was G. Hortense
Bowden. Originally from Boston, Massachusetts, she took over the music
department in 1920. Fields commended this teacher for her professionalism
in placing talent and ability foremost. "She was a beautiful chocolate brown,
smart, and did things her own way," Fields explained. "In getting together
her choir at Avery, she picked whoever had talent, paying no attention to
what family they came from and without regard to whether they were rich or
poor. Miss Borden [Bowden] found voices among those pupils that nobody
else knew anything about. She found musical ability where nobody else ex-
pected to find it. And then she really worked with those children." On the
evening of January 17, 1921, Bowden, accompanied by James R. Logan and
the Aurorean Trio, performed a benefit recital for the school in its chapel.
This concert exemplified the Coxes' perception and fostering of cultural
activities as a bridge to transcend color and caste lines.[127]

Students slighted by Florence Clyde sometimes found a good deal of
solace from Jeannette Cox, whose features were decidedly more ethnic than
her husband's. Sarah Green Oglesby admired Jeannette Cox for being "very
open minded. . . . Her ideals were not of Charleston. She didn't see some of
the things we accepted. . . . she didn't see the caste system. She brought her
children up that they should have culture . . . but don't fall right into the line
of Charleston." The efforts of Jeannette Cox were reinforced by Benjamin
Cox. Ignoring Clyde's displeasure, he placed the dark-skinned Sarah Green
in charge of the tuition boxes. Oglesby's appraisal of Jeannette Cox was con-
firmed by the role she played in transforming the Phyllis Wheatley Club into
a "social crucible." Oglesby and Singleton, as well as Clyde, were members.
One of the former pupils to visit Clyde in her old age, Oglesby, along with
Singleton, recommended that one of the city's public elementary schools be
named after her.[128]

The Phyllis Wheatley Club, having a number of members married to

doctors and other professional men, appeared to some non-Averyites to be another manifestation of the aristocratic conceit. Jeannette Cox failed to take into consideration the hostility and suspicions engendered by decades of division. Mamie Fields and two nurses from the local black hospital organized another group of twenty women. Called the Modern Priscilla, the club took its name from a Boston art magazine for ladies and had much in common with the older clubs, which subscribed to the "Lifting as We Climb" philosophy. As in the Phyllis Wheatley, teachers made up a significant portion of the new club's membership. Susie Dart Butler, of the Phyllis Wheatley, was also a Modern Priscilla.

The attitude of Fields's group demonstrated the difficulty of laying to rest Charleston's aristocratic conceit, even as it was fading. In 1927 the State Federation of Colored Women's Clubs decided to hold its annual meeting at Avery. Each club in the city federation was to assume some task in preparation for that meeting. The older clubs asked the Modern Priscillas to provide the dinner for the main program. Refusing to be "the cooks and maids for the evening," Fields's group instead proposed a buffet, whereby each club contributed a number of dishes. "We arrived turned out in our summer silk dresses and carrying our palmetto fans," she remembered. "We put down our covered dishes and then sat down as fine as everybody else." [129]

Ironically, as black Charlestonians began confronting the color line less obliquely, the issue became a pressing national problem, occasioned by the great migration of blacks northward. The triumph of racial radicalism and the new opportunities afforded by industrialism encouraged thousands of black South Carolinians to leave the state. Even before World War I the presence of black South Carolinians in urban communities like Harlem was significant enough for the migrants to organize the Sons and Daughters of South Carolina and to sponsor regular South Carolina Days. [130]

World War I accelerated the great migration. With the labor supply from Europe virtually cut off between 1916 and 1919, a great demand for black labor resulted. The black population rose dramatically in the various northern cities between 1910 and 1920. Conversely, during the 1920s, South Carolina recorded a loss of 204,000 blacks, a decline of 8.2 percent. In 1930 one-quarter of all native South Carolinians, 87 percent of them blacks, lived outside the state. New York and Philadelphia were especially popular destinations for black South Carolinians. Between 1917 and 1923 nearly one of every two blacks leaving South Carolina for the North settled in Philadelphia. [131]

The rapid influx of large numbers of southern blacks, many from poor rural areas, caused some middle-class blacks in these northern cities to

fear the loss of their hard-won economic and status gains. In New York, Chicago, Boston, and Philadelphia, they scrambled to put some distance between themselves and the newcomers. The color line became a convenient means for the oldtimers to erect a protective barrier. Color prejudice among black northerners was hardly a new phenomenon. "Light-complexioned free South Carolinians" who migrated north during the late 1850s were blamed for bringing "their color prejudice to the North, creating discord and divisiveness in the Black Community." Some dark-skinned southerners also carried their biases with them. Robert Abbott, who chafed at the discrimination he had suffered from the "blue-veined elite" in Savannah, Georgia, preferred hiring dark-skinned persons to mulattoes on his Chicago *Defender*. In Philadelphia, the color-and-class line was severe, appearing in various institutions, such as the churches and YWCA, much as it had in Charleston before World War I. As in Charleston, anecdotes have survived; some have an unreal quality. One woman remembered a club of workingmen during the early part of the twentieth century called "the 'Yellow Daffodils,' because every man was yellow." [132]

It was in this milieu that Marcus Garvey made his appeal to the black migrants with a version of the traditional uplift philosophy that was shaped by his Jamaican background. He described "the bulk of our people" as "contemptible—that is to say, they are entirely outside the pale of cultured appreciation." The task of his Universal Negro Improvement and Conservation Association was "to go among the people and help them up to a better state of appreciation among the cultured classes, and raise them to the standard of civilized approval." This standard sometimes amounted to adopting the cultural forms of the British Empire. Garvey had little appreciation for Afro-American folk culture. Disdaining jazz and the spirituals, he claimed they were appreciated by blacks who did not know any better music. [133]

Garvey's appeal rested on his "black is beautiful" philosophy. Many southern blacks, raised in a white society that constantly belittled their dark-skin color, had internalized some of the disparaging notions promulgated by whites. Garvey, stressing racial purity and demanding that officeholders in his organization be 100 percent Negro, appealed to the deep resentment these migrants felt toward the light-skinned older residents who were discriminating against them. The color-line tensions engendered by the great migration gave credence to Garvey's assertion that a three-tier system existed. Advocating a racial solidarity that excluded the light-skinned blacks, he proposed using this group as a "buffer class which would bear the brunt of race prejudice between whites and blacks." In attacking W. E. B. Du Bois as a "monstrosity," Garvey catered to a deeply held prejudice against mulattoes

among southern blacks. In the long run Garvey was mistaken and the movement for a more inclusive racial solidarity picked up momentum as whites, northern and southern, continued to label all Afro-Americans "black." Even in Philadelphia, the color line faded. It had fostered a constructive competition between the migrants and the old elite, who, finding themselves both outnumbered and outvoted, modified their attitude. However, as in Charleston, the color line left "bitter resentments," which linger today.[134]

CHAPTER

5

The Struggle to Survive,
1936–1947

In February 1936, a few months before Benjamin F. Cox retired, John A. McFall was a speaker at the annual Race Relations Sunday, held in Charleston's Central Baptist Church. "I am of the opinion that the principal cause [for the hatred, bitterness, and prejudice between the races] is the absence of a common parity in culture," he told the audience, "a parity which should have the quality of making each individual, irrespective of his walk in life, a useful, worthwhile citizen. When this parity is shared . . . we begin to know our neighbors. Color disappears and strange to say, we find our neighbors are human."

At first McFall's speech on race uplift sounded remarkably similar to the address given by Alonzo G. Townsend to fellow Avery alumni in the 1890s. But as McFall continued, he expressed a pessimism not present in Townsend's speech. Whereas the Methodist minister denied the existence of any real race problem, McFall charged that prejudice against blacks "has deprived us of the full enjoyment of the rights of citizenship" and "that measure of education which would bring us to a clearer conception of life and its responsibilities. It surrounds us with economic barriers beyond which we cannot pass. It restricts the wages paid for our energy to a mere pittance when compared with that paid to others for the like amount of work. It imposes unjust and excessive taxes upon us, and compels us to pay these taxes from the meagre dole we receive. It writes upon the statute books of every Southern state the most iniquitous laws this country has ever witnessed. It seeks to sink us into serfdom. It brutishly slays us and none need answer for the crime." McFall asked, "Is it not to be wondered at then, that Negroes have lost faith in white America?" He described the race problem as "a cancer that is rapidly eating into the vitals of the nation."[1]

A subsequent "furor" proved that McFall's pessimism was warranted. In 1936 the University of South Carolina Alumni Association decided to honor Alonzo G. Townsend, the oldest living graduate, with a "gold headed walking stick." The impending award was nothing less than a reaffirmation of his deeply held belief in the social uplift philosophy and his efforts to live it as a teacher and preacher. However, when the alumni council discovered that Townsend was black, the gold-headed cane never materialized and the octogenarian died about four months after the initial decision to grant him the honor. The Charleston *News and Courier,* although conceding Townsend was doubtlessly "a good negro," thoroughly approved of the decision to withdraw the honor. The newspaper instinctively recognized the dangers in publicly acknowledging and accepting the cultural parity of individual blacks, especially when the South was facing renewed federal intervention via the courts. It warned that to bestow such an honor on the black alumnus would give legitimacy to Radical Reconstruction, a period of "desecration," when "aliens, carpetbaggers, scalawags, the scum of the earth, bad negroes and many deluded negroes took over the state and occupied it by force." Fearful that black South Carolinians would again seek admission, the Charleston daily loathed conceding that any black person was ever qualified to enter the university. Its fears were borne out because in 1938, Charles B. Bailey of Columbia, South Carolina, "graduate of a negro college," applied for admission to its law school.[2]

It was in this milieu, compounded by social forces unleashed by World War II, that Averyites continued to move in the direction of collective activism. This movement was closely intertwined with their struggle to prevent Avery from being closed or downgraded, which they perceived as detrimental to the race's effort to achieve cultural parity.

Diverging Visions

Although Fred L. Brownlee praised Cox's principalship in *New Day Ascending* (1946), the AMA executive secretary and other home office officials were extremely critical of the man in private. To some degree, they resented him because he had managed to obtain considerable independence from the AMA to govern Avery as he saw fit. Officials such as Brownlee considered themselves progressives hampered by traditionalists like Cox. Brownlee confided to one of Cox's successors, L. Howard Bennett, that "really nothing much" had happened during the man's tenure. Another AMA official

told an Avery teacher that Cox was "lazy" but had an able teaching corps to help him.[3]

According to Cox's daughter, Ann Rheba Davis, both parents remained "proud of their connection with this purposeful organization," although they felt that some of the AMA officials were "perhaps—'high-handed' (expecting undue service, etc.)." Despite the cooperation and support of the Avery people, the annual Lincoln Fund drives and other money-raising activities took their toll on the couple. "Each year the contribution of the AMA decreased and the quota raised by Avery, *increased*," their daughter explained. "Money-raising year after year became an increasing burden." In 1936 Cox accepted the offer of Thomas Elsa Jones, president of Fisk, to return to his beloved alma mater as superintendent of buildings and grounds.[4]

Actually, Brownlee and other home office officials were quite traditional and had a good deal in common with Cox, who was a product of the AMA system. They, too, subscribed fully to the social uplift concept. Brownlee, originally from Ohio, completed his undergraduate and M.A. studies at Ohio State University. A graduate of Union Theological Seminary in New York, he also did graduate work at Columbia University's Teachers College. He joined the AMA as a corresponding secretary in 1920. Twenty-one years later as executive or general secretary, he explained the AMA's position to a potential donor by describing education as an important means of bringing about democratic change in America. Because the main purpose of education was "character training and character building," which were "essentially a matter of growth in religious experience," religion remained central to all AMA work. In the 1940s the home office was still asking about the "religious interests," "moral reliability," and "refinement" of teaching candidates. Like Cox, it was dedicated to producing not only religiously inclined but cultured race leaders.[5]

The differences between the home office and Avery supporters, however, were real enough. In 1919 the home office nearly closed all of its urban secondary schools in the South because it no longer considered them community outreach missions but stereotyped them as traditional institutions serving primarily the aspirations of a black middle-class clientele. Constrained by dwindling financial resources, it wanted these educational facilities to be subsumed by public authorities so that it could concentrate on directly helping the disadvantaged, particularly the tenant farmers and other rural poor. The AMA always had as its mission the moral and social regeneration of all peoples. The evils of the world could be solved by a generous dose of Christianity and democracy. The Great Depression and the New Deal fostered the social activism implicit in the AMA mission even during

the "pioneer days" of Radical Reconstruction. The New Deal and its efforts at social experimentation gave the AMA further impetus to refashion its educational program in the South to reach the rural poor. In 1934 it turned over its primary and secondary educational work in Brick, North Carolina, to public authorities and founded an experimental school where tenant farmers lived and studied for five years to prepare themselves to become landowners. A cooperative credit union and store were established as part of the community. At the end of the five years a resident student was to have acquired good credit ratings and enough money to make a down payment on a farm. The formula to organize Brick Rural Life School and Community Cooperative was also employed to turn over Dorchester Academy in Liberty County, Georgia, to public authorities and to develop an educational program for tenant farmers in the area. Fred L. Brownlee explained that by using Brick as a model, the AMA fashioned an "educational procedure" to help the most disadvantaged "strengthen their position in life with a degree of economic security, and slowly evolve their own scales of values through co-operative enterprises." [6]

Ruth A. Morton was in charge as director of schools and community relations. Born in Kansas City, Missouri, in 1900, Miss Morton graduated from the University of Denver in 1929. A devout Methodist, she finished her M.A. in theology at the University of Chicago in 1934. Her thesis, "The Religious Significance of an American Folk School," reflected the impact of the Great Depression. Condemning capitalism for producing "selfish individualism," "materialistic debauchery," and "a state of coma from which it . . . cannot actually revive," she suggested a new cooperative order. Based on an American folk school movement, it would begin with education and draw its impetus from Ashland College in Grant, Michigan. Morton's study of Ashland convinced her that the principles of the Danish folk high school movement could be applied to the American public school via John Dewey's experimentalism. Influenced by Oxford's Toynbee Hall and Jane Addams's Hull House, Morton proposed that "a rural social settlement . . . taken from the Danish Folk School movement" be "adapted to American soil." In 1935 the AMA appointed her director of Lincoln Normal School, in Marion, Alabama, to reorganize the curriculum along these lines. Thus, her educational perspective fitted nicely with the direction in which the AMA was heading, but it did not augur well for Avery, an urban black school dedicated to the liberal arts and a concept of social uplift that encouraged participation in the American business enterprise system. [7]

The AMA's increased emphasis on a cooperative "people's movement" and democratic activism during the 1930s and 1940s was bolstered by World

War II's revitalizing the AMA's mission to end caste in America. Brownlee concurred with the former presidential candidate Wendell Wilkie that "it is not racial classifications nor ethnological considerations which bind men together; it is shared concepts and kindred objectives." The war was teaching Americans "that the test of a people is their aim and not their color." Determined to end "the blight of segregation," the AMA decided in 1942 to "concentrate its attention on the field of race relations, particularly in the Negro-white area." A race relations department was created at Fisk under black sociologist Charles S. Johnson, who was also social studies director at the university and race relations codirector for the Julius Rosenwald Foundation. The terrible race riots of 1943 confirmed the AMA in its new course. After a major riot in Detroit the home office dispatched a member of its race relations staff to work with the teachers of that city to establish "intercultural practices within the schools." Johnson, considering the race-related problems of this northern city representative of those facing the entire nation, designed a three-week workshop dealing with these issues.[8]

Avery parents and alumni generally supported AMA efforts to make the student body more conscious of current social problems. The school continued to provide the leadership of the local NAACP. At the same time Avery supporters believed in the importance of retaining the institute's tradition of academic excellence. They perceived the school as a flagship for achieving racial uplift. During the 1930s and 1940s it was the only black high school in Charleston accredited by both the state and the Southern Association of Colleges and Secondary Schools. In 1935 W. A. Schiffley, assistant state supervisor of Negro schools, characterized Avery's teacher training department as the best in South Carolina. Many hoped Avery would develop into a college to serve blacks unable to leave the Low Country to continue their higher education. After Cox retired, alumni continued lobbying to turn the institute into a college. Although the AMA and Avery supporters upheld in common the social uplift philosophy, tensions surfaced as each side worked toward a different vision of the school's future.[9]

By the late 1930s the home office's discontent with its Charleston school became public. In 1939 Avery and Ballard in Macon, Georgia, were its only two remaining urban secondary schools that had not been turned over to public authorities or assimilated into the new rural life program. Despite the unique contributions of both as "cultural centers," the AMA did not appreciate their usefulness because they were not serving "their communities as effectively as is the case in rural areas." Rather than abruptly abandoning the two schools and alienating their black clientele, as they had by earlier closures, the AMA proposed that both could "learn how to cooperate with

the city school systems" so that "in time the public school systems" would "assume the full responsibility for the academic work of these schools," or "they might become distinctive schools—experimental schools as it were— applying the principles of life-related education."[10]

The 1938 AMA annual report stated the rationale of the home office for discontinuing Avery as it was. Not only was the physical plant inadequate, but the school contributed to the problems of an "Old South" city, hopelessly wedded to the past. "Like Charleston it has class," the report announced. "Traditions and customs change more slowly in Charleston than anywhere else." The school reflected some of the negative aspects of the city's elitism. "It is hard for an organization which was created to destroy caste to have to admit that Avery has not escaped the temptations of aristocracy. A Charlestonian is different; so is an Averyite." AMA officials feared that Avery's existence disinclined the city to establish an accredited public high school for blacks. "What is to be done about Avery Institute?" the report asked rhetorically. Expressing the ambivalent feelings of AMA officials, it continued, "The alumni are crazy about it. Parents crowd all its rooms with their children, and pay tuition regularly." Like the parents and alumni, the principal and faculty were committed to the school. Furthermore, as a center of cultural uplift, "Avery unites the Negroes of all denominations in a common enterprise. They support its concerts, plays and entertainments, and make a great event of its annual commencements." Conceding that the AMA was proud of the school's graduates and that its colleges vied for them, the report declared, "So we remain open minded and keep on helping Avery. But we cannot postpone our final decision much longer; the building won't stand it. To go on means an ample campus and an adequate building."[11]

Privately, AMA officials were more unreservedly critical of Avery and its black clientele. In *New Day Ascending,* published about a year before Avery became public, Fred L. Brownlee more candidly expressed his perception of the school and its problems. He was extremely critical of caste and class at Avery. To support his generalizations, the secretary quoted a letter from the AMA archives describing the city's "Negro aristocracy." He asserted, "They have the point of view of the old, blue blooded South, and contain a great proportion of Caucasian blood. They have elegant tastes; are polite and charming. They starve in poverty for culture, and have sent an enormous proportion of students to the college which best expresses them— Fisk University." Brownlee continued, "Their interests are fundamentally academic and traditional, and they bitterly resent any lowering of ancient standards by the introduction of practical subjects. Highly developed caste on the basis of color is among them. Some were slaveowners. Many of them

have rare old mahogany furniture and have lived in their homes for several generations. There is an impassable barrier between them on the color line which goes as far as to divide their cemeteries on this basis. The saying is that everyone in Charleston who can read and write has a private school, usually in the elementary grades, in a private house." [12]

The AMA hesitated to abandon Avery abruptly in part because of the strong support of the alumni and parents. Moreover, officials thought they had found in Frank A. DeCosta a principal who shared their vision but also had sufficient credibility among Charleston's black elite to implement AMA policies at the school. One of the city's "Negro aristocracy," he was the brother of Herbert A. DeCosta, Sr., the prominent black contractor, whose clientele was made up of wealthy whites. Born in 1910, the last of eleven children, Frank attended Ellen Sander's private school between 1915 and 1920 before he went to Avery. He was one of the best all-around students the institute ever produced. A superb athlete and skilled debater, he graduated as valedictorian in 1927. He duplicated his record at Lincoln University, Pennsylvania, where he graduated in 1931 as valedictorian. [13]

Although Frank DeCosta was a member of one of those first families criticized by Brownlee, the home office was convinced that the Averyite had imbibed fully the AMA philosophy. Ruth A. Morton described him as "practically born into the American Missionary Association." After he graduated from Lincoln University, DeCosta's first full-time job was teaching mathematics at Avery. He left two years later to do graduate work at Atlanta University and then the University of Pennsylvania. In 1934 he became director of AMA's Burrell School in Florence, Alabama. The following year he was offered a position as an assistant supervisor with the Tennessee Valley Authority. After serving about a year, he returned to Avery as Benjamin Cox's replacement. DeCosta was very much in tune with AMA educational philosophy. Believing education should concern itself with "the development of the whole child" and "training in community participation," DeCosta felt that the best approach was to help the student realize "how and to what extent his demands and those of society may be merged," society in America being an "ever-changing" and "democratic" one. DeCosta also maintained, "the activities engaged in by the learner should have practical significance," which did not mean they "should be restricted to those that result in the construction of a physical object." [14]

Despite DeCosta's establishment of a student cooperative store and other attempts to imbue Avery with his "progressive" philosophy, AMA officials found his administration a great disappointment. By 1938 they realized he was not transforming Avery into the kind of experimental school they

wanted. Moreover, DeCosta had misgivings about turning Avery over to the city. In 1938 he had tried to persuade the city school board to give it an annual gift of one thousand dollars as "a whole-hearted gesture of good-will" for its seventy-three years of service to the community. However, in 1941 his decision to pursue graduate studies at the University of Pennsylvania caught not only the alumni but also the AMA, especially Ruth Morton, by surprise. Although AMA friends who visited Avery found DeCosta "quite able," the association, arguing that the man did not want to return, denied the alumni's request that he be given a leave of absence. After a trip to Avery in March 1941 Morton told Brownlee, "I am thoroughly convinced that whenever a principal says everything is going well and that he has no problems, it is time to look for another leader. Mr. DeCosta is definitely leaving, but were it not so, I should have asked him to go, even if the heavens had caved in upon me. There are problems everywhere, crying for solution—problems which have nothing to do with buildings, but with people and their doings; problems which are not connected with the larger city program in which we are interested, but those which could be tackled here on the grounds if one had the vision to do so." Upon calmer reflection, Morton conceded De-Costa's strengths. In 1942, after he passed his Ph.D. comprehensive exams, she recommended him for a Talladega position.[15]

Ruth Morton considered the problems posed by Avery and DeCosta's departure a challenge. "Now a surprise for you," she told Brownlee after her March trip. "Personally I hope we do not close Avery Institute for some years. There has always been a puzzle in my mind about this institution." Besides, she doubted the AMA would "get any place by closing the school and making the people angry. They pay half the bills and they are intensely interested, regardless of what we might say. I have faith enough in human nature to believe that if the best minds are represented here, then those minds can be challenged for the social good." Morton's solution was to get "our 'new' program" under way before closing out the school. Apparently, the AMA had discontinued in other cities its traditional secondary schools before securely establishing a "functional" operation; in the case of Ballard and Dorchester, this had engendered considerable ill will. Morton counseled against doing this at Avery because she thought they were "dealing with a different caliber of people." She specifically recommended that the AMA appoint "our common grounds man" to head Avery nominally with an assistant to "carry much of the drudgery." This would free the "common grounds man" to establish the "new" program. As Burke improved under the leadership of William H. Grayson, Jr., the AMA would be able to do "functional" work and the people would "not feel the loss when Avery as

a school closes." Thus, its existence became inextricably connected with Burke's development.[16]

Armed with the promise of the Avery Alumni Association "to take a more active part in the financial support of the school and any program which will make for its expansion," Ruth Morton set out in earnest to find an appropriate successor to DeCosta. In addition to being black, the new "common grounds" principal would need to know "the philosophy of functional education both in theory and in practice." The position would be difficult to fill because Morton believed Charleston to be "perhaps the most conservative cultural center in the South." Factors such as caste and class still existing within the city were "accentuated" at Avery. On the basis of letters of reference, L. Howard Bennett was exactly the "common grounds man" the AMA wanted. The most fulsome praise came from Charles S. Johnson, who first recommended the Averyite for the position. The black sociologist informed Morton that Bennett not only was one of "the five most worthwhile and promising graduates of Fisk over the past fifteen years" but also had "the point of view in education that you are anxious that your principals should have in the administration of a functional school program; and he likes Charleston and has high standing in that city with all of the important local groups." The future AMA race relations director concluded, "Mr. Bennett represents in all-around qualities the finest personality that it has been my privilege to recommend to the American Missionary Association." [17]

Born in Charleston in 1913, L. Howard Bennett was the youngest of eight children, all of whom attended Avery; five graduated from the school. Family connections with Avery went back to the brother of Bennett's mother, Graham Howard, who graduated as valedictorian. Bennett's maternal grandfather, Samuel Kendrain Howard, was a slave of the Doar family, who educated him alongside their children and had him attend with them Bethel Methodist Church in Charleston. Teaching a Sunday school class there, Samuel Howard developed a reputation as a preacher. After the Civil War he joined the AME ministry and helped found Allen University. His only daughter met and married an AME preacher, Henry William Benjamin Bennett, when both were living in McClellanville, South Carolina. Henry Bennett, educated at Simonton School in Charleston and the Theological Seminary of Allen University, was pastor of Georgetown's Bethel AME Church. The couple sent their oldest child, Isaiah Samuel, to Charleston to attend Avery, where he graduated as valedictorian. In 1905 Henry Bennett became pastor of Charleston's Emanuel AME Church. Ten years later, when L. Howard Bennett was just two and a half years old, the father died, leaving his widow to struggle with putting the remaining children through school.[18]

In 1924 L. Howard Bennett entered Avery. To help support the family and pay his way through school, he was a newspaper carrier, a waiter for the city's Francis Marion Hotel, and a chemistry-biology lab assistant at Avery. Emulating Frank A. DeCosta, he excelled in academics and at a variety of extra-curricular activities, including drama, the school newspaper (editor-in-chief), basketball (varsity captain), debate, and school government (class president and business manager, student council member). With Benjamin Cox's blessing, he entered Fisk in 1931.[19]

Like DeCosta, Bennett repeated his Avery performance in college. Having received only a nominal scholarship, he worked his way as a waiter. At the end of his freshman year he was awarded the Gabriel scholarship for his outstanding academic performance. When Fisk did not measure up to Cox's glowing accounts, Bennett with other students devised a five-point plan to improve its intellectual atmosphere and school spirit. In the summer of 1934 the university employed him as a field research assistant. Graduating cum laude in 1935 with a major in sociology and minor in history, Bennett was appointed field secretary to conduct Fisk's scholarship campaign. He remained in that position until 1939, when he received a Julius Rosenwald Foundation fellowship to study public administration and administrative law at the University of Chicago, where he was "one of the outstanding leaders" at the International House. Less than a year later he was stricken with tuberculosis but recovered sufficiently in 1941 to be a social science lecturer at Charleston's summer institute for teachers, under the direction of the Burke principal, William H. Grayson, Jr. That year Bennett married Marian Clae Brown, a 1936 Fisk graduate.[20]

Heeding Charles Johnson's counsel that Bennett was "the type of person for whom various institutions are making bids," Ruth Morton contacted the Averyite while he was visiting his relatives in Charleston. Offering him eighteen hundred dollars a year, plus housing, she told him that the AMA wanted a principal "who will look beyond the immediate school situation, making the entire city of Charleston a social laboratory," with Avery as "the leader in progressive movements." Bennett accepted the challenge. Like the home office, he hoped to use Avery as a "platform or center from which to make social change effective in Charleston."[21]

The two world wars engendered a number of problems facing the black community. Housing was one of the most serious. World War I caused an influx of people from the country, looking for work. Not all could find decent jobs, leading to "a growing population of poorer Negroes," particularly on the predominantly black East Side. World War II further aggravated the situation. In 1942, cooperating with the local Negro Housing Council, Bennett arranged for Avery students to do the "legwork" for a survey

documenting the overcrowding caused by defense workers to convince the Federal Housing Bureau in Washington, D.C., of the need for a housing project. Starting to canvass black residential areas on Lincoln's birthday, the students viewed the project as "a continuation of the work of [the] emancipation of Negroes in Charleston." Some were "appalled" by the conditions they encountered. A participant, Ethel Richardson, wrote for the school newspaper, "This was one of the most educational and practical projects in which we have engaged. All of us got a chance to see why we have social and economic problems. This gave us a chance to apply our limited education to practical problems." [22]

Bennett's willingness to involve himself in solving the local problems engendered by World War II led to what was probably his greatest contribution to the Charleston community. The war aggravated racial tensions as thousands of rural whites and blacks, looking for jobs, poured into the city. The rural whites carried with them an extremely hostile attitude toward blacks. "It was not beneath them," Bennett recently remembered, "to throw a black on the ground and step on them just like they weren't even there." Bennett experienced firsthand such hostility while he was getting onto a bus at the corner of Wentworth and King streets in downtown Charleston. As Bennett prepared to board, he stepped in front of a white man. When the man grabbed his arm, Bennett shoved him off. The irate white threatened, "Nigger, we take knives and cut Niggers' heads off like yours." Undaunted, Howard shot back, "We take people like you and knock your damn teeth out of your head." The black principal recognized that the incident was not an isolated one, but was "indicative of the kind of tensions which were really beginning to develop in this community." Charles S. Johnson, conducting a workshop for Avery teachers before the school term began, suggested that the principal find a way to communicate to authorities "the seriousness of this situation." [23]

At root, the problem was an economic one. Apparently, in an attempt to reduce tensions, the Charleston Naval Shipyard had stopped hiring black workers, infuriating them. Some complained to Bennett. Believing in making "alliances with the more progressive white leadership in the community," the Avery principal set up a conference with Admiral Arthur W. Radford, commander of the Charleston Naval Base. Before the meeting, Bennett consulted with a fellow NAACP member, James R. Logan, who briefed him on jobs at the shipyard. At the conference, Radford was stunned to find that during a period of manpower shortages, blacks were not being hired. He provided Bennett with a list of shipyard positions that needed filling. The rehiring of blacks began and the white monopoly on shipyard jobs was broken. [24]

Racial friction, engendered by the transportation of defense workers to and from the shipyard, developed at the facility gates and spilled over into the community. On Labor Day 1943 Bennett conferred with Radford about the situation. As a result, Bennett drew up a statement that the admiral issued under his own name and read on the air. Charles S. Johnson, in Charleston at the time, helped Bennett compose the speech. In addition, Bennett, joined by black public school principals including fellow Averyites Wilmot Fraser and William Grayson, formed a committee with Clarence O. Getty, the white general secretary of the local YMCA, to meet with the Charleston mayor, Henry W. Lockwood, to discuss the situation. Lockwood, balking at establishing an "interracial" committee, finally agreed to a "biracial" one. Thus, tensions were immediately reduced and a race riot was averted. But more important, because of Bennett's initiative, blacks gained a permanent foothold at the shipyard. "A cross section view of local Navy jobs," reported the Charleston *News and Courier* in 1952, "reveals many members of Charleston's Negro community in responsible positions. They fill civil service posts ranging from electrical engineer through supply expert to security guard. Hundreds are employed at the Charleston Naval Shipyard as skilled craftsmen—shipwrights, joiners, pipefitters, riggers and the like." [25]

These shipyard employees often sent their children to Avery. Edward A. Stroud and his wife were factory workers at the naval facility. Dismissed by the American Tobacco Company for helping to organize the first labor union at its Charleston plant, Stroud obtained employment at the shipyard; he retired in 1967 as a caulker. Sarah Marie Stroud was recruited after L. Howard Bennett helped open up the yard to blacks. Her daughter from a previous marriage, Lucille Simmons (Whipper), attended Burke but transferred to Avery at the insistence of the pastor's wife, who recognized the girl as college material. Growing up in the Ansonborough housing project on the East Side, Lucille remembers her Avery teachers, particularly Margaret Rutland Poinsette, as "role models." Graduating from the school in 1944, Lucille went on to earn a B.A. from Talladega (1948) and an M.A. from the University of Chicago (1955). After spending many years as a teacher and administrator in the Charleston County public school system, she became head of human relations at the College of Charleston. In 1986, after her retirement, she was elected Charleston County's first black woman legislator. Her husband, Benjamin Whipper, pastor of St. Matthew Baptist Church and a retired shipyard employee, is a descendant of the Reconstruction legislator William J. Whipper. [26]

L. Howard Bennett understood that the AMA wanted him to become an "effective vehicle for relating Avery to the larger social economic political issues," but he resisted converting the school into "something of a social

welfare center." Now having the perspective of forty years, he is convinced that AMA officials wanted him to do "away with the academic program" even before they hired him. Bennett bridled at Brownlee's claim that "nothing much" had happened at Avery during the Cox years. On the contrary, he felt that Cox had set "a tone in this town for excellence in scholarship." Moreover, he took issue with Ruth Morton's blanket condemnation of Avery and its graduates as elitist. In extended conversations with Brownlee and Morton, he argued that if whites could have their "elite" feeder schools for Harvard, Yale, and Princeton, why should not black colleges like Fisk and Talladega have their equivalents? Finally he contended that if Avery were to become public, the school "would be under enormous pressure" from whites to impart the kind of education they wanted blacks to have. Here Bennett was on particularly sound grounds. A. B. Rhett, a staunch proponent of industrial education for blacks, was still city school superintendent. Also, the Charleston school commissioners continued monitoring the schools for any deviation from racial orthodoxy. In 1944 they cautioned Simonton's principal about a poem, "Colored to the Rear," that appeared in the student publication, the *Chatterbox*. Considering the poem "out of place and calculated to have an extremely bad effect in the relations of the races," the commissioners threatened to discontinue the publication "if a similar item was published in the future." [27]

Although Bennett agreed Avery needed more of a social vision, the solution, he believed, was "by holding out to the people a new possibility of a new and greater Avery, that they would be willing to cooperate in effecting an agreeable transition." The black principal resented the home office's attitude that it knew "what was best for colored people." He labeled Morton's appraisal of Avery "a white woman's evaluation of a high level of black culture." Some feeling for the smug attitude of AMA officials can be gleaned from remarks made by Brownlee in 1948 after the school had gone public. He compared the AMA to a parent faced with an unruly child. It, "like many a fond and beloved parent," had been "tried out." [28]

In 1942 the AMA Board of Home Missions decided to discontinue gradually "all regular, stereotyped primary and secondary school work, in cooperation with the public schools," and to develop "specialized schools, such as the Brick Rural Life School." Therefore, Ruth Morton's visit to Avery in November 1943 alerted Bennett to an impending crisis over Avery's future and his. Although the AMA director of schools found the high school department in good condition and its teachers competent, she complained that some of them had "little social vision and so do not stretch the thinking of their pupils in world-mindedness." She was sorely disappointed with the "pathetic" situation of the lower grades, charging, "There isn't a good

teacher in the group." Although Morton praised Bennett for his efforts with Robert F. Morrison, Wilmot Fraser, and William Grayson, fellow Avery- ites, to obtain a new USO building in the city, she was unhappy over the housing situation. "Sometimes Charleston seems hopeless," she complained. In December the black principal visited Nashville, Tennessee, where he discussed Avery with Charles Johnson, Fred Brownlee, and Ruth Morton. Before returning home, Bennett traveled to New York City to investigate a job offer from the national USO, which was impressed by his role in estab- lishing its black Charleston branch. USO officials offered Bennett a position as associate regional executive at a salary of forty-five hundred dollars per year. He was guaranteed tenure for the duration of the war and six months thereafter.[29]

That month Bennett apprised the home office of the USO job offer. He informed AMA officials that his current salary was insufficient to cover his expenses. More important, there was the uncertainty over Avery's future and his connection with it. Thinking that to sever completely his relation- ship with the school would retard the progress already made in influencing the people to accept the AMA's new course, he proposed a leave of absence. USO officials were willing to give him "sufficient opportunities to periodi- cally return to the city, keep things together, and further the efforts to secure greater local support and new support from wealthy individuals."[30]

Ruth Morton reacted to Bennett's proposal with stern formality. "The American Missionary Association can make no pretense of competing with government salaries," she replied. "Although our salary scale is low, we are paying as much as our funds warrant. Offers similar to the one being made you are received daily by others of our workers. Some stay with the A.M.A. because they prefer the work even at a lower salary. Some leave with regrets because, as you express it, 'they are caught in a financial squeeze.' I am sorry, but there is nothing more we can do about it now." Morton denied Bennett's request for a leave of absence because there was no way of deter- mining how long the war would last. "Our hands would be tied," she argued, "in working out future policies before you return, and Avery would be with- out leadership for far too long a time." After seeking the advice of Charles S. Johnson, Bennett reluctantly resigned, effective January 15, 1944. Morton lamented, "This is the first time in my nine years in this position that one of our principals has resigned in the middle of the school year." With Bennett's enthusiastic approval, she coaxed Florence A. Clyde out of a planned retire- ment to stay on as interim director. Clyde would be helped by two teachers, Alphonso W. Hoursey and Reynold N. Scott, until a permanent successor could be chosen.[31]

Bennett was probably correct in assuming forty years later that no matter

what he did, the AMA was determined to alter Avery's future radically. At an AMA committee meeting held in Cleveland during January 1944, Ruth Morton and Fred Brownlee noted that all other secondary institutions in the system had been terminated by merging them with public schools or transforming them into experimental schools. Although conceding that Avery had produced an impressive number of teachers and other professionals, the two AMA officials argued that the school, located in a city with "the cultural standards of 'Gone With the Wind,' " was unable to provide the necessary leadership for "a genuine people's movement." Illiteracy in Charleston was still increasing. Moreover, World War II had produced a doubling of the city's black population and with it increasing racial unrest, juvenile delinquency, inadequate transportation facilities, and a severe housing shortage. Avery, they contended, provided individual blacks a way to avoid collective responsibility for these community problems. Ambitious black parents "sent their children to Avery, thus draining away the best leadership from agitation for better public schools." [32]

Brownlee and Morton presented three alternative ways to establish "a genuine people's movement" in Charleston: (1) close the school entirely and open up an urban service, perhaps like Flanner House, "a social center for Negroes in Indianapolis"; (2) cooperate with the public schools in furnishing special services for a few years; (3) establish a "transition form of private school administration" with the Avery parents for the next three or four years if they were willing "to double the tuition charges and assume full responsibility themselves for operating" the school with a thorough understanding of AMA's future plans. Whatever course was taken, the two AMA officials recommended, "Discontinue Avery Institute, as it is now operating, June 1, 1944." [33]

To prevent the closing of the school as well as a clash between the AMA and the Avery people, L. Howard Bennett worked out with the home office a proposal for a "new and greater Avery." Before leaving the school, he explained the situation and presented the proposal to the Avery people at the first meeting of an advisory committee established in the fall of 1943. He began by noting that it had long been a policy of the AMA to turn over its secondary schools to public authorities. Because of shrinking resources and "new areas of concern," the association would not likely develop Avery into a college. The AMA had already decided to abandon the school's two-year teacher-training program accredited by the state as a junior college. Besides keeping its existing institutions of higher learning open, the association wanted to lessen racial tensions and encourage "Negro-white cooperation" by concentrating on race relations. It was also moving in the direction of

common-ground work to improve socioeconomic conditions in rural and urban communities through cooperative group action.[34]

"What then is to be the fate, the future of Avery Institute," Bennett asked the group. Since city officials were " 'not now' interested" in acquiring the school, there was only one course of action open to the Avery people if they wanted to maintain the support of the AMA. Out of the common-ground work could evolve a self-supporting community adult educational program —"a people's institute, a people's college." Avery could become an "institute for leadership training," eventually located at a new site on Johns or James Island. In such "a unique rural-urban setting," the institute would provide "a natural setting that could be a laboratory to aid in training youth to make an intelligent approach to the problems of rural and urban communities." One of its main functions would be to produce a more responsive black leadership, which conceived of its role in terms of "group advancement rather than personal achievement." [35]

Bennett's resignation, coupled with the proposal, jarred the Avery people. In the past they had surmounted such crises by raising enough funds to mollify the home office. Again they went into action. A "Committee of One Hundred," under the leadership of Alphonso W. Hoursey, promised to raise ten thousand dollars to help carry on the operation of the school for 1944–1945. Pleased by the Avery people's initiative, Brownlee praised the committee as an example of a "people's movement." With his blessing, Ruth Morton worked out the specifics of an agreement. The Avery people were to place ten thousand dollars on deposit in New York as a trust fund. The AMA would then issue contracts for the next year. Morton as the AMA director of schools was to serve "in an advisory capacity if the people wish[ed] her cooperation and administrative counsel." Avery's steering committee, organized to help a campaign committee manage the ten thousand dollar fund-raising drive, would act as a temporary administrative council. It would select L. Howard Bennett's replacement and increase the tuition by 50 percent of present rates each school year between 1944 and 1946.[36]

Although increased tuition prevented many talented but less fortunate students from attending Avery, money, as much as official policy, dictated the home office's actions. The promise from the Avery people to raise $10,000 as well as their assent to the tuition hikes was a great relief to the AMA. The school was a financial drain on its resources. AMA officials were constantly looking for alternative ways to finance it. In 1941 their friend William E. Sweet, acting as the go-between, approached the financier Bernard M. Baruch for money. There was some indication that Baruch could be persuaded because of his ties to the Low Country and his reputation as a "liberal

minded" philanthropist. A native of South Carolina, Baruch had recently donated $150,000 for a hospital in Charleston. Moreover, when Eleanor Roosevelt visited him at his Low Country plantation, the two had discussed the matter of black education in the South. But Baruch refused Sweet's request for $250,000 to support various AMA schools.[37]

At 7:15 P.M. on March 31, 1944, Avery kicked off its "Ten Thousand Dollar Fund Drive" on the Charleston radio station WCSC. Although Arthur J. Clement, Jr., chaired the campaign committee, John A. McFall primarily designed the strategy combining media blitz with a personal touch. Two thousand letters soliciting support were mailed. One hundred and fifty campaign workers followed up by personally contacting the receivers. In addition, flyers were distributed, and both radio time and advertisements in the local newspapers were purchased. The campaign made a special effort to reach whites, sending letters of appeal to many white Charlestonians. An article published in a local newspaper, probably through McFall's influence, reminded readers that Avery had saved city taxpayers "the cost of maintaining a school." The *News and Courier* ran an editorial that directly asked "the white people of Charleston" to help Avery. According to Florence A. Clyde, "the white people contributed generously." On May 5, 1944, Clyde, as acting director, sent Fred L. Brownlee a check for ten thousand dollars. Shortly thereafter, at Morton's urging, the parents elected a permanent administrative council.[38]

With money and a permanent administrative council in hand, the most pressing issue now was choosing a new director. Alphonso Hoursey was a serious contender. A product of the AMA system, he had worked more than sixteen years for the association. Besides the experience as a teacher and administrator, he had the academic credentials. His M.A. thesis was based on a study of Avery and its graduates to improve its curriculum. He had taken the lead in organizing the Committee of One Hundred to begin the fund-raising efforts. Moreover, Hoursey had considerable local support, particularly from older Averyites. "A stranger will have to learn the people, those who are friends, and those who can be approached," Clyde explained to Morton. "Having seen new principals, I know how long it takes them to get the run of things. We did not have trouble with Messrs. DeCosta and Bennett because they were Charleston men. Mr. Hoursey knows these children, is interested in them, and is particularly tactful in handling these boys." Strengthening her appeal further, Clyde added, "It is my candid opinion that the majority of parents will work with him better than with a stranger. Please give him the chance."[39]

But Hoursey was too traditional for the home office. He had been passed

over when the AMA selected L. Howard Bennett to replace Frank A. De-
Costa. When it passed Hoursey over again to appoint another faculty mem-
ber, Charles H. Nicholas, Bennett's assistant, it made the disappointed
Averyite director of the junior high school department with an increase in
salary to mollify him and free Bennett for community outreach work. "Or-
dinarily persons who have served on a staff cannot step into a position of
leadership within the same school and make fundamental changes," Morton
informed Hoursey. "Teachers are very frequently appointed to an assistant
principalship who would never be appointed to a principalship." Nicholas,
also a product of the AMA system who aspired to be principal, resigned in
1943 for a college position. Hoursey, as Clyde noted, "stayed through the
changes and accepted them, worked faithfully with each administrator." [40]

Despite the local support and esteem Hoursey had, AMA officials invited
the other contender, Samuel T. Washington, and his wife for a July inter-
view at the New York home office. Washington, born in the nation's capital
in 1901, was educated in the public schools of Newport, Rhode Island.
After graduating from Lincoln University, Pennsylvania, in 1923, he held
various teaching or administrative positions in Kentucky and Wilmington,
Delaware, and at AMA's LeMoyne College in Memphis, Tennessee; Geor-
gia Normal College in Albany; Lowndes County Training School in Valdosta,
Georgia; and Hubbard Training School in Forsyth, Georgia. While study-
ing for his M.A. in accounting and finance at Atlanta University, he worked
as a teller-bookkeeper at a local bank. For a while he was a business man-
ager in Atlanta for the National Youth Administration. With the outbreak of
the war he returned to Newport to work for the U.S. Navy in "a business
capacity." [41]

Washington was hesitant to take the Avery principalship on such short
notice. He did not even have the opportunity to visit Charleston and the
school before he had to make his decision. All he knew about the local
situation came from the New York interview. He also conceded that his
forte and interest were bookkeeping and finances rather than administration.
However, for Morton, Washington's financial expertise was all-important.
In August she traveled to Charleston to finalize his appointment with the
newly created administrative council, which "unanimously" confirmed her
choice. [42]

The beginning of the school year coincided with Washington's arrival,
allowing him little time to prepare for his new assignment. Given his ex-
pertise in finances rather than administration, his lack of familiarity with
Charleston, and the short notice he was given, Washington was uncomfort-
able in the position, and not many months after his arrival, he contemplated

leaving for a job in the business office at Talladega. But he postponed telling the administrative council about his decision to seek employment elsewhere after a fire broke out at the school in the beginning of March 1945. The fire caused damages totaling nearly thirty thousand dollars. According to his wife, he "didn't want it to appear that he was running out of a difficult situation or unwilling to stick to a hard task." Actually, the black principal handled the crisis well. The work of the school continued as the high school students assembled in Dart Hall for classes. The episode engendered a degree of unity, which, however, was short-lived. The question of Avery's future was resurrected as "old Charlestonians wept bitterly" over the damage to the building.[43]

In March 1945 Brownlee traveled to Charleston to survey the situation firsthand. The fire damage was not as "general" as he had expected, but he discerned a "general feeling that Washington is not dynamic enough; that Avery has poor teachers; that Avery has dropped in quality a lot." Washington, concentrating on the internal affairs of the school, had failed to reach and influence the larger community as Bennett had. Arthur J. Clement, Jr., chairman of the administrative council, agreed with Brownlee. Attributing Washington's appointment to a shortage of qualified administrators caused by the war, Clement assured Brownlee, "With peace in Europe and readjustments beginning to take place, certainly within the next year we should be able to secure a more professional staff for Avery."[44]

As resigned as Washington was to leaving Avery (he even intimated as much to Ruth Morton), the decision to fire him came as a shock. Neither Brownlee nor the administrative council bothered to consult him. "The sudden decision that *Mr. Washington would not be back at Avery next year* without at least a *mutual discussion* of the situation is a great *moral* letdown," his wife explained in a tearful letter to Ruth Morton. At Morton's suggestion, Brownlee sent to all AMA college presidents letters recommending Washington as "a superior business manager."[45]

As in the case of Washington, the home office actively intervened in Avery's affairs. It perceived what the democratic path for the school was and acted accordingly. Despite the local support for Hoursey, Washington was appointed. When he proved a disappointment, he was abruptly dismissed. In the same manner, the home office pushed for the establishment of the administrative council even before it began searching for Bennett's replacement. To be composed primarily of parents, the new council was to act as a kind of lobby group for the home office's vision of what Avery should become. The council was to be a vanguard to help a "progressive" principal develop the school into a "people's institute" and thus establish in Charles-

ton a "people's movement." On the other hand, John A. McFall and other older Averyites wanted the school to develop into a junior college, ideally through the financial backing of the state. Perceiving the need for such an institution to serve the Low Country, they preferred reconvening the old board of trustees to organizing a new administrative council, because the reincorporation charter of 1925 provided for the establishment of a college. McFall, although then living in Nashville, Tennessee, led the effort. He argued that the management of the school should be left in the hands of the board of trustees, composed of older Averyites and friends who had proved their expertise.[46]

The whole notion of the trustee board's assuming the management of the school was anathema to the AMA officials. They maintained, it "no longer functioned." McFall contended that the charter authorizing the board was "still in full force and effect." Hoursey, Clyde, and C. S. Ledbetter, although sympathizing with the black pharmacist, found themselves caught in the middle of the ensuing struggle between Morton and him. The AMA official made no pretense about her direct intervention in the affairs of the school. "This may seem like an attempt to influence the thinking of the people at Avery," she wrote Hoursey, "and I suppose it is." Wondering whether there had been "bickering again in the group which served as a board of trustees a number of years ago," she complained, "their selfishness killed what might have been a very good council and in addition very nearly killed the institution." She warned, "If such a board gets under way again, I am afraid that it will write the death warrant for Avery Institute, for as you know the American Missionary Association will not pull it through again." She urged Hoursey and Clement, Jr., to take the lead in dissolving the old board and replacing it with an administrative council "made up almost exclusively of parents." Morton addressed a similar letter to Florence Clyde.[47]

When Clyde showed McFall portions of Morton's letter, the old Averyite wrote back, accusing the AMA official of being "grossly misinformed." The old board "never once wrangled over the charter. Neither did it ever seek to assume or to exercise any powers that were not delegated to it." He explained that the most expedient way to seek funds from the South Carolina General Assembly via the Charleston County delegation was to reconvene the board. "This plan," he informed Morton, "had the unanimous approval of the members of the old Trustees Board" still residing in Charleston, specifically C. S. Ledbetter (president), E. B. Burroughs, Jr., Robert F. Morrison, J. W. Brawley, and A. J. Clement, Sr. But as McFall pointed out, on learning of her attitude, Ledbetter had declined formally convening the board. The former trustee-treasurer also stated, "I shall gladly vacate any position

and refrain from accepting any if such can perpetuate Avery Institute for its community." [48]

In response to McFall's challenge, and at Arthur Clement, Jr.'s, request, Morton, who was elected to the newly formed administrative council, traveled to Charleston to attend its first meeting in May 1944. Soon thereafter it was announced she was to replace Clyde as acting principal. The council was chaired by Clement, Jr., a parent who had not been active in the actual operation of the school until the fire. Having completed his education outside the state, Clement was not fully informed about the function of the old board; he was not even aware that his father had been a member. Despite an esteem for McFall, he apparently did not know the full extent of the pharmacists's efforts to make the school a junior college. Moreover, he admired Ruth Morton and shared her concern over a polarization within the black community centering around Avery. He noted that some blacks believed two cultures were developing, with Burke going one way and Avery another. He hoped a public Avery would serve to unite the community along the lines of academic and cultural excellence. Other council members included two old trustees, Robert F. Morrison and E. B. Burroughs, Jr. Avery teachers also elected to the council were Florence A. Clyde, William E. Bluford, Alphonso W. Hoursey (secretary), and Geneva P. Singleton. [49]

Despite assertions to the contrary, McFall persisted in his belief that the election of the new council did not preclude a revival of the old charter. He communicated with Paul M. Macmillan, chairman of the board of trustees for the College of Charleston, about Avery's future. McFall wanted Avery, while retaining all of its present departments, to develop a junior college division with a four-year teacher training program that led to a B.A. degree. In August 1944 the city board of education had adopted the policy of hiring only college graduates as permanent teachers. McFall's proposal would enable local blacks to meet this requirement without leaving the Low Country to continue their higher education. Forwarding Morton copies of his correspondence with Macmillan, McFall sought from the AMA "assurance that I have not exceeded my rights in so replying." Morton tried to forestall McFall's efforts by urging him to take the matter to the new administrative council. [50]

In the interim nearly the entire Avery senior class sent to the College of Charleston application requests. Expecting a backlash against Avery, McFall temporarily shelved his plan to circulate a petition, urging the Charleston County delegation to support the school as a junior college. Actually, the affair worked to Avery's advantage. McFall's proposal seemed attractive alongside possible litigation against the college. "We have been consider-

ing the Avery proposition," Macmillan told McFall in October 1944, "and I am glad to be able to say that many of the substantial citizens here have agreed that Avery should get the support that is needed. We will speak to the legislators at once, and prepare the way for your request. . . . It is well to remember that you spoke to me about the needs of Avery before the college had received any letters from Avery students." Within a week McFall asked AMA officials to give him some idea of the cost of operating Avery as a junior college. Although they opposed the idea, they honored his request. Brownlee also mentioned that Morton and he would discuss the idea with McFall and the administrative council in December.[51]

Apparently, the December conference never occurred. Some time toward the end of October, Ruth Morton met with the administrative council in Charleston and presented the wishes of the AMA. She convinced the members to adopt a new constitution instead of reviving the old charter. Instead of pursuing McFall's proposal, she wanted them to follow AMA policy by seeking support from the city board of education. "The Constitution has been finally adopted," Hoursey reported to Morton in January 1945, but "the matters regarding the relationships with Dr. McFall are still being discussed." About two weeks later Arthur J. Clement, Jr., as council chairman, formally notified Morton that further action on McFall's proposition had been postponed until September 1945. However, the fire of March 10 jeopardized not only McFall's plans but the entire existence of Avery.[52]

On March 19 and 20 Fred L. Brownlee visited Charleston to estimate the fire damage and iron out an agreement with the administrative council. The fire damage was not as extensive as he had thought. He took issue with Herbert A. DeCosta, Sr.'s, estimate for repairing it. According to Brownlee, the black contractor "had figured everything that had burned and not a few things which had not burned." For Brownlee, Herbert A. DeCosta, Sr., and his family symbolized the best and worst of the Charleston black elite. During his two-day visit the AMA official stayed with the DeCostas, whom he termed "Charlestonian blue bloods." He noted, "Mr. DeCosta evidently has made & is making a lot of money. He wears a thousand dollar diamond. Their house has splendid [?] and very fine furniture." Brownlee did not realize how recently the DeCosta family had acquired such wealth. Herbert's youngest brother Frank remembered that the ten older brothers and sisters, still in their teens, "had jobs of one sort or another" to help out since their father had died when Frank was only ten months old.[53]

After meeting with the members of the administrative council, Brownlee concluded that the "group really wants a college." They also requested that the AMA proceed with the repair of the building. The session with

the council probably shook some of Brownlee's preconceptions, because he admitted in his log of the visit that he left the city with "many conflicting thoughts and feelings about Avery." [54]

Despite these conflicting thoughts, Brownlee's trip to Charleston strengthened his resolve that Avery ultimately become part of the city public school system, perhaps even by merging with Burke. During his two-day stay he visited Burke and noted the progress it had made under the leadership of William H. Grayson, Jr. Brownlee also conferred with Grayson, now supervisor of the city's black public schools. Whatever his motives, Grayson, an ardent proponent of public education, reinforced most of the preconceptions Brownlee and the other AMA officials held about Avery. His success confirmed to these officials that the Avery people's fears about their school's going public were unwarranted. [55]

In 1941 AMA officials had considered appointing Grayson principal of Avery. Because "this would be a boon to us but a tragedy for the city," they passed him over for L. Howard Bennett. According to their scenario, while Bennett was preparing the "common ground" by reaching out to the community, Grayson was to improve Burke to the point that "the people will not feel the loss when Avery as a school closes." At the same time Grayson was to win the confidence of the city school board and its superintendent, A. B. Rhett. Although Burke was not accredited in 1942 by the state because of inadequate physical equipment, Grayson with a core of dedicated Averyites was able to upgrade the curriculum so that in September 1944 the school received an "A" rating from the Southern Association of Colleges and Secondary Schools. The black principal was also obviously successful in wooing Rhett and the city school commissioners because the board appointed him supervisor of its black schools in 1944. [56]

Grayson reinforced Brownlee's preconceptions by pointing out some of Avery's problems as a private school. The most pressing issue was that the state had recently equalized the salaries of white and black teachers. Grayson speculated that the salaries might rise to as much as twenty-seven hundred dollars per year. This fanned Brownlee's fears that the AMA would not be able to compete financially with the public schools. In addition, the city's new policy of employing only college graduates as permanent elementary and secondary teachers made Avery normal graduates ineligible. Moreover, Grayson believed that there were many talented but disadvantaged blacks not being helped by Avery. He felt he could reach them through Burke. Although not allowed to hire music teachers, he developed an excellent music program at the black industrial school. He employed Eugene C. Hunt as an English instructor but also had the Averyite teach choral singing. Hunt established

a 250-voice chorus at the school. Grayson hired another Averyite, Holland W. ("Toby") Daniels, to organize a band in addition to performing his regular duties as a mathematics teacher. Daniels's father, Paul G. Daniels, was president of Jenkins Orphanage, and the son would later become its director. Through Daniels's hard work, Burke soon had an outstanding band. Dramatic activities were also offered. Besides her regular teaching duties, Sarah Green Oglesby was the drama coach. Seeing the AMA school as a competitor, Grayson boasted to Brownlee that Burke had already "outstripped Avery" and was "destined to leave Avery in the shade unless Avery gets busy." The black educator felt that the time had come "for Avery to do something distinctive." He supported the endeavors of Arthur J. Clement, Jr., and Herbert A. DeCosta, Sr., to persuade Brownlee at an informal meeting in DeCosta's home that Avery should become a junior college. However, in private he told Brownlee he was "agreeable" to the school's being turned into a social welfare center along the lines of Flanner House and the people's movement.[57]

Although Grayson was successful in winning the confidence of the AMA home office and the Charleston school board, he could not gain the support of the Avery people who did not want their school to merge with Burke. The history of Shaw Memorial School, which had been transformed into a social center, made their apprehension understandable. However, perceiving their reluctance as a manifestation of pride, the former Burke principal was not able to sympathize with their desire to preserve Avery. Perhaps Grayson agreed with the AMA that Avery's continued existence as a private institution encouraged the city school board and the black community not to push for Burke's accreditation by either the state or the Southern Association of Colleges and Secondary Schools. During the informal meeting with Brownlee at DeCosta's home, Grayson pointed out that it was up to the people to petition the school board to apply for Burke's accreditation since the board had refused to take the initiative. Although Clement responded by assuring that a petition would be submitted to the board by its next meeting, Grayson did not believe that a bridge of mutual assistance could be established between the two schools because of the Avery people's attitude.[58]

In May 1945 Ruth Morton proposed that the two schools undertake a joint venture. That year the administrative council had voted to abolish vocational courses at Avery because of lack of space and funds. The AMA official asked the supervisor of the city's black schools to reconsider a proposal once advanced by Frank A. DeCosta to allow Avery students to attend vocational classes at Burke. In 1943 L. Howard Bennett and she had tried to persuade A. B. Rhett and the city school board to cooperate. If Grayson could succeed

where they had failed, she hoped the project would help "bridge the gap of jealousy between the two schools and serve as a demonstration to our group that a public high school can be conducted on a pretty high plane." Grayson considered the suggestion "splendid" but stated that the Avery patrons had to approach the school board with the proposal. "To be frank," he explained, "I honestly believe that the day is very very far away when the local Avery patrons would entertain the desire of making such a request. This attitude will continue as long as there is a general philosophy that to attend Avery gives one added prestige, whether or not the educational advantages are greater and meeting their particular needs." Grayson contended that the prosperity brought on by the war only encouraged such feelings, which would remain as long as money was "so plentiful." Thanking the Averyite for his "frank and honest letter," Ruth Morton lamented, "The attitudes at Avery make me heartsick, but we are hanging on with the hope that perhaps in the years ahead when the going becomes worse we can salvage something of honest good will from the pride of the people." A year later Grayson resigned his position as supervisor of the city's black schools to work for the AMA in its race relations department.[59]

After Brownlee returned to New York with his findings, Ruth Morton felt strong enough to deal directly with John A. McFall, who still held considerable influence over the administrative council. "Each step which has been taken has not been by any one individual," she wrote to him. "After a long and intelligent discussion," the administrative council "decided, not as individuals but as a group, that they were not yet ready for these steps which you were urging upon them. Because this was a group decision[,] Mr. Clement, chairman of the council, was requested to write you the next day concerning this matter. At that time you had not yet come to Charleston." Morton forwarded copies of her letter to Clement, Hoursey, and C. S. Ledbetter. McFall, acquiescing in the decision, stated that his "interest in the school has not diminished and shall continue though it may be only in a less active manner."[60]

Although the administrative council concurred with the AMA's plans to continue Avery as a high school, the association did not contact DeCosta to proceed with repairing the building. When Clement urged Brownlee to stick to the decision arrived at during his visit, Brownlee replied in a letter formally presenting the AMA's prerequisites for keeping the school open at least two more years. The administrative council was told to convene a meeting of Avery parents, patrons, and friends to explain the situation to them. First, they would discuss what kind of physical facilities Avery needed if it were to compete with Burke; this included a spacious library and a

well-equipped science building. Second, they had to agree to hiring only graduates of four-year colleges as teachers. Third, teachers' salaries had to be increased to a yearly average of about two thousand dollars each to bring them on line with what white teachers were receiving in the public schools. This would be achieved by another hike in tuition and an annual raising of twelve thousand dollars. The Avery people were to organize a campaign to raise the twelve thousand dollars for 1946–1947 by May 1, 1946. If they agreed to all these conditions, the AMA would notify DeCosta to go ahead with the repairs.[61]

On Wednesday evening, May 23, 1945, Clement convened the required meeting at Central Baptist Church. To the assembly of about 275 people, he read Brownlee's letter. After a lengthy protest from Robert F. Morrison, the group accepted Brownlee's conditions by a vote of 143 to 5. Some, feeling the parents should decide, abstained from voting but expressed their support for the effort. A committee was formed to head the new fund-raising campaign, to be concluded by December 15, 1945. An Avery parent and graduate, Reginald C. Barrett, who made the motion to concur with the AMA mandate, was elected to this committee. Succeeding Clement as chairman of the administrative council, he would continue to play an active role in keeping Avery open. To help spur the fund-raising efforts, the AMA agreed to begin the repair of the building.[62]

With Avery's existence assured for another two years, the AMA and the administrative council sought to find a replacement for Samuel Washington. In June 1945 Clement asked John H. McCray, an Avery alumnus now living in Columbia, to sound out John F. Potts, a Navy recruiter stationed in that city. Potts was no stranger to South Carolina. He had been a teacher and administrator in the Columbia public school system. He also had relatives and friends in Charleston. Clement had met him one summer in Flat Rock, North Carolina, and they had played tennis almost every day. Having a high opinion of the man, Clement had kept in contact with him while he was principal in Columbia.[63]

Born in Hot Springs, Arkansas, in 1908, John Potts attended the public schools there and later at Flat Rock. He completed his high school and college education at Columbia's Benedict College, where he graduated in 1930 summa cum laude as a history major with a minor in political science and sociology. In 1937 he received an M.A. in American history with a minor in high school administration from Cornell University. During the summer of 1941 he took education courses at Harvard University. His educational career began as principal of Flat Rock Elementary School during 1930–1931. He then went to Columbia, where he served as assistant prin-

cipal of Waverley Elementary School for two years, then assistant principal
and social science teacher at Booker T. Washington High School for three
years. He moved to Gary, Indiana, where he was a social science teacher at
Roosevelt High School while he did research for his M.A. thesis. He re-
turned to Columbia and became principal of Waverley High School. He was
also in charge of teacher training at Allen University. His other activities in-
cluded directing in-service training of the elementary school teachers in the
Columbia public school system and serving as a consultant in social science
and education for a teachers' workshop at Jackson College in Mississippi.
It was probably in Columbia that he met his future wife, Muriel Logan, of
Petersburg, Virginia, who was teaching at Carver Junior High School. In
1942 Potts joined the Navy Reserve to become a chief petty officer in charge
of recruiting blacks in South Carolina.[64]

Potts had all those attributes attractive to the Averyites. Described by
the Columbia supervisor of Negro schools as "a lover of books. . . . well-
liked by everyone," he was cultured, affable, bright, religious (Baptist), and
highly educated. His interest in music, art, and dramatics was shared by his
wife, Muriel, Francis L. Cardozo's granddaughter, who had a B.S. (Virginia
State College) and M.S. (University of Michigan) in music. One of Potts's
Charleston cousins was the former Lucille Mears, who married a fellow
Averyite, Peter Poinsette, the brother of Septima P. Clark. According to
Arthur J. Clement, Jr., Potts had "a personality and temperament that would
fit into our local community life."[65]

Potts also appealed to the home office. His interest in social welfare was
evident from his M.A. thesis, "A History of the Growth of the Negro Popu-
lation of Gary, Indiana." With Japan's surrender imminent, AMA officials
particularly wanted a person of his qualifications to do the race relations
and community outreach work which they felt would be needed to allevi-
ate the postwar problems and increased frictions expected. Moreover, Potts
was flexible. After praising Avery's emphasis on academics, he asked Ruth
Morton, "Will that continue to be the function of Avery or has the emphasis
shifted." Sharing the "progressive" attitude of AMA officials toward educa-
tion and social change, Potts accepted their preconceptions of Avery as "old
Charlestonian." He seemed to concur that Charlestonians were "a proud
people who live too much in the past."[66]

In late July 1945 Potts traveled to New York for an interview with Morton
and Brownlee. He expressed some concern about salary, permanency of the
position, repair of the fire damage, and fund-raising, but he left satisfied.
The only real obstacle was getting him an early release from the navy. Failing
to obtain the cooperation of his immediate commanders, the AMA appealed

to the head of the navy chaplain service in Washington, D.C. The delay was serious enough for the AMA to consider appointing Mrs. William H. Grayson, Jr., as interim principal. However, the Japanese surrendered, the release was secured, and on August 28, 1945, the administrative council issued Potts a twelve-month contract, commencing September 1, 1945.[67]

Continuity

In 1946 Fred L. Brownlee justified the AMA's decision to withdraw support from Avery by noting publicly that the institute had remained relatively static during its entire existence as a private school. "The curriculum was set along New England classical lines," the AMA official claimed, "and has so remained to the present day. French, Latin, English, the sciences and mathematics still hold first place in the list of offerings." Brownlee was correct in perceiving the persistence of an Avery tradition. The school's emphasis on a classical or liberal arts curriculum, teacher training, Protestant ethic, character building, and service always remained strong.[68]

According to Alphonso W. Hoursey's M.A. thesis study of the school in the 1930s, much had remained the same. The three traditional levels continued to exist: primary and elementary, junior high school, and senior high school. Besides a college preparatory tract, the senior high school still offered normal training, beginning in the eleventh grade. Those wanting to become certified elementary school teachers in South Carolina had an additional year of normal training. The normal program was not eliminated until 1945. The annual enrollment seldom varied much between 400 and 430. Of this total enrollment, the senior high school, starting with the ninth grade and including the "normal class" or those taking the extra year of teacher training, comprised between 225 and 275 annually. The school usually graduated somewhere between 50 and 60 seniors each year. Twenty to 30 teacher trainees annually completed the normal class. The college preparatory and normal tracks still contained much that was classical, or liberal arts, though the curriculum was modified to meet changing college entrance and teacher training requirements. In 1941 Avery was one of only five black schools in South Carolina that were accredited associates of the Southern Association of Colleges and Secondary Schools. This status allowed Avery graduates to enter without examination any college recognizing the association's members.[69]

Reinforced by an indigenous ethos dating from antebellum times, the Avery educational tradition continued to value vocational training as a means

to instill the Protestant ethic and practical skills considered important in turning out useful citizens. Although the manual and domestic arts were made electives by the 1930s and such training was minimal, some students felt compelled to take these electives, so ingrained was the ethos in their psyche. Even today graduates proudly display in their homes the wooden tables and chests they made in workshop. The table fashioned by the son and namesake of Herbert A. DeCosta, Sr., is closely safeguarded by the family. When Alphonso W. Hoursey surveyed the graduates of the 1930s, he found that many wanted vocational and trade as well as business and commercial courses added to the curriculum to provide "the background . . . needed both for securing and making success in positions."[70]

The emphasis on the importance of character building and the Protestant ethic never waned at Avery. In 1939 a HI-Y Club of fifteen young men, including Herbert A. DeCosta, Jr., was organized "to create, maintain, and extend throughout our school and community high standards of Christian character," which included "clean speech, clean scholarship, and clean athletics, and clean living." By 1942 the women had their counterpart, the Tri-Y Club, composed of thirty-three members. Geneva P. Singleton was faculty adviser.[71]

With the possible exception of the Coxes and Florence Clyde, Alphonso W. Hoursey was probably the faculty member most intent on upholding Avery's tradition of right living, manners, and culture. The director of the junior high school, who taught Latin, French, English, psychology, and education during his long career at Avery, became the chief adviser to the HI-Y Club. His concern for manners and civility was such that in 1942 he advised the AMA home office that he intended to provide courses in "etiquette and courtesy" for the seventh, eighth, and ninth graders. Hoursey had every reason to expect a favorable response from the home office, which regularly sent the principal copies of such inspirational tomes as Alfred Grant Walton's *Life Is What You Make It* (1942) and Brownlee's own *New Day Ascending* as gifts to the graduating seniors.[72]

For teachers, like Hoursey, culture was a concept that applied to all aspects of an Avery education, including athletics. Using the school newspaper as his vehicle, Hoursey lectured to the entire student body in 1944 on "good sportsmanship." He argued "that the program of athletics in any school is but a part of the larger cultural program of the institution." Citing the ancient Greeks as setting a precedent, he explained what a "classical" education at Avery meant. "In attempting to define culture," he wrote, "the Greeks set forth their aim of education—'Culture is the harmonious development of the whole man.' They devoted much attention to philosophy, art, the drama,

and rhetoric, but always and ever present in their curriculum were courses designed to develop the body. . . . So that no matter how much attention they devoted to the development of the intellect, always they kept before them the doctrine 'MENS SANA IN CORPORE SANO,' (a healthy mind in a healthy body)." What provoked Hoursey's exhortation was the students' unhealthy tendency, as he perceived, to exhibit "the rottenest kind of sportsmanship" at athletic events. He reminded his young readers that the purpose of football and basketball was "not to win regardless." The Greeks, he asserted, placed "excellence of performance" ahead of winning.[73]

Given such an interpretation of "classical" education, intramural sports were highly valued at Avery. Composed of representatives from the seventh grade through the normal class, an athletic directorate established a "well-rounded" program so that "all participants may be trained in initiative, self-control, co-operation, and fine sportsmanship; and that a fine, wholesome school spirit may prevail." In 1939 the directorate, led by the junior class vice president, Richard Fields, offered paddle tennis, ping-pong, table tennis, horse shoes, basketball, volleyball, and chinese checkers. To raise money for interscholastic football and basketball, the directorate annually sponsored a "Miss Avery" popularity contest and a "Miss Avery" dance as well as a "Get Acquainted" social.[74]

As under Cox, music continued to serve as a vehicle to reach out to the community. In 1938 a small student chorus known as the Avery Singers was organized to go out into the community to perform at churches and special programs. Two years later the music program was given a boost with the arrival of D. Jack Moses. Born in St. Petersburg, Florida, Moses graduated from Morehouse College in Atlanta. With him in charge, the usual fall concert of the music department featured an innovation. In 1941 the highlight of the program was Christmas music from many lands, preceded by an impressive candlelighting service. In May 1942 Moses presented his "Extravaganza Classique," which, like the Yuletide concert, became an annual community event. The 1942 program was divided into four parts—Concert Hall (performed by the Avery Philharmonic Male Ensemble), Convict Camp (depicting the hardships blacks must endure), Opera (light and grand, with costumes), and Religious Worship (including "Hallelujah, Amen!" and Schubert's "Ave Maria").[75]

Music and drama were closely intertwined at Avery. When the Avery Singers performed in Brunswick, Georgia, in 1939, their "program was augmented by a one act play presented by members of the chorus who were also members of the Dramatic Club." Under the guidance of Margaret Rutland Poinsette, the club sponsored in 1937 "an inter-class one-act play contest"

to promote an enthusiasm for drama. To present *Wuthering Heights* in 1940, the students "built the stage set, plotted the lighting, worked on costumes, collected properties and arranged for publicity on sales of tickets."[76]

The social uplift philosophy preached at Avery continued to stress service to the community as well as academic excellence. Frank A. DeCosta embodied the ideal. L. Howard Bennett, calling him "an idol of mine," explained, "He was not only a top flight student, he was the best in his class. He was also the best athlete at Avery." In 1939 the seniors codedicated their yearbook to DeCosta "for his strength of character and power of leadership, for his earnest work to promote the advancement of education, for his constant mindfulness of the best interest of the student body, and for his wonderful achievement, being the first Avery graduate to return as principal." In November of that year the school newspaper described DeCosta as "a native Charlestonian and a person of great influence," who "has a deep interest in civic and social welfare." Many other graduates besides DeCosta and Bennett pursued a career in education. In 1940 the *National Negro Digest* reported that 75 percent of the black teachers in Charleston County, and 65 percent of those in the city, as well as "four local city principals, a majority of the professional men, local contractors, and other businessmen of their race" had attended Avery.[77]

The New Deal and World War II opened up new opportunities for Avery graduates to serve the community. During the Depression more money was spent on medical care for the poor. By 1939 McClennan Hospital and Training School for Nurses was annually processing more than seven thousand patients in its outpatient department, causing "a great demand for colored nurses." Avery students finishing the eleventh grade could file applications with McClennan, where as nurse trainees they paid a tuition of thirty-five dollars annually for three years of study. During the last year of the war Avery commencement exercises included graduates of the Hospital and Training School for Nurses. Avery's cooperation with McClennan exemplified how the school in continuing to uphold the social uplift philosophy modified and expanded its program to meet the needs of its students and the community.[78]

Change

Avery was never as static and nonprogressive as AMA officials asserted. Belief in democratic change, particularly through education, was a cherished tradition at the school. If the earliest missionaries wanted to recreate the "pure democracy" of New England at Avery by imbuing their students with

the educational theories of Pestalozzi, their twentieth-century counterparts thought they were hastening the advent of another millennium by actualizing the philosophy of John Dewey. The optimism of these black principals and teachers was fostered by the times. Northern politicians, sensitive to a sizable black constituency arising out of the large migrations of the past decades, were willing to push for reform in the South. The unrest of the times was also fueled by the impact of the Great Depression, the New Deal, and World War II. Out of this ferment emerged the civil rights movement and a Second Reconstruction. Averyites did much to shape this movement in the Low Country and the rest of South Carolina. During the 1910s they helped lay its foundations in the Low Country by strongly supporting the NAACP and its campaign to get black teachers into the Charleston public school system. Again in the 1940s they set the momentum for educational reform in the city by leading the NAACP efforts to equalize the salaries between white and black public school teachers. This time, however, Avery students, implementing the philosophy of John Dewey to its logical end, added a new dimension, a "youth movement ideal," to democratic change in the Low Country.

Of the Avery principals who advocated John Dewey's philosophy of education, Frank A. DeCosta and L. Howard Bennett especially shared his democratic optimism. Dewey's outlook noticeably influenced the educational changes enacted at Avery by DeCosta. "A general characteristic of Avery's curricula is flexibility," the *National Negro Digest* reported in 1940. "It always has been the belief of the school that programs of studies should be determined by the interests and needs of pupils. Another characteristic is freedom of pupil-participation in the affairs of the school." The digest noted that among the "many progressive and new programs under way at Avery. . . . DeCosta, with the assistance of his young people, has organized a cooperative store at the institution . . . headed by a young female student. He believes in credit unions and, in fact, stands for everything that is conducive to clean and lasting progress."[79]

L. Howard Bennett, a protege of Charles S. Johnson, was an equally ardent proponent of democratic change. In explaining his educational philosophy, Bennett was clearly a Deweyite. "The education of the Negro child," he believed, "requires a vast departure from the traditional pattern. The educational program must take into consideration the minority status of the Negro, the effect such a status has had on individual personality. It should seek to equip the Negro child with a wholesome appraisal of himself—a healthy self-estimate—and respect for his background. Finally it must equip him with tools and techniques capable of producing united group effort,

fuller participation in the full stream of American life, and ideals of world citizenship." The theme of the 1941 commencement exercises, "education for democracy through personal growth," indicated the thrust Bennett was striving to make.[80]

The Averyite J. Andrew Simmons demonstrated during his principalship (1932–1945) at Columbia's Booker T. Washington High School how progressive education built on the social uplift philosophy Cox transmitted to his students. In 1940 the *National Negro Digest* lauded Simmons for broadening "the activities and functions of the school to meet changing conditions and to enable the pupils to adjust themselves to the increasing demands of the community." Many credited Simmons with "turning Booker T. Washington from merely a good academic high school into a complete social environment." Simmons's assistant, Fannie Phelps Adams, remembered that the black principal "was not the kind to just sit in the office. . . . Every teacher had to visit the home of every child in his class. Simmons felt that was the only way you could really understand the child's needs."[81]

Avery principals, teachers, and staff believed that education should expand the horizon of individuals. Mary Lois Strawn, critic teacher (evaluator of student teachers) and instructor for grades three and four, declared, "My philosophy of education is that education is concerned with the growth and development of a person through the continuous acquiring of new experiences in all aspects of living." Although Vernita Camille Vaughn, a music instructor, and others agreed that education should point out "the necessity of conforming to the mores of the community," they also advocated "the desirability of remaining true to one's ideal and remaining an individual." Most of the teachers probably would have endorsed the educator Sidney Hook's interpretation of Dewey's educational philosophy, which stressed the remaking of existing conditions, not merely the adapting of the individual to those conditions. They perceived education as a prerequisite for citizenship. The social science teacher Mildred H. Handy felt that "education, especially on the high-school level, should prepare the students for community living and for civic usefulness" and impart "the type of experience which will help the student to choose a life career and to become a good citizen in whatever community in which he may live or work."[82]

One of the reasons Dewey was so popular among the black teachers was that his philosophy was compatible with character training, a time-honored practice at Avery. For these black teachers, such training was closely intertwined with their belief that the educated person should be service-oriented. Deweyism fostered this outlook. Madge H. Washington, the Avery librarian whose husband was principal, explained, "I believe that education should

create a strong desire in every one not only to try to procure security and happiness for himself and family but to help others as well." According to Mary Lois Strawn, education would produce "men and women . . . whose actions contribute to the welfare of the Group."[83]

This sense of service, expressed in the language of Deweyism and implicit in the social uplift concept, was bolstered by the study of black history and culture. In 1915 Carter G. Woodson organized the Association for the Study of Negro Life and History. He was joined by a small group of black Ph.D.'s, some of whom were intimate friends within his intellectual circle. Woodson and his colleagues used the association to foster racial uplift by documenting black contributions to the American past. Like Dewey, they hoped to change the society through the application of "scientific" logic and methods in their research and writing. Better race relations would result. The *Journal of Negro History* served as their organ. Eventually, Woodson's followers and other like-minded black scholars found their way onto the faculties of black colleges and universities such as Fisk. At their urging, these institutions made black history a permanent part of the curriculum. The graduates of these institutions, mostly teachers, carried their interest in black history to their work on the high-school level. By 1926 supporters of black history inaugurated in the schools Negro History Week, the precursor of Negro History Month.[84]

The significance of the work being done by Woodson and the other black scholars was not lost to the Avery people. Not surprisingly, Averyites were attracted to Woodson's journal. Emphasizing black builders, achievers, and heroes, as well as focusing on antebellum free blacks, the early issues of the publication more accurately reflected the heritage and traditions of Charleston's black elite. It was no accident that the journal published the study by the Averyite C. W. Birnie of black education in antebellum Charleston.[85]

Avery reflected the reverberations being felt as the graduates of Fisk and the other black universities pursued careers in education and transmitted their interest in black history to their students. Armstead A. Pierro, the athletic director at Avery, studied Negro history under Rayford W. Logan at Morehouse College in Atlanta. While at Fisk, L. Howard Bennett, besides studying under Charles S. Johnson, was influenced by Woodson's colleague Alrutheus A. Taylor, who described Bennett as an advocate of social justice and "economic reconstruction within the capitalistic system." Bennett joined Woodson's association.[86]

The interest of Avery teachers in black history was manifested in the books, journals, and other publications they read. Asked to name books recently read, Avery teachers in the 1940s usually mentioned some dealing

with race. Bennett's wife, Marian, listed *Native Son* by Richard Wright, *The Etiquette of Race Relations in the South* by Bertram W. Doyle, and *Shadow of the Plantation* by Charles S. Johnson. Richard Wright's *Native Son* was especially popular with the faculty; six teachers included it on their reading lists. Some of the periodicals mentioned were *Negro Digest, Crisis, Opportunity,* and the *Journal of Negro Education.*[87]

Like Cox, his successors at Avery recognized the important relationship between black history and racial uplift. In 1942 Alphonso A. Hoursey recommended that a course in Negro history be made a part of the social studies program in the junior high department. Avery principals continued the practice of inviting noted black scholars to address the student body. In 1942 L. Howard Bennett enlisted Charles S. Wesley, dean of the graduate school at Howard University, to give the graduating sermon at the baccalaureate services. In his speech, "Education as Emancipation," Wesley exhorted the graduates "to free themselves from the chains forged by the schools and in the textbooks that theirs is an ignoble heritage; that the homeland of their ancestors is a land for conquest and oppression; that America is not their land as much as anyone else's." In 1945 Samuel T. Washington invited Horace Mann Bond, a former classmate at Lincoln University, to be the commencement speaker. Bond was president of Fort Valley State College in Georgia.[88]

Avery students imbibed the progressive attitudes of their teachers and principals. The class of 1940 noticeably bore the mark of its principal, Frank A. DeCosta. To institute the Avery Cooperative Society and Store, he with William Bluford's assistance offered a two-week course on cooperatives in the summer of 1939. Class representatives from the seventh grade through the normal class sat on the board of directors with Bluford as adviser. The purpose was to establish a store to sell books, school supplies, and lunches to the faculty and students at prices "as reasonable as those of other retail business establishments." The project proved very popular among the students, with 250 participating. The cooperative store continued to operate even after DeCosta's departure. In 1942 profits were returned to the students in the form of dividends or gifts to the school. DeCosta's students also shared their principal's belief in the potential of American democracy. In 1939 the senior class prophecy envisioned a "New World" of social equality by the 1960s, when "Man will be judged not by his race, color, or creed, but by his ability and aptitude."[89]

Students enrolled in Julia Mae Brogdon's course "Problems in Democracy" took their lessons literally. Hired by L. Howard Bennett, Brogdon taught a good deal of black history in her classes and involved her stu-

dents in practical civic lessons. In addition to teaching the social sciences, she served as adviser of the cooperative store. Her interest in black history and civic activities probably evolved from her participation in the AME church. Her father, R. E. Brogdon, was the Emanuel AME pastor and an NAACP leader. In 1937 Brogdon graduated from AME's Allen University in Columbia, where she had taken a course in black history. Obtaining an M.A. in secondary education from Atlanta University in 1940, she took courses from Horace Mann Bond and W. E. B. Du Bois. A close friend of Du Bois's goddaughter, she was invited to dine with the black scholar. Later Du Bois personally sent her materials on black history to use in her problems in democracy course at Avery. Described by a colleague as a "dynamic teacher" involved in the group work of her church and possessing the gift of helping to "solve social problems," Brogdon was active in the NAACP. She began teaching at Avery in September 1943. The next year she accepted a better-paying position at Morris College in Sumter, South Carolina, where she trained students from rural areas to become teachers. During her brief stay at Avery she encouraged class discussions in her course that had consequences lasting long after her departure. A confirmed follower of Dewey, Brogdon believed that "a child learns by doing." She thought "that education should be centered around the child preparing him for good citizenship, to live harmoniously in his society, to learn to cope with economic, political, social and educational problems intelligently." For this Deweyite, education could lead to a democratic reconstruction of the entire society. "If the children of today are trained properly through our educative processes," she concluded, "many of our social problems will be solved in the same way that medical research has products for eradicating certain diseases."[90]

The 1944 seniors taking "Problems in Democracy" with Brogdon were ripe for some kind of activism. Bennett's efforts to involve Avery students in projects like the public housing survey had made them more aware of the social problems and inequities besetting the black community. Some of the seniors, facing the draft, bitterly resented their exclusion from the College of Charleston. When the acting principal Florence A. Clyde withdrew the traditional privilege of seniors' sitting on the Avery front lawn or leaving the campus for lunch, the students staged a successful three-day boycott of classes. Under the influence of John H. Wrighten, Jr., a disabled World War II veteran, their participation in a letter-writing project during May 1944, requesting from the College of Charleston information on admission requirements, yielded repercussions that extended beyond the campus and black community.[91]

Born in 1921, the son of an Edisto farmer who highly valued education,

John H. Wrighten, Jr., was encouraged by his mother to become a boarding student at Avery in 1935. Struck by an urban segregation far more pervasive than on Edisto, he asked his American history teacher why it existed. W. E. Bluford told the class that it was a way of keeping blacks in their place economically. Disillusioned, Wrighten temporarily quit Avery. After marrying, he returned to the school in 1941 as a junior but was drafted into the army. His time in the service was cut short by serious ulcer problems. While recuperating at the Veterans' Hospital in Columbia, he managed to attend a meeting in which John H. McCray and others organized South Carolina's Progressive Democratic party. Determined to become a lawyer, he returned to Avery in March 1943 and completed his senior year in three months.[92]

The situation of John Wrighten, selected by the seniors to represent them on the letter-writing project, illustrated the dilemma faced by black high school graduates who desired to continue their education but could not leave the Low Country. Married with two children, he did not want to relocate to Orangeburg in order to attend South Carolina State College. After discussing the matter with Julia Brogdon, a fellow Emanuel AME parishioner, he sent the College of Charleston a letter seeking admission in July 1943. His request met with unsatisfactory results, forcing him to enroll at South Carolina State. Determined to try again next year with the support of Avery seniors, he remained in contact with them. This young disabled veteran apparently held some sway over the students and recent graduates. Probably influenced by discussions in Brogdon's social science classes, by February 1944 they had organized a Junior NAACP chapter on the campus. Like Wrighten, many of the members were recent Avery graduates. During the following summer the group, with Wrighten as acting president, sought affiliation with the national office. Even after Wrighten returned to South Carolina State College in the fall of 1944, he remained an active member of the chapter and followed through on the controversial letter-writing project.[93]

This project evolved naturally enough out of problems in democracy class discussions. Among the course activities, the seniors visited the Charleston Naval Shipyard. When the class assignment turned to taxes, one of John A. McFall's relatives, sent from New York to attend Avery, noted that the City College of New York was tax-supported and admitted blacks. That fact raised the question, Why did the College of Charleston, also supported by tax dollars, not admit blacks? The decision of the thirty-two members of the senior class to write to the college for admission requirements was a class project. Clyde's informant reported that "the letter writing was assigned as home work in the Problems of Democracy Class. They were told

failure to do so would be a mark against their grade." One of the seniors, Hazel Stewart, recalled taking envelopes and stamps to class for the explicit purpose of writing the letters. Wrighten, at South Carolina State, also sent a letter of inquiry. On September 29, 1944, he reported the effort as a project of the Charleston chapter of the Junior NAACP.[94]

The acting college president George D. Grice forwarded one of the controversial letters to the trustee board chairman, Paul M. Macmillan, who agreed to Grice's handling the dilemma by notifying the inquirers that their letters had been referred to the board. College officials tried to keep the incident out of the newspaper, but the *News and Courier* broke the story on Sunday, June 11, 1944. The next day the paper predicted that such attempts by "colored agitators" could destroy the white public school and college system in South Carolina. If this "negro invasion," encouraged by "outside agencies" and the Roosevelt administration, were to revolutionize the corrupt school system into a private one, education for whites would improve and cost less. The Charleston *Evening Post,* echoing similar sentiments, branded the efforts of the Avery graduates as "part of an inspired movement to break down the social, educational and political institutions of the South." Both newspapers declared that the college would revert to a totally private institution rather than admit blacks.[95]

If there was a conspiracy among the students to challenge southern mores, it was theirs and Brogdon's alone. Supremely confident of the soundness of the project, the teacher saw no need to consult her superiors. "I did not know they were being written," Clyde reported to Ruth Morton. "Mrs. Singleton and Mr. Hoursey knew nothing. So it was done without consulting those in charge." Although Brogdon asked the students to obtain their parents' permission before mailing the letters, some conveniently forgot to do so, much to their parents' chagrin. Hazel Stewart's mother asked, "How did you get yourself involved in something like this?" Ruth Morton viewed the whole incident as a "stunt" since she knew "of no white college similar to the one in Charleston who would admit our graduates, however fine they are." She hoped "the storm may blow over and be forgotten. If not, it may rob Avery of some support from public funds which the school had hoped to secure." Brogdon herself was delighted that the students' actions received the attention they did; she feared that the letters would simply be ignored.[96]

The black community was split over the issue. "Some people here (colored) feel it was the thing to do," Clyde observed. "Others feel, after the appeal and response by white citizens, it was not." She informed Morton that some of the "business and professional men who have contact (with the powers that be)" and were involved in the Avery fund-raising campaign thought it

was "the wrong time to get those people against the school." John A. McFall, thinking the uproar would doom his plan to obtain state funding for Avery, temporarily ceased his campaign. Despite any misgivings Avery administrators might have had, they never shared them with Brogdon. She suffered absolutely no deleterious repercussions.[97]

In early October Wrighten sent to the College of Charleston from the South Carolina State campus a letter describing himself as "the Chairman of the Applications to the College of Charleston." Signing it as "President of the Charleston Chapter of the Junior N.A.A.C.P.," he expected some decision to be reached by October 16, 1944. To head off problems, McFall tried to dissociate Avery and the Charleston NAACP from the whole incident. He informed Paul M. Macmillan that the Charleston NAACP was "entirely without knowledge of the movement." He asked Arthur J. Clement, Jr., vice president of the branch and also head of Avery's administrative council, to communicate the same message. McFall attributed the students' actions to a "mere youth movement ideal" and Wrighten's "exaggerated ego." He suspected that the real objective of the effort was "to seek financial aid through scholarships to other schools."[98]

After receiving a letter from Macmillan, McFall privately predicted that the "incident, though it provoked much comment, may perhaps rebound in good for Avery. From [Macmillan's] letter I surmise that some action may be forthcoming, the nature of which I do not know. Perhaps it may be the granting of scholarships at State College to those applicants. In which event Avery would not benefit. Neither would our community derive the value it would if Avery could be advanced into a Junior College for academic students and a full four year course for teachers." Shortly thereafter the city agreed to provide six South Carolina State College scholarships.[99]

Wrighten deeply resented the compromise. Two local NAACP officials, J. W. Brawley and Robert Morrison, told him that it was not the right time for forcing the issue. Avery's very existence, already tenuous, might have been adversely affected. Like McFall, they probably realized that the College of Charleston would revert to a private status rather than desegregate. Chastised by the experience, Wrighten was more determined than ever to become a lawyer. After finishing State, he instituted a suit in which J. Waties Waring ruled in 1947 that the USC law school had to accept Wrighten, or South Carolina had to establish a law school at State. The Avery principal, John F. Potts, hired Wrighten to teach the problems in democracy course while the suit was pending. In 1952 Wrighten graduated from the new law school at State.[100]

Ironically, as McFall predicted, the students' letter-writing project suc-

ceeded in winning white support for Avery. In 1946 Grice and Macmillan "appeared before the Charleston county delegation on behalf of a plan to establish a negro college in Avery Institute." A year later college officials, writing to O. T. Wallace, a state senator, and Lionel K. Legge, a state representative, asked the Charleston County delegation to appropriate $130,000 for Avery because "if Avery is not supported, the College of Charleston is always under the threat that negro students will have to be admitted. If Avery accepts public funds, the College will be safe from attack." The AMA now had the opportunity, if it chose, to help the Avery people gain state and county backing to develop their school into a college serving Low Country blacks.[101]

As the student unrest indicated, Avery was being shaped by national and international events. Despite the AMA's nonmilitaristic stance, hundreds of Avery graduates and former students, including women, left Charleston to serve in the armed forces during World War II. Leroy Anderson's army experiences illustrated the impact of the war on these young people. When Anderson left the entrance examination ahead of all the other recruits, the white officer in charge was convinced he had not finished it. Much to the officer's surprise, the black recruit scored higher on it than he had. Given the Averyite's high test score and clerical abilities, he wound up as a secretary to a white colonel from Pennsylvania. As part of a segregated unit at Fort Bragg, North Carolina, Anderson, in six months' time, became a sergeant major and the battalion clerk for the Forty-eighth Quartermaster Corps. As his troopship was about to leave for the war in the Pacific, he was pulled out at the intervention of Eleanor Roosevelt. His father had written to her that he did not mortgage his home and send his boy to college to become an enlisted man in the army. He said, either return Leroy home or allow him to become an officer. The son served in the South Pacific as a captain.[102]

For the students, as well as the graduates serving in the armed forces, the war was a chance for blacks to participate fully as citizens and to fight discrimination at home. At the urging of the Pittsburgh *Courier,* a black newspaper, the students supported the Double "V" Campaign. The 1942 commencement program, "New Channels of Opportunity for Negro Youth," manifested the patriotism and hope generated by the war. Hazel Evangeline Lum, whose brother Harry was one of this country's first black flight officers, spoke on the topic "Negro pilots win wings." Other student presentations included "Women's Opportunity for Maintaining Morale among Service Men," "New Opportunities Bring New Places for Negro Women," "Negro Schools and Colleges Arm for Defense," "The Negro Youth in Defense Work," and "New Opportunities for Negro Youths on All Fronts."[103]

Some Avery students were not so optimistic. World War II highlighted racism at home. Dorothy Bacot noted in her article for the school newspaper that despite critical manpower shortages, blacks were discriminated against "in defense industries, the American Red Cross, the Army and the Navy." Civilian and military police continued to mistreat black soldiers. The Avery student exhorted, "The Negro must continue to fight until the ideals of democracy exist throughout the land." In 1943 Thomas F. Conlon, a private from "up north" stationed at the Citadel, wrote to the editor of the Charleston *News and Courier* to express his dismay "at seeing discrimination in action . . . negroes forced to sit in the rear of the bus as if they had some loathsome disease." Reacting to an editorial charging that "the Democratic party is run by negroes," the young man asked white Charlestonians, "If you consider him your inferior because, by the accident of birth, his skin is black tell me the difference between your attitude and Hitler's attitude." [104]

Replies to Conlon's letter were immediate, hostile, even threatening. "I am a Southerner, a native of Charleston," wrote one person. "I firmly believe in discrimination and segregation of the races, and it is very evident that our Jim Crow laws are responsible for the fact that we do not have any serious racial disturbances in the South. . . . You are showing your ignorance when you compare us with Hitler. We are human." A woman from North Charleston, who identified herself as "having been reared in one of the South's best known families," declared, "The negro is not equal to whites in mind, morals or color (read your bible)." Underlying this woman's assertions was a very real fear that blacks were gaining power in the national Democratic party. The great migration of blacks northward was having its political impact. To placate an ever-increasing black electorate in the large northern cities, white congressional candidates promised to advocate the vote for blacks living in the South. White southerners saw a good deal of hypocrisy in this.[105]

Ironically, the North Charleston woman's worst fears became a reality because of the rulings of an aristocratic white Charlestonian, the federal judge J. Waties Waring. Born in 1880, Waring could boast having ancestors who arrived in Charleston from England during 1670. Eight generations of his family had served the city and state in a variety of capacities. His father and two uncles had been in the Confederate army. Waring, a graduate of the College of Charleston, went on to earn a law degree and, during the Wilson administration, was named an assistant U.S. attorney for the eastern district of South Carolina. The young lawyer ran the Charleston office. His political connections served him well. He was city attorney in the 1930s during the mayoral administration of Burnett Rhett Maybank. Waring was also campaign manager for South Carolina's U.S. senator "Cotton" Ed Smith.

When Maybank joined Smith in the U.S. Senate, Waring was named a federal judge for the eastern district of South Carolina. Married to a "home town belle of Episcopalian upbringing" no less impeccable than his own, Waring bought a home "South of Broad" and settled into the social life of the Charleston elite.[106]

Opponents described Waring as "the man who started all the trouble." They attributed his change of heart to his divorcing his first wife and marrying soon thereafter in 1945 an outspoken proponent of human rights. Within seven years, the federal judge made decisions that began overturning the state's racially oppressive laws. In 1948 he struck down an effort by the state to circumvent the U.S. Supreme Court ruling in *Smith v. Allwright* outlawing the white primary. He horrified the entire white South by urging the NAACP counsel, Thurgood Marshall, to make segregation rather than separate-but-equal the issue in the Clarendon County school case. He was outvoted two to one, but the case was sent to the U.S. Supreme Court. It could very well have been used as a basis for the court's famous 1954 ruling. But the justices wanted to avoid inflaming the Deep South, so they chose to make their decision in the Kansas case *Brown v. Board of Education of Topeka*.[107]

Waring continued a process begun by South Carolina blacks under NAACP leadership. Avery still served as a center of NAACP activities with many of its people active in Charleston and other state branches. E. B. Burroughs, Jr. (Avery, 1911), the son of Methodist minister E. B. Burroughs, and John H. McCray (1931) were presidents of the Charleston branch in the 1930s. Arthur J. Clement, Jr., before serving as president during the 1950s, was secretary and vice president. In 1937 Avery people who were local NAACP officials included John H. McCray (president), Arthur J. Clement, Jr. (secretary), and W. W. Jones (assistant secretary). Ellen Sanders, J. W. Brawley, and E. B. Burroughs, Jr., were on the executive committee with Clement's father as legal adviser. Two Avery principals, Frank A. DeCosta and L. Howard Bennett, were both members of the branch. Bennett served on its executive committee in 1942. A number of Avery teachers, besides Julia Brogdon, were NAACP members. In 1939 William Bluford was the secretary of the Charleston branch; three years later he was on its executive committee. Some of the faculty had joined the organization before they entered Avery. The teacher and librarian Fannie Ella Frazier had been vice president and president of her local NAACP while she was a student at Talladega. Not surprisingly, Avery students organized a Junior NAACP chapter during World War II.[108]

In the late 1930s the Charleston branch experienced considerable turmoil after its president, John H. McCray, in a letter on chapter stationery to

the local *News and Courier,* expressed some misgivings over the NAACP's national campaign to persuade Congress to pass a federal antilynch law. McCray, fearing that campaign rhetoric might provoke more violence against black South Carolinians, asserted, "Soon or late, no one will care to lynch. And we [Southern Negroes] are content to wait." On April 13, 1937, the newspaper published his letter with the headline "States the Position for Southern Negroes." [109]

"What do you advise should be done with the president of the local branch, who so betrays the aims of the national organization?" an irate member of the Charleston executive committee, Louise Purvis Bell, asked the national NAACP secretary, Walter White. In a letter to the newspaper, Bell described McCray as "an uncle Tom and a traitor" who "is in no way qualified to 'state the position of Southern Negroes.' " Shortly afterward the local NAACP secretary, Arthur J. Clement, Jr., wrote to the daily that the branch "requested, received, and accepted" McCray's resignation. On April 24, 1937, the paper published a letter from Walter White, repudiating McCray's stance. [110]

McCray was hardly an Uncle Tom. He subsequently moved to Columbia, where he became editor of the *Lighthouse and Informer,* championing "the cause of Negroes everywhere." Later as state chairman of the Progressive Democratic party, he joined with the NAACP leader James M. Hinton to contest the seating of the all-white regular delegation to the Democratic national convention in the 1940s. He as well as Hinton supported the attempt of John H. Wrighten, Jr., to enter the USC law school. [111]

The problems of Charleston's NAACP branch transcended one man. The situation reflected a national trend. In the wake of the economic crisis following World War I NAACP leadership turned away from direct-action campaigns. The membership and number of chapters declined dramatically. In 1919 there were 100,000 members, but by the end of the 1920s the total dropped to 30,000. By 1923 roughly 200 of the 449 branches were dead or inactive. [112]

In 1939 national officials of the organization made discreet inquiries into the situation in Charleston. McCray's successor, William H. Miller, described most of the two hundred members as "dilatory[,] lethargic and noncommittal." Miller explained, "The Negro population here is obsessed with unmitigated fear of the dominant group and in consequence moves with the greatest caution. . . . so thoroughly are they conditioned by the Authority group that each feels that he can be saved only by a meekness that superlatives can-not adequately qualify. He must try to win for himself by himself." Another president, Jesse E. Beard, although a presiding elder in the Edisto

district of the AME church, placed the blame for such lethargy on his fellow black preachers. "I fear that too many preachers," he informed Walter White in 1943, "are more concerned about the 'Golden Streets' than they are about the streets we have to walk first down here." Perhaps desiring to bolster the spirit of the Charleston branch, the Swedish economist Gunnar Myrdal and the Howard University professor Ralph J. Bunche joined it in 1939.[113]

During the early 1940s the branch, under the leadership of an Averyite, J. Arthur Brown, was galvanized into action on the teacher salary equalization issue. This was part of a state NAACP campaign led by a Baptist minister, James M. Hinton, from Columbia. His chief lieutenant was Brown, who eventually succeeded Arthur J. Clement, Jr., as president of the Charleston branch. Born in 1914 in the home of his grandmother at 195 Line Street in Charleston, Clement's successor was the son of Arthur and Millie Ellison Brown. Millie Brown was a distant relative of William Ellison, the prominent upcountry black slaveowner. Having attended Claflin College, she returned to Charleston to become a teacher on Johns Island. In 1912 she married Arthur Brown, who grew up on James Island, where he attended school through the third grade and learned his trade as a carpenter. Despite his limited formal education, he became a Charleston contractor, building homes for wealthy whites. Against the advice of friends who told him he might antagonize whites, he built a beautiful home for his family on Kennedy Street and Ashley Avenue.[114]

In 1920 J. Arthur Brown, age six, attended Dart Hall kindergarten and then Simonton, which was being remodeled. As a result double sessions were instituted at Shaw. The Shaw students attended in the morning and the Simonton pupils in the afternoon. Finishing Simonton, Brown enrolled at Burke, where he completed the first half of the eighth grade before his mother decided to send him to Avery, which was then under the principalship of Benjamin F. Cox. She believed that the quality of education was higher at the AMA institute. Some of the public school teachers had been hired, she felt, because of their relatives' connections with elite white families (such as "cooking in Miss Jones' kitchen"). Avery also offered courses unavailable in the public schools, such as physics, Latin, and French. Moreover, Millie Brown liked its emphasis on speech, especially the rhetoricals.[115]

At Avery Brown saw and heard important intellectuals whom Cox invited. More important, he came under the influence of J. Andrew Simmons. Today he remembers imitating Simmons by changing his signature to J. Arthur Brown. Like Simmons, Brown chafed at some of the discrimination to which he and his peers were subjected. On his long trek to Avery from the family house on Ashley and Kennedy, he and his friends were required to stay on

one side of Rutledge Avenue, while the white children walked on the other side of the street. As his group passed by the High School of Charleston and Porter Military Academy, white students tossed ugly epithets, and sometimes stones, at them. The black students secretly retaliated by throwing "For Whites Only" benches into Colonial Lake. Segregation at the Citadel particularly galled Brown. Close enough to hear morning reveille, he bitterly resented being denied the right to attend the military college. "It really bothered me," he recalled in 1978, "when I graduated from Avery and couldn't enroll at the Citadel, because my skin was the wrong color and three Japanese youths were allowed to attend. I had only to travel across the town to get to the Citadel while they had to travel half-way around the world." [116]

After graduating from Avery, Brown worked his way through South Carolina State College, doing chores in the dining room and being Marion Birnie Wilkinson's driver. Receiving his degree in 1937, he searched for a job in Charleston. Frank A. DeCosta introduced him to Robert C. Weaver, a member of Franklin Roosevelt's so-called black cabinet. With Weaver's help he obtained a position as a tenant selection clerk for the Meeting Street Manor, a housing project. Eventually Brown turned to real estate and insurance, businesses affording some protection from the economic pressures of whites. [117]

Exactly when Brown joined the NAACP is unclear, but it was probably after he returned to Charleston from college. One day a fellow Averyite, Oliver ("Snookie") Hasell, introduced him to James M. Hinton. Hasell, like Hinton, was involved in selling insurance. As state manager of the Pilgrim Insurance Company, the Baptist minister often traveled to Charleston. Brown and Hinton soon developed a rapport. They accompanied the NAACP attorney Thurgood Marshall up and down the state in his efforts to challenge discrimination. [118]

Hinton decided to tackle the salary equalization issue directly. He would handle the Columbia area, while Brown would deal with Charleston. With A. B. Rhett as its superintendent, the Charleston school board was a particularly tough nut to crack. At the time the board had not even worked out a policy to award retiring black teachers pensions and did so on an individual basis. When an Averyite, Esther F. Alston (1894), wanted to retire in 1942, she was pensioned $25 a month but still had to do some office work at Simonton. In March 1943 Rhett informed the board that Hinton planned to raise the salary equalization issue. That year in the city of Charleston, which comprised Charleston County School District 20, white public school teachers received annual salaries ranging from $900 to $1,340, while their black counterparts were paid between $600 and $750. The salary range for white

principals was from \$2,500 to \$3,500 a year; for black principals, \$1,100 to \$1,450.[119]

Hinton and Brown chose a Burke history teacher, Malissa Theresa Smith, to test the issue. A graduate of Avery (1934) and South Carolina State College with two years of teaching experience, Smith was the first cousin of J. Andrew Simmons. She and her sister Irma had been reared in his home. According to Brown, salary equalization had been one of the factors involved in "Pearly" Simmons's resignation from Simonton. Irma E. Sams remembered that "Pearly" prepared Malissa "for what was going to happen—loss of position as teacher at Burke School." On June 24, 1943, Smith filed a petition with the school board. Its lawyer, H. L. Erckmann, informed his client in a letter dated July 22, 1943, that unequal pay based on race was unconstitutional. On August 6 the board met to deal with Smith's complaint. It was pointed out that the board had the authority to revise whatever regulations it desired, except for race or color, to grade and classify its teachers and principals. Besides voting to abolish its current method, the board passed a resolution that without regard to race or color all of its teachers and principals would be graded and classified "not only in respect to their certificates, but due consideration given to character, age, experience, preparation, teaching ability, and general fitness, and that all future salaries" would "be based on these qualifications." The plaintiff, Malissa Smith, did not answer the resolution because the board had found a way to dismiss her in October on the basis of her recent marriage and a technical ruling pertaining to an absence. The board had a policy of allowing married women to teach during the war, but only on a case-by-case basis. At this point Simmons encouraged his cousin "to go on, insisted that she go to New York to begin work on her master's." Individuals who supported her included J. Michael Graves, principal of Laing School in Mt. Pleasant. An active member of the NAACP and the Progressive party, he, like Brown, had been influenced by Simmons, who had taught him biology at Avery. Looking back, Malissa, currently residing in Atlanta, recalled that some blacks had feared to acknowledge her on the streets during the crisis.[120]

Undaunted, Brown and Hinton decided to find a male teacher to replace Malissa. They chose Brown's close friend Eugene C. Hunt, but Hunt had just been classified 1-A by the draft board, and they feared the suit might lead to his being immediately reclassified. At Hunt's suggestion they turned to his good friend and fellow Burke teacher, Viola Louise Duvall. A graduate of Howard University, Duvall was a science instructor with three years of teaching experience. On November 10, 1943, her suit against the city school board and superintendent was filed with the federal district court of

J. Waties Waring on behalf of her "individually and on behalf of the Negro teachers and principals in the School District No. 20, Charleston County." She was represented by Thurgood Marshall of the NAACP and a Columbia attorney, Harold R. Boulware. Protocol required that a member of the South Carolina bar be present. Duvall's suit illustrated how the state NAACP networking, based on the Pilgrim Insurance telephone system, worked. She would report any mistreatment by whites to Oliver Hasell, Pilgrim's district manager in Charleston. He, in turn, would relay the information to Hinton, who would then decide what to do.[121]

On February 10, 1944, Waring heard the case. Four days later he enjoined and restrained the board and the superintendent "from discriminating in the payment of salaries . . . on account of race or color." By 1946, two years after Waring's decision, black teachers in District 20 were finally receiving the same salaries as their white counterparts. During August of that year the city school superintendent, A. B. Rhett, retired; he died soon afterward. His death symbolized the end of an era of racial radicalism in Charleston. As important as this victory was, it demonstrated the resiliency of institutional racism. The day Malissa T. Smith Burkhalter was fired, the board began searching for alternative ways to pay black teachers less than whites. In a letter dated February 15, 1944, a day after Waring announced his decision, the board's counsel noted that it could still set "salaries based on individual qualifications, capacities and abilities." Over the opposition of most teachers, white and black, the board turned to the National Teacher Examinations for hiring and pay purposes. As one white observer concluded, "the great majority would not like to stand any examination." Some black teachers agreed to take it to show that they could pass it, but all of them resented the reason for its adoption. In August 1944 the board adopted the policy of employing only college graduates as permanent teachers.[122]

As for J. Andrew Simmons, rather than be dismissed for his participation in the salary equalization campaign in Columbia, he resigned in 1945 from his principalship of Booker T. Washington High School and moved to New York City, where he worked for its department of welfare. His accomplishments during this period of his career included founding a home for children from broken families, serving on a U.S. task force to rehabilitate educational facilities in the Pacific area after World War II, and being the first black elected to his central district school board. When he died in 1966, his body was taken back to Charleston for burial. Fellow Averyites, including J. Arthur Brown and Alphonso W. Hoursey, were among his pallbearers.[123]

H. Carl Moultrie (Avery, 1932), chief judge of the Superior Court for the District of Columbia. (Courtesy Avery Research Center)

G. Franklin Edwards (Avery, 1932), Howard University sociologist and colleague of E. Franklin Frazier. (Courtesy Moorland-Spingarn Research Center, Howard University)

Society for the Preservation of Spirituals performing at the College of Charleston, 1960. (Courtesy Special Collections, Robert Scott Small Library, College of Charleston, Charleston, S.C.)

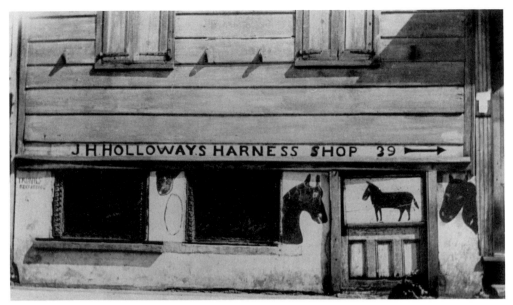

Holloway Harness Shop, 39 Beaufain Street, ca. 1933. The shop was founded in the early nineteenth century by Richard Holloway. (Photograph by Baxter Snark, Gibbes Art Gallery/Carolina Art Association, Charleston, S.C.)

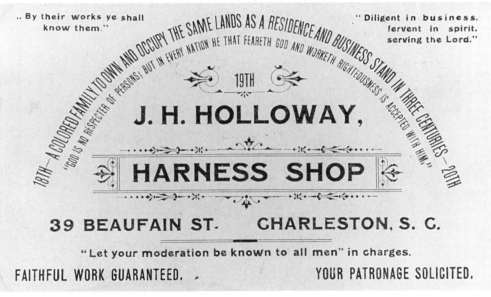

J. H. Holloway Harness Shop business card, front. (Photograph by Baxter Snark, Gibbes Art Gallery/Carolina Art Association)

Centennial Home of the Holloways.

Richard Holloway built the home on lands he got from his Father-in-law, who bought it in the 18th Century.

"For I know him that he will command his children and his household after him, and they shall keep the way of the Lord.

"Know old Charleston ? Hope you do!
Born there ? Don't say so. I was too:
Born in a house with a shingle roof:
Standing still, if you must have proof.
 And has stood for more than a Century.

J. H. Holloway Harness Shop business card, back. (Photograph by Baxter Snark, Gibbes Art Gallery/Carolina Art Association)

George Shrewsbury, antebellum butcher and slaveowner, was a Democratic city councilman during Congressional Reconstruction.

A Charleston advocate of Practical Reconstruction, A. Toomer Porter founded Franklin Street High School and was pastor of St. Mark's Episcopal Church, both for blacks. (Reprinted from Porter, Led On!)

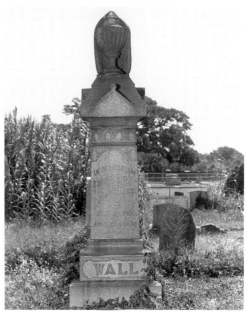

Established in 1856, the Brotherly Associa-
tion was one of many antebellum black burial
societies in Charleston. (Photograph by
William McSweeney, in author's possession)

Gravestone of Edward Power Wall (1815–
92), Humane and Friendly burial grounds,
Charleston, S.C. (Photograph by William
McSweeney, in author's possession)

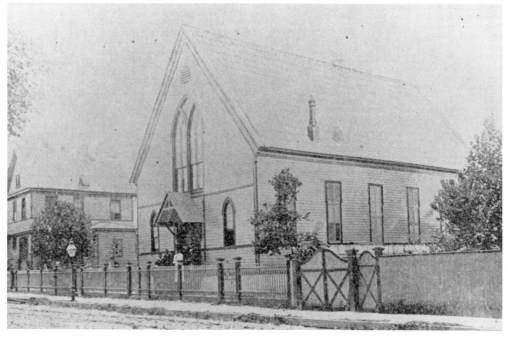

Plymouth Congregational Church and parsonage, 1895. (Reprinted from James T. Haley,
comp., Afro-American Encyclopedia, or, the Thoughts, Doings, and Sayings of the
Race *[Nashville: Haley & Florida, 1895], 640.)*

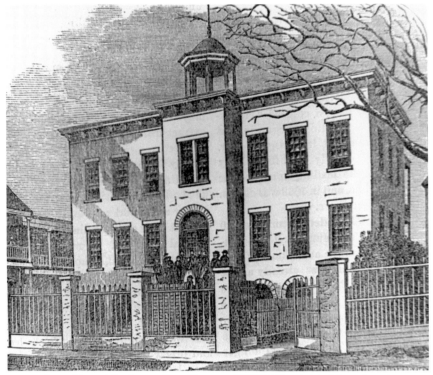

Avery Normal Institute, 1870. (Courtesy AMISTAD, reprinted from American Missionary *14 [May 1870], cover.)*

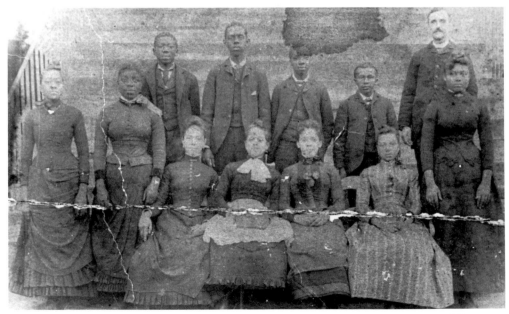

Class of 1888. Morrison A. Holmes is standing in the back row, far right; David R. Hill, next to Holmes, was the first black principal of the Charleston Colored Industrial School, later called Burke Industrial High School. (Courtesy Avery Research Center)

Morrison A. Holmes, principal of Avery (1886–1907). (Courtesy AMISTAD, reprinted from American Missionary *54 [Apr–Jun 1900]: 62.)*

Edward A. Lawrence (Avery, 1875) taught at Avery for almost twenty years and was interim principal until Holmes's replacement was found.

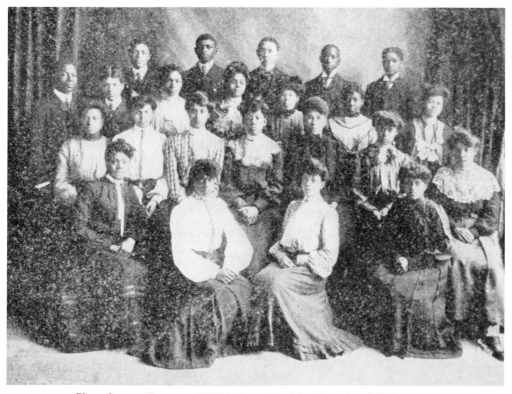

Class of 1905. (Courtesy AMISTAD, reprinted from American Missionary *59 [April 1905]: 119.)*

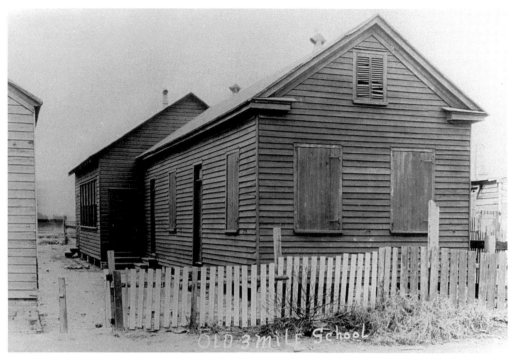

Averyites often taught at rural sites like Old Three Mile School, located east of the Cooper River. (Courtesy Collections of Charleston County School District)

Elbert M. Stevens, principal of Avery (1907–10). (Courtesy AMISTAD, reprinted from American Missionary 61 *[Oct 1907]: 237.)*

Benjamin F. Cox was the first permanent black principal (1915–36) after Francis L. Cardozo. (Courtesy AMISTAD, reprinted from American Missionary 73 *[Oct 1919]: 359.)*

Avery's last white teachers, ca. 1914. (Courtesy H. Louise Mouzon)

Jeannette Keeble Cox founded Avery's Phyllis Wheatley Literary Club, part of a national black women's club movement. (Photograph by William Mills, Silver Spring, Md., courtesy Mrs. Anna Cox Davis)

H. Louise Mouzon (Avery, 1914) taught at Burke for thirty-seven years. (Courtesy H. Louise Mouzon)

"Our First Colored Faculty," c. 1915. Front row, from left: A. W. Murrell (physics, chemistry, manual training), Lois Johns (English, history), Mrs. B. F. Cox (matron), Marie Forrest (domestic science, sewing), Mrs. A. L. DeMond (music), B. F. Cox (principal, algebra, botany); back row, from left: E. P. Morrison (seventh grade), S. E. Hamilton (Latin, Greek), P. R. Oberdorfer (English), F. A. Clyde (eighth grade), Oscelletta Davies (fifth and sixth grades). (Courtesy Avery Research Center, reprinted from The Pinnacle: A Book of the Class of 1916.)

Avery's first basketball team, ca. 1915. (Courtesy Avery Research Center)

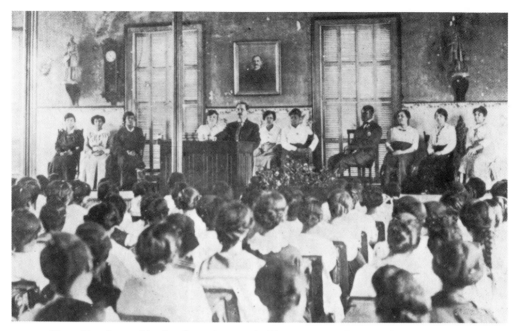

Cox addressing weekly chapel meeting, 1916. (Courtesy Avery Research Center, reprinted from The Pinnacle: A Book of the Class of 1916.*)*

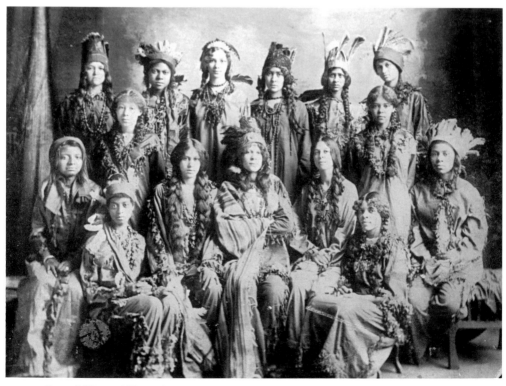

Cast of "Song of Hiawatha," 1916. Septima Poinsette Clark is seated at far right, middle row. (Courtesy Avery Research Center)

Lucille Turner McCottry in graduation dress, 1907. (Courtesy Avery Research Center)

Charlotte McFall in graduation dress, 1918. Cox mandated that the cost of the dresses not exceed $1.25. (Courtesy Avery Research Center)

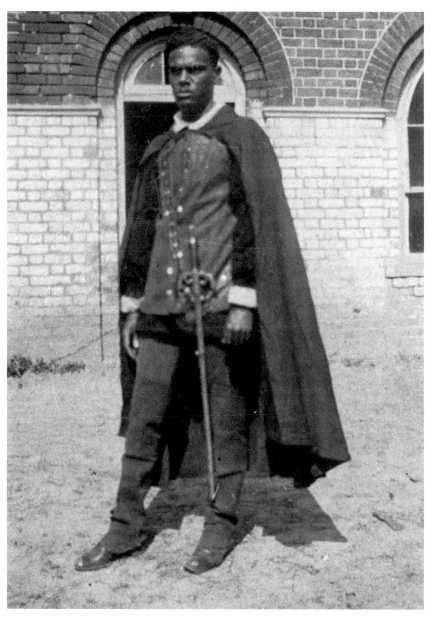

Under Cox, the senior classes began a tradition of performing Shakespeare. Here Aurelius Robertson is in costume for a 1918 performance of Twelfth Night. *(Courtesy Avery Research Center)*

J. Donovan Moore (Avery, 1899), an accomplished organist and pianist who had studied at the New England Conservatory, tutored a number of Avery students. (Courtesy AMISTAD, reprinted from American Missionary *79 [Apr 1925]: 59.)*

Edwin A. "Teddy" Harleston (Avery, 1900), a portrait painter and first president of Charleston's NAACP, came under the influence of W. E. B. Du Bois at Atlanta University. (Courtesy Mrs. Edwina H. Whitlock)

W. E. B. Du Bois, center, sight-seeing in Charleston with Benjamin F. Cox, behind Du Bois's right shoulder; Edwin A. Harleston, standing first left; and Edward C. Mickey, kneeling first left, March 1917. (Courtesy Avery Research Center)

Class of 1918. Second row, left, Benjamin F. Cox; top row, second from right, Joseph I. Hoffman; first row, left, Sarah Green Oglesby. (Courtesy Avery Research Center)

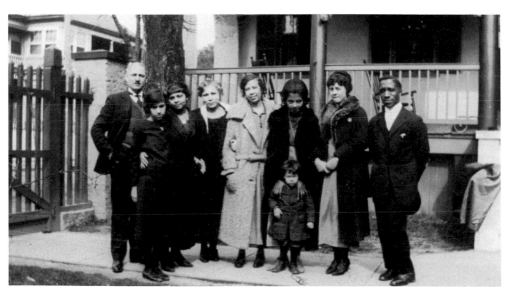

Cox family and faculty friends in front of teachers' home, 1920s. Social science teacher Charlotte DeBerry Tracy is holding the youngest Cox boy, Hadley. (Courtesy Mrs. Charlotte D. Tracy)

Fred L. Brownlee, general secretary of the American Missionary Association, 1929. (Courtesy AMISTAD, reprinted from American Missionary 21 [Jan 1929]: 264.)

J. Andrew Simmons (Avery, 1920), a science teacher at Avery, left to head a local public elementary school and, later, Booker T. Washington High School in Columbia. (Courtesy Avery Research Center)

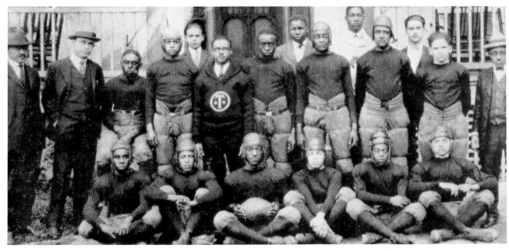

Avery's first football team, 1924. (Courtesy Avery Research Center)

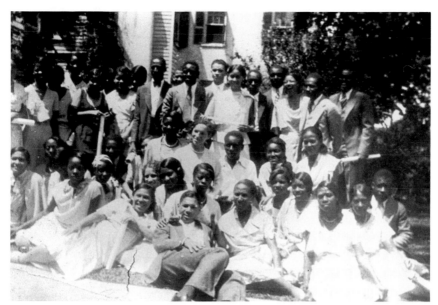

Class of 1932. Wendell F. Cox, sitting on grass, bottom row, center; Anna DeWees Kelly, sitting far left; H. Carl Moultrie, standing ninth from left; behind Moultrie's left shoulder, G. Franklin Edwards. (Courtesy Mrs. Anna D. Kelly)

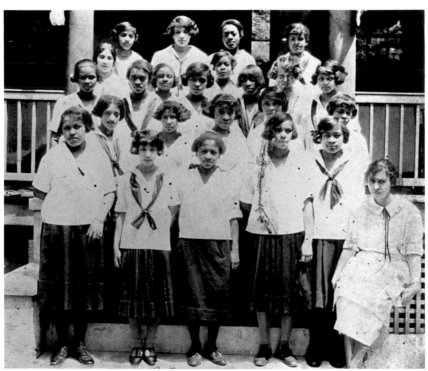

Girls' glee club, 1925. Maude Smith, a graduate of Avery (1915) and Fisk, was in charge of the school's music program. (Courtesy Avery Research Center)

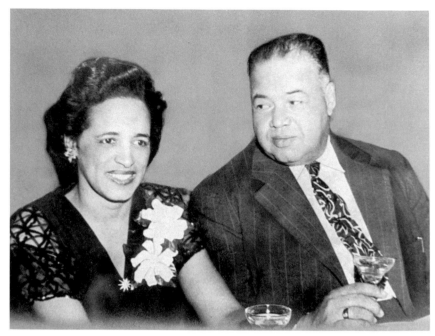

Dr. and Mrs. Joseph I. Hoffman, pictured here in the 1950s, were close friends of the Coxes. (Courtesy Dr. and Mrs. J. I. Hoffman)

A role model for many of the women students, Margaret Rutland Poinsette organized the Avery Dramatic Club in 1932. (Courtesy Lois A. Simms)

John Whittaker, a popular French teacher and director of choral music at Avery, was formerly a member of the Fisk Jubilee Singers. (Courtesy Avery Research Center)

An educator and founder of Dart Hall
Library, Susie Dart Butler was active in
the black women's club movement and the
Charleston Interracial Committee. (Courtesy
Charleston County Public Library, John L.
Dart branch)

As head of the Charleston Interracial Com-
mittee, Clelia P. McGowan helped establish
the city's public library system. (Courtesy
South Carolina Historical Society)

Frank A. DeCosta (Avery, 1927) was the
first Averyite to become permanent principal
(1936–41). (Courtesy Avery Research Cen-
ter, reprinted from The Averyite Nineteen
Hundred and Thirty-Nine.)

Samuel T. Washington was principal during
the fire of 1945. (Courtesy AMISTAD)

Robert Francis Morrison (Avery, 1902) opened an Esso service station in Charleston after a teaching career and work with the railroad. (Courtesy Mrs. Constance Morrison Thompson)

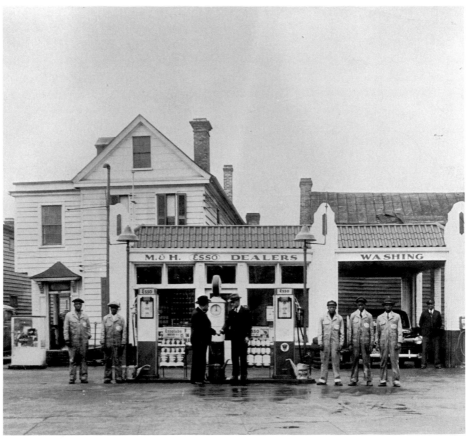

Robert Morrison's service station, 179 Coming Street. (Courtesy Mrs. Constance Morrison Thompson)

Leroy F. Anderson (Avery, 1935), a captain in the U.S. Army in the South Pacific during World War II, grew up on "Little" Smith Street. (Courtesy Dr. Leroy Anderson)

As a child, St. Julian Dash, Jr. (Avery, 1934), lived at 148 "Little" Smith Street in one of many closely knit black neighborhoods in the city. (Courtesy Dr. Leroy Anderson)

St. Julian Dash, Jr., joined other neighborhood talent to form an orchestra. He later went to New York to become a tenor saxophonist in Erskine Hawkins's band. (Courtesy Dr. Leroy Anderson)

Jametta White, "Miss Avery," 1939. The Miss Avery popularity contest was an annual event to raise money for athletics. (Courtesy Avery Research Center, reprinted from The Averyite Nineteen Hundred and Thirty-Nine.*)*

Cheerleaders, 1939, from left, H. Lum, H. Hutchinson, C. Pelzer, L. Pearson, C. Middleton. (Courtesy Avery Research Center, reprinted from The Averyite Nineteen Hundred and Thirty-Nine.*)*

A Fisk graduate, L. Howard Bennett (Avery, 1931) was appointed principal in 1941 to move Avery in a more progressive direction. (Courtesy Avery Research Center)

Like her husband, Marian Clae Bennett was a strong proponent of Deweyism. (Courtesy AMISTAD)

When Bennett resigned, Florence A. Clyde (Avery, 1891), supervisor of the practice school, was appointed interim principal. (Courtesy Avery Research Center, reprinted from The Averyite Nineteen Hundred and Thirty-Nine.)

A. B. Rhett, superintendent of Charleston city schools (1911–44), advocated industrial education for blacks. (Courtesy Collections of the Charleston County School District)

John A. McFall was a pharmacist and Avery trustee who wanted the school to become a state-supported junior college. (Courtesy McFall family)

Ruth A. Morton, the director of secondary schools for the American Missionary Association, opposed McFall. (Courtesy AMISTAD, reprinted from Brownlee, New Day Ascending.*)*

Julia Mae Brogdon, who later married Clifton A. Purnell, had Avery seniors send letters of application to the College of Charleston in 1944. (Courtesy Mrs. Clifton A. Purnell)

John H. Wrighten (Avery, 1943), a World War II veteran who joined Avery seniors applying to the College of Charleston. (Courtesy Charleston Chronicle*)*

Malissa T. Smith (Avery, 1934) taught at Burke Industrial High School but lost her job after seeking salary equalization for Charleston black teachers in 1943. (Courtesy Mrs. Irma E. Sams)

John McCray (Avery, 1931) was president of the Charleston NAACP and, later, editor of Lighthouse and Informer *in Columbia, where he helped organize the Progressive Democrats. (Courtesy Charleston* Chronicle*)*

Receiving an Omega Psi Phi achievement award, Judge J. Waties Waring addressed the fraternity at Morris Street Baptist Church, April 30, 1949. Also on the podium are Mrs. Waring; Avery principal John F. Potts; Avery choral director D. Jack Moses; H. Carl Moultrie; and Benjamin Mays. (Courtesy Avery Research Center)

WORK | # The Chatter-Box | SUCCEED

Vol. 7 Published by Simonton School—Charleston, S. C., February, 1944 No. 3

Simonton Host to Representatives From the Port of Embarkation

During chapel exercises on Friday, February 4, 1944, the first in a series of patriotic programs outlined by the steering committee to stimulate interest in our Fourth War Loan Drive, we had as our guest speaker, Lieutenant S. R. Bright, Chaplain at the Port of Embarkation. Chaplain Bright delivered a very stirring and inspiring address to the student body. Also present was Captain W. B. Crocker, Chaplain of 514th B. N. C., Port of Embarkation, who, too, gave a short but interesting talk. The following non-commissioned officers were presented to the student body by Chaplain Bright:

S-Sgt. Romeo R. Turner, 782 Med. Sn. Co. C. P. E.; 1st Sgt. Andrew H. Logan, 315, 2nd Qm. Ser. Co. 26, 1st Bn.; 1st Sgt. Junious T. Blake, 315, 1st Qm. Ser. Co. 26, 1st Bn.; 1st Sgt. Leroy Houston, Det. T. C.; and Mr. Leroy Chisolm, 2nd Class Officers' Mate, of the U. S. Navy. Mr. Chisolm is a former student of Simonton School, and is attached to the amphibian unit serving overseas for the past two years. He was engaged in six outstanding battles in the South Pacific, wounded in action, and was the recipient of the Purple Heart.

The following plays are scheduled as a part of the series of programs.

"Sharing America", 6-1, by Miss C. L. Brogdon—Feb. 28th.

"Message From Bataan", 6-6, by Miss L. T. Perry—March 3rd.

"We Will Do Our Part", 4-5, by Miss M. C. Patrick—March 2nd.

"Simonton has gone to war—the squander bug must die!"

—oOo—

Courtesy

Would you like to be courteous? To be courteous is to be polite and thoughtful of others. If we are always thoughtful we may think of ourselves as being an "Ideal Simonton Student". I would like for all of the pupils of Simonton to make up their minds to be an "Ideal Student". To do so we must use some Golden Keys.

Some of these keys that we should use at all times are: "Thank you", "I am sorry", "If you please", "Excuse me", "You are welcome", and "I beg your pardon".

If we would make up our minds to use these keys, a good many of the fights will be avoided, there will be less arguments around our school, and we will all live like members of one big happy family around "Dear Old Simonton". Come on, schoolmates, let's make up our minds to use these Golden Keys.

Alfred Brown, 6-1.

A Message for Boys

Do not talk, enemy's ears are listening,

A slip of the lip will sink a ship.

Tin cans will help win the war,

Tin cans will help heal,

Tin cans will help feed our boys on battlefields,

And help to keep our boys strong and healthy.

Lelia Hunter, 6-6.

—oOo—

Let's Buy 'Em And Keep 'Em

War bonds speed victory. Every American fighting man has a dream. A dream of the day to come, of the day when the war is won. The day when he can return home to family and friends and to live once again in the realms of peace. We at home can help his dream become a realization by doing the little things asked of us to speed victory. We can buy bonds and more bonds, and keep on doing it until our boys come home. Let us back the attack. Buy more stamps and bonds. Stamps are on sale every day at the school. Let's continue buying them.

Jeanette Roper, 7-4.

Here is a group of Simonton's little folk doing their bit to help their country; they have gone out 100 per cent to make our Fourth War Loan Drive a big success. These little folks are quite aware that there is a war going on, and they are anxious to do all they can to help the men who are fighting for a better future for the world. Simonton has as its goal $1,500 in stamps and $400 worth of bonds during this drive, and we are determined not to fall short of that.

Colored To The Rear

"To ride any Southern bus the prices are so dear,

You pay the same as anyone but "colored to the rear;"

Hey, there! Stand back and let those white folks by,

If you boys aren't careful someone is going to die.

The camp is out in the country, seven miles out of town,

No use to try to hitch a ride because your skin is brown,

You leave loved ones behind you to fight for Democracy,

But at times you stop to wonder, What has it done for me?

Out on the battlefield it's true you fight with all your might,

There is no "Colored to the rear", for death no black or white.

On far flung shores you fight each day, no thought of race or creed.

You are fighting for world freedom though you are not yet freed.

Enlisted in some Northern camp you stay about a week,

Then to the South and prejudice denied the right to speak,

My God! May peace deliver me from death, from blood, from tear,

From racial strife of Southern life, from "Colored to the rear".

By Marthalee Harriet Gray, Grade 7-1.

From the Pittsburgh Courier.

February Month of Many Birthdays

February is the month, as the saying goes — "great people are born". We celebrate the birthdays of Abraham Lincoln, the signer of the Emancipation Proclamation; George Washington, the father of our Country; Edison and others.

It is very seldom we hear of Negroes celebrating the birthdays of our great Negroes.

In the month of February, we find that we have some great Negroes born. Some of these Negroes are:

Langston Hughes, born Feb. 1, 1902, in Joplin, Mo.; a student and poet.

Emmet J. Scott, born Feb. 13, 1873; an educator, and also secretary to Booker T. Washington.

Richard Allen, born Feb. 14, 1760; founded the A. M. E. church in Philadelphia, the greatest organization for Negroes in the world, because of prejudice against his race.

John A. Gragg, born Feb. 18, 1877, in Eureka, Kansas. The first colored man elected President of Howard University but did not accept. A bishop in the A. M. E. Church. Was elected by the Federated Council of Churches to visit our soldiers on the many battle fronts.

Frederick Douglass, noted American, anti-slavery, agitator and statesman, who once said: "What was possible for me is possible for you. Do not think because you are colored you can not accomplish anything. Strive earnestly to add to your knowledge. So long as you remain in ignorance, so long will you fail to command the respect of your fellow men."

Alfred Brown, 6-1.

—oOo—

Pupils Prepare For Stamp & Bond Rally

Copies of war stamp and bond songs to be sung in various familiar tunes are being distributed to all pupils. The entire school-community will gather on the school ground to sing, yell, and have short speeches from each class to accelerate the purchases of stamps and bonds.

—oOo—

Pupils of Simonton Send Records To USO Units

A collection of fine recordings were collected by the pupils of Simonton School to help keep up the morale of our fighting men overseas. This gift will be turned over to the American Legion Auxiliary.

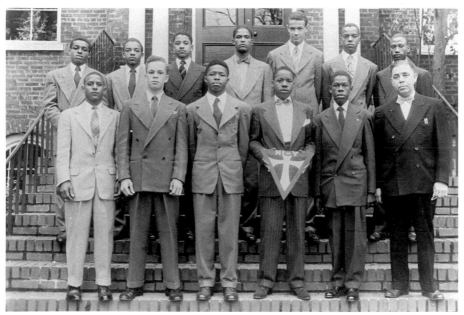

Avery HI-Y Club. A. W. Hoursey (Avery, 1920), front row, far right, was advisor of this club dedicated to promoting high standards of Christian character. (Courtesy Avery Research Center)

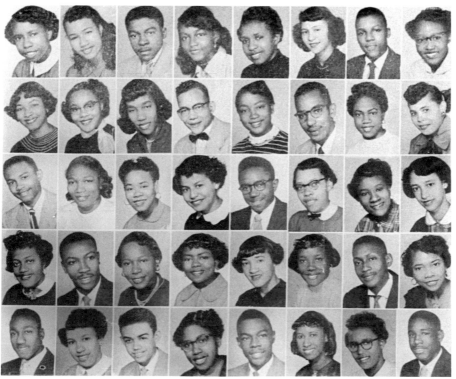

Avery's last graduating class, 1954. (Courtesy AMISTAD, reprinted from Avery Tiger, *April 1954, 3.)*

Senior high school supervisor and dean of women at Avery, Geneva P. Singleton successfully made the transition to Burke Industrial High School. (Courtesy Burke High School, reprinted from the 1959 Bulldog, *Burke High School, Charleston, S.C.)*

Anna D. Kelly (Avery, 1932), executive director of Charleston's YWCA Coming Street branch, introduced Septima Poinsette Clark to Highlander Folk School. (Courtesy Mrs. Anna D. Kelly)

Charleston businessman Arthur J. Clement, Jr., was the first head of Avery's administrative council and president of the Charleston NAACP. (Courtesy Avery Research Center)

Septima Poinsette Clark (Avery, 1916) was an educator and national civil rights leader. (Courtesy Special Collections, Robert Scott Small Library, College of Charleston, Charleston, S.C.)

J. Arthur Brown (Avery, 1933), a local businessman, NAACP president, and civil rights activist who coordinated and led the legal assault on segregation in Charleston. (Courtesy Brown family)

Millicent Edyth Brown, shown in her Rivers High School yearbook, 1966. (Courtesy Collections of the Charleston County School District)

Wilmot J. Fraser (Avery, 1926), supervisor of Negro schools, district 20 (1960–66). (Courtesy Charleston News and Courier*)*

Richard E. Fields (Avery, 1940), Charleston's first black municipal judge since Reconstruction. (Courtesy Avery Research Center)

Eugene C. Hunt (Avery, 1935), College of Charleston's first tenured black professor, helped found the Avery Institute of Afro-American History and Culture. (Courtesy Charleston News and Courier*)*

Lucille S. Whipper (Avery, 1944), first president of the Avery Institute of Afro-American History and Culture, became Charleston County's first black woman legislator in 1986. (Courtesy Whipper family)

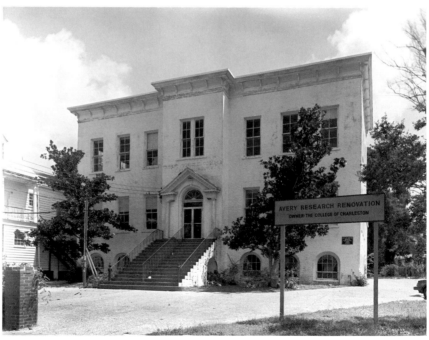

The Avery Research Center, co-founded by the College of Charleston and the Avery Institute of Afro-American History and Culture, is to be located in the main Avery building. (Photograph by William McSweeney, 1988, in author's possession)

Avery's Transition from a Private to a Public School, 1945–1947

During the first two years of John F. Potts's tenure his actions justified the AMA's faith in him. Stressing community outreach, he worked with the various black organizations to establish a "people's movement" at the grass roots level. With their cooperation he started an adult education program called the People's Institute. In March 1947 an AMA report of his "common ground work" stated, "Courses were offered Wednesday evening for eight weeks. There was an assembly with a news seminar and a special feature was juvenile delinquency, parent education, health, etc. About sixty people attended. Entirely interracial courses were offered,—consumer's education, everyday math, ever[y]day English, church choir, bible, art appreciation and 'Know your Charleston.' " The memorandum mentioned that the Avery students had established a cooperative café, which they made available to black groups in the evenings because there was "nothing of the kind in the city." By 1947 Potts was also active in Shaw Center, primarily funded by the Community Chest. "I'm on its Board," he reported. "Shaw is a typical settlement house—various clubs for people of all ages, day nursery, wood-working and cabinet-making, home-making, music and art appreciation, place for meetings of interracial and other social welfare committees." [124]

In addition to his community outreach work and regular duties as principal, Potts prepared the way for Avery's becoming part of the city public school system. First, he had to allay the Avery people's fears, probably fostered by the transformation of Shaw Memorial School into a social center. "Then there is the Shaw Center," Potts explained. "To begin with it was a private school like Avery, but never had adequate support and was miserably housed. It was finally condemned by the city authorities; those in charge were forbidden to conduct a school there. Since then it has been doing a down-at-the-earth job in various ways." (In 1947 the interracial Charleston Welfare Council described the former school building as "an old, but extremely well built and well preserved structure.") Despite their fears, Potts was able to persuade the Avery people to accept the inevitable—the transition of their school from a private to a public one. Second, he established good relationships with the city school authorities.[125]

In 1982, looking back on his years as Avery principal, Potts stated that he knew the school would eventually become public, but he hoped to stem the tide for a while because he felt there were things a private institution could do which a public one could not. The AMA, not intending to continue supporting a private high school in Charleston indefinitely, pushed for the transition. But more important, changes were occurring to make

the takeover possible. The fear of outside intervention pushed white authorities to make concessions improving black public education. Like many southern governmental agencies, the school board in Charleston began significantly increasing the money it was spending on black schools after the blacks themselves started filing lawsuits. This funding increase was an effort to make the separate-but-equal doctrine more of a reality and thus forestall any integration.[126]

There was some evidence, even when the city school superintendent was A. B. Rhett, that the board might move toward taking over Avery as it had Shaw. In 1942 Burchill Richardson Moore, who was a teacher and principal in the city public school system, reported in his study of its black schools "that the most urgent need is another high school. Although the pressure has been somewhat alleviated by the private schools [Avery and Immaculate Conception], the condition is still acute. The creation of another high school would allow Burke Industrial School to function solely as an industrial school, for which purpose it was founded." [127]

The history of the Catholic schools, Immaculate Conception and St. Peter's, demonstrated that private institutions continued to supplement and alleviate the inadequate public school facilities for blacks in Charleston. Until Buist was opened in 1921, many black children had to attend private schools like St. Peter's, established in 1870 just north of Wentworth. The Catholic church finally closed it in 1936 to curtail the expense of operating both it and Immaculate Conception (founded in 1903). In 1917 the Oblate Sisters of Divine Providence, an order of black nuns, took over both St. Peter's and Immaculate Conception. Relocating the latter to a newly constructed facility on Coming Street in 1930 enabled it to develop a high school department. The first senior class graduated in 1934. The next year the high school was accredited by the state.[128]

Burchill Moore noted in 1942 that although Burke was not accredited by South Carolina "because of the inadequacy of certain physical equipment," the city school board expected "to remedy the situation as soon as possible." Three years later the Charleston *News and Courier*, lukewarm about public education but fearful of outside intervention, came out in support of getting Burke accredited. However, the city school board decided to "discontinue forthwith any plans or steps which have heretofore been taken" to accredit Burke because "its action in this matter was premature in view of the present lack of facilities in this institution." [129]

Despite such determined opposition, an Averyite, Robert F. Morrison, sought to rally the public behind the cause at a meeting held at Morris Street Baptist Church on July 6, 1945. Members of the committee to draw

up a petition included the Averyite James Wieters Brawley, a postman; William E. Bluford; and the Morris Brown AME pastor, R. I. Lemon. All three were NAACP leaders. Also on the committee was Harriet Porcher Stoney Simons, wife of Albert Simons, a Charleston architect. Robert Morrison; the Emanuel AME pastor, R. E. Brogdon; and the white author John Bennett were appointed to discuss the matter with the school board.[130]

Nine days after the meeting the *News and Courier* published an article by John Bennett, who remonstrated that Charleston, with proportionately the largest black population of any city in the state, had no accredited black public high school. He argued, "If, in objection, it be offered that an overwhelming flood of negro students from the county would swamp the city school, a fear which apparently has arisen from uncertain interpretation of the school laws, that is a matter which can be easily and equally adjusted." All he asked was that the board make "a very definite, frank declaration of its intention to raise the Burke school to the full level of an accredited high school the moment means shall become available so to do. Such an announcement would allay, prevent and put an end to racist tension at a time when such tension is being fomented by self-seeking propagandists throughout the length and breadth of the country." Shortly thereafter the city school board set up a special committee to study the matter. By 1947 Burke was accredited by the state, but it was not accredited by the Southern Association of Colleges and Secondary Schools until 1954.[131]

Understandably, most Averyites had little faith in the city school board, especially one run by the "Old South" proponent A. B. Rhett. Resigning in August 1946, he was replaced by a man able to win the confidence of the Averyites. Born in Charleston in 1889, George C. Rogers, Sr., was the son of a painter and wallpaper hanger. A 1910 Citadel graduate, he was every bit as aristocratic as Rhett in bearing, but decidedly more progressive, having received his master's degree from Columbia University. Beginning his educational career in 1910 by teaching for a year at Georgia Military Academy, he returned to Charleston to be vice principal at Simonton, then principal of Courtenay. In 1934 he became acting superintendent of the city's public schools and was later named A. B. Rhett's assistant. For six years he served simultaneously as assistant city school superintendent and principal of Memminger until he succeeded Rhett.[132]

According to Fred L. Brownlee, the Averyites had resisted the transition to a public school "graciously" until Rogers, "a new superintendent with proper attitudes, a man who inspired confidence came to office." Almost immediately Rogers and Potts developed a rapport that made the transition possible. Toward the end of 1946 they began meeting to discuss ways the

city could financially help Avery. On January 28, 1947, Reginald C. Barrett, chairman of Avery's administrative council, asked the city school board for a formal response to Potts's oral request for financial aid. Board lawyers advised the school commissioners to request "the county and city to make sufficient donations to Avery to enable the Institution to function properly." Implicit in the reasoning was the hope that such help might mute any attempt to desegregate the city-supported College of Charleston. However, the board chairman, J. F. Seignious, told the administrative council that the city could not help a private institution. He suggested that the council formally request that the board take over Avery as part of District 20. The AMA might rent out the Avery building or deed it over to the board for a number of years. Brownlee and Potts met with Rogers and board members to work out the arrangement. The Charleston County legislative delegation interceded, offering the AMA twenty thousand dollars to help it operate Avery during 1947–1948 "on a private basis." The AMA, however, was "reluctant" to do so or to grant its use "on a private school basis." The association, Brownlee informed Rogers, was "disposed to proceed along those lines" tentatively reached. After "serious consideration," the administrative council agreed with "the plans to integrate Avery into the public school system." During the period when negotiations were being finalized, the Charleston Welfare Council in cooperation with the National Urban League published a report noting the overcrowded conditions of the city's black public schools and recommending that the city take over Avery. "The American Missionary Association's withdrawal of financial support from Avery," it pointed out, "has imposed a considerable annual burden upon the local population." [133]

By the terms of the agreement, the city school board would lease the Avery building for the next twenty years at fifteen hundred dollars per annum. The institute would continue to operate as a college-preparatory high school with Potts remaining as principal. He and his staff would work for the city rather than the AMA. It was still hoped within the black community that Avery would develop into a college. In June 1947 John H. McCray wrote to George Rogers, Sr., "We understand that the city of Charleston has assumed operation of Avery Institute and may develop it into a four-year college for negroes." Rogers immediately replied that the city had no such plans. [134]

For Brownlee, the agreement vindicated AMA policy. In January 1948 he returned to Charleston to evaluate the outcome. The school commissioners and George Rogers, Sr., had "lived up to every promise and have done so with a plus margin." He noted that teachers' salaries had risen dramatically from $1,500 to $3,650. The quality of the school was "as high as it ever was," and the parents no longer paid tuition. Brownlee quoted Potts as saying,

"Really, I can complain of nothing, have only praise for all that has happened. I'm very happy, much encouraged, and plan to stay. The A.M.A. did the right thing, at the right time, and in the right way in making the change." Brownlee also took the opportunity to criticize opponents of the transition, such as Frank A. DeCosta, who conceded that "conditions are much better than he expected." Most Averyites, the AMA secretary recalled, did not want their school to change, "unless it was made a junior college." Although the local people *"surrendered,"* they *"never willingly accepted* the change which came to pass." However, events proved the AMA correct. Brownlee added, "The tragedy in all this was that the people never really knew or understood the A.M.A.—its deepest thoughts, highest ideals, its methods of work, its concern about people learning to face their own problems and solving them collectively." [135]

CHAPTER

6

Avery as a Public School,
1947–1954

With Avery's continued existence assured, euphoria prevailed. Under John F. Potts the school preserved much of what older Averyites cherished. The importance of culture and social uplift was emphasized as strongly as ever. Avery remained an academically fine high school, producing service-oriented graduates. Potts, like L. Howard Bennett, extended the school's influence into the larger community. A city board of school commissioners filled the role formerly exercised by the AMA home office, but with an enlightened superintendent such as George C. Rogers, Sr., in charge, the change promised to bring forth an era of good feelings.

The decline of the color line at Avery, accelerated by World War II, was further hastened when the school became public. The war increased prosperity in Charleston, enabling more black parents to send their children to Avery, despite the tuition raises to meet AMA demands. When the school turned public, tuition no longer was a hurdle to the children of less affluent parents. Increased access to Avery, leading to a more heterogenous student body, bolstered changing attitudes toward the color line, already discredited as provincial. Potts, who became principal toward the end of the war, consciously sought to end any lingering manifestation of the color line at the school. Averyites themselves grew vocally critical of its remnants. Many were actively involved in the NAACP's efforts to overturn the more oppressive aspects of discrimination in South Carolina.

Just as the school was becoming a more effective vehicle to unite Charleston's black community, it was closed. Averyites viewed the closure as a conspiracy by white Charleston to undermine an increasingly effective black leadership. For them it was no coincidence that the school's termination coincided with the historic ruling of the U.S. Supreme Court in 1954 that segregation in public schools was unconstitutional. The initial decision to

abandon the school was made during NAACP efforts to desegregate the College of Charleston.

Charleston's white leaders had no incentive to keep Avery open. They were not blind to the fact that the school was a center of NAACP activities, especially after Averyites eagerly embraced the federal judge J. Waties Waring and his wife, Elizabeth Avery Waring. Moreover, when Avery was private, it not only saved white taxpayers money but presented a possible way to preserve segregation at the College of Charleston. As a private institution, Avery had the potential to develop into a black counterpart. However, when the school turned public, it became a financial liability to white Charlestonians. Also, its steady producing of competent ambitious graduates highlighted the absence of college training facilities for blacks in the Low Country. Thus, the city school board, wanting to retrench, saw no reason to keep Avery open. Outside educational "experts" affirmed the board's plans by suggesting that merging Avery with Burke was the most efficient way to educate the city's black teenagers. The board's course was reinforced indirectly by black educational critics who faulted Avery for excessive elitism.

Continuity

According to John F. Potts, who oversaw Avery's transition from a private to a public school, the transfer generated little immediate change. Many of the teachers had been employed when it was private or were Avery graduates. Potts's assistant principal, Alphonso W. Hoursey, was an Averyite hired by Benjamin F. Cox. Other oldtimers included Geneva P. Singleton, Margaret Rutland Poinsette, and Charlotte Tracy. Tracy, who was at the school in the 1920s but retired after her marriage, returned to teach after the war. Averyites on the staff included J. Michael Graves, Lois Simms, and Lucille A. Williams. All three had fine academic credentials. Graves, who majored in chemistry at Fisk, also had an M.S. from South Carolina State College. Besides teaching science, he was adviser to both the science and junior HI-Y clubs. An accomplished pianist and organist, he assisted D. Jack Moses with the choral society. Lois Simms graduated from Avery in 1937 as valedictorian. In 1941 she received her B.A. from Johnson C. Smith University in Charlotte, North Carolina. L. Howard Bennett hired her to assist Florence A. Clyde in the practice teaching department. Simms later taught at Laing School in Mt. Pleasant and the Henry P. Archer School in the city. She transferred to Burke in 1945. In 1952 she returned to Avery to teach ninth-grade English. Two years later she finished her M.A. in educa-

tion at Howard University. Lucille Williams attended Immaculate Conception before she enrolled at Avery in 1935. Her father was headwaiter at the elite Henry's Restaurant. Her mother, an Averyite, taught in the tricounty area. Following in her mother's footsteps, Williams worked at a three-teacher school in Dorchester County after she completed Avery's normal program in 1938. In 1941 Jenkins Orphanage employed her to handle grades one through three. She left to attend Agricultural & Technical College in Greensboro, North Carolina, where she received her B.A. in 1944. With the help of Geneva P. Singleton, she obtained a position at Avery to teach in the kindergarten and lower grades. She was shifted as Avery shed its lower grades under Potts. By the fall of 1953 she was teaching the eighth grade. Attending the University of Chicago during the summers, she received her M.A. in 1951.[1]

After Avery dropped its teacher training program in 1945, it gradually eliminated the lower grades and concentrated on developing its college preparatory track. By October 1953 the seventh grade, "the last remaining class of the elementary school," had been discontinued. The total enrollment that year was 408 (178 men, 230 women). Of these students, 115 wanted to go on to college; most listed black colleges as their first choice. That same year a majority of the 66 newly enrolled students said they chose Avery because of its reputation for "scholarship, character, leadership and service."[2]

A bit apprehensive over its transfer, Potts sought to reassure the AMA and the Avery people that the school would be able to maintain its traditional emphasis on character and culture. In September 1947, as it embarked on its first year as a public school, he described for Fred L. Brownlee "the Avery student," who, besides being good in his subjects, "is generally agreeable, fairminded, honest, clean in words and deeds." The Coxes would have been delighted with the description. About a year later Potts reported to Ruth A. Morton, "Since most of the people have seen that Avery is maintaining the same high standards, they are not concerned about the transfer."[3]

The new students from "all over" the city, were every bit as "smart" as their predecessors. They scored well on the standard exams but were less respectful toward the teachers. They tended to be "louder" and "smarter" with "their tongues." In the fall of 1952 the Charleston chief of police felt obliged to call to the attention of George Rogers, Sr., complaints about the behavior of some of the Avery students while they were going to and from the school. One incident involved crowding the sidewalk and "sassing" a white citizen. Some Avery teachers strived to control these tendencies by teaching etiquette in the classroom. In 1953 S. B. Long's English classes

studied "Emily Post and other references on etiquette" for the Christmas holidays.[4]

Editorials and articles in the *Avery Tiger*, probably inspired, if not written, by its adviser, Alphonso W. Hoursey, stressed the importance of refined behavior in public. Some of the students themselves were outspokenly critical of what they considered a decline in Avery's cultural standards. Robert ("Bob") Miller, writing a column for the school newspaper, asked in December 1952, "Are We Cultured?" He recalled, "Not too long ago, one of the chief goals of our schools was to make cultured people of the pupils attending. Avery has always had a record of developing culture within her walls. But do we always reflect this training?" In another article, Miller reminded his readers that culture and social uplift were closely intertwined at Avery, where students learned "the ideals of culture and refinement" as well as "formal subjects."[5]

The commencement programs as well as the student newspaper demonstrated that cultured behavior was still esteemed and still emphasized. At the 1949 commencement exercises the Avery HI-Y Club awarded Kenneth Henry for exhibiting the "most exemplary behavior among boys for four years" and James Hilton for being the "best mannered boy in the senior class and school." The Beta Alpha Sigma chapter of Delta Sigma Theta sorority honored Helen Bolds for "exemplification of the ideals of true womanhood." In 1953 Miller, senior class president as well as editor-in-chief of the school newspaper, received both the HI-Y prize "for the most exemplary behavior among the boys for four years" and the Good Citizenship Award established by the class of 1926.[6]

Culture continued to mean the development of the whole individual. Consequently, music, drama, and sports functioned in much the same manner as they had in the past in instilling culture and character. D. Jack Moses, as adviser to the choral society, and Margaret Rutland Poinsette, as drama coach, kept the tradition alive. Under Moses the Avery choral society went on producing and performing the Extravaganza Classique. The 1954 rendition included "the choral society, boys and girls glee clubs, and the a cappella choir, assisted by the Dance Group and Corps de Ballet." That year Poinsette's students performed Moliére's three-act comedy *The Imaginary Invalid*.[7]

Culture at Avery still had a black dimension. Potts, like his predecessors, invited noted blacks to visit Avery. These guests included E. Franklin Frazier, Langston Hughes, and W. E. B. Du Bois. Often such dignitaries and other celebrities visiting Charleston, including Roland Hayes, boarded

with the Potts family at their 54 Montagu[e] residence, which they had pur-
chased from the AMA. The impact of these visitors was reinforced by other
activities. In February 1951 the Avery PTA sponsored a program for Negro
History Week. The school newspaper regularly ran "New Books," a column
in which pertinent publications on the black experience were reviewed.[8]

Sports particularly illustrated that character building remained important
to Avery parents and teachers. At a 1950 PTA banquet honoring the football
team, Etta Clark, whose son was a member, spoke on "what we expect foot-
ball to do for our boys." She stated that the sport was "to teach . . . habits of
health, good morals, and to develop in them the ideals of manhood." Jesse
Purvis, the team captain, noted "that football keeps boys off the streets and
therefore keeps them out of trouble." The head coach, Luther S. Bligen,
agreed. A graduate of Avery and South Carolina State College with an M.A.
from New York University, Bligen declared "that his interest in the mem-
bers of the team went far beyond that of winning ball games." He tried "to
help them prepare for life." In the same issue that reported the banquet,
Alphonso Hoursey advocated "the highest ideals of clean sportsmanship and
physical, mental, and moral development in athletics." The school news-
paper described the assistant principal as "the oldest faculty member, in
point of service. . . . a great sports lover and fan," who felt that the most
gratifying award for a teacher was "setting in the path of usefulness the feet
of one who might otherwise have been the world's worst failure." Hoursey
himself was proud of the fact that he was the first black ever to be "awarded
the HI-Y merit pin."[9]

World War II, causing the dispersion of Avery students throughout the
country, fostered the efforts of Avery principals and teachers to undermine
class and color distinctions by advocating "cultural parity." Leroy Ander-
son's tour in the army, for instance, took him to San Francisco, where he
attended opera performances as often as possible. The experiences of these
Averyites showed them how parochial and undemocratic "old Charleston"
could be.[10]

Some exclusiveness, however, lingered. Graduates from the class of 1944
remembered not being encouraged to socialize with their Burke peers. In
1946 twelve years after graduating from Avery, Edwina (Gussie Louise)
Whitlock, the niece of Edwin A. Harleston, informed readers of the Gary,
Indiana, *American* that Charlestonians "got pretty screwy standards of accep-
tance." Whitlock recalled that Charleston's black aristocracy could be
divided into four groups along the lines of family, color, achievement, and
money. The aristocracy of family was "based on how long one's family was
free before Abraham Lincoln tried to stop all that sort of foolishness." Fol-

lowing close behind was the "aristocracy of color." Although branding the old anecdote about the panel-and-comb test at St. Mark's as "ridiculous," Edwin Harleston's niece claimed that most Charlestonians "classify people according to what shade of tan they present to the world in winter time. . . . The cafe au lait complexion of a Joe Louis just couldn't make the grade." The third category, achievement, included persons like Kelly Miller and Ernest E. Just, who were accepted by the first two groups "in direct proportion to the national acclaim and recognition" they had gained. The money elite was the "least recognized of all," Whitlock remembered.[11]

Whitlock, brought up in the social and cultural circles of the first families, reflected the intellectual estrangement experienced by some Averyites who left Charleston and the South to fulfill their career aspirations. She was the daughter of Edwin A. Harleston's youngest brother, Robert, and Marie Forrest Harleston. Like the Harlestons, the Forrests, most likely descendants of antebellum free blacks, sent their children to Avery. After attending the AMA school and graduating from Howard University, Marie Forrest Harleston taught home economics at Avery during the first year it had an all-black faculty. Her sister, Elise Forrest, graduated from Avery in 1908 and pursued a teaching career before she turned to photography under the encouragement of her brother-in-law and future husband, Edwin A. Harleston. Both Gussie and her younger sister Sylvia also attended Avery. Because their parents contracted tuberculosis, Sylvia was sent to their aunt, Eloise Harleston Jenkins, while Gussie went "to live in the Teddy Harleston household." She recalled, "we entertained the leading folk on the national scene in our home. College presidents, YWCA executives, Dr. Gregory of the Bahai Movement, the NAACP big-wigs—Mary White Ovington, James Weldon Johnson, W. E. B. Du Bois on more than one occasion; Mary McLeod Bethune, Julia Peterkin." Then when her uncle Teddy died while she was still in the ninth grade, Gussie, switching her name to Edwina Augusta, explained, "I joined my sister in the D. J. Jenkins home where we had all the amenities of 'black royalty,' servants, chauffeurs, a tennis court in our back yard—and another kind of exposure: playing host to the celebrated 'Black Billy Sunday,' the Washington evangelist; C. C. Spaulding, founder of North Carolina Mutual, again Mary McLeod Bethune."[12]

After graduating from Avery in 1934, Edwina entered Talladega, where she received her B.A. in 1939. While studying journalism at Northwestern University (on the Evanston and Chicago campuses), she held various journalistic positions. For a while she was a rewrite editor for the Associated Negro Press in Chicago; then she became a reporter and later national church editor of the Baltimore *Afro-American Newspaper*. She was a feature

and rewrite editor for the Chicago *Defender* and even worked as an editor of the *Negro Digest* under John Johnson, who later began publishing *Jet* and *Ebony* magazines. Her marriage in 1945 to a fellow student, Henry Whitlock, took her to Gary, Indiana. Her husband and she purchased from his father the weekly Gary *American* and ran it together for sixteen years. About a year after Henry's death, she moved with her four children to Los Angeles, California, where she held a public relations job with Family Savings and Loan for more than two years. After taking courses at the University of California, Berkeley, she became a state social worker. Retired and currently residing in Charleston, Whitlock still describes Charleston as "a comparatively small city" where "'family' and 'achievement' are still of paramount importance" and "the underlying motif persists." [13]

Ironically, as World War II hastened the fading of the color line in Charleston, the issue became the object of national exposés. The same year Whitlock's article was published (she sent a copy to John Johnson), *Ebony* predicted that Charleston's "snobbish Negro aristocracy" was "'passing' out of existence." Like Fred L. Brownlee, *Ebony* perceived Herbert A. DeCosta, Sr., as a "typical representative of the old Charleston nobility" who viewed "the new trends with alarm." The magazine reported, "Fair offspring of Negro nobility shocked their elders by banding with dark veterans to escort voters to polls in recent elections." [14]

John F. Potts apparently subscribed to Brownlee's history of color and caste in Charleston, as described in *New Day Ascending*. "We're a proud people who live too much in the past," Potts told the AMA in 1948, two years after Brownlee's book appeared. "We like to keep Charleston as Charleston always has been. That was the position of Avery. Avery was Charlestonian. There are three races in Charleston—white people, mulattoes, and Negroes. A Charleston mulatto has better standing than a white Yankee." But, Potts asserted, "Charleston has begun to change. It will learn by experience some day that we're all one race, that what is good for one is good for all and what is good for all is good for each." Potts strove to open the school to more people in the community. Without the tuition, it became even less a preserve of an elite, as bright students were drawn from all over the city, including the East Side. As the student body became more heterogeneous, the percentage of fair-skinned students diminished. Charlotte Tracy, highly critical of the color and class distinctions she found when she first taught at Avery during the 1920s, noted that these differences had lessened in the mid-1940s when she returned to teach. [15]

The Korean War, like World War II, quickened the demise of "old Charleston" attitudes. As in the past, Averyites served in the country's armed

forces. Even a tradition of antimilitarism inculcated by the AMA gave way to a patriotic support of the war. In 1953 the Avery HI-Y Club opposed "military training in public high schools," but when the issue was placed on a schoolwide referendum, the students voted 114 to 40 for military instruction. However, as the war dragged on, some Avery students, like many Americans, began to express doubts. In 1952 Bob Miller commented in the school newspaper, "As the end of their high school days approach, many boys are losing interest in what they will get for Christmas. . . . When will this phoney police action end? . . . Why can't all this wrangling end?" A few months later he wrote, "Winning a peace at the sacrifice of lives and at the cost of purchasing arms is beginning to provoke" many Americans. The Korean and Japanese governments, gaining from the war, "are unwilling to terminate hostilities." Miller concluded, "Freedom is one of man's highest goods, but it should not be made expendable in the interest of avaricious governments." In expressing his concern over the costs of the prolonged Korean conflict, Miller revealed that some Avery students shared the cold war attitudes prevalent in America during the 1950s. In June 1953 the graduating senior condemned in his column the "deadlocks" in the truce talks as "periods during which the Reds strengthened their powers to further aggression." He asked when the United Nations was going to launch its "'get tough' policy."[16]

But if Avery students were staunch anti-Communists, they remained internationalists. For them human relations, national and international, were interconnected. In February 1951 the school newspaper headlined, "United Nations Declare Human Rights as Foundation for World Peace." For the students the declaration was affirming "that the fundamental rights of the individual expressed in the Bill of Rights of the United States should be the rig[h]ts of all mankind." In 1953 the Avery Dramatic Club participated in "International Theater month, a world wide movement sponsored each March in the United States American National Theater and Academy and the United States national commission of UNESCO." The commencement theme for that year was "improving human relations," dramatized in a pageant beginning with "the home" and ending with "one world."[17]

Citizenship training remained an important element in an Avery education, especially since South Carolina blacks could vote. A student, William Clement, noted, "At Avery students are given many opportunities to practice citizenship and democracy." Student elections as well as the school newspaper served this purpose. In 1952 Earl Maxwell was elected president of the student council on the Progressive party ticket with the slogan "All the Girls Like Earl." A year later he was defeated by the Loyalist party candi-

date, Carolyn Tolbert, and her slogan, "A Girl, Not Earl." The problems in American democracy course continued to be an important vehicle for citizenship training. In 1952 class members visited the chambers of the local city council, where they became "councilmen for a day." Frank J. Johnson, the custodian, explained to them the city manager plan of government as well as the duties of the mayor and council. That year the class members organized the student council elections, in which 350 students registered to cast their ballots by using voting machines at the Cannon Street YMCA. The seniors also staged a national convention with each homeroom "entitled to as many votes as it sent delegates to the convention." On the eve of the actual presidential election the students canvassed "house to house," to urge citizens "to vote." [18]

The philosophy behind the problems in American democracy course predisposed Avery students toward involvement in the political system. Bob Miller argued that "John Dewey's philosophy of education in an American democracy, 'to give to every individual the opportunity to develop his highest stature,' expresses a right that belongs to everyone in this land of ours." In an earlier article the student accused South Carolina voters of being "blinded by prejudice" in accepting an amendment to the state constitution which repealed a provision requiring their legislature to provide public schools.[19]

John F. Potts, the Avery principal, an ardent believer in civic involvement, set an example for the students. Like L. Howard Bennett, he was extremely effective in extending the school's influence into the larger community, which included the nearby Sea Islands. In November 1952 his wife, Muriel, an English teacher at Haut Gap High School on Johns Island, arranged for her students to visit Avery and present a panel discussion, "The Coming Elections." Potts worked with a number of community service agencies, including the Charleston Welfare Council, the Lyceum, and the Extension Service and Summer School. The Extension Service was designed to offer city and county teachers the opportunity to improve themselves professionally, the Lyceum to bring cultural events to the city's black public schools and community. In 1949 Potts was named to the black auxiliary board of the Charleston Family Agency, which he considered helpful in coordinating "relations between the Negro and white communities." Moreover, Potts was instrumental in building a professional library for Charleston teachers and was active in a variety of educational associations. President of South Carolina's black Palmetto State Teachers Association, he also served as a regional vice president of the American Teachers Association. In 1951 he was elected president of the Association of Colleges and Secondary Schools for Negroes, which had a membership of 71 colleges and 155 high schools.[20]

Potts's involvement in civic affairs demonstrated his belief in American

democracy. J. Waties Waring's rulings only confirmed his optimism. "It is really a pleasure to be living in the South during this history-making period," Potts wrote in August 1948. "Things are happening now which many of us did not expect to see for years to come. I refer particularly to the decision of Judge Waring and the opening of the Democratic Primaries to Negroes." Under Potts Avery continued to be a bastion of support for the NAACP. The alumni remained a source of leadership. The school newspaper regularly reported the activities of the local branch, led by Arthur J. Clement, Jr. (president) and J. Arthur Brown (secretary). In February 1954 the paper reported Walter White's speech at Emanuel AME Church, in which the NAACP official predicted that the South would not abandon its public schools should the U.S. Supreme Court outlaw segregation. The school newspaper also published articles sympathetic to desegregation. In 1953 student columnists hailed the decision of the white baseball team in Savannah, Georgia, to employ black players. The team traveled to College Park in Charleston to play the local Royals. Avery students, given their predisposition, were potential NAACP recruits, especially desirable since they would soon become voters. The Charleston NAACP membership drive in 1949 included a School Students' Week, dedicated "to our future citizens." [21]

Avery's student body continued to be service-oriented. Even though the school no longer provided teacher training, many of the graduates pursued careers in education. In 1951 the students organized the Ralph Bunche Future Teachers of America Club, "a group of young people who expect to adopt teaching as their profession." The purpose of the club was to give "the members some training and experience in their chosen profession." Two years later the student newspaper reported that "Teaching was chosen by more students than was any other occupation." Of the 222 students polled, 47 mentioned teaching. Another 41 indicated nursing. Many of the women entered nursing because of a "critical demand" for health service personnel, further intensified by the Korean War. The poll results reflected the sentiments of the student Clayton Whitney. In his article "What Success Means to Me," published in the April 1954 issue of the school newspaper, Whitney defined success as entailing the "earnest desire to work for the welfare of others." [22]

Closure

John F. Potts's initial optimism over Avery's future was in part engendered by the increased willingness of South Carolina to appropriate more money for black education. In a frantic effort to prevent integration by making the

policy of separate-but-equal a possibility, South Carolina proposed a $75 million bond issue for school construction in 1951. That year it began in earnest its "equalization" efforts. During the next two years it earmarked $37.8 million for black schools. This sum represented 65 percent of all allocations made during that period for the sales-tax-supported school expansion program. A. B. Rhett's replacement as superintendent, George C. Rogers, Sr., also seemed promising. Except for less money for the library, "everything else is going better than I had expected," Potts told the AMA in 1948. "The superintendent has been fine. He's educationally literate and progressive. He receives me graciously and talks with me man to man. He visits the classes and suggests improvements. He has done everything he promised to do and more. . . . He suggested a bond issue of $450,000 for a primary school for Negroes. The bond issue was approved." About a year later Potts reported, "The Superintendent and School Board have been very cordial and cooperative."[23]

Rogers's tenure as superintendent was marked by civility and a spirit of cooperation. Even after the Warings were vilified by local whites, the city school board, under Rogers, allowed blacks to hold a testimonial for the couple at Buist. Moreover, to facilitate communications between municipal authorities and the black community, Rogers instituted a black advisory committee. In addition to black principals and teachers, the committee included representatives from the PTA Council, the Federated Women's Clubs, the Metropolitan Council of Negro Women, and the Ministerial Union. Many of the positions were filled by Averyites. Septima P. Clark represented the Federated Women's Clubs, while her sister-in-law Mrs. Peter Poinsette was a PTA Council member. Joseph I. Hoffman, Jr., was sent by the Medical Association. The Burke teacher Eugene C. Hunt was secretary.[24]

The Advisory Committee, like the Charleston Interracial Committee, was designed to be "a channel of communications." According to Rogers, it would also act as "a safety valve so that urgent matters can be thought through before they become pressure points." In 1951 when Rogers discussed teachers' involvement in politics, he counseled that they were "safe" if they spoke for "better schools." He claimed "that we have great freedom here, and that he knows of no other southern city where we can be so free in expressing ourselves. We can write a letter and it'll even be published in the News & Courier." A committee member, qualifying Rogers's statements, added, "even if it is torn apart in the editorial." As a safety valve, the board allowed committee members to inform the superintendent of deplorable conditions within the schools. Septima Clark, for example, reported Archer's bad lunchroom situation.[25]

As well meaning and "progressive" as George Rogers, Sr., may have been, there was a limit to what he could do, especially given the board's penchant for financial retrenchment. Another public high school for blacks was needed. Although Haut Gap High School was serving the black students on Johns Island by 1950, this did not substantially alleviate the crowded conditions at Burke. As late as 1954, while 1,605 students attended the city's three white public high schools, 2,046 blacks were crammed into Avery and Burke. Feeling the need to cut back spending, in September 1948 the board commissioned John E. Brewton, field service director at George Peabody College for Teachers, in Nashville, Tennessee, to conduct a survey of the Charleston schools. Brewton's group had made similar studies in the state. The survey was to be conducted from October 1, 1948, to May 1, 1949, with the final report presented in May 1949. "I believe that their findings will determine to a great degree, the future of Avery as far as the total picture is concerned," John F. Potts informed Fred L. Brownlee in November 1948. The survey, extremely critical of Avery's physical plant, recommended its abandonment. The report also urged the board to "tear down old Burke" and "erect new unit." Rather than committing additional revenues to the construction of a brand-new comprehensive unit as recommended or to the establishment of a third high school, the board opted to merge Avery with an enlarged and modernized Burke facility. On May 23, 1949, the school commissioners, concerned with mounting costs, decided unanimously to close Avery, "contingent on the accrediting of Burke Industrial School as soon as possible" by the Southern Association of Colleges and Secondary Schools.[26]

Avery parents and alumni organized a meeting in June to protest the closure. They conceded that "in time Avery should be abandoned, as the educational trend of the day is to provide a community with a comprehensive high school," offering academic, commercial, trade, and technical courses, but now was not the time to close Avery. Potts, feeling the plea fell on deaf ears, resolved to meet with the Burke principal to facilitate the merger. Rogers sympathized with the petitioners. At the May meeting he told the board, "Avery is a member of the Southern Association, Burke is not, and if Avery is discontinued we would be without a certified college preparatory school for Negroes." The closing of Avery would save only an additional forty thousand dollars. In October 1949 Rogers recommended that Avery be kept open because of a classroom shortage.[27]

An increased black high school enrollment forced the board to reconsider its decision. Plans to close Avery were postponed until a new wing was added to Burke. In January 1952 city school commissioner, John F. Seignious, advocated the construction of "a new Negro high school to replace Avery."

Rogers replied that "the proposed wing at Burke would take care of all Avery High School students as soon as the county areas west of the Ashley furnished high schools for their Negro students." A few weeks later Rogers unveiled the architect's drawing for the Burke addition at a meeting of the Advisory Committee. "Why should they all go to one school," the Avery PTA representative Thelma Simmons queried Rogers. "There are so many students at Burke now that they walk the streets all day." Rogers, arguing for "one complete plant," explained that an additional black high school as Seignious recommended would deplete "all the available funds." The superintendent noted "that it seemed wiser to the Board to complete Burke School, and in the mid 1950s (1955) perhaps to build a new high school."[28]

By 1953 the closing of Avery seemed imminent. "Currently, as for so many years, there is the rumor of the closing of the doors of Charleston's oldest Negro high school," Bob Miller wrote in the June issue of the *Avery Tiger*. "Through the halls of Avery have passed all types of men and women, many of whom have contributed much to their society." Miller added, "To change representing progress no one objects. The change we should like to see would be one truly representing progress . . . namely that a school be built along the lines representing the most modern set up and equipment for carrying out the training of boys and girls to meet the demands of changing conditions to replace Avery."

On April 13, 1954, the Charleston *News and Courier*, announcing "Avery High School to Be Abandoned," reported that the city school board approved a merger of the school with Burke. "We feel," Rogers said, "that the children will have so many more opportunities in the new school, a far richer program than was possible at Avery." Rogers added that the Avery facility was a firetrap, and that the board did not intend to spend additional money on a building it did not own. Two days later two hundred Avery supporters met at the school and signed a petition protesting the merger "on grounds of overcrowding, lack of recreational facilities, inequality of opportunity." Reginald C. Barrett, chairman of the PTA committee in charge of the meeting, pointed out that the merger would result in the concentration of 4,223 students in one block, specifically 2,407 at Burke and directly opposite it at A. B. Rhett Elementary School another 1,816. The board, agreeing to review its decision, set a final hearing on May 6, at which time, fifteen blacks, representing "PTA groups, Federated Missionary Society, Central Labor Union, and NAACP," presented the petition. Read by J. Arthur Brown, it requested that the board not abandon Avery "without first having built a preplanned modern high school building complete with auditorium, gymnasium and cafeteria." The board, reconvening on May 12, decided in executive session "to continue with its announced plan" to merge Avery with Burke.[29]

Although there is no direct evidence, many Avery people believed that the school was closed in reaction to increased black activism, the rulings of J. Waties Waring, and the decision of the U.S. Supreme Court to outlaw segregation in public education. In the atmosphere created by these events a fine college preparatory school such as Avery, which encouraged participation in organizations like the NAACP, loomed as a particular threat to the segregated society of white Charleston. Many individuals closely affiliated with Avery were in the forefront of the activism which aroused the fears and anxieties of white Charlestonians. "A. J. Clement, who was last year made head of the NAACP here, appeared before the school board and made a very fine and splendid protest against their announced program," Waring noted in 1952. "He baldly stated that integration had to come but even under the present laws and decisions, they were acting unfairly. The importance of the incident was not what results may be obtained but that a Negro in Charleston appeared before an all white school board and in a fine deliberate and well calculated speech laid down the law to them and told them that the colored people intend to press for their rights in every particular." In 1955 J. Arthur Brown, then president of the Charleston NAACP, presented to the board a petition, signed by the local NAACP vice president, John H. Wrighten, Jr., and some forty-six parents, to remind the school commissioners, "you are duty bound to take immediate concrete steps leading to early elimination of segregation in the public schools." [30]

As the civil rights era began to unfold, it was clear that Charleston's black elite was on a collision course with the city's white leadership. This was symbolized by their mutually exclusive feelings toward the Warings. White Charleston hated the couple with a passion. Elizabeth Avery Waring, an outspoken critic of segregation, was singled out for special abuse. The Charleston white elite blamed the "twice-divorced Northern woman," originally from Detroit, for contributing to her husband's transformation into a "cold" troublemaker seeking revenge for the ostracism resulting from his "social misstep." [31]

Among Charleston blacks the Warings were heroes. Most Avery people openly expressed their admiration for the couple. In 1948 John Potts presented Elizabeth Waring a copy of Fred Brownlee's *New Day Ascending*. According to the black principal, she was "related to the Charles Avery for whom Avery is named." Despite crank phone calls, many letters to the local newspaper, and pressure from the white central committee of the Charleston YWCA, Septima P. Clark, head of the administration committee for the black branch, refused to ask the group to withdraw its invitation to Elizabeth Waring to address its annual meeting. "She talked plainly and she laid it on," Clark recalled. Waring told white Charlestonians that "they were decadent

and low-down and she promised them that they would be getting their just deserts. . . . She really laid the whip to the backs of the people in Charleston and the South." When the South Carolina governor Burnett Maybank, later U.S. senator, charged in 1950 that the Warings were not liberal enough to have blacks "in their home socially," the couple gave an interracial luncheon at their mansion. Samuel Grafton, who attended the affair, described it in his article for *Collier's*. At Elizabeth Waring's request, Grafton did not list the names of the seven guests because she feared they might become targets for reprisals. Septima P. Clark, Ruby P. Cornwell, Mrs. Harry Guenveur, her daughter Mildred Cherry, and Susie Dart Butler were the Avery people invited. The other two blacks were John Fleming, and Roscoe Wilson of Florence, South Carolina.[32]

In February 1952 Waring retired from the bench. On November 6, 1954, the NAACP honored him with a testimonial dinner at Buist. Arthur J. Clement, Jr., was master of ceremonies and Thurgood Marshall a scheduled speaker. Waring himself addressed the gathering. Soon afterward he and Elizabeth moved to New York City. When Waring died in 1968, his body was shipped back to Charleston for burial. A memorial service was held at St. Matthew Baptist Church. J. Arthur Brown arranged the service by contacting Lucille Simmons Whipper, whose husband was pastor. Ruby P. Cornwell, a former Avery teacher and close friend of the Warings, sent to the Charleston *News and Courier* a eulogy extolling the judge as a prophet.[33]

As hostile as Charleston whites were toward the Warings, they were not unanimous in their feelings about Avery. Most, whose daily existence was not directly touched by the school, were probably indifferent to it. Several Averyites recalled that some whites, resenting the student traffic, wanted the school out of their neighborhood. Some white neighbors developed an appreciation for the school; others did not see it in so detrimental a light. One couple, living next to the school, was saddened when it closed. In 1957 a white city school board member, David M. Murray, noted "that he had lived within one block of Avery School and that the neighborhood felt little effect from the Negroes there." Several white Charleston merchants, especially those with shops along King Street, benefited from the business the students and their parents generated. These merchants advertised regularly in the *Avery Tiger*.[34]

At a time when white Charlestonians feared outside intervention, Avery's continued existence became intertwined with the issue of desegregating the College of Charleston. In January 1949 a state NAACP leader, James M. Hinton, put Charleston officials on notice that his organization officially condemned any plan which offered scholarship aid for blacks to attend col-

leges and universities outside the city. He threatened to bring suit against the College of Charleston on the grounds that since blacks paid taxes, the institution was "as much theirs as other people's." Hinton also forwarded the applications of several qualified blacks, who, having graduated from Avery or Burke, wanted to continue their education at the college. College officials tried to resurrect the idea of turning Avery into a state-supported junior college, but the project never materialized.[35]

According to Waring, Hinton's efforts failed because the College of Charleston president, George D. Grice, struck a deal with Walter White, Thurgood Marshall, and local black leaders whereby the city offered six South Carolina State scholarships to preserve the status quo. Marshall, denying the rumors of such a deal, made it "crystal clear" to Grice in June 1949 that the national NAACP backed Hinton. The next month a group of local black citizens, led by Arthur J. Clement, Jr., repudiated the six scholarships as a "guise" to "perpetuate segregation." They also expressed their support of Hinton's actions against the college. Apparently, the scholarship arrangement with the city was worked out by Robert F. Morrison, who, probably like John A. McFall, believed that the college would become private rather than desegregate.[36]

However laudable Hinton's intentions, the NAACP campaign was doomed. College officials were willing to forgo the eighty-five thousand dollars annually received from the city (fifty thousand dollars) and county (thirty-five thousand dollars) to cover half of the institution's operating costs. As early as January 1948 H. L. Erckmann, counsel to the city school board and the college, had advised Paul M. Macmillan that the college would be in a strong position if the city turned over its interest in the college property to the board of trustees. When the trustees made the request in February 1949, an alderman, William H. Burton, protested that this course would "deprive many Charlestonians of a college education." Despite his opposition and that of a fellow alderman, Irwin D. Karesh, the city council, with the support of the mayor, William McG. Morrison, awarded the title of the college property to the board of trustees for one dollar. Shortly thereafter, in March, the state legislature received a bill modifying the college charter to enable the institution to revert to private control. The next month, the governor, J. Strom Thurmond, signed the bill into law.[37]

While maneuverings were under way to keep the college segregated, the city school board decided to close Avery. However, it was forced to postpone its plans until it belatedly kept its promise to have Burke accredited by the Southern Association of Colleges and Secondary Schools in 1954. White educators such as George C. Rogers, Sr., and John E. Brewton can hardly be

condemned for advocating Avery's closing, when black experts heartily concurred. The most telling criticism of Avery was that of Lewis K. McMillan, a South Carolina State College professor, who described his father as "a poor unschooled Allendale County farmer." The son, sorely disappointed with the education he received at Voorhees Institute and Benedict College, went on to Howard University, where he completed his Ph.D. thesis, an indictment of "Negro education in the state of South Carolina." Published in 1952, McMillan's work was probably influenced by his bitter experience at State. In 1953 he wrote to the governor, James Byrnes, an angry letter protesting his dismissal by an all-white board of trustees and an aging president, who "hounds into desperation those of superior training and surrounds himself with sycophants." [38]

McMillan's book covered the various black schools alphabetically under four categories ranging from "nonexisting institutions of higher learning" to "the senior public college." Beginning his survey with Avery Normal Institute, McMillan relied heavily on Fred L. Brownlee's accounts of the historical origins of the school. The black educator noted, "It is easy to exaggerate the work done, beyond the high school level, through the years by Avery Normal Institute. Indeed, if the plight of Charleston's Negro Population had not been so bad, this proud little tragio-comedy would be the funniest in all the history of Afro-South Carolina." Although conceding that Avery had produced the city's black leaders, as well as doing "a pretty good job" as a secondary school, McMillan accused the institute of lacking "all semblances of the missionary spirit. It never occurred to its leadership, its teaching personnel, its students, or its graduates that it was Avery's responsibility to transform Charleston and Charleston County from general primitiveness to universal civilization. The little proud school was shot through with the spirit of caste and class based merely upon the mechanics of color. A reactionary white Charleston must certainly have seen in a reactionary Avery Normal Institute its most effective instrument of keeping the mass of the Negroes forever in their place." Like Brownlee, McMillan saw "a new day" in black education "slowly, dimly dawning for the city" because of Burke, where over twenty-five hundred students, representing "every element of Negro life in Charleston," were "enjoying a high school education at public expense." [39]

The merging of Avery with Burke was unsettling for everybody involved. The city school board offered John Potts a position as supervisor of its black schools. He chose instead to become president of Voorhees in Denmark, South Carolina. On Sunday, May 23, 1954, thirteen black community groups sponsored an appreciation service for the Pottses at Buist audito-

rium. Arthur J. Clement, Jr., narrated Potts's achievements; both the Avery and Burke choruses performed.[40]

Despite some fears, the two student bodies merged without any real difficulty. This was hardly surprising since the two groups socialized together extensively. Events like the annual Avery-Burke football game, school dances, and church affairs encouraged this. Before Burke became a four-year high school, it was not unusual for its students to continue their education at Avery. Moreover, when Avery became public, the two schools undertook such joint academic ventures as a public book review at Dart Hall during National Educational Week in 1948.[41]

Although Burke was still called an "industrial school," it was beginning to produce the kind of students usually associated with Avery. In 1948 Burke senior, Merton Simpson, who was greatly influenced by his teacher Sarah Green Oglesby, won first prize at the Central Fair art show in Tasley, Virginia, for his abstract painting "Streetsalad." It was the third year in a row the teenager had placed first. His "Stillife Sonata" was awarded second prize. Simpson's works were subsequently exhibited at New York galleries and Atlanta University. White Charleston artists, such as William Halsey, included his paintings in their private collections. Besides teaching art to children at Shaw Center, Simpson, through Halsey's intervention, worked at Gibbes Art Gallery, a private museum patronized by the city's white elite. Simpson was also an accomplished musician.[42]

According to a Burke administrator, it was the teachers who caused the most tensions during the merger. On the one hand, some Burke faculty faulted the newcomers for having a sense of superiority. On the other hand, some Avery teachers were astounded at the little homework Burke students were assigned. Newcomers like J. Michael Graves were given brand-new preparations they resented. Graves, who never taught physics at Avery, was assigned that subject as well as chemistry, math, and choir. Serious friction, however, was minimal because many of the Burke teachers, like Eugene C. Hunt and Sarah Green Oglesby, were Averyites themselves. Although Burke was larger and more impersonal, much of the routine for the newcomers remained the same. Graves was assigned the same homeroom class he had had at Avery.[43]

The AMA official Philip M. Widenhouse, noting that the Avery PTA protested the closing, concluded that the merger was a "wise decision," provided the school board proceeded "with the erection of additional facilities to meet the expected increase in enrollment over the next few years." Many years later Fred L. Brownlee told L. Howard Bennett that he finally under-

stood what Bennett and the Avery people had been attempting to achieve at the school. Arthur J. Clement, Jr., who had cooperated with the transition of Avery into a public school, perceived the closing as a "tragedy."[44]

Less than a year after Avery was abandoned, Charles E. Palmer, desiring to relocate his business college, purchased the property from the AMA for twenty-six thousand dollars. Once alleged to be a "firetrap," the Avery building became the nucleus of the Palmer College campus. Although the new owner proposed making some renovations, including additional rest rooms, air-conditioning, and a central heating plant, he pronounced the main "building . . . an impressive and substantial edifice." Eventually, this downtown campus, with the former Avery building still as the nucleus, became part of the state-supported Trident Technical College system.[45]

CHAPTER

7

*Averyites and the Civil Rights
Movement in the Low Country,
1954–1969*

Although Avery closed in 1954, its influence on the Low Country persisted. Leroy Anderson, for example, attempted to turn W. Gresham Meggett High School, James Island, where he was principal between 1953 and 1960, into a "little Avery." More important, Averyites involved themselves in the emerging civil rights movement. Some gained national recognition. L. Howard Bennett moved to Minneapolis, where he headed the city's NAACP. Appointed a municipal judge by the governor, Orville L. Freeman, Bennett was extremely critical of the Eisenhower administration's handling of civil rights. In 1958 he told a Charleston gathering at Emanuel AME Church that President Dwight David Eisenhower "could have prevented the troubles in Little Rock and elsewhere and also averted the hard-core resistance to integration in the South" had he shown more forceful leadership. During the Johnson-Humphrey administration, he served as an assistant secretary of state for civil rights.[1]

Averyites were in the forefront of the civil rights movement in the Low Country, furnishing the leadership of the local NAACP, the oldest and most active civil rights organization in Charleston. They established a close connection with Highlander Folk School in Monteagle, Tennessee, which provided the local movement crucial financial support, outside expertise, and a forum to unite the Low Country's black leadership. Averyites created and were part of a network of leaders and organizations that would enable diverse, and sometimes disparate, groups to coalesce around issues raised by the movement. They were involved in all the major civil rights struggles in the Low Country, including the establishment of Citizenship Schools (1957), the NAACP's ongoing legal campaign to end segregation in

public accommodations and education (1955–), the sit-ins and Charleston movement of the early 1960s, and the Charleston hospital strike of 1969. Although some historians have attributed the relative lack of violence in South Carolina during the civil rights movement to a more flexible white leadership, the presence of a sophisticated black leadership played its part. "I would venture to add," the historian George C. Rogers, Jr., son of the late school superintendent, recently observed, "it was also because there was a parallel black network which at many points touched the white network."[2]

Perhaps even more than the Civil War, the civil rights movement united white South Carolinians against what they considered another Yankee invasion. Low Country politicians vied with one another in denouncing integration. The First Congressional District congressman L. Mendel Rivers described the civil rights movement as "an unholy alliance to destroy the white civilization—and the orderly way of life as it is known in the South." Before 1956 Ernest F. Hollings was firmly in the segregationist camp. The local newspaper, particularly Thomas R. Waring, was extremely supportive of the segregationist-oriented White Citizens' Councils. Ironically, Mendel Rivers's successful efforts to expand the federal military presence in the Low Country fostered a modernization which opened the door to federal desegregation. In 1953, after prodding from the Eisenhower administration, the navy acted to end segregation at the country's southern bases. The Charleston Naval Shipyard desegregated its cafeteria, while an alarmed local newspaper correctly predicted: "Navy To 'De-segregate' Toilets Next." Despite white Charlestonians' view of the movement as a Yankee-imposed Second Reconstruction, much of it was homegrown. J. Waties Waring was no outsider. Moreover, he was able to render his rulings only because black South Carolinians voiced their grievances before his court.[3]

Highlander, Septima Clark, Esau Jenkins, and the Citizenship Schools

Located at Monteagle, Grundy County, central Tennessee, Highlander Folk School traces its origins to Lilian Johnson in the 1920s. Finding herself in a coal mining region populated with poor people, Johnson encouraged the development of cooperatives, including the first credit union chartered in Tennessee. In 1932 Johnson volunteered and eventually deeded her remodeled farmhouse to Myles Horton and his wife, Zilphia, who continued her work. Two years later Highlander was chartered by the state of Tennessee. The school's chief purpose was "to encourage these people to make

use of the school to improve their personal lives and social conditions, and to apply the principles and spirit of democracy to everyday life." In 1935 Highlander expanded its programs to include the entire South, but in the 1940s the school mainly worked with persons who were members of organizations, such as labor unions. In the 1940s several black Charlestonians who participated in the strike against the American Tobacco Company had attended Highlander, but it was not until the early 1950s that the school would become a fixture in the Low Country. The renewed connection between Highlander and Low Country blacks owed its origin to Anna DeWees Kelly, who graduated from Avery's teacher training program in 1932. (She addressed her fellow graduates on "the future of the educated woman.")[4]

Kelly's experiences were initially similar to those of many normal student graduates. She found herself teaching in a one-room schoolhouse in Colleton County, where she boarded with a prosperous sharecropper and his family. Four years later she moved to another school at St. George, and finally to one in Conway, both in South Carolina. Determined to complete her education, she graduated from Fisk University in 1949 and went on to Atlanta University for an M.A. in the School of Social Work. At Atlanta she became involved with the Urban League, the local NAACP, and the Southern Regional Council on Human Relations. Her M.A. thesis, dealing with community planning, took her to Chicago for her fieldwork. In 1951 Anna Kelly returned to Charleston as director of the teenage program at the YWCA Coming Street branch. She soon became its executive secretary. In this capacity, she attended a conference on childhood and youth in Washington, D.C., where she met George Mitchell, chairman of the Executive Council of Highlander Folk School and of the Southern Regional Council on Human Relations, who recommended that she attend Highlander. In the summer of 1952 Kelly received an invitation to a two-week workshop there. Septima Clark agreed to serve as temporary executive secretary. Returning from Highlander after a second visit in 1953, Kelly recruited Clark for a summer workshop in 1954.[5]

Clark felt comfortable working for an organization whose aims were similar to those of the American Missionary Association. Like the AMA, Highlander was Protestant-oriented, interracial, international, and democratic in outlook. Myles Horton once turned down an appointment to head an AMA school in Tennessee in order to spend a year in Denmark studying folk schools. If the AMA first inspired Clark to teach on the islands, Highlander would return her in a similar capacity. In her first workshop in the summer of 1954, Clark helped write two brochures: *What Is a Workshop* and *A Guide to Action for Public School Desegregation*. She also made plans "for

using the Highlander technique in my own community." Specifically, this involved organizing a countywide Parent-Teachers Association and sending the Hortons to Charleston for a one-day PTA workshop on "problems related to health and social welfare." Clark, who eventually became a full-time member of the Highlander staff, recruited for Highlander workshops South Carolinians who in turn encouraged others. Subsequent recruits included some of the most important civil rights leaders in the Low Country: Esau Jenkins, Bernice Robinson, J. Arthur Brown, James G. Blake, and William Saunders. The most important of these was probably Esau Jenkins.[6]

Born on Johns Island in 1910, the son of a struggling farmer who barely was able to eke out an existence for his family on the island, Esau Jenkins quit school after the fourth grade. After helping his father raise cotton for four or five years, Jenkins turned to truck farming. The need to take his produce into the city prompted him to buy a truck, with which he also carried his children to Burke Industrial School. He managed eventually to operate a small fruit shop in Charleston on President Street, and later, the J. and P. Motel and Cafe on Spring Street.[7]

Jenkins understood instinctively that Johns Island blacks needed to shape the forces of modernization that were acting on them. Most of the black islanders lived on plantations, were sharecroppers, or were small farmers. With the advent of the big farms, they needed some sort of collective action to survive. Many of their children were forced to look for jobs in mainland Charleston, while those who remained were hard-pressed to survive. In 1948, the year Waring rendered his ruling on the right of blacks to vote in the Democratic primary, Jenkins and eight of his neighbors founded the Progressive Club. They decided that their members must become literate and politically informed so they could register to vote and win concessions from local politicians. The group also realized that the club must provide concrete ways for the islanders to improve themselves economically. Specifically, this meant establishing a means of transportation between the island and Charleston because many islanders now worked in the city as longshoremen or in the tobacco industry, and because a number of small farmers wanted a way to transport and sell their produce in the city. Jenkins set up a bus line between the island and the city, and later from Summerville into Charleston. Jenkins used his bus to educate his riders so they could vote.[8]

By 1954 Jenkins had become the preeminent black leader on Johns Island, an assistant pastor of his church, head of the Parent-Teacher Association, president of the two-hundred-member Citizen Club, and member of the executive board of the Charleston NAACP. Nevertheless, he was stymied in his attempts to expand his bus-school into something more permanent.

Local teachers and school authorities, fearful of what the white authorities might do, refused to let him use one of the school buildings. Jenkins finally turned to Septima Clark for advice. She convinced him to accompany her to a Highlander workshop on the United Nations during the summer of 1954. When asked how the group could best support the UN in their own communities, Jenkins said that what the people on Johns Island needed was a school to teach them to read and write, enabling them to vote.[9]

Funded by the Emil Schwarzhaupt Foundation, Myles Horton spent six months on Johns Island assessing the situation. Highlander agreed eventually to give Jenkins and his Progressive Club an interest-free loan of fifteen hundred dollars to purchase an old schoolhouse. Highlander also paid the nominal salary for a teacher and supplied money for equipment. Clark had experience teaching adults and understood their particular problems. In Columbia she had taught adult illiterates in a night program directed by Wil Lou Gray, a pioneer in the movement to end illiteracy in South Carolina. For Clark the critical factor was the teacher. Having once taught on the islands, she recognized the antipathy urban and island blacks had for one another. Eschewing traditional teachers, Septima Clark suggested Bernice Robinson, her cousin, for the position. Born February 7, 1914, in Charleston, Robinson was the last of nine children. Her father was a bricklayer. Educated in the city's public elementary schools, she continued her studies in New York City. Returning to Charleston in 1947, she passed a Civil Service Examination and was placed on a waiting list. Called to an interview at the Charleston Naval Supply Station, she was rejected because she was black. Instead, she made her livelihood by working as a beautician and dressmaker. In 1951 she became involved in the Charleston NAACP. She also accompanied Esau Jenkins to Highlander in the summer of 1954.[10]

The first Citizenship School, designed to help Johns Island adults become "responsible citizens in one's community," was begun on January 7, 1957. The school term consisted of two-hour weekly evening meetings for two months. With Clark's aid, Robinson devised a teaching method based on the motivation of the students. The desire to register and vote was important, but there were other more pressing pragmatic reasons. Clark noted, "They wanted to know, too, how to fill in order forms when ordering merchandise from mail order houses, and how to fill in money order forms at the post office." The schools spread quickly to adjacent islands, and into North Charleston. In establishing Citizenship Schools, Septima Clark and Esau Jenkins helped bridge the gap between Charleston and island blacks. The Citizenship Schools generated a change in attitudes, as Charleston blacks began to realize that the islands had produced something unique. Moreover,

according to Myles Horton, "the technical know-how, skills and personnel from Charleston" were "indispensable to the actual achievement of the full potentialities of the Johns Island organization." The net effect was a more united black community, critical for the upcoming civil rights struggles in the city. Eventually Bernice Robinson and Septima Clark helped spread similar schools throughout the Deep South. Arrangements were made to transfer the program to the Southern Christian Leadership Conference, of which Clark was now a staff member. By 1970 perhaps one hundred thousand blacks had become literate through Citizenship Schools.[11]

The NAACP, J. Arthur Brown, and John H. Wrighten, Jr.

Nearly all of the Low Country participants at Highlander were members of the NAACP. Septima Clark, Esau Jenkins, and Bernice Robinson had been active in the Charleston branch. Septima Clark had also managed to recruit J. Arthur Brown. He and his family attended Highlander summer workshops. Brown was one of a long line of Averyites who had headed the Charleston NAACP. When he assumed the presidency of the Charleston branch after 1953, the branch membership zoomed from three hundred to one thousand. Together with the lawyer John H. Wrighten, Jr., Brown used his study in the basement of his Charleston home to plot a legal campaign against Jim Crow in the Low Country. Both men and their families faced Ku Klux Klan threats and other intimidation, including cross burnings near their Charleston homes. Building on earlier efforts begun by his NAACP predecessors, Brown focused his legal efforts on public accommodations and public education. Perhaps one of Brown's most personally satisfying moments as president of the Charleston NAACP occurred when, together with a fellow Averyite, Reginald Barrett, he forced the Charleston's Stadium Commission to allow the black high schools to use Johnson Hagood Stadium in 1959. In his youth the only way he and his friends could be admitted into the stadium to attend Citadel football games was to clean up the field. When the Citadel started losing, D. S. McAlister habitually ran them out of the stadium. McAlister headed the Municipal Stadium Commission.[12]

Brown and the Charleston NAACP met stiffer resistance in desegregating the Charleston Municipal Golf Course. Resentful of having to travel to Savannah or Wilmington to play, a number of young black golfers, at Brown's suggestion, wrote letters in 1958 requesting the city Golf Course Commission "for racially mixed play at the public links." When their letters went unanswered, they decided on Sunday, November 23, 1958, to attempt entry

on the course, only to find it surrounded by police. Four golfers, including John H. Cummings, John E. Chisolm, Robert Johnson, and Benjamin Wright, brought suit against the city. The immediate reaction of the city was to put the 134-acre course up for sale, until it was discovered that if the land was no longer used as a golf course, it would revert to its original owners, the Edisto Realty Company. The city managed to delay the inevitable until the federal judge Ashton H. Williams ordered the course desegregated as of July 1961.[13]

John Wrighten refrained from joining the suit involving the golf course because he doubted there were more than "fifty Negroes in Charleston who even knew how to play golf." More than a golf course, Low Country blacks needed beach facilities. In 1952 South Carolina had twenty-one state parks, but only five of them were designated for blacks. The problem was even more acute in the Low Country, since blacks could not use Edisto State Park. In 1953 Arthur J. Clement, Jr., sent a letter to the Charleston legislative delegation requesting them to open up Edisto State Park to blacks. Ernest Hollings drafted the group's reply, denying the request. Three years later J. Arthur Brown and the Charleston NAACP financed a suit brought by Etta Clark, an Avery parent, and others attempting to desegregate Edisto beach. Their lawyer was John Wrighten. The case reached the Fourth Circuit Court, but the issue became moot because the South Carolina Commission of Forestry closed the beach entirely. The legislature reaffirmed this decision. Brown and the NAACP later successfully enjoined all the state parks, forcing officials to "close them all up or open them." [14]

The most difficult challenge facing the Charleston NAACP was the desegregation of the city's public schools. In 1953 the branch, headed by Arthur J. Clement, Jr., sponsored a mass meeting at Morris Brown AME Church, at which J. Andrew Simmons branded segregation as "un-natural." He predicted that the United States Supreme Court would soon issue a decision as monumental as *Plessy v. Ferguson* (1896). By 1955 even conservative NAACP leaders like Robert F. Morrison rallied to the cause of integration. "We older Negroes know," Morrison concluded after surveying fifty years of black public education in Charleston County, "that the only way for the future Negro children to get a chance to get an education equal to whites in this atomic age is for us to go to the same schools that teach the same things we want. . . . The Supreme Court and all well-thinking people realize that the separate but equal law has been given a 60 year test and failed." [15]

The same year that Robert F. Morrison recounted the history of black public education in the city, the Charleston NAACP president, J. Arthur Brown, announced in July the branch's efforts to integrate local elemen-

tary and secondary schools. Two hundred and fifty parents petitioned to have several of the area school districts integrated. By September Charleston's Board of School Commissioners had received a petition asking for immediate steps to end segregation in the city's schools.[16]

Faced with the specter of integration, Charleston County built six black school "structures" between 1954 and 1955. When it became clear that even conservative black leaders like Morrison would no longer accept the status quo, the school board began taking a harder line, especially after the NAACP helped kill a 1957 bond referendum designed to build more segregated black schools. Symbolic of the change was the retirement as of July 1, 1955, of George C. Rogers, Sr., who had reached the mandatory retirement age. Indicative of the board's attitude was its refusal to name any of the new schools after blacks, though black community groups offered some specific suggestions. When Edwin Harleston's name was mentioned, the superintendent reminded the group that he "had been president of the local NAACP at the time." The board was in no mood to name one of its schools after a member of the NAACP while it was in the process of dismissing teachers who belonged to it, for instance, Septima P. Clark.[17]

In part, the board was merely reflecting a statewide crackdown on black teachers who joined the NAACP. In 1955 the sixty-five-hundred member black Palmetto Education Association, under the leadership of its executive secretary, the Averyite Walker E. Solomon, publicly supported the Brown decision in a letter to a legislative committee chaired by the state senator Marion Gressette. Shortly thereafter a Low Country state senator, T. Allen Legare, Jr., introduced legislation requiring that all officers and employees of the state sign an oath denying membership in the Ku Klux Klan or the NAACP. The final version of the bill allowed local school board superintendents considerable latitude in enforcing the bill's provisions. Dozens of South Carolina black teachers lost their jobs, including Septima Clark and Henry P. Hutchinson. Hutchinson was particularly vulnerable because he was extremely active in the Charleston NAACP and was a close ally of J. Arthur Brown.[18]

Chastised but not beaten, Brown and the NAACP continued their challenge. On October 15, 1960, nine black parents asked the District 20 superintendent, Thomas Carrere, to transfer their children to white schools. Carrere ruled against the action because the parents had not filed their requests four months before the beginning of the school year. The District 20 board upheld the superintendent. The parents included NAACP leaders J. Arthur Brown, Fred D. Dawson, and B. J. Glover, pastor of Emanuel AME Church. J. Arthur Brown's daughter Minerva, for example, consented to become part of the suit. The parents were required to go through a series of time-

consuming steps, such as obtaining the approval of their local principal and the supervisor of Negro schools. Denied at every turn, they continually appealed the decision to a higher authority. So much time had elapsed that Minerva Brown had graduated from Burke High School, making her application moot. Brown then substituted his thirteen-year-old daughter Millicent as a plaintiff. On August 23, 1963, the federal district judge, J. Robert Martin, "ended the blanket segregation of secondary schools in South Carolina with the ordered admission of 11 Negro students in Charleston County this fall." Martin also ordered that parents be notified ten days before the 1963–1964 school year that "every child in District 20 has. . . . the right to attend a school freely selected without regard to race or color," and that the parents' "request for initial assignment or transfer of pupils in order to attend a school with members of the other race will be freely granted." On August 30, 1963, the Charleston *News and Courier* proclaimed, "Public School Segregation Ends Today in Charleston." [19]

For Millicent Brown and her family, the ordeal was just beginning. The family was subject to crank phone calls at all hours of the day and night. The day Millicent Brown desegregated Rivers High School in Charleston there were bomb scares. Before Millicent Brown ever stepped foot into Rivers High School any chance for a meaningful integration was probably remote. A private school movement almost immediately undermined the effort. In 1959 members of the group surveyed various facilities in Charleston to house a private system. Philosophically the movement had a kindred spirit in the Charleston *News and Courier*, which reported the group's activities, and the College of Charleston president, George D. Grice, who became the movement's chief academic adviser. The college offered "refresher" courses for former teachers wanting to participate in the effort. The state legislature was more than willing to do its part. In 1963 the lawmakers provided a "tuition grant program" allowing children attending public schools to be transferred to private schools. Looking back at the years at Rivers High School in 1978, Millicent Brown described her graduation as a "step forward," but her presence as a token one. [20]

Such activities only confirmed the board in its course of action. Describing "separate schools . . . in the best interest of both races," it "instructed its attorneys to take all steps possible to reverse the District Court's decision." Failing in that effort, in 1964 the board instituted a Pupil Assignment and Transfer Plan minimizing the amount of integration. Approved by Martin, signed April 1965, it required that the parents send in an application stating where they wanted to send their children to school. The board made clear that it would base its decision on the preference of the parents, the school's capacity to meet the educational needs of the pupil, availability of space,

and distance the pupil lived from each school. The board also hampered the process by allowing dozens of white students permission to obtain tuition vouchers to attend private schools.[21]

In September 1966 429 black children were attending four formerly white schools alongside nearly 1,800 white students. Blacks composed a significant percentage of the High School of Charleston (12 percent), Memminger (17 percent), Rivers (19 percent), and Simons (25 percent). Nevertheless, the board's so-called Freedom of Choice Plan ensured that by 1967 most blacks, 90 percent, would attend all-black schools. Brown and his allies were even less successful in their efforts to desegregate the College of Charleston. While Clemson was accepting its first black student, Harvey Gantt, in 1963, the College of Charleston was rejecting a black graduate of Bonds-Wilson High School. In 1965 twenty South Carolina colleges agreed to comply with Title VI of the 1964 Civil Rights Act, but the College of Charleston did not sign it until 1966. "We are unhappy," wrote Grice's successor, Walter R. Coppedge, "but are frankly in a position where they might perhaps institute suit to recover funds lent to students from 1956 to 1960." Coppedge left the college to become assistant vice president of academic affairs at Virginia Commonwealth University, in Richmond. A strong proponent of a classical education, he described an attempt in 1968 to make the College of Charleston part of a state system an "act of cultural barbarism."[22]

J. Arthur Brown and South Carolina blacks were more successful in bringing about the peaceful integration of Clemson University in 1963. A group of businessmen, Clemson alumni, and politicians, all friends of the school, decided that Clemson would remain open despite an order to desegregate. Fortunately, they had a good deal of support from the then lame duck governor, Ernest Hollings, a realist, who envisioned a more modern industrial South. The Hollings family were not racial radicals. Through family patriarch Adolph's intervention Peter Poinsette, an Averyite, obtained a job delivering the U.S. mail in Charleston. In 1911, while attending Avery, Poinsette went to work for Henry L. Willie, a German, who owned a grocery store on the corner of Henry and Elizabeth streets. Willie urged Poinsette to take the Civil Service Examination for postman. Poinsette always finished near the top of the list, but he was never contacted because his picture was on his application. Willie eventually convinced one of his card-playing cronies, Adolph Hollings, who ran a wholesale paper business on East Bay Street, to intervene on Poinsette's behalf. Hollings apparently shared his father's more enlightened attitudes on race, because in 1940 he attended the Republican national convention as part of an interracial delegation.[23]

The successful desegregation of Clemson University was in large part

due to Hollings's careful planning, which included finding a suitable black candidate able to stand any harassment. While publicly sticking to the segregationist line, Hollings covertly contacted the state NAACP president, J. Arthur Brown, and a black Charleston businessman, George Kline, for advice. Brown and Kline, independent of one another, asked Eugene C. Hunt, a Burke teacher and Averyite, for the names of possible candidates. Hunt provided them with three names, and transcripts, which he had obtained without the Burke principal's permission. With Hunt's information in hand, Hollings and Kline conferred. The next step was to obtain the approval of the parents of the three candidates. The Gantt family agreed. Harvey's father, Christopher Gantt, had been supportive of some of J. Arthur Brown's earlier civil rights efforts. Harvey Gantt was well suited for the task at hand. As a Burke student he had participated in the downtown Charleston sit-ins of 1960. He also had some experience in dealing with a nearly all-white college environment. Gantt was currently attending Iowa State University. Ironically, he was there on a grant from the state of South Carolina. Rather than admit blacks to white schools in the state, South Carolina subsidized their education outside it. When the day for Gantt to travel to Clemson University from Charleston arrived in January 1963, he was accompanied by J. Arthur Brown.[24]

The Sit-Ins (1960), the Charleston Movement (1963), and the Hospital Strike (1969)

The 1960s marked an important watershed in the Low Country civil rights campaign. More than ever, the movement became both youth- and direct action–oriented. In Charleston, legal efforts were overshadowed by the sit-ins of 1960 and the mass demonstrations of the Charleston movement in 1963. The former Avery teacher Ruby P. Cornwell fully understood the importance of youth involvement. She herself was arrested in an attempt by adults to integrate Charleston's Fort Sumter Hotel, located on the Battery. In a letter to an Avery graduate written in 1968, Cornwell recalled her own private wars with segregation: "I have lived in the South all my life. I have felt that the only way one could live under these conditions and retain one's self-respect, was to fight it and continue to change these things." But Cornwell attributed these changes to "our young people . . . the ones who did this for us. In '63 I only joined in *their* demonstrations. A few other adults did also." A year later the final phase of the Charleston civil rights movement was launched, involving poor black women, poorly paid and discriminated

against, who decided to stage a strike against the Medical College of South Carolina. They, too, built on a foundation established by those who went before them.[25]

The Charleston sit-ins of April 1960 were part of a popular national grass roots movement begun at North Carolina Agricultural and Technical College in Greensboro, North Carolina, in 1959. Burke High School students, inspired by two Averyites, Eugene C. Hunt and J. Michael Graves, conducted the local effort. According to James G. Blake, president of the school's Junior NAACP, the inspiration for the sit-ins arose from the classes of the two Burke teachers. Specifically, the plan entailed targeting lunch counters at several variety stores, including F. W. Woolworth, W. T. Grant, and S. H. Kress. In early April 1960 twenty-four students were arrested and detained until the NAACP put up bail. Those arrested included James G. Blake, Delano Meriwether, Minerva Brown, and Harvey Gantt. The decision to sit in was supported by the local NAACP. B. J. Glover and J. Arthur Brown called for a boycott of the stores involved. The students' lawyer was John H. Wrighten, Jr.[26]

City authorities managed to contain the demonstrations by not overreacting, but the issue remained potentially explosive. On April 8, 1962, the Charleston NAACP held a mass meeting at St. Matthew Baptist Church, in which the state conference president, J. Arthur Brown, and those assembled publicly delineated their grievances against the King Street merchants. They employed no black sales personnel, "although 50 to 85% of the King street trade is derived from Negroes." Many refused to accord blacks courtesy titles or allow them to use their lunch counters. They also discriminated against them in "rest-room, drinking fountain and other convenience facilities." The group launched a protest picketing and "selective buying" campaign. Within a year the Charleston movement was born, "backed by the NAACP— national organization, state conference and Charleston and North Charleston branches, including youth councils of each branch." Although members of the Congress of Racial Equality were involved, the movement was primarily an NAACP effort. The campaign was kicked off at a "mass meeting June 7, 1963 at Calvary Baptist Church where James G. Blake . . . sounded 'The Battle Cry of Freedom.'" Composed of volunteers pledged to nonviolence, the Charleston movement held "nightly meetings, rotating at different churches." Demonstrators picketed "outstanding stores in King Street for better job opportunities and desegregation of store facilities, waiting rooms, lounges." On June 9, 1963, the demonstrations began with a prayer march. Motels, theaters, and restaurants were the first targets. Within two weeks

more than two hundred persons were arrested, mostly teenagers, but including a sprinkling of adults, J. Arthur Brown, Esau Jenkins, B. J. Glover, Fred D. Dawson, and Herbert U. Fielding, among them. The adults were arrested while trying to be served at the Fort Sumter Hotel on the Battery.[27]

Students, led by James G. Blake, formed the core of the demonstrators. A graduate of Burke High School, Blake was a veteran of the movement. He attended Highlander, together with Septima Clark and Bernice Robinson. In 1960 Blake led the Charleston sit-in efforts and was a member of Burke's Junior NAACP. He left Charleston to attend Morehouse College in Atlanta. In 1963 he returned to the city as a youth member of the NAACP's national board of directors. On June 19, 1963, Blake made public the demands of the Charleston movement: (1) appointment of a biracial committee to study the problems of segregation and discrimination; (2) desegregation of all restaurants, theaters, swimming pools, and playgrounds; (3) upgrading in the rank of Negro policemen; (4) equalization of job opportunities for blacks; (5) elimination of segregationist practices at the state-supported Medical College of South Carolina. Other demands later included the appointment of blacks to a housing committee to help families displaced by the proposed cross-town expressway, inclusion of blacks in white-collar jobs filled by the city, and withdrawal of all charges against those who took part in the demonstrations.[28]

By the first week of July it was clear to the white establishment that the Charleston movement was broadly based. Moreover, the movement received a boost when the NAACP executive secretary, Roy Wilkins, visited the city and addressed a meeting at Emanuel AME Church. Facing a black community and economic pressure on downtown merchants, Charleston's city council obtained a temporary injunction against further demonstrations. The mayor J. Palmer Gaillard, Jr., also agreed to meet with black leaders to "discuss the present problems." After talking with the mayor in closed session, four black leaders, J. Arthur Brown, B. J. Glover, B. J. Cooper, and Herbert U. Fielding, announced little progress.[29]

On July 16 when the decision was to be made on the continuance of the injunction, five hundred demonstrators gathered at the office of the Charleston *News and Courier* to protest its editorial policies. Exactly what happened is not clear. Authorities proclaimed it a "near riot," although those involved were not so sure. Mass arrests followed. In an effort to raise the huge amount of bail required, J. Arthur Brown and Herbert U. Fielding chartered a plane to Columbia. The incident at the *News and Courier* stunned a city that prided itself on its lack of racial confrontations. After the seventh week of demon-

strations the mayor and city merchants were ready to come to some sort of accommodation. By mid-August the merchants nearly all had fallen into line. The head of a local chapter of the National Association for the Preservation of White People complained bitterly that the businessmen had "capitulated" to the demands. Gaillard told the press he would "rebuff" the movement's ultimatum, but he consented to the core of their demands, save for the de-segregation of city playgrounds and swimming pools. Gaillard also accepted a fourteen-member voluntary "bi-racial community relations committee." Averyites on it included Herbert A. DeCosta, Jr.; Herbert U. Fielding; and T. C. McFall.[30]

By Christmas 1963 desegregation had made some inroads into Charles-ton. In 1960 after the sit-ins the downtown Charleston library had quietly desegregated its facilities. The downtown bus station eliminated separate facilities. Some of the hotels and lunch counters were also desegregated. Likewise, desegregation of the city's schools, public and parochial, began in the fall of 1963. Finally, there was some evidence that the "employment of Negroes in downtown retail stores . . . has been steadily increased."[31]

The sit-ins and mass demonstrations, despite their successes, revealed a split among Charleston's black leaders. A comparison of Arthur Clem-ent, Jr., and J. Arthur Brown is instructive. They attended Avery and were past presidents of the Charleston NAACP. Both men ran for elective office: Clement for Congress against L. Mendel Rivers in 1950, Brown for the General Assembly two years later. Both were businessmen. Both abhorred segregation. "Any local system that denies me the opportunity to participate in a cultural benefit at Dock Street Theatre," Clement wrote in 1951, "that denies me the [a]esthetic exposure at the Gibb[e]s Art Gallery or keeps me out of a rest room in a city owned building on Marion Square is doomed to failure." Clement concluded: "And irrespective of whether or not the timid and scared souls that your people have created in Clarendon County and throughout the South said so, I know that in their hearts they want to es-cape from the barriers of segregation, not because of a desire to mix with White people, but rather because of an innate and strong desire to give full wing to the full development of a God created personality." Similarly, when the governor, Ernest Hollings, complained that he felt "segregated" from the National Democratic party in 1960, Brown replied: "To feel the pangs of segregation on an organization basis is not nearly as bad as to have this immoral evil enforced as it affects the very life blood and daily existence of a race of people because of their color, thereby, curtailing their every move in a society in a manner set forth to rob them of their human dignity."[32]

The difference between the two men ostensibly involved the demonstra-

tions, but the core of the dispute dealt with the uplift philosophy. Clement saw demonstrations as antithetical to it. In 1964 Clement told a graduating class at C. A. Brown High School that he "would not lose his dignity by turning to demonstrating in the streets." "When I think of where we have come and where we are destined to go," he told the young people, "I would not let that (segregation) be a problem. Under God's guidance and in God's pattern, young men and women have faced the same obstacles but have reached out and grasped success." He urged his listeners to save money in order to open their own businesses rather than picket for jobs. For Arthur Clement, Jr., the demonstrations (bailing people out of jail) were too costly and were counterproductive. Rather than bringing about the cultural parity of the races, they ultimately polarized them. This outcome ran counter to traditional NAACP policy, which envisioned a mutual respect emanating from cultural parity. Clement recalled that after the Supreme Court rendered its historic ruling in 1954, the national NAACP invited state presidents to a conference in Atlanta, detailing how they should prepare their constituents for the integration of restaurants, waiting rooms, and buses. They counseled, for example, that blacks in working clothes not sit next to well-dressed people. A firm believer in the bootstrap philosophy, Clement became Charleston's leading black Republican in 1972.[33]

Reaching maturity during the Great Depression, J. Arthur Brown developed a greater appreciation for mass collective action. Graduating from Avery on the eve of the New Deal, Brown was exposed to progressive graduates and teachers like Frank A. DeCosta and J. Andrew Simmons. DeCosta helped him obtain a position with the city's housing authority by introducing him to Robert Weaver. While Clement was following in his father's footsteps as an agent and superintendent of the North Carolina Mutual Life Insurance Company, Brown was witnessing firsthand the critical housing shortages facing urban blacks. Unlike the insurance executive, he attended Highlander. The father of three daughters involved in the movement, Brown ultimately endorsed mass demonstrations. While reaffirming his belief in nonviolence, he wrote: "We no longer intend to remain complacent while gross injustices are thrust upon us. We don't intend to appease those who desire to drag their feet. . . . It is against injustices that these sit-ins are directed. They are in the best traditions of this country from the Boston Tea Party to the Kress, Woolworth, Grant's Walgreen, etc, Coffee Party."[34]

However "radical" or "revolutionary" Charleston's white establishment considered J. Arthur Brown and the Charleston movement, the early civil rights victories did little initially to better the economic life of the majority of Low Country blacks. If the civil rights movement in the Low Country

can be viewed as a progressive uniting of all segments of the black community, then the Charleston hospital strike of 1969 was the final stage in which the movement addressed the concerns of the most poorly paid and discriminated-against sector in the black community, the working women, especially those who were heads of households. Led by Mary Moultrie, these black hospital workers managed to mobilize the various Low Country civil rights organizations as well as the national labor movement behind their 113-day strike. Their success, in part, was based on the entire evolution of the civil rights movement in the Low Country, which Averyites did much to shape.[35]

One of the major unresolved demands of the 1963 demonstrations was the issue of discrimination at the city's Medical College (now University). In February 1965 the NAACP, led by J. Arthur Brown, James Blake, and DeQuincy Newman, organized a protest march in part to "initiate action . . . to bring an end to segregated practices at the Medical College." Probably because of such publicity, the U.S. Department of Health, Education and Welfare (HEW) named a four-person committee, composed of J. Arthur Brown; Reginald Barrett; the NAACP branch president, Russell Brown; and T. C. McFall, "to inspect the S.C. Medical College Hospital for compliance with the [Civil Rights] act." Such efforts, however, did little to help the largely black and mostly female paraprofessional corps at the Medical College Hospital and the Charleston County Hospital. Poorly paid ($1.30 per hour) and discriminated against, these nonprofessionals (licensed practical nurses, nursing assistants, dietary staff, orderlies, and janitors) were sometimes given professional duties. Their jobs included training young white professionals, who were usually paid more but were not always as proficient as the blacks who trained them. In February 1968 five black nonprofessionals about to go on duty asked the white nurse for the patients' charts. She refused. The five blacks walked off the job and were fired.[36]

The incident was no surprise to Mary Moultrie. The daughter of a Charleston Navy Yard worker, she had gone to New York City, where she was hired as a licensed practical nurse. When she returned to Charleston in 1966, the Medical College slotted her as a nurse's aide. But Moultrie was no novice to organization. Not only was she knowledgeable about unions, she had once worked with Guy Carawan and Esau Jenkins on community projects. She was familiar with Highlander and Bernice Robinson and William Saunders. Moultrie turned to Saunders for advice.[37]

Born in New York City in the 1930s, William ("Bill") Saunders was sent at the age of one and a half to Johns Island to be reared, where he fell under the spell of his Sunday school superintendent, Esau Jenkins, who bused him

and other students into Charleston's Burke High School. Returning from the Korean War, the black veteran used the G.I. Bill to complete his schooling at Laing High School. In 1959 Esau Jenkins persuaded him to attend Highlander.[38]

William Saunders arranged a meeting for Moultrie with Reginald Barrett, an Averyite and a member of the committee appointed by HEW, and Isaiah Bennett, the business director of the local tobacco workers union (Local 15A of the Retail, Wholesale and Department Store Unions) and state director of the National Hospital Workers. The women were eventually reinstated but recognized that some organizing was necessary for them to keep their jobs. The meeting with Barrett made it clear that the problems they faced were common throughout the Medical College. With Bennett's blessing, ten workers gathered "for weekly meetings at the ramshackle tobacco union hall." The group eventually organized 550 of the 600 nonprofessional workers at the Medical College Hospital and at the Charleston County Hospital. It was logical that the group should meet there because in 1945 the tobacco union had gone out on strike to raise wages from eight to thirty cents an hour. One of the veterans of the strike, Lillie Doster, provided Mary Moultrie with timely advice. William Saunders also used his *Lowcountry Newsletter* to inform the community of what was going on at the hospitals and elsewhere.[39]

Determined to "resist this union in its attempts to get in here with every legal means at our disposal," William McCord, president of the Medical College, refused Mary Moultrie's written request for a meeting and one from John Cummings, president of Local 15A. At Doster and Bennett's suggestion, Moultrie's group became affiliated with New York Local 1199, Retail Drug and Hospital Employees Affiliate of the International Retail, Wholesale and Department Store Union, which was also the parent of Bennett's tobacco union. Moultrie's request coincided with big labor's nationwide effort to organize hospital workers. Affiliation with New York Union 1199 gave the new Charleston Union 1199B access to national labor support. Labor's friends in Congress would pressure the Nixon administration to settle the strike amicably.[40]

As pressure mounted the president, William McCord, agreed to meet with Moultrie and a delegation of workers, but a March 18 meeting broke down when McCord named eight hand-picked employees as part of the workers' delegation. The next day Moultrie and eleven other activists were fired, beginning the 113-day Charleston hospital strike.[41]

Moultrie and 1199B profited mightily from labor support, but they were able to mount such a successful challenge only because of the foundation laid by the civil rights movement. The Citizenship Schools, Highlander,

the NAACP, and the Charleston movement prepared the way for the hospital strike. Mary Moultrie was influenced by her predecessors Esau Jenkins, Bernice Robinson, Lillie Doster, and William Saunders. In a sense, the Charleston movement was a kind of rehearsal for those demonstrations mounted during 1969. The churches, the youth, and the NAACP again rallied to the cause. Finally, the whole issue of discrimination at the Medical College had been raised by James Blake and the Charleston movement.[42]

No Averyites were involved directly in the walkout. They were of an older generation than Mary Moultrie's. Few belonged to the working poor, but the rank discrimination against blacks prevalent at the Medical College made them receptive to the cause. Perry Metz, for example, had been "persistently insulted" during priestly visits to the hospital. His fellow minister, Henry L. Grant, head of the city's St. John's Episcopal Mission, remembered a white nurse's yelling, "Boy, you can't go down that hall" as he attempted to administer the Sacraments to the sick. When the strike began, Grant was a leader, and Metz's Zion Olivet United Presbyterian Church became a place "where the workers often met for rallies."[43]

Other Averyites provided less direct but valuable support. Through the committee appointed by HEW, which included three Averyites, Mary Moultrie heard that many people at the Medical College were suffering similar injustices. It was probably input from the same group that convinced HEW investigating teams that widespread discrimination existed at the Medical College. In June HEW, citing thirty-seven civil rights violations, requested that the Medical College submit an affirmative action plan or risk losing federal funds. This action negated McCord's assertions that the strike did not involve civil rights. It also caused the establishment, at least temporarily, to take a more moderate stance. The governor, Robert E. McNair, indicated his willingness to comply with federal guidelines, and McCord seemed on the verge of rehiring those fired as well as those striking. Only the intervention of L. Mendel Rivers and J. Strom Thurmond forced HEW to back down, aborting what might have been the beginning of a move toward real negotiations.[44]

The strike was settled successfully because of a combination of "Union Power, Soul Power." Specifically this involved uniting labor and the Southern Christian Leadership Conference (SCLC). According to Mary Moultrie, Septima Clark was instrumental in unifying the two groups behind the strike. In bringing such prominent national civil rights leaders as Coretta King and Ralph Abernathy to Charleston, SCLC bolstered community support for the mass marches, the demonstrations, and the boycott of the city's public schools and the downtown merchants. The arrests of Abernathy gal-

vanized the community and helped bring the issue to a head. As the strike became increasingly costly to Charleston, Gaillard named a Citizens' Committee to seek ways of ending the dispute. The presence of Esau Jenkins on the committee suggested that the mayor was serious in his efforts. However, Gaillard found his hands tied. McNair declared that the state could not bargain with any union. Some people advocated closing the Medical College permanently.[45]

The strike ended because the Nixon White House wanted the strike settled; it feared growing national racial confrontations. A prominent Charleston banker, Hugh C. Lane, conceded privately that conditions for blacks at the Medical College were scandalous. Rather than alleviating the problems, McCord's administration compounded them by its inept handling of the strike. By threatening to cut off funds, the government hoped to persuade the state's white establishment to come to terms. Moreover, there was some indication that some of the local strike leaders, unhappy with the actions of their outside allies, were willing to negotiate. McNair persuaded Saunders and Grant to mediate the negotiations. Saunders helped the two sides hammer out an agreement, which called for (1) the rehiring of all workers on the payroll as of March 15, (2) the creation of a six-step employee grievance plan, (3) the promise of $1.60 per hour minimum wage. On June 27 the strike ended at the Medical College. By July 19 a settlement was also reached with the union at the Charleston County Hospital.[46]

The hospital strike produced few lasting benefits for the workers directly involved. They had settled for a memorandum of agreement rather than a written contract. The grievance procedure failed because the hospital handpicked the board administering it, and the hospital reneged on a promise to allow workers to pay their union dues via a check-off system at the credit union. After several years of harassment Moultrie left the hospital and Union 1199B ceased to exist.[47]

Despite its failure, the hospital strike was part of a long-term civil rights movement that registered considerable collective impact on the Low Country. That effort had united a Low Country black population historically splintered by color, class, and geography. Herbert Fielding may have been exaggerating when he stated in 1978 that before 1950, "light-skinned blacks had little to do with the darker complexioned blacks," but he agreed that the civil rights movement had halted this pattern. Moreover, in mounting such an impressive effort in the 1960s with virtually no local white support, it did much to lift the self-esteem of Low Country blacks. It shattered white Charleston's self-serving image of itself, or what Mary Moultrie termed the " 'We have always been good to our Negroes' smugness." For years blacks

had been tolerated, Moultrie noted, "often . . . with fondness only because . . . someone had to iron Missy's dresses and stroll quaintly through the white neighborhoods selling raw shrimp." One by-product of the hospital strike was a more positive appreciation of blackness. Reporters described Mary Moultrie's "Afro-hairdo" as a "token of her rejection of that sort of magnolia scented attitude." Sometimes the new pride translated into a dislike for lighter-skinned blacks. "When black became beautiful," Herbert Fielding observed in 1978, "darker complexioned blacks began to look down on lighter-skinned blacks as having used their color to gain more acceptance from whites." [48]

The most pragmatic result of the civil rights movement in the Low Country was the growing political clout resulting from Waring's ruling. Oliver T. Wallace, a state senator, was one of the first white politicians to woo the black vote openly. On October 18, 1949, Wallace, a devout New Dealer, addressed the Charleston County Association of Black Baptist Churches at the city's Union Baptist Church. According to a reporter, "The rabble-rousing was done by a filling station operator, Robert F. Morrison." The aging Averyite "pulled no punch and although I thought he was enjoying the immunity of the building . . . he has made similar demands in public." Morrison was "dissatisfied with everything including the lack of adequate schools, . . . that half of Edisto state park was not available to his race, that he had to pay taxes to retire the debt on Johnson Hagood Stadium which he couldn't use and several other existing conditions." In 1951 Wallace actively pursued the black vote in his race for mayor, as did the incumbent, William McG. Morrison. Although Wallace lost, the independent candidate, later a leader in the private school movement, failed to make the run-off. He conceded that the "bulk of the negro vote" had gone to his Democratic opponents. In 1959 the black vote nearly prevented J. Palmer Gaillard, Jr., from being elected mayor. In releasing the voting results by precinct to the editor of the local *News and Courier*, Charleston's clerk of council, A. J. Tamsberg, cautioned against making the information public, "thereby . . . available to negro leaders. Some of it is quite startling." [49]

By 1956 blacks had become active at the grass roots level of Charleston County's Democratic party. "For the first time in contemporary history, Negroes won posts in clubs here," a local newspaper reported. Twenty-nine, including a former Avery teacher, Ruby P. Cornwell, were elected delegates to the county's Democratic convention. Although St. Julian Devine was elected to Charleston's city council in 1967, real progress only came after the hospital strike, which generated a substantial increase in black

voter registration. Even the Republicans conceded the need to recognize the importance of the black vote. In December 1969 Arthur G. Ravenel, a Republican candidate for governor and former member of the legislature, warned his fellow Republicans that "no Republican can be elected unless he gets some of the Negro vote. You've got to ask for it . . . I'm going to do it openly, not sneaking around in alleys." Unlike during the First Reconstruction, the conservative party accepted the legitimacy of the black vote and pursued it accordingly. In 1969 the Averyite Richard E. Fields became "the first Negro in modern times to be associate judge of the Municipal Court of Charleston." After graduating from Avery, Fields attended West Virginia State College, then Howard University Law School. In 1946 he was admitted to the South Carolina bar; three years later he began his practice in Charleston. Fields was nominated for the judgeship by a conservative white city councilman, William H. Grimball, Jr. The history of black Charleston, as symbolized in the nomination of Fields and the story of Avery, had come full circle to the more positive side of Wade Hampton's vision. Citing "the active role of Negroes during the administration of Gov. Wade Hampton in the 1870s as a precedent," Grimball predicted, "we have now reached the stage when we can get back on the road laid down by Hampton. We have reached the point where the color of a man's skin should not make any difference." [50]

NOTES

Sources frequently cited have been identified by the following abbreviations:

AHR	*American Historical Review*
AMAA	American Missionary Association Archives, Amistad Research Center, Tulane University, New Orleans, La.
AMISTAD	Amistad Research Center, Tulane University, New Orleans, La.
ARC	Avery Research Center, College of Charleston
CCPC	Charleston County Probate Court
CCPL	Charleston County Public Library, King Street Branch
CCRMC	Charleston County Register of Mesne and Conveyance
CLS	Charleston Library Society
HREC	Highlander Research and Educational Center, New Market, Tenn.
JNH	*Journal of Negro History*
JSH	*Journal of Southern History*
LC	Library of Congress, Washington, D.C.
NA	National Archives, Washington, D.C.
OAR, CCSD	Office of Archives and Records, Charleston County School District
SCDAH	South Carolina Department of Archives and History, Columbia, S.C.
SCHM	*South Carolina Historical Magazine*
SCHS	South Carolina Historical Society, Charleston, S.C.
SCRSSL	Special Collections, Robert Scott Small Library, College of Charleston, Charleston, S.C.
SPEC	St. Philip's Episcopal Church, Charleston, S.C.

PREFACE

1. Joel Williamson, *After Slavery: The Negro in South Carolina during Reconstruction, 1861–1877* (Chapel Hill: University of North Carolina Press, 1965); Charleston *News and Courier,* June 4, 1977; New York *Times,* June 2, 1980.

2. My initial judgment to begin with the antebellum period was confirmed by Robert C. Morris's excellent monograph, *Reading, 'Riting, and Reconstruction: The*

Education of Freedmen in the South, 1861–1870 (Chicago: University of Chicago Press, 1981), 86–89.

INTRODUCTION

1. John A. Alston, "Calhoun Statue Quelled Furor," Charleston *News and Courier*, October 23, 1972, 1B; Jane E. Allen, "Dedicated Women Raised Money for Statue of 'The Great Nullifier,'" Charleston *News and Courier*, June 13, 1983, 1B.

2. Edmund L. Drago and Ralph Melnick, "The Old Slave Mart Museum, Charleston, South Carolina: Rediscovering the Past," *Civil War History* 27 (Summer 1981): 138–54; Septima Poinsette Clark, with LeGette Blythe, *Echo in My Soul* (New York: E. P. Dutton and Co., 1962), 46.

3. Daniel Alexander Payne, *Recollections of Seventy Years* (Nashville: A.M.E. Sunday School Union, 1888; New York: Arno Press, 1969), 24–25.

4. Elizabeth Jacoway, *Yankee Missionaries in the South: The Penn School Experiment* (Baton Rouge: Louisiana State University Press, 1980). Recent works, though critical of the missionaries, have been more favorably inclined toward them. See Jacqueline Jones, *Soldiers of Light and Love: Northern Teachers and Georgia Blacks, 1865–1873* (Chapel Hill: University of North Carolina Press, 1980), and Joe M. Richardson, *Christian Reconstruction: The American Missionary Association and Southern Blacks, 1861–1890* (Athens: University of Georgia Press, 1986). For a valuable synthesis of black education in the South, which places the topic in its economic context, see James D. Anderson, *The Education of Blacks in the South, 1860–1935* (Chapel Hill: University of North Carolina Press, 1988). Although Anderson is critical of northern philanthropy and missionary paternalism, he recognizes the democratic idealism of the missionaries.

5. Mamie Garvin Fields, with Karen Fields, *Lemon Swamp and Other Places: A Carolina Memoir* (New York: Free Press, 1983), 13, 24; E. Franklin Frazier, *Black Bourgeoisie: The Rise of a New Middle Class in the United States* (New York: Free Press, 1957; Collier Books, 1962), 65–72, 195, 204 n. 29; G. Franklin Edwards, "E. Franklin Frazier," in Rayford Logan and Michael R. Winston, eds., *Dictionary of American Negro Biography* (New York: W. W. Norton and Co., 1982), 241–44; Harold Cruse, *The Crisis of the Negro Intellectual* (New York: William Morrow and Co., 1967), 443–45.

6. The best discussion of the historiography on intragroup color differences is Theodore Hershberg and Henry Williams, "Mulattoes and Blacks: Intragroup Color Differences and Social Stratification in Nineteenth-Century Philadelphia," in Theodore Hershberg, ed., *Philadelphia Work, Space, Family, and Group Experience in the Nineteenth Century* (Oxford: Oxford University Press, 1981), 392–434. The issue usually has been dealt with in works about mulattoes. The classic work is Edward Byron Reuter, *The Mulatto in the United States, Including the Role of Mixed-Blood Races throughout the World: A Dissertation Submitted to the Faculty of Graduate School of Arts and Literature in Candidacy for the Degree of Doctor of Philosophy, Department of Sociology* (Boston: Richard G. Badger, 1918; New York: Negro Universities Press, 1969). This has been superseded by Joel Williamson, *New People: Miscegenation and Mulattoes in the United States* (New York: Free Press, 1980). Williamson's notes constitute an exhaustive list of relevant books.

Since the publication of the Hershberg and Williamson books, other important

works, specifically dealing with South Carolina, have appeared. Michael P. Johnson and James L. Roark have coauthored two important books, *Black Masters: A Free Family of Color in the Old South* (New York: W. W. Norton and Co., 1984), and *No Chariot Let Down: Charleston's Free People of Color on the Eve of the Civil War* (Chapel Hill: University of North Carolina Press, 1984; New York: W. W. Norton and Co., 1986). Allen B. Ballard traced intragroup color differences from South Carolina to Philadelphia in *One More Day's Journey: The Story of a Family and a People* (New York: McGraw-Hill Book Co., 1984). Larry Koger has completed an exhaustive and valuable study of black South Carolina slaveowners in *Black Slaveowners: Free Slave Black Masters in South Carolina, 1790–1860* (Jefferson, N.C.: McFarland and Co., 1985). See also Willard B. Gatewood, Jr., "Aristocrats of Color: South and North, the Black Elite, 1880–1920," *JSH* 54 (February 1988): 3–20.

7. Charleston *News and Courier*, November 13, 1986. I attended memorial services for Grant on November 14, 1986, at Wesley United Methodist Church, Charleston. See *Home Coming Celebration for Ralph Thomas Grant, Sr., Wesley United Methodist Church, 446 Meeting Street, Charleston, South Carolina, November 14, 1986*, in author's possession.

8. For a wonderful pictorial history of the islanders, see Guy Carawan and Candie Carawan, *Ain't You Got a Right to the Tree of Life? The People of Johns Island, South Carolina—Their Faces, Their Words, and Their Songs* (New York: Simon and Schuster, 1966). There is a revised and enlarged edition (1989) by the University of Georgia Press. For a current appraisal, see Patricia Jones-Jackson, *When Roots Die: Endangered Traditions on the Sea Islands* (Athens: University of Georgia Press, 1987). A recent book on the Gullah people is Margaret Washington Creel, *"A Peculiar People": Slave Religion and Community-Culture among the Gullahs* (New York: New York University Press, 1988).

9. Calhoun as quoted in James M. McPherson, *The Abolitionist Legacy from Reconstruction to the NAACP* (Princeton: Princeton University Press, 1975), 204–5; Fredrika Bremer, *The Homes of the New World: Impressions of America* (New York: Harper and Brothers, 1853; Negro Universities Press, 1968), 1: 305; Fields, *Lemon Swamp*, 57; Lucille A. Williams, interview with the author, Mt. Pleasant, S.C., September 25, 1984. Calhoun anecdotes abound. Today the bronze statue is turning black. Some blacks see this as divine retribution.

10. John F. Potts, interview with the author, Charleston, April 17, 1982; G. Franklin Edwards, curriculum vitae in author's possession, n.d.; Edwards, "E. Franklin Frazier," 241–44; J. Michael Graves, interview with the author, Charleston, March 7, 1985. Graves was Edwards's classmate at Avery.

11. See Reuter's discussion of the federal census in *The Mulatto in the United States*, 11 n. 1; Johnson and Roark, *Black Masters*, 37; William W. Freehling, "Denmark Vesey's Peculiar Reality," in Robert H. Abzug and Stephen E. Maizlish, eds., *New Perspectives on Race and Slavery in America: Essays in Honor of Kenneth M. Stampp* (Lexington: University of Kentucky Press, 1986), 29.

CHAPTER 1. ANTEBELLUM CONTEXT

1. Robert L. Harris, Jr., "Charleston's Free Afro-American Elite: The Brown Fellowship Society and The Humane Brotherhood," *SCHM* 82 (October 1981): 290.

2. Frances Anne Kemble, *Journal of a Residence on a Georgian Plantation in 1838–*

1839 (New York: Alfred Knopf, 1961; New American Library, 1975), 36–38; Charles Fraser, *Reminiscences of Charleston, Lately Published in the Charleston Courier, and Now Revised and Enlarged by the Author* (Charleston: John Russell, 1854), 9–11, 14–15; William H. Pease and Jane H. Pease, *The Web of Progress: Private Values and Public Styles in Boston and Charleston, 1828–1843* (New York: Oxford University Press, 1985), 41–42, 223–24.

3. Frederick A. Ford, *Census of the City of Charleston, South Carolina, for the Year 1861, Illustrated by Statistical Tables, Prepared under the Authority of the City Council* (Charleston: Evans and Cogswell, 1861), 9–10; Ira Berlin and Herbert Gutman, "Natives and Immigrants, Free Men and Slaves: Urban Workingmen in the Antebellum South," *AHR* 88 (December 1983): 1181–86; Ira Berlin, *Slaves without Masters: The Free Negro in the Antebellum South* (New York: Pantheon Books, 1974; Vintage Books, 1976), 221.

4. Michael P. Johnson, "Wealth and Class in Charleston in 1860," in Walter J. Fraser and Winfred B. Moore, Jr., eds., *From the Old South to the New: Essays on the Transitional South* (Westport, Conn.: Greenwood Press, 1981), 66–67, 71, 73; E. Horace Fitchett, "The Free Negro in Charleston, South Carolina" (Ph.D. diss., University of Chicago, 1950), tables 22 and 23; Frederick Law Olmstead, *Journey in the Seaboard Slave States*, as quoted in William Oliver Stevens, *Charleston, Historic City of Gardens* (New York: Dodd, Mead, and Co., 1946), 234–35; A. Toomer Porter, *Led On! Step by Step Scenes from Clerical, Military, Educational, and Plantation Life in the South, 1828–1898: An Autobiography* (New York: G. P. Putnam's Sons, 1898), 92, 95, 106–11.

5. Richard S. Dunn, "The English Sugar Islands and the Founding of South Carolina," *SCHM* 72 (April 1971): 81–93; Jno. P. Thomas, Jr., "The Barbadians in Early South Carolina," *SCHM* 31 (April 1930): 75–92; Fraser, *Reminiscences of Charleston*, 56–58; Pease and Pease, *The Web of Progress*, 122–23. I am borrowing the term "aristocratic ethos" from Eugene D. Genovese, *Roll, Jordan, Roll: The World the Slaves Made* (New York: Pantheon Books, 1974; Vintage Books, 1976), 113–23.

6. Thomas D. Clark, ed., *South Carolina: The Grand Tour, 1780–1865* (Columbia: University of South Carolina Press, 1973), 49, 53; Fields, *Lemon Swamp*, 2, 11; Ford, *Census of the City of Charleston, South Carolina, for the Year 1861*, 9, 13; *Population of the United States in 1860, Compiled from the Original Returns of the Eighth Census under the Direction of Secretary of the Interior, by Joseph C. G. Kennedy, Superintendent of Census* (Washington, D.C.: Government Printing Office, 1864), 452. Of the 37,290 slaves listed in the Charleston District, 2,887 were termed mulatto. For a breakdown of occupations, see J. L. Dawson and H. W. DeSaussure, *Census of the City of Charleston, South Carolina, for the Year 1848, Exhibiting the Condition and Prospects of the City, Illustrated by Many Statistical Details, Prepared under the Authority of the City Council* (Charleston: J. B. Nixon, 1849), 30–34. The 1848 census may have underestimated the city's slave population by one-third, and the free black by one-quarter. See Anne W. Chapman, "Inadequacies of the 1848 Charleston Census," *SCHM* 81 (January 1980): 24–34.

7. Cornelius C. Scott, "When Negroes Attended the State University," *The State*, Columbia, May 8, 1911, 9; Richard C. Wade, *Slavery in the Cities: The South, 1820–1860* (New York: Oxford University Press, 1964), 143–79; Genovese, *Roll, Jordan, Roll*, 562; C. W. Birnie, "Education of the Negro in Charleston, South Carolina,

Prior to the Civil War," *JNH* 12 (January 1927): 14; Payne, *Recollections*, 19; Fields, *Lemon Swamp*, 2; R. Tomlinson to R. K. Scott, July 1, 1867, Records of the Education Division of Refugees, Freedmen, and Abandoned Lands (M803), Record Group 105, Records of the Bureau of Refugees, Freedmen, and Abandoned Lands, NA [hereafter cited as Records of the Education Division (M803), RG 105].

8. Francis A. Mood, *Methodism in Charleston: A Narrative of the Chief Events Relating to the Rise and Progress of the Methodist Episcopal Church in Charleston, S.C., with Brief Notices of Early Ministers Who Labored in That City*, ed. Thomas O. Sumners (Nashville: E. Stevenson and J. E. Evans for the Methodist Episcopal Church, South, 1856), 174–75; Kenneth R. Manning, *Black Apollo of Science: The Life of Ernest Everett Just* (New York: Oxford University Press, 1983), 5–9; Mary Anne Just, and George Just, Record of Wills, vol. 46, pp. 136, 299–300, CCPC; George Just, July 10, 1853, Charleston County Death Records (file card index), CCPL; James B. Browning, "The Beginning of Insurance Enterprise among Negroes," *JNH* 22 (October 1937): 428; J. G. Bass to E. Holloway on the death of Richard Holloway, Sr., June 29, 1845, Holloway Family Papers, SCRSSL; Payne, *Recollections*, 17; vol. S-12, p. 557, CCRMC.

9. Mood, *Methodism in Charleston*, 190–92; W. H. Lawrence, *The Centenary Souvenir, Containing a History of the Centenary Church, Charleston, and an Account of the Life and Labors of Reverend R. V. Lawrence, Father of the Pastor of Centenary Church* (Philadelphia: Collins Printing House, 1885), xiv.

10. Edgar Paul Westmoreland, "A Study of Negro Public Education in the State of South Carolina, with Particular Reference to the Influences of the Reconstruction Period" (Master's thesis, Howard University, 1935), 15; T. Erskine Clarke, "An Experiment in Paternalism: Presbyterians and Slaves in Charleston, South Carolina," *Journal of Presbyterian History* 53 (Fall 1975): 223–38.

11. Clarke, "An Experiment in Paternalism," 223–38.

12. Porter, *Led On*, 61–80, 90–95.

13. Westmoreland, "A Study of Negro Public Education in the State of South Carolina," 14, 18–19; Wade, *Slavery in the Cities*, 173–74; John Belton O'Neall, *The Negro Law of South Carolina, Collected and Digested by John Belton O'Neall, One of the Judges of the Court of Law and Errors of Said State, under a Resolution of the State Agricultural Society of South Carolina* (Columbia: John G. Bowman [printer], 1848), 23; Lawrence, *The Centenary Souvenir*, xiv; Fields, *Lemon Swamp*, 2. According to Fields, Abram and the other children of Thomas Middleton taught Berry to read and write.

14. Clarke, "An Experiment in Paternalism," 223, 236; Clarence Earl Walker, *A Rock in a Weary Land: The African Methodist Episcopal Church during the Civil War and Reconstruction* (Baton Rouge: Louisiana State University Press, 1982), 4–11.

15. Mood, *Methodism in Charleston*, 43–46, 64, 123, 130–33; James H. Holloway, *Why I Am a Methodist: A Historical Sketch of What the Church Had Done for the Colored Children Educationally, as Early as 1790 at Charleston, S.C.* ([Charleston]: R. Wainwright [printer], 1909).

16. Mood, *Methodism in Charleston*, 43–45, 64, 87–91, 97–98, 104–9, 130–33; Marina Wikramanayake, *A World in Shadow: The Free Black in Antebellum South Carolina* (Columbia: University of South Carolina Press, 1973), 124–26; Charleston *City Gazette*, December 30, 1817; Robert Starobin, ed., *Denmark Vesey: The Slave Conspiracy of 1822* (Englewood Cliffs, N.J.: Prentice-Hall, 1970), 2.

17. Mood, *Methodism in Charleston,* 187, 189–90, 201; Lawrence, *The Centenary Souvenir,* viii, xiv; Williamson, *After Slavery,* 185; *Population of the United States in 1860,* 452. For Weston and Smith, see notes 68 and 69.

18. Ford, *Census of the City of Charleston, South Carolina, for the Year 1861,* 9, 14; Dawson and DeSaussure, *Census of the City of Charleston, South Carolina, for the Year 1848,* 9, 31, 34–35; Berlin, *Slaves without Masters,* 221; Berlin and Gutman, "Natives and Immigrants, Free Men and Slaves," 1186; *Constitution and Rules of Humane Brotherhood, Organized June 19th, 1843,* 1–2; Wikramanayake, *A World in Shadow,* 82–83. In *List of the Tax Payers of the City of Charleston for 1860* (Charleston: Evans and Cogswell, 1861), 315–34, the following were listed as Indian: William H. Bentham, Amelia L. Cornwell, R. E. Dereef, Joseph Dereef, W. E. Dewees, Elizabeth Fox, Elias Garden, Mary Ann Gardener, Sarah Howard, John B. Matthews, Ann Mitchell, Harriet Mitchell, Augustus Ryan, and W. N. Seymour. The Brown Fellowship Society included R. E. Dereef, Joseph Dereef, and William W. Seymour. The Friendly Moralists were Augustus Ryan and William Bentham. William W. Seymour, Richard E. Dereef, Joseph Dereef, Elias Garden, and W. E. Dewees belonged to the Friendly Union. See *Constitution and By-Laws of the Friendly Union Society, Charleston, S.C., Organized May 4th, 1813, Incorporated* (Charleston: Karrs and Welch [printers and binders], 1889), 22–25; *Rules and Regulations of the Brown Fellowship Socitey* [sic], *Established at Charleston, S.C., 1st November, 1790* (Charleston: J. B. Nixon, 1844), 25–27; and Proceedings of the Friendly Moralist Society, SCRSSL [hereafter cited as FMS].

19. *Report on the Free Colored Poor of the City of Charleston* (Charleston: Burgess and James, 1842), 10; Wikramanayake, *A World in Shadow,* 79; *List of the Tax Payers of the City of Charleston for 1860,* 315–34; Berlin and Gutman, "Natives and Immigrants, Free Men and Slaves," 1183; Berlin, *Slaves without Masters,* 221; Samuel M. Wigfall, Record of Wills, 241/3, CCPC.

20. Ford, *Census of the City of Charleston, South Carolina, for the Year 1861,* 14; *List of the Tax Payers of the City of Charleston for 1860,* 315–34. I have used the number of adults found in the 1861 census. *Population of the United States in 1860,* 52, lists an aggregate of 3,237 "free colored" (black and mulatto) living in the eight wards and neck area of the city.

21. *List of the Tax Payers of the City of Charleston for 1860,* 315–34; Fitchett, "The Free Negro in Charleston, South Carolina," tables 22 and 23.

22. FMS, December 8, 1845, June 8, 1846; Francis Wilkinson, Record of Wills, 158/19, CCPC; Baptisms, Marriages, and Burials, 1823–1940, 2 vols., SPEC; Holloway, *Why I Am a Methodist,* 7–8; Dawson and DeSaussure, *Census of the City of Charleston, South Carolina, for the Year 1848,* iv; State Free Negro Capitation Tax Book, Charleston, 1841, SCDAH.

23. *List of the Tax Payers of the City of Charleston for 1860,* 315–34; *Constitution and Rules of Humane Brotherhood,* 1; Wikramanayake, *A World in Shadow,* 79–87; R. S. Purse, *Charleston City Directory and Strangers' Guide for 1856* (New York: F. Trow, 1856), 201; Fields, *Lemon Swamp,* 2. Eugene C. Hunt remembered such families.

24. *List of the Tax Payers of the City of Charleston for 1860,* 315–34; E. Horace Fitchett, "The Traditions of the Free Negro in Charleston, South Carolina," *JNH* 25 (April 1940): 148–49; Fitchett, "The Free Negro in Charleston, South Carolina," 48, 331–33; T. C. Fay, *Charleston Directory and Strangers' Guide for 1840 and*

1841 . . . (Charleston: N.p., 1840), 100; Johnson and Roark, *Black Masters,* 208, and *No Chariot Let Down;* Holloway Family Papers; Richard Holloway, Record of Wills, vol. 43, pp. 891–95, CCPC; Report of James W. Gray, Master in Equity, South Carolina, Elizabeth Holloway vs. Richard Holloway & Edward Holloway, Exors and their Heirs and Devisees of Richard Holloway, decd, Master-in-Equity Files, SCDAH; Thomas R. Waring, "Nonagenarian Enjoys Her Memories," Charleston *News and Courier–Evening Post,* May 3, 1981, 2E. For a discussion of the shortage of black males, see note 28 and later discussion in this chapter.

25. *List of the Tax Payers of the City of Charleston for 1860,* 315–34; Porter, *Led On,* 196–98, 280–85; Carter G. Woodson, "Free Negro Owners of Slaves in the United States in 1830," *JNH* 9 (January 1924): 41–85. For a critique of Woodson, see Koger, *Black Slaveowners,* 19–22, 80–81, 158, chapter 6, and R. Halliburton, Jr., "Free Black Owners of Slaves: A Reappraisal of the Woodson Thesis," *SCHM* 76 (July 1975): 129–42.

26. Koger, *Black Slaveowners,* 16, 80–81, 158, chapter 6; Juliet Eggart, Record of Wills, vol. 40, p. 138, CCPC; Purse, *Charleston City Directory and Strangers' Guide for 1856,* 205; *List of the Tax Payers of the City of Charleston for 1860,* 319; Theodore D. Jervey, *The Slave Trade: Slavery and Color* (Columbia: State Co., 1925), 220–21; FMS, June 11, 1848 (Michael Eggart's speech). Eggart was married to Richard E. Dereef's eldest daughter, Joanna (for documentation, see note 67, as well as Johnson and Roark, *Black Masters,* 217).

27. Koger, *Black Slaveowners,* 71–72; Jervey, *The Slave Trade,* 221–24; *List of the Tax Payers of the City of Charleston for 1859* (Charleston: Walker, Evans, and Co., 1860), 391–92. The Holloway Family Papers contain a certificate licensing Richard Holloway, Sr., as an exhorter. See later discussion in this chapter on the importance of free black artisans working in the "Country."

28. Wikramanayake, *A World in Shadow,* 15–16; Berlin, *Slaves without Masters,* 264, 279; Thomas Holt, *Black over White: Negro Political Leadership in South Carolina during Reconstruction* (Urbana: University of Illinois Press, 1977), 24; Jervey, *The Slave Trade,* 154; Koger, *Black Slaveowners,* 12–13; Dawson and DeSaussure, *Census of the City of Charleston, South Carolina, for the Year 1848,* 11–16; James Petigru Carson, *Life, Letters, and Speeches of James Louis Petigru: The Union Man of South Carolina* (Washington, D.C.: W. H. Lowdermilk and Co., 1920), 66, 70–71.

29. Euline W. Brock, "Thomas W. Cardozo: Fallible Black Reconstruction Leader," *JSH* 47 (May 1981): 186–89; Ballard, *One More Day's Journey,* 35–36.

30. Richard and Gilbert Wall, Miscellaneous Treasury Accounts, Office of First Auditor, General Accounting Office, Record Group 217, NA [hereafter cited as Richard and Gilbert Wall, Record Group 217].

31. Richard Wall, Record of Wills, vol. 42, p. 378, CCPC. FMS, June 12, 1843; November 13, 1843. Richard Wall, in his will executed at his death in 1842, leaves his estate to "my Sons William Wall, Edward P. Wall, Lancelot Franklin Wall and their Mother Amelia Wall." For further documentation, see baptism records dated May 1, 1818, December 10, 1830, n.d. 1839, and February 4, 1850, in Baptisms, Marriages, and Burials, 1823–1940, SPEC; Leonard Mears and James Turnbull, *The Charleston Directory [for 1859,] Containing the Names of the Inhabitants, a Subscribers' Business Directory, Street Map of the City, and an Appendix of Much Useful Information* (Charleston: Walker, Evans, and Co., 1859), 215; Purse, *Charleston City Directory and*

Strangers' Guide for 1856, 205–6; Dorilla Motte, Record of Wills, vol. 50, pp. 280–82, CCPC; L. F. Wall and S. S. Motte, April 11, 1837, Marriage Settlement, vol. Q-10, pp. 256–57, CCRMC.

32. Richard and Gilbert Wall, Record Group 217. J. Dane Hargrove, of the Diplomatic Branch of the National Archives, sent me a letter on August 19, 1986, with an excerpt ("Thirtieth Congress. Sess. I. Ch. 19, 22. 1848") from the *Statutes at Large of the United States,* 214, describing "An Act for the Relief of the Heirs of John Paul Jones," approved March 21, 1848.

33. Wikramanayake, *A World in Shadow,* 110–11; Charleston *News and Courier* as cited in Fitchett, "The Free Negro in Charleston, South Carolina," 248–49; Citizens of Charleston, n.d., no. 2801-1, General Assembly Petitions, SCDAH; Berlin, *Slaves without Masters,* 238–39. A relative of Wall told me the anecdote about the Confederate general.

34. Starobin, ed., *Denmark Vesey,* 133–37; Freehling, "Denmark Vesey's Peculiar Reality," 29.

35. Jervey, *The Slave Trade,* 223–25.

36. Wikramanayake, *A World in Shadow,* 73, 80–84; Fitchett, "The Traditions of the Free Negro in Charleston, South Carolina," 144–47; L. F. Wall and S. S. Motte, April 11, 1837, Marriage Settlement, vol. Q-10, pp. 256–57, CCRMC; Fraser, *Reminiscences of Charleston,* 59–61; Pease and Pease, *The Web of Progress,* 140; Margaret L. Coit, *John C. Calhoun: American Portrait* (Boston: Houghton Mifflin Co., 1950), 318; Joseph Walker Barnwell, "Life and Recollections of Joseph Walker Barnwell," transcript, 1929, vol. 1, pp. 364–86, CLS; *Rules and Regulations of the Brown Fellowship Society; Catalogue of the Teachers and Pupils, Avery Normal Institute, Charleston, S.C., with Courses of Study, Names of Graduates, and General Information, June 1906* (Charleston: Walker, Evans, and Cogswell, 1906), 25 [hereafter cited as *Avery Catalogue, 1906*]; Scott, "When Negroes Attended the State University"; Porter, *Led On,* 307, 310; Clarke, "An Experiment in Paternalism," 232–34; Mood, *Methodism in Charleston,* 169, 204–5; Charles E. Thomas, ed., "The Diary of Anna Hasell Thomas (July 1864–May 1865)," *SCHM* 74 (July 1973): 138 n. 8; Payne, *Recollections,* 24–25; *Year Book, 1884, City of Charleston, So. Ca.* (Charleston: News and Courier Book Presses, n.d.), 267. The city yearbooks were published annually. Hereafter they will be cited by title and date alone.

37. Purse, *Charleston City Directory and Strangers' Guide for 1856,* 202, 209, 213, 217; *South Carolina Leader,* Charleston, December 9, 1865.

38. Fitchett, "The Traditions of the Free Negro in Charleston, South Carolina," 145–49; Wikramanayake, *A World in Shadow,* 84, 89; Shearer Davis Bowman, "Antebellum Planters and *Vormarz* Junkers in Comparative Perspective," *AHA* 85 (October 1980): 780–81; Birnie, "Education of the Negro in Charleston, South Carolina, Prior to the Civil War," 13, 20. C. Wainwright Birnie graduated from Avery in 1891. He later obtained an M.D. and practiced medicine in Sumter, S.C. See *Avery Catalogue, 1906,* 30.

39. Birnie, "Education of the Negro in Charleston, South Carolina, Prior to the Civil War," 15, 18; Robert L. Harris, Jr., "Early Black Benevolent Societies, 1780–1830," *Massachusetts Review* 20 (Autumn 1979): 604–5, 609, 617; Wikramanayake, *A World in Shadow,* 123–31; Edward Holloway to Brother, March 16, 1857, Holloway Family Papers.

40. Frederick Cooper, "Elevating the Race: The Social Thought of Black Leaders, 1827–1850," *American Quarterly* 24 (December 1972): 604–25. Julie Winch, *Philadelphia's Black Elite: Activism, Accommodation, and the Struggle for Autonomy, 1787–1848* (Philadelphia: Temple University Press, 1988) documents the antebellum Charleston-Philadelphia connections.

41. *Rules and Regulations of the Brown Fellowship Society;* Wikramanayake, *A World in Shadow*, 81, 84–85; *Constitution and Rules of Humane Brotherhood;* FMS; *Constitution and By-Laws of the Friendly Union Society;* Payne, *Recollections*, 14; Browning, "The Beginning of Insurance Enterprise among Negroes," 417–32; Harris, "Early Black Benevolent Societies, 1780–1830," 603–25.

42. Payne, *Recollections*, 14–15, 17, 34–35; J. G. Bass to E. Holloway, June 29, 1845, Holloway Family Papers.

43. Harris, "Early Black Benevolent Societies, 1780–1830," 612–13, 619; George J. Gongaware, comp., *The History of the German Friendly Society of Charleston, South Carolina, 1766–1916* (Richmond: Garrett and Massie, 1935); *List of the Tax Payers of the City of Charleston for 1859*, 399; Peter H. Wood, *Black Majority: Negroes in Colonial South Carolina from 1670 through the Stono Rebellion* (New York: Alfred A. Knopf, 1974), 181–83; Wikramanayake, *A World in Shadow*, 79, 103, 106, 176–78; *Rules and Regulations of the Brown Fellowship Society;* Thomas R. Waring, "Mount Pleasant Dah at 94 Still Minds Her 'Baby,' Now 81," Charleston *News and Courier–Evening Post*, November 15, 1987, 3E. European Americans probably considered Jehu strictly Biblical (II Kings, 9 and 10); Charleston's free blacks may have perceived it as both Biblical and African in origin.

44. Proceedings of the Clionian Debating Society, March 1, 15, 1848; December 14, 1848; January 1, 1851; CLS [hereafter cited as CDS]. The proceedings date from November 9, 1847 (first meeting), to September 22, 1851. See also tables I and II in Susan M. Bowler and Edmund L. Drago, "Black Intellectual Life in Antebellum Charleston," paper, Organization of American Historians, April 7, 1984.

45. CDS, November 23, 1847; March 1, 15, 22, 1848; May 17, 1848; February 7, 15, 1849; March 7, 28, 1849; April 11, 1849; May 20, 23, 1849; August 15, 1849; October 4, 8, 1849; December 26, 1849; January 1, 1850; March 20, 27, 1850; September 11, 1850; October 14, 1850; November 4, 1850; December 2, 1850; March 10, 1851; April 14, 1851; May 7, 1851. See entire proceedings for list of topics.

46. CDS, December 22, 1847; January 5, 1848; February 16, 23, 1848; January 7, 1849; February 4, 1850; April 10, 17, 1850. David Moltke-Hansen, "Charleston Library Society Microfiche Register," *SCHM* 83 (April 1982): 193; Anne King Gregorie, "The First Decade of the Charleston Library Society," in Robert L. Meriwether, ed., *The Proceedings of the South Carolina Historical Association, 1935* (Columbia: South Carolina Historical Association, 1935), 5–6; J. H. Easterby, *A History of the College of Charleston, Founded 1770* ([Charleston, S.C.]: N.p., 1935), 18.

47. Easterby, *A History of the College of Charleston*, 138; "Autobiography of F. A. Mood," photoduplicate transcript, no. 34-528-29, pp. 15, 32–34, SCHS; Chrestomathic Literary Society, Boxes CCLI, CCLII, CCLXXI, College of Charleston Archives, SCRSSI.. CDS, December 15, 1847; January 12, 19, 1848; October 8, 1848; January 1, 1850. See entire CDS for debate topics.

48. CDS, March 15, 1848; September 18, 1848; July 5, 12, 1849; October 8,

1849; December 26, 1849; April 3, 10, 1850; July 17, 1850; September 18, 1850; October 2, 1850; December 2, 1850; March 10, 1851; July 28, 1851; August 25, 1851. Bowler and Drago, "Black Intellectual Life in Antebellum Charleston," tables I and II. Holloway, *Why I Am a Methodist,* documents some of the Clionians who were Methodists. For background on S. W. Beard, see Edmund L. Drago, *Black Politicians and Reconstruction in Georgia: A Splendid Failure* (Baton Rouge: Louisiana State University Press, 1982), appendix.

49. CDS, May 17, 1848; January 1, 1851.

50. CDS, January 12, 1848; August 15, 1849; April 14, 1851.

51. CDS, December 22, 1847; May 21, 1849; May 29, 1850. Carter G. Woodson, *Mind of the Negro,* 74, as quoted in Wikramanayake, *A World in Shadow,* 181.

52. Pease and Pease, *The Web of Progress,* 111–12; Fields, *Lemon Swamp,* 2; Chrestomathic Literary Society, SCRSSL; CDS, August 11, 1851. Dueling by a member of Charleston's free black elite has yet to be documented.

53. Johnson and Roark, *Black Masters,* 173–94, 236–37, 241; Harris, "Charleston's Free Afro-American Elite," 289–90, 304–10.

54. Starobin, ed., *Denmark Vesey,* 2, 5, 149–51; Johnson and Roark, *Black Masters,* 43; William W. Freehling, *Prelude to Civil War: The Nullification Controversy in South Carolina, 1816–1836* (New York: Harper and Row, Torchbook Edition, 1968), 228–29; Pease and Pease, *The Web of Progress,* 45, 132–33; Mood, *Methodism in Charleston,* 145–50; Clark, ed., *South Carolina,* 154, 164–65.

55. Payne, *Recollections,* 25, 27–41; William J. Simmons, *Men of Mark: Eminent, Progressive, and Rising* (Cleveland: Geo. M. Rewell and Co., 1887; New York: Arno Press, 1968), 1081–2.

56. David J. McCord, ed., *The Statutes at Large of South Carolina,* edited under authority of the legislature, vol. 7, *Containing the Acts Relating to Charleston Courts, Slaves, and Rivers* (Columbia: A. S. Johnston [printer], 1840), 468–70; Peter Guilday, *The Life and Times of John England, First Bishop of Charleston (1768–1842)* (New York: America Press, 1927) 2: 151–56; Freehling, *Prelude to Civil War,* 340–48.

57. State Free Negro Capitation Tax Book, Charleston, 1843, SCDAH; FMS, June 13, 1842; Robert F. Durden, "The Establishment of Calvary Protestant Episcopal Church for Negroes in Charleston," *SCHM* 65 (January 1964): 63–84.

58. Durden, "The Establishment of Calvary Protestant Episcopal Church for Negroes," 63–84.

59. Ford, *Census of the City of Charleston, South Carolina, for the Year 1861,* 9–10; CDS, November 16, 23, 1847; FMS, June 11, 1848; Purse, *Charleston City Directory and Strangers' Guide for 1856,* 205.

60. One day a white couple, schoolteachers, came into my office with a manuscript, "Proceedings of the Friendly Moralist Society," which had passed down through the woman's family. The couple was directed to me by Susan M. Bowler, a colleague at the College of Charleston. Bowler and I decided to prepare the manuscript for publication. Although our efforts never bore fruit, this book, specifically chapter 1, benefited greatly from the project. I wish to acknowledge Bowler's contribution.

For the views of Michael P. Johnson and James L. Roark, see their different interpretations in " 'A Middle Ground': Free Mulattoes and the Friendly Moralist Society of Antebellum Charleston," *Southern Studies* 21 (Fall 1982): 246–65, as well as *Black Masters,* 195–323, and *No Chariot Let Down.*

Harris, "Charleston's Free Afro-American Elite," 298–301, found fourteen members of the Brown Fellowship Society and ten members of the Humane Brotherhood in *List of the Tax Payers of the City of Charleston for 1859*, 383–404. I found in the same source eight members of the nineteen Friendly Moralists who attended the annual meeting on June 12, 1843. They were W. Bentham, C. Holloway, S. Holloway, F. Main, E. Wall, J. Weston, E. Wilkinson, and F. Wilkinson. Thus, I was able to calculate that the average value of real estate per member in each society was as follows: Brown Fellowship, $8,272.85; Friendly Moralist, $2,768.75; and Humane Brotherhood, $1,832.00. Nine members of the Brown Fellowship owned a total of thirty-six slaves; three Friendly Moralists had seven and two in the Humane Brotherhood owned two.

According to Dawson and DeSaussure, *Census of the City of Charleston, South Carolina, for the Year 1848*, 16, there were only 298 "free persons of color" between the ages of fifteen and eighty. Granted Chapman's conclusion in "Inadequacies of the 1848 Charleston Census," 30, that the census excluded one-quarter of the free black population, the total number of free blacks in that age bracket could not have exceeded 373. If three-quarters of these were mulatto, the number eligible for FMS membership was probably around 280.

61. FMS, February 13, 27, 1843; April 10, 1843. Fitchett, "The Free Negro in Charleston, South Carolina," 126 n. 2. The number 280 may be too high since FMS members had to be over the age of fifteen. Before 1846 the proceedings reveal that no member petitioned the society to get money back because he was leaving the state. But between April 13, 1846, and August 2, 1848, at least 5 members did. Main's address on June 13, 1853, mentions the splits of 1841, 1848, and 1853. I am assuming that the FMS membership never surpassed 50 since no more than 40 members ever attended any one meeting. The Brown Fellowship Society, the Humane Brotherhood, and the Friendly Union Society each limited the size of their membership.

62. Lawrence, *The Centenary Souvenir*, viii–ix; Williamson, *After Slavery*, 185. FMS, August 9, 1841; October 11, 1841; June 13, 1853. The proceedings open by mentioning that a former secretary absconded with the minute books.

63. FMS, June 12, 1843; March 11, 1844; April 8, 1844; May 13, 1844; June 10, 1844. Manning, *Black Apollo of Science*, 7.

64. See FMS for dates mentioned in text. The debate on the meaning of *brown* occurred on October 9, 1848. The thirty-seven members attending meetings from June 11 to October 16, 1848 were: E. Wall, P. Thorne, M. Eggart, C. Holloway, S. Holloway, F. Main, J. Barrow, G. Meyers, F. Smith, J. Weston, T. Mishow, J. Mishow, J. W. Hayne, H. J. D. Cardozo, W. Bentham, T. Kirk, J. R. Mayrant, W. C. Moultrie, H. Heyward, F. Wilkinson, P. Wilkinson, E. Wilkinson, L. Cabeuil, R. Gordon, W. Osborne, J. Wilson, A. Ryan, L. Wall, J. Gordon, P. Saltus, E. Richards, G. Glover, A. M. Tardiff, R. Bing, T. Chion, J. Nelson, J. Clark. Of these thirty-seven, seventeen stopped attending after October 16, 1848. I have assumed that they were secessionists: E. Wall, P. Thorne, M. Eggart, J. Barrow, T. Mishow, J. Hayne, H. J. D. Cardozo, W. Bentham, T. Kirk, H. Heyward, L. Cabeuil, J. Wilson, A. Ryan, L. Wall, J. Gordon, G. Glover, A. Tardiff. On April 9, 1849, the proceedings identify five seceders, all of whom are on my list of seventeen: P. M. Thorne, E. P. Wall, W. H. Bentham, T. Mishow, and James L. Wilson.

65. *Constitution and Rules of Humane Brotherhood*, 1, 8. FMS, April 9, 1849; June 12, 1854; August 14, 1854; October 9, 1854; November 13, 1854. Purse, *Charleston City Directory and Strangers' Guide for 1856*, 217. For an account of the struggle and the society's gradual recovery in membership, see FMS, February 8, 1847, through June 10, 1850.

66. The loan dispute is recorded in FMS, June 21, 1847, through August 22, 1848. For background on FMS members mentioned, see works of Johnson and Roark; Purse, *Charleston City Directory and Strangers' Guide for 1856*, 205, 213, 221; *List of the Tax Payers of the City of Charleston for 1859*, 392, 403; Tax Book, Free Persons of Color, Charleston, 1862, CLS; Tax Book, Free Persons of Color, Charleston, 1864, Charleston City Archives. In 1859 Charles Holloway paid taxes on five thousand dollars' worth of real estate, and Edward P. Wall, fifteen hundred dollars'.

67. Of thirty-seven members attending from June 11 to October 16, 1848, I have information on religious affiliation for twenty-three. Of these, eleven were seceders, and twelve remained in the society. Six of the eleven seceders had close ties with St. Philip's Episcopal Church: E. Wall, L. Wall, and J. Gordon were baptized there, and P. Thorne, G. Glover, and A. Tardiff had children baptized in the church. The five others were Methodists: W. Bentham, T. Mishow, J. W. Hayne, Michael Eggart, and Augustus Ryan. The latter two had some Episcopal connections. In 1845 Eggart became the godfather of Edward P. Wall's son, Richard Pell Wall. Ryan and his wife, Hannah, had their daughter Julia baptized at Grace Episcopal Church in 1851.

I have eliminated P. Saltus from the twelve who continued to attend meetings because he stopped attending after November 7, 1848, making him a possible seceder. Of the remaining eleven, seven were Methodists: C. Holloway, S. Holloway, F. Main, E. Richards, T. Chion, J. Clark, and F. Wilkinson. Two of these seven Methodists, Clark and Chion, had children baptized at St. Philip's, and F. Wilkinson became the sponsor for his brother Paul's child, Margaret, in 1845. The other four of the eleven who did not secede probably belonged to St. Philip's; three—G. Meyers, J. Mayrant, and P. Wilkinson—were married there, and J. Nelson had a child baptized at the church.

To determine who were Methodists, see Holloway, *Why I Am a Methodist;* Trinity Methodist Episcopal Church, Book C, Roll of Colored Members, 1821–1868 [Original, Trinity M.E. Church, Charleston], SCHS; Centenary Methodist Episcopal Church Records, 6 vols., Centenary Methodist Episcopal Church, Charleston, S.C. For Episcopal connections, see Baptisms, Marriages, and Burials, 1823–1940, SPEC; Parish Register, Grace Episcopal Church, Charleston, S.C. For background on the Thornes, see John Thorne, Record of Wills, vol. 36, p. 1034, CCPC; John Thorne, Record of Wills, 273/3, CCPC; State Free Negro Capitation Tax Books, Charleston, 1846, 1851, SCDAH. On the Dereefs, see Johnson and Roark, *Black Masters*, 203, 217.

68. Holloway Family Papers; Mood, *Methodism in Charleston*, 187, 189; Payne, *Recollections*, 14–15, 17; Lawrence, *The Centenary Souvenir*, viii–ix; Holloway, *Why I Am a Methodist;* FMS, June 9, 1845; FMS, October 9, 1848; Centenary Methodist Episcopal Church Records, volume recording classes and class leaders, 1857 entries; Williamson, *After Slavery*, 185.

69. Clarke, "An Experiment in Paternalism," 227–30; Holloway, *Why I Am a Methodist;* Johnson and Roark, *Black Masters*, 231.

70. Porter, *Led On,* 196; *List of the Tax Payers of the City of Charleston for 1860,* 330; Baptisms, Marriages, and Burials, 1823–1940, SPEC; Holloway, *Why I Am a Methodist;* Francis Wilkinson, Record of Wills, 158/9, CCPC; Birnie, "Education of the Negro in Charleston, South Carolina, Prior to the Civil War," 21.

71. Lawrence, *The Centenary Souvenir,* viii–xvi; Williamson, *After Slavery,* 185; Bernard Edward Powers, Jr., "Black Charleston: A Social History, 1822–1885" (Ph.D. diss., Northwestern University, 1982), 189–91; W. O. Weston to T. W. Cardozo, June 24, 1865, AMAA (1821–1891); Pease and Pease, *The Web of Progress,* 45, 132–33; Mood, *Methodism in Charleston,* 145–50.

72. Wikramanayake, *A World in Shadow,* 169–70; Koger, *Black Slaveowners,* 18–19; Edward Holloway to Brother, March 16, 1857, Holloway Family Papers.

73. Johnson and Roark, *Black Masters,* 233–95, and Johnson and Roark, eds., *No Chariot Let Down.*

74. See note 73.

75. Payne, *Recollections,* 11–26; Birnie, "Education of the Negro in Charleston, South Carolina, Prior to the Civil War," 13; Wikramanayake, *A World in Shadow,* 102.

76. FMS, June 11, 1848; Juliet Eggart, Record of Wills, vol. 40, p. 138, CCPC; Johnson and Roark, *Black Masters,* 107–9; Wikramanayake, *A World in Shadow,* 73, 106.

77. Payne, *Recollections,* 11–26, 40.

78. Ibid., 15, 19–26, 35–38; George M. Fredrickson, "Self-Made Hero," *New York Review of Books* 32 (June 27, 1985): 3–4; Johnson and Roark, *Black Masters,* 107–9; Wikramanayake, *A World in Shadow,* 73, 106.

79. Payne, *Recollections,* 19–41; Wikramanayake, *A World in Shadow,* 135, 168.

80. "Autobiography of F. A. Mood," 15, 32–33; Holloway, *Why I Am a Methodist;* Birnie, "Education of the Negro in Charleston, South Carolina, Prior to the Civil War," 19; Johnson and Roark, *Black Masters,* 246.

81. Birnie, "Education of the Negro in Charleston, South Carolina, Prior to the Civil War," 15–16, 21; Lawrence, *The Centenary Souvenir,* xv–xvi; "Autobiography of F. A. Mood," 15, 32–33; Scott, "When Negroes Attended the State University"; Simmons, *Men of Mark,* 162–63; Drago, *Black Politicians and Reconstruction in Georgia,* appendix; Payne, *Recollections,* 36. State Free Negro Capitation Tax Book, Charleston, 1860, Carter G. Woodson Collection, Manuscript Division, LC, lists Edward and Simeon Beard as living on Coming Street.

82. Payne, *Recollections,* 14; *Constitution and Rules of Humane Brotherhood,* 7–8. FMS, June 14, 1847; November 8, 1847; February 14, 1848; September 18, 1848; October 12, 1848; December 28, 1848; August 13, 1849; May 19, 1851.

83. W. O. Weston to T. W. Cardozo, June 24, 1865, AMAA. CDS, November 9, 1847; December 1, 1847; February 2, 1848; July 17, 1850. Brock, "Thomas W. Cardozo," 88; Joe M. Richardson, "Francis L. Cardozo: Black Educator during Reconstruction," *Journal of Negro Education* 48 (Winter 1979): 73.

84. Francis Wilkinson, Record of Wills, 158/19, CCPC; Jacob Weston, Record of Wills, vol. 50, pp. 221–24, CCPC; Holt, *Black over White,* 53, 70; John Richard Dennett, *The South As It Is, 1865–1866,* edited and with an introduction by Henry M. Christman (London: Sidgwick and Jackson, 1965), 217; T. W. Cardozo to M. E. Strieby, July 1, 1865, AMAA.

85. Charleston *Mercury,* December 1, 1862; Charleston *Daily Courier,* December 1, 1862.

86. Payne, *Recollections,* 161–63.

CHAPTER 2. RECONSTRUCTION, 1865–1877

1. R. Tomlinson to C. Holloway, invitation, May 5, 1868, Holloway Family Papers; *The Twenty-Second Annual Report of the American Missionary Association, and the Proceedings at the Annual Meeting* (New York: American Missionary Association, 1886), 41. Hereafter, AMA annual reports will be cited as *AMA Annual Report* with the publication date.

2. Brock, "Thomas W. Cardozo," 186 n. 10; William C. Hine, "Frustration, Factionalism, and Failure: Black Political Leadership and the Republican Party in Reconstruction Charleston, 1865–1877" (Ph.D. diss., Kent State University, 1979), 131–33, 137–42, 169, 492–96.

3. Hine, "Frustration, Factionalism, and Failure," 140–42, 152, 163–68, 255–56, 270, 294–302, 323–33, 344–441; Holt, *Black over White,* table 5.

4. New York *Times,* February 22, 1865; New York *Tribune,* March 2, 1865.

5. Augustus Field Beard, *A Crusade of Brotherhood: A History of the American Missionary Association* (Boston: Pilgrim Press, 1909; New York: Krause Reprint Co., 1970), 3–32; W. J. Richardson to Bro. Richards, February 24, 1865, AMAA.

6. *American Missionary,* New York, 11 (January 1867): 10–12; *American Missionary* 11 (March 1867): 58–60; "Reconstruction at the Foundation," *American Missionary* 19 (April 1875); Beard, *A Crusade of Brotherhood,* 146–48; Jones, *Soldiers of Light and Love,* 3, 14–15, 18–30, 109; Clara Merritt De Boer, "The Role of Afro-Americans in the Origin and Work of the American Missionary Association, 1839–1877" (Ph.D. diss., Rutgers University, 1979), 555–63.

7. W. J. Richardson to G. Whipple, February 24, 1865; T. W. Cardozo to W. E. Whiting, April 11, 1865; T. W. Cardozo to [?], September 1, 1865; F. L. Cardozo to E. P. Smith, May 1, 1868; J. B. Corey to E. P. Smith, October 13, 1868; E. M. Pierce to E. P. Smith, November 19, 1868; AMAA. Avery Institute Records, Addendum, Temporary Register, Avery Institute, 1865–1947, Historical Notes, 2–3, AMAA Addendum [hereafter cited as "Historical Notes, Avery Institute, 1865–1947"]; *Catalogue of the Teachers and Pupils of Avery Normal Institute, Charleston, South Carolina, with Courses of Study, General Information, and List of Graduates, June 1899* (Charleston: Daggett Printing Co., 1899), 23 [hereafter cited as *Avery Catalogue, 1899*].

8. Brock, "Thomas W. Cardozo," 183–89; Richardson, "Francis L. Cardozo," 73; Simmons, *Men of Mark,* 430.

9. Luther P. Jackson, "The Educational Efforts of the Freedmen's Bureau and Freedmen's Aid Societies in South Carolina, 1862–1872," *JNH* 8 (January 1923): 18–19; Dennett, *The South As It Is,* 216; R. Tomlinson to R. K. Scott, July 1, 1867, and Report of Schools for the Freedmen in the State of South Carolina for the Month of November 1865, both in Records of the Education Division (M803), RG 105. W. J. Richardson to G. Whipple, March 20, 1865; E. A. Lane to G. Whipple, April 4, 1865; T. W. Cardozo to M. E. Strieby, April 29, 1865; T. W. Cardozo to

S. Hunt, July 1, 1865; AMAA. New York *Times,* April 16, 1865; Charleston *Courier,* July 1, 1865; De Boer, "The Role of Afro-Americans in the Origin and Work of the American Missionary Association," 457.

10. T. W. Cardozo to M. E. Strieby, June 8, 13, 16, 22, 1865; T. W. Cardozo to M. E. Strieby, July 18, 1865; T. W. Cardozo to W. E. Whiting, April 11, 1865; T. W. Cardozo to My Dear Sir, April 29, 1865; H. H. Hunter to W. E. Whiting, May 6, 1865; AMAA. Brock, "Thomas W. Cardozo," 188; *AMA Annual Report (1865),* 23–24; De Boer, "The Role of Afro-Americans in the Origin and Work of the American Missionary Association," 458, 463–64.

11. "Historical Notes, Avery Institute, 1865–1947," 2. H. H. Hunter to W. E. Whiting, May 6, 1865; H. H. Hunter to M. E. Strieby, May 16, 1865; R. Tomlinson to G. Whipple, June 14, 1865; T. W. Cardozo to S. Hunt, June 23, 1865; AMAA. Jackson, "The Educational Efforts of the Freedmen's Bureau and Freedmen's Aid Societies in South Carolina," 19; *National Freedman,* New York, 6 (June 1, 1865): 151; De Boer, "The Role of Afro-Americans in the Origin and Work of the American Missionary Association," 458.

12. T. W. Cardozo to M. E. Strieby, April 29, 1865; T. W. Cardozo to W. E. Whiting, May 10, 1865; H. H. Hunter to M. E. Strieby, May 6, 16, 1865; AMAA. *American Missionary* 9 (July 1865): 154; De Boer, "The Role of Afro-Americans in the Origin and Work of the American Missionary Association," 457.

13. Jackson, "The Educational Efforts of the Freedmen's Bureau and Freedmen's Aid Societies in South Carolina," 13, 18. R. Tomlinson to G. Whipple, June 14, 1865; T. W. Cardozo to S. Hunt, June 23, 1865; AMAA. Holt, *Black over White,* 87.

14. H. H. Hunter to M. E. Strieby, May 6, 1865; T. W. Cardozo to W. E. Whiting, May 10, 1865; R. Tomlinson to G. Whipple, June 14, 1865; AMAA. Jackson, "The Educational Efforts of the Freedmen's Bureau and Freedmen's Aid Societies in South Carolina," 19; *American Missionary* 9 (July 1865): 153–54; *AMA Annual Report (1867),* 32; De Boer, "The Role of Afro-Americans in the Origin and Work of the American Missionary Association," 457.

15. R. Tomlinson to G. Whipple, June 14, 1865; T. W. Cardozo to Friends in the Rooms, August 17, 1865; F. L. Cardozo to G. Whipple and M. E. Strieby, August 18, 1865; AMAA. Brock, "Thomas W. Cardozo," 189, 197.

16. F. L. Cardozo to S. Hunt, December 2, 1865; F. L. Cardozo to M. E. Strieby, August 13, 1866; F. L. Cardozo to M. E. Strieby, September 12, 1866; AMAA. *American Missionary* 11 (January 1867): 10–12; *American Missionary* 11 (March 1867): 58.

17. "Historical Notes, Avery Institute, 1865–1947," 2. C. Atkins to S. Hunt, October 24, 1865; F. L. Cardozo to S. Hunt, November 7, 1865; F. L. Cardozo to S. Hunt, December 30, 1865; F. L. Cardozo to G. Whipple and M. E. Strieby, December 2, 1865; AMAA.

18. Jacob Frederick Schirmer diary, June 19, 1866, Jacob Frederick Schirmer, Diaries, ca. 1826–1886, 7 MS vols., no. 34-55-61, SCHS; Board of Trustees—Minutes, "Journal of the Proceedings of the Board of Trustees of the College of Charleston—commencing on the 8th of November 1865 (first meeting after the war) to 5th December 1887," 30, College of Charleston Archives, SCRSSL; Williamson, *After Slavery,* 232.

19. F. L. Cardozo to G. Whipple, October 21, 1865; F. L. Cardozo to G. Whipple,

January 27, 1866; F. L. Cardozo to S. Hunt, August 3, 1866; F. L. Cardozo to M. E. Strieby, August 13, 1866; AMAA.

20. F. L. Cardozo to M. E. Strieby, August 13, 1866; F. L. Cardozo to G. Whipple and M. E. Strieby, October 3, 1866; AMAA.

21. F. L. Cardozo to M. Holmes, June 21, 1902, reprinted in *Avery Tiger*, Charleston, December 1939; *Catalogue, Avery Normal Institute, Charleston, S.C., with Announcements for 1910–1911: May 1910* (Charleston: Avery Press, 1910), 7 [hereafter cited as *Avery Catalogue, 1910*].

22. F. L. Cardozo to S. Hunt, March 10, 1866; F. L. Cardozo to E. P. Smith, October 25, 1866; AMAA. *AMA Annual Report (1867)*, 32–33.

23. *AMA Annual Report (1866)*, 27–28; *AMA Annual Report (1867)*, 32–33; *American Missionary* 10 (April 1866): 79. F. L. Cardozo to S. Hunt, March 10, 1866; F. L. Cardozo to E. P. Smith, October 25, 1866; AMAA. Porter, *Led On*, 106, 112–13.

24. "Historical Notes, Avery Institute, 1865–1947," 2. F. L. Cardozo to E. P. Smith, December 8, 1866; F. L. Cardozo to E. P. Smith, April 24, 1867; C. T. Chase to E. P. Smith, April 15, 1867; AMAA. Vol. B-15, p. 419, CCRMC; *Directory of the City of Charleston, to Which Is Added a Business Directory, 1860* (Charleston: W. E. Ferslew, 1860), 12; F. L. Cardozo to M. Holmes, June 21, 1902, in *Avery Tiger*, December 1939.

25. F. L. Cardozo to S. Hunt, November 7, 1865; F. L. Cardozo to E. P. Smith, February 23, 1867; F. L. Cardozo to E. P. Smith, May 28, 1867; AMAA. *American Missionary* 12 (July 1868): 148; Charleston *Daily Courier*, May 6, 1868; *AMA Annual Report (1868)*, 41. According to *Avery Catalogue, 1910*, 7, the building was erected at a cost of twenty-five thousand dollars, which may have included the purchase of the lot.

26. "Historical Notes, Avery Institute, 1865–1947," 2. F. L. Cardozo to S. Hunt, November 7, 1865; M. E. Strieby, August 13, 1866; AMAA. Report of Schools for Freedmen in the State of South Carolina for the Month of November 1865, Records of the Education Division (M803), RG 105; *American Missionary* 10 (December 1866): 270–71; *AMA Annual Report (1867)*, 33; Simmons, *Men of Mark*, 429–30; Richardson, "Francis L. Cardozo," 81–83; De Boer, "The Role of Afro-Americans in the Origin and Work of the American Missionary Association," 478; *Avery Catalogue, 1899*, 22; *Avery Catalogue, 1906*, 22.

27. C. Atkins to S. Hunt, October 24, 1865; P. A. Alcott to S. Hunt, November 7, 1865; E. J. Adams to G. Whipple, November 18, 1865; F. L. Cardozo to G. Whipple and M. E. Strieby, December 2, 1865; F. L. Cardozo to E. P. Smith, November 4, 1867; E. L. Boring to E. P. Smith, January 13, 1868; J. B. Corey to E. P. Smith, October 29, 1868; M. A. Warren to E. P. Smith, October 18, 1869; and flyer *Avery Institute, Fourth Anniversary, March 1873;* all in AMAA. *American Missionary* 10 (August 1866): 175–76; *American Missionary* 11 (September 1867): 208; *American Missionary* 14 (February 1870): 26.

28. Williamson, *After Slavery*, 224, 227; E. L. Deane to O. O. Howard, n.d. [ca. 1870], Records of the Education Division (M803), RG105; *AMA Annual Report (1870)*, 2.

29. *Avery Catalogue, 1906*, 24; "Historical Notes, Avery Institute, 1865–1947," 3; *American Missionary* 17 (October 1873): 219–20; *AMA Annual Report (1878)*, 68; *Sholes' Directory of the City of Charleston, November 15, 1878* (Charleston: A. E. Sholes,

n.d.), 34; *Year Book, 1880, City of Charleston, So. Ca.*, 122–24; Charleston *News and Courier*, April 27, 1905; Jackson, "The Educational Efforts of the Freedmen's Bureau and Freedmen's Aid Societies in South Carolina," 19–20.

30. Scott, "When Negroes Attended the State University"; *American Missionary* 17 (October 1873): 219–20; De Boer, "The Role of Afro-Americans in the Origin and Work of the American Missionary Association," 474, 480; Simmons, *Men of Mark*, 1052–3; Louis R. Harlan, ed., *The Booker T. Washington Papers* (Urbana: University of Illinois Press, 1972–1975), 4: 297 n. 1; *Avery Catalogue, 1906*, 25–26.

31. Scott, "When Negroes Attended the State University"; Pamela Mercedes White, "'Free and Open': The Radical University of South Carolina, 1873–1877" (Master's thesis, University of South Carolina, 1975), 43.

32. Scott, "When Negroes Attended the State University"; J. K. Jillson to J. T. Ford, October 25, 1873, Letter Copy Book no. 13 (July 25, 1873, to November 7, 1873), 386, State Superintendent of Education Correspondence, SCDAH.

33. Scott, "When Negroes Attended the State University"; White, "'Free and Open'"; *American Missionary Association Catalogue of Avery Normal Institute, 35 Bull Street, Charleston, S.C., 1883–1884* (Charleston: Walker, Evans, and Cogswell [printer], 1884), 11–12 [hereafter cited as *Avery Catalogue, 1884*]; Simmons, *Men of Mark*, 162–63; A. B. Caldwell, ed., *History of the American Negro, South Carolina Edition* (Atlanta: A. B. Caldwell, 1919), 729; Purse, *Charleston City Directory and Strangers' Guide for 1856*, 215.

34. Scott, "When Negroes Attended the State University"; Caldwell, ed., *History of the American Negro, South Carolina Edition*, 729–34; "Education: South Carolina Fights Illiteracy," special South Carolina edition, *National Negro Digest* (ca. 1940), 52–54 [hereafter cited as "South Carolina Fights Illiteracy"].

35. See note 34.

36. Caldwell, ed., *History of the American Negro, South Carolina Edition*, 210–12; Purse, *Charleston City Directory and Strangers' Guide for 1856*, 204; Ethel Evangeline Martin Bolden, "Susan Dart Butler—Pioneer Librarian" (M.S. thesis, Atlanta University, 1959); Burchill Richardson Moore, "A History of the Negro Public Schools of Charleston, South Carolina, 1867–1942" (Master's thesis, School of Education, University of South Carolina, 1942), 23–32; Frank Lincoln Mather, ed., *Who's Who of the Colored Race: A General Biographical Dictionary of Men and Women of African Descent* (Chicago: N.p., 1915), 1: 85–86; *Fourth Annual Circular and Prospectus of the Charleston Normal and Industrial Institute*, ca. 1898, and J. L. Dart to A. H. Grimke, January 10, 1899, both in Charleston Industrial Institute [folder], Archibald H. Grimke Papers, Moorland-Spingarn Research Center, Howard University, Washington, D.C.

37. *Fourth Annual Circular and Prospectus of the Charleston Normal and Industrial Institute*, and J. L. Dart to A. H. Grimke, January 10, 1899, Charleston Industrial Institute [folder], Archibald H. Grimke Papers; Harlan, ed., *The Booker T. Washington Papers*, 2: 255; Harlan, ed., *The Booker T. Washington Papers*, 4: 295–98, 468–69; Louis R. Harlan and Raymond W. Smock, eds., *The Booker T. Washington Papers*, (Urbana: University of Illinois Press, 1976–1977), 6: 147–48, 250–51; Whitefield McKinlay Papers, Carter G. Woodson Collection, Manuscript Division, LC.

38. New York *Times*, July 3, 1874; Charleston *Daily News* as quoted in *American Missionary* 10 (August 1866): 175–76.

39. De Boer, "The Role of Afro-Americans in the Origin and Work of the Ameri-

can Missionary Association," 466. P. A. Alcott to S. Hunt, November 29, 1865; F. L. Cardozo to G. Whipple, January 27, 1866; AMAA.

40. *AMA Annual Report (1868)*, 42; item on Plymouth Church, *American Missionary* 12 (January 1868); *American Missionary* 14 (August 1870): 183–85; *American Missionary* 15 (May 1871): 112–13; *American Missionary* 16 (May 1872): 106; *American Missionary* 51 (June 1897): 182–83. E. W. Merritt to E. P. Smith, March 17, 1867; J. T. Ford to E. P. Smith, December 21, 1869; J. T. Ford to E. M. Cravath, June 25, 1872; AMAA. Holt, *Black over White*, 85, 87, 158.

41. A. W. Farnham to M. E. Strieby, June 20, 1877; A. W. Farnham to M. E. Strieby, July 11, 1877; AMAA.

42. C. C. Scott to M. E. Strieby, August 10, 1878; A. W. Farnham to M. E. Strieby, August 19, 1878; AMAA. According to Maude T. Jenkins, Lawrence's son was named Farnham. For citations on Lawrence, see chapter 3.

43. T. W. Cardozo to S. Hunt, June 23, 1865; T. W. Cardozo to M. E. Strieby, July 18, 1865; F. L. Cardozo to S. Hunt, October 10, 1865; F. L. Cardozo to S. Hunt, December 2, 1865; S. Stansbury to S. Hunt, November 29, 1866; F. L. Cardozo to E. P. Smith, May 28, 1867; H. C. Foote to E. M. Cravath, January 19, 1874; AMAA. *American Missionary* 9 (August 1865): 175; *AMA Annual Report (1866)*, 28.

44. P. A. Alcott to G. Whipple, December 28, 1865; M. A. Warren to E. M. Cravath, May 3, 1873; AMAA. *American Missionary* 10 (August 1866): 175–76.

45. R. Tomlinson to G. Whipple, June 14, 1865; F. L. Cardozo to S. Hunt, December 2, 1865; F. L. Cardozo to G. Whipple, January 27, 1866; P. A. Alcott to S. Hunt, March 27, 1866; AMAA. *American Missionary* 10 (August 1866): 175–76.

46. A. D. Munro to G. Whipple, April 15, 1869; M. A. Warren to E. P. Smith, November 27, 1869; M. A. Warren to E. P. Smith, March 29/April 1, 1870; AMAA. *A Brief History of Laing School, Mt. Pleasant, S.C., Covering Sixty Years of Service, 1866–1926* . . . in Laing School Folder, Miscellaneous Papers, ARC.

47. Jones, *Soldiers of Light and Love*, 34; De Boer, "The Role of Afro-Americans in the Origin and Work of the American Missionary Association," 463–64; *American Missionary* 10 (August 1866): 175–76; *AMA Annual Report (1878)*, 67.

48. Jones, *Soldiers of Light and Love*, 38; Holt, *Black over White*, 86 n. 52; T. W. Cardozo to M. E. Strieby, June 16, 1865; F. L. Cardozo to S. Hunt, October 10, 1865; AMAA. De Boer, "The Role of Afro-Americans in the Origin and Work of the American Missionary Association," 458, 463.

49. Holt, *Black over White*, 46, 70; De Boer, "The Role of Afro-Americans in the Origin and Work of the American Missionary Association," 463–64, 472. T. W. Cardozo to M. E. Strieby, June 16, 1865; F. Rollins to [?], June 22, 1865; F. L. Cardozo to G. Whipple and M. E. Strieby, December 2, 1865; AMAA.

50. F. L. Cardozo to M. E. Strieby, June 13, 1866; F. L. Cardozo to M. E. Strieby, August 13, 1866, AMAA. R. Tomlinson to R. K. Scott, July 1, 1867, Records of the Education Division (M803), RG 105; *AMA Annual Report (1866)*, 27; *AMA Annual Report (1869)*, 26; *AMA Annual Report (1878)*, 67; Dennett, *The South As It Is*, 217–18.

51. *Avery Institute, Fourth Anniversary, March 1873*, and flyer *Courses of Six Lecturers for the Benefit of Their Fair*, ca. 1865, AMAA.

52. W. O. Weston to T. W. Cardozo, June 24, 1865, AMAA.

53. *American Missionary* 11 (April 1867): 74. J. A. Van Allen to S. Hunt, October 31, 1866; J. A. Van Allen to E. P. Smith, February 16, 1867; F. L. Cardozo to E. P. Smith, April 9, 1867; AMAA.

54. S. Stansbury to S. Hunt, November 29, 1866; F. L. Cardozo to E. P. Smith, December 24, 1866; F. L. Cardozo to E. P. Smith, January 10, 1867; F. L. Cardozo to E. P. Smith, May 28, 1867; S. Stansbury to E. P. Smith, January 10, 1867; S. Stansbury to E. P. Smith, January 30, 1867; AMAA. De Boer, "The Role of Afro-Americans in the Origin and Work of the American Missionary Association," 467.

55. Porter, *Led On*, 196–98, 280–85.

56. Hine, "Frustration, Factionalism, and Failure," 164, 266, 270, 492.

57. Ibid., 274–75.

58. Ibid., 326–27, 333–34, 495; Porter, *Led On*, 296; Charleston *News and Courier*, March 8, 1875.

59. Porter, *Led On*, 296; Hine, "Frustration, Factionalism, and Failure," 441.

60. Jervey, *The Slave Trade*, 224; Ballard, *One More Day's Journey*, 96; Holt, *Black over White*, 46, 54, table 5; W. O. Weston to T. W. Cardozo, June 24, 1865, AMAA; Hine, "Frustration, Factionalism, and Failure," 349, 496.

61. Council Journal, Proceedings, June 2, 1868, Charleston City Archives; Hine, "Frustration, Factionalism, and Failure," 131, 349.

62. Charleston *News and Courier*, as quoted in Fitchett, "The Free Negro in Charleston, South Carolina," 248–49; Hine, "Frustration, Factionalism, and Failure," 204–5; William C. Hine, "The 1867 Charleston Streetcar Sit-Ins: A Case of Successful Black Protest," *SCHM* 77 (April 1976): 111–12. "Manhood Not Scholarship Is the First Aim of Education" was the motto adopted by the Avery student newspaper. See *Avery News*, Charleston, October 1931, and *Avery Tiger*, November 1939.

63. Berlin, *Slaves without Masters*, 388.

64. *AMA Annual Report (1867)*, 33; *AMA Annual Report (1869)*, 26. M. A. Warren to E. P. Smith, May 21, 1869; M. A. Warren to E. P. Smith, March 29/April 1, 1870; AMAA. *American Missionary* 10 (August 1866): 175–76; Charleston *Daily Courier*, April 19, 1867.

65. R. Tomlinson to R. K. Scott, July 1, 1867, Records of the Education Division (M803), RG 105; M. A. Warren to E. P. Smith, March 29/April 1, 1870, AMAA.

66. T. W. Cardozo to S. Hunt, June 23, 1865, AMAA; Dennett, *The South As It Is*, 218; Charleston *Courier*, July 1, 1865.

67. The Shaw episode is documented in J. T. Ford to E. M. Cravath, April 17, 1875; J. W. Shaw to E. M. Cravath, April 19, 1875; M. Shaw to E. M. Cravath, May 25, 1875; J. T. Ford to M. E. Strieby, July 16, 1875; A. W. Farnham to M. E. Strieby, November 1, 1875; AMAA. See also *AMA Annual Report (1874)*, 42; *AMA Annual Report (1875)*, 47; *American Missionary* 14 (February 1870): 26.

68. *Avery Institute, Fourth Anniversary, March 1873*, and A. W. Farnham to M. E. Strieby, February 10, 1877, AMAA. *AMA Annual Report (1878)*, 67.

69. F. L. Cardozo to S. Hunt, December 2, 1865, AMAA.

70. *Yearbook, 1880, City of Charleston, So. Ca.*, 125; *AMA Annual Report (1869)*, 26. S. Stansbury to E. P. Smith, January 30, 1867; M. A. Warren to E. M. Cravath, September 30, 1870, with newspaper clipping attached; M. A. Warren to E. M. Cravath, December 16, 1871; A. W. Farnham to M. E. Strieby, April 10, 1876; A. W. Farnham to M. E. Strieby, January 23, 1877; AMAA.

71. M. A. Warren to E. M. Cravath, October 11, 1870; M. A. Warren to E. M. Cravath, August 27, 1872; M. A. Warren to C. M. Cravath, May 11, 1873; M. A.

Warren to E. M. Cravath, December 6, 1873; A. W. Farnham to M. E. Strieby, January 27, 1877; AMAA. New York *Times*, July 3, 1874; George Brown Tindall, *South Carolina Negroes, 1877–1900* (Columbia: University of South Carolina Press, 1952), 218; Moore, "A History of the Negro Public Schools of Charleston, South Carolina, 1867–1942," 8–9.

72. Moore, "A History of the Negro Public Schools of Charleston, South Carolina, 1867–1942," 5–9.

73. E. L. Deane to O. O. Howard, January 20, 1870, Records of the Education Division (M803), RG 105; Charleston *News and Courier*, June 12, 1948; New York *Times*, July 3, 1874; M. A. Warren to E. M. Cravath, August 27, 1872, AMAA; *Year Book, 1890, City of Charleston, So. Ca.*, 122–23; Moore, "A History of the Negro Public Schools of Charleston, South Carolina, 1867–1942," 5–9, 13.

74. *Year Book, 1880, City of Charleston, So. Ca.*, 122-24; Charleston *News and Courier*, April 27, 1905; R. Tomlinson to R. K. Scott, July 1, 1868, Records of the Education Division (M803), RG 105; Jackson, "The Educational Efforts of the Freedmen's Bureau and Freedmen's Aid Societies in South Carolina," 19–20.

75. *Year Book, 1880, City of Charleston, So. Ca.*, 122–24. Charleston *News and Courier*, April 27, 1905; March 14, 1925; December 26, 1972. *Sholes' Directory of the City of Charleston, November 15, 1878*, 32–34; Record of Certificates Issued by the City Board of Examiners, Charleston, So. Ca., from May 10, 1875 to [1895], p. 2, OAR, CCSD; *Avery Catalogue, 1906*, 25. Shaw teachers who graduated from Avery were Sallie O. Cruikshank (1874), Martha C. Gadsen (1873), and Susan A. Schmidt (1874).

76. *Year Book, 1880, City of Charleston, So. Ca.*, 126–27; *Year Book, 1883, City of Charleston, So. Ca.*, 205; *Year Book, 1884, City of Charleston, So. Ca.*, 189–90. M. A. Warren to E. M. Cravath, August 27, 1872; A. W. Farnham to M. E. Strieby, May 2, 1876; AMAA.

77. Porter, *Led On*, 198–99, 209–11, 224–25, 366, 437–38.

78. Ibid., 209–11, 222–23, 225; Moore, "A History of the Negro Public Schools of Charleston, South Carolina, 1867–1942," 14–15; vol. N-15, pp. 370–72, CCRMC.

79. Porter, *Led On*, 199–200, 223–25, 307–8, 332–36; Moore, "A History of the Negro Public Schools of Charleston, South Carolina, 1867–1942," 15–16; *Year Book, 1898, City of Charleston, So. Ca.*, 266; Williamson, *After Slavery*, 214–15; Charles Emerson, comp., *Hooper's Directory, Trade Index, and Shippers' Guide for Charleston, S.C., 1874–1875, Containing a Complete Street Directory, Names of the Inhabitants* (N.p.: George W. Hooper and Co., n.d.), 32; E. L. Deane to O. O. Howard, January 20, 1870, Records of the Education Division (M803), and K. B. Savage to E. L. Deane, June 30, 1870, with Franklin High School leaflet attached, Superintendent of Education, Unregistered Letters, June 1865–Oct. 1870, Letters Received, no. 2961, both in RG 105.

80. M. A. Warren to E. P. Smith, October 18, 1869; M. A. Warren to E. M. Cravath, December 6, 1873; AMAA. *American Missionary* 14 (February 1870): 26.

81. McPherson, *The Abolitionist Legacy*, 173. J. P. Richardson to [?], January 24, 1872; M. A. Warren to E. M. Cravath, September 17, 1872; AMAA. Beard, *A Crusade of Brotherhood*, 148; *American Missionary* 11 (March 1867): 58–60.

82. F. L. Cardozo to E. P. Smith, May 1, 1868; F. L. Cardozo to E. P. Smith, May 26, 1868; E. M. Pierce to E. P. Smith, May 25, 1868; A. D. Munro to E. P. Smith, January 22, 1869; W. W. Hicks to E. P. Smith, September 13, 1869; AMAA.

83. C. Atkins to E. P. Smith, October 27, 1868; J. B. Corey to W. E. Whiting, October 27, 1868; J. B. Corey to E. P. Smith, October 22, 1868; J. B. Corey to E. P. Smith, November 3, 1868; G. Pease to E. P. Smith, November 4, 1868; G. Pease to E. P. Smith, November 10, 1868; G. Pease to E. P. Smith, November 12, 1868; Mrs. Byrd [et al.] to E. P. Smith, November 14, 1868; E. M. Pierce to E. P. Smith, November 4, 1868; E. M. Pierce to E. P. Smith, November 19, 1868; E. M. Pierce to E. P. Smith, November 21, 1868; E. M. Pierce to E. P. Smith, January 7, 1869; A. D. Munro to E. P. Smith, January 22, 1869; AMAA. J. B. Corey to H. Neide, December 17, 1868, Superintendent of Education, Registered Letters Received, Feb. 1868–Jan. 1869, no. 2960, RG 105.

84. E. M. Pierce to E. P. Smith, May 20, 1869; E. M. Pierce to E. P. Smith, July 30, 1869; M. A. Warren to E. P. Smith, June 8, 1869; E. M. Pierce to E. A. Ware, September 2, 1869; M. A. Warren to E. M. Cravath, August 24, 1872; AMAA. Morris, *Reading, 'Riting, and Reconstruction,* 70.

85. M. A. Warren to E. M. Cravath, October 11, 1870; M. A. Warren to E. M. Cravath, October 22, 1870; M. A. Warren to E. M. Cravath, May 3, 1873; M. A. Warren to E. M. Cravath, May 11, 1873; M. A. Warren to E. M. Cravath, December 23, 1873; J. T. Ford to E. M. Cravath, April 4, 1873; J. T. Ford to E. M. Cravath, April 29, 1873; J. T. Ford to E. M. Cravath, January 3, 1874; J. T. Ford to M. E. Strieby, July 16, 1875; AMAA.

86. A. W. Farnham to M. E. Strieby, April 20, 1876; A. W. Farnham to M. E. Strieby, June 20, 1877; A. W. Farnham to M. E. Strieby, July 11, 1877; A. W. Farnham to M. E. Strieby, July 20, 1877; S. Hardy to Emerson, May 16, 1876; S. Hardy to Emerson, April 26, 1877; W. G. Marts to M. E. Strieby, June 7, 1877; W. G. Marts to M. E. Strieby, June 18, 1877; W. G. Marts to M. E. Strieby, July [7?], 1877; AMAA. *AMA Annual Report (1876),* 68.

87. M. A. Warren to [?], December 12, 1876; A. W. Farnham to M. E. Strieby, January 23, 1877; AMAA.

CHAPTER 3. THE GILDED AGE, 1878–1915

1. *Avery Catalogue, 1910,* 8, 14–21; *Avery Catalogue, 1906,* 12–17; *Avery Catalogue, 1884,* 14–19; *AMA Annual Reports (1878–1915);* City Board of School Commissioners Minute Books, 1913–1957, January 1913–June 1919, p. 353 (January 5, 1916), OAR, CCSD; American Missionary Association Minutes, Executive Committee Book, Beginning March 1900, p. 8 (May 8, 1900), AMAA Addendum; *Circular of Information of Avery Normal Institute, 35 Bull Street, Charleston, S.C., Eighteenth Year— 1882–1883* (Atlanta: Jas. B. Harrison and Co. [printer], 1882), 5–7 [hereafter cited as *Avery Catalogue, 1883*].

2. *Avery Catalogue, 1883,* 4–7; *Avery Catalogue, 1884,* 19; *Avery Catalogue, 1910,* 8, 15–16; *Year Book, 1882, City of Charleston, So. Ca.,* 268–69.

3. McPherson, *The Abolitionist Legacy,* 210–12; F. L. Cardozo to E. P. Smith, May 28, 1867, AMAA; Jones, *Soldiers of Light and Love,* 113–16; Will S. Monroe, *History of the Pestalozzian Movement in the United States* (Syracuse: G. W. Bardeen, 1907; New York: Arno Press, 1969), 1–4, 16–17, 61–126, 135–36, 169–85; Johann Heinrich Pestalozzi, *The Education of Man: Aphorisms* (Philosophical Library, 1951; New York: Greenwood Press, 1969), vii–xii.

4. Morris, *Reading, 'Riting, and Reconstruction*, 70; Richard Edwards and Mortimer A. Warren, *The Analytical Speller, Containing Lists of the Most Useful Words in the English Language, Progressively Arranged, and Grouped According to Their Meaning, with Abbreviations, Rules for Capitals, etc.* (Chicago: Geo. Sherwood and Co., 1871), 1–3, 23, 26; Scott, "When Negroes Attended the State University"; Mortimer A. Warren, *The Graded Class-Word Speller, Containing Several Thousand Words, Grouped in Classes, and Arranged to Form a Progressive Course in Spelling, Together with a Complete Course in Phonic Analysis, Designed, Also, as an Introduction to the Dictionary and an Aid in the Practice of English Composition* (New York: Taintor Brothers and Co., 1876), 1–48.

5. M. A. Warren to My dear Sir, May 15, 1886, Letters Received, 1869-1886, State Superintendent of Education Correspondence, SCDAH; Monroe, *History of the Pestalozzian Movement*, original cover page, and 4; *Year Book, 1883, City of Charleston, So. Ca.*, 205–8; Robert J. Fridlington, "Emily Huntington," in Edward T. James, ed., *Notable American Women, 1607–1950: A Biographical Dictionary* (Cambridge, Mass.: Belknap Press of Harvard University Press, 1971) 2:239–40; *Avery Catalogue, 1906*, 29; Naming Columbus Street School, Naming East Bay School, Box 863, OAR, CCSD.

6. *Avery Normal Institute Commencement, June the Twentieth and Twenty-First, MDCCCXCIX [1899]* [hereafter cited as *Avery Commencement Program, 1899*]; Emerson E. White, *The Art of Teaching: A Manual for Teachers, Superintendents, Teachers' Reading Circles, Normal Schools, Training Classes, and Other Persons Interested in the Right Training of the Young* (New York: American Book Co., 1901), 17, 65; Reuben Post Halleck, *Psychology and Psychic Culture* (New York: American Book Co., 1895); Albert Lynd, "Who Wants Progressive Education? The Influence of John Dewey on the Public Schools," in Reginald D. Archambault, ed., *Dewey on Education Appraisals* (New York: Random House, 1966), 191–208; Pestalozzi, *The Education of Man*, xii; McPherson, *The Abolitionist Legacy*, 210–12; Israel Scheffler, "Educational Liberalism and Dewey's Philosophy," in Archambault, ed., *Dewey on Education Appraisals*, 101–3. *Avery Catalogue, 1906*, 17, lists the "Text Books." James's quotation is used in an advertisement on the back of White, *The Art of Teaching*.

7. Monroe, *History of the Pestalozzian Movement*, 77–83, 91–92; Payne, *Recollections*, 19–26; "Officers and Members of the Avery Alumni Ass'n. . . ," ca. 1915, Shrewsbury Papers, ARC.

8. *Avery Catalogue, 1899*, 14–18, 20; *Avery Catalogue, 1906*, 14–17; *Avery Catalogue, 1910*, 15–16.

9. Fridlington, "Emily Huntington," 239–40; McPherson, *The Abolitionist Legacy*, 210–12; American Missionary Association Minutes, Executive Committee Book, Beginning March 1900, p. 8 (May 8, 1900), AMAA Addendum; *Avery Catalogue, 1883*, 4; *Avery Catalogue, 1906*, 19; *Avery Catalogue, 1910*, 8–9, 14–16; *Year Book, 1883, City of Charleston, So. Ca.*, 206.

10. *American Missionary* 36 (July 1882): 205–6; *American Missionary* 39 (December 1885): 359–61; *American Missionary* 59 (February 1905): 34–35; Beard, *A Crusade of Brotherhood*, 219–20.

11. Beard, *A Crusade of Brotherhood*, chapters 2–4, 15; H. Paul Douglass, *Christian Reconstruction in the South* (Boston: Pilgrim Press, 1909), 18–19, 28, 32; *American Missionary* 59 (February 1905): 34–35.

12. Amos W. Farnham, North Hannibal, N.Y., 1875–1879; Samuel D. Gaylord,

Grundy Centre, Iowa, 1879–1880; William L. Gordon, Jefferson, Wisc., 1880–1882; Amos W. Farnham, North Hannibal, N.Y., 1882–1883; John A. Nichols, Merrimac, Mass., 1883–1884; William M. Bristoll, Minneapolis, Minn., 1884–1886; Morrison A. Holmes, M.A., Lee, Mass., 1886–Feb. 1907; Edward A. Lawrence, Charleston, S.C., 1907; Elbert M. Stevens, M.A., Rapid City, S.D., 1907–1910; T. Newton Owens, M.A., Bristol, R.I., 1910–1912; Frank B. Stevens, Iowa, 1912–1914. For background on the principals, see *AMA Annual Reports (1876–1915); Avery Catalogue, 1899,* 23; Clark, *Echo in My Soul,* 24; *American Missionary* 61 (October 1907): 237; *Year Book, 1883, City of Charleston, So. Ca.,* 205; Charleston *News and Courier,* September 9, 1884. For an account of the earthquake and damages to Avery, see *American Missionary* 40 (October 1886): 274–75; *American Missionary* 41 (January 1887): 3; *American Missionary* 41 (March 1887): 76.

13. *Avery Catalogue, 1906,* faculty page, 13, 15, 19, 25–26; *Avery Catalogue, 1910,* 5.

14. *American Missionary* 45 (May 1891): 181–83; *American Missionary* 54 (April, May, June 1900): 61–67; *American Missionary* 63 (July 1909): 435; *AMA Annual Report (1891),* 55.

15. *American Missionary* 54 (April, May, June 1900): 64; *American Missionary* 59 (April 1905): 119–21; *American Missionary* 63 (July 1909): 435–37.

16. *Avery Echo,* Charleston, June 1888; *The Pinnacle: A Book of the Class of 1916* ([Charleston]: R. Leonard Wainwright, n.d.); Clark, *Echo in My Soul,* 24; *American Missionary* 44 (November 1890): 330; *American Missionary* 54 (April, May, June 1900): 64; *Avery Catalogue, 1883,* 9; *Avery Catalogue, 1884,* 24; *Avery Catalogue, 1899,* 21; *Avery Catalogue, 1906,* 21; *Avery Catalogue, 1910,* 10–11.

17. *American Missionary* 47 (September 1893): 277–78; *American Missionary* 59 (April 1905): 121–22; Joseph J. Boris, ed., *Who's Who in Colored America: A Biographical Dictionary of Notable Living Persons of African Descent in America,* 2d ed. (New York: Who's Who in Colored America Corp., [1928–1929]), 303.

18. *Avery Catalogue, 1910,* 13; *American Missionary* 69 (June 1915): 149–50.

19. *AMA Annual Report (1876),* 68; *Avery Catalogue, 1883,* 11; *Avery Catalogue, 1884,* 20; *Avery Catalogue, 1899,* 20; *Avery Catalogue, 1906,* 13, 20; *Avery Catalogue, 1910,* 12; *High School of Charleston: Proceedings upon the Occasion of Opening of the School House, Corner Meeting and George Streets, January 3, 1881, Scholarships, Prospectus, etc.* (Charleston: Published by order of the City Council of Charleston, News and Courier Book Presses [printer], n.d.), 39; Easterby, *A History of the College of Charleston,* 96–98, 235–39; Clark, *Echo in My Soul,* 17.

20. Charleston *News and Courier,* September 19, 1892; *Avery Catalogue, 1883,* 12; *Avery Catalogue, 1884,* 21–22; *Avery Catalogue, 1899,* 21; *Avery Catalogue, 1906,* 20; *Avery Catalogue, 1910,* 12.

21. *Avery Catalogue, 1883,* 12; *Avery Catalogue, 1884,* 21–22; *Avery Catalogue, 1899,* 21; *Avery Catalogue, 1906,* 20; *American Missionary* 45 (August 1891): 293–95; Beard, *A Crusade of Brotherhood,* 256–61; Jeffrey P. Green, *Edmund Thornton Jenkins: The Life and Times of an American Black Composer, 1894–1926* (Westport, Conn.: Greenwood Press, 1982), 9.

22. *American Missionary* 40 (September 1886): 252; *American Missionary* 51 (June 1897): 182–84; *American Missionary* 57 (November 1903): 282; George C. Rowe, *Our Heroes: Patriotic Poems on Men, Women, and Sayings of the Negro Race* (Charleston: Walker, Evans, and Cogswell, 1890), 63; *Examinations and Twentieth Anniversary*

Exercises, Avery Normal Institute, Charleston, South Carolina, June 21, 24, 25, and 26, 1885 [hereafter cited as *Avery Examinations, 1885*]; *The Graduating Class of Avery Normal Institute Request the Honor of Your Presence at Their Commencement Exercises at Eight O'Clock P.M., Friday, May the Thirty-First, Nineteen Hundred and Eighteen, Morris Street Baptist Church, Charleston, South Carolina* [hereafter cited as *Avery Commencement Invitation, 1918*]; *AMA Annual Report (1884),* 50; *AMA Annual Reports (1912–1920);* A. W. Farnham to D. E. Emerson, March 18, 1876, AMAA. For a brief history of Plymouth, see pamphlet *One Hundred Fifteenth Anniversary of Plymouth Congregational Church, United Church of Christ, Saturday, April 17, 1982–Sunday, April 18th, 1982* ([Charleston?]: N.p., [1982?]).

23. E. J. Adams to G. Whipple, June 23, 1865; E. J. Adams to G. Whipple, July 27, 1865; F. L. Cardozo to M. E. Strieby, March 17, 1866; F. L. Cardozo to M. E. Strieby, April 12, 1866; J. T. Ford to L. Bacon, June 6, 1872; J. T. Ford to E. M. Cravath, June 4, 1873; S. C. Coles to M. E. Strieby, May 1876; AMAA. *AMA Annual Report (1865),* 24; T. M. Haddock and J. E. Baker, comps., *Charleston City Directory, 1875–1876* (Charleston: Walker, Evans, and Cogswell, 1875), 368.

24. A. W. Farnham to D. E. Emerson, March 18, 1876; S. C. Coles to M. E. Strieby, May n.d. 1876; AMAA.

25. A. W. Farnham to M. E. Strieby, June 20, 1877; A. W. Farnham to M. E. Strieby, July 11, 1877; W. G. Marts to [?], February 8, 1877; W. G. Marts to M. E. Strieby, June 18, 1877; W. G. Marts to M. E. Strieby, July 7[?], 1877; W. G. Marts to M. E. Strieby, July 25, 1877; W. G. Marts to M. E. Strieby, March 25, 1878; AMAA. *American Missionary* 31 (February 1877): 6; *AMA Annual Report (1877),* 73; *Avery Catalogue, 1906,* 26.

26. J. S. Hardy to D. E. Emerson, April 26, 1877; A. W. Farnham to M. E. Strieby, July 11, 1877; A. W. Farnham to M. E. Strieby, April 14, 1878; W. G. Marts to M. E. Strieby, June 18, 1877; W. G. Marts to M. E. Strieby, February 20, 1878; J. S. Knight to M. E. Strieby, February 20, 1878; W. A. Patten to M. E. Strieby, February 28, 1878; Cong'l Church to M. E. Strieby, March 8, 1878; G. M. Watkins, B. W. Wilkerson, T. Myzck, Abraham Simmons, H. J. Brevard, A. S. Owens, G. W. Brown to M. E. Strieby, March 18, 1878; R. F. Markham to M. E. Strieby, April 9, 1878; AMAA. *AMA Annual Report (1877),* 73.

27. R. F. Markham to M. E. Strieby, April 9, 1878; R. F. Markham to M. E. Strieby, April 11, 1878; R. F. Markham to Plymouth Congregational Church of Charleston, April 11, 1878; A. W. Farnham to M. E. Strieby, April 14, 1878; T. Cutler to M. E. Strieby, April 20, 1878; T. Cutler to M. E. Strieby, May 2, 1878; Plymouth Congregational Church (col'd) to Our Congregational Friends, November 1, 1878; A. W. Farnham to M. E. Strieby, November 18, 1878; AMAA. *American Missionary* 33 (June 1879): 174–75; *American Missionary* 51 (June 1897): 182–83.

28. Charleston *News and Courier,* April 8, 1882; *Year Book, 1880, City of Charleston, So. Ca.,* 122, 125–28; *Year Book, 1883, City of Charleston, So. Ca.,* 204; *Year Book, 1884, City of Charleston, So. Ca.,* 188–90; Porter, *Led On,* 236–41, 256, 280–87, 318–19, 437–38, 455–59, 462.

29. *Year Book, 1882, City of Charleston, So. Ca.,* 267–69; *Avery Catalogue, 1883,* 3; Charleston *News and Courier,* July 12, 1883.

30. Charleston *News and Courier,* July 2, 3, 5, 12, 1883; August 20, 1883.

31. Charleston *News and Courier,* August 20, 1883; *Year Book, 1884, Charleston, So.*

Ca., 190–91. Compare and contrast *Avery Catalogue, 1883*, 4–7 (curriculum under A. W. Farnham) with *Avery Catalogue, 1884*, 14–19 (curriculum under J. A. Nichols).

32. Charleston *News and Courier*, July 3, 1883; July 24, 1954. *Sholes' Directory of the City of Charleston, 1883* (Charleston: A. E. Sholes, n.d.), 38, 185, 188, 277, 452, 455, 485; Thomas Yenser, ed., *Who's Who in Colored America: A Biographical Dictionary of Notable Living Persons of African Descent in America*, 4th ed. (New York: Who's Who in Colored America, 1933–1937), 55; Lawrence, *The Centenary Souvenir*, vii–ix, xiii–xiv, xxii, xxv; *Avery Catalogue, 1884*, 6, 10; "Historical Notes, Avery Institute, 1865–1947," 4; Boris, ed., *Who's Who in Colored America*, 32.

33. *Year Book, 1893, City of Charleston, So. Ca.*, iii; *Year Book, 1901, City of Charleston, So. Ca.*, 232–33, 240; J. L. Dart to A. H. Grimke, January 10, 1899, and *Fourth Annual Circular and Prospectus of the Charleston Normal and Industrial Institute*, Charleston Industrial Institute [folder], Archibald H. Grimke Papers; Charleston *News and Courier*, July 3, 12, 1883; *Sholes' Directory of the City of Charleston, 1883*, 39, 168; Beard, *A Crusade of Brotherhood*, 260; *American Missionary* 45 (August 1891): 293–95; Holt, *Black over White*, appendix A. For Crum and Stevens, see notes 80, 85, and 86.

34. *American Missionary* 35 (August 1881): 242–43; *American Missionary* 60 (September 1906): 208–10; Thomas R. Waring, "Son of Slave Credits Religious Atmosphere," Charleston *News and Courier–Evening Post*, December 13, 1981, 2E; Marcellus Forrest, interview with the author and Eugene C. Hunt, Charleston, February 12, 1981; Scott, "When Negroes Attended the State University." For a list of the graduates between 1872 and 1905, see *Avery Catalogue, 1906*, 25–36. I use this catalogue to indicate in the text when individuals graduated from the school; it also often gives their occupation and city of residence at the time, as well as the maiden and married names of several of the women graduates (for example, Small-Gordon, Hayne-Small).

35. Jervey, *The Slave Trade*, 221–25; Powers, "Black Charleston," 146; *Avery Catalogue, 1906*, 23–36; *List of the Tax Payers of the City of Charleston for 1859*, 381–405; *List of the Tax Payers of the City of Charleston for 1860*, 313–34; Purse, *Charleston City Directory and Strangers' Guide for 1856*, 199–223; Charleston *News and Courier*, June 25, 1886; *"Vestigia Nulla Retrorsum": Sixteenth Annual Re-Union, Avery Alumni Association, Avery Hall, Charleston, S.C., Monday, July 4th, 1892—Ten Thirty O'Clock A.M.* (Charleston: Frank Thorne [printer], ca. 1892) [hereafter cited as *Re-Union, Avery Alumni Association, 1892*]. I have noted some of the family names found in the 1856 city directory and/or lists of the city taxpayers for 1859 and 1860.

36. Charleston *News and Courier*, July 6, 1880; *Avery Catalogue, 1899*, 23; *Avery Catalogue, 1906*, 23, 25–36, faculty page; *Avery Catalogue, 1910*, 4–5, 13–14; *AMA Annual Report (1879)*, 44; *Re-Union, Avery Alumni Association, 1892; The Pinnacle.* For biographical data on Harleston, see Edwina H. Whitlock, "Edwin A. Harleston," in *Edwin A. Harleston: Painter of an Era, 1882–1931* ([Detroit]: Your Heritage House, 1983), 9–28. For Lawrence and Gregory, see notes 47 and 48.

37. *Avery Catalogue, 1899*, 23; *Avery Catalogue, 1906*, 23–24, 26, calendar and trustee page; *Avery Catalogue, 1910*, 4, 13; Charleston *News and Courier*, July 5, 1883; "Historical Notes, Avery Institute, 1865–1947," 4; *Re-Union, Avery Alumni Association, 1892*. The reunions were usually held around the Fourth of July, following the commencement.

38. Henry Thomas Riley, ed., *Dictionary of Latin Quotations, Proverbs, Maxims, and*

Mottos, Classical and Mediaeval, Including Law Terms and Phrases, with a Selection of Greek Quotations (London: H. G. Bohn, 1856), 490–91. Charleston *News and Courier*, February 4, 7, 1881; July 5, 1881; February 4, 1882. *Avery Catalogue, 1883*, 12; *Avery Catalogue, 1906*, 26; A. W. Farnham to M. E. Strieby, July 11, 1877, AMAA. *Re-Union, Avery Alumni Association, 1892; American Missionary* 37 (August 1883): 236–37.

39. *American Missionary* 54 (April, May, June 1900): 61, 63; Holt, *Black over White*, appendix A; *Constitution and Rules of Humane Brotherhood*, 1. Using *Avery Catalogue, 1906*, 25–36, I have surveyed the occupations of graduates between 1872 and 1905. My computations are rounded off and thus do not add up to 100 percent. Of the 552 students, 281 had occupations listed. I used a copy of the catalogue that had some occupations penciled in. I did not include these additions in the following figures: teachers, 150 (53.4 percent); dressmakers, 29 (10.3 percent); clerks, 15 (5.3 percent); students, 13 (4.6 percent); physicians, 8 (2.8 percent); tailors, 6 (2.1 percent); barbers, 15 (5.3 percent); carpenters, 6 (2.1 percent); porters, 3 (1.1 percent); lawyers, 3 (1.1 percent); pharmacists, 2 (0.7 percent); ministers, 5 (1.8 percent); dentists, 3 (1.1 percent); undertakers, 2 (0.7 percent); others, 28 (10 percent).

40. *Avery Catalogue, 1906*, 25–36; Scott, "When Negroes Attended the State University"; Charleston *News and Courier*, March 23, 1888; "Officers and Members of the Avery Alumni Ass'n . . . ," Shrewsbury Papers.

41. *Hospital Herald*, Charleston, 1 (January 25, 1899): announcements, 1; *Hospital Herald* 1 (April 1899): list of Hospital Association officers; *Hospital Herald* 1 (May 1899): 8; *Hospital Herald* 1 (July 1899): 5. Pamphlet *Dedication, McClennan-Banks Memorial Hospital, Inc., of Charleston County* ([Charleston?]: N.p., [1959?]), in Waring Historical Library, Medical University of South Carolina, Charleston, S.C. Charleston *News and Courier*, September 12, 1977; November 20, 1986. W. Augustus Low and Vergil A. Clift, eds., *Encyclopedia of Black America* (New York: McGraw-Hill Book Co., 1981), 166–67.

42. See note 41; Harlan and Smock, eds., *The Booker T. Washington Papers*, 6: 147–48; Caldwell, ed., *History of the American Negro, South Carolina Edition*, 647–49; clipping "A Great Man Has Fallen in Our Midst," Charleston *Messenger*, December 12, 1931, in James R. Logan Scrapbook, private hands, Charleston, S.C.; Application for Charter, dated February 27, 1917, National Association for the Advancement of Colored People Papers, Charleston, S.C., Manuscript Division, LC [hereafter cited as NAACP Papers]; *Walsh's 1925–1926 Charleston, South Carolina City Directory, Forty-Fourth Year* (Charleston: Southern Printing and Publishing Co., n.d.), 670; Charleston *Evening Post*, October 19, 1964; Eugene C. Hunt, conversation on E. B. Burroughs, Jr., December 22, 1988. For more on Johnson and Burroughs, Jr., see chapters 4 and 5, respectively.

43. *Hospital Herald* 1 (May 1899): 8; Mather, ed., *Who's Who of the Colored Race*, 1: 194; I. A. Newby, *Black Carolinians: A History of Blacks in South Carolina from 1895 to 1968* (Columbia: University of South Carolina Press, 1973), 54–55.

44. Charleston *News and Courier* as cited in *American Missionary* 41 (April 1887): 104; W. E. B. Du Bois, *The Negro in Business: Report of a Social Study Made under the Direction of Atlanta University, Together with the Proceedings of the Fourth Conference for the Study of the Negro Problems, Held at Atlanta University, May 30–31, 1899*, Atlanta University Publications, no. 4 ([Atlanta?], 1899), 6, 27; Tindall, *South*

Carolina Negroes, 1877–1900, 141; Waring, "Nonagenarian Enjoys Her Memories"; Holloway Family Papers; Charleston *Chronicle,* April 2, 1983; clipping, Charleston *Messenger,* December 3, 1910, and pamphlet *Sylvia,* 1913, both in James R. Logan Scrapbook; *The Charleston City Directory, 1890, Together with a Compendium of Governments, Institutions, and Trades of the City* (Charleston: Southern Directory and Publishing Co., 1890), 470, 703, 718; *Charleston, S.C., City Directory for 1901, Containing a General Business Directory . . .* (Charleston: W. H. Walsh Directory Co., 1901), 290, 569, 603, 929; *Avery Catalogue, 1906,* 25–36; Fields, *Lemon Swamp,* 22; Whitlock, "Edwin A. Harleston," 9; *Hospital Herald* 1 (July 1899): 12; T. F. Boone to W. J. Fraser, December 14, 1959, with biographical sketch of John A. McFall attached, Naming Columbus Street School, Naming East Bay School, Box 863, OAR, CCSD; Asa H. Gordon, *Sketches of Negro Life and History in South Carolina* (Privately printed, 1929; Columbia: University of South Carolina Press, 1970), 139; Felder Hutchinson, interview with the author and Eugene C. Hunt, Charleston, July 16, 1985.

45. Mather, ed., *Who's Who of the Colored Race,* 1: 182; *Avery Catalogue, 1906,* 35–36.

46. *Charleston, S.C. City Directory for 1901,* 273, 596; Charleston *News and Courier,* July 24, 25, 1954; T. F. Boone to W. J. Fraser, December 14, 1959, with biographical sketch of John A. McFall attached, Naming Columbus Street School, Naming East Bay School, Box 863, OAR, CCSD; Thomas A. McFall, Record of Wills, 643/12, CCPC; *Avery Catalogue, 1899,* 33; *Avery Catalogue, 1906,* 33; *Avery Catalogue, 1910,* 13–14; *Thirty-Third Commencement, Zion Presbyterian Church, Avery Normal Institute, June Twenty-First–Twenty-Second, MDCCCXCVIII [1898]* [hereafter cited as *Avery Commencement Program, 1898*]; *Avery Commencement Invitation, 1918; Graduating Exercises of Avery Normal Institute at Morris Street Baptist Church on Friday, May 31st, 1918 at Eight P.M.* (Charleston: J. R. Harlee [printer], n.d.) [hereafter cited as *Avery Commencement Program, 1918*]; *Hospital Herald* 1 (April 1899): 10–11; *Hospital Herald* 1 (July 1899): 12; "Historical Notes, Avery Institute, 1865–1947," 5; *AMA Annual Report (1901),* 60. J. J. McMahon to M. L. Deas, December 6, 1901; M. L. Deas to J. J. McMahon, n.d. [December 1901?]; J. J. McMahon Papers, State Superintendent of Education Correspondence, SDAH.

47. Clipping, Brooklyn *Daily Eagle,* October 31, 1937, and E. A. Lawrence to Mrs. G. Shrewsbury, April 14, 1879, Shrewsbury Papers. *Avery News,* October 1931; *Avery Catalogue, 1906,* 23, 25–26, calendar and trustee page; A. W. Farnham to M. E. Strieby, February 10, 1877, AMAA. For Lawrence's years at Avery, see AMA annual reports which cover those years and his brief tenure as principal in 1907. The James R. Logan Scrapbook has a flyer advertising Lawrence's Brooklyn business, 747 Marcy Avenue.

48. *Re-Union, Avery Alumni Association, 1892;* Charleston *News and Courier,* June 26, 1891; Gayle Morrison, *To Move the World: Louis G. Gregory and the Advancement of Racial Unity in America* (Wilmette, Ill.: Bahai Publishing Trust, 1982), 3–18, 31, 41.

49. "South Carolina Fights Illiteracy," 29–30; *Avery Catalogue, 1906,* 29; *AMA Annual Reports (1892–1897);* Gordon, *Sketches of Negro Life and History in South Carolina,* 179–85; Caldwell, ed., *History of the American Negro, South Carolina Edition,* 293. For details on the father, Richard Birnie, see text dealing with St. Mark's Episcopal Church and Avery's 1883 curriculum crisis.

50. "South Carolina Fights Illiteracy," 1, 29–30; Caldwell, ed., *History of the*

American Negro, South Carolina Edition, 293–95; Purse, *Charleston City Directory and Strangers' Guide for 1856,* 222; Scott, "When Negroes Attended the State University"; Columbia *Palmetto Leader,* March 19, 1932; Dumas Malone, ed., *Dictionary of American Biography* (New York: Charles Scribner's Sons, 1935–1936, 1963), 10: 229–30.

51. *Avery Catalogue, 1906,* 19, 25–36; *American Missionary* 54 (April, May, June 1900): 61, 63; Fields, *Lemon Swamp,* 40–41.

52. Mather, ed., *Who's Who of the Colored Race,* 1: 86–87, 261. Clipping, Norfolk *Journal and Guide,* February 19, 1938, and another newspaper clipping, unidentified, same date, both obituaries for Edward Porter Davis, in Howardian File, Moorland-Spingarn Research Center, Howard University, Washington, D.C.

53. *American Missionary* 45 (May 1891): 181–83; *American Missionary* 60 (September 1906): 208, 210; *AMA Annual Report (1891),* 55; E. C. Mickey to J. R. Logan, February 24, 1915, James R. Logan Scrapbook. Eugene C. Hunt made me aware of the Holmes Fund.

54. A. Coward to M. A. Warren, March 6, 1886; A. Coward to M. A. Warren, March 18, 1886; Letter Copy Book no. 30 (October 20, 1885, to August 23, 1886), 274, 289–91, State Superintendent of Education Correspondence, SCDAH. M. A. Warren to My dear Sir [A. Coward], April 17, 1886; M. A. Warren to My dear Sir [A. Coward], May 15, 1886; M. A. Warren to My dear Sir [A. Coward], May 31, 1886; Letters Received, 1869–1886, State Superintendent of Education Correspondence, SCDAH.

55. Photograph of Avery's last five white teachers, ARC; H. Louise Mouzon, interview with the author and Eugene C. Hunt, Charleston, November 20, 1980; Clark, *Echo in My Soul,* 25–26; Whitlock, "Edwin A. Harleston," 10; *The Faculty of Avery High School Presents the Senior Class in "Avery—Past, Present, and Future," a Pageant Written and Staged by the Honor Graduates under the Direction of Fannie Ella Frazier Hicklin in the Henry P. Archer School Auditorium on Tuesday Evening, June 5, 1951 at Eight O'Clock.* For Tuttle and Marsh at Avery, see AMA annual reports for those school years. According to Clark, Tuttle and Marsh stayed at Avery about two years beyond 1914 and were there when she graduated in 1916. Eugene C. Hunt told me how Marsh treated him when he was at Talladega.

56. Charleston *News and Courier,* July 5, 1890; *Avery Catalogue, 1906,* 25; Scott, "When Negroes Attended the State University"; clipping, Charleston *News and Courier,* March 21, 1937, James R. Logan Scrapbook.

57. Simmons, *Men of Mark,* 466–73, 1052–54; Scott, "When Negroes Attended the State University"; *Avery Tiger,* November 1939. T. McCants Stewart to T. McCants Stewart, Jr., July 30, 1891; T. McCants Stewart to T. McCants Stewart, Jr., August 8, 1891; T. McCants Stewart to T. McCants Stewart, Jr., June 11, 1892; Stewart-Flippin Papers, Moorland-Spingarn Research Center, Howard University, Washington, D.C.; Harlan, ed., *The Booker T. Washington Papers,* 2: 255.

58. *Avery Catalogues, 1883, 1884, 1899, 1906, 1910; Year Book, 1882, City of Charleston, So. Ca.,* 268–69; *Year Book, 1883, City of Charleston, So. Ca.,* 205–8; *Avery Echo,* June 1888; Charleston *News and Courier,* September 19, 1892; *Circulating Library of Avery Normal Institute* (N.p., ca. 1880s). ARC has some diplomas.

59. *Avery Catalogue, 1883,* 11, calendar page; *Avery Catalogue, 1899,* 20, calendar page; *Avery Catalogue, 1906,* 19, calendar page; *American Missionary* 43 (August

1889): 222–23; *American Missionary* 60 (September 1906): 208–10; Charleston *News and Courier*, June 20, 1906; Mather, ed., *Who's Who of the Colored Race*, 1: 192–93; Harlan, ed., *The Booker T. Washington Papers*, 4: 255–56; Bremer, *The Homes of the New World*, 1: 268, 303–5; *A History of the Calhoun Monument at Charleston, S.C.* (Charleston: Lucas, Richardson, and Co., 1888), 36–37; Fields, *Lemon Swamp*, 57. For commencements and other Avery ceremonies covered in Charleston *News and Courier*, see March 26, 1880; June 29, 1881; July 1, 5, 1881; June 22, 23, 28, 1884; July 3, 5, 1884; June 20, 22, 27, 1885; July 3, 1885; June 23, 24, 25, 1886; July 1, 1887; June 18, 20, 21, 22, 1888; July 4, 1888; June 25, 26, 1889; July 2, 1889; June 18, 19, 1890; July 5, 1890; June 20, 23, 26, 1891; June 27, 30, 1892; June 17, 30, 1893; June 27, 28, 1894; June 20, 27, 1895; June 23, 25, 1896; June 24, 28, 1897; June 23, 1898; June 23, 1899; June 16, 23, 1900; June 15, 24, 26, 1901; June 26, 1902; June 18, 20, 1906; May 18, 1913; May 18, 24, 1914. For more accounts of the commencement exercises, see *American Missionary* 32 (September 1878): 270–71; *American Missionary* 35 (August 1881): 242–43; *American Missionary* 36 (July 1882): 205–6; *American Missionary* 37 (August 1883): 236–37; *American Missionary* 39 (August 1885): 226; *American Missionary* 43 (August 1889): 222–23; *American Missionary* 44 (September 1890): 281–82; *American Missionary* 45 (August 1891): 293–95; *American Missionary* 46 (September 1892): 292–94; *American Missionary* 47 (September 1893): 277–78; *Avery Echo*, June 1888; *Avery Commencement Programs, 1898, 1899; Nineteen Hundred and One, Avery Normal Institute, the Twentieth Century Class Requests the Honor of Your Presence at the Anniversary Exercises, June 21–26* [hereafter cited as *Avery Commencement Invitation, 1901*]; *Commencement, Avery Institute, Nineteen Hundred and Nine, Charleston, S.C.* [hereafter cited as *Avery Commencement Program, 1909*]; *The Graduating Class of Avery Normal Institute Announces the Graduation Exercises, May the Twenty-First and Twenty-Fourth, Nineteen Hundred and Eleven, Zion Presbyterian Church, Charleston, South Carolina* [hereafter cited as *Avery Commencement Announcement, 1911*].

60. *American Missionary* 39 (August 1885): 226; *AMA Annual Report (1885)*, 61; "Officers and Members of the Avery Alumni Ass'n. . . ," Shrewsbury Papers.

61. *Avery Catalogue, 1910*, 5, 8–10, 24.

62. Ibid., 8–9, 15; *Year Book, 1883, City of Charleston, So. Ca.*, 205–7; *Avery Catalogue, 1883*, 7–8; *American Missionary* 39 (August 1885): 226; *American Missionary* 54 (April, May, June 1900): 61, 65.

63. *American Missionary* 54 (April, May, June 1900): 61, 65; *American Missionary* 69 (June 1915): 149–50; *Avery Catalogue, 1906*, 18; Clark, *Echo in My Soul*, 24–26; Harlan, ed., *The Booker T. Washington Papers*, 4: 297–98. Several older Avery graduates said that they or their sisters made their own graduation dresses.

64. *American Missionary* 40 (September 1886): 252–53; *American Missionary* 69 (June 1915): 149–50; *Avery Commencement Program, 1898*. Charleston *News and Courier*, June 22, 1888; June 30, 1893; June 25, 1896; June 23, 1898. *Avery Echo*, June 1888.

65. "Officers and Members of the Avery Alumni Ass'n. . . ," Shrewsbury Papers.

66. *Avery Echo*, June 1888; *Avery Catalogue, 1883*, 9; *Avery Catalogue, 1884*, 23. Charleston *News and Courier*, April 6, 7, 1883; January 10, 1884; June 13, 20, 1884; June 12, 1885. CDS, February 28, 1849, March 21, 1849, mentions Henry Cardozo, Jr., as a member.

67. *Avery Catalogue, 1906*, 15–17, faculty page; *Examinations and Twenty-First Anniversary Exercises, Avery Normal Institute, Charleston, South Carolina, June 20, 22, 23, and 24, 1886* [hereafter cited as *Avery Examinations, 1886*]; *American Missionary* 60 (September 1906): 208–9; Rowe, *Our Heroes*, table of contents page.

68. Charleston *News and Courier*, March 19, 1880; June 26, 1891. *Year Book, 1883, City of Charleston, So. Ca.*, 208; *Course of Six Lecturers, for the Benefit of Their Fair*, AMAA; *Avery Examinations, 1885;* Fields, *Lemon Swamp*, 1, 41, 45; "Officers and Members of the Avery Alumni Ass'n. . . ," Shrewsbury Papers.

69. *Avery Catalogue, 1899*, 18, 20; *Avery Catalogue, 1906*, 17–18, 20; *Avery Catalogue, 1910*, 11, 12; Charleston *News and Courier*, October 20, 1883.

70. Peter Poinsette, interview with the author and Eugene C. Hunt, Charleston, March 31, 1981; Leroy Anderson, interview with the author, Charleston, July 10, 1985; Eugene C. Hunt, interview with the author, Charleston, August 28, 1980, November 4, 1980, December 4, 1985. *Avery Catalogue, 1906*, 33; *American Missionary* 79 (April 1925): 59; Green, *Edmund Thornton Jenkins*, 4–11, 24, 39, 43, 59, 95–110. See advertisement by Moore in *The Pinnacle*. For a survey of James R. Logan's musical activities, see his scrapbook.

71. Clipping, *Southern Reporter*, Charleston, June 10, 1911; clippings, *Produce to Win*, Charleston, October 29, 1943, March 31, 1944; graduation speech of James R. Logan, "Dear parents and friends. . . ," Morris Street School, 1889; stationery letterhead of Zion Presbyterian Sunday School, Calhoun Street, Charleston, S.C.; stationery letterhead of Carpenters' Band Association of Local Union No. 809, Charleston, S.C.; blank Scholarship Application form of Prince Hall Lodge No. 46, Free and Accepted Masons, Charleston, S.C.; program "Selections by Choir for Sunday Afternoon, Mar. 28, 1915 [Zion Presbyterian Church]"; *Manhood*, Cannon Street Branch, YMCA, Charleston, S.C., 1 (September 11, 1920); and card *Good for One Lesson, Piano, Anna E. Logan, Residence: 177 President Street, Dial 8670;* all in James R. Logan Scrapbook. See also Green, *Edmund Thornton Jenkins*, 22–24, 38–39.

72. Clipping, *Produce to Win*, Charleston, October 29, 1943; clipping, *Southern Reporter*, Charleston, June 10, 1911; clippings, New York *Age*, December 19, 1907, December 23, 1916; clipping, Charleston *Messenger*, November 14, 1914; and program *Recital by Miss G. Hortense Bowden at Avery Hall, Monday Evening, January 17, 1921;* all in James R. Logan Scrapbook. For Jervey (1905/1906–1910) and Morrison (1901/1902–1911/1912), see AMA annual reports for those years.

73. *Avery Catalogue, 1906;* Caldwell, ed., *History of the American Negro, South Carolina Edition*, 552. Eugene C. Hunt, who briefly took piano lessons from Moore, described his bearing and appearance to me. Boston advertised in *The Pinnacle*.

74. Barbara Welter, "The Cult of True Womanhood, 1820–1860," *American Quarterly* 18 (Summer 1966): 151–74; Allen F. Davis, *American Heroine: The Life and Legend of Jane Addams* (London, Oxford, and New York: Oxford University Press, 1975), 204–5; *Avery Catalogue, 1906*, 18, 25; *Avery Catalogue, 1910*, 9, 13; *American Missionary* 32 (September 1878): 270–71. Charleston *News and Courier*, June 26, 1891; June 27, 1895; June 16, 1900. *Avery Commencement Programs, 1898, 1899*.

75. Welter, "The Cult of True Womanhood," 174; *Year Book, 1883, City of Charleston, So. Ca.*, 205, 207; *Avery Catalogue, 1883*, 6–8; *Avery Catalogue, 1899*, 16–18; *Avery Catalogue, 1906*, 15–16, 36. Charleston *News and Courier*, June 30, 1893;

June 28, 1894; June 21, 22, 1905; May 24, 1914. For a general survey of the movement, see Maude Thomas Jenkins, "The History of the Black Woman's Club Movement in America" (Ed.D. diss., Teachers College, Columbia University, 1984).

76. *Avery Catalogue, 1906*, 25, faculty page; Record of Certificates Issued by the City Board of Examiners, Charleston, So. Ca., from May 10, 1875 to [1895], p. 2, and City Board of School Commissioners Minute Books, June 1930–December 1935, p. 177 (September 8, 1931), OAR, CCSD; "South Carolina Fights Illiteracy," 29–30; Gordon, *Sketches of Negro Life and History in South Carolina*, 179–83; Boris, ed., *Who's Who in Colored America*, 303. Douglass, *Christian Reconstruction*, 277, makes the parallel between blacks and women. Persons I interviewed recalled Sallie O. Cruikshank in such terms.

77. Photograph of Wade Hampton and followers including Mears, ARC; Tindall, *South Carolina Negroes, 1877–1900*, 40; Lucille Mears Poinsette, interview with the author and Eugene C. Hunt, Charleston, April 2, 1981. Charleston *News and Courier*, September 27, 1879; April 30, 1881; March 6, 7, 21, 25, 1882. William Ashmead Courtenay, Biography File, CCPL. For a good account of Avery, see *Yearbook, 1880, City of Charleston, So. Ca.*, 125–26, and *American Missionary* 44 (November 1890): 330.

78. Francis Butler Simkins and Robert Hilliard Woody, *South Carolina during Reconstruction* (Chapel Hill: University of North Carolina Press, 1932), 564–69; Holt, *Black over White*, 220; Tindall, *South Carolina Negroes, 1877–1900*, 29–30, 35–40, 68–91.

79. Lawrence, *The Centenary Souvenir*, xxvi–xlvii.

80. Waring, "Son of Slave Credits Religious Atmosphere"; Herbert Greer McCarriar, Jr., "A History of the Missionary Jurisdiction of the South of the Reformed Episcopal Church, 1874–1970," *Historical Magazine of the Protestant Episcopal Church* 41 (June 1972): 197–220; Charleston County School District Minute Book, June 1878 to April 1920, p. 57 (June 29, 1880), and p. 61 (September 22, 1880), OAR, CCSD; *Avery Catalogue, 1906*, 29; Tindall, *South Carolina Negroes, 1877–1900*, 219; *Avery Echo*, June 1888.

81. Francis Butler Simkins, *Pitchfork Ben Tillman: South Carolinian* (Baton Rouge: Louisiana State University Press, 1944; first paperback printing, 1967), 154; Randolph Werner, "'New South' Carolina: Ben Tillman and the Rise of Bourgeois Politics, 1880–1893," paper, Fourth Citadel Conference on the South, Charleston, April 11–13, 1985; Joel Williamson, *The Crucible of Race: Black-White Relations in the American South since Emancipation* (New York: Oxford University Press, 1984), 132–33, 140–41, 146–47, 301–2, 305–6, 318.

82. *Journal of the Constitutional Convention of the State of South Carolina . . .* (Columbia: Charles A. Calvo, Jr. [state printer], 1895), 8–9, 12, 102, 106, 125, 148, 206, 260, 443–68; Williamson, *The Crucible of Race*, 113; Susan Bowler and Frank Petrusak, "The Constitution of South Carolina: Historical and Political Perspectives," in Luther F. Carter and David S. Mann, eds., *Government in the Palmetto State* (Columbia: Bureau of Governmental Research and Services, University of South Carolina, 1983), 37; George B. Tindall, "The Question of Race in the South Carolina Constitutional Convention of 1895," *JNH* 30 (July 1952): 277–303; Tindall, *South Carolina Negroes, 1877–1900*, 67, 80–90; Newby, *Black Carolinians*, 42–44.

83. Tindall, *South Carolina Negroes, 1877–1900*, 291–93, 300; Newby, *Black Caro-*

linians, 44, 46–50; *Hospital Herald* 1 (February 1899): 5–6; Fields, *Lemon Swamp*, 45–50; John P. Radford, "Delicate Space: Race and Residence in Charleston, 1860–1880," *Essays on the Human Geography of the Southeastern United States* 16 (June 1977): 17–37; Charleston *News and Courier*, October 10, 1910.

84. Simkins, *Pitchfork Ben Tillman*, 394–98, 416–18; Williamson, *The Crucible of Race*, 116–17, 130–39.

85. Simkins, *Pitchfork Ben Tillman*, 416–18; Harlan and Smock, eds., *The Booker T. Washington Papers*, 6: 147–48; clipping, Charleston *News and Courier*, December 10, 1908, James R. Logan Scrapbook; *American Missionary* 45 (May 1891): 181–82.

86. W. D. Crum to Mac, January 10, 1902 [1903?]; S. W. Bennett to W. McKinlay, April 15, 1903; Whitefield McKinlay Papers. Simkins, *Pitchfork Ben Tillman*, 417; August Meier, *Negro Thought in America, 1880–1915: Racial Ideologies in the Age of Booker T. Washington* (Ann Arbor: University of Michigan Press, 1963), 272.

87. Clipping, Charleston *Messenger*, April 10, 1915, James R. Logan Scrapbook; Simkins, *Pitchfork Ben Tillman*, 399–400, 487–90; Ronald D. Burnside, "Racism in the Administrations of Governor Cole Blease," in George Rogers, Jr., ed., *The Proceedings of the South Carolina Historical Association, 1964* (Columbia: South Carolina Historical Association, 1964), 43–51; Newby, *Black Carolinians*, 83–86.

88. Burnside, "Racism in the Administrations of Governor Cole Blease," 46–47, 50; unidentified newspaper clipping, dated January 27, 1911, James R. Logan Scrapbook; Tindall, *South Carolina Negroes, 1877–1900*, 231–32; David L. Carlton, *Mill and Town in South Carolina, 1880–1920* (Baton Rouge: Louisiana State University Press, 1982), 8–11, 224–25, 242, 244–46.

89. J. L. Dart to A. H. Grimke, January 10, 1899, and *Fourth Annual Circular and Prospectus of the Charleston Normal and Industrial Institute*, Charleston Industrial Institute [folder], Archibald H. Grimke Papers; *Charleston, S.C. City Directory for 1900, Containing a General and Business Directory . . .* (Charleston: Lucas and Richardson Co., 1900), 45.

90. J. M. Griggs to Superintendent of Public Instruction, State of South Carolina, January 5, 1901; J. J. McMahon to J. M. Griggs, January 18, 1901; J. J. McMahon Papers. J. L. Dart to A. H. Grimke, January 10, 1899, and flyer *The Negro Co-operative and Protective Union of Charleston, S.C. (Incorporated.)*, n.d., Charleston Industrial Institute [folder], Archibald H. Grimke Papers; *Avery Catalogue, 1906*, 25, 27; J. L. Mitchell to J. R. Logan, August 31, 1904, James R. Logan Scrapbook; "Officers and Members of the Avery Alumni Ass'n. . . ," Shrewsbury Papers.

91. Anna F. Johnson, "An Age of Advancement—Our Men Must Advance," October 25, 1906, James R. Logan Scrapbook; *Year Book, 1896, City of Charleston, So. Ca.*, 267.

92. *The Negro Co-operative and Protective Union of Charleston, S.C. (Incorporated.)*, Charleston Industrial Institute [folder], Archibald H. Grimke Papers; *Avery Catalogue, 1906*, 25, 27; Yenser, ed., *Who's Who in Colored America*, 53.

93. Tindall, *South Carolina Negroes, 1877–1900*, 194–95; Felder Hutchinson, interview, July 16, 1985; Porter, *Led On*, 308, 332–36.

94. The account of the St. Mark's struggle is based on all the following sources: M. A. Warren to E. P. Smith, March 29/April 1, 1870, AMAA. Marcellus Forrest, interview, February 12, 1981. Waring, "Son of Slave Credits Religious Influence."

Tindall, *South Carolina Negroes, 1877–1900,* 68–69, 194–200. Porter, *Led On,* 307–10. Charleston *News and Courier,* February 4, 7, 1881; February 4, 1882; April 16, 1888; May 3, 4, 5, 7, 8, 14, 1888. [Charleston] *Messenger,* ca. January 1888.

95. Moore, "A History of the Negro Public Schools of Charleston, South Carolina, 1867–1942," 13–17, 25–26, 29, 37, 39; clipping, New York *Age,* May 6, 1909, James R. Logan Scrapbook; Porter, *Led On,* 224; Charleston *News and Courier,* April 27, 1905; *Year Book, 1883, City of Charleston, So. Ca.,* 201–3; *Year Book, 1884, City of Charleston, So. Ca.,* 186.

96. *Year Book, 1890, City of Charleston, So. Ca.,* 119, 121, 124; *Year Book, 1893, City of Charleston, So. Ca.,* 177–78; *Year Book, 1902, City of Charleston, So. Ca.,* 236, 241; *Year Book, 1903, City of Charleston, So. Ca.,* 261, 265; Moore, "A History of the Negro Public Schools of Charleston, South Carolina, 1867–1942," 13, 19–23; clipping, New York *Age,* May 6, 1909, James R. Logan Scrapbook; Clark, *Echo in My Soul,* 16–24; Newby, *Black Carolinians,* 84.

97. Mary Taylor, *A History of the Memminger Normal School, Charleston, S.C.* ([Charleston?]: N.p., 1954), 57–59; Moore, "A History of the Negro Public Schools of Charleston, South Carolina, 1867–1942"; Charleston *News and Courier,* June 17, 1986; J. L. Dart to A. H. Grimke, January 10, 1899, Charleston Industrial Institute [folder], Archibald H. Grimke Papers. See the annual reports of the superintendent of city public schools and the principal of the High School of Charleston in the city yearbooks, 1882–1914. As cited in Easterby, *A History of the College of Charleston,* 235–39, the 1839 municipal ordinance, which establishes the High School of Charleston, states that for one hundred years, starting on July 1, 1839, the city shall annually appropriate one thousand dollars for a fund to be used for the maintenance and improvement of the school.

98. *Year Book, 1893, City of Charleston, So. Ca.,* 179–80; Moore, "A History of the Negro Public Schools of Charleston, South Carolina, 1867–1942," 23–26, 29, 31–32; *Fourth Annual Circular and Prospectus of the Charleston Normal and Industrial Institute,* Charleston Industrial Institute [folder], Archibald H. Grimke Papers; *American Missionary* 40 (September 1886): 253–54; Peter Manigault, "Negroes in City Schools Once Had White Teachers," Charleston *News and Courier,* April 28, 1954, 10A; *Walsh's Charleston, South Carolina 1911 City Directory, Twenty-Ninth Year* (Charleston: Walsh Directory Co., 1911), 86; *Walsh's Charleston, South Carolina 1912 City Directory, Thirtieth Year* (Charleston: Walsh Directory Co., 1912), 40; *Burke High School, Charleston, South Carolina, 1974–1975 Student Bulletin* ([Charleston?]: N.p. [1957?]), John L. Dart Hall Branch, Charleston County Public Library, Charleston, S.C.; Caldwell, ed., *History of the American Negro, South Carolina Edition,* 210–12; Augustine Thomas Smythe, Biography File, CCPL. One of the sons of family patriarch Thomas Smyth changed his surname to Smythe. The other brothers did not. J. Adger Smyth, the mayor, kept the original version of the family name.

99. Clipping, Charleston *News and Courier,* November 3, 1913, James R. Logan Scrapbook.

100. Clark, *Echo in My Soul,* 17–19; Fields, *Lemon Swamp,* 41–45; Whitlock, "Edwin A. Harleston," 10. *American Missionary* 40 (September 1886): 252–54 contains a letter critical of the white public school teachers, signed A. J. H., probably the Avery teacher Anna Hammond, who taught at Avery from 1885 through 1887. See

AMA annual reports for those years. *The Charleston City Directory, 1886, Together with a Compendium of Governments, Institutions, and Trades of the City, to Which Is Added a Complete Gazetteer of Charleston and Berkeley Counties* (Charleston: Ross A. Smith and Lucas and Richardson, 1886), 258, lists her as "Hammond Miss Anna B., teacher Avery Normal Institute, r 10 Broad." *AMA Annual Report (1887)* identifies her middle initial as *B* rather than *J*. The 1886 city directory also lists a bookseller and stationer named Isaac Hammond whose place of residence is 10 Broad.

101. Joseph I. Hoffman, interview with the author and Eugene C. Hunt, Charleston, September 25, 1980, October 9, 1980; Fields, *Lemon Swamp*, 44–45; Clark, *Echo in My Soul*, 21–22.

102. Manigault, "Negroes in City Schools Once Had White Teachers."

103. Lawrence, *The Centenary Souvenir*, xxxiii, xlvi–xlvii; Charleston *News and Courier*, March 23, 1888; *Avery Catalogue, 1906*, 27; *The Negro Co-operative and Protective Union of Charleston, S.C. (Incorporated.)*, Charleston Industrial Institute [folder], Archibald H. Grimke Papers.

104. A. Coward to M. A. Warren, March 6, 1886; A. Coward to M. A. Warren, May 24, 1886; Letter Copy Book no. 30 (October 20, 1885, to August 23, 1886), 274, 449–50, State Superintendent of Education Correspondence. M. A. Warren to My dear Sir [A. Coward], April 17, 1886; M. A. Warren to Col. Coward, June 3, 1886; Letters Received, 1869–1886, State Superintendent of Education Correspondence.

105. *Avery Catalogue, 1906*, 29–31; W. E. Milligan to the colored teachers of Charleston, July 1, 1902, J. J. McMahon Papers; *Avery Examinations, 1886*.

106. Joseph I. Hoffman, interview, September 25, 1980, October 9, 1980; J. Michael Graves, interview, March 7, 1985; Lucille Mears Poinsette, interview, April 2, 1981; Peter Poinsette, interview, March 31, 1981. Arthur J. Clement, Jr., interview with the author and Eugene C. Hunt, Charleston, August 27, 1986. Lucille Mears Poinsette, phone conversation, August 16, 1985; Septima Clark, phone conversation, August 16, 1985; Joseph I. Hoffman, phone conversation, August 16, 1985. *Avery Catalogue, 1906*, 25–36; Fields, *Lemon Swamp*, 40–41; Clark, *Echo in My Soul*, 16–19; *AMA Annual Report (1866)*, 26; *AMA Annual Report (1867)*, 31; *Walsh's Charleston, South Carolina 1914 City Directory, Thirty-Second Year* (Charleston: Walsh Directory Co., 1914), 85, 584, 596, 636, 644; Caldwell, ed., *History of the American Negro, South Carolina Edition*, 210–12; *The Pinnacle;* T. F. Boone to W. J. Fraser, December 14, 1959, with biographical sketch of John A. McFall attached, Naming Columbus Street School, Naming East Bay School, Box 863, OAR, CCSD; Edwina H. Whitlock, questionnaire, August 4, 1986; Bolden, "Susan Dart Butler—Pioneer Librarian"; Susan Dart Butler, "Making a Way to Start a Library," John L. Dart Hall Branch, Charleston County Public Library. Julia Wilson Pope provided me with a list of some of these schools and their locations. Catherine Winslow is mentioned in chapter 2.

107. Clark, *Echo in My Soul*, 16–19; Septima Clark, phone conversation, August 16, 1985; Charleston *News and Courier*, September 10, 1956; Naming Columbus Street School, Naming East Bay School, Box 863, OAR, CCSD; City Board of School Commissioners Minute Books, October 1924–April 1930, petition, dated December 17, 1925, from Inter-Racial Committee, p. 105 (January 6, 1926), OAR, CCSD. Lucille Mears Poinsette offered the number one hundred in a brief phone conversation, August 16, 1985.

108. Manigault, "Negroes in City Schools Once Had White Teachers"; Charleston *News and Courier,* April 28, 1954; Theodore Hemmingway, "Beneath the Yoke of Bondage: A History of Black Folks in South Carolina, 1900–1940" (Ph.D. diss., University of South Carolina, 1976), 352–53; Robert Burke Everett, "Race Relations in South Carolina, 1900–1932" (Ph.D. diss., University of Georgia, 1969), 75–78; *The State,* Columbia, January 28, 1914.

109. Photograph of Logan and his coworkers, and clipping, Charleston *News and Courier,* October 24, 1911, both in James R. Logan Scrapbook.

110. John Hammond Moore, "South Carolina's Reaction to the Photoplay, The Birth of a Nation," in George C. Rogers, Jr., ed., *Proceedings of the South Carolina Historical Association, 1963* (Columbia: South Carolina Historical Association, 1964), 30–40; "Officers and Members of the Avery Alumni Ass'n. . . ," Shrewsbury Papers.

111. Fields, *Lemon Swamp,* 23–24, 64; Holloway Family Papers; Brown (Century) Fellowship Society Minutes, p. 240 (December 7, 1892), SCRSSL; Williamson, *The Crucible of Race,* 512; Meier, *Negro Thought in America, 1880–1915,* 152, 300–301. Mae Holloway Purcell told me about the legal complications of the property sale.

112. Fields, *Lemon Swamp,* 24, 63.

113. Ballard, *One More Day's Journey,* 166–67; *Avery Catalogue, 1899,* 8, 33; *Avery Catalogue, 1906,* 33; *Avery Catalogue, 1910,* 13–14; *AMA Annual Report (1901),* 60; *Avery Commencement Program, 1898.* J. J. McMahon to M. L. Deas, December 6, 1901; M. L. Deas to J. J. McMahon, n.d. [December 1901?]; J. J. McMahon Papers.

114. Felder Hutchinson, interview, July 16, 1985.

115. Ibid.; Edwina H. Whitlock, "First Person Singular," Gary *American,* June 21, 1946. Felder Hutchinson, born in the 1920s, said this anecdote probably preceded his birth.

116. Fields, *Lemon Swamp,* 24.

117. Clipping, dated April 10, 1915, James R. Logan Scrapbook, does not identify the newspaper by title, but internal evidence, including issue number, confirms that it is from the Charleston *Messenger.*

118. Ibid.; Manigault, "Negroes in City Schools Once Had White Teachers."

119. Tindall, *South Carolina Negroes, 1877–1900,* 48–49, 54–58; Tindall, "The Question of Race in the South Carolina Constitutional Convention of 1895," 280; Manigault, "Negroes in City Schools Once Had White Teachers."

120. Clipping, [Charleston *Messenger*], April 10, 1915, James R. Logan Scrapbook.

121. Ibid.; *American Missionary* 32 (June 1878): 174–75.

122. *American Missionary* 68 (April 1914): 25; American Missionary Association Minutes, Executive Committee Book, Beginning October 1913, pp. 29–30 (May 12, 1914), and p. 55 (June 9, 1914), AMAA Addendum; William Pickens, *Bursting Bonds: The Heir of Slaves* (1923; enlarged edition, Boston: Jordan and More Press, 1929), 134, 150–52, 165; clipping, [Charleston *Messenger*], April 10, 1915, James R. Logan Scrapbook; McPherson, *The Abolitionist Legacy,* 292. None of the sources McPherson cites mentions Pickens by name. This includes Lura Beam, *He Called Them by Lightning: A Teacher's Odyssey in the Negro South, 1908–1919* (Indianapolis: Bobbs-Merrill Co., 1967), 89, 150–54.

123. Pickens, *Bursting Bonds,* 134, 141–52, 169–70, 175–77.

124. Fields, *Lemon Swamp,* 23–24.

125. *American Missionary* 54 (April, May, June 1900): 61–62; *Constitution and Rules of Humane Brotherhood;* Browning, "The Beginning of Insurance Enterprise among Negroes," 424, 426–27; Purse, *Charleston City Directory and Strangers' Guide for 1856,* 207, 209, 220; *List of the Tax Payers of the City of Charleston for 1859,* 391, 401; *List of the Tax Payers of the City of Charleston for 1860,* 330–31. FMS, September 13, 1841; March 9, 1846; April 13, 1846; July 11, 1853. *Avery Catalogue, 1906,* 25–36; Edward Mickey, Record of Wills, 310/11, CCPC; Edward H. Mickey, Record of Wills, 428/36, CCPC; Mickey-Harleston tombstones, Unity and Friendship Burial Society Cemetery, Charleston, S.C.; Whitlock, "Edwin A. Harleston"; Holt, *Black over White,* appendix A. Compare the list of graduates in *Avery Catalogue, 1906* with the city tax lists for 1859 and 1860. Browning, who studied the descendants of the members of the Humane Brotherhood in the 1930s, wrote: "The dark men committed race suicide, for as they accumulated property they almost always married fairer women." Viewed from another perspective, the free brown elite was becoming less fair. Today, nobody, including relatives of the Harlestons, recalls that Mickey family patriarch Edward H. Mickey (died 1883) was dark.

126. Clark, *Echo in My Soul,* 14–16, 80; *The Pinnacle;* Fields, *Lemon Swamp,* 2, 13, 47.

127. Charleston *News and Courier,* September 16, 17, 1960; *Avery Catalogue, 1906,* 28, 36; *Avery Catalogue, 1910,* 18, 22–24; *Avery Examinations, 1885;* "Charleston Snobbish Negro Aristocracy 'Passing' Out of Existence," *Ebony* 1 (October 1946): 17; Joseph I. Hoffman, interview, September 25, 1980, October 9, 1980; Harlan and Smock, eds., *The Booker T. Washington Papers,* 6: 147. Julia Craft DeCosta told me about her ancestry. William Crum, who married Ellen Craft, the daughter of the fugitive slaves William and Ellen Craft, is her uncle. The DeCosta family tombstone in the Unity and Friendship Society Cemetery lists three generations, beginning with Benjamin DeCosta (1834–1870) and his wife Martha E. Adams (1883–1915). According to folklore, there were misgivings.

128. Ray Stannard Baker, "Following the Color Line," *American Magazine* 63 (April 1907): 564–66; Ray Stannard Baker, *Following the Color Line* (New York: Doubleday, Page, 1908); *Fourth Annual Circular and Prospectus of the Charleston Normal and Industrial Institute* and *The Negro Co-operative and Protective Union of Charleston, S.C. (Incorporated.),* Charleston Industrial Institute [folder], Archibald H. Grimke Papers; Caldwell, ed., *History of the American Negro, South Carolina Edition,* 212; Meier, *Negro Thought in America, 1880–1915,* 152.

129. Newby, *Black Carolinians,* 145; Charleston *News and Courier,* July 31, 1937; *Year Book, 1898, City of Charleston, So. Ca.,* 266–67; Green, *Edmund Thornton Jenkins,* 4–11; Caldwell, ed., *History of the American Negro, South Carolina Edition,* 210–12, 557–60; Porter, *Led On,* 224; Moore, "A History of the Negro Public Schools of Charleston, South Carolina, 1867–1942," 16–18; Orphan Aid Society, Obear-Osmar Papers, no. 2452, South Caroliniana Library, University of South Carolina, Columbia, S.C.; Tindall, *South Carolina Negroes, 1877–1900,* 278–79. Clipping, "Orphan Aid Society Met—for Year 1909," Charleston *Messenger,* n.d., James R. Logan Scrapbook, identifies Jenkins as the editor of the newspaper.

130. Clipping, Charleston *Messenger,* January 7, 1911, and J. L. Mitchell to J. R. Logan, August 31, 1904, James R. Logan Scrapbook; photograph, "Dr. W. E. B. Du Bois and Sight-seeing Party," ARC.

131. Clipping, Charleston *Messenger,* January 7, 1911, James R. Logan Scrapbook; Green, *Edmund Thornton Jenkins,* 22–24, 27; *Avery Catalogue, 1906,* 34; Whitlock, "Edwin A. Harleston," 9, 20; Application for Charter, dated February 27, 1917, NAACP Papers.

132. Caldwell, ed., *History of the American Negro, South Carolina Edition,* 749–51; Arthur J. Clement, Jr., interview, August 27, 1986; "Historical Notes, Avery Institute, 1865–1947," 5; L. P. Bell to W. White, April 16, 1937, and A. J. Clement, Jr., to the Editor, Charleston *News and Courier,* n.d. (ca. 1937), NAACP Papers.

133. Caldwell, ed., *History of the American Negro, South Carolina Edition,* 749–51; Arthur J. Clement, Jr., interview, August 27, 1986; *Avery Catalogue, 1906,* 30; Leroy F. Anderson, "Arthur J. H. Clement, Jr., Dies," *Avery Institute of Afro-American History and Culture Bulletin* 6 (Fall 1986): 1; "Historical Notes, Avery Institute, 1865–1947," 6; W. H. Grayson to A. J. Clement, Jr., August 29, 1944, AMAA Addendum; Charleston *News and Courier,* September 24, 25, 1986. *The Faculty and Class of Nineteen Twenty-Six of Avery Institute Request Your Presence at the Commencement Exercises, Wednesday, May the Twenty-Six, Morris Street Baptist Church, Eight O'Clock* [hereafter cited as *Avery Commencement Invitation, 1926*] lists Irma Lauretta Robinson as a graduate. *The Faculty and Class of Nineteen Twenty-Eight of Avery Institute Request Your Presence at the Commencement Exercises on the Evening of Wednesday, June Sixth, Eight O'Clock, Morris Street Baptist Church* [hereafter cited as *Avery Commencement Invitation, 1928*] lists Emma Edith Clement as a graduate and commencement speaker. *The Faculty and Class of Nineteen Thirty of Avery Institute Request Your Presence at the Commencement Exercises on the Evening of Wednesday, June Fourth, Eight O'Clock, Morris Street Baptist Church, Charleston, South Carolina* [hereafter cited as *Avery Commencement Invitation, 1930*] lists William Arthur Clement as an honor graduate. *The Faculty of Avery High School Presents the Senior Class in "Avery—Past, Present, and Future"* lists Arthur J. Howard Clement as a four-year honor student. *Programme of the Eighty-Seventh Commencement of Avery High School, Charleston, South Carolina, Wednesday, June 4, 1952, Eight P.M., Morris Street Baptist Church* [hereafter cited as *Avery Commencement Program, 1952*] lists William Joseph Clement as a four-year honor graduate.

134. Green, *Edmund Thornton Jenkins,* 22–24; clipping, [Charleston *Messenger*], April 10, 1915, James R. Logan Scrapbook; *Avery Catalogue, 1910,* 21; Eugene C. Hunt, interview, August 28, 1980, November 4, 1980, December 4, 1985. Clipping, "Orphan Aid Society Mct—for Year 1909," Charleston *Messenger,* n.d., James R. Logan Scrapbook, identifies Logan as "associate news editor" of the paper.

135. Card, *A Rare Novelty: A Musicale and Assembly Will Be Given at Carpenter's Hall, Line Street, Monday Evening, September 9, 1912 under the Auspices of the Young Men's Christian Association. . .* ; clipping, New York *Age,* December 23, 1915; and clipping, [Charleston *Messenger*], April 10, 1915; all in James R. Logan Scrapbook. J. Michael Graves, interview, March 7, 1985.

136. Williamson, *New People,* 112–13, 118–19; Fields, *Lemon Swamp,* 46–47, 64; Felder Hutchinson, interview, July 16, 1985; Bureau of the Census, *Thirteenth Census of the United States, Taken in the Year 1910,* vol. 3, *Population 1910 Reports by States, with Statistics for Counties, Cities, and Other Divisions, Nebraska–Wyoming, Alaska, Hawaii, and Puerto Rico, Prepared under the Supervision of William C. Hunt, Chief Statistician for Population* (Washington, D.C.: Government Printing Office, 1913), 658, 666. Some

of the older graduates mentioned class members' leaving for the North and passing for white.

CHAPTER 4. THE COX ERA, 1914–1936

1. *American Missionary* 77 (January 1923): 538; *The Congregationalist and Herald of Gospel Liberty Continuing the Recorder, the Advance, and the American Missionary,* Boston, 118 (February 2, 1933): 136.

2. *The Congregationalist and Herald of Gospel Liberty* 118 (February 2, 1933): 136; *The Congregationalist and Herald of Gospel Liberty* 118 (May 4, 1933): 577; *American Missionary* 74 (July 1920): 201–2; *American Missionary* 84 (December 4, 1930): 753; Williamson, *The Crucible of Race,* 473–74.

3. Abstract "History of Avery Institute, Charleston, S.C.," ca. 1941, 48–49, AMAA Addendum; flyer *Burrell Normal School, George N. White, Principal,* n.d., AMAA Addendum; pamphlet, Jeannette (Mrs. Benjamin F.) Cox, *Albany Normal School, Albany, Georgia,* stamp dated June 8, 1909, AMAA Addendum; *American Missionary* 68 (October 1914): 408; A. R. Cox-Davis to E. C. Hunt, June 25, 1986, private hands, Charleston, S.C.; poem " 'Our Faculty,' 1914–1915" in *The Pinnacle.*

4. See note 3.

5. L. Howard Bennett, interview with the author and Eugene C. Hunt, Charleston, June 23–24, 1981; *American Missionary* 79 (April 1925): 64; *AMA Annual Report (1927),* 24.

6. Sarah Green Oglesby, interview with the author and Eugene C. Hunt, Charleston, October 14, 28, 1980; *AMA Annual Report (1928),* 28–29; *AMA Annual Report (1929),* 38; Columbia *Palmetto Leader,* May 31, 1930.

7. *AMA Annual Report (1928),* 28–29; *The Southern Regional Council: Its Origin and Purpose* (Atlanta: Southern Regional Council, 1944), 3; Charleston *News and Courier,* May 16, 1919.

8. Fields, *Lemon Swamp,* 192–93; Charleston *News and Courier,* August 15, 1956; Clelia D. Hendrix, "Women in Politics," *South Carolina Women,* Columbia, 7 (Summer 1986): 1; Whitlock, "Edwin A. Harleston," 24; City Board of School Commissioners Minute Books, October 1924–April 1930, petition, dated December 17, 1925, from Inter-Racial Committee, p. 105 (January 6, 1926), OAR, CCSD; C. P. McGowan to E. A. Harleston, July 20, 1926, Edwin A. Harleston Papers, Edwina Harleston Whitlock, Charleston, S.C.

9. Whitlock, "Edwin A. Harleston," 24. Columbia *Palmetto Leader,* November 28, 1925; January 24, 1931.

10. Columbia *Palmetto Leader,* January 24, 1931; City Board of School Commissioners Minute Books, October 1924–April 1930, p. 212 (April 6, 1927).

11. City Board of School Commissioners Minute Books, October 1924–April 1930, petition, dated December 17, 1925, from Inter-Racial Committee, p. 105 (January 6, 1926); Butler, "Making a Way to Start a Library." Charleston *News and Courier,* May 19, 1957; June 5, 1959. Fields, *Lemon Swamp,* 209.

12. *American Missionary* 69 (June 1915): 149–50; *American Missionary* 77 (January 1923): 538–40; *Avery News,* October 1931; L. Howard Bennett, interview, June 23–24, 1981; Joseph I. Hoffman, interview, September 25, 1980, October 9, 1980;

Eugene C. Hunt, interview, August 28, 1980, November 4, 1980, December 4, 1985. Lois Simms, interview with the author, Charleston, August 28, 1984; Lillian Ransier Wright, interview with the author and Eugene C. Hunt, Charleston, April 10, 1981.

13. L. Howard Bennett, interview, June 23–24, 1981; Lillian Ransier Wright, interview, April 10, 1981. Charlotte D. Tracy, interview with the author, Charleston, November 24, 1982; Ruby P. Cornwell, interview with the author and Eugene C. Hunt, Charleston, November 24, 1982. *American Missionary* 69 (June 1915): 149–50.

14. *AMA Annual Report (1930)*, 42; Frederick L. Brownlee, *Some Lights and Shadows of 1932–1933* (New York: 1933), 48–49; *The Faculty and Class of Nineteen Thirty-Five of Avery Institute Request Your Presence at Their Commencement Exercises on Wednesday Evening, June Fifth, Eight O'Clock, Morris Street Baptist Church, Charleston, South Carolina* [hereafter cited as *Avery Commencement Invitation, 1935*]. Leroy Anderson, interview, July 10, 1985; Joseph I. Hoffman, interview, September 25, 1980, October 9, 1980; Lois Simms, interview, August 28, 1984; Eugene C. Hunt, interview, August 28, 1980, November 4, 1980, December 4, 1985; Peter Poinsette, interview, March 31, 1981; Sarah Green Oglesby, interview, October 14, 28, 1980; L. Howard Bennett, interview, June 23–24, 1981; Arthur J. Clement, Jr., interview, August 27, 1986; Ruby P. Cornwell, interview, November 24, 1982; Charlotte D. Tracy, interview, November 24, 1982.

15. Joseph I. Hoffman, interview, September 25, 1980, October 9, 1980; Lillian Ransier Wright, interview, April 10, 1981. *American Missionary* 73 (October 1919): 359–61.

16. Ellen Wiley Hoffman, interview with the author and Eugene C. Hunt, Charleston, September 18, 1980; Peter Poinsette, interview, March 31, 1981; J. Michael Graves, interview, March 7, 1985; *Avery News*, October 1931; Joe M. Richardson, *A History of Fisk University, 1865–1946* (University: University of Alabama Press, 1980), 149–52; "Principals and Teachers at Avery Institute, Charleston, South Carolina," attached with R. A. Morton to J. F. Potts, September 19, 1949, AMAA Addendum; *American Missionary* 79 (April 1925): 59; *The Avery Song. Poem by Beulah Shecut, 1928; Music by Maude H. Smith, 1915* ([Charleston]: Avery Normal Institute, n.d.); *AMA Annual Report (1932)*, 37. Commencement invitations and programs, beginning 1918, usually list "Hallelujah Chorus." ARC has a picture of Maude Smith with the glee club.

17. Lillian Ransier Wright, interview, April 10, 1981; Sarah Green Oglesby, interview, October 14, 28, 1980; J. Michael Graves, interview, March 7, 1985; program *The Senior Class Presents "The District Attorney," a Comedy Drama in Three Acts by Orvin E. Wilkins, Friday Evening, May 16th, 1930, Curtain at 8 P.M. in the School Auditorium*, AMAA Addendum; *Avery Tiger*, December 1942; *The Averyite, Nineteen Hundred and Thirty-Nine* (Charleston: Senior Class of Avery Institute, n.d.); Frederick L. Brownlee, *Facing Facts: A Review of the American Missionary Association's Eighty-Ninth Year*, 68. Poinsette kept a scrapbook used in an Avery exhibit. I saw in this exhibit a playbill entitled "Shakespeare's 'As You Like It,' 1917." While I was viewing the exhibit, a graduate told me about Poinsette's remarks on the way that drama built character. Eugene C. Hunt recollected to me the magic she achieved in transforming Avery Hall into a set.

18. Program *Boys' Annual Speaking Contest, Avery Auditorium, Monday, May 25, 1936, Eight P.M.*; program *Girls' Annual Speaking Contest, Avery Auditorium, Tues-*

day, May 26, 1936, Eight P.M.; Joseph I. Hoffman, interview, September 25, 1980, October 9, 1980; Sarah Green Oglesby, interview, October 14, 28, 1980; J. Michael Graves, interview, March 7, 1985; Leroy Anderson, interview, July 10, 1985; Anna D. Kelly, interview with the author, Charleston, August 20, 1984; Leroy Anderson, phone conversation, December 22, 1988; *Avery Commencement Invitation, 1918.* Older Avery graduates told me they delivered their rhetoricals in the evening at a local church (for instance, Zion Presbyterian or Morris Street Baptist). Eugene C. Hunt informed me of the importance of being chosen to speak at the commencement exercises. For the topics, see the invitations and programs in ARC.

19. Frederick L. Brownlee and William A. Daniel, *Review of the Mission Field for Year 1933–1934,* 52; *American Missionary* 70 (July 1916): 223–24; *AMA Annual Report (1930),* 42; *AMA Annual Report (1932),* 37; *The Pinnacle; Avery Tiger,* December 1951; three-page biography of Robert F. Morrison, Robert F. Morrison Papers, Constance Morrison Thompson, Detroit, Mich. I saw in an Avery exhibit a photograph entitled "Avery's First Basketball Team, 1915."

20. Sarah Green Oglesby, interview, October 14, 28, 1980; Lillian Ransier Wright, interview, April 10, 1981; Charlotte D. Tracy, interview, November 24, 1982; Eugene C. Hunt, interview, August 28, 1980, November 4, 1980, December 4, 1985; Mrs. Theodore (Thelma Hoursey) Simmons, interview with the author and Eugene C. Hunt, Charleston, March 26, 1981.

Jeannette Cox's advice, however quaint it appears today, dealt with a real problem. As a coeducational institution, Avery placed the two sexes in a proximity considered potentially dangerous. School officials tried to compensate for the problem by separating the men and women during recreational times on the school grounds. Class activities were strictly chaperoned. According to the oldest graduates, the class prom was actually a banquet rather than a dance. By the 1940s, dancing was part of the prom because women graduates had dance cards. Sometimes parents removed their children from Avery, even sending them away to schools outside the city, to break up real or imagined involvements. A girl's misfortune (pregnancy) was sometimes presented as an object lesson to her peers. For Cox, women were apparently considered more capable of exercising the self-discipline at times lacking in the men. Rumors of the sexual misdeeds of some of the community's prominent leaders, including ministers, probably only served to reinforce such attitudes.

21. Ellen Wiley Hoffman, interview, September 18, 1980; "A History—by Administrations—of the Phyllis Wheatley Literary and Social Club by Jeannette Keeble Cox [1934]," 1–10, 23, 26, 28, 31–32, 39, 41, 47–48, 51, 57, 66, 68–69, ARC [hereafter cited as "History, Phyllis Wheatley"]; *Avery Catalogue, 1906,* 25–36; *Avery Catalogue, 1910,* 21–23; Eric S. Wells's comments, dated May 4, 1969, on his April 17, 1929, Avery essay dealing with "Charleston vendors," Eric S. Wells Papers, AMISTAD; *Avery Commencement Program, 1918. AMA Annual Report (1917)* lists the staff.

22. "History, Phyllis Wheatley," 4, 7–8, 16–19, 21, 23, 25–28, 30, 32–33, 37–39, 43, 45–46, 51, 54–56; program *Piano Recital by William S. Lawrence, Pianist, Assisted by Roland W. Hayes, Tenor, at Morris Street Baptist Church, Monday Evening, February 28th, 1916 at 8-15 O'Clock, James R. Logan Scrapbook; American Missionary* 79 (April 1925), 59; Whitlock, "Edwin A. Harleston," 18; program *A Drama Entitled Lady Windermere's Fan Presented by The Phyllis Wheatley Literary Society at Avery Hall, Friday Eve., May 5, 1922,* Edwin A. Harleston Papers; flyer *The Phyllis Wheatley Liter-*

ary Society of Charleston, S.C., Will Present before the Summer School in the Chapel of State College on Wed. Evening, July 12, a Drama of Modern Life Entitled "Lady Winde[r]mere's Fan" by Oscar Wilde, the Noted English Writer, Edwin A. Harleston Papers; R. F. Mickcy to E. A. Harleston, July 17, 1922, Edwin A. Harleston Papers.

23. "History, Phyllis Wheatley," 1–8, 11, 14–15, 21–26, 28–31, 33–39, 45–47, 51, 56–59, 61–62; Fields, *Lemon Swamp*, 197–99; Gordon, *Sketches of Negro Life and History in South Carolina*, 180–82.

24. "History, Phyllis Wheatley," 21, 49, 34–35; Gordon, *Sketches of Negro Life and History in South Carolina*, 185–86; E. Franklin Frazier, *The Negro in the United States* (New York: Macmillan Co., 1949), 532–33.

25. Joseph I. Hoffman, interview, September 25, 1980, October 9, 1980; Ellen Wiley Hoffman, interview, September 18, 1980; Thomas R. Waring, "Lowcountry Doctor Takes in Shingle," Charleston *News and Courier–Evening Post*, August 24, 1981, 2E; "History, Phyllis Wheatley," 49; *Avery Catalogue, 1906*, 31; *Avery Commencement Invitation, 1918.*

26. Clark, *Echo in My Soul*, 27–28, 73.

27. Ibid., 32–33, 36–39, 53–54.

28. Ibid., 36–37, 40–41, 49–51, 54, 73–74.

29. Ibid., 53–54.

30. Ibid., 40–45, 47–49, 54–58, 73–75; *[Programme, Avery Normal Institute] 1925;* Mrs. Theodore (Thelma Hoursey) Simmons, interview, March 26, 1981.

31. Clark, *Echo in My Soul*, 40–41, 48, 51–52.

32. Fields, *Lemon Swamp*, 83–85, 104–5.

33. *AMA Annual Report (1930)*, 42; *Avery Commencement Invitation, 1928;* Charleston *News and Courier–Evening Post*, January 13, 1985.

34. Alphonso William Hoursey, "A Follow-Up Survey of Graduates of Avery Institute, Charleston, South Carolina, for Years 1930–1940" (Master's thesis, University of Michigan, 1941), attached with A. W. Hoursey to R. A. Morton, July 19, 1941, AMAA Addendum; *The Faculty and Graduating Class of Avery Normal Institute Request the Honor of Your Presence at the Commencement Exercises at Eight O'Clock, Wednesday, May the Twenty-Sixth, Nineteen Hundred and Twenty, Morris Street Baptist Church, Charleston, S.C.* [hereafter cited as *Avery Commencement Invitation, 1920*]; *Ninety Years After. . . ?* 40; W. E. B. Du Bois, *The Philadelphia Negro: A Social Study, 1899* (New York: Schocken Books, 1967), 1, 170–71, 309–11. The survey was made by Alphonso W. Hoursey, an Avery graduate (1920), who returned to teach at his alma mater later in the twenties and studied the Avery graduates of the 1930s for his M.A. thesis. Hoursey sent questionnaires to the 557 individuals graduating between 1930 and 1940, a period that covered the last part of the Cox era and four years thereafter. Of the 557 Averyites who were sent questionnaires, 499, or 89.6 percent, responded. More than three-quarters of these 499 graduates were single. Of the 342 listing their occupations, 237, or 69.3 percent, were teachers. Of the 105 non-teachers, 27, or 25.7 percent, were professionals (ministers, doctors, dentists, trained nurses, undertakers, musicians, insurance agents, news agents, interior decorators). Another 26, or 24.8 percent, of the nonteachers could be described as white-collar workers (office workers, clerks, government employees). The remaining 52, or 49.5 percent, of the nonteachers were laborers, mechanics, carpenters, porters, painters, bricklayers, factory workers, bellmen, waiters, maids, chauffeurs, messengers, theater

ushers, barbers, beauticians, newspaper workers, sailors, and playground attendants. Of the total 499 Averyites responding to Hoursey's questionnaire, 426, or 85.4 percent, resided in South Carolina. The great preponderance of these 426 (287, or 67.4 percent) lived in Charleston County. Most of the rest lived in or near the surrounding tricounty area: Berkeley (32, or 7.5 percent); Dorchester (33, or 7.7 percent); Colleton (30, or 7.0 percent). The remaining 44, or 10.3 percent, resided elsewhere in South Carolina.

35. Charlotte D. Tracy, interview, November 24, 1982; Clark, *Echo in My Soul,* 59.

36. Leroy Anderson, interview, July 10, 1985; J. Michael Graves, interview, March 7, 1985; Eugene C. Hunt, interview, August 28, 1980, November 4, 1980, December 4, 1985. *Avery Commencement Invitation, 1935.*

37. Anderson interview; Graves interview; Hunt interview; Thomas R. Waring, "First Black Teaches Speech at College of Charleston," Charleston *News and Courier–Evening Post,* December 2, 1984, 2F.

38. See note 37; Charleston *News and Courier,* April 21, 1986.

39. Anderson interview; Graves interview; Hunt interview; Waring, "First Black Teaches Speech at College of Charleston."

40. See note 39.

41. See note 39; Lois Simms, interview, August 28, 1984. The Avery graduate Elmore Browne also told me about the East Side.

42. Clark, *Echo in My Soul,* 20–21, 29–31; Fields, *Lemon Swamp,* 24–25; J. Michael Graves, interview, March 7, 1985; Anna D. Kelly, interview, August 20, 1984; Thomas R. Waring, "Teaching Is Her Life," Charleston *News and Courier–Evening Post,* November 14, 1982, 2E.

43. Felder Hutchinson, interview, July 16, 1985. Columbia *Palmetto Leader,* January 4, 11, 1930; May 31, 1930; November 1, 1930. I was invited to visit one of the fraternity houses.

44. Anderson interview; Graves interview; Hunt interview; Waring, "First Black Teaches Speech at College of Charleston"; Charleston *News and Courier,* December 21, 1966; *The State,* Columbia, March 25, 1934; *Who's Who in America, 1974–1975,* 38th ed. (Chicago: Marquis Who's Who, 1974), 2: 2838.

45. Hutchinson interview; Anderson interview; Graves interview; Hunt interview; *The Averyite, Nineteen Hundred and Thirty-Nine.*

46. Anderson interview; Graves interview; Hunt interview; Waring, "First Black Teaches Speech at College of Charleston"; *Good for One Lesson, Piano, Anna E. Logan, Residence: 177 President Street, Dial 8670,* James R. Logan Scrapbook; *Avery Tiger,* February 1941.

47. Anderson interview; Graves interview; Hunt interview; Peter Poinsette interview.

48. Anderson interview; Graves interview; Hunt interview; Hutchinson interview; Arthur J. Clement, Jr., interview; James R. Logan Scrapbook; three-page biography of Robert F. Morrison, Robert F. Morrison Papers; *The Averyite, Nineteen Hundred and Thirty-Nine.* Charleston *News and Courier,* February 19, 1950; January 24, 25, 1954. Arthur J. Clement, Jr., "Alumni Pay Tribute to a Principal," Charleston *Evening Post,* June 4, 1982, [10A], and "Two Hundred Fifty Years of Afro-American Business in Charleston," *Avery Institute of Afro-American History and Culture Bulletin*

3 (Spring 1985). Clement wrote regularly for local newspapers and gave lectures. Herbert Fielding, who recalled reading McFall's MS, told me that McFall had tried unsuccessfully to get it published.

49. Lillian Ransier Wright, interview, April 10, 1981; James R. Logan Scrapbook; Holloway Family Papers, SCRSSL; Charleston *Chronicle*, April 2, 1983; Waring, "Nonagenarian Enjoys Her Memories"; Browning, "The Beginning of Insurance Enterprise among Negroes," 417–32; Fitchett, "The Traditions of the Free Negro in Charleston, South Carolina," 139–52; Birnie, "Education of the Negro in Charleston, South Carolina, Prior to the Civil War," 13–21; Gordon, *Sketches of Negro Life and History in South Carolina*, 136–39. When Eugene C. Hunt and I were giving a tour of Charleston's black cemeteries as part of a gala reunion sponsored by the Avery Institute of Afro-American History and Culture in July 1985, a tour member related how Logan shared his scrapbook with the youth.

50. Felder Hutchinson, interview, July 16, 1985; "History, Phyllis Wheatley."

51. J. A. Bell to author, December 18, 1956; Marriage Register, June 20, 1923, in Parish Records, 1866–1965, St. Mark's Protestant Episcopal Church, Charleston, microfiche no. 50-328, SCHS; Harlan, ed., *The Booker T. Washington Papers*, 2: 517–18; Bell Family Papers, SCRSSL.

52. *Program, Emancipation Day, to Be Held at Morris Street Baptist Church on Friday, Jan. 1st, 1926*, Edwin A. Harleston Papers; *Avery Tiger*, October 1951; Charleston *News and Courier*, July 31, 1937. I have seen programs for the services of both Daniel J. Jenkins and his son Edmund. Hunt can barely recall what he sang for Daniel Jenkins's funeral service.

53. See the burial societies, Brotherly Association and Friendly Union, off Meeting and Cunnington streets in Charleston.

54. *American Missionary* 77 (January 1923): 538–40; *American Missionary* 79 (April 1925): 64; F. L. Brownlee to E. A. Harleston, May 2, 1924, Edwin A. Harleston Papers; flyer *Avery's Deeds and Needs*, ca. 1927.

55. Three-page biography of Robert F. Morrison, Robert F. Morrison Papers; Executive Committee and Administrative Committee [minutes] from June 1919 to April 1930, pp. 8–9 (July 8, 1919), AMAA Addendum.

56. "American Missionary Association Educational Commission: Suggested Topics and Assignments," n.d., Beam-Douglas Papers, AMISTAD. Avery Alumni Association to Dear Friend, type dated September 21, 1923, but hand dated October 1924; C. Thompson to J. A. McFall, April 29, 1924; F. L. Brownlee to E. A. Harleston, May 2, 1924; and handwritten notes on "Meeting of Avery Advisory Board, Jan 10, 1925, 50 Cannon St"; Edwin A. Harleston Papers. Three-page biography of Robert F. Morrison, Robert F. Morrison Papers; Executive Committee and Administrative Committee [minutes] from June 1919 to April 1930, pp. 331–32 (May 14, 1925), and p. 345 (September 15, 1925), AMAA Addendum. For founding of NAACP branch in Charleston, see later discussion in this chapter.

57. Three-page biography of Robert F. Morrison, Robert F. Morrison Papers; *The Pinnacle; Avery Tiger*, December 1951; *Avery Catalogue, 1906*, 32–33, 35; Naming Columbus Street School, Naming East Bay School, Box 863, OAR, CCSD; Purse, *Charleston City Directory and Strangers' Guide for 1856*, 215, 222. For Constance W. Morrison's years on the Avery faculty, see *AMA Annual Reports (1902–*

1912); Edna P. Morrison, *(1913–1927);* Serena Hamilton, *(1915–1918).* Robert Morrison's daughter, Constance M. Thompson, working on the family genealogy, assembled the Wilkinson connection.

58. Three-page biography of Robert F. Morrison, Robert F. Morrison Papers. Executive Committee and Administrative Committee [minutes] from June 1919 to April 1930, pp. 331–32 (May 14, 1925), and p. 345 (September 15, 1925); and J. A. McFall to R. A. Morton, May 30, 1944; AMAA Addendum. Avery Alumni Association to Dear Friend, type dated September 21, 1923, but hand dated October 1924; and F. L. Brownlee to E. A. Harleston, May 2, 1924; Edwin A. Harleston Papers. *AMA Annual Report (1925),* 18–19.

59. Ellen Wiley Hoffman, interview, September 18, 1980; *AMA Annual Report (1927),* 24, 52; *American Missionary* 81 (May 1927): 714–15; *Avery's Deeds and Needs;* Charleston *News and Courier,* January 15, 1927.

60. Brownlee, *Some Lights and Shadows of 1932–1933,* 49; *Avery News,* October 1931; *Avery Tiger,* November 1940; *Avery's Deeds and Needs.* Flyer *Celebrating the Ninth Anniversary of the Avery Club of Brooklyn,* 1937; F. A. Clyde to H. E. Williams, May 5, 1944; J. A. McFall to R. A. Morton, May 30, 1944; S. T. Washington to H. E. Williams, February 15, 1945; AMAA Addendum. H. M. Barre to E. [S. Wells], July 21, 1950, Eric S. Wells Papers.

61. C. Thompson to J. A. McFall, April 29, 1924; F. L. Brownlee to C. S. Ledbetter, January 6, 1925; "Meeting of Avery Advisory Board, Jan 10, 1925, 50 Cannon St"; F. L. Brownlee to C. S. Ledbetter, Western Union Telegram, January 5, 1925; Edwin A. Harleston Papers. City Board of School Commissioners Minute Books, October 1924–April 1930, pp. 110–12 (February 3, 1926); p. 124 (February 8, 1926); pp. 139–40 (April 7, 1926).

62. *Avery's Deeds and Needs; American Missionary* 79 (April 1925): 64–65.

63. *American Missionary* 80 (January 1926): 459; Clement, "Alumni Pay Tribute to a Principal."

64. F. L. Brownlee to E. A. Harleston, May 2, 1924; F. L. Brownlee to E. A. Harleston, March 13, 1925; F. L. Brownlee to C. S. Ledbetter, January 6, 1925; E. C. Mickey to E. A. Harleston, January 22, 1926; Edwin A. Harleston Papers. *American Missionary* 77 (January 1923): 538–40; *AMA Annual Report (1925),* 18–19; J. A. McFall to R. A. Morton, May 30, 1944, AMAA Addendum; Executive Committee and Administrative Committee [minutes] from June 1919 to April 1930, pp. 331–32 (May 14, 1925), p. 345 (September 15, 1925), AMAA Addendum.

65. E. C. Mickey to E. A. Harleston, January 22, 1926, Edwin A. Harleston Papers; R. A. Morton to A. W. Hoursey, May 12, 1944, AMAA Addendum; J. A. McFall to R. A. Morton, May 30, 1944, AMAA Addendum; Executive Committee and Administrative Committee [minutes] from June 1919 to April 1930, pp. 331–32 (May 14, 1925), p. 345 (September 15, 1925), AMAA Addendum; and "Historical Notes, Avery Institute, 1865–1947," 5, AMAA Addendum.

66. L. Howard Bennett, interview, June 23–24, 1981; John F. Potts, interview, April 17, 1982; Ruby P. Cornwell, interview, November 24, 1982. *AMA Annual Report (1926);* Caldwell, ed., *History of the American Negro, South Carolina Edition,* 224–26.

67. Clark, *Echo in My Soul,* 24–25; Charleston *News and Courier,* June 19, 1972; Charlotte D. Tracy, interview, November 24, 1982; "History of Avery Institute, Charleston, S.C.," 38–39, AMAA Addendum. *AMA Annual Report (1927),* 24; *AMA*

Annual Report (1929), 38; *AMA Annual Report (1931)*, 36; *AMA Annual Report (1932)*, 37; Brownlee, *Facing Facts*, 68.

68. Hoursey, "A Follow-Up Survey of Graduates of Avery Institute, Charleston, South Carolina, for Years 1930–1940," AMAA Addendum; Employment Applications and Appointment Contracts, 1926–1947, William E. Bluford, Susie A. Butler, Florence A. Clyde, Frank A. DeCosta, AMAA Addendum [hereafter cited as EAAC]; *Avery Tiger*, November 1941, December 1942, December 1950, May 1951; *AMA Annual Report (1927)*, 52; *AMA Annual Report (1932)*, 37; *The Faculty and Class of Nineteen Thirty-Four of Avery Institute Request Your Presence at the Commencement Exercises on the Evening of Wednesday, June Sixth, Eight O'Clock, Morris Street Baptist Church, Charleston, South Carolina* [hereafter cited as *Avery Commencement Invitation, 1934*].

69. Clark, *Echo in My Soul*, 24; "Class History," *The Pinnacle;* Fred L. Brownlee, *New Day Ascending* (Boston: Pilgrim Press, 1946), 136–37; L. Howard Bennett, interview, June 23–24, 1981.

70. "History, Phyllis Wheatley," 2–3, 9, 11, 21, 45, 49, 53.

71. Ibid., 7, 9, 16–17, 27, 32, 38–39, 45–46, 54–56, 59–60, 67.

72. *The Pinnacle;* Clement, "Alumni Pay Tribute to a Principal."

73. J. Michael Graves, interview, March 7, 1985; Leroy Anderson, interview, July 10, 1985.

74. EAAC, William E. Bluford; Mrs. B. F. Cox to Mr. Dill, February 11, 1926, NAACP Papers; Carter G. Woodson, *The Mis-Education of the Negro* (Washington, D.C.: Associated Publishers, 1933; New York: AMS Press, 1972), ix–xiv. Also see Avery commencement invitations and programs for those years indicated in text. Bluford, on his AMA application dated April 25, 1930, lists Logan as a reference for his scholastic ability.

75. *Avery News*, October 1931; Whitlock, "Edwin A. Harleston," 19, 26; communication to author from Smithsonian Institution Traveling Exhibition Service, Washington, D.C., "Portraits in Black: Outstanding Americans of Negro Origin from the Harmon Collection of the National Portrait Gallery," ca. 1984.

76. McPherson, *The Abolitionist Legacy*, 292–94; *American Missionary* 68 (April 1914): 25; Clark, *Echo in My Soul*, 24–25. Executive Committee [minute] Book, Beginning October 1913, pp. 29–30 (May 12, 1914), p. 55 (June 9, 1914), AMAA Addendum. *The Pinnacle*, dedication page.

77. *American Missionary* 70 (July 1916): 222–24; *American Missionary* 79 (April 1925): 64–65; "Historical Notes, Avery Institute, 1865–1947," 5.

78. Manigault, "Negroes in City Schools Once Had White Teachers"; City Board of School Commissioners Minute Books, January 1913–June 1919, p. 9 (February 5, 1913).

79. Application for Charter, dated February 27, 1917, NAACP Papers; E. A. Harleston to J. R. Shillady, November 2, 1918, NAACP Papers; *Avery Commencement Program, 1918; Walsh's Charleston, South Carolina 1917 City Directory, Thirty-Fifth Year* (Charleston: Walsh Directory Co., 1917), 601, 623; *Avery Catalogue, 1906*, 34–35; *Avery Catalogue, 1910*, 22; Whitlock, "Edwin A. Harleston," 9–28. Mae Holloway Purcell told me Susie Dart Butler attended Avery before she transferred to Atlanta University.

80. Whitlock, "Edwin A. Harleston," 9–28; *Avery Catalogue, 1910*, 22; Savan-

nah *Tribune*, May 14, 1931; A. Locke to Mrs. Harleston, May 12, 1931, Edwin A. Harleston Papers.

81. Photograph of Du Bois with members of sight-seeing party, dated March 1917, ARC; E. C. Mickey to Dear Sirs, April 3, 1921, NAACP Papers; *Avery Commencement Program, 1918; The Graduating Class of Avery Normal Institute Requests the Honor of Your Presence at Their Commencement Exercises at Eight O'Clock P.M., Wednesday, May the Twenty-Fourth, Nineteen Hundred and Twenty-Two, Morris Street Baptist Church, Charleston, South Carolina* [hereafter cited as *Avery Commencement Invitation, 1922*]; Williamson, *The Crucible of Race*, 130–39. Edwina H. Whitlock told me about Harleston's relationship with Du Bois at Atlanta University.

82. Application for Charter, dated February 27, 1917; E. A. Harleston to J. R. Shillady, November 2, 1918; C. S. Ledbetter to R. W. Bagnell, February 19, 1923; Mrs. B. F. Cox to Mr. Dill, February 11, 1926; Director of Branches to Mrs. B. F. Cox, February 19, 1926; clipping, Charleston *Messenger*, hand dated June 20, 1925; clipping, *The Omaha Guide*, hand dated March 26, 1927; Membership Report Blank, dated February 12, 1931; M. W. Ovington to E. B. Burroughs, January 12, 1934; E. B. Burroughs to M. W. Ovington, January 19, 1934; NAACP Papers. "History, Phyllis Wheatley," 21; Whitlock, "Edwin A. Harleston," 24.

83. R. H. Mickey to R. Nash, Western Union Telegram, May 10, 1917; broadside, Richard H. Mickey, Secretary, Committee of Colored Citizens, to Dear Sir, May 10, 1917; E. A. Harleston to J. R. Shillady, November 2, 1918; NAACP Papers. Meier, *Negro Thought in America, 1880–1915*, 223.

84. Clipping, Charleston *News and Courier*, letter to editor, signed Edwin A. Harleston, April 15, 1919; notice *The Atlanta University Club of Charleston Presents Miss Inez H. Spencer, Class 1912, in a Pianoforte Recital and The War Cross, a Military Play in Two Acts by Edwin A. Harleston, Class 1904, Tuesday Evening, August 27th, 1918 at Harleston Hall*; ticket *"The War Cross," a Two Act Play by Edwin A. Harleston, at Harleston Hall, Tuesday Evening, August 27, 1918 at 9 o'clock, Piano Numbers by Inez H. Spencer, Admission 50 Cents*; Edwin A. Harleston Papers. Whitlock, "Edwin A. Harleston," 14, 18.

85. Charleston newspaper clippings, "Negroes Deplore the Mob Spirit," n.d., and "All Quiet in Town after the Rioting," hand dated May 13, 1919, Edwin A. Harleston Papers; Whitlock, "Edwin A. Harleston," 14; Charleston *News and Courier*, May 11, 12, 13, 16, 1919.

86. See note 85; Boris, ed., *Who's Who in Colored America*, 23.

87. E. A. Harleston to J. R. Shillady, November 2, 1918, NAACP Papers; Charleston *News and Courier*, January 15, 1919; Whitlock, "Edwin A. Harleston," 13. See also City Board of School Commissioners Minute Books, January 1913–June 1919, petition dated April 5, 1916, on p. 353; pp. [?] (May 3, 1916); pp. 537, 555 (December 4, 1918).

88. Moore, "A History of the Negro Public Schools of Charleston, South Carolina, 1867–1942," 32; Charleston *News and Courier*, April 28, 1954; City Board of School Commissioners Minute Books, January 1913–June 1919, pp. 497–98 (April 29, 1918); City Board of School Commissioners Minute Books, October 1924–April 1930, p. 44 (April 1, 1925).

89. Charleston *News and Courier*, January 15, 22, 31, 1919; unidentified newspaper clipping, "An Objection Cured," ca. January 1919, Edwin A. Harleston Papers;

Clark, *Echo in My Soul,* 59–61; Whitlock, "Edwin A. Harleston," 13; City Board of School Commissioners Minute Books, January 1913–June 1919, p. 556 (January 9, 1919), p. 558 (January 18, 1919).

90. Unidentificd newspaper clippings, "Affidavit by Chairman of Board of Registers" and "An Objection Cured," both ca. January 1919; W. E. B. Du Bois to E. A. Harleston, February 10, 1920; Edwin A. Harleston Papers. Charleston *News and Courier,* April 16, 1963; Whitlock, "Edwin A. Harleston," 13; Moore, "A History of the Negro Public Schools of Charleston, South Carolina, 1867–1942," 37–38.

91. City Board of School Commissioners Minute Books, June 1919–June 1924, p. 216 (September 29, 1921) (Hill). City Board of School Commissioners Minute Books, June 1930–December 1935, p. 151 (March 25, 1932) (Simmons); p. 245 (September 14, 1933) (Berry); p. 250 (October 4, 1933) (Fraser). City Board of School Commissioners Minute Books, January 1936–March 1940, p. 100 (November 4, 1936) (Fraser); p. 435 (July 24, 1939) (Grayson). *Avery's Deeds and Needs.* Charleston *News and Courier,* November 13, 1952 (Berry); June 22, 1976 (Grayson). *Burke High School, Charleston, South Carolina, 1974–1975 Student Bulletin* (Hill, Berry, Grayson); Moore, "A History of the Negro Public Schools of Charleston, South Carolina, 1867–1942," 42–45 (Simmons, Grayson, Berry, Fraser); *Avery Catalogue, 1906,* 29 (Hill); *Avery Commencement Invitation, 1920* (Simmons); *[Programme, Avery Normal Institute] 1925* (Grayson); *Avery Commencement Invitation, 1926* (Fraser); eulogy "Ladies and Gentlemen, Wilmot Jefferson Fraser upon His Retirement, June 24, 1970," in author's possession.

92. City Board of School Commissioners Minute Books, June 1919–June 1924, p. 124 (June 3, 1920), p. 188 (April 6, 1921).

93. City Board of School Commissioners Minute Books, June 1919–June 1924, p. 201 (June 7, 1921), pp. 209–210 (June 22, 1921), p. 215 (June 30, 1921), p. 216 (September 29, 1921), p. 262 (March 8, 1922), pp. 266, 272 (April 5, 1922).

94. City Board of School Commissioners Minute Books, June 1919–June 1924, p. 122 (Junc 3, 1920), p. 144 (October 6, 1920), p. 160 (December 1, 1920); City Board of School Commissioners Minute Books, October 1924–April 1930, p. 44 (April 1, 1925); City Board of School Commissioners Minute Books, June 1930–December 1935, pp. [?] (June 8, 1932); City Board of School Commissioners Minute Books, April 1940–July 1946, p. 338 (September 8, 1944); Moore, "A History of the Negro Public Schools of Charleston, South Carolina, 1867–1942," 41–42; Charleston *News and Courier,* March 19, 1949.

95. Hemmingway, "Beneath the Yoke of Bondage," 242; "South Carolina Fights Illiteracy," 52–54; City Board of School Commissioners Minute Books, Junc 1930–December 1935, p. 11 (June 25, 1930), p. 151 (March 25, 1932), pp. 152–53 (April 22, 1932); Edwin D. Hoffman, "The Genesis of the Modern Movement for Equal Rights in South Carolina, 1930–1939," *JNH* 44 (October 1959): 352–54; Newby, *Black Carolinians,* 236; *Avery Commencement Invitations, 1928, 1930; AMA Annual Report (1927),* 52; Irma E. Sams, questionnaire, August 1986; five newspaper obituary clippings on Simmons, ca. 1966, J. Andrew Simmons Papers, Irma E. Sams, Atlanta, Ga.; J. Michael Graves, interview, March 7, 1985. *Avery Commencement Invitation, 1920* lists Andrew St. James Simmons as a graduatc. Irma E. Sams verifies that her cousin changed his name to James Andrew Simmons. Description of Simmons is partly based on Eugene C. Hunt's characterization of him.

96. City Board of School Commissioners Minute Books, June 1930–December 1935, pp. 152–53 (April 22, 1932), p. 177 (September 8, 1932).

97. Hoffman, "The Genesis of the Modern Movement for Equal Rights in South Carolina, 1930–1939," 352–54; "South Carolina Fights Illiteracy," 52–54; Hemmingway, "Beneath the Yoke of Bondage," 242; Columbia *Palmetto Leader*, March 14, 1936; Columbia *Lighthouse and Informer*, February 11, 1945; Clark, *Echo in My Soul*, 80–83.

98. Richardson, *A History of Fisk University, 1865–1946*, 84–100; Clark, *Echo in My Soul*, 80–83; J. Andrew Simmons, "Professional and Cultural Background of the Teachers in the South Carolina High Schools for Negroes" (Master's thesis, Teachers College, Columbia University, n.d.); I. E. Sams to D. Moniz, December 21, 1985, J. Andrew Simmons Papers; pamphlet, J. Andrew Simmons, *The Fisk Situation*, J. Andrew Simmons Papers.

99. City Board of School Commissioners Minute Books, January 1913–June 1919, p. 587 (May 7, 1919); City Board of School Commissioners Minute Books, October 1924–April 1930, p. 475 (April 2, 1930); City Board of School Commissioners Minute Books, June 1930–December 1935, p. 177 (September 8, 1932); City Board of School Commissioners Minute Books, January 1936–March 1940, p. 109 (December 2, 1936).

100. City Board of School Commissioners Minute Books, June 1930–December 1935, p. 337 (September 12, 1934).

101. City Board of School Commissioners Minute Books, January 1913–June 1919, letter dated April 5, 1916, p. 353; City Board of School Commissioners Minute Books, June 1919–June 1924, p. 162 (December 1, 1920), pp. 193, 195 (May 4, 1921), pp. [?] (September 29, 1921), pp. [?] (November 2, 1921), p. 307 (October 31, 1922), p. 446 (May 7, 1924); City Board of School Commissioners Minute Books, October 1924–April 1930, p. 39 (March 4, 1925); City Board of School Commissioners Minute Books, June 1930–December 1935, p. 258 (November 1, 1933); City Board of School Commissioners Minute Books, January 1936–March 1940, p. 100 (November 4, 1936), p. 465 (January 10, 1940); Moore, "A History of the Negro Public Schools of Charleston, South Carolina, 1867–1942," 38–39, 41, 44.

102. City Board of School Commissioners Minute Books, August 1946–February 1951, p. 12 (September 17, 1946); Moore, "A History of the Negro Public Schools of Charleston, South Carolina, 1867–1942," 13, 32.

103. City Board of School Commissioners Minute Books, January 1913–June 1919, letter dated April 5, 1916, p. 353; City Board of School Commissioners Minute Books, October 1924–April 1930, p. 39 (March 4, 1925); City Board of School Commissioners Minute Books, January 1936–March 1940, p. 169 (June 11, 1937), pp. 364–365 (March 1, 1939); Moore, "A History of the Negro Public Schools of Charleston, South Carolina, 1867–1942," 19–23; *Year Book, 1893, City of Charleston, So. Ca.*, 178; Gordon, *Sketches of Negro Life and History in South Carolina*, title page, 269; Newby, *Black Carolinians*, 231. For a discussion of the conservative implications of the Hampton model, see Anderson, *The Education of Blacks in the South, 1860–1935*, chapter 2.

104. *Avery's Deeds and Needs;* F. A. DeCosta to A. B. Rhett, May 7, 1938, Avery Institute, Box 891, OAR, CCSD.

105. H. Louise Mouzon, interview, November 20, 1980; Waring, "Teaching Is Her Life"; Charleston *Chronicle*, July 13, 1985.

106. Sarah Green Oglesby, interview, October 14, 28, 1980.

107. Clipping, Charleston *Messenger*, hand dated August 23, 1930, James R. Logan Scrapbook; E. C. Mickey to Dear Sirs, April 3, 1921, NAACP Papers; Joseph I. Hoffman, interview, September 25, 1980, October 9, 1980; Charleston *News and Courier*, April 9, 1938; Caldwell, ed., *History of the American Negro, South Carolina Edition*, 215–17.

108. J. Michael Graves, interview, March 7, 1985; Arthur J. Clement, Jr., interview, August 27, 1986; Fields, *Lemon Swamp*, 24; *Walsh's 1925–1926 Charleston, South Carolina City Directory, Forty-Fourth Year* (Charleston: Southern Printing and Publishing Co., n.d.), 560, 670. E. C. Mickey to Dear Sirs, April 3, 1921; W. H. Miller to E. F. Morrow, March 15, 1939; E. F. Morrow to W. H. Miller, March 18, 1939; program *Sunday Afternoon, October 25, 1953, Annual Mass Meeting, Centenary Methodist Church;* NAACP Papers. *Manhood*, Cannon Street Branch, YMCA, Charleston, S.C., 1 (September 11, 1920), James R. Logan Scrapbook.

109. Charleston *News and Courier*, April 16, 1922; D. J. Jenkins to R. G. [A. B.?] Rhett, March 29, 1922, with program *Now for the Opening Features of the Famous Lincoln Park, Easter Monday, April 17, 1922* attached, Picnic Playground—Colored, Box 896, OAR, CCSD; "South Carolina Fights Illiteracy," 62. Eugene C. Hunt confirmed park location.

110. "Officers and Members of the Avery Alumni Ass'n. . . ," Shrewsbury Papers; Kelly Miller, "These 'Colored' United States," *Messenger* 7 (1925): 377; City Board of School Commissioners Minute Books, June 1930–December 1935, pp. 152–153 (April 22, 1932).

111. Miller, "These 'Colored' United States," 376–77, 400; Ballard, *One More Day's Journey*, 166; Clark, *Echo in My Soul*, 80; Charlotte D. Tracy, interview, November 24, 1982.

112. Charlotte D. Tracy, interview, November 24, 1982; "History, Phyllis Wheatley," 37, 44; Charleston *News and Courier*, February 20, 1949; *Avery Tiger*, October 1953.

113. Charleston *News and Courier*, October 3, 1948; February 20, 1949. Felder Hutchinson, interview, July 16, 1985. Membership Reports, February 7, 1934, and January 29, 1939, NAACP Papers.

114. Charlotte D. Tracy, interview, November 24, 1982; Leroy Anderson, interview, July 10, 1985.

115. See note 114; Sarah Green Oglesby, interview, October 14, 28, 1980.

116. Charlotte D. Tracy, interview, November 24, 1982; Lucille A. Williams, interview, September 25, 1984; Leroy Anderson, interview, July 10, 1985; J. Michael Graves, interview, March 7, 1985; Eugene C. Hunt, interview, August 28, 1980, November 4, 1980, December 4, 1985. Charleston *News and Courier*, March 26, 1986; *The Faculty and Class of Nineteen Thirty-Eight of Avery Institute Request Your Presence at the Graduation Exercises on the Evening of Wednesday, June First, Eight O'Clock, Morris Street Baptist Church, Charleston, South Carolina* [hereafter cited as *Avery Commencement Invitation, 1938*].

117. Interviews of Avery people cited, especially Tracy, Anderson, Graves, and Oglesby.

118. *Avery Catalogue, 1906*, 30; *AMA Annual Report (1903)*, 51; "List of colored teachers in Charleston County this date," February 2, 1901, J. J. McMahon Papers; Naming Columbus Street School, Naming East Bay School, Box 863, OAR, CCSD;

Charleston *News and Courier,* February 22, 1967; entry Rosa E. Clyde [Florence's sister], May 21, 1882, Parish Records, 1866–1965, St. Mark's Protestant Episcopal Church, Charleston, microfiche no. 50-328, SCHS; Rosa Clyde, Record of Wills, 874/145, CCPC; *Sholes' Directory of the City of Charleston for 1877–1878* (Charleston: A. E. Sholes, n.d.), 184; Joseph I. Hoffman, interview, September 25, 1980, October 9, 1980. An Avery graduate, who would not be interviewed on tape, used the term "color struck" in describing Clyde. Eugene C. Hunt remembered that Clyde attended St. Mark's.

119. Lois Simms, interview, August 28, 1984; Leroy Anderson, interview, July 10, 1985; Joseph I. Hoffman, interview, September 25, 1980, October 9, 1980. *The Averyite, Nineteen Hundred and Thirty-Nine;* R. A. Morton to F. A. Clyde, December 31, 1943, AMAA Addendum; *Avery Tiger,* May 1951; Naming Columbus Street School, Naming East Bay School, Box 863, OAR, CCSD. At an Avery event, December 7, 1985, Herbert Fielding told me about Clyde.

120. Clark, *Echo in My Soul,* 13, 16–19; Clark, phone conversation, August 16, 1985.

121. Gussie [E. H. Whitlock] to Tantie, November 13, 1933, Edwina H. Whitlock papers, Edwina Harleston Whitlock, Charleston, S.C.; *Avery Commencement Invitation, 1934;* Fields, *Lemon Swamp,* 47; Arthur J. Clement, Jr., interview, August 27, 1986; L. Howard Bennett, interview, June 23–24, 1981; Sarah Green Oglesby, interview, October 14, 28, 1980. Eugene C. Hunt told me about the anecdotes.

122. Charlotte D. Tracy, interview, November 24, 1982; L. Howard Bennett, interview, June 23–24, 1981; Fields, *Lemon Swamp,* 193; A. R. Cox-Davis to E. C. Hunt, June 25, 1986, private hands, Charleston, S.C.; L. Howard Bennett, "Benjamin Ferdinand Cox, 1897, Passes," unidentified Fisk bulletin (November 1952), 9, in author's possession.

123. Clark, *Echo in My Soul,* 25–26.

124. Sarah Green Oglesby, interview, October 14, 28, 1980; Arthur J. Clement, Jr., interview, August 27, 1986. *AMA Annual Reports (1921–1923)* list John M. Moore, A.B., on Avery faculty. My account of the Whittaker incident is based on Leroy Anderson's interview, July 10, 1985, and subsequent communications with Anderson during December 1988, at which time he elaborated on his original comments to "capture the nuances of the incident."

125. *Avery Tiger,* December 1942; Clark, *Echo in My Soul,* 58–60; Fields, *Lemon Swamp,* 12; Ellen Wiley Hoffman, interview, September 18, 1980; Lois Simms, interview, August 28, 1984; *Avery Commencement Invitation, 1928; Walsh's 1928 Charleston, South Carolina City Directory, Forty-Sixth Year* (Charleston: Southern Printing and Publishing Co., n.d.), 798; Edwina H. Whitlock, questionnaire, August 4, 1986; L. H. Bennett to F. L. Brownlee, September 16, 1943, AMAA Addendum; R. A. Morton to S. T. Washington, August 30, 1944, AMAA Addendum.

126. Fields, *Lemon Swamp,* 12, 196; *Avery News,* October 1931; Leroy Anderson, interview, July 10, 1985.

127. *AMA Annual Report (1921),* 46; *The Senior Class of Avery Normal Institute Requests the Honor of Your Presence at Their Graduating Exercises, Wednesday Evening, May Twenty-Fifth at Eight O'Clock, Morris Street Baptist Church [1921]* [hereafter cited as *Avery Commencement Invitation, 1921*]; Fields, *Lemon Swamp,* 91–92; program *Recital by Miss G. Hortense Bowden at Avery Hall, Monday Evening, January 17, 1921 Assisted*

by the Aurorean Trio at 8:15 O'clock, Benefit of Avery Institute, Prof. B. F. Cox, Principal,
James R. Logan Scrapbook.

128. Sarah Green Oglesby, interview, October 14, 28, 1980; "History, Phyllis
Wheatley," 1–5, 21, 45; Naming Columbus Street School, Naming East Bay School,
Box 863, OAR, CCSD.

129. "History, Phyllis Wheatley," 5, 8, 16–17, 24, 28, 34, 37, 45, 49–50, 54, 56,
66; Fields, *Lemon Swamp*, 197–99, 209.

130. Ballard, *One More Day's Journey*, viii, 3–4, 183; Gilbert Osofsky, *Harlem, the
Making of a Ghetto: Negro New York, 1890–1930* (New York: Harper and Row, 1966),
31–32.

131. Ballard, *One More Day's Journey*, 8–9, 13, 185; Allan H. Spear, *Black Chicago:
The Making of a Negro Ghetto, 1890–1920* (Chicago: University of Chicago Press,
1967), 140; Newby, *Black Carolinians*, 193; Osofsky, *Harlem, the Making of a Ghetto*,
129.

132. Osofsky, *Harlem, the Making of a Ghetto*, 43; Ballard, *One More Day's Journey*,
96, 198–200; Berlin, *Slaves without Masters*, 391.

133. Garvey as quoted and interpreted in Clarence E. Walker, "The Virtuoso
Illusionist: Marcus Garvey," manuscript, December 6, 1983, 6–7.

134. Ibid., 23; Charles S. Johnson, *Growing Up in the Black Belt: Negro Youth in the
Rural South* (Washington, D.C.: American Council on Education, 1941; New York:
Schocken Books, 1967), xii–xiii, 256–64; Roi Ottley, *"New World A-Coming": In-
side Black America* (New York: Literary Classics, 1943; Arno Press, 1968), 68–81;
Ballard, *One More Day's Journey*, 201–2.

CHAPTER 5. THE STRUGGLE TO SURVIVE, 1936–1947

1. Clipping, Charleston *News and Courier*, February 17, 1936, James R. Logan
Scrapbook.

2. Clippings, Charleston *News and Courier*, March 21, 1937, August 23, 1938,
James R. Logan Scrapbook.

3. Brownlee, *New Day Ascending*, 136–37; L. Howard Bennett, interview, June 23–
24, 1981; Ruby P. Cornwell, interview, November 24, 1982.

4. A. R. Cox-Davis to E. C. Hunt, June 25, 1986, private hands, Charleston, S.C.;
Gus [E. H. Whitlock] to Tantie, March 8, 1934, Edwina H. Whitlock Papers; *AMA
Annual Report (1930)*, 42; L. Howard Bennett, interview, June 23–24, 1981.

5. Brownlee, *New Day Ascending*, vii–viii. W. E. Sweet to F. L. Brownlee, April 24,
1941; W. E. Sweet to F. L. Brownlee, July 3, 1941; F. L. Brownlee to W. E. Sweet,
April 26, 1941, with "Policies and Procedures of the American Missionary Associa-
tion," April 26, 1941, attached; EAAC, Julia Mae Brogdon; AMAA Addendum.

6. Brownlee, *New Day Ascending*, 265–68; Richardson, *Christian Reconstruction*,
260; "Avery Institute, Charleston, South Carolina: A memorandum for consider-
ation by the A.M.A. Division Committee at Cleveland, January 24–27, 1944, time of
meeting to be announced at Cleveland," AMAA Addendum.

7. R. A. Morton to L. H. Bennett, January 31, 1944, AMAA Addendum; Teacher's
Record, Ruth A. Morton, AMAA Addendum; Ruth Alma Morton, "The Religious
Significance of an American Folk School" (Master's thesis, Department of Christian

Theology and Ethics, University of Chicago, 1934), 2–5, 47–48, 102, 108; Brownlee, *Facing Facts*, 42; Brownlee, *New Day Ascending*, 265–66.

8. EAAC, Julia Mae Brogdon; Brownlee, *New Day Ascending*, 245–50, 266–68.

9. *A Continuing Service: A Reprint from the Annual Report for 1938 of the Board of Home Missions of the Congregational and Christian Churches Covering the Work of the American Missionary Association Division for the Year Ending May 31, 1938* (New York: [1938?]), 33–34; Brownlee, *Facing Facts*, 68. City Board of School Commissioners Minute Books, August 1946–February 1951, letter from superintendent, dated May 23, 1949, pp. 200–201; and pp. 202–3 (May 23, 1949).

10. *Accelerating Social Evolution: A Reprint from the Annual Report for 1939 of the Board of Home Missions of the Congregational and Christian Churches Covering the Work of the American Missionary Association Division for the Year Ending May 31, 1939* (New York: 1939[?]), 15; *Bread and Molasses: A Reprint from the Annual Report for 1940 of the Board of Home Missions of the Congregational and Christian Churches Covering the Work of the American Missionary Association Division for the Year Ending May 31, 1940* (New York: 1940[?]), 17; *A Continuing Service*, 34–35.

11. *A Continuing Service*, 33–35.

12. Brownlee, *New Day Ascending*, 134–38.

13. EAAC, Frank A. DeCosta. Julia Craft DeCosta confirmed to me that Frank was her husband's brother.

14. R. A. Morton to B. Gallagher, July 8, 1942, AMAA Addendum; EAAC, Frank A. DeCosta, AMAA Addendum.

15. *A Continuing Service*, 33–34; *Avery Tiger*, November 1939. R. A. Morton to F. L. Brownlee, March 26, 1941; W. E. Sweet to F. L. Brownlee, March 31, 1941; C. I. Young to the American Missionary Association, June 12, 1941; F. L. Brownlee to C. I. Young, June 20, 1941; R. A. Morton to G. L. Collins, July 14, 1941; R. A. Morton to B. Gallagher, July 8, 1942; and "Memorandum Covering Visit to Avery Institute, Charleston, South Carolina—January 16–17, 1948," January 21, 1948; AMAA Addendum. F. A. DeCosta to A. B. Rhett, May 7, 1938, Avery Institute, Box 891, OAR, CCSD. For a current definition of "functional education," see Carter V. Good, ed., *Dictionary of Education*, 3d ed. (New York: McGraw-Hill Book Co., 1973), 254.

16. R. A. Morton to F. L. Brownlee, March 26, 1941, AMAA Addendum.

17. C. I. Young to the American Missionary Association, June 12, 1941; R. A. Morton to G. L. Collins, July 14, 1941; C. S. Johnson to R. A. Morton, July 24, 1941; C. S. Johnson to R. A. Morton, August 9, 1941; EAAC, L. Howard Bennett; AMAA Addendum. L. Howard Bennett, interview, June 23–24, 1981.

18. EAAC, L. Howard Bennett; L. Howard Bennett, interview, June 23–24, 1981.

19. See note 18.

20. See note 18; *Avery Tiger*, November 1941.

21. C. S. Johnson to R. A. Morton, August 9, 1941, AMAA Addendum; R. A. Morton to L. H. Bennett, August 18, 1941, AMAA Addendum; L. Howard Bennett, interview, June 23–24, 1981.

22. Fields, *Lemon Swamp*, 194–95; *Avery Tiger*, February 1942.

23. L. Howard Bennett, interview, June 23–24, 1981; R. A. Morton to Mr. Hickman, memorandum, August 31, 1942, AMAA Addendum.

24. L. Howard Bennett, interview, June 23–24, 1981; J. H. Green to R. Wilkins, May 17, 1942, NAACP Papers; *Baldwin and Southern's Charleston, South Carolina City Directory, 1942,* master ed. (Charleston: Baldwin Directory Co., and Southern Printing and Publishing Co., n.d.), 683.

25. L. Howard Bennett, interview, June 23–24, 1981; *Baldwin and Southern's Charleston, South Carolina City Directory, 1942,* 223, 309; F. L. Brownlee to W. Palmer, July 30, 1945, AMAA Addendum; F. L. Brownlee to J. E. Meredith, August 6, 1945, AMAA Addendum; Charleston *News and Courier,* August 17, 1952.

26. Lucille S. Whipper, questionnaire, January 19, 1987; Lois T. Shealy, ed., *Biographies and Pictures of Members of the Senate and House of Representatives and Officers, State of South Carolina, 1987 Session, (Excerpt from 1987 Legislative Manual) Corrected to December 22, 1986* (Columbia: [State Legislature?], n.d.), 67; Charleston *News and Courier,* July 1, 1987; program *Funeral Services for the Late Mr. Edward A. Stroud,* in author's possession.

27. L. Howard Bennett, interview, June 23–24, 1981; R. A. Morton to L. H. Bennett, December 31, 1943, AMAA Addendum; L. H. Bennett to F. L. Brownlee, March 23, 1944, AMAA Addendum; City Board of School Commissioners Minute Books, April 1940–July 1946, p. 306 (March 1, 1944).

28. L. Howard Bennett, interview, June 23–24, 1981. L. H. Bennett to R. A. Morton and F. L. Brownlee, December 9, 1943; "Memorandum Covering Visit to Avery Institute, Charleston, South Carolina—January 16–17, 1948"; memorandum "Charleston Steps Ahead," ca. 1947[?]; AMAA Addendum.

29. "Avery Institute, Charleston, South Carolina: A memorandum for consideration by the A.M.A. Division Committee at Cleveland, January 24–27, 1944, time of meeting to be announced at Cleveland"; R. A. Morton to L. H. Bennett, November 17, 1943; L. H. Bennett to F. L. Brownlee, December 9, 1943; AMAA Addendum. Fields, *Lemon Swamp,* 193.

30. L. H. Bennett to R. A. Morton and F. L. Brownlee, December 9, 1943, AMAA Addendum.

31. R. A. Morton to L. H. Bennett, December 15, 1943; R. A. Morton to L. H. Bennett, December 31, 1943; L. H. Bennett to R. A. Morton, December 26, 1943; L. H. Bennett to R. A. Morton, January 20, 1944; R. A. Morton to F. A. Clyde, December 31, 1943; F. A. Clyde to R. A. Morton, January 3, 1944; L. H. Bennett to R. A. Morton, Western Union Telegram, January 7, 1944[?]; R. A. Morton to Miss Wernert, memorandum, January 15, 1944; R. A. Morton to St. Julian Walker, May 31, 1944; R. A. Morton to A. W. Hoursey, May 31, 1944; AMAA Addendum.

32. "Avery Institute, Charleston, South Carolina: A memorandum for consideration by the A.M.A. Division Committee at Cleveland, January 24–27, 1944, time of meeting to be announced at Cleveland," AMAA Addendum; L. Howard Bennett, interview, June 23–24, 1981.

33. See note 32.

34. See note 32. L. H. Bennett to R. A. Morton and F. L. Brownlee, December 9, 1943; L. H. Bennett to F. L. Brownlee, March 23, 1944, with "The A.M.A., Transition, and Avery Institute" attached; AMAA Addendum.

35. See notes 32 and 34.

36. A. W. Hoursey to F. L. Brownlee, February 29, 1944; F. L. Brownlee to A. W.

Hoursey, March 13, 1944; R. A. Morton to A. W. Hoursey, March 13, 1944; A. W. Hoursey to H. Desort, June 22, 1944, with report on ten-thousand-dollar campaign, June 22, 1944, attached; AMAA Addendum.

37. John F. Potts, interview, April 17, 1982. W. E. Sweet to F. L. Brownlee, March 31, 1941; W. E. Sweet to F. L. Brownlee, April 24, 1941; W. E. Sweet to F. L. Brownlee, July 3, 1941, with W. E. Sweet to B. M. Baruch, July 3, 1941, attached; F. L. Brownlee to W. E. Sweet, April 26, 1941, with "Facts about the American Missionary Association," April 26, 1941, and "Policies and Procedures of the American Missionary Association," April 26, 1941, attached; AMAA Addendum.

38. A. J. Clement, Jr., to R. A. Morton, April 9, 1944; C. S. Ledbetter to R. A. Morton, April 24, 1944; F. A. Clyde to F. L. Brownlee, May 5, 1944; F. A. Clyde to R. A. Morton, March 31, 1944, with flyers *Avery Institute $10,000 Campaign Fund* and *$10,000 School Fund Campaign Sponsored by Interested Citizens of Charleston for Avery Institute* attached; F. A. Clyde to R. A. Morton, April 3, 1944, with newspaper clippings "Help for Avery" and "Avery Institute Asks for Support" attached; F. A. Clyde to R. A. Morton, May 16, 1944; F. A. Clyde to R. A. Morton, June 22, 1944; R. A. Morton to F. A. Clyde, May 12, 1944; R. A. Morton to A. W. Hoursey, May 12, 1944; R. A. Morton to A. W. Hoursey, May 31, 1944; A. W. Hoursey to R. A. Morton, May 22, 1944; J. A. McFall to R. A. Morton, May 30, 1944; AMAA Addendum.

39. F. A. Clyde to R. A. Morton, June 5, 1944; R. A. Morton to A. J. Clement, Jr., June 2, 1944; R. A. Morton to A. J. Clement, Jr., August 1, 1944; AMAA Addendum.

40. R. A. Morton to C. H. Nicholas, June 2, 1941; A. W. Hoursey to R. A. Morton, June 25, 1942; R. A. Morton to A. W. Hoursey, July 1, 1942; C. H. Nicholas to F. L. Brownlee, August 23, 1943; F. L. Brownlee to C. H. Nicholas, August 25, 1943; R. A. Morton to L. H. Bennett, December 31, 1943; F. A. Clyde to R. A. Morton, June 5, 1944; F. L. Brownlee, Avery Log, March 19–20, 1945; AMAA Addendum. *Avery Tiger,* November 1941.

41. R. A. Morton to S. T. Washington, Postal Telegraph Telegram, July 27, 1944; R. A. Morton to S. T. Washington, Postal Telegraph Telegram, July 31, 1944; S. T. Washington to R. A. Morton, Western Union Telegram, received by AMA, July 31, 1944; R. A. Morton to F. A. Clyde, August 29, 1944, with biographical sketch on S. T. Washington attached; and EAAC, Samuel T. Washington; AMAA Addendum.

42. R. A. Morton to A. W. Hoursey, March 13, 1943; R. A. Morton to A. W. Hoursey, May 12, 1944; R. A. Morton to A. W. Hoursey, May 31, 1944; R. A. Morton to A. J. Clement, Jr., Western Union Telegram, August 18, 1944; R. A. Morton to A. W. Hoursey, Western Union Telegram, n.d.; R. A. Morton to F. A. Clyde, August 29, 1944; R. A. Morton to S. T. Washington, August 30, 1944; M. H. Washington to R. A. Morton, May 11, 1945; AMAA Addendum.

43. S. T. Washington to R. A. Morton, January 21, 1945; F. L. Brownlee to L. C. Ketchum, March 27, 1945; C. S. Ledbetter to R. A. Morton, March 28, 1945; L. C. Ketchum to F. L. Brownlee, April 7, 1945; M. H. Washington to R. A. Morton, May 19, 1945; T. Manigault to R. A. Morton, June 10, 1945; F. L. Brownlee, Avery Log, March 19–20, 1945; and memorandum "Avery Institute Burns," ca. 1945; AMAA Addendum.

44. F. L. Brownlee, Avery Log, March 19–20, 1945; and A. J. Clement, Jr., to F. L. Brownlee, May 10, 1945; AMAA Addendum.

45. S. T. Washington to R. A. Morton, January 21, 1945; M. H. Washington to R. A. Morton, May 11, 1945; R. A. Morton to M. H. Washington, May 17, 1945; R. A. Morton to F. L. Brownlee, memorandum, May 9, 1945; AMAA Addendum.

46. R. A. Morton to A. W. Hoursey, March 13, 1944; R. A. Morton to A. W. Hoursey, May 12, 1944; R. A. Morton to A. W. Hoursey, May 31, 1944; C. S. Ledbetter to R. A. Morton, April 24, 1944; R. A. Morton to F. A. Clyde, May 12, 1944; F. A. Clyde to R. A. Morton, May 16, 1944; A. W. Hoursey to R. A. Morton, May 22, 1944; J. A. McFall to R. A. Morton, May 30, 1944; J. A. McFall to R. A. Morton, September 13, 1944; R. A. Morton to E. B. Stern, June 7, 1944; handwritten list "Members of the Steering Committee," ca. 1944; "Historical Notes, Avery Institute, 1865–1947," 5; AMAA Addendum. P. M. Macmillan to J. A. McFall, September 8, 1944; J. A. McFall to P. M. Macmillan, September 12, 1944, with "Suggested Amendment of the Constitution and By-laws of 'Avery Institute' Incorporated" attached; Correspondence Relating to Application by Negroes for Entrance into the College, College of Charleston Archives, SCRSSL.

47. F. A. Clyde to F. L. Brownlee, May 5, 1944; R. A. Morton to A. W. Hoursey, May 12, 1944; R. A. Morton to F. A. Clyde, May 12, 1944; J. A. McFall to R. A. Morton, May 30, 1944; A. W. Hoursey to R. A. Morton, May 22, 1944; AMAA Addendum.

48. J. A. McFall to R. A. Morton, May 30, 1944, AMAA Addendum.

49. L. H. Bennett to F. L. Brownlee, September 16, 1943; R. A. Morton to A. W. Hoursey, May 31, 1944; R. A. Morton to A. J. Clement, Jr., June 2, 1944; R. A. Morton to E. B. Stern, June 7, 1944; R. A. Morton to S. T. Washington, August 30, 1944; R. A. Morton to S. T. Washington, September 15, 1944; R. A. Morton to J. A. McFall, March 21, 1945; F. L. Brownlee, Avery Log, March 19–20, 1945; AMAA Addendum. Arthur J. Clement, Jr., interview, August 27, 1986.

50. J. A. McFall to R. A. Morton, August 3, 1944, with J. A. McFall to C. S. Ledbetter, August 3, 1944, attached; J. A. McFall to R. A. Morton, September 13, 1944, with J. A. McFall to P. M. Macmillan, September 12, 1944, attached; R. A. Morton to J. A. McFall, September 18, 1944; J. A. McFall to R. A. Morton, October 16, 1944, with P. M. Macmillan to J. A. McFall, October 11, 1944, and J. H. Wrighten to College of Charleston, October 6, 1944, attached; W. H. Grayson to A. J. Clement, Jr., August 29, 1944; AMAA Addendum.

51. See note 50; F. L. Brownlee to J. A. McFall, October 20, 1944, AMAA Addendum.

52. C. S. Ledbetter to F. L. Brownlee, November 22, 1944[?]; R. A. Morton to A. W. Hoursey, December 19, 1944; A. W. Hoursey to R. A. Morton, January 3, 1945; A. J. Clement, Jr., to R. A. Morton, January 27, 1945; R. A. Morton to J. A. McFall, March 21, 1945; T. Manigault to R. A. Morton, June 11, 1945; "Avery Institute Burns"; "Charleston Steps Ahead," 6; "Memorandum Covering Visit to Avery Institute, Charleston, South Carolina—January 16–17, 1948"; AMAA Addendum.

53. F. L. Brownlee, Avery Log, March 19–20, 1945; and EAAC, Frank A. DeCosta; AMAA Addendum.

54. F. L. Brownlee, Avery Log, March 19–20, 1945, AMAA Addendum.

55. Ibid.; *Burke High School, Charleston, South Carolina, 1974–1975 Student Bulletin;* City Board of School Commissioners Minute Books, April 1940–July 1946, p. 338 (September 8, 1944), p. 353 (November 14, 1944); City Board of School Commissioners Minute Books, August 1946–February 1951, p. 4 (August 7, 1946).

56. See note 55; R. A. Morton to F. L. Brownlee, March 26, 1941, AMAA Addendum; "Historical Notes, Avery Institute, 1865–1947," 6, AMAA Addendum; Moore, "A History of the Negro Public Schools of Charleston, South Carolina, 1867–1942," 50.

57. F. L. Brownlee, Avery Log, March 19–20, 1945, AMAA Addendum; "Historical Notes, Avery Institute, 1865–1947," 6, AMAA Addendum; Sarah Green Oglesby, interview, October 14, 28, 1980; Eugene C. Hunt, conversation, April 28, 1986.

58. "Avery Institute, Charleston, South Carolina: A memorandum for consideration by the A.M.A. Division Committee at Cleveland, January 24–27, 1945, time of meeting to be announced at Cleveland"; F. L. Brownlee, Avery Log, March 19–20, 1945; R. A. Morton to A. J. Clement, Jr., April 24, 1945; "Charleston Steps Ahead," 5; "Memorandum Covering Visit to Avery Institute, Charleston, South Carolina— January 16–17, 1948"; AMAA Addendum.

59. R. A. Morton to W. H. Grayson, May 17, 1945; R. A. Morton to W. H. Grayson, May 28, 1945; W. H. Grayson to R. A. Morton, May 25, 1945; "Historical Notes, Avery Institute, 1865–1947," 6; AMAA Addendum. L. H. Bennett to Board of School Trustees, District Number 20, May 4, 1943, with memorandum, L. H. Bennett to School Board of Charleston, South Carolina, n.d., attached, Avery Institute, Box 891, OAR, CCSD; City Board of School Commissioners Minute Books, August 1946–February 1951, p. 4 (August 7, 1946), OAR, CCSD.

60. R. A. Morton to J. A. McFall, March 21, 1945; R. A. Morton to A. J. Clement, Jr., March 22, 1945; C. S. Ledbetter to R. A. Morton, March 28, 1945; J. A. McFall to R. A. Morton, April 3, 1945; AMAA Addendum.

61. A. J. Clement, Jr., to F. L. Brownlee, May 10, 1945; F. L. Brownlee to A. J. Clement, Jr., May 14, 15, 1945; AMAA Addendum.

62. Geneva P. Singleton, minutes, May 23, 1945; A. J. Clement, Jr., to F. L. Brownlee, May 24, 1945; R. A. Morton to A. J. Clement, Jr., May 29, 1945; AMAA Addendum. *Avery Commencement Invitation, 1930;* City Board of School Commissioners Minute Books, August 1946–February 1951, R. C. Barrett to J. F. Seignious, January 28, 1947, on pp. 24–26 (February 3, 1947). For more on Barrett, see chapter 6.

63. A. J. Clement, Jr., to R. A. Morton, July 3, 1945, with J. H. McCray to A. J. Clement, Jr., July 2, 1945, and J. F. Potts to A. J. Clement, Jr., July 2, 1945, attached; J. F. Potts to R. A. Morton, July 9, 20, 1945; EAAC, John F. Potts; AMAA Addendum. Charleston *News and Courier,* April 12, 1954; Arthur J. Clement, Jr., interview, August 27, 1986; Avery News, October 1931.

64. See note 63; John Foster Potts, "A History of the Growth of the Negro Population of Gary, Indiana" (Master's thesis, Cornell University, 1937), vita.

65. See notes 63 and 64. R. A. Morton to J. R. Reddix, Western Union Telegram, July 13, 1945; J. R. Reddix to R. A. Morton, Western Union Telegram, July 18, 1945; memorandum, "Avery Institute, Charleston, S.C.," March 11, 1947; AMAA

Addendum. Lucille Mears Poinsette, phone conversation, April 21, 1986; John F. Potts, interview, April 17, 1982.

66. J. F. Potts to R. A. Morton, July 20, 1945; F. L. Brownlee to W. Palmer, July 30, 1945; R. A. Morton to J. F. Potts, July 31, 1945; F. L. Brownlee to J. E. Meredith, August 6, 1945; "Charleston Steps Ahead"; "Memorandum Covering Visit to Avery Institute, Charleston, South Carolina—January 16–17, 1948"; and EAAC, John F. Potts; AMAA Addendum.

67. J. F. Potts to R. A. Morton, July 20, 1945; J. F. Potts to R. A. Morton, July 27, 1945; J. F. Potts to R. A. Morton, August 3, 1945; J. F. Potts to R. A. Morton, August 13, 1945; R. A. Morton to J. F. Potts, August 1, 1945; R. A. Morton to J. F. Potts, August 2, 1945; R. A. Morton to J. F. Potts, August 9, 1945; R. A. Morton to J. F. Potts, August 14, 1945; R. A. Morton to J. F. Potts, August 17, 1945; R. A. Morton to J. F. Potts, August 20, 1945; F. L. Brownlee to W. Palmer, July 30, 1945; F. L. Brownlee to J. E. Meredith, August 6, 1945; F. L. Brownlee to R. E. Clement, August 14, 1945; R. A. Morton to V. Brown, August 28, 1945; John F. Potts, Expense Account for New York Trip, July 25–26, 1945; EAAC, John F. Potts; AMAA Addendum.

68. Brownlee, *New Day Ascending*, 134–38.

69. Hoursey, "A Follow-Up Survey of Graduates of Avery Institute, Charleston, South Carolina, for Years 1930–1940"; "Historical Notes, Avery Institute, 1865–1947"; *Avery Catalogue, 1899*, 16–18; *Avery Catalogue, 1906*, 15–18; *Avery Catalogue, 1910*, 9, 15–16; Lewis K. McMillan, *Negro Higher Education in the State of South Carolina* ([Orangeburg, S.C.]: Author, [1952]), 3.

70. Hoursey, "A Follow-Up Survey of Graduates of Avery Institute, Charleston, South Carolina, for Years 1930–1940," 58–59.

71. *Avery Tiger*, November 1939, June 1940, November 1942.

72. A. W. Hoursey to R. A. Morton, July 28, 1942, with tentative curriculum outlines for the seventh, eighth, and ninth grades attached; M. V. White to L. H. Bennett, April 28, 1942; EAAC, Rutherford Hayes Strider; EAAC, Samuel T. Washington; AMAA Addendum. *Avery Tiger*, December 1939, December 1950. Several graduates remembered receiving Brownlee's book.

73. *Avery Tiger*, November 1944; *The Averyite, Nineteen Hundred and Thirty-Nine*.

74. *The Averyite, Nineteen Hundred and Thirty-Nine*.

75. Ibid.; *Avery Tiger*, November 1940, November 1941, February 1942, May 1942, May 1951, December 1952, June 1953, December 1953, April 1954.

76. *The Averyite, Nineteen Hundred and Thirty-Nine; Avery Tiger*, June 1940.

77. L. Howard Bennett, interview, June 23–24, 1981; *The Averyite, Nineteen Hundred and Thirty-Nine; Avery Tiger*, November 1939, December 1942; "South Carolina Fights Illiteracy," 42.

78. *The Averyite, Nineteen Hundred and Thirty-Nine; Avery Tiger*, November 1939; *Programme of the Eightieth Commencement of Avery Institute, Charleston, South Carolina, Eight P.M., Wednesday, May 30, 1945, Morris Street Baptist Church* [hereafter cited as *Avery Commencement Program, 1945*].

79. "South Carolina Fights Illiteracy," 42–43.

80. EAAC, L. Howard Bennett; *Commencement Exercises, Nineteen Forty-One, Avery Institute, Charleston, S.C.* [hereafter cited as *Avery Commencement Program, 1941*].

81. "South Carolina Fights Illiteracy," 52–54; Dave Moniz, "The road to success: Columbia lost many of best and brightest graduates of BTW," Columbia newspaper clipping, ca. 1986, J. Andrew Simmons Papers.

82. EAAC: Julia Mae Brogdon, Rutherford Hayes Strider, Armstead Antoine Pierro, Susie A. Butler, Florence A. Clyde, Frank A. DeCosta, L. Howard Bennett, Marian Clae Bennett, Rose Mary Frayser, Mary Lois Strawn, Lucille L. Jones, Vernita Camille Vaughn, Elizabeth Suell Jackson, Mrs. Mildred H. Handy. Hoursey, "A Follow-Up Survey of Graduates of Avery Institute, Charleston, South Carolina, for Years 1930–1940"; *Avery Tiger,* November 1941; Sidney Hook, "John Dewey: His Philosophy of Education and Its Critics," in *Dewey on Education Appraisals,* edited by Archambault, 127–59.

83. Hook, "John Dewey: His Philosophy of Education and Its Critics," 149–50. EAAC: Madge Hughes Washington, Helen Miriam Stoddard, Mary Lois Strawn, Sadie Casander Flowers.

84. August Meier, and Elliott Rudwick, *Black History and the Historical Profession, 1915–1980* (Urbana: University of Illinois Press, 1986), chapter 1.

85. Ibid., 10–11, 240; Birnie, "Education of the Negro in Charleston, South Carolina, Prior to the Civil War," 13–21.

86. EAAC: L. Howard Bennett, Marian Clae Bennett, Armstead A. Pierro, Dowling Martin Bolton, Julia Mae Brogdon, John F. Potts, Helen Miriam Stoddard. Meier and Rudwick, *Black History and the Historical Profession, 1915–1980,* 71, 74–77.

87. EAAC: Marian Clae Bennett, Julia Mae Brogdon, Earl Ramsey Claiborne, Frank A. DeCosta, Rose Mary Frayser, Mary Lois Strawn, Rutherford Hayes Strider, Elizabeth Suell Jackson, L. Howard Bennett.

88. A. W. Hoursey to R. A. Morton, July 28, 1942, with tentative curriculum outlines for the seventh, eighth, and ninth grades attached; M. H. Washington to R. A. Morton, May 11, 1945; AMAA Addendum. *Avery Commencement Program, 1945; Avery Tiger,* May 1942.

89. *Avery Tiger,* November 1939, May 1942; "South Carolina Fights Illiteracy," 43–44; *The Averyite, Nineteen Hundred and Thirty-Nine.*

90. Julia Brogdon Purnell, interview with the author, Baton Rouge, November 13, 1987. EAAC, Julia Mae Brogdon; J. M. Brogdon to R. A. Morton, July 15, 1944; AMAA Addendum. J. M. Hinton to G. D. Grice, March 13, 1949, Correspondence Relating to Application by Negroes for Entrance into the College, College of Charleston Archives. Lucille Whipper, interview, Charleston, March 2, 1976; Louis Holman, interview, Charleston, March 22, 1976; SCRSSL.

91. Julia Brogdon Purnell, interview, November 13, 1987; Lucille Whipper, interview, March 2, 1976; Louis Holman, interview, March 22, 1976. Robert Graves, interview, Charleston, March 11, 1976, SCRSSL.

92. William Peters, "A Southern Success Story," *Redbook* 115 (June 1960): 99–102.

93. Lucille Whipper, interview, March 2, 1976; Robert Graves, interview, March 11, 1976; Louis Holman, interview, March 22, 1976; J. H. Wrighten to Whom It May Concern, July 17, 1943, Correspondence Relating to Application by Negroes for Entrance into the College, College of Charleston Archives; "Complete Transcription of Conference, South Carolina Voices of the Civil Rights Movement, November 5–6,

1982," 86–87, ARC [hereafter cited as "Voices"]; *The Faculty and Classes of Nineteen Forty-Three of Avery Institute Request Your Presence at the Graduation Exercises on the Evening of Friday, June Fourth, Eight O'Clock, Morris Street Baptist Church, Charleston, South Carolina* [hereafter cited as *Avery Commencement Invitation, 1943*]; Charleston *News and Courier,* November 14, 1969; John H. Wrighten, questionnaire, October 1, 1986. E. Gadsden to NAACP, February 20, 1944; J. A. Gourdine to R. Hurley, July 12, 1944; J. A. Gourdine to R. Hurley, August 10, 1944; J. H. Wrighten to R. Hurley, September 4, 1944; J. H. Wrighten to R. Hurley, September 29, 1944; R. Hurley to J. H. Wrighten, September 9, 1944; NAACP Papers.

94. F. A. Clyde to R. A. Morton, June 13, 1944, with newspaper clippings attached, AMAA Addendum. Julia Brogdon Purnell, interview, November 13, 1987; Lucille Whipper, interview, March 2, 1976; Robert Graves, interview, March 11, 1976; Louis Holman, interview, March 22, 1976. G. D. Grice to P. M. Macmillan, May 19, 1944, with H. Scipio to Registrar, College of Charleston, May 15, 1944, attached, Correspondence Relating to Application by Negroes for Entrance into the College, College of Charleston Archives. Hazel Stewart, interview, Charleston, March 9, 1976, SCRSSL. "Voices," 86–87; J. H. Wrighten to R. Hurley, September 29, 1944, NAACP Papers.

95. F. A. Clyde to R. A. Morton, June 13, 1944, with newspaper clippings attached, AMAA Addendum. G. D. Grice to P. M. Macmillan, May 19, 1944, with H. Scipio to Registrar, College of Charleston, May 15, 1944, attached; [P. M. Macmillan] to G. D. Grice, May 20, 1944; G. D. Grice to H. A. Mouzon, June 9, 1944; Correspondence Relating to Application by Negroes for Entrance into the College, College of Charleston Archives.

96. F. A. Clyde to R. A. Morton, June 18, 1944; F. A. Clyde to R. A. Morton, June 22, 1944; AMAA Addendum. Julia Brogdon Purnell, interview, November 13, 1987; Hazel Stewart, interview, March 9, 1976.

97. Julia Brogdon Purnell, interview, November 13, 1987. F. A. Clyde to R. A. Morton, June 13, 1944; F. A. Clyde to R. A. Morton, June 22, 1944; AMAA Addendum. J. A. McFall to P. M. Macmillan, September 12, 1944, Correspondence Relating to Application by Negroes for Entrance into the College, College of Charleston Archives.

98. J. H. Wrighten to R. Hurley, September 29, 1944, NAACP Papers; J. A. McFall to R. A. Morton, October 16, 1944, with P. M. Macmillan to J. A. McFall, October 11, 1944, and J. H. Wrighten to College of Charleston, October 6, 1944, attached, AMAA Addendum; J. A. McFall to P. M. Macmillan, October 19, 1944, Correspondence Relating to Application by Negroes for Entrance into the College, College of Charleston Archives.

99. J. A. McFall to R. A. Morton, September 13, 1944, with J. A. McFall to P. M. Macmillan, September 12, 1944, attached, AMAA Addendum. [P. M. Macmillan] to J. A. McFall, September 8, 1944; J. A. McFall to P. M. Macmillan, September 12, 1944, with "Suggested Amendment of the Constitution and By-laws of 'Avery Institute' Incorporated" attached; Correspondence Relating to Application by Negroes for Entrance into the College, College of Charleston Archives. Carl T. Rowan, *South of Freedom* (New York: Alfred A. Knopf, 1952), 95–96.

100. "Voices," 86–87; Peters, "A Southern Success Story," 102; John H.

Wrighten, questionnaire, October 1, 1986; Richard Kluger, *Simple Justice: The History of Brown v. Board of Education and Black America's Struggle for Equality* (London: Andre Deutsch, 1977), 299; Charleston *News and Courier*, November 14, 1969.

101. Charleston *News and Courier*, May 22, 1949; letters to O. T. Wallace and L. K. Legge, April 8, 1947, Correspondence Relating to Application by Negroes for Entrance into the College, College of Charleston Archives.

102. Flyer *Avery Institute $10,000 Campaign Fund* attached with F. A. Clyde to R. A. Morton, March 31, 1944; J. A. McFall to P. M. Macmillan, September 12, 1944, attached with J. A. McFall to R. A. Morton, September 13, 1944; memorandum "Data on AMA Colleges and Schools, Avery Institute," ca. 1945; A. J. Clement, Jr., to F. L. Brownlee, May 10, 1945; AMAA Addendum. Leroy Anderson, interview, July 10, 1985.

103. "Data on AMA Colleges and Schools, Avery Institute," AMAA Addendum; *Avery Tiger*, May 1942, November 1942, December 1942; *Graduating Exercises of the Seventy-Seventh Commencement of Avery Institute, Charleston, South Carolina, Eight P.M. O'Clock, Wednesday, June 3, 1942, Morris Street Baptist Church* [hereafter cited as *Avery Commencement Program, 1942*]. Eugene C. Hunt told me Harry Lum was Hazel's brother.

104. *Avery Tiger*, December 1942; Charleston newspaper clippings, ca. 1943, AMAA Addendum.

105. Charleston newspaper clippings, ca. 1943; and F. A. Clyde to R. A. Morton, June 13, 1944, with clipping "Another Step in the Wrong Direction," Charleston *Evening Post*, June 12, 1944, attached; AMAA Addendum. Newby, *Black Carolinians*, 193–95.

106. James A. Wechsler, "He Started It," New York *Post*, May 14, 1964, 28; Kluger, *Simple Justice*, 295–305; Rowan, *South of Freedom*, 83–100; Tinsley E. Yarbrough, *A Passion for Justice: J. Waties Waring and Civil Rights* (New York: Oxford University Press, 1987).

107. Wechsler, "He Started It"; Samuel Grafton, "Lonesomest Man in Town," *Collier's*, April 29, 1950, 20; Kluger, *Simple Justice*, 297–305, 365–66, chapter 25 passim; Yarbrough, *A Passion for Justice*.

108. Membership Report Blanks, February 12, 1931, January 29, 1939; program *Sunday Afternoon, October 25, 1953, Annual Mass Meeting, Centenary Methodist Church;* [M. W. O.] to E. B. Burroughs, January 12, 1934; L. P. Bell to W. White, April 16, 1937; J. H. Green to R. Wilkins, May 17, 1942; E. Gadsden to NAACP, February 20, 1944; J. A. Gourdine to R. Hurley, July 12, 1944; J. A. Gourdine to R. Hurley, August 10, 1944; J. H. Wrighten to R. Hurley, September 4, 1944; J. H. Wrighten to R. Hurley, September 29, 1944; R. Hurley to J. H. Wrighten, September 9, 1944; NAACP Papers. EAAC: L. Howard Bennett, Madge H. Washington, Mary Lois Strawn, Julia Mae Brogdon, Fannie Ella Frazier, Elizabeth Suell Jackson. J. A. McFall to P. M. Macmillan, October 9, 1944, Correspondence Relating to Application by Negroes for Entrance into the College of Charleston, College of Charleston Archives; L. Howard Bennett, interview, June 23–24, 1981; J. Arthur Brown, interview, with the author and Eugene C. Hunt, Myrtle Beach, August 14, 1985; *Avery Tiger*, December 1942; *Avery Commencement Announcement, 1911*.

109. Charleston *News and Courier*, April 13, 1937.

110. L. P. Bell to W. White, April 16, 1937, with typed copies each of clipping

"States the Position for Southern Negroes," Charleston *News and Courier*, April 13, 1937, and L. P. Bell to Editor, *The News and Courier*, April 16, 1937, attached, NAACP Papers. Charleston *News and Courier*, April 24, 1937; May 26, 1937.

111. Howard H. Quint, *Profile in Black and White: A Frank Portrait of South Carolina* (Washington, D.C.: Public Affairs Press, 1958), 6–7; "Data on AMA Colleges and Schools, Avery Institute," AMAA Addendum; "Voices," 88.

112. Judith Stein, *The World of Marcus Garvey: Race and Class in Modern Society* (Baton Rouge: Louisiana State University Press, 1986), 131–32, 161–62.

113. W. H. Miller to E. F. Morrow, March 15, 1939; E. F. Morrow's secretary to W. H. Miller, March 18, 1939; J. E. Beard to W. White, May 11, 1943; *Sunday Afternoon, October 25, 1953, Annual Mass Meeting, Centenary Methodist Church;* and Membership Report, November 9, 1939; NAACP Papers.

114. J. Arthur Brown, interview, August 14, 1985.

115. Ibid.

116. Ibid.; Charleston *News and Courier*, December 10, 1978.

117. J. Arthur Brown, interview, August 14, 1985.

118. Ibid.

119. Ibid.; Charleston *News and Courier*, November 11, 1943; December 4, 1943. *Avery Catalogue, 1906*, 31; City Board of School Commissioners Minute Books, April 1940–July 1946, p. 210 (October 7, 1942), p. 241 (March 9, 1943).

120. City Board of School Commissioners Minute Books, April 1940–July 1946, pp. 268–70 (August 6, 1943), p. 276 (October 6, 1943), p. 308 (March 28, 1944). J. Arthur Brown, interview, August 14, 1985; J. Michael Graves, interview, March 7, 1985; Eugene C. Hunt, interview, August 28, 1980, November 4, 1980; December 4, 1985. Charleston *News and Courier*, November 11, 1943; December 4, 1943. *Avery Commencement Invitation, 1934;* Clark, *Echo in My Soul*, 80–83; Columbia *Lighthouse and Informer*, February 11, 1945; Irma E. Sams, questionnaire, August 1986; five newspaper obituary clippings on Simmons, ca. 1966, J. Andrew Simmons Papers; Edwina H. Whitlock, conversation, December 22, 1988.

121. City Board of School Commissioners Minute Books, April 1940–July 1946, loose letter, H. L. Erckmann to J. A. Johnston, February 15, 1944, with Waring's ruling attached, at p. 306 (March 1, 1944). J. Arthur Brown, interview, August 14, 1985; Eugene C. Hunt, interview, August 28, 1980, November 4, 1980, December 4, 1985. Oliver ("Snookie") Hasell, conversation, June 24, 1986. Charleston *News and Courier*, November 11, 1943; December 4, 1943. Columbia *Lighthouse and Informer*, February 11, 1945.

122. City Board of School Commissioners Minute Books, April 1940–July 1946, p. 278 (October 6, 1943), p. 285 (November 3, 1943), p. 356 (December 6, 1944), and loose letter, H. L. Erckmann to J. A. Johnston, February 15, 1944, with Waring's ruling attached, at p. 306 (March 1, 1944). City Board of School Commissioners Minute Books, August 1946–February 1951, p. 12 (September 17, 1946). W. H. Grayson to J. A. Clement, Jr., August 29, 1944, AMAA Addendum; Eugene C. Hunt, interview, August 28, 1980, November 4, 1980, December 4, 1985.

123. Five newspaper obituary clippings on Simmons, ca. 1966, J. Andrew Simmons Papers.

124. Memorandum, "Avery Institute, Charleston, S.C.," March 11, 1947; "Charleston Steps Ahead," 4–7; "Memorandum Covering Visit to Avery Institute,

Charleston, South Carolina—January 16–17, 1948"; AMAA Addendum. Stephen L. Nelson, comp. and ed., *Charleston Looks at Its Services for Negroes: A Condensed Report of the Findings and Recommendations of the Inter-Racial Study Committee of the Charleston Welfare Council in Cooperation with the Community Relations Project of the National Urban League, May 1947, Charleston, South Carolina* ([Charleston?]: N.p., [1947?]), p. D4.

125. See note 124.

126. John F. Potts, interview, April 17, 1982.

127. City Board of School Commissioners Minute Books, April 1940–July 1946, p. 277 (October 6, 1943), pp. 299–302 (March 1, 1944); Moore, "A History of the Negro Public Schools of Charleston, South Carolina, 1867–1942," 46, 50; Charleston *News and Courier*, July 10, 1956.

128. *Fiftieth Anniversary Reunion of Immaculate Conception High School, July 6–8, 1984, Charleston, S.C.* (Charleston: N.p. [1984]), 9–10, 12, 14; Moore, "A History of the Negro Public Schools of Charleston, South Carolina, 1867–1942."

129. Moore, "A History of the Negro Public Schools of Charleston, South Carolina, 1867–1942," 50. Charleston *News and Courier*, June 26, 1945; July 3, 7, 1945.

130. Charleston *News and Courier*, July 5, 7, 22, 1945; Naming Columbus Street School, Naming East Bay School, Box 863, OAR, CCSD. E. F. Morrow to W. E. Bluford, January 28, 1939; J. H. Green to R. Wilkins, May 17, 1942; Membership Report Blank, November 18, 1940; NAACP Papers. *Avery Tiger,* December 1951; *Avery Commencement Program, 1898; Who's Who in America, 1974–1975*, 2: 2838; *Who's Who of American Women: A Biographical Dictionary of Notable Living American Women,* 1st ed. (Chicago: Marquis–Who's Who, 1958), 1: 1178; *Baldwin and Southern's Charleston, South Carolina City Directory, 1944–1945,* master ed. (Charleston: Baldwin Directory Co., n.d.), 709. The adult evening educational program consisted of only two elementary classes for many years. In 1958 Morrison took the initiative to persuade city and county officials to expand it, so that those who dropped out between the seventh and twelfth grades could obtain a high school diploma.

131. Charleston *News and Courier,* July 15, 22, 1945; Nelson, comp. and ed., *Charleston Looks at Its Services for Negroes,* pp. A3–A4; Patty Sauls, Southern Association of Colleges and Secondary Schools, phone conversation, Columbia, South Carolina, August 7, 1986.

132. City Board of School Commissioners Minute Books, April 1940–July 1946, p. 277 (October 6, 1943), pp. 299–302 (March 1, 1944). City Board of School Commissioners Minute Books, August 1946–February 1951, p. 12 (September 17, 1946). Charleston *News and Courier,* January 6, 1954. G. C. Rogers, Jr., to author, January 20, 1989.

133. "Memorandum Covering Visit to Avery Institute, Charleston, South Carolina—January 16–17, 1948"; "Charleston Steps Ahead"; AMAA Addendum. City Board of School Commissioners Minute Books, August 1946–February 1951, R. C. Barrett to J. F. Seignious, January 28, 1947, on pp. 24–26 (February 3, 1947); and pp. 26–27 (February 5, 1947). H. L. Erckmann to Board of Trustees, School District No. 20, November 12, 1946; F. L. Brownlee to G. C. Rogers, April 17, 1947; R. C. Barrett to F. L. Brownlee, April 21, 1947; Avery Institute, Box 891, OAR, CCSD. Nelson, comp. and ed., *Charleston Looks at Its Services for Negroes,* title page, subtitle page "Report of the Education Sub-Committee," and pp. A6–A7, A9.

134. "Memorandum Covering Visit to Avery Institute, Charleston, South Carolina—January 16–17, 1948"; "Charleston Steps Ahead"; AMAA Addendum. J. C. McCray to G. C. Rogers, June 9, 1947; G. C. Rogers to J. H. McCray, June 10, 1947; Avery Institute, Box 891, OAR, CCSD.

135. City Board of School Commissioners Minute Books, August 1946–February 1951, letter from F. L. Brownlee, May 8, 1947, on pp. 40–41 (May 1947). "Memorandum Covering Visit to Avery Institute, Charleston, South Carolina—January 16–17, 1948"; "Charleston Steps Ahead"; AMAA Addendum.

CHAPTER 6. AVERY AS A PUBLIC SCHOOL, 1947–1954

1. John F. Potts, interview, April 17, 1982; Lois Simms, interview, August 28, 1984; J. Michael Graves, interview, March 7, 1985; Charlotte D. Tracy, interview, November 24, 1982; Lucille A. Williams, interview, September 25, 1984; *Avery Tiger*, December 1951, December 1952, October 1953, December 1953; L. Simms to AMA, March 2, 1952, AMAA Addendum; *Avery Commencement Invitation, 1938; The Faculty and Classes of Nineteen Forty-Two of Avery Institute Request Your Presence at the Graduation Exercises on the Evening of Wednesday, June Third, Eight P.M. O'Clock, Morris Street Baptist Church, Charleston, South Carolina* [hereafter cited as *Avery Commencement Invitation, 1942*].

2. *Avery Tiger*, November 1944, May 1949, March 1951, April 1951, November 1951, November 1952, February 1953, April 1953, October 1953, December 1953. *Public Schools of Charleston, South Carolina: A Survey Report* (Nashville: Division of Surveys and Field Services, George Peabody College for Teachers, 1949), 6–7; McMillan, *Negro Higher Education in the State of South Carolina*, 3.

3. John F. Potts, "The Avery Student," September 29, 1947; J. F. Potts to R. A. Morton, August 21, 1948; AMAA Addendum.

4. Lois Simms, interview, August 28, 1984; C. H. Ortmann to G. C. Rogers, October 27, 1952, Avery Institute, Box 891, OAR, CCSD; *Avery Tiger*, December 1953.

5. *Avery Tiger*, June 1949, December 1950, December 1952, February 1953, June 1953.

6. *Programme of the Eighty-Fourth Commencement of Avery High School, Charleston, South Carolina, Monday, June 13, 1949, Eight P.M., Morris Street Baptist Church* [hereafter cited as *Avery Commencement Program, 1949*]; *Avery Tiger*, June 1953.

7. *Avery Tiger*, April 1954.

8. John F. Potts, interview, April 17, 1982; *Avery Tiger*, February 1951, February–March 1952. F. L. Brownlee to W. Nelson, September 12, 1949; J. F. Potts to F. L. Brownlee, February 14, 1950; AMAA Addendum.

9. *Avery Tiger*, March 1949, December 1950.

10. Lois Simms, interview, August 28, 1984; John F. Potts, interview, April 17, 1982; Charlotte D. Tracy, interview, November 24, 1982; Leroy Anderson, interview, July 10, 1985. *Public Schools of Charleston, South Carolina*, 2–4.

11. Hazel Stewart, interview, March 9, 1976; Lucille Whipper, interview, March 2, 1976; Whitlock, " 'First Person Singular,' "; *Avery Commencement Invitation, 1934*.

12. Purse, *Charleston City Directory and Strangers' Guide for 1856*, 206; *List of the*

Tax Payers of the City of Charleston for 1859, 389; *List of the Tax Payers of the City of Charleston for 1860*, 321; *Avery Catalogue, 1906*, 25–36; *Avery Catalogue, 1910*, 17, 21–22; *The Pinnacle*, "Our First Colored Faculty" page; *AMA Annual Report (1915)*, 41; Whitlock, "Edwin A. Harleston," 9–28; Edwina H. Whitlock, questionnaire, August 4, 1986.

13. Edwina H. Whitlock, questionnaire, August 4, 1986.

14. "Charleston Snobbish Negro Aristocracy 'Passing' Out of Existence." Edwina H. Whitlock told me she sent John Johnson a copy of her item on the four aristocracies.

15. Lois Simms, interview, August 28, 1984; Charlotte D. Tracy, interview, November 24, 1982; John F. Potts, interview, April 17, 1982. "Charleston Steps Ahead," 7, AMAA Addendum. See also "Memorandum Covering Visit to Avery Institute, Charleston, South Carolina—January 16–17, 1948," AMAA Addendum, which appears to be a similar account of Brownlee's visit but does not give Potts's reaction to his speech.

16. *Avery Tiger*, February 1951, December 1952, February 1953, April 1953, June 1953, December 1953.

17. Ibid., February 1953; *Programme of the Eighty-Eighth Commencement of Avery High School, Charleston, South Carolina, Wednesday, June 3, 1953, Eight P.M., Morris Street Baptist Church* [hereafter cited as *Avery Commencement Program, 1953*].

18. *Avery Tiger*, February 1951, October 1951, October 1952, November 1952, December 1952, October 1953.

19. Ibid., November 1952, June 1953.

20. Ibid., November 1952. J. F. Potts to F. L. Brownlee, August 21, 1948; J. F. Potts to R. A. Morton, August 21, 1948; AMAA Addendum. Charleston *News and Courier*, June 28, 1949; December 10, 1951. *Public Schools of Charleston, South Carolina*, 40.

21. J. F. Potts to R. A. Morton, August 21, 1948, AMAA Addendum; *Avery Tiger*, April 1953; flyers *Join NAACP Now!! 40th Anniversary Membership Drive, March 8th through May 3rd, 1949* and *Full Citizenship Is Everybody's Business. . . . The Charleston Branch NAACP Invites You . . . Tuesday, January 19, 1954, 8 P.M., Emanuel A.M.E. Church, Calhoun Street*, NAACP Papers.

22. *Avery Tiger*, February 1951, December 1952, June 1953, December 1953.

23. Charleston *News and Courier*, June 7, 1953. "Memorandum Covering Visit to Avery Institute, Charleston, South Carolina—January 16–17, 1948"; "Charleston Steps Ahead"; J. F. Potts to R. A. Morton, August 21, 1948; AMAA Addendum. Minutes of the Advisory Committee to Mr. George C. Rogers, Superintendent of Education, Charleston County, 1949–1951, p. 40 (January 30, 1951), ARC [hereafter cited as Minutes, Advisory Committee, with page numbers referring to a typed copy in author's possession].

24. City Board of School Commissioners Minute Books, April 1951–September 1957, p. 181 (December 7, 1954). Minutes, Advisory Committee, pp. 13–14 (March 28, 1950), pp. 32–33 (November 14, 1950), pp. 34–35, 37 (December 12, 1950), p. 40 (January 30, 1951), pp. 44–46 (February 27, 1951), p. 49 (March 27, 1951). *Public Schools of Charleston, South Carolina*, 46–47, 54.

25. Minutes, Advisory Committee, pp. 6, 11–12 (January 30, 1950), pp. 34–35 (December 12, 1950), p. 57 (May 1, 1951), pp. 68, 73 (November 26, 1951).

26. Charleston *News and Courier*, September 15, 1948; June 7, 1949; April 15,

1954. City Board of School Commissioners Minute Books, August 1946–February 1951, pp. 202–3 (May 23, 1949), pp. 204–6 (May 30, 1949). *Public Schools of Charleston, South Carolina,* 143, 156; J. F. Potts to F. L. Brownlee, November 16, 1948, AMAA Addendum.

27. J. F. Potts to R. A. Morton, September 10, 1949; R. E. Fields to F. L. Brownlee, June 21, 1949, with copy of letter sent to Charleston county delegation and chairman of the city board of education by a committee representing the Avery PTA, Avery Alumni Association, and concerned citizens, dated June 18, 1949, attached; AMAA Addendum. City Board of School Commissioners Minute Books, August 1946–February 1951, pp. 202–3 (May 23, 1949), pp. 223–24 (October 5, 1949), and letter from superintendent dated May 23, 1949, on pp. 200–1. Good, ed., *Dictionary of Education,* 267.

28. J. F. Potts to F. L. Brownlee, March 30, 1950, AMAA Addendum; Charleston *News and Courier,* January 3, 1952. Minutes, Advisory Committee, p. 49 (March 27, 1951), pp. 74, 77–78 (January 21, 1952).

29. Charleston *News and Courier,* April 15, 1954; City Board of School Commissioners Minute Books, April 1951–September 1957, p. 147 (April 21, 1954), p. 148 (May 6, 1954), p. 149 (May 12, 1954).

30. John F. Potts, interview, April 17, 1982; J. W. Waring to H. T. Delaney, January 28, 1952, J. Waties Waring Papers, Moorland-Spingarn Research Center, Howard University, Washington, D.C.; City Board of School Commissioners Minute Books, April 1951–September 1957, p. 151 (June 4, 1954), and loose letters at pp. 208–9 (September 7, 1955). Most Averyites I talked to believed that there was some kind of conspiracy to close the school.

31. Grafton, "Lonesomest Man in Town"; Wechsler, "He Started It."

32. J. F. Potts to R. A. Morton, August 21, 1948, AMAA Addendum; Clark, *Echo in My Soul,* 95–100, 102; Grafton, "Lonesomest Man in Town." During a phone conversation on May 26, 1986, Ruby P. Cornwell told me the names of the guests and Waring's reason.

33. J. W. Waring to H. T. Delaney, January 28, 1952, J. Waties Waring Papers; *A Testimonial Dinner and Presentation of Bronze Plaque Commemorating the Historic Contribution of the Honorable J. Waties Waring, United States District Judge, Retired, in the Clarendon County, South Carolina Case against Public School Segregation Given by the South Carolina Conference of the National Association for the Advancement of Colored People, Buist School, Charleston, South Carolina, November 6, 1954* ([Charleston?]: N.p., [1954?]); Charleston *News and Courier,* January 12, 1968; R. P. Cornwell to E. S. Wells, September 23, 1968, with clipping, Charleston *News and Courier,* January 23, 1968, attached, Eric S. Wells Papers; J. Arthur Brown, interview, August 14, 1985; "Blessed Assurance: The Music Ministry of St. Matthew Baptist Church, Charleston, South Carolina," record jacket.

34. J. A. McFall to R. A. Morton, May 30, 1944, AMAA Addendum; C. H. Ortmann to G. C. Rogers, October 27, 1952, Avery Institute, Box 891, OAR, CCSD; Constituent Board Minutes, District 20, 1956–1978, December 12, 1956–June 17, 1957, p. 106 (June 17, 1957), OAR, CCSD; *Avery Tiger,* October 1953, December 1953. Many Averyites mentioned that some neighbors wanted the school closed. I talked to one elderly white couple, living next to the school, who said they were saddened when it closed.

35. Charleston *News and Courier,* January 29, 1949; May 22, 1949. J. M. Hinton

to G. D. Grice, March 13, 1949; G. D. Grice to J. M. Hinton, March 14, 1949; R. Bryan to The Registrar, March 15, 1949; Correspondence Relating to Application by Negroes for Entrance into the College, College of Charleston Archives.

36. J. W. Waring to H. T. Delaney, January 28, 1952; T. Marshall to G. D. Grice, June 2, 1949; memorandum on Richard E. Fields letterhead, "Citizens Meeting at Coming Street, Y.W.C.A., Friday, July 22, 1949"; J. Waties Waring Papers. Rowan, *South of Freedom*, 95–96; J. Arthur Brown, interview, August 14, 1985; J. A. McFall to P. M. Macmillan, October 19, 1944, Correspondence Relating to Application by Negroes for Entrance into the College, College of Charleston Archives.

37. H. L. Erckmann to P. M. Macmillan, January 23, 1948, Correspondence Relating to Application by Negroes for Entrance into the College, College of Charleston Archives. Charleston *News and Courier*, January 30, 1949; February 22, 23, 1949; March 2, 18, 24, 1949; April 20, 1949. Charleston *Evening Post*, January 29, 1949.

38. McMillan, *Negro Higher Education in the State of South Carolina*, title page, dedication page, vii–ix; L. K. McMillan to J. Byrnes, September 18, 1954, Race Issues, 1942–1960s, no. 23-432/3, Thomas R. Waring Papers, SCHS.

39. McMillan, *Negro Higher Education in the State of South Carolina*, xi–xii, 1–6.

40. John F. Potts, interview, April 17, 1982; Charleston *News and Courier*, April 12, 13, 1954; City Board of School Commissioners Minute Books, April 1951–September 1957, p. 141 (March 3, 1954); program *Appreciation Service Honoring Mr. and Mrs. John F. Potts, Sunday, May 23, 1954, Buist School Auditorium, 5 P.M., Dr. John M. Metz, Presiding.*

41. Charleston *News and Courier*, November 17, 1948; J. Michael Graves, interview, March 7, 1985; John F. Potts, interview, April 17, 1982. Averyites who attended Burke include Joseph I. Hoffman, Sarah Green Oglesby, and J. Arthur Brown.

42. Charleston *News and Courier*, September 9, 1948; July 19, 1949. Sarah Green Oglesby, interview, October 14, 28, 1980. Eugene C. Hunt told me Halsey helped Simpson get the job at Gibbes Art Gallery, now called Gibbes Museum of Art.

43. D. J. Moses to G. C. Rogers, June 5, 1954; A. W. Hoursey to G. C. Rogers, July 1, 1954; Avery Institute, Box 891, OAR, CCSD. J. Michael Graves, interview, March 7, 1985; Lucille A. Williams, interview, September 25, 1984; H. Louise Mouzon, interview, November 20, 1980.

44. P. Widenhouse to J. T. Enwright, April 23, 1954, AMAA Addendum; Arthur J. Clement, Jr., interview, August 27, 1986. During a phone conversation with me on May 26, 1986, Ruby P. Cornwell, who taught L. Howard Bennett at Avery, recalled his mentioning Brownlee's words.

45. Book L-60, p. 73, CCRMC; Charleston *News and Courier*, October 2, 1954.

CHAPTER 7. AVERYITES AND THE CIVIL RIGHTS MOVEMENT
IN THE LOW COUNTRY, 1954–1969

1. Leroy Anderson, interview, July 10, 1985; L. Howard Bennett, interview, June 23–24, 1981; "List of Negro Teachers for Charleston County, 1959–1960," OAR, CCSD. Charleston *News and Courier*, October 27, 1958; July 6, 1965.

2. George C. Rogers, Jr., "Who Is a South Carolinian?" *SCHM* 89 (January 1988): 10.

3. Charleston *News and Courier*, May 14, 1953; August 10, 1953; December 31,

1953; January 8, 1954; August 26, 1955; November 29, 1955; October 22, 1957; November 10, 1958; May 14, 1969. W. J. Simmons to T. R. Waring, September 6, 1955, Citizen's Councils, 1955–1956, no. 23-393/2; and T. R. Waring to W. R. Willauer, January 22, 1959, Citizen's Councils, 1958–1960, no. 22-393/4; both in Thomas R. Waring Papers. Andrew McDonald Secrest, "In Black and White: Press Opinion and Race Relations in South Carolina, 1954–1964" (Ph.D. diss., Duke University, 1972), vi, 123, 206. For Hollings, see Charleston *News and Courier*, December 12, 1952; April 23, 1954; August 7, 1954; September 16, 1955.

4. Clark, *Echo in My Soul*, 122–34; Charles L. Dibble, "Highlander Controversy Began in 1932," Charleston *News and Courier*, August 20, 1964, 5D; Carl Tjerandsen, "The Highlander Heritage: Education for Social Change," *Convergence* 16, no. 2 (1983): 10–22; "Voices," 64–65; Anna D. Kelly, interview, August 20, 1984; *The Faculty and Class of Nineteen Thirty-Two of Avery Institute Request Your Presence at the Commencement Exercises on the Evening of Wednesday, June First, Eight O'Clock, Morris Street Baptist Church, Charleston, South Carolina* [hereafter cited as *Avery Commencement Invitation, 1932*].

5. Anna D. Kelly, interview, August 20, 1984; Clark, *Echo in My Soul*, 119–20.

6. Clark, *Echo in My Soul*, 111–21, 131–32, 167, 174, 196–98; Dibble, "Highlander Controversy Began in 1932"; Frank Adams, with Myles Horton, *Unearthing Seeds of Fire: The Idea of Highlander* (Winston-Salem, N.C.: John F. Blair, 1975), chapters 1–3; Tjerandsen, "The Highlander Heritage," 11–12.

7. Charleston *News and Courier*, October 31, 1972; Carawan and Carawan, *Ain't You Got a Right to the Tree of Life*, 9, 158, 160–62.

8. Carawan and Carawan, *Ain't You Got a Right to the Tree of Life*, 9, 28–29, 167; Charles L. Dibble, "Esau Jenkins Proud of Club's Progress," Charleston *News and Courier*, August 19, 1964, 3B; "Voices," 167–68; Clark, *Echo in My Soul*, 135–37.

9. Tjerandsen, "The Highlander Heritage," 13; Clark, *Echo in My Soul*, 135–42; Carawan and Carawan, *Ain't You Got a Right to the Tree of Life*, 168; Carl Tjerandsen, *Education for Citizenship: A Foundation's Experience* (Santa Cruz, Calif.: Emil Schwarzhaupt Foundation, 1980), 152.

10. Adams, *Unearthing Seeds of Fire*, 114; Tjerandsen, *Education for Citizenship*, 152–57; Clark, *Echo in My Soul*, 89, 139–42, 148–50; Mabel Montgomery, *South Carolina's Wil Lou Gray: Pioneer in Adult Education, a Crusader, Modern Model* (Columbia, S.C.: Vogue Press, 1963), xvi, 41, 59, 62; Bernice Robinson, interview with Sue Thrasher and Elliot Wiggington, New Market, November 9, 1980, HREC.

11. Clark, *Echo in My Soul*, 142–66; Tjerandsen, *Education for Citizenship*, 163–64, 170–71; Adams, *Unearthing Seeds of Fire*, 118, 131–33; Charleston *News and Courier*, May 16, 1965.

12. Bernice Robinson, interview, November 9, 1980; Clark, *Echo in My Soul*, 111–13; "Voices," 280; Peters, "A Southern Success Story," 105; J. Arthur Brown, interview, August 14, 1985; Charleston *News and Courier*, October 14, 1959. J. Arthur Brown informed me about the cross burning. Wrighten's wife, the former Dorothy Lillian Richardson, and their daughter, Doris Wrighten Powell, told me about the intimidation as well as the cross burning.

13. Charleston *News and Courier*, November 24, 1958; December 19, 1958; June 9, 29, 1960; November 9, 29, 1960; December 22, 1960. J. Arthur Brown, interview, August 14, 1985.

14. Peters, "A Southern Success Story," 104. Charleston *News and Courier*, March

27, 1949; February 17, 22, 1952; April 4, 1952; May 1, 1952; July 13, 1953; August 17, 18, 1953; September 15, 1953; March 29, 1956; April 24, 1956; July 6, 1965. "Voices," 75–76, 90. Brown was building on earlier efforts by Arthur J. Clement, Jr., Robert F. Morrison, and W. W. Jones, who also attended Avery.

15. Charleston *News and Courier,* August 17, 1953; October 9, 1955.

16. Charleston *News and Courier,* July 31, 1955; City Board of School Commissioners Minute Books, April 1951–September 1957, loose petition, "To: City of Charleston, South Carolina—School Board District no. 20 And Superintendent of Schools of District no. 20 Charleston, S.C.," n.d.; and loose letter, Chairman of Board of Trustees, School District No. 20 of Charleston County to J. A. Brown, September 1955, at pp. 208–9.

17. Charleston *News and Courier,* October 11, 1955; June 19, 1959. City Board of School Commissioners Minute Books, April 1951–September 1957, p. 143 (March 15, 1954), p. 185 (January 13, 1955), p. 212 (October 12, 1955), p. 251 (December 12, 1956), pp. 260–61 (February 6, 1957), p. 275 (May 29, 1957), p. 277 (June 24, 1957). Constituent Board Minutes, District 20, December 12, 1956–June 17, 1957, pp. 8–9 (December 12, 1956), pp. 13–15 (January 9, 1957). Constituent Board Minutes, District 20, October 14, 1959–January 9, 1967, p. 36 (October 12, 1960). Clark, *Echo in My Soul,* 89, 111–12. The school board would only reluctantly turn over underenrolled white schools to blacks, in what J. Arthur Brown described as an "appeasement" measure. The board also declined to name schools after Thomas E. Miller and Joseph C. Berry. The new superintendent, W. Robert Gaines, publicly refuted Robert F. Morrison's charges.

18. Clark, *Echo in My Soul,* 175. Charleston *News and Courier,* October 30, 1955; November 23, 24, 1955; January 21, 1956; April 17, 1956. "Voices," 77, 105–7, 173–74.

19. Charleston *News and Courier,* June 19, 1959; October 20, 1960; May 11, 1961; June 9, 1961; August 11, 1961; September 5, 1961; January 20, 1962; May 29, 1962; August 4, 6, 23, 30, 1963. Constituent Board Minutes, District 20, October 14, 1959–January 9, 1967, pp. 38–39 (November 9, 1960), pp. 70–71 (July 29, 1961), pp. 72–73 (August 30, 1961), pp. 156–57 (June 12, 1963).

20. Charleston *News and Courier,* March 21, 1961; August 23, 24, 1963; September 4, 7, 20, 22, 1963; November 7, 1963; December 10, 1978. T R W to Peter, November 19, 1963, with Tony to Waring, November 19, 1963, attached, George D. Grice [file], no. 23-401/11, Thomas W. Waring Papers. Grice complained about the newspaper's coverage, which actually was extensive. For a discussion of the relationship of Thomas R. Waring and the *News and Courier* to the private school movement, see Secrest, "In Black and White," 363.

21. Constituent Board Minutes, District 20, October 14, 1959–January 9, 1967, pp. 160–61 (August 22, 1963), pp. 190–91 (April 8, 1964), p. 227 (April 14, 1965).

22. Constituent Board Minutes, District 20, October 14, 1959–January 9, 1967, p. 228 (September 7, 1966); Constituent Board Minutes, District 20, 1966–1978, p. 292 (May 8, 1967). Charleston *News and Courier,* August 20, 23, 1963; May 16, 1965; September 8, 1965; September 6, 1968; October 2, 1969. W. R. Coppedge to R. Haymaker, July 16, 1966, Correspondence Relating to Application by Negroes for Entrance into the College of Charleston, College of Charleston Archives; J. Lofton to T. R. Waring, July 29, 1964, with attachments, College of Charleston [file], 1964–

1968, no. 23-394/6, Thomas R. Waring Papers. John Lofton, associate editor of the Pittsburgh *Post Gazette* and an alumnus of the college, persuaded a number of graduates to sign a petition asking the chairman of the College of Charleston board of trustees to admit students on "academic and personal achievement without reference to race."

23. Davis R. Holland, "A History of the Desegregation Movement in the South Carolina Public Schools during the Period 1954–1976" (Ph.D. diss., Florida State University, 1978), 54–68; Charleston *News and Courier,* January 10, 1963; John G. Sproat, "'Firm Flexibility': Perspectives on Desegregation in South Carolina," in Abzug and Maizlish, eds., *New Perspectives on Race and Slavery in America,* 183 n. 23; Peter Poinsette, interview, March 31, 1981; Thomas R. Waring, "Mailman Enjoys Retirement," Charleston *News and Courier-Evening Post,* June 6, 1982, 2E; *Walsh's 1925–1926 Charleston, South Carolina City Directory, Forty-Fourth Year,* 259; Tjerandsen, *Education for Citizenship,* 173.

24. J. Arthur Brown, interview, August 14, 1985; Eugene C. Hunt, interview, August 28, 1980, November 4, 1980, December 4, 1985; "Voices," 198; Charleston *News and Courier,* November 14, 1962. I was told that Brown accompanied Gantt to Clemson.

25. R. P. Cornwell to E. S. Wells, September 23, 1968, Eric S. Wells Papers.

26. Newby, *Black Carolinians,* 317–18, 323; "Voices," 196–201, 218; Charleston *News and Courier,* April 6, 7, 12, 20, 24, 1960.

27. See note 26; flyer, "Notice, Notice, Notice, Selective Buying" and synopsis "The Charleston Movement," Race Issues, 1942–1960s, no. 23-434/1, no. 23-435/1, Thomas R. Waring Papers; "The Charleston Movement: N.A.A.C.P. Report to the Community," ca. August 1963, Record Group 1-III-28, Civil Rights—South Carolina, HREC; Charleston *News and Courier,* June 10, 21, 23, 26, 1963.

28. See notes 26 and 27; Charleston *News and Courier,* July 31, 1963; "Voices," 199–201, 218–19.

29. Charleston *News and Courier,* July 7, 8, 10, 11, 12, 13, 31, 1963.

30. Secrest, "In Black and White," 370. Charleston *News and Courier,* July 17, 18, 23, 1963; August 1, 2, 8, 16, 17, 18, 1963; September 26, 27, 1963; December 17, 1963.

31. Charleston *News and Courier,* December 23, 1960; February 11, 1961; December 17, 1963.

32. Charleston *News and Courier,* July 15, 1951; December 3, 1957; July 13, 1960; February 28, 1961; May 18, 1964. Walter B. Weare, *Black Business in the New South: A Social History of the North Carolina Mutual Life Insurance Company* (Urbana: University of Illinois Press, 1973), 90; J. Arthur Brown, interview, August 14, 1985; *Sunday Afternoon, October 25, 1953, Annual Mass Meeting, Centenary Methodist Church,* NAACP Papers. A. J. Clement, Jr., to B. Collier, October 22, 1951, Race Issues, 1942–1960s, no. 23-432/2, Thomas R. Waring Papers.

33. Charleston *News and Courier,* May 18, 1964; Arthur J. Clement, Jr., interview, August 27, 1986.

34. J. Arthur Brown, interview, August 14, 1985; Charleston *News and Courier,* February 28, 1961.

35. Memorandum "Prominent Negroes of Charleston, S.C.," May 1963, with "Add List of Prominent Negroes in Charleston" attached, Race Issues, 1942–1960s

no. 23-435/1, Thomas R. Waring Papers; "Voices,"40–53. The best overall account of the hospital strike is Leon Fink, "Union Power, Soul Power: The Story of 1199B and Labor's Search for a Southern Strategy," *Southern Changes* 5 (March–April 1983): 9–20.

36. "Voices," 40–43, 46; Fink, "Union Power, Soul Power," 11. Charleston *News and Courier,* February 22, 1965; June 24, 1965; November 23, 1968.

37. Fink, "Union Power, Soul Power," 11–12; "Voices," 41–43; Charleston *News and Courier,* August 24, 1969.

38. Bill Saunders, interview, with Lucy Phenix, New Market, June 19, 20, 21, 1981, HREC. Charleston *News and Courier,* May 24, 1968; December 10, 1978. Fink, "Union Power, Soul Power," 11–12.

39. Bill Saunders, interview, June 19, 20, 21, 1981; Fink, "Union Power, Soul Power," 11–12; "Voices," 40–43, 60–69. Charleston *News and Courier,* December 4, 1968; August 24, 1969.

40. Charleston *News and Courier,* November 23, 1968; May 15, 16, 1969; August 24, 1969. "Voices," 44.

41. Fink, "Union Power, Soul Power," 10, 12–13.

42. "Voices," 56–57; Charleston *News and Courier,* August 24, 1969.

43. Charleston *News and Courier,* April 19, 1964; August 24, 1969.

44. Charleston *News and Courier,* June 24, 1965; June 18, 1969. "Voices," 43; Fink, "Union Power, Soul Power," 18. For McCord's denial, see documentary, "I Am Somebody," Moe Foner, executive producer.

45. "Voices," 43–44. Charleston *News and Courier,* April 2, 30, 1969; May 1, 2, 7, 9, 11, 12, 15, 1969; June 21, 1969; August 24, 1969.

46. Memorandum, Thomas R. Waring, "Summary of a Conference Today (Sept. 29, 1969) with Hugh Lane," September 29, 1969, Hospital Strike, 1969, no. 23-406/8, Thomas R. Waring Papers; Bill Saunders, interview, June 19, 20, 21, 1981; "Voices," 41. Charleston *News and Courier,* June 28, 1969; August 24, 1969. Fink, "Union Power, Soul Power," 15.

47. "Voices," 41–46; Fink, "Union Power, Soul Power," 20; Charleston *News and Courier,* June 28, 1969.

48. Charleston *News and Courier,* August 24, 1969; December 10, 1978.

49. D. T. Henderson to Chief, memorandum, October 1949; A. J. Tamsberg to T. R. Waring, June 15, 1959; Race Issues, 1942–1960s, no. 23-432/1, no. 23-434/8; Thomas R. Waring Papers. T R W to Peter, November 19, 1963, with Tony to Waring, November 19, 1963, attached, George D. Grice [file], no. 23-401/11, Thomas R. Waring Papers. Charleston *News and Courier,* July 15, 1951.

50. Charleston *News and Courier,* February 26, 1956; March 1, 1956; February 26, 1969; December 14, 1969. Tjerandsen, *Education for Citizenship,* 172; Fink, "Union Power, Soul Power," 19.

BIBLIOGRAPHY

MANUSCRIPTS AND COLLECTIONS

Amistad Research Center, Tulane University, New Orleans, La.
 American Missionary Association Archives, 1821–1891.
 American Missionary Association, [New] Addendum, to the American
 Missionary Association Archives, 1869–.
 Beam-Douglas Papers.
 Eric S. Wells Papers.
Avery Research Center, College of Charleston, Charleston, S.C.
 "Complete Transcription of Conference, South Carolina Voices of the Civil
 Rights Movement, November 5–6, 1982."
 Minutes of the Advisory Committee to Mr. George C. Rogers, Superintendent
 of Education, Charleston County, 1949–1951.
 Miscellaneous Papers: Joyce Ravenel Butler Folder; John L. Dart Folder;
 Charleston Interracial Committee, 1942–1953, Folder; Charles Mason Folder;
 Laing School Folder.
 "A History—by Administrations—of the Phyllis Wheatley Literary and Social
 Club by Jeannette Keeble Cox [1934]."
 Plymouth Congregational Church, Charleston, 1942–1948.
 Shrewsbury Papers.
Centenary Methodist Episcopal Church, Charleston, S.C.
 Records. 6 vols.
Charleston County Probate Court, Charleston, S.C.
 Record of Wills.
Charleston County Public Library, John L. Dart Hall Branch, Charleston, S.C.
 Avery File.
 Dart Hall File.
 Negro Biography File.
Charleston County Public Library, King Street Branch, Charleston, S.C.
 Biography File.
 Charleston County Death Records, 1821–1926 (File Card Index).
Charleston County Register of Mesne and Conveyance, Charleston, S.C.
Charleston Library Society, Charleston, S.C.
 Hinson Clippings.
 Joseph Walker Barnwell, "Life and Recollections of Joseph W. Barnwell."
 Transcript, 1929. 2 vols.
 Proceedings of the Clionian Debating Society.
 Tax Book, Free Persons of Color, Charleston, 1862.
City Archives, Charleston, S.C.
 Council Journal.
 Tax Book, Free Persons of Color, 1864.

Grace Episcopal Church, Charleston, S.C.
 Parish Register.
Highlander Research Center, New Market, Tenn.
 Record Group 1-III-28, Civil Rights—South Carolina.
Library of Congress, Manuscript Division, Washington, D.C.
 National Association for the Advancement of Colored People Papers,
 Charleston, S.C.
 Carter G. Woodson Collection: Whitefield McKinlay Papers; State Free Negro
 Capitation Tax Book, Charleston, 1860.
Moorland-Spingarn Research Center, Howard University, Washington, D.C.
 Stewart-Flippin Papers.
 E. Franklin Frazier Papers.
 Archibald H. Grimke Papers.
 Howardian File.
 Ernest Everett Just Papers.
 Kelly Miller Papers.
 J. Waties Waring Papers.
National Archives, Washington, D.C.
 Records of the Bureau of Refugees, Freedmen, and Abandoned Lands. Record
 Group 105.
 General Accounting Office, Office of First Auditor, Miscellaneous Treasury
 Accounts, Richard and Gilbert Wall. Record Group 217.
Office of Archives and Records, Charleston County School District,
 Charleston, S.C.
 Avery Institute. Box 891.
 Charleston County School District Minute Book, June 1878 to April 1920.
 City Board of School Commissioners Minute Books, 1913–1957.
 Constituent Board Minutes, District 20, 1956–1978.
 Naming Columbus Street School. Naming East Bay School. Box 863.
 Picnic Playground—Colored. Box 896.
 Principals Reports—Negro Schools. Box 900.
 Record of Certificates Issued by the City Board of Examiners, Charleston, So.
 Ca., from May 10, 1875 to [1895].
Records in Possession of Private Individuals.
 Edwin A. Harleston Papers, Edwina Harleston Whitlock, Charleston, S.C.
 James R. Logan Scrapbook, private hands, Charleston, S.C.
 Robert F. Morrison Papers, Constance Morrison Thompson, Detroit, Mich.
 J. Andrew Simmons Papers, Irma E. Sams, Atlanta, Ga.
 Edwina H. Whitlock Papers, Edwina Harleston Whitlock, Charleston, S.C.
 John Wrighten Papers, John Wrighten, New London, Conn.
St. Philip's Episcopal Church, Charleston, S.C.
 Baptisms, Marriages, and Burials, 1823–1940. 2 vols.
South Carolina Department of Archives and History, Columbia, S.C.
 General Assembly Petitions.
 Master-in-Equity Files.
 State Free Negro Capitation Tax Books, Charleston, 1841, 1843, 1846, 1851,
 1852, 1855.
 State Superintendent of Education Correspondence: Letter Copy Book no. 13

(July 25, 1873, to November 7, 1873), and no. 30 (October 20, 1885, to August 23, 1886); Letters Received, 1869–1886; J. J. McMahon Papers.

South Carolina Historical Society, Charleston, S.C.

"Autobiography of F. A. Mood." Photoduplicate Transcript. No. 34-528-29.

St. Mark's Protestant Episcopal Church, Charleston. Parish Records, 1866–1965. Microfiche. No. 50-328.

Jacob Frederick Schirmer. Diaries, ca. 1826–1886. 7 MS vols. No. 34-55-61.

G. H. Walker. "The Brown Fellowship Society." W.P.A. Project. 1930s. No. 30-14-3.

Thomas R. Waring Papers: Citizen's Councils, 1955–1960, No. 23-393/2–4; College of Charleston, 1964–1968, No. 23-394/6; George D. Grice, No. 23-401/11; Hospital Strike, 1969, No. 23-406/8; Race Issues, 1942–1960s, Nos. 23-432 through 23-435.

Trinity Methodist Episcopal Church, Book C, Roll of Colored Members, 1821–1868 [Original, Trinity M.E. Church, Charleston].

South Caroliniana Library, University of South Carolina, Columbia, S.C.

Abraham Middleton Papers. No. 1447.

Ellison Family Paper, 1845–1870, 1882. No. 695.

Wil Lou Gray Papers. No. 848.

Obear-Osmar Papers, Orphan Aid Society. No. 2452.

Special Collections, Robert Scott Small Library, College of Charleston, Charleston, S.C.

Bell Family Papers.

Brown (Century) Fellowship Society Minutes.

Septima Poinsette Clark Papers.

College of Charleston Archives: Board of Trustees—Minutes; Chrestomathic Literary Society, Boxes CCLI, CCLII, CCLXXI; Correspondence Relating to Application by Negroes for Entrance into the College.

Holloway Family Papers [formerly Holloway Family Scrapbook].

Proceedings of the Friendly Moralist Society.

Waring Historical Library, Medical University of South Carolina, Charleston, S.C.

Lucy H. Brown File.

INTERVIEWS AND ORAL HISTORIES

(At Avery Research Center unless otherwise indicated)

Anderson, Leroy. With the author. Charleston, July 10, 1985.

Bennett, L. Howard. With the author and Eugene C. Hunt. Charleston, June 23–24, 1981.

Brown, J. Arthur. With the author and Eugene C. Hunt. Myrtle Beach, August 14, 1985.

Clement, Arthur J., Jr. With the author and Eugene C. Hunt. Charleston, August 27, 1986.

Cornwell, Ruby P. With the author and Eugene C. Hunt. Charleston, November 24, 1982.

Forrest, Marcellus. With the author and Eugene C. Hunt. Charleston, February 12, 1981.

Graves, J. Michael. With the author. Charleston, March 7, 1985.

Graves, Robert. Charleston, March 11, 1976. Special Collections, Robert Scott Small Library, College of Charleston.

Hoffman, Ellen Wiley. With the author and Eugene C. Hunt. Charleston, September 18, 1980.

Hoffman, Joseph I. With the author and Eugene C. Hunt. Charleston, September 25, 1980, October 9, 1980.

Holman, Louis. Charleston, March 22, 1976. Special Collections, Robert Scott Small Library, College of Charleston.

Hunt, Eugene C. With the author. Charleston, August 28, 1980, November 4, 1980, December 4, 1985.

Hutchinson, Felder. With the author and Eugene C. Hunt. Charleston, July 16, 1985.

Kelly, Anna D. With the author. Charleston, August 20, 1984.

Mouzon, H. Louise. With the author and Eugene C. Hunt. Charleston, November 20, 1980.

Oglesby, Sarah Green. With the author and Eugene C. Hunt. Charleston, October 14, 28, 1980.

Poinsette, Lucille Mears. With the author and Eugene C. Hunt. Charleston, April 2, 1981.

Poinsette, Peter. With the author and Eugene C. Hunt. Charleston, March 31, 1981.

Potts, John F. With the author. Charleston, April 17, 1982.

Purnell, Julia Brogdon. With the author. Baton Rouge, November 13, 1987.

Robinson, Bernice. With Sue Thrasher and Elliot Wiggington. New Market, November 9, 1980. Highlander Research and Education Center.

Saunders, Bill. With Lucy Phenix. New Market, June 19, 20, 21, 1981. Highlander Research and Education Center.

Simmons, Mrs. Theodore (Thelma Hoursey). With the author and Eugene C. Hunt. Charleston, March 26, 1981.

Simms, Lois. With the author. Charleston, August 28, 1984.

Stewart, Hazel. Charleston, March 9, 1976. Special Collections, Robert Scott Small Library, College of Charleston.

Tracy, Charlotte D. With the author. Charleston, November 24, 1982.

Whipper, Lucille. Charleston, March 2, 1976. Special Collections, Robert Scott Small Library, College of Charleston.

Williams, Lucille A. With the author. Mt. Pleasant, S.C., September 25, 1984.

Wright, Lillian Ransier. With the author and Eugene C. Hunt. Charleston, April 10, 1981.

AMERICAN MISSIONARY ASSOCIATION REPORTS (Chronological)

American Missionary Association Annual Reports. New York: 1862–1932.

Brownlee, Frederick L. *Some Lights and Shadows of 1932–1933.* New York: 1933.

Brownlee, Frederick L., and William A. Daniel. *Review of the Mission Field for Year 1933–1934.*

Straight Ahead [1934/1935].

Brownlee, Frederick L. *Facing Facts: A Review of the American Missionary Association's Eighty-Ninth Year.*

Ninety Years After. . . ?

Perplexing Realities. New York: 1937.

A Continuing Service: A Reprint from the Annual Report for 1938 of the Board of Home Missions of the Congregational and Christian Churches Covering the Work of the American Missionary Association Division for the Year Ending May 31, 1938. New York: 1938[?].

Accelerating Social Evolution: A Reprint from the Annual Report for 1939 of the Board of Home Missions of the Congregational and Christian Churches Covering the Work of the American Missionary Association Division for the Year Ending May 31, 1939. New York: 1939[?].

Bread and Molasses: A Reprint from the Annual Report for 1940 of the Board of Home Missions of the Congregational and Christian Churches Covering the Work of the American Missionary Association Division for the Year Ending May 31, 1940. New York: 1940[?].

Seeking a Way: A Partial Reprint of the Biennial Report of the American Missionary Association for 1942–1944. New York: 1944.

Freedom Stepping Ahead: A Reprint of the American Missionary Association's Section of the Biennial Report of the Board of Home Missions of the Congregational and Christian Churches for 1947–1948. New York: 1947[?].

AVERY SOURCES (Arranged Topically and by Year)

Catalogues and Circulars

Circular of Information of Avery Normal Institute, 35 Bull Street, Charleston, S.C., Eighteenth Year—1882–1883. Atlanta: Jas. P. Harrison and Co. [printer], 1882.

Circulating Library of Avery Normal Institute. N.p., ca. 1880s.

American Missionary Association Catalogue of Avery Normal Institute, 35 Bull Street, Charleston, S.C., 1883–1884. Charleston: Walker, Evans, and Cogswell [printer], 1884.

Catalogue of the Teachers and Pupils of Avery Normal Institute, Charleston, South Carolina, with Courses of Study, General Information, and List of Graduates, June 1899. Charleston: Daggett Printing Co., 1899.

Catalogue of the Teachers and Pupils, Avery Normal Institute, Charleston, S.C., with Courses of Study, Names of Graduates, and General Information, June 1906. Charleston: Walker, Evans, and Cogswell, 1906.

Catalogue, Avery Normal Institute, Charleston, S.C., with Announcements for 1910–1911: May 1910. Charleston: Avery Press, 1910.

Invitations, Programs, Exercises

Examinations and Twentieth Anniversary Exercises, Avery Normal Institute, Charleston, South Carolina, June 21, 24, 25, and 26, 1885.

Examinations and Twenty-First Anniversary Exercises, Avery Normal Institute, Charleston, South Carolina, June 20, 22, 23, and 24, 1886.

*The Class of Eighty-Nine Request the Pleasure of Your Company at Their Graduating
 Exercises at Avery Hall, Wednesday, June 26th at Four O'Clock P.M.*
*Avery Normal Institute Baccalaureate at Centenary Methodist Episcopal Church, June 20,
 1897. Sermon at Four-Thirty P.M. by Rev. H. E. Frohock, Subject: "New Order of
 Nobility." Evening Address at Eight-Thirty by Prof. Morris A. Holmes, M.A., Subject:
 "The Work of Life."* [Charleston?]: J. J. Chisolm [printer], n.d.
*Thirty-Third Commencement, Zion Presbyterian Church, Avery Normal Institute, June
 Twenty-First–Twenty-Second, MDCCCXCVIII [1898].*
*Avery Normal Institute Commencement, June the Twentieth and Twenty-First,
 MDCCCXCIX [1899].*
*Nineteen Hundred and One, Avery Normal Institute, the Twentieth Century Class
 Requests the Honor of Your Presence at the Anniversary Exercises, June 21–26.*
Commencement, Avery Institute, Nineteen Hundred and Nine, Charleston, S.C.
*The Graduating Class of Avery Normal Institute Announces the Graduation Exercises,
 May the Twenty-First and Twenty-Fourth, Nineteen Hundred and Eleven, Zion
 Presbyterian Church, Charleston, South Carolina.*
*The Graduating Class of Avery Normal Institute Request the Honor of Your Presence at
 Their Commencement Exercises at Eight O'Clock P.M., Friday, May the Thirty-First,
 Nineteen Hundred and Eighteen, Morris Street Baptist Church, Charleston, South
 Carolina.*
*Graduating Exercises of Avery Normal Institute at Morris Street Baptist Church on
 Friday, May 31st, 1918 at Eight P.M.* Charleston: J. R. Harlee [printer], n.d.
*The Graduating Class of Avery Normal Institute Requests the Honor of Your Presence at
 Their Commencement Exercises at Morris Street Baptist Church, Friday, May the
 Twenty-Third at Eight O'Clock P.M., Nineteen Hundred and Nineteen.*
*The Faculty and Graduating Class of Avery Normal Institute Request the Honor of Your
 Presence at the Commencement Exercises at Eight O'Clock, Wednesday, May the
 Twenty-Sixth, Nineteen Hundred and Twenty, Morris Street Baptist Church,
 Charleston, S.C.*
*The Senior Class of Avery Normal Institute Requests the Honor of Your Presence at Their
 Graduating Exercises, Wednesday Evening, May Twenty-Fifth at Eight O'Clock, Morris
 Street Baptist Church [1921].*
*The Graduating Class of Avery Normal Institute Requests the Honor of Your Presence at
 Their Commencement Exercises at Eight O'Clock P.M., Wednesday, May the Twenty-
 Fourth, Nineteen Hundred and Twenty-Two, Morris Street Baptist Church, Charleston,
 South Carolina.*
[Programme, Avery Normal Institute] 1925.
*The Faculty and Class of Nineteen Twenty-Six of Avery Institute Request Your Presence at
 the Commencement Exercises, Wednesday, May the Twenty-Six, Morris Street Baptist
 Church, Eight O'Clock.*
*The Faculty and Class of Nineteen Twenty-Eight of Avery Institute Request Your Presence
 at the Commencement Exercises on the Evening of Wednesday, June Sixth, Eight
 O'Clock, Morris Street Baptist Church.*
*The Faculty and Class of Nineteen Thirty of Avery Institute Request Your Presence at the
 Commencement Exercises on the Evening of Wednesday, June Fourth, Eight O'Clock,
 Morris Street Baptist Church, Charleston, South Carolina.*
The Faculty and Class of Nineteen Thirty-Two of Avery Institute Request Your Presence at

the Commencement Exercises on the Evening of Wednesday, June First, Eight O'Clock,
 Morris Street Baptist Church, Charleston, South Carolina.
The Faculty and Class of Nineteen Thirty-Four of Avery Institute Request Your Presence at
 the Commencement Exercises on the Evening of Wednesday, June Sixth, Eight O'Clock,
 Morris Street Baptist Church, Charleston, South Carolina.
The Faculty and Class of Nineteen Thirty-Five of Avery Institute Request Your Presence at
 Their Commencement Exercises on Wednesday Evening, June Fifth, Eight O'Clock,
 Morris Street Baptist Church, Charleston, South Carolina.
The Faculty and Class of Nineteen Thirty-Seven of Avery Institute Request Your Presence
 at the Graduation Exercises on the Evening of Wednesday, June Second, Eight O'Clock,
 Morris Street Baptist Church, Charleston, South Carolina.
The Faculty and Class of Nineteen Thirty-Eight of Avery Institute Request Your Presence at
 the Graduation Exercises on the Evening of Wednesday, June First, Eight O'Clock,
 Morris Street Baptist Church, Charleston, South Carolina.
The Faculty and Classes of Nineteen Forty of Avery Institute Request Your Presence at the
 Graduation Exercises on the Evening of Wednesday, June Twelfth, Eight O'Clock,
 Morris Street Baptist Church, Charleston, South Carolina.
Commencement Exercises, Nineteen Forty, Avery Institute, Charleston, S.C.
Commencement Exercises, Nineteen Forty-One, Avery Institute, Charleston, S.C.
The Faculty and Classes of Nineteen Forty-One of Avery Institute Request Your Presence at
 the Graduation Exercises on the Evening of Wednesday, June Fourth, Eight O'Clock,
 Morris Street Baptist Church.
Baccalaureate Service of Avery Institute at Morris Street Baptist Church, Sunday,
 May 31, 1942, Three P.M.
The Faculty and Classes of Nineteen Forty-Two of Avery Institute Request Your Presence at
 the Graduation Exercises on the Evening of Wednesday, June Third, Eight P.M.
 O'Clock, Morris Street Baptist Church, Charleston, South Carolina.
Graduating Exercises of the Seventy-Seventh Commencement of Avery Institute,
 Charleston, South Carolina, Eight P.M. O'Clock, Wednesday, June 3, 1942, Morris
 Street Baptist Church.
The Faculty and Classes of Nineteen Forty-Three of Avery Institute Request Your Presence
 at the Graduation Exercises on the Evening of Friday, June Fourth, Eight O'Clock,
 Morris Street Baptist Church, Charleston, South Carolina.
The Faculty and Members of the Graduating Class Invite You to Attend the Exercises of the
 Seventy-Ninth Commencement of Avery Institute, Charleston, S.C. [1944].
The Faculty and Classes of Nineteen Forty-Five of Avery Institute Request Your Presence at
 the Graduation Exercises on the Evening of Wednesday, May Thirtieth, Eight O'Clock,
 Morris Street Baptist Church, Charleston, South Carolina.
Programme of the Eightieth Commencement of Avery Institute, Charleston, South
 Carolina, Eight P.M., Wednesday, May 30, 1945, Morris Street Baptist Church.
The Faculty and Classes of Nineteen Forty-Six of Avery Institute Request Your Presence at
 the Graduation Exercises on the Evening of Friday, May Thirty-First, Eight O'Clock,
 Morris Street Baptist Church, Charleston, South Carolina.
The Faculty and Members of the Graduating Classes Invite You to Attend the Exercises of
 the Eighty-Second Commencement of Avery Institute [1947].
Programme of the Eighty-Second Commencement of Avery Institute, Charleston, South
 Carolina, Thursday, May 29, 1947, Eight P.M., Zion Presbyterian Church.

Programme of the Eighty-Fourth Commencement of Avery High School, Charleston, South
 Carolina, Monday, June 13, 1949, Eight P.M., Morris Street Baptist Church.
The Faculty and Class of Nineteen Fifty of Avery High School Request Your Presence at the
 Graduation Exercises on the Evening of Tuesday, June Sixth at Eight O'Clock, Morris
 Street Baptist Church, Charleston, South Carolina.
The Faculty of Avery High School Presents the Senior Class in "Avery—Past, Present, and
 Future," a Pageant Written and Staged by the Honor Graduates under the Direction of
 Fannie Ella Frazier Hicklin in the Henry P. Archer School Auditorium on Tuesday
 Evening, June 5, 1951 at Eight O'Clock.
The Faculty and Class of Nineteen Hundred and Fifty-One of Avery High School Request
 Your Presence at the Graduation Exercises on the Evening of Wednesday, June Sixth at
 Eight O'Clock, Henry P. Archer School, Charleston, South Carolina.
Programme of the Eighty-Seventh Commencement of Avery High School, Charleston,
 South Carolina, Wednesday, June 4, 1952, Eight P.M., Morris Street Baptist Church.
Programme of the Eighty-Eighth Commencement of Avery High School, Charleston, South
 Carolina, Wednesday, June 3, 1953, Eight P.M., Morris Street Baptist Church.
Programme of the Eighty-Ninth Commencement of Avery High School, Charleston, South
 Carolina, Thursday, June 10, 1954, Eight P.M., Morris Street Baptist Church.

School Newspapers

Avery Echo
Avery News
Avery Tiger

Miscellaneous

Appreciation Service Honoring Mr. and Mrs. John F. Potts, Sunday, May 23, 1954, Buist
 School Auditorium, 5 P.M., Dr. John M. Metz, Presiding.
The Averyite, Nineteen Hundred and Thirty-Nine. Charleston: Senior Class of Avery
 Institute, n.d.
Avery's Deeds and Needs. Ca. 1927.
The Avery Song. Poem by Beulah Shecut, 1928; Music by Maude H. Smith, 1915.
 [Charleston]: Avery Normal Institute, n.d.
Boys' Annual Speaking Contest, Avery Auditorium, Monday, May 25, 1936, Eight P.M.
Children's Day at Avery Normal Institute, Tuesday, Nine O'Clock A.M., July 2, 1878.
Girls' Annual Speaking Contest, Avery Auditorium, Tuesday, May 26, 1936, Eight P.M.
Home Coming Celebration for Ralph Thomas Grant, Sr., Wesley United Methodist
 Church, 446 Meeting Street, Charleston, South Carolina, November 14, 1986.
The Pinnacle: A Book of the Class of 1916. [Charleston]: R. Leonard Wainwright, n.d.
Public Program in Celebration of the Forty-Fifth Anniversary of the Class of 1932, Avery
 Institute, Friday Evening, June 3, 1977, Eight O'Clock, Zion Olivet United
 Presbyterian Church, 134 Cannon Street, Charleston, South Carolina.
Twenty-Fourth Annual Re-Union of the Alumni Association of Avery Normal Institute,
 July 4th, 1899.
"Vestigia Nulla Retrorsum": Sixteenth Annual Re-Union, Avery Alumni Association,
 Avery Hall, Charleston, S.C., Monday, July 4th, 1892—Ten Thirty O'Clock A.M.
 Charleston: Frank Thorne [printer], ca. 1892.

CHARLESTON CENSUS, DIRECTORIES, REPORTS,
AND YEARBOOKS (Chronological)

Fay, T. C. *Charleston Directory and Strangers' Guide for 1840 and 1841.* . . .
Charleston: N.p., 1840.
Report on the Free Colored Poor of the City of Charleston. Charleston: Burgess and
James, 1842.
Dawson, J. L., and H. W. DeSaussure. *Census of the City of Charleston, South
Carolina, for the Year 1848, Exhibiting the Condition and Prospects of the City,
Illustrated by Many Statistical Details, Prepared under the Authority of the City
Council.* Charleston: J. B. Nixon, 1849.
*The Charleston City and General Directory for 1855, Containing the Names of the
Inhabitants, Their Occupations, Places of Business, and Dwelling Houses, a Business
Directory.* Charleston: David M. Gazlay, 1855.
Purse, R. S. *Charleston City Directory and Strangers' Guide for 1856.* New York:
F. Trow, 1856.
Mears, Leonard, and James Turnbull. *The Charleston Directory [for 1859,] Containing
the Names of the Inhabitants, a Subscribers' Business Directory, Street Map of the City,
and an Appendix of Much Useful Information.* Charleston: Walker, Evans, and Co,
1859.
List of the Tax Payers of the City of Charleston for 1859. Charleston: Walker, Evans,
and Co., 1860.
List of the Tax Payers of the City of Charleston for 1860. Charleston: Evans and
Cogswell, 1861.
Directory of the City of Charleston, to Which Is Added a Business Directory, 1860.
Charleston: W. E. Ferslew, 1860.
Ford, Frederick A. *Census of the City of Charleston, South Carolina, for the Year 1861,
Illustrated by Statistical Tables, Prepared under the Authority of the City Council.*
Charleston: Evans and Cogswell, 1861.
Burke, and Boinest, comps. *Charleston Directory, 1866, Containing the Names of the
Inhabitants and an Appendix of Much Useful Information.* New York: M. B. Brown
and Co., [printer], 1866.
*Charleston City Directory for 1867–1868, Containing the Names of the Inhabitants of the
City, Their Occupations, Places of Business, and Dwelling Houses, Business Register,
Public Institutions, Banks, etc., etc.* Charleston: Jno. Orrin Lea and Co., n.d.
*Jowitt's Illustrated Charleston City Directory and Business Register, 1869–1870,
Containing a Complete Street Directory, the Names of the Inhabitants, Their Places of
Business, Occupations, and Residences, a Miscellaneous Record of City Government,
Public Institutions, etc., etc., with Lithographic Map of City.* Charleston: Walker,
Evans, and Cogswell, 1869.
Directory for 1872–1873. Charleston: Walker, Evans, and Cogswell, n.d.
Emerson, Charles, comp. *Hooper's Directory, Trade Index, and Shippers' Guide for
Charleston, S.C., 1874–1875, Containing a Complete Street Directory, Names of the
Inhabitants.* N.p.: George W. Hooper and Co., n.d.
Haddock, T. M., and J. E. Baker, comps. *Charleston City Directory, 1875–1876.*
Charleston: Walker, Evans, and Cogswell, 1875.
*Smith's South Carolina Business Directory, Trade Index, and Shipper's Guide,
1876–1877.* Charleston: Marion C. Smith, 1876.

Sholes' Directory of the City of Charleston for 1877–1878. Charleston: A. E. Sholes, n.d.

Sholes' Directory of the City of Charleston, November 15, 1878. Charleston: A. E. Sholes, n.d.

Year Book, City of Charleston, So. Ca. Charleston: 1880–.

Sholes' Directory of the City of Charleston, January 1881. N.p.: Sholes and Co., 1881.

Sholes' Directory of the City of Charleston, 1883. Charleston: A. E. Sholes, n.d.

The Charleston City Directory, 1886, Together with a Compendium of Governments, Institutions, and Trades of the City, to Which Is Added a Complete Gazetteer of Charleston and Berkeley Counties. Charleston: Ross A. Smith and Lucas and Richardson, 1886.

The Charleston City Directory, 1890, Together with a Compendium of Governments, Institutions, and Trades of the City. Charleston: Southern Directory and Publishing Co., 1890.

Charleston, S.C. City Directory for 1900, Containing a General and Business Directory Charleston: Lucas and Richardson Co., 1900.

Charleston, S.C. City Directory for 1901, Containing a General Business Directory. . . . Charleston: W. H. Walsh Directory Co., 1901.

Walsh's Charleston, S.C. City Directory for 1902, Nineteenth Year. . . . (Charleston: W. H. Walsh Directory Co., 1902.

Walsh's Charleston, South Carolina 1910 City Directory, Twenty-Eighth Year. Charleston: Walsh Directory Co., 1910.

Walsh's Charleston, South Carolina 1911 City Directory, Twenty-Ninth Year. Charleston: Walsh Directory Co., 1911.

Walsh's Charleston, South Carolina 1912 City Directory, Thirtieth Year. Charleston: Walsh Directory Co., 1912.

Walsh's Charleston, South Carolina 1914 City Directory, Thirty-Second Year. Charleston: Walsh Directory Co., 1914.

Walsh's Charleston, South Carolina 1917 City Directory, Thirty-Fifth Year. Charleston: Walsh Directory Co., 1917.

Walsh's 1925–1926 Charleston, South Carolina City Directory, Forty-Fourth Year. Charleston: Southern Printing and Publishing Co., n.d.

Walsh's 1928 Charleston, South Carolina City Directory, Forty-Sixth Year. Charleston: Southern Printing and Publishing Co., n.d.

Hill's Charleston (South Carolina) City Directory, 1932. Richmond, Va.: Hill Directory Co., 1932.

Baldwin's and Southern's Charleston, South Carolina City Directory, 1936. Master ed. Charleston: Baldwin Directory Co., and Southern Printing and Publishing Co., 1936.

Baldwin and Southern's Charleston, South Carolina City Directory, 1942. Master ed. Charleston: Baldwin Directory Co., and Southern Printing and Publishing Co., n.d.

Baldwin and Southern's Charleston, South Carolina City Directory, 1944–1945. Master ed. Charleston: Baldwin Directory Co., n.d.

Hill's Charleston (Charleston County, S.C.) City Directory, 1968. Richmond, Va.: Hill Directory Co., n.d.

CONSTITUTIONS, BY-LAWS, RULES, AND REGULATIONS

Constitution and By-Laws of the Friendly Union Society, Charleston, S.C., Organized May 4th, 1813, Incorporated. Charleston: Karrs and Welch [printers and binders], 1889.

Constitution and Rules of Humane Brotherhood, Organized June 19th, 1843.

Rules and Regulations of the Brown Fellowship Socitey [sic], *Established at Charleston, S.C., 1st November, 1790.* Charleston: J. B. Nixon, 1844.

FEDERAL CENSUS DOCUMENTS

Bureau of the Census. *Thirteenth Census of the United States Taken in the Year 1910.* Vol. 3, *Population 1910 Reports by States, with Statistics for Counties, Cities, and Other Divisions, Nebraska–Wyoming, Alaska, Hawaii, and Puerto Rico, Prepared under the Supervision of William C. Hunt, Chief Statistician for Population.* Washington, D.C.: Government Printing Office, 1913.

Fourteenth Census of the United States Taken in the Year 1920. Vol. 2, *Population 1920: General Report and Analytical Tables Prepared under the Supervision of William C. Hunt, Chief Statistician.* Washington, D.C.: Government Printing Office, 1922.

Population of the United States in 1860, Compiled from the Original Returns of the Eighth Census under the Direction of Secretary of the Interior, by Joseph C. G. Kennedy, Superintendent of Census. Washington, D.C.: Government Printing Office, 1864.

U.S. Congress. House, 52d Congress, 1st Sess, Mis. Doc. No. 340, Part 18. *Report on Population of the United States at the Eleventh Census: 1890, Part 1.* Washington, D.C.: Government Printing Office, 1895.

NEWSPAPERS AND PERIODICALS

Boston
 The Congregationalist and Herald of Gospel Liberty Continuing the Recorder, the Advance, and the American Missionary.
Charleston
 Chronicle; City Gazette; Courier; Daily Courier; Daily News; Daily Republican; Hospital Herald; Evening Post; Lighthouse; Mercury; Messenger; News and Courier; South Carolina Leader.

Columbia
 Lighthouse and Informer; Palmetto Leader; The State.
New York
 American Missionary; Crisis; National Freedman; Post; Times; Tribune.
Savannah
 Tribune.
Washington, D.C.
 Colored American Magazine.

ARTICLES

Allen, Jane E. "Dedicated Women Raised Money for Statue of 'The Great Nullifier.'" Charleston *News and Courier,* June 13, 1983, 1B.

Alston, Elizabeth. "Church History." In *Emanuel A.M.E. Church, Charleston, South Carolina*. N.p., n.d.

Alston, John A. "Calhoun Statue Quelled Furor." Charleston *News and Courier*, October 23, 1972, 1B.

Anderson, Leroy F. "Arthur J. H. Clement, Jr., Dies." *Avery Institute of Afro-American History and Culture Bulletin*, 6 (Fall 1986): 1.

Baker, Ray Stannard. "Following the Color Line." *American Magazine* 63 (April 1907): 564–66.

Bennett, L. Howard. "Benjamin Ferdinand Cox, 1897, Passes." Unidentified Fisk bulletin (November 1952), 9.

Berlin, Ira, and Herbert Gutman. "Natives and Immigrants, Free Men and Slaves: Urban Workingmen in the Antebellum South." *American Historical Review* 88 (December 1983): 1175–1200.

Birnie, C. W. "Education of the Negro in Charleston, South Carolina, Prior to the Civil War." *Journal of Negro History* 12 (January 1927): 13–21.

"Blessed Assurance: The Music Ministry of St. Matthew Baptist Church, Charleston, South Carolina." Record Jacket.

Bowler, Susan, and Frank Petrusak. "The Constitution of South Carolina: Historical and Political Perspectives." In *Government in the Palmetto State*, edited by Luther F. Carter and David S. Mann, 27–44. Columbia: Bureau of Governmental Research and Services, University of South Carolina, 1983.

Bowman, Shearer Davis. "Antebellum Planters and *Vormarz* Junkers in Comparative Perspective." *American Historical Review* 85 (October 1980): 780–808.

Brock, Euline W. "Thomas W. Cardozo: Fallible Black Reconstruction Leader." *Journal of Southern History* 47 (May 1981): 183–206.

Browning, James B. "The Beginning of Insurance Enterprise among Negroes." *Journal of Negro History* 22 (October 1937): 417–32.

Burnside, Ronald D. "Racism in the Administrations of Governor Cole Blease." In *The Proceedings of the South Carolina Historical Association, 1964*, edited by George Rogers, Jr., 43–57. Columbia: South Carolina Historical Association, 1964.

Chapman, Anne W. "Inadequacies of the 1848 Charleston Census." *South Carolina Historical Magazine* 81 (January 1980): 24–34.

"Charleston Snobbish Negro Aristocracy 'Passing' Out of Existence." *Ebony*. 1 (October 1946): 17.

Clarke, T. Erskine. "An Experiment in Paternalism: Presbyterians and Slaves in Charleston, South Carolina." *Journal of Presbyterian History* 53 (Fall 1975): 223–38.

Clement, Arthur J., Jr. "Alumni Pay Tribute to a Principal." Charleston *Evening Post*, June 4, 1982, [10A].

———. "Two Hundred Fifty Years of Afro-American Business in Charleston." *Avery Institute of Afro-American History and Culture Bulletin* 3 (Spring 1985).

Cooper, Frederick. "Elevating the Race: The Social Thought of Black Leaders, 1827–1850." *American Quarterly* 24 (December 1972): 604–25.

Dibble, Charles L. "Advancement Is Goal of Progressive Club." Charleston *News and Courier*, August 17, 1964, 1.

————. "Esau Jenkins Proud of Club's Progress." Charleston *News and Courier*, August 19, 1964, 3B.

————. "Highlander Controversy Began in 1932." Charleston *News and Courier*, August 20, 1964, 5D.

————. "Progressive Club Assisted by Highlander Staff." Charleston *News and Courier*, August 18, 1964, 6B.

Drago, Edmund L., and Ralph Melnick. "The Old Slave Mart Museum, Charleston, South Carolina: Rediscovering the Past." *Civil War History* 27 (Summer 1981): 138–54.

Dunn, Richard S. "The English Sugar Islands and the Founding of South Carolina." *South Carolina Historical Magazine* 72 (April 1971): 81–93.

Durden, Robert F. "The Establishment of Calvary Protestant Episcopal Church for Negroes in Charleston." *South Carolina Historical Magazine* 65 (January 1964): 63–84.

"Education: South Carolina Fights Illiteracy." Special South Carolina edition. *National Negro Digest* (ca. 1940), 1–62.

Edwards, G. Franklin. "The Contributions of E. Franklin Frazier to Sociology." *Journal of Social and Behavioral Sciences* 13 (Winter 1967): 25–29.

————. "E. Franklin Frazier." In *Dictionary of American Negro Biography*, edited by Rayford Logan and Michael R. Winston, 241–44. New York: W. W. Norton and Co., 1982.

Fink, Leon. "Union Power, Soul Power: The Story of 1199B and Labor's Search for a Southern Strategy." *Southern Changes* 5 (March–April 1983): 9–20.

Fitchett, E. Horace. "The Origin and Growth of the Free Negro Population of Charleston, South Carolina." *Journal of Negro History* 26 (October 1941): 421–37.

————. "The Status of the Free Negro in Charleston, South Carolina, and His Descendants in Modern Society." *Journal of Negro History* 32 (1947): 430–51.

————. "The Traditions of the Free Negro in Charleston, South Carolina." *Journal of Negro History* 25 (April 1940): 139–52.

Fredrickson, George M. "Self-Made Hero." *New York Review of Books* 32 (June 27, 1985): 3–4.

Freehling, William W. "Denmark Vesey's Peculiar Reality." In *New Perspectives on Race and Slavery in America: Essays in Honor of Kenneth M. Stampp*, edited by Robert H. Abzug and Stephen E. Maizlish, 25–47. Lexington: University of Kentucky Press, 1986.

Fridlington, Robert J. "Emily Huntington." In *Notable American Women, 1607–1950: A Biographical Dictionary*, vol. 2., edited by Edward T. James, 239–40. Cambridge, Mass.: Belknap Press of Harvard University Press, 1971.

Gatewood, Willard B., Jr. "Aristocrats of Color: South and North, the Black Elite, 1880–1920." *Journal of Southern History* 54 (February 1988): 3–20.

Grafton, Samuel. "Lonesomest Man in Town." *Collier's*, April 29, 1950, 20.

Gilpin, Patrick J. "Charles S. Johnson and the Race Relations Institutes at Fisk University." *Phylon* 41 (1980): 300–11.

Glasco, Laurence A. "Black and Mulatto: Historical Bases for Afro-American Culture." *Black Line* 2 (Fall 1971): 22–30.

Gregorie, Anne King. "The First Decade of the Charleston Library Society." In *The Proceedings of the South Carolina Historical Association, 1935*, edited by Robert L. Meriwether, 3–10. Columbia: South Carolina Historical Association, 1935.

Halliburton, R., Jr. "Free Black Owners of Slaves: A Reappraisal of the Woodson Thesis." *South Carolina Historical Magazine* 76 (July 1975): 129–42.

Harris, Robert L., Jr. "Charleston's Free Afro-American Elite: The Brown Fellowship Society and The Humane Brotherhood." *South Carolina Historical Magazine* 82 (October 1981): 289–310.

————. "Early Black Benevolent Societies, 1780–1830." *Massachusetts Review* 20 (Autumn 1979): 603–25.

Hemmingway, Theodore. "Prelude to Change: Black Carolinians in the War Years, 1914–1920." *Journal of Negro History* 65 (Summer 1980): 212–27.

Hendrix, Clelia D. "Women in Politics." *South Carolina Women*, Columbia, 7 (Summer 1986): 1.

Hershberg, Theodore. "Free Blacks in Antebellum Philadelphia: A Study of Ex-Slaves, Freeborn, and Socioeconomic Decline." In *Philadelphia Work, Space, Family, and Group Experience in the Nineteenth Century*, edited by Theodore Hershberg, 368–91. Oxford: Oxford University Press, 1981.

Hershberg, Theodore, and Henry Williams. "Mulattoes and Blacks: Intragroup Color Differences and Social Stratification in Nineteenth-Century Philadelphia." In *Philadelphia Work, Space, Family, and Group Experience in the Nineteenth Century*, edited by Theodore Hershberg, 392–434. Oxford: Oxford University Press, 1981.

Hine, William C. "Black Politicians in Reconstruction Charleston, South Carolina." *Journal of Southern History* 49 (November 1983): 555–84.

————. "The 1867 Charleston Streetcar Sit-Ins: A Case of Successful Black Protest." *South Carolina Historical Magazine* 77 (April 1976): 110–15.

Hoffman, Edwin D. "The Genesis of the Modern Movement for Equal Rights in South Carolina, 1930–1939." *Journal of Negro History* 44 (October 1959): 346–69.

Hook, Sidney. "John Dewey: His Philosophy of Education and Its Critics." In *Dewey on Education Appraisals*, edited by Reginald D. Archambault, 127–59. New York: Random House, 1966.

Jackson, Luther P. "The Educational Efforts of the Freedmen's Bureau and Freedmen's Aid Societies in South Carolina, 1862–1872." *Journal of Negro History* 8 (January 1923): 1–40.

Johnson, Michael P. "Wealth and Class in Charleston in 1860." In *From the Old South to the New: Essays on the Transitional South*, edited by Walter J. Fraser and Winfred B. Moore, Jr., 65–80. Westport, Conn.: Greenwood Press, 1981.

Johnson, Michael P., and James L. Roark. "'A Middle Ground': Free Mulattoes and the Friendly Moralist Society of Antebellum Charleston." *Southern Studies* 21 (Fall 1982): 246–65.

Jones, Clifton R. "Social Stratification in the Negro Population: A Study of Social Classes in South Boston, Virginia." *Journal of Negro Education* 15 (Winter 1946): 4–12.

Knight, Edgar W. "Reconstruction and Education in South Carolina." *South Atlantic Quarterly* 18 (October 1919): 350–64.

Lively, Adam. "Continuity and Radicalism in American Black Nationalist Thought, 1914–1929." *Journal of American Studies* 18 (August 1984): 207–35.

Lynd, Albert. "Who Wants Progressive Education? The Influence of John Dewey on the Public Schools." In *Dewey on Education Appraisals*, edited by Reginald D. Archambault, 191–208. New York: Random House, 1966.

McCarriar, Herbert Greer, Jr. "A History of the Missionary Jurisdiction of the South of the Reformed Episcopal Church, 1874–1970." *Historical Magazine of the Protestant Episcopal Church* 41 (June 1972): 197–220.

Manigault, Peter. "Negroes in City Schools Once Had White Teachers." Charleston *News and Courier*, April 28, 1954, 10A.

Miller, Kelly. "These 'Colored' United States." *Messenger* 7 (1925): 376–77, 400.

Moltke-Hansen, David. "Charleston Library Society Microfiche Register." *South Carolina Historical Magazine* 83 (April 1982): 175–201.

Moore, John Hammond. "South Carolina's Reaction to the Photoplay, The Birth of a Nation," In *The Proceedings of the South Carolina Historical Association, 1963*, edited by George C. Rogers, Jr., 30–40. Columbia: South Carolina Historical Association, 1964.

O'Neill, Stephen. "The Struggle for Black Equality Comes to Charleston: The Hospital Strike of 1969." In *The Proceedings of the South Carolina Historical Association, 1986*, edited by George C. Rogers, Jr., 30–40. Columbia: South Carolina Historical Association, 1986.

Parrish, Charles H. "Color Names and Color Notions." *Journal of Negro Education* 15 (Winter 1946): 13–20.

Peters, William. "A Southern Success Story." *Redbook* 115 (June 1960): 41.

Radford, John P. "Delicate Space: Race and Residence in Charleston, 1860–1880." *Essays on the Human Geography of the Southeastern United States* 16 (June 1977): 17–37.

Richardson, Joe M. "Francis L. Cardozo: Black Educator during Reconstruction." *Journal of Negro Education* 48 (Winter 1979): 73–83.

Rogers, George C., Jr. "Who Is a South Carolinian?" *South Carolina Historical Magazine* 89 (January 1988): 3–12.

Rowe, George C. "The Negroes of the Sea Islands." *Southern Workman* 29 (December 1900): 709–15.

Scheffler, Israel. "Educational Liberalism and Dewey's Philosophy." In *Dewey on Education Appraisals*, edited by Reginald D. Archambault, 96–110. New York: Random House, 1966.

Scott, Cornelius C. "When Negroes Attended the State University." *The State*, Columbia, May 8, 1911, 9.

Siles, David L. "John Dewey." In *International Encyclopedia of Social Sciences*, vol. 4. New York: Macmillan Co. and Free Press, 1968.

Sproat, John G. " 'Firm Flexibility': Perspectives on Desegregation in South Carolina." In *New Perspectives on Race and Slavery in America: Essays in Honor of Kenneth M. Stampp*, edited by Robert H. Abzug and Stephen E. Maizlish, 164–84. Lexington: University of Kentucky Press, 1986.

Sweat, Edward F. "Francis L. Cardozo—Profile of Integrity in Reconstruction Politics." *Journal of Negro History* 46 (October 1961); 217–32.

Thomas, Charles E., ed. "The Diary of Anna Hasell Thomas (July 1864–May 1865)." *South Carolina Historical Magazine* 74 (July 1973): 138.

Thomas, Jno. P., Jr. "The Barbadians in Early South Carolina." *South Carolina Historical Magazine* 31 (April 1930): 75–92.

Tindall, George B. "The Question of Race in the South Carolina Constitutional Convention of 1895." *Journal of Negro History* 37 (July 1952): 277–303.

Tjerandsen, Carl. "The Highlander Heritage: Education for Social Change." *Convergence* 16, no. 2 (1983): 10–22.

Waring, Thomas R. "First Black Teaches Speech at College of Charleston." Charleston *News and Courier–Evening Post*, December 2, 1984, 2F.

———. "Lowcountry Doctor Takes in Shingle." Charleston *News and Courier–Evening Post*, August 24, 1981, 2E.

———. "Mailman Enjoys Retirement." Charleston *News and Courier–Evening Post*, June 6, 1982, 2E.

———. "Mount Pleasant Dah at 94 Still Minds Her 'Baby,' Now 81." Charleston *News and Courier–Evening Post*, November 15, 1987, 3E.

———. "Nonagenarian Enjoys Her Memories." Charleston *News and Courier–Evening Post*, May 3, 1981, 2E.

———. "Real Estate Agent Says 'There's No Place Like Charleston.' " Charleston *News and Courier–Evening Post*, November 8, 1981, 2E.

———. "Reminiscing Healthy Topic." Charleston *News and Courier–Evening Post*, September 7, 1980, 2E.

———. "Son of Slave Credits Religious Atmosphere." Charleston *News and Courier–Evening Post*, December 13, 1981, 2E.

———. "Teaching Is Her Life." Charleston *News and Courier–Evening Post*, November 14, 1982, 2E.

Welter, Barbara. "The Cult of True Womanhood, 1820–1860." *American Quarterly* 18 (Summer 1966): 151–74.

Wechsler, James A. "He Started It." New York *Post*, May 14, 1964, 28.

Whitlock, Edwina H. "Edwin A. Harleston," In *Edwin A. Harleston: Painter of an Era, 1882–1931*, 9–28. [Detroit]: Your Heritage House, 1983.

———. " 'First Person Singular.' " Gary *American*, June 21, 1946.

Woodson, Carter G. "Free Negro Owners of Slaves in the United States in 1830." *Journal of Negro History* 9 (January 1924): 41–85.

BOOKS, PAMPHLETS, AND FLYERS

Adams, Frank, with Myles Horton. *Unearthing Seeds of Fire: The Idea of Highlander*. Winston-Salem, N.C.: John F. Blair, 1975.

Alvord, John W. *Letters from the South, Relating to the Condition of the Freedmen, Addressed to Major General O. O. Howard, Commissioner, Bureau R.F. and A.L., by J. W. Alvord, Gen. Sup't Education*. Washington, D.C.: Howard University Press, 1870.

———. *Semi-Annual Reports on Schools for Freedmen, 1866–1870*. Washington, D.C.: Government Printing Office, 1866–1870.

Anderson, James D. *The Education of Blacks in the South, 1860–1935*. Chapel Hill: University of North Carolina Press, 1988.

Archambault, Reginald D., ed. *Dewey on Education Appraisals*. New York: Random House, 1966.

Baker, Melvin C. *Foundations of John Dewey's Educational Theory*. New York: Atherton Press, 1966.

Baker, Ray Stannard. *Following the Color Line*. New York: Doubleday, Page, 1908.

Ballard, Allen B. *One More Day's Journey: The Story of a Family and a People*. New York: McGraw-Hill Book Co., 1984.

Beam, Lura. *He Called Them by Lightning: A Teacher's Odyssey in the Negro South, 1908–1919*. Indianapolis: Bobbs-Merrill Co., 1967.

Beard, Augustus Field. *A Crusade of Brotherhood: A History of the American Missionary Association*. Boston: Pilgrim Press, 1909. New York: Krause Reprint Co., 1970.

Berlin, Ira. *Slaves without Masters: The Free Negro in the Antebellum South*. New York: Pantheon Books, 1974. Vintage Books, 1976.

Boris, Joseph J., ed. *Who's Who in Colored America: A Biographical Dictionary of Notable Living Persons of African Descent in America*. 2d ed. New York: Who's Who in Colored America Corp., [1928–1929].

Bremer, Fredrika. *The Homes of the New World: Impressions of America*. 2 vols. New York: Harper and Brothers, 1853. Negro Universities Press, 1968.

Brownlee, Fred L. *New Day Ascending*. Boston: Pilgrim Press, 1946.

Bullock, Henry Allen. *A History of Negro Education in the South from 1619 to the Present*. Cambridge, Mass.: Harvard University Press, 1967.

Burke High School, Charleston, South Carolina, 1974–1975 Student Bulletin. [Charleston?]: N.p., [1975?].

Burton, Orville Vernon. *In My Father's House Are Many Mansions: Family and Community in Edgefield, South Carolina*. Chapel Hill: University of North Carolina Press, 1985.

Butchart, Ronald E. *Northern Schools, Southern Blacks, and Reconstruction: Freedmen's Education, 1862–1875*. Westport, Conn.: Greenwood Press, 1980.

Caldwell, A. B., ed. *History of the American Negro, South Carolina Edition*. Atlanta: A. B. Caldwell, 1919.

Caravaglios, Maria Genoino. *The American Catholic Church and the Negro Problem in the Eighteenth–Nineteenth Centuries*. Edited by Ernest L. Unterkoefler. Charleston, S.C., and Rome, Italy: Maria Genoino Caravaglios, 1974.

Carawan, Guy, and Candie Carawan. *Ain't You Got a Right to the Tree of Life? The People of Johns Island, South Carolina—Their Faces, Their Words, and Their Songs*. New York: Simon and Schuster, 1966.

Carlton, David L. *Mill and Town in South Carolina, 1880–1920*. Baton Rouge: Louisiana State University Press, 1982.

Carson, James Petigru. *Life, Letters, and Speeches of James Louis Petigru: The Union Man of South Carolina*. Washington, D.C.: W. H. Lowdermilk and Co., 1920.

Clark, Septima Poinsette, with LeGette Blythe. *Echo in My Soul*. New York: E. P. Dutton and Co., 1962.

Clark, Thomas D., ed. *South Carolina: The Grand Tour, 1780–1865*. Columbia: University of South Carolina Press, 1973.

Cohen, David W., and Jack P. Greene, eds. *Neither Slave nor Free: The Freedmen of African Descent in the Slave Societies of the New World.* Baltimore: Johns Hopkins University Press, 1972. Paperback, 1974.

Coit, Margaret L. *John C. Calhoun: American Portrait.* Boston: Houghton Mifflin Co., 1950.

Creel, Margaret Washington. *"A Peculiar People": Slave Religion and Community-Culture among the Gullahs.* New York: New York University Press, 1988.

Cruse, Harold. *The Crisis of the Negro Intellectual.* New York: William Morrow and Co., 1967.

Curry, Leonard P. *The Free Black in Urban America, 1800–1850: The Shadow of the Dream.* Chicago: University of Chicago Press, 1981.

Curtin, Philip D. *Two Jamaicas: The Role of Ideas in a Tropical Colony, 1830–1865.* Cambridge, Mass.: Harvard University Press, 1955. New York: Atheneum, 1975.

Daniels, Josephus. *The Life of Woodrow Wilson, 1856–1924.* USA: Will H. Johnston, 1924.

Davis, Allen F. *American Heroine: The Life and Legend of Jane Addams.* London, Oxford, and New York: Oxford University Press, 1975.

Dedication, McClennan-Banks Memorial Hospital, Inc., of Charleston County. [Charleston?]: N.p., [1959?].

Dennett, John Richard. *The South As It Is, 1865–1866.* Edited and with an Introduction by Henry M. Christman. London: Sidgwick and Jackson, 1965.

Douglass, H. Paul. *Christian Reconstruction in the South.* Boston: Pilgrim Press, 1909.

Drago, Edmund L. *Black Politicians and Reconstruction in Georgia: A Splendid Failure.* Baton Rouge: Louisiana State University Press, 1982.

Drake, St. Claire, and Horace Cayton. *Black Metropolis: A Study of Negro Life in a Northern City.* Vol. 2. New York: Harcourt, Brace, and Co., 1945. Revised and enlarged. Harcourt, Brace, and World, 1970.

Du Bois, W. E. B. *Black Reconstruction in America: An Essay toward a History of the Part Which Black Folk Played in the Attempt to Reconstruct Democracy in America, 1860–1880.* 1935. Reprint. New York: Atheneum, 1975.

——— . *The Negro in Business: Report of a Social Study Made under the Direction of Atlanta University, Together with the Proceedings of the Fourth Conference for the Study of the Negro Problems, Held at Atlanta University, May 30–31, 1899.* Atlanta University Publications, no. 4. [Atlanta?], 1899.

——— . *The Philadelphia Negro: A Social Study, 1899.* New York: Schocken Books, 1967.

Easterby, J. H. *A History of the College of Charleston, Founded 1770.* [Charleston, S.C.]: N.p., 1935.

Edwards, Richard, and Mortimer A. Warren. *The Analytical Speller, Containing Lists of the Most Useful Words in the English Language, Progressively Arranged, and Grouped According to Their Meaning, with Abbreviations, Rules for Capitals, etc.* Chicago: Geo. Sherwood and Co., 1871.

Edwin A. Harleston: Painter of an Era, 1882–1931. [Detroit]: Your Heritage House, 1983.

Edwards, G. Franklin. *The Negro Professional Class.* Glencoe, Ill.: Free Press, 1959.

Fickling, Susan Markey. *Slave Conversion in South Carolina, 1830–1860*. Columbia: University of South Carolina Press, 1924.
Fields, Mamie Garvin, with Karen Fields. *Lemon Swamp and Other Places: A Carolina Memoir*. New York: Free Press, 1983.
Fiftieth Anniversary Reunion of Immaculate Conception High School, July 6–8, 1984, Charleston, S.C.. Charleston: N.p., [1984].
Fraser, Charles. *Reminiscences of Charleston, Lately Published in the Charleston Courier, and Now Revised and Enlarged by the Author*. Charleston: John Russell, 1854.
Fraser, Walter J., Jr. *Charleston! Charleston!: The History of a Southern City*. Columbia: University of South Carolina Press, 1989.
Frazier, E. Franklin. *Black Bourgeoisie: The Rise of a New Middle Class in the United States*. New York: Free Press, 1957. Collier Books, 1962.
———. *The Negro in the United States*. New York: Macmillan Co., 1949.
Freehling, William W. *Prelude to Civil War: The Nullification Controversy in South Carolina, 1816–1836*. New York: Harper and Row, Torchbook Edition, 1968.
Genovese, Eugene D. *Roll, Jordan, Roll: The World the Slaves Made*. New York: Pantheon Books, 1974. Vintage Books, 1976.
Glen, John M. *Highlander: No Ordinary School, 1932–1962*. Lexington: University of Kentucky Press, 1988.
Gongaware, George J., comp. *The History of the German Friendly Society of Charleston, South Carolina, 1766–1916*. Richmond: Garrett and Massie, 1935.
Good, Carter V., ed. *Dictionary of Education*. 3d ed. New York: McGraw-Hill Book Co., 1973.
Gordon, Asa H. *Sketches of Negro Life and History in South Carolina*. Privately printed, 1929. Columbia: University of South Carolina Press, 1970.
Green, Jeffrey P. *Edmund Thornton Jenkins: The Life and Times of an American Black Composer, 1894–1926*. Westport, Conn.: Greenwood Press, 1982.
Guilday, Peter. *The Life and Times of John England, First Bishop of Charleston (1768–1842)*. Vol. 2. New York: America Press, 1927.
Hale, William Bayard. *Woodrow Wilson: The Story of His Life*. Garden City and New York: Doubleday, Page, and Co., 1913.
Halleck, Reuben Post. *Psychology and Psychic Culture*. New York: American Book Co., 1895.
Harlan, Louis R., ed. *The Booker T. Washington Papers*. Vols. 2–4. Urbana: University of Illinois Press, 1972–1975.
Harlan, Louis R., and Raymond W. Smock, eds. *The Booker T. Washington Papers*. Vols 5–7. Urbana: University of Illinois Press, 1976–1977.
Hershberg, Theodore, ed. *Philadelphia Work, Space, Family, and Group Experience in the Nineteenth Century: Essays toward an Interdisciplinary History of the City*. Oxford: Oxford University Press, 1981.
High School of Charleston: Proceedings upon the Occasion of Opening the School House, Corner Meeting and George Streets, January 3, 1881, Scholarships, Prospectus, etc. Charleston: Published by order of the City Council of Charleston, News and Courier Book Presses [printer], n.d.
A History of the Calhoun Monument at Charleston, S.C. Charleston: Lucas, Richardson, and Co., 1888.
Holloway, James H. *Why I Am a Methodist: A Historical Sketch of What the Church*

Had Done for the Colored Children Educationally, as Early as 1790 at Charleston, S.C.
[Charleston]: R. Wainwright [printer], 1909.
Holt, Thomas. *Black over White: Negro Political Leadership in South Carolina during Reconstruction.* Urbana: University of Illinois Press, 1977.
Huggins, Nathan Irvin. *Black Odyssey: The Afro-American Ordeal in Slavery.* New York: Pantheon Books, 1977.
Jacoway, Elizabeth. *Yankee Missionaries in the South: The Penn School Experiment.* Baton Rouge: Louisiana State University Press, 1980.
Jervey, Theodore D. *The Slave Trade: Slavery and Color.* Columbia: State Co., 1925.
Johnson, Allen, ed. *Dictionary of American Biography.* Vol. 1. New York: Charles Scribner's Sons, 1964.
Johnson, Charles S. *Growing Up in the Black Belt: Negro Youth in the Rural South.* Washington, D.C.: American Council on Education, 1941. New York: Schocken Books, 1967.
Johnson, Michael P., and James L. Roark. *Black Masters: A Free Family of Color in the Old South.* New York: W. W. Norton and Co., 1984.
Johnson, Michael P., and James L. Roark, eds. *No Chariot Let Down: Charleston's Free People of Color on the Eve of the Civil War.* Chapel Hill: University of North Carolina Press, 1984. New York: W. W. Norton and Co., 1986.
Jones, Howard. *Mutiny on the* Amistad: *The Saga of a Slave Revolt and Its Impact on American Abolition, Law, and Diplomacy.* New York: Oxford University Press, 1987.
Jones, Jacqueline. *Soldiers of Light and Love: Northern Teachers and Georgia Blacks, 1865–1873.* Chapel Hill: University of North Carolina Press, 1980.
Jones-Jackson, Patricia. *When Roots Die: Endangered Traditions on the Sea Islands.* Athens: University of Georgia Press, 1987.
Journal of the Constitutional Convention of the State of South Carolina. . . . Columbia: Charles A. Calvo, Jr. [state printer], 1895.
Kemble, Frances Anne. *Journal of a Residence on a Georgian Plantation in 1838–1839.* New York: Alfred Knopf, 1961. New American Library, 1975.
Kluger, Richard. *Simple Justice: The History of Brown v. Board of Education and Black America's Struggle for Equality.* London: Andre Deutsch, 1977.
Knight, Edgar Wallace. *The Influence of Reconstruction on Education in the South.* New York: Teachers College, Columbia University, Contribution to Education, no. 60., 1913. Arno Press, 1969.
Koger, Larry. *Black Slaveowners: Free Slave Black Masters in South Carolina, 1790–1860.* Jefferson, N.C.: McFarland and Co., 1985.
Korn, Bertram Wallace. *Jews and Negro Slavery in the Old South, 1789–1865.* Philadelphia: Reform Congregation Keneseth Israel, Elkins Park, Pa., 1961.
Lawrence, W. H. *The Centenary Souvenir, Containing a History of the Centenary Church, Charleston, and an Account of the Life and Labors of Reverend R. V. Lawrence, Father of the Pastor of Centenary Church.* Philadelphia: Collins Printing House, 1885.
Litwack, Leon F. *Been in the Storm So Long: The Aftermath of Slavery.* New York: Alfred A. Knopf, 1979.
Lockwood, Sara E. H., and Mary Alice Emerson. *Composition and Rhetoric for Higher Schools.* Boston: Ginn and Co., 1901.

Low, W. Augustus, and Virgil A. Clift, eds. *Encyclopedia of Black America*. New York: McGraw-Hill Book Co., 1981.

McCord, David J., ed. *The Statutes at Large of South Carolina*. Edited under authority of the legislature. Vol. 7, *Containing the Acts Relating to Charleston Courts, Slaves, and Rivers*. Columbia: A. S. Johnston [printer], 1840.

McMillan, Lewis K. *Negro Higher Education in the State of South Carolina*. [Orangeburg, S.C.]: Author, [1952].

McPherson, James M. *The Abolitionist Legacy from Reconstruction to the NAACP*. Princeton: Princeton University Press, 1975.

Malone, Dumas, ed. *Dictionary of American Biography*. Vols. 3, 10. New York: Charles Scribner's Sons, 1935–1936, 1963.

Manning, Kenneth R. *Black Apollo of Science: The Life of Ernest Everett Just*. New York: Oxford University Press, 1983.

Mather, Frank Lincoln, ed. *Who's Who of the Colored Race: A General Biographical Dictionary of Men and Women of African Descent*. Vol. 1. Chicago: N.p., 1915.

Meier, August. *Negro Thought in America, 1880–1915: Racial Ideologies in the Age of Booker T. Washington*. Ann Arbor: University of Michigan Press, 1963.

Meier, August, and Elliott Rudwick. *Black History and the Historical Profession, 1915–1980*. Urbana: University of Illinois Press, 1986.

Monroe, Will S. *History of the Pestalozzian Movement in the United States*. Syracuse: G. W. Bardeen, 1907. New York: Arno Press, 1969.

Montgomery, D. H. *The Leading Facts of American History*. New York: Chautauqua Press, 1891.

Montgomery, Mabel. *South Carolina's Wil Lou Gray: Pioneer in Adult Education, a Crusader, Modern Model*. Columbia, S.C.: Vogue Press, 1963.

Mood, Francis A. *Methodism in Charleston: A Narrative of the Chief Events Relating to the Rise and Progress of the Methodist Episcopal Church in Charleston, S.C., with Brief Notices of Early Ministers Who Labored in That City*. Edited by Thomas O. Sumners. Nashville: E. Stevenson and J. E. Evans for the Methodist Episcopal Church, South, 1856.

Morris, Robert C. *Reading, 'Riting, and Reconstruction: The Education of Freedmen in the South, 1861–1870*. Chicago: University of Chicago Press, 1981.

Morrison, Gayle. *To Move the World: Louis G. Gregory and the Advancement of Racial Unity in America*. Wilmette, Ill.: Bahai Publishing Trust, 1982.

Nelson, Stephen L., comp. and ed. *Charleston Looks at Its Services for Negroes: A Condensed Report of the Findings and Recommendations of the Inter-Racial Study Committee of the Charleston Welfare Council in Cooperation with the Community Relations Project of the National Urban League, May 1947, Charleston, South Carolina*. [Charleston?]: N.p., [1947?].

Newby, I. A. *Black Carolinians: A History of Blacks in South Carolina from 1895 to 1968*. Columbia: University of South Carolina Press, 1973.

———. *The South: A History*. New York: Holt, Rinehart and Winston, 1978.

O'Brien, Michael, and David Moltke-Hansen, eds. *Intellectual Life in Antebellum Charleston*. Knoxville: University of Tennessee Press, 1986.

One Hundred Fifteenth Anniversary of Plymouth Congregational Church, United Church of Christ, Saturday, April 17, 1982–Sunday, April 18th, 1982. [Charleston?]: N.p., [1982?].

O'Neall, John Belton. *The Negro Law of South Carolina, Collected and Digested by John Belton O'Neall, One of the Judges of the Court of Law and Errors of Said State, under a Resolution of the State Agricultural Society of South Carolina.* Columbia: John G. Bowman [printer], 1848.

Osofsky, Gilbert. *Harlem, the Making of a Ghetto: Negro New York, 1890–1930.* New York: Harper and Row, 1966.

Ottley, Roi. *"New World A-Coming": Inside Black America.* New York: Literary Classics, 1943. Arno Press, 1968.

Payne, Daniel Alexander. *Recollections of Seventy Years.* Nashville: A.M.E. Sunday School Union, 1888. New York: Arno Press, 1969.

Pease, William H., and Jane H. Pease. *The Web of Progress: Private Values and Public Styles in Boston and Charleston, 1828–1843.* New York: Oxford University Press, 1985.

Pestalozzi, Johann Heinrich. *The Education of Man: Aphorisms.* Philosophical Library, 1951. New York: Greenwood Press, 1969.

Pickens, William. *Bursting Bonds: The Heir of Slaves.* 1923. Enlarged edition. Boston: Jordan and More Press, 1929.

Pitts, Raymond J. *Reflections on a Cherished Past: Reflections of the Ballard Normal School Experience by Graduates with Commentary by Raymond J. Pitts.* Sacramento: Author, 1980.

Porter, A. Toomer. *Led On! Step by Step Scenes from Clerical, Military, Educational, and Plantation Life in the South, 1828–1898: An Autobiography.* New York: G. P. Putnam's Sons, 1898.

Proceedings of the Constitutional Convention of South Carolina. [Held at Charleston, Beginning January 14th and Ending March 17th, 1868, Including the Debates and Proceedings, Reported by J. Woodruff, Phonographic Reporter]. Vol. 1. Charleston: Published by order of the Convention, 1868. New York: Arno Press, 1968.

Public Schools of Charleston, South Carolina: A Survey Report. Nashville: Division of Surveys and Field Services, George Peabody College for Teachers, 1949.

Quint, Howard H. *Profile in Black and White: A Frank Portrait of South Carolina.* Washington, D.C.: Public Affairs Press, 1958.

Reuter, Edward Byron. *The Mulatto in the United States, Including the Role of Mixed-Blood Races throughout the World: A Dissertation Submitted to the Faculty of Graduate School of Arts and Literature in Candidacy for the Degree of Doctor of Philosophy, Department of Sociology.* Boston: Richard G. Badger, 1918. New York: Negro Universities Press, 1969.

Richardson, Joe M. *Christian Reconstruction: The American Missionary Association and Southern Blacks, 1861–1890.* Athens: University of Georgia Press, 1986.

———. *A History of Fisk University, 1865–1946.* University: University of Alabama Press, 1980.

Riley, Henry Thomas, ed. *Dictionary of Latin Quotations, Proverbs, Maxims, and Mottos, Classical and Mediaeval, Including Law Terms and Phrases, with a Selection of Greek Quotations.* London: H. G. Bohn, 1856.

Rose, Willie Lee. *Rehearsal for Reconstruction: The Port Royal Experiment.* Indianapolis: Bobs-Merrill Co., 1964.

Rowan, Carl T. *South of Freedom.* New York: Alfred A. Knopf, 1952.

Rowe, George C. *Our Heroes: Patriotic Poems on Men, Women, and Sayings of the Negro Race.* Charleston: Walker, Evans, and Cogswell Co., 1890.

Shealy, Lois T., ed. *Biographies and Pictures of Members of the Senate and House of Representatives and Officers, State of South Carolina, 1987 Session, (Excerpt from 1987 Legislative Manual) Corrected to December 22, 1986.* Columbia: [State Legislature?], n.d.

Simkins, Francis Butler. *Pitchfork Ben Tillman: South Carolinian.* Baton Rouge: Louisiana State University Press, 1944. First paperback printing, 1967.

Simkins, Francis Butler, and Robert Hilliard Woody. *South Carolina during Reconstruction.* Chapel Hill: University of North Carolina Press, 1932.

Simmons, William J. *Men of Mark: Eminent, Progressive, and Rising.* Cleveland: Geo. M. Rewell and Co., 1887. New York: Arno Press, 1968.

The Southern Regional Council: Its Origin and Purpose. Atlanta: Southern Regional Council, 1944.

Souvenir Booklet: Anniversary of Zion Presbyterian Church, March 14th thru 21st, 1948, 123 Calhoun Street, Charleston, S.C. Charleston: J. J. Furlong and Son, ca. 1948.

Spear, Allan H. *Black Chicago: The Making of a Negro Ghetto, 1890–1920.* Chicago: University of Chicago Press, 1967.

Starobin, Robert, ed. *Denmark Vesey: The Slave Conspiracy of 1822.* Englewood Cliffs, N.J.: Prentice-Hall, 1970.

Steele, G. M. *Outlines of Bible Study: A Four-Years Course for Schools and Colleges.* Boston: Sibley and Co., 1889.

Stein, Judith. *The World of Marcus Garvey: Race and Class in Modern Society.* Baton Rouge: Louisiana State University Press, 1986.

Stevens, William Oliver. *Charleston, Historic City of Gardens.* New York: Dodd, Mead, and Co., 1946.

Swint, Henry Lee. *The Northern Teacher in the South, 1862–1870.* Nashville: Vanderbilt Press, 1941. New York: Octagon Books, 1967.

Taylor, Alrutheus Ambush. *The Negro in South Carolina during Reconstruction.* Washington, D.C.: Association for the Study of Negro Life and History, 1924.

Taylor, Mary. *A History of the Memminger Normal School, Charleston, S.C.* [Charleston?]: N.p., 1954.

A Testimonial Dinner and Presentation of Bronze Plaque Commemorating the Historic Contribution of the Honorable J. Waties Waring, United States District Judge, Retired, in the Clarendon County, South Carolina Case against Public School Segregation, Given by the South Carolina Conference of the National Association for the Advancement of Colored People, Buist School, Charleston, South Carolina, November 6, 1954. [Charleston?]: N.p., [1954?].

Thomason, John Furman. *The Foundations of the Public Schools of South Carolina.* Columbia: State Co., 1925.

Thompson, E. P. *The Making of the English Working Class.* London: Victor Gollanz, 1965.

Tindall, George Brown. *South Carolina Negroes, 1877–1900.* Columbia: University of South Carolina Press, 1952.

Tjerandsen, Carl. *Education for Citizenship: A Foundation's Experience.* Santa Cruz, Calif.: Emil Schwarzhaupt Foundation, 1980.

Wade, Richard C. *Slavery in the Cities: The South, 1820–1860.* New York: Oxford University Press, 1964.

Walker, Clarence Earl. *A Rock in a Weary Land: The African Methodist Episcopal*

Church during the Civil War and Reconstruction. Baton Rouge: Louisiana State
 University Press, 1982.
Warren, Mortimer A. *The Graded Class-Word Speller, Containing Several Thousand
 Words, Grouped in Classes, and Arranged to Form a Progressive Course in Spelling,
 Together with a Complete Course in Phonic Analysis, Designed, Also, as an Introduction
 to the Dictionary and an Aid in the Practice of English Composition.* New York:
 Taintor Brothers and Co., 1876.
Weare, Walter B. *Black Business in the New South: A Social History of the North
 Carolina Mutual Life Insurance Company.* Urbana: University of Illinois Press,
 1973.
Webster, Laura Josephine. *The Operation of the Freedmen's Bureau in South Carolina.*
 Smith College Studies in History, vol. 1. Northampton, Mass.: Smith College
 Department of History, 1916.
White, Emerson E. *The Art of Teaching: A Manual for Teachers, Superintendents,
 Teachers' Reading Circles, Normal Schools, Training Classes, and Other Persons
 Interested in the Right Training of the Young.* New York: American Book Co., 1901.
Who's Who in America, 1974–1975. Vol. 2. 38th ed. Chicago: Marquis–Who's Who,
 1974.
*Who's Who of American Women: A Biographical Dictionary of Notable Living American
 Women.* Vol. 1. 1st ed. Chicago: Marquis Who's Who, 1958.
Wikramanayake, Marina. *A World in Shadow: The Free Black in Antebellum South
 Carolina.* Columbia: University of South Carolina Press, 1973.
Williamson, Joel. *After Slavery: The Negro in South Carolina during Reconstruction,
 1861–1877.* Chapel Hill: University of North Carolina Press, 1965.
——— . *The Crucible of Race: Black-White Relations in the American South since
 Emancipation.* New York: Oxford University Press, 1984.
——— . *New People: Miscegenation and Mulattoes in the United States.* New York: Free
 Press, 1980.
Willson, John O. *Sketch of the Methodist Church in Charleston, S.C., 1785–1887.*
 Charleston: Lucas Richardson and Co., 1888.
Winch, Julie. *Philadelphia's Black Elite: Activism, Accommodation, and the Struggle for
 Autonomy, 1787–1848.* Philadelphia: Temple University Press, 1988.
Wood, Peter H. *Black Majority: Negroes in Colonial South from 1670 through the Stono
 Rebellion.* New York: Alfred A. Knopf, 1974.
Woodson, Carter G. *Free Negro Heads of Families in the United States in 1830 Together
 with a Brief Treatment of the Free Negro.* Washington, D.C.: Association for the
 Study of Negro Life and History, 1925.
——— . *The Mis-Education of the Negro.* Washington, D.C.: Associated Publishers,
 1933. New York: AMS Press, 1972.
Yarbrough, Tinsley E. *A Passion for Justice: J. Waties Waring and Civil Rights.* New
 York: Oxford University Press, 1987.
Yenser, Thomas, ed. *Who's Who in Colored America: A Biographical Dictionary of
 Notable Living Persons of African Descent in America.* 4th ed. New York: Who's Who
 in Colored America, 1933–1937.

PAPERS, THESES, DISSERTATIONS, AND
MISCELLANEOUS UNPUBLISHED WORKS

Abbott, Martin L. "The Freedmen's Bureau in South Carolina, 1865–1872."
Ph.D. diss., Emory University, 1954.

Anderson, James Douglas. "Education for Servitude: The Social Purposes of
Schooling in the Black South, 1870–1930." Ed.D. diss., University of Illinois,
1973.

Bolden, Ethel Evangeline Martin. "Susan Dart Butler—Pioneer Librarian." M.S.
thesis, Atlanta University, 1959.

Bowler, Susan M., and Edmund L. Drago. "Black Intellectual Life in Antebellum
Charleston." Paper, Organization of American Historians, Los Angeles,
California, April 7, 1984.

De Boer, Clara Merritt. "The Role of Afro-Americans in the Origin and Work of
the American Missionary Association, 1839–1877." Ph.D. diss., Rutgers
University, 1979.

Devlin, George Alfred. "South Carolina and Black Migration, 1865–1940: In
Search of the Promised Land." Ph.D. diss., University of South Carolina, 1984.

Everett, Robert Burke. "Race Relations in South Carolina, 1900–1932." Ph.D.
diss., University of Georgia, 1969.

Fitchett, E. Horace. "The Free Negro in Charleston, South Carolina." Ph.D. diss.,
University of Chicago, 1950.

Hemmingway, Theodore. "Beneath the Yoke of Bondage: A History of Black Folks
in South Carolina, 1900–1940." Ph.D. diss., University of South Carolina,
1976.

Hine, William C. "Frustration, Factionalism, and Failure: Black Political
Leadership and the Republican Party in Reconstruction Charleston,
1865–1877." Ph.D. diss., Kent State University, 1979.

Holland, Davis R. "A History of the Desegregation Movement in the South
Carolina Public Schools during the Period 1954–1976." Ph.D. diss., Florida
State University, 1978.

Jenkins, Maude Thomas. "The History of the Black Woman's Club Movement in
America." Ed.D. diss., Teachers College, Columbia University, 1984.

Johnson, Clifton H. "The American Missionary Association, 1846–1861: A Study
of Christian Abolitionism." Ph.D. diss., University of North Carolina, 1958.

"Ladies and Gentlemen, Wilmot Jefferson Fraser upon His Retirement, June 25,
1970."

Moore, Burchill Richardson. "A History of the Negro Public Schools of
Charleston, South Carolina, 1867–1942." Master's thesis, School of Education,
University of South Carolina, 1942.

Morton, Ruth Alma. "The Religious Significance of an American Folk School."
Master's thesis, Department of Christian Theology and Ethics, University of
Chicago, 1934.

Neale, Diane. "Benjamin Ryan Tillman: The South Carolina Years." Ph.D. diss.,
Kent State University, 1976.

O'Connell, Neil J. "The Religious Origins and Support of the Highlander Folk
School." Paper, Southern Labor History Conference, Georgia State University,
Atlanta, Ga., May 5, 1978.

Potts, John Foster. "A History of the Growth of the Negro Population of Gary, Indiana." Master's thesis, Cornell University, 1937.

Powers, Bernard Edward, Jr. "Black Charleston: A Social History, 1822–1885." Ph.D. diss., Northwestern University, 1982.

Secrest, Andrew McDonald. "In Black and White: Press Opinion and Race Relations in South Carolina, 1954–1964." Ph.D. diss., Duke University, 1972.

"A Short History of the Shaw Monument Fund: Shaw Community Center at 22 Mary Street, Charleston, South Carolina." N.d.

Simmons, J. Andrew. "Professional and Cultural Background of the Teachers in the South Carolina High Schools for Negroes." Master's thesis, Teachers College, Columbia University, n.d.

Stavisky, Leonard P. "The Negro Artisan in the South Atlantic States, 1800–1860: A Study of Status and Economic Opportunity with Special Reference to Charleston." Ph.D. diss., Columbia University, 1958.

Terry, Robert Lewis. "J. Waties Waring, Spokesman for Racial Justice in the New South." Ph.D. diss., University of Utah, 1970.

Walker, Clarence E. "The Virtuoso Illusionist: Marcus Garvey." Manuscript, December 6, 1983.

Werner, Randolph. " 'New South' Carolina: Ben Tillman and the Rise of Bourgeois Politics, 1880–1893." Paper, Fourth Citadel Conference on the South, Charleston, April 11–13, 1985.

Westmoreland, Edgar Paul. "A Study of Negro Public Education in the State of South Carolina, with Particular Reference to the Influences of the Reconstruction Period." Master's thesis, Howard University, 1935.

White, Pamela Mercedes. " 'Free and Open': The Radical University of South Carolina, 1873–1877." Master's thesis, University of South Carolina, 1975.